THE SOUL OF A NATION READER

THE
SOUL OF
A NATION
READER

WRITINGS BY AND ABOUT
BLACK AMERICAN ARTISTS,
1960–1980

**EDITED BY MARK GODFREY
AND ALLIE BISWAS**

GREGORY R. MILLER & CO.

CONTENTS

1972

NOTE TO THE READER

Of the approximately 230 individual texts included in this anthology, many are reproduced in their entirety, including some of considerable length. Others have been edited not strictly for length but because portions of the text are not relevant to the debates about Black art outlined in Mark Godfrey's introduction to this volume. Such omissions are indicated either by an ellipsis in square brackets [. . .] or by a short characterization of the omitted text, also in square brackets and *italicized*. Text in square brackets that is *not* italicized appeared in exactly that manner in the original publication (i.e., within square brackets and in roman type). Similarly, ellipses that are *not* enclosed in square brackets were present in the original publication.

Other than these abridgements, the texts have been edited only to correct obvious unintentional misspelling of words and names and to italicize titles of works and exhibitions that originally appeared in roman type. Unconventional spelling and capitalization that might be construed as intentional have been retained (followed by [*sic*] in some instances). As remains the case today, there was no consensus during the period covered by the anthology about whether to capitalize the word "Black," and the treatment varies throughout the original texts. In Godfrey's and Allie Biswas's newly written contributions to this volume, however, both "Black" and "White" are capitalized, in an acknowledgment that race is not a "natural" category but a socially constructed one.

In the table of contents and the headers preceding the texts, authors' names are given exactly as they appeared in the original publications (with any necessary clarifications in square brackets). In the introductions to each text by Biswas (as well as in Godfrey's and Zoé Whitley's contributions), authors' and artists' names are given in full, including middle names or initials and suffixes, according to the individual's preferred practice.

Notes appear at the end of a text or group of texts covered by a single introduction. Notes in square brackets are by this volume's editors, providing clarifications, citations, or cross-references. All other notes have been reproduced verbatim from the original publications.

FOREWORD

The "Soul of a Nation" Reader collects more than two hundred texts by and about Black artists and "Black art" that were first published in the 1960s, 1970s, and early 1980s in the United States. My work on the anthology began in London around 2014 while I was a senior curator at Tate Modern researching acquisitions for Tate's permanent collection in a team of curators led by Frances Morris. Already having important works in the collection by major African American artists from the 1990s onward, we began to look back and acquire works by artists such as Norman Lewis, Barkley L. Hendricks, Senga Nengudi, and Jack Whitten. One of the North American patrons supporting these acquisitions was Pamela J. Joyner, and she soon asked me to write an essay about abstraction in the late 1960s for a forthcoming book about her collection. My first book, *Abstraction and the Holocaust*, had looked at the ways artists responded to the calamities of the mid-twentieth century through abstraction, and I was very interested to think about how artists such as Whitten, Frank Bowling, Sam Gilliam, and others had addressed the politics of the civil rights movement without making recognizable images: this was the subject of my essay for the book edited by Courtney J. Martin, *Four Generations: The Joyner/Giuffrida Collection of Abstract Art.*

In the process of researching the Tate acquisitions and the Joyner/Giuffrida essay, I read texts by and about many artists. I was struck, first of all, by the intensity of the discussions among the artists, and second, by how difficult it was to find the texts unless one had access to a substantial research library. Some texts were completely inaccessible in the United Kingdom. I had frequently consulted anthologies about Pop, Minimalism, and conceptual art when studying American postwar art, and it seemed obvious that there should also be an anthology of texts about the debates over "Black art" during the same time period. In these other anthologies, discussions among artists centered around categories such as painting and sculpture, illusion and reality, dematerialization, criticality, and consumer culture. Black artists were interested in all these questions but also asked other ones, including what the responsibility of the artist is in response to political crisis, where and how to exhibit, and whether or not a Black aesthetic even exists.

Just as I was reading texts from the 1960s by Bowling, Benny Andrews, and others, I heard from Massimiliano Gioni, who, that year, was chairing the jury for the Absolut Art Award. He had nominated me for the award for art writing and invited me to propose a book that Absolut would help to fund if I won. I proposed this anthology and, in May 2015, won the prize. Saskia Neuman, then directing Absolut's art activities, was extremely supportive

and continued to be as the project developed. After winning the award, I approached Darren Walker at the Ford Foundation for funds matching those from Absolut to help research the publication, and he graciously agreed. I am truly grateful to him and the Ford Foundation for their early support of the project.

By mid-2015, it was becoming clear to me that an exhibition related to the debates I was encountering would also be compelling, bringing together artists of different groups and in different cities, all of whom thought about "Black art" in different ways, sometimes eager to define it, sometimes rejecting the term. Thanks to the support of Frances Morris and Achim Borchardt-Hume, the exhibition was confirmed for Tate's schedule for the summer of 2017. Zoé Whitley, then a research curator at Tate, joined me as co-curator, and we continued the research for the show together, visiting artists' studios, selecting works, and conceiving the catalogue and public program, assisted by Priyesh Mistry. Working with Zoé has been a wonderful experience; we learned so much together, and I am incredibly grateful for our years of conversations about the art and artists and politics we were thinking about, and for her friendship. *Soul of a Nation: Art in the Age of Black Power* opened at Tate Modern, and it has been humbling to watch as the show has traveled to the Crystal Bridges Museum of American Art, the Brooklyn Museum, the Broad, the de Young, and the Museum of Fine Arts, Houston, and to work with curators at each institution who shaped the show for their audiences: Lauren Haynes, Ashley James, Sarah Loyer, Timothy A. Burgard, and Kanitra Fletcher, respectively.

Meanwhile, with Absolut's and the Ford Foundation's funds secured, work on the anthology continued, and Allie Biswas joined me first as a research assistant and then as the volume's coeditor. Allie has been the most resourceful, patient, and efficient partner in this publication, hunting down texts in archives and libraries up and down the East Coast. The anthology gradually grew to the shape it is now, and Allie led the way in writing introductions for each text. Below, Allie thanks the many people who helped in finding the texts. In addition, I wish to thank David Lusenhop, Nigel Freeman, and halley k. harrisburg.

Over the five years between the Absolut Art Award and the publication of *The "Soul of a Nation" Reader*, I was able to meet a number of curators, art historians, and artists whose advice, conversation, and work helped to shape this book. They include Thelma Golden, Linda Goode Bryant, Susan E. Cahan, Mary Schmidt Campbell, A. C. Hudgins, Margo Natalie Crawford, Huey Copeland, Sampada Aranke, Tuliza Fleming, Rebecca Zorach, Kerry James Marshall, Theaster Gates, Martine Syms, Lorna Simpson, and Glenn Ligon as well as my colleagues on the Advisory Committee of the Getty Research Institute's African American Art History Initiative: Kellie Jones, Andrianna Campbell-LaFleur, Bridget R. Cooks, Andrea Barnwell Brownlee, Erin Christovale, Gary Simmons, Richard J. Powell, Katy Siegel, and Getty

staff members LeRonn Brooks, James Cuno, Andrew Perchuk, and Rebecca Peabody. As Allie and I worked, this anthology also drew on the bibliographies of several books published since the project began: Abdul Alkalimat, Romi Crawford, and Rebecca Zorach's *The Wall of Respect: Public Art and Black Liberation in 1960s Chicago*; Susan E. Cahan's *Mounting Frustration: The Art Museum in the Age of Black Power*; Margo Nathalie Crawford's *Black Post-Blackness: The Black Arts Movement and Twenty-First-Century Aesthetics*; Darby English's *1971: A Year in the Life of Color*; Kellie Jones's *South of Pico: African American Artists in Los Angeles in the 1960s and 1970s*; and Catherine Morris and Rujeko Hockley's *We Wanted a Revolution: Black Radical Women, 1965–85*.

Most of all, I am grateful to the artists and writers whose words are published here. Of them, I have had the great privilege to meet Dawoud Bey, Frank Bowling, Dana C. Chandler Jr., David C. Driskell, Melvin Edwards, Sam Gilliam, David Hammons, Barkley L. Hendricks, Jae Jarrell, Wadsworth Jarrell, Carolyn Lawrence, Samella S. Lewis, Senga Nengudi, Lorraine O'Grady, Joe Overstreet, Howardena Pindell, Raymond Saunders, Nelson Stevens, Faith Ringgold, Betye Saar, Timothy Washington, Jack Whitten, Gerald Williams, Randy Williams, and William T. Williams as well as the families of Roy DeCarava, Norman Lewis, Alvin Loving, and Charles White. I would also like to thank David Hammons for granting permission to use a detail from his body print *Black First, America Second* (1970) on the cover of this book as well as Lois Plehn and Connie Tilton for their help in facilitating this.

When work on this book began, we envisaged that it would include about fifty texts. But as research revealed more and more important writing, the anthology expanded in potential scope, and I approached Gregory R. Miller, who immediately agreed to publish the book. Greg has been the most supportive of publishers and I thank him immensely, together with Alexander Johns, Jennifer Bernstein, Amelia Kutschbach, Julia Ma, Tina Henderson, Michelle Peng, and the incredible Miko McGinty.

MARK GODFREY

A project of this nature would not be viable were it not for the decades of tremendous work that has been carried out by libraries and archives across the United States and elsewhere. From the outset, the evolution of our book was dependent on locating the essays, exhibition reviews, dialogues, and declarations that appear here—and that have been so carefully preserved by cultural institutions.

The initial stages of research required me to be on the ground in New York, where I was fortunate enough to become closely acquainted with the Schomburg Center for Research in Black Culture in Harlem. The Schomburg is an invaluable resource for literature relating to African American

history, and I am extremely grateful, in particular, to the librarians Diana Tan and Troy Belle, who were always at hand. Thanks also to Lori Salmon and the Art and Architecture Collection of the New York Public Library, Kat Stefko at Bowdoin College Library, Amanda Focke at the Fondren Library at Rice University, and DeLisa Minor Harris at the John Hope and Aurelia E. Franklin Library at Fisk University as well as to the Brooklyn Public Library, Pratt Institute Libraries, Yale University Library, Fleet Library at Rhode Island School of Design, Boston Public Library, and British Library. Emory University's Rose Library, where I was assisted by Randall K. Burkett, Heather Oswald, and Kathleen Shoemaker, was another critical site.

The research holdings at museums proved to be essential. Mimi Lester and Elizabeth Gwinn at the Studio Museum in Harlem offered valuable support throughout. Jenny Tobias at the Museum of Modern Art Library, whom I first encountered a decade ago when I was an intern at the museum, was, as always, generous in her assistance. I would also like to thank Piper Severance at the Los Angeles County Museum of Art, Joseph Newland at the Menil Collection, Ivy Blackman at the Whitney Museum of American Art, Richard Rinehart at the Samek Art Museum, and Rachel High at the Metropolitan Museum of Art.

Others to thank include Anne Doran, Zoe Sternberg, and Andrea Mihalovic as well as Maggie Barrett and David Godfrey, who took the photographs that appear on pages 289–308.

Identifying and searching for the texts for the anthology also led to correspondence with those who personally knew the artists and authors featured here. It has meant a lot to receive the support of Susan Batson, Emory Douglas, Avatar and Evelyn Neal, Erika Fine, Susan Haller, Grace Hopkins, Claude Lewis, Jam Donaldson, Elissa Kline, and Julia and Useni Perkins.

As the book materialized, I was grateful for the conversations I was able to have with a number of artists in New York, including Adam Pendleton, Rina Banerjee, Meleko Mokgosi, Rashid Johnson, and Hank Willis Thomas. Similarly, the encouragement of Phong Bui and all at the *Brooklyn Rail* must be acknowledged. I would also like to thank Courtney J. Martin for her friendship. Finally, I am immensely grateful to my coeditor, Mark Godfrey, for the incredible opportunity to contribute to what we believe is a most vital and overdue publication.

ALLIE BISWAS

INTRODUCTION

MARK GODFREY

In April 1971, the artist Frank Bowling wrote an essay for the New York–based publication *ARTnews* developing arguments he had presented in an earlier series of essays called "Discussion on Black Art," published in *Arts Magazine*. The 1971 text was titled "It's Not Enough to Say 'Black Is Beautiful,'" and in it, Bowling championed the work of certain American artists to whom he was artistically and socially connected, including Melvin Edwards, Al Loving, William T. Williams, and Daniel LaRue Johnson. Bowling explained how an "esthetic of black art" worked in their paintings—one that had to do with "secrecy and disguise," with the idea of "turning such things as language inside out," with "signifying" one set of ideas to some viewers and other ideas to other viewers. Most critics would have labeled these artists' work "abstract," but Bowling did not use that term, because he was sensitive to the various meanings embedded in their art and to their ways of disrupting and transforming current artistic conventions.[1]

In supporting these artists, Bowling contrasted their work with the kind of image-based, overtly politicized art that, at the time, was more often heralded as exemplary of a Black aesthetic. Bowling cast that art aside as "Social Realism." Unwilling to look closely at the complex aesthetic and material qualities of works by the artists he opposed, who were, in fact, very different from one another, Bowling shunned all of them as mere message makers. He concluded of their work: "None of it measures up to the impact or immediacy of a television newscast." Bowling was referring here to "certain New York, Boston and Chicago artists," name-checking Benny Andrews, Dana C. Chandler Jr., and Gary Rickson while also alluding to the AfriCOBRA group. In addition to dismissing their art, he referred disparagingly to texts they had published, including Andrews's article "On Understanding Black Art," which appeared in the *New York Times* in June 1970. Bowling probably also knew Jeff Donaldson's "AFRICOBRA 1: *10 in Search of a Nation*," which came out in *Black World* four months later, and Chandler's catalogue introduction for the exhibition *12 Black Artists from Boston*, which had been mounted in 1969 at Brandeis University's Rose Art Museum in Waltham, Massachusetts.

Setting aside an assessment of the arguments Bowling made, or indeed those of Andrews, Chandler, or Donaldson, we can say for certain that "It's Not Enough to Say 'Black Is Beautiful'" is evidence of a robust discussion, in print, among artists who passionately argued for radically different ideas of Black art. The discussion had begun in the early 1960s, during the key years of the civil rights movement, when "Negro" artists (as they called themselves then) asked what their practices meant at such a turbulent moment in

history. The discussion grew louder during the advent of Black Power, when artists redefined themselves as "Black" and "Afro-American," then as "African American." By 1971, the discussion was reaching a crescendo. Many artists dedicated themselves, in both their art and their writing, to outlining what a Black aesthetic could mean; others, who wanted to maintain a distance between their work and these questions, found it impossible to operate in the public realm without being challenged to explain what "Black art" meant to them. The discussion, by this time, involved different proposals about how Black artists should or should not deal with politics, about what audiences they should address and inspire, where they should try to exhibit, how their work should be curated, and whether there was or was not such a category as "Black art" in the first place.

Months after Bowling's essay was printed, in September 1971, a small show titled *Black Art: The Black Experience* was mounted at Occidental College in Los Angeles, coorganized by the independently run, Black-owned Brockman Gallery. The curator was an Occidental student named Steve Smith, who was researching Black art in his coursework. Smith's short catalogue set out three approaches taken by contemporary Black artists. First, he discussed abstract artists such as Sam Gilliam, whose work (Smith felt) did not express any "racial feeling." Next, he mentioned those "who have turned to Africa and its traditional art forms for inspiration." Finally, he described those who were "engaged in a type of personal social comment based upon their insight as black men in America." Artists from this last group were the subject of Smith's show: first among them was David Hammons, joined by David Bradford, Marie Johnson, John Outterbridge, and Noah Purifoy. Like a good concientious researcher, Smith backed up his argument with quotations from texts by Romare Bearden, Bowling, Hammons, and others and supplied a bibliography, listing no fewer than twenty-seven articles published about "Black art" since 1966, four of which were by Bowling.

Smith's specific claims for Hammons and Purifoy were not the most nuanced arguments that appeared about their work in those early days, but what is important to note is how many texts Smith brought to bear on his curatorial investigation. By this date, the young LA curator would have had little opportunity to see Gilliam's or Bowling's actual work, as those artists had not traveled to the West Coast, just as Hammons and the others in Smith's show had probably not been to New York. It would be some time before most of the East Coast artists traveled to California, whereas the Californians showed in New York the next year, when all five of Smith's artists were included in the Studio Museum in Harlem's 1972 exhibition *Eleven from California*. The point is that *before* the artists met in person or saw one another's work, many were aware of both the shared and the disputed ideas about Black art, thanks to articles of the kind Smith so rigorously cited.

These texts were readily available to Smith because they had all recently appeared in print, but since that time, they have not been anthologized; many

are now extremely difficult to find, even in well-stocked university libraries—this despite the huge interest art historians have taken in the aesthetic debates of the 1960s and the great attention paid to the same era in African American studies. There are many anthologies of key texts by artists and critics associated with Minimalism and Conceptual art but no books bringing together key texts by or about Black artists of the period. There are anthologies gathering key source texts on the Black Arts Movement, such as John H. Bracey Jr., Sonia Sanchez, and James Smethurst's *SOS—Calling All Black People: A Black Arts Movement Reader*, published in 2014, but unsurprisingly, that reader reflects the movement's focus on poetry, theater, and music rather than visual art. A painting by Nelson Stevens graces the cover, but no texts by Stevens's AfriCOBRA colleagues are included.

The present anthology sets out to republish many of the key texts that were available to individuals such as Bowling and Smith in the hope that a fuller account of the art of the period can be made. Of course, this book cannot claim to be exhaustive, and there will surely be texts we have missed. Inevitably, these will be pointed out by reviewers, and said reviewers are encouraged to direct their readers to the texts so that the picture created of the period can be richer still. In this introduction, I will outline the parameters determining which texts have been included here, then discuss the kinds of texts featured and where they were published and give a short account of the different approaches taken to the matter of a Black aesthetic over the period in question, approximately 1963 to 1980.

DEFINING THE CONTENTS

This anthology shares a genealogy with *Soul of a Nation: Art in the Age of Black Power*, so there are texts by or about most of the artists with work in that exhibition.[2] Rather than gathering any and all related source material, however, the guiding principle in selecting texts for inclusion here is that, when they appeared, they took a position within an ongoing public debate. The debate concerned the role and predicament of Black artists, or of Black women artists specifically; the possibility or impossibility of a Black aesthetic in general and in specific media; the status of abstraction in Black art; what kind of institutions should house the work of Black artists; why Black art needed to be supported by dealers and collectors; what kind of exhibitions by Black artists were necessary or problematic; and art criticism itself—who had the right to discuss Black art. Some texts articulate a shared sense of ambition and purpose among artists who knew one another and who sometimes formed collectives; some texts give an indication of disagreement among Black artists. But each text was part of a debate. Almost all the texts are about visual art, but there are also a few key texts by theorists of the Black Arts Movement, such as Amiri Baraka (formerly LeRoi Jones), Larry Neal, and Addison Gayle Jr., and by critics who opposed their views, such as Martin Kilson. These essays are not explicitly concerned with visual art,

but they clearly informed the debate, and precisely because of their relative silence about painting, sculpture, and photography (as opposed to music, poetry, and theater), other writers were encouraged to develop original and varied positions about those other art forms.

Before turning to the kinds of texts that appear here, a few words on what is *not* included. Essays that focus on a single artist's work—whether published in a magazine or an exhibition catalogue—and that concentrate on the development of an oeuvre rather than the artist's position vis-à-vis "Black art" are not anthologized here, because this is not a compendium of *all* the texts on Black artists from this period. A few monographic texts, however, *do* locate an artist's practice in a wider discourse, and so they are included. The exclusion of most monographic texts means, for instance, that important essays and introductions by Mary Schmidt Campbell for Studio Museum in Harlem shows of the 1970s and early 1980s, including those devoted to Melvin Edwards (1978), Beauford Delaney (1978), Barkley L. Hendricks (1980), and Sam Gilliam (1983), do not appear here. They should still be understood as key sources for researchers of this period.

Letters between artists are not included, because of their private nature, and the same is true of studio notes. Jack Whitten's studio notes from this period have recently been published, and many of his observations are extremely pertinent to the debates covered in this anthology. He complained in his notes that powerful New York institutions seemed to acquire his works for reasons of tokenism rather than out of a commitment to his art; he was angry about the way these museums went on to exhibit the works they owned by Black artists in outposts in New York's boroughs, as community projects, rather than hanging them in their headquarters. "The [Metropolitan] museum purchased the painting [of mine] to use it as a political vehicle," he wrote on April 20, 1976, after the Met showed the work, *Delta Group II* (1975), in *Selected Black Artists* at the Bedford-Stuyvesant Restoration Corporation.[3] Certainly, Whitten would have shared his thoughts with his close friends at the time, but because they were not more publicly articulated, they are not published here.

Memoirs about the period are also not included because they appeared *after* it: Faith Ringgold's *We Flew over the Bridge*, for example, is a key text for understanding these debates, but it came out only in 1995. Ringgold was not often published in the 1960s and 1970s, so her voice is little represented here. This is, of course, out of step with the impact her works had at the time, an observation that leads to a more general point about Black women artists of the period: When trying to research, make, and exhibit their art, they had to face not only the racism and sexism of art colleges, galleries, and museums but the related exclusions imposed by magazine and newspaper editors. They also faced sexism from male Black artists, as we can infer from the cast of characters at the important panel discussions of the time. Included here are key texts such as Kay Brown's "'Where We At' Black Women Artists,"

published in the *Feminist Art Journal* in 1972, and Elizabeth Catlett's "The Role of the Black Artist," published in 1975 in the *Black Scholar*, but there are, inevitably, far fewer texts by women than by men.

The period of the 1960s and 1970s also saw incredibly important contributions to the field of African American art history. Black art historians and artist–art historians such as Carroll Greene Jr., David C. Driskell, and Samella S. Lewis published extensive accounts of African American art from the eighteenth century to the 1970s. Some of these texts are included here, but the historical material has been reduced so that the focus is on the authors' judgments of contemporary art. Other scholars produced work that had a profound impact on contemporary artists, including Robert Farris Thompson, whose essay "African Influence on the Art of the United States" was published by Yale University Press in 1969 in its symposium volume *Black Studies in the University*. Drawing on incredible fieldwork, Thompson took issue with the claim that "slavery in the United States destroyed the creative memories of newly arrived Africans" and located continuities of form and sensibility in the sculpture, ceramics, and basketry of African and African American artists, concluding that "the traditional art of the Afro-American in the United States represents a fusion and simplification of some of the themes of the sculpture of West Africa."[4] Like his later books, this essay was extremely useful for artists such as Bowling, who cited it two years later, and Hammons, but it is not included here because it does not deal with the work of these artists. Similarly, Arnold Rubin's 1975 *Artforum* article "Accumulation: Power and Display in African Sculpture" changed Betye Saar's approach to her shrine sculptures, leading her to invite viewers to add offerings to them, but Rubin's article did not refer to contemporary African American art, so it, too, is not included.[5]

So much for what is not here. As for what *is* included, the anthologized writers are artists, curators, critics, art historians, journalists, and sometimes celebrated literary figures invited to write on art. Of the artists, some were giving statements or interviews as one-offs (it was a convention of publications then to ask artists whose work was being exhibited or reproduced to publish a formal statement). Others, like Bowling, Andrews, and Donaldson, would have seen themselves as artist-critics akin to other, White artists publishing at the time, like Robert Morris and Donald Judd, and would also have taken their cues from Bearden, who had published important critical essays in the 1930s.[6] In addition to manifestos and position papers like Bowling's "It Is Not Enough to Say 'Black Is Beautiful,'" the artist-written texts in this volume include catalogue introductions and essays, exhibition reviews, and magazine articles as well as interviews and transcripts of public lectures and round-table discussions. Some texts cannot be attributed to a single writer: They were open letters and press releases composed by like-minded artists and art workers who were coming together to make a joint declaration or announce the formation of a pressure group to protest institutional racism.

Examples of such groups include Chicago's Organization of Black American Culture (OBAC), which released a pertinent statement in 1967;[7] Los Angeles's Black Arts Council (BAC), founded in 1968 and chaired by Claude Booker and Cecil Fergerson; and New York's Black Emergency Cultural Coalition (BECC), founded in 1969 and chaired by Benny Andrews and Cliff Joseph.

Putting aside the content of the texts in the anthology, it is useful to recall the different places where they originally appeared; what follows is a kind of typology of those places of publication. The question of *what* was published is always linked to the question of *where*, and spending some time thinking about the opportunities that existed (or did not exist) for writers (especially Black writers) engaged in these subjects, and the opportunities they created for themselves, is worthwhile.

We can start with mainstream newspapers and magazines. Although Black cultural matters were rarely covered, the debate about "Black art" was so fervent that it did, indeed, receive exposure in some of the most widely read publications of the time. In April 1970, *Time* magazine put out a special issue on "Black America" featuring a cover by Jacob Lawrence (a gouache portrait of Jesse Jackson). Inside, the art column was titled "Object: Diversity." The writer (who, in keeping with *Time*'s editorial practice, was not individually credited) launched straight into the debate, asking in the first line, "Is there such a thing as black art?" The piece was accompanied by specially commissioned photographs of Black-made murals in Chicago, Boston, and Detroit and portraits taken in studios and museums of Dana C. Chandler Jr., Melvin Edwards, Malcolm Bailey, David Hammons, Richard Hunt, Sam Gilliam, Daniel LaRue Johnson, and Joe Overstreet. (Once again, we should pause to note the lack of women and the fact that while several of the New Yorkers knew one another, Hammons had not yet mixed with them, except on *Time*'s pages.)

The mainstream art press (most of which was published in New York, with an East Coast slant) gave minimal coverage to Black artists and to the discussions around Black art—a reflection of editorial bias as well as of the exclusions imposed by art museums and the art market. Yet, little though there was, texts did appear from time to time in almost all the magazines. *ARTnews* covered the New York–based Spiral group in 1966, a year after its only exhibition, with a piece by Jeanne Siegel. In 1969, *Art Journal* published Elsa Honig Fine's article "The Afro-American Artist: A Search for Identity," which would later become the core of one of the earliest surveys of African American art. *Art in America* put a Sam Gilliam "drape" painting on its cover in September 1970, when it published Barbara Rose's roundup "Black Art in America." *Art International* offered the first published interview with David Hammons in October 1970. *Arts Magazine* was more dedicated in its coverage and, unlike the titles mentioned so far, commissioned texts from Black writers, publishing Ishmael Reed in 1967 and later giving Frank Bowling space to develop his series on Black art over several issues. Another

publication, *Art Gallery*, invited Carroll Greene Jr. to guest-edit its April 1970 issue, turning over the first thirty-five pages of the magazine to him, first for his survey essay "Perspective: The Black Artist in America" and then for a series of responses to his question "Black Art: What Is It?" for which Greene received responses from Bearden, Ringgold, and others. *Art Gallery*'s editor was evidently proud to publish Greene's article, which he called "the most comprehensive representation of Afro-American art ever published in a national magazine." *Artforum*'s record was, by contrast, pitiful. The editor John Coplans invited Lowery Stokes Sims to publish a bibliography about African American art in April 1973, but other than that and a 1970 profile of Sam Gilliam, the magazine hardly touched the subject. This became the subject of a confrontation between Coplans and Dana C. Chandler Jr. in 1973, when the New York Cultural Center hosted an event titled "Black Artists/ White Critic." Chandler asked Coplans, "Do you have a black art critic on your staff, and if not, why not?" which led to a furious row that almost ended the evening's events. Coplans passed the buck, explaining that because New York galleries didn't show many Black artists, the magazine couldn't cover them, and noting the paucity of Black critics. Chandler asked why he hadn't ever published Edmund Barry Gaither or Samella S. Lewis, and Coplans again dodged, asking Chandler why Black-run publications themselves didn't do more for Black art.

Exhibition catalogues were another vehicle for texts by curators, guest artist-curators, and museum directors. Group shows with "Black art" as the explicit subject first appeared in 1968: Some were general surveys viewed with skepticism even by some of the participants (William T. Williams called them "sociological" in the Metropolitan Museum of Art's 1968 symposium "The Black Artist in America," discussed below); some were specific, dedicated to a group of artists with a shared formal language. In 1968, the Minneapolis Institute of Arts mounted *30 Contemporary Black Artists*, which was soon followed, in October, by *New Perspectives: Black Art* at the Oakland Museum. The Art Gallery at the State University of New York at Stony Brook put on *5+1*, coorganized by Bowling, in 1969. Also in 1969, the Rose Art Museum asked Dana C. Chandler Jr. to help organize *12 Black Artists from Boston*, and the Brooklyn Museum staged *New Black Artists*. On the West Coast, the La Jolla Museum of Art presented *Dimensions of Black* in February 1970; later that year, the Fine Arts Gallery at California State College in Los Angeles mounted *Two Generations of Black Artists*; and, as already mentioned, Occidental College hosted *Black Art: The Black Experience* in September 1971. Earlier in 1971, another show called *Black Experience*, with a completely different list of artists, opened at the Bergman Gallery of the University of Chicago, curated by Keith Morrison. Related exhibitions continued to take place over the years that followed—for instance, *Directions in Afro-American Art*, held in 1974 at the Herbert F. Johnson Museum of Art at Cornell University in Ithaca, New York. Interest even took root abroad,

as when the Musée Rath in Geneva mounted Henri Ghent's *8 artistes afro-américains* in 1971. Each of these shows was a chance for writers to redefine what they felt was pressing about the subject, and several emerging Black curators and artist-curators published their first essays in this context.

When such exhibitions took place at larger museums, the critical discussion about Black art escalated, as did debate about the curatorial politics surrounding them. Newspaper art critics took note, and artists took it upon themselves to weigh in, whether they supported or fervently disagreed with the curatorial premise. We see this first in the aftermath of an exhibition coorganized by the National Center of Afro-American Artists and the Museum of Fine Arts, Boston, and curated by Edmund Barry Gaither. *Afro-American Artists: New York and Boston* opened at the two venues in May 1970. Hilton Kramer reviewed the show for the *New York Times*, and this was also the occasion for the paper to publish Benny Andrews, as mentioned earlier. In 1972, Carroll Greene Jr. guest-curated *A Panorama of Black Artists* at the Los Angeles County Museum of Art (LACMA), and the critic William Wilson wrote a complex response in the *Los Angeles Times*. In the year between the Boston and LA shows, Robert M. Doty's *Contemporary Black Artists in America* opened at the Whitney Museum of American Art, New York. At such a prominent venue, the stakes were even higher, and as Susan E. Cahan has recently shown in her book *Mounting Frustration: The Art Museum in the Age of Black Power*, the exhibition was met with staunch opposition, especially from prominent Black artists. Nigel Jackson, who ran the independent gallery Acts of Art in Greenwich Village, curated *Rebuttal to the Whitney Museum Exhibition*, complete with a catalogue text. In a letter to *Artforum*, John E. Dowell Jr., Sam Gilliam, Daniel LaRue Johnson, Joe Overstreet, Melvin Edwards, Richard Hunt, and William T. Williams explained their withdrawal from the show, stating that "the Whitney Museum has anti-curated its survey which results in misrepresenting and discrediting the complex and varied culture and visual history of the African American." Tom Lloyd, whose light constructions had been the subject of the inaugural monographic show at the Studio Museum in Harlem, went the furthest in his efforts. He gathered other Black artists and critics—among them, Amiri Baraka and Jeff Donaldson—and self-published a pamphlet titled *Black Art Notes*.

With Lloyd's pamphlet in mind, I want to turn away from the mainstream press and art press and from catalogues published by mainstream (White-run) museums to another set of platforms that allowed writers to participate in the discourse around Black art: self-published pamphlets and publications released by newly established Black-run art galleries and institutions. The painter Raymond Saunders read Ishmael Reed's *Arts Magazine* article on the Black Arts Movement in 1967 and, worried by its position, wrote the essay *Black Is a Color* and put it out as a self-published pamphlet, defending his right to work in the tradition of formalism, where black might be just another hue among many. Self-publication was also the route taken by many artists' groups

of the time. Do not wait for a magazine to publish you, or for an established art museum to show your work. Make your own shows. Put out your own texts. This was how the Spiral artists, in 1965, produced a small catalogue to accompany their show at a rented space on Christopher Street in New York, with a joint statement by Romare Bearden, Norman Lewis, Hale Woodruff, and the other members. A year later, Noah Purifoy organized *66 Signs of Neon*, bringing together works he and other artists had made from debris collected in the aftermath of the Watts Rebellion in Los Angeles—and again, his show was accompanied by a small catalogue. The Brockman Gallery opened in Los Angeles in 1968 and gave exhibitions to many Black artists, including Purifoy, David Hammons, and John Outterbridge. Some of the press releases for the shows were simple announcements, but others, like the one for Purifoy's 1971 show *Niggers Ain't Gonna Never Ever Be Nothin'—All They Want to Do Is Drink and Fuck*, incorporated powerful artists' statements. As a commercial enterprise, the Brockman Gallery inspired Linda Goode Bryant to open her gallery, Just Above Midtown (JAM), in New York in 1974; occasionally, JAM also published key texts, such as that in Bryant's catalogue *Contextures*.

Bryant had previously worked at the Studio Museum in Harlem, setting up its education department, and that museum, which had opened in September 1968, itself published important texts. Clearly, its ability to publish was constrained by available human and financial resources, but nonetheless, in its infancy, the museum generated one of the earliest essays on the photographer Roy DeCarava, to accompany his 1969 show *Thru Black Eyes*, as well as the director Edward Spriggs's essay on AfriCOBRA, in the pamphlet accompanying the group's second show at the museum, in 1971; Jeff Donaldson's essay on Elizabeth Catlett in the same year; and a selection of artists' statements for the 1972 show *Eleven from California*. Early shows at the Studio Museum, such as *X to the 4th Power*, also led to important reviews in the *New York Times* and in art magazines. Other, smaller public Black institutions and art spaces, such as Berkeley's Rainbow Sign and Chicago's DuSable Museum of African American History, either could not afford to put out publications or concentrated their publishing programs on poetry and literature, but some of the historically Black colleges and universities (HBCUs) operated art museums that published important texts, which, in this anthology, include one from David C. Driskell's 1975 show *Amistad II: Afro-American Art*, mounted at Fisk University in Nashville.

There were also attempts to create entirely new publications for discussions of Black art, unconnected to any particular institution or artists' group. In 1971, Edmund Barry Gaither founded *ABA: A Journal of Affairs of Black Artists*, writing in his introductory text that many had "felt the need for some organ of opinion which could begin to facilitate the discussion and interpretation of the work of the black visual artist." Gaither published polemical essays by JoAnn Whatley and Abdul Alkalimat, included here, as well as art-historical essays and brief news items, and he hoped that the journal

would appear quarterly, but with no income from advertising, the inaugural issue was also the last. In the field of photography, Joe Crawford and Beuford Smith (a member of the Kamoinge Workshop) founded the *Black Photographers Annual* in 1973. The magazine was devoted to image makers, but the editors persuaded none other than Toni Morrison to introduce the first issue and James Baldwin to write in the third. Sadly, the annual only ran to four issues, the last of which was barely distributed. Samella S. Lewis's activities in Los Angeles were more sustained. An artist and art historian, she won a fifteen-thousand-dollar grant from the National Endowment for the Arts and used it to found the publishing company Contemporary Crafts. In 1969, she coedited, with Ruth G. Waddy, the first volume of *Black Artists on Art*, a monumental project for which the editors gathered statements from dozens of artists working across the country. The second volume appeared in 1971, and five years later, Lewis founded a new journal, *Black Art: An International Quarterly*, which soon changed its name to *International Review of African American Art* and ran for several years. In 1978, the first edition of her historical survey *Art: African American* was published by Harcourt Brace Jovanovich in New York. A couple of years later, Camille Billops and James Hatch launched *Artist and Influence: The Journal of Black American Cultural History*, a compendium of lengthy oral histories of various figures, including visual artists such as Norman Lewis.

Turning away from publications specifically geared to art, we can now focus on the Black press, as many of the anthologized texts originally appeared there. The Black press ranged from eminent journals such as *The Crisis* to newer cultural and scholarly journals, activist newspapers, and the glossy magazines, full of advertising, that came out of the Johnson Publishing Company in Chicago, most famously *Ebony*. All featured different kinds of occasional writing on art. *The Crisis* published Bayard Rustin's 1970 essay "The Role of the Artist in the Freedom Struggle," written in honor of Jacob Lawrence, and Lawrence's response. *Ebony* reported on Chicago's *Wall of Respect*, the first major mural of the period, realized by artists associated with OBAC, and ran well-illustrated features on the most celebrated Black artists, such as Charles White, but it also published Larry Neal's 1969 essay "Any Day Now: Black Art and Black Liberation." *Liberator*, published in Harlem from 1961 onward and edited by Lowell P. Beveridge Jr., pitched itself as "the voice of the Afro-American protest movement in the United States and the liberation movement of Africa." In 1965, Neal interviewed Joe Overstreet for the magazine. Beginning in 1967, in Oakland, *The Black Panther* was published weekly as the voice of the party; its art director, Emory Douglas, in addition to designing its notorious covers and back pages, published more or less the same manifesto three times (each time with slight revisions): "Position Paper 1 on Revolutionary Art" in October 1968, "To the People and All Revolutionary Artists" in January 1970, and "Revolutionary Art: A Tool for Liberation" in June of the same year.

The Chicago weekly *Negro Digest*, which renamed itself *Black World* in 1970, was a journal for politicized cultural criticism edited by Hoyt Fuller. It was on *Black World*'s pages that Jeff Donaldson chose to publish the manifesto "AFRICOBRA 1: *10 in Search of a Nation*" in October 1970. The journal later gave space to other important texts, including a debate on the Black aesthetic between Martin Kilson, a political science professor at Harvard University, and Addison Gayle Jr., a literary critic and professor of English at Baruch College in New York. *Black Creation: A Quarterly Review of Black Arts and Letters*, founded in 1968 by Fred Beauford, a journalism student at New York University, published other important essays on Black culture, including texts on Roy DeCarava and a round table on Black photographers, included here. *Encore*, a New York–based weekly news magazine first published in 1975, featured several articles by Benny Andrews, including a text on the gallery Just Above Midtown. The present volume also draws some texts from anthologies of Black Arts Movement writings that came out during the period, predominantly addressing poetry, music, and theater. Such anthologies included Amiri Baraka and Larry Neal's 1968 collection *Black Fire: An Anthology of Afro-American Writing* and Floyd B. Barbour's *The Black 70's*, in which the DuSable Museum's director Margaret G. Burroughs published her text "To Make a Painter Black," a call for proud figuration and one of the most scathing attacks on abstract artists.

Finally, constituting a final category of texts are transcripts of round-table discussions and public lectures that took place in prominent arenas. Some of these appear in print for the first time here, such as Charles White's 1969 LACMA lecture "Art and Soul"; others were circulated at the time, such as the extraordinary discussion "The Black Artist in America: A Symposium," published in the *Metropolitan Museum of Art Bulletin* in 1969.

THE BLACK AESTHETIC

The round table held at the Metropolitan Museum of Art was one of the period's most electrifying debates about "Black art" because of its location, timing, and cast of characters. The Met was the most powerful art institution in the country, and when the round table was organized, the museum was in the process of putting together *Harlem on My Mind: Cultural Capital of Black America, 1900–1968*, which, even before opening, was facing criticism for the organizers' failure to involve living artists in the show. The round table must have taken place in the later summer of 1968, as participants refer to Tom Lloyd's forthcoming inaugural show at the Studio Museum (which opened in September) and to the imminent *30 Contemporary Black Artists* at the Minneapolis Institute of Arts (which opened in October). Although, predictably, no women were invited on the panel, it did bring together seven artists from different generations and with extremely different politics and opinions, from Hale Woodruff and Jacob Lawrence to the youngsters Lloyd, William T. Williams, Sam Gilliam, and Richard Hunt. Romare Bearden chaired,

and his opening questions raised topics everyone could address from experience and without much discord: about career opportunities, galleries, museums, and money. But it all kicked off when Tom Lloyd spoke up.

The only panelist who aligned himself with the new politics of Black nationalism (which Williams found "dangerous"), Lloyd said, "I think there's going to be Black art, I think there's going to be a separate Black community." He insisted that Black art should be "relevant to the Black community" and that Black artists should be "working in Black communities." Lloyd's words would have rankled artists on the panel who had spent decades hoping their art could be exhibited in places like the Met and who did not have only Black audiences in mind when making their art. More than this, everyone knew that Lloyd himself was making geometric, abstract sculptures that incorporated flashing colored light bulbs, and so they challenged him to explain why this was "Black art" and how it was relevant to the community in Harlem where he was about to exhibit. Jacob Lawrence put his assessment as clearly as possible: "You are an artist who happens to be Black, but you're not a Black artist." Unfazed by his seniors' hostility and skepticism, Lloyd dug in.

To have an idea of "Black art," as Lloyd did, meant believing in the related notion of a "Black aesthetic." For Lloyd, this seems to have resided in the energy of Black art, whatever its form, and in its capacity to excite and inspire Black viewers. Most of the other panelists, particularly Lawrence, did not believe in the concept of "Black art," so they did not put forth their own ideas of a Black aesthetic. Hale Woodruff, however, made an attempt. He wasn't sure he knew what it meant in visual art but recognized that it had to transcend "subject matter." In music, he felt that it was located in a kind of minor key and was "almost unexplainable" but "always identifiable."

The Met round table exposes not only the diversity of approaches toward understanding the Black aesthetic but also the difficulties of defining it even for those who thought it existed. Many of the texts in this anthology are not concerned with the Black aesthetic in any way, addressing instead institutional struggles, audiences, and the responsibilities of Black artists—but while those texts mostly speak for themselves, the discussion of the Black aesthetic deserves further introduction. So, in what follows, I'll sketch out some of the broad ideas that surrounded the term in this period, with the acknowledgment that there had, of course, been different formulations earlier on, in the writings of Alain Locke and others.[8] Before turning to texts linked to the work of particular visual artists and artists' collectives, it is helpful to look at a more general debate about the Black aesthetic and at the different positions held, on the one side, by the Black Arts Movement critics Amiri Baraka and Larry Neal and, on the other, by the political scientist Martin Kilson and the art historian David C. Driskell.

Baraka and Neal saw the Black Arts Movement as a sister movement to Black Power. While the latter aimed for political liberation, the Black Arts Movement, as Neal characterized it, was "primarily concerned with the

cultural and spiritual liberation of Black America. It takes upon itself the task of expressing, through various art forms, the Soul of the Black Nation." Both writers clearly defined the movement's task as nation building—in Baraka's words, "The purpose of our writing is to create the nation." But what exactly was the Black *aesthetic*? Neal addressed this question in "Any Day Now: Black Art and Black Liberation," the previously mentioned essay that ran in *Ebony* in August 1969, and Baraka in his "The Black Aesthetic," published in *Negro Digest* in September of the same year. Baraka summed up the Black aesthetic succinctly as "[f]eelings about reality" and went on to *demonstrate* it, more than to describe it, breaking up his words and sentences to create the energy he was trying to explain, just as he did in his poetry and live readings. Neal's articulation of the Black aesthetic took a more classic route, through argumentation and history.

Neal started with a dictionary definition of "aesthetic" ("a branch of philosophy relating to the nature of forms of beauty, especially found in the fine arts") and declared that this definition was "worthless." "What the Western white man calls an 'esthetic' is fundamentally a dry assembly of dead ideas. . . . There is nothing in [it] about *people*." The Black aesthetic had to be rooted in "people" and "feeling," but not with the focus on sex and the body that was so dear to the new counterculture. An aesthetic with people and feeling at its core meant instead one that was rooted in collective Black experience. Neal started his historical excursus with the institution of the Black church and the development of the blues within it: In the blues, Black people created not entertainment but art with an ethical purpose, with "spiritual and ritual energy," to fortify themselves to survive oppression. From the blues, Neal moved on to later manifestations of the Black aesthetic, focusing on Langston Hughes, who drew on the blues in developing a "style of poetry which springs forcefully and recognizably from a Black life style; a poetry whose very tone and concrete points of reference [are] informed by the feelings of the people as expressed in the gospel and blues songs." Neal also cited jazz musicians such as Billie Holiday and John Coltrane, in whose work "we find the purest and most powerful expression of the Black experience in America."

Neal clarified that the Black aesthetic was not to be found in "protest" art, as it must balance expressions of "pain" and "aspiration." The Black artist had to go beyond "merely reflecting the oppression and the conditions engendered by the oppression." Black art had to validate the "positive aspects of our life style" and encapsulate a "Vision of a Liberated Future." Black artists had to "take the energy and the feeling of the blues . . . and shape these into an art that stands for the spiritual helpmate of the Black Nation." "Make a form," Neal concluded, "that uses the Soul Force of Black culture, its life styles, its rhythms, its energy, and direct that form toward the liberation of Black people."

There was one more component of the Black aesthetic: It involved the annihilation of White ideas of the aesthetic. Neal wrote, "We also mean the

destruction of the white thing. We mean the destruction of white ways of looking at the world." In his essay, Neal mentioned Andy Warhol and implied that Pop art was one manifestation of a contemporary White aesthetic; Baraka, in other writings, targeted abstraction for the same reason. In these years, at least, Baraka did not try to differentiate between kinds of abstraction, nor did he pay attention to formal links between the music of Coltrane and the art of Sam Gilliam, for instance (which others later did); instead, he saw abstraction straightforwardly, as *the* most institutionally validated style in mainstream contemporary art, and therefore as necessarily exemplary of a White aesthetic. For this reason, when invited by Tom Lloyd to contribute to the aforementioned pamphlet *Black Art Notes*, critiquing the Whitney's 1971 *Contemporary Black Artists in America* show, Baraka attacked Richard Hunt (who, remember, had sat with Lloyd on the Met's panel), writing that artists such as Hunt "do not actually exist in the black world at all. They are within the tradition of white art, blackface or not." Decrying the presence of other abstract artists in the show (Al Loving, for instance), Baraka complained, "A Black Arts show full of whiteartists in Black face, soulpimps, pathological niggers who love white flesh, is the white man's idea of what a black arts show is all about."

To sum up, for these two Black Arts Movement thinkers, the Black aesthetic grew from the experience of a people rather than from an abstract conception of beauty. It was an expression of communal experience, as opposed to the individualism espoused by White modernist artists from Joyce to Picasso (Baraka wrote of the "collective spirit of Blackness"); it was located in the tone, feeling, and energy of an artwork; it was an articulation of both pain and positivity; it could provide spiritual as well as political liberation; and it absolutely countered any aesthetic form associated with institutionally validated, market-affirmed White art.

Martin Kilson and David C. Driskell were two contemporary writers concerned with Black art who took positions starkly opposed to those outlined above. For Kilson, there was no such thing as a Black aesthetic; Driskell, meanwhile, came to a different conclusion than Neal and Baraka about what a Black aesthetic might be. Regarding the very meaning of the term "aesthetic," both Kilson and Driskell began from philosophical bases fundamentally different from those of Neal and Baraka. Kilson argued that it did not make philosophical sense to align aesthetics with ideology or politics. Art should not be made to serve any function, whether it be uplift or political incitement. Black Arts Movement theorists, he said, judged art according to its use and its measurable effect on viewers rather than on its ability to foster "contemplation." Placing art in the service of politics was no different from what happened under "Communist and Fascist movements." Kilson concluded that the Black Arts Movement's "approach to the Black aesthetic is simply an ideological and political exercise. It has nothing whatever to do with the creation of a true aesthetic form." Writing two years later in

the catalogue for his show *Two Centuries of Black American Art*, Driskell argued that Black artists who aimed mainly for their work to be "a lesson in social history or an instrument of social change" were acting "upon premises that are more pertinent to ethics than aesthetics." Driskell pushed for art that would be valued "purely for its power to captivate the spectator" and for that value to be seen in the work's "formal organization." He asked for the "imaginative, sensuous totality" of the artwork to be respected. The Black aesthetic was possible if one attended to all these aspects of art.

IN ARTISTS' OWN WORDS

We can come back now to some of the main ways visual artists themselves formulated ideas of the Black aesthetic.[9] In his 1970 text "AFRICOBRA 1: *10 in Search of a Nation*," Jeff Donaldson came closest to Baraka and Neal, with an emphasis on communal production, on feeling, and on expressions of anger as well as joy and uplift. Indeed, Donaldson quoted Baraka's poem "It's Nation Time," and in 1979, Neal wrote an essay about AfriCOBRA for an exhibition catalogue (also anthologized here). Donaldson's 1970 manifesto was a sustained and complex definition of the Black aesthetic in image making (Donaldson was not concerned with painting per se and, indeed, deemed it important that painted images be turned into easily distributed prints so that more people could see them). Donaldson wrote, "We strive for images inspired by African people/experience and images which African people can relate to directly without formal art training and/or experience. . . . We try to create images that appeal to the senses—not to the intellect." Such images had several characteristics: They embodied the "expressive awesomeness" of Black life; they had formal structures based on African rhythms ("symmetry that is free, repetition with change, based on African music and African movement"); they were "organic looking, feeling forms." The images were filled with "color that is free of rules and regulations. . . . Superreal color for Superreal images." A particularly important quality was "shine": "We want the things to shine, to have the rich lustre of a just-washed 'fro, of spit-shined shoes, of de-ashened elbows and knees and noses." Donaldson's most complex idea was that images should "mark the spot where the real and the over-real, the plus and the minus, the abstract and the concrete—the reet and the replete meet." These ideas have been unpacked at length elsewhere by Margo Natalie Crawford,[10] but what seems important is that the Black aesthetic, for Donaldson, was neither "social realism" nor the "overreal" (the fantastical), neither straight depiction nor abstraction, but something that held opposites in tension. "Mimesis at midpoint," as Barbara Jones-Hogu later put it.

Other artists who aligned themselves with the Black Arts Movement outlook took slightly different approaches in defining the Black aesthetic. Like Neal and Baraka, Dana C. Chandler Jr. spoke about the need to "develop our standards concerning black art" and to move away from "castrating white standards." "Black expressionism," as he called his work, had to avoid being

"subtle," and the way to achieve this was through "vivid colors, raw, earthy, much use of Day-glo." From a similar intellectual position to Chandler's, Faith Ringgold took a very different approach to color. Calling on Black art to avoid "fantasy" at all costs and commit itself to "truth," she argued that it "must use its own color black to create its light, since that color is the most immediate black truth. Generally, black art must not depend upon lights or light contrasts in order to express its blackness, either in principle or fact." This statement of 1970 was clearly connected to Ringgold's *Black Light* paintings, in which she mixed black into every color to darken the tone of the whole surface.

The aesthetic ideas proposed by AfriCOBRA, Chandler, and Ringgold contrast with the statements of Emory Douglas, which concentrate more on the idea of "revolutionary art" for Black subjects than on "Black art" per se. As noted earlier, Douglas first published his "Position Paper 1 on Revolutionary Art" in *The Black Panther* in 1968. Like Ringgold, Douglas believed in an art committed to truth telling; like Neal, he insisted that "revolutionary art is an art that flows from the people" and that "the people are the inspiration to the artist"; like Baraka, he understood art's role as a "tool of liberation." For Douglas, however, revolutionary art had nothing to do with what Neal called the "positive aspects" of Black life or Donaldson called "expressive awesomeness." Instead, "Revolutionary Art gives a physical confrontation with tyrants, and also enlightens the people to continue their vigorous attack by educating the masses through participation and observation." Douglas's most powerful statement was "The Ghetto itself is the Gallery for the Revolutionary Artist's drawings." And for him, the ghetto replaced not just the gallery but the art school: "Revolutionary Art is learned in the ghetto. . . . Not in the schools of fine art." As stirring as these words were, they skipped over the fact that Douglas himself had studied at City College of San Francisco. Douglas may not have used the term "aesthetic" in his statements on "Revolutionary Art," but, as the artist Sam Durant has pointed out, his work certainly developed a particular aesthetic, drawing on precedents such as John Heartfield's photomontages; Alexander Rodchenko's and El Lissitzky's graphics, with their use of powerful diagonals and bold colors; and George Grosz's "grotesque caricatures."[11]

Representing a somewhat earlier generation but increasingly influential in the 1960s and 1970s thanks to his faculty position at the Otis Art Institute in Los Angeles, Charles White made art that was figurative like Donaldson's, Ringgold's, and Douglas's but that manifested a very different idea of what the Black aesthetic could be. White focused neither on inventing new Black forms nor on destroying White ones. And far from abandoning the "schools of fine art" dismissed by Douglas, he had studied in and currently taught in them. White believed that an artist should learn and excel in the traditional (Western) crafts of drawing, printmaking, and painting and *then* use them to create a Black aesthetic. As Benny Andrews clarified in a special 1980 issue of the New York–based journal *Freedomways* devoted to White one

year after his death, Black artists like White did not have the resources for endless studio experimentation, but they did have pencils and paper, and that is why drawing was so important to them. White did not write long theses about the Black aesthetic, but the talk he gave at LACMA in 1969, included here, reveals the one word he used to express what the Black aesthetic meant for him: "soul." Soul was an aesthetic quality of his images that transcended any factual information they might convey. Soul had to do with the mood conjured by White's artistic decisions—the angle onto a figure, the way it was framed within the borders of the sheet or canvas, the use of light and shade to establish its weight and presence, the pose and expression.

According to James Hinton in the pamphlet for his fellow photographer Roy DeCarava's Studio Museum show *Thru Black Eyes* in 1969, DeCarava was the first practitioner "to devote serious attention to the black aesthetic as it relates to photography." A contemporary of Charles White, DeCarava is quoted on the subject of Black "spiritualism," a word close to White's "soul," in the same pamphlet. This meant much more than DeCarava's stated commitment elsewhere to "say something honest and positive about poor, Black people" and to address "Black people first." Rather, the Black aesthetic in photography had to do with a combination of feeling and form. DeCarava described the "intensity" of his work and his ambition to make it as "completely honest and as deeply emotional as I can." A. D. Coleman, reviewing *Thru Black Eyes* in *Popular Photography*, argued that DeCarava not only was true to his own "deepest feelings" but used his "self-knowledge for the purpose of confronting honestly and expressing the deepest emotions of others"—all while avoiding "sentiment." His photographs were ungimmicky and "straightforward" and had a "flowing tenderness"; his prints, "unusually sensitive to subtle tonal gradations," were "never harsh or exaggerated, filled instead with the delicate interplay of dark and light." The Black aesthetic in photography, apparently, had to do with using emotional and chromatic tones harmoniously so that, in DeCarava's words, one could "reach people inside, way down—to give them a quiver in their stomach."

As we've already seen, at the very beginning of this introduction, Frank Bowling's theory of a Black aesthetic was far removed from any of the other ideas discussed thus far. Setting aside feeling and soul, liberation and uplift, he identified it primarily with attitude and tactics. In his statement for the *5+1* show at SUNY–Stony Brook, he said that the Black aesthetic had to do with "that powerful, instinctive, and intelligent ability which Blacks have shown time and again, despite inflicted degradations, to rearrange found things, redirecting the 'things' of whatever environment in which Blacks are thrown, placed, or trapped." For Bowling, "rearranging found things" could apply to the way Bob Thompson approached a tradition of figurative painting inherited from Matisse, or the way Melvin Edwards treated dominant conventions of Post-Minimalist sculpture, "rerouting" them so that his works suggested one set of ideas to many in his audience while "signifying" other meanings

to Black viewers. Anticipating some of the arguments Henry Louis Gates Jr. would make fifteen years later in *The Signifying Monkey*, Bowling wrote, "The traditional esthetic of black art, often considered pragmatic, uncluttered and direct, really hinges on secrecy and disguise."

Bowling also argued that one of the "positive virtues" of Black art was "an awareness of the solid canons of traditional African artistic expression and thought (which have contributed to 20th century western art)." This point introduces still other ways practicing artists argued for the existence of a Black aesthetic: broadly speaking, by claiming that the Black aesthetic meant a rejuvenation or retrieval of the core aesthetic principles of African art. But what did this actually mean? In 1931, Alain Locke had argued that African American artists should study African art to motivate "a vital, new and racially expressive art."[12] Locke's encouragements lay behind the paintings Lois Mailou Jones made in the early 1970s following her visits to Africa as well as a host of other figurative work of the period that bore a visual resemblance to various kinds of African art. A related but more compelling idea, not so reliant on the mere appearance of an artwork, was that contemporary Black artists inherited their sense of improvisation from African art. Thus, in 1975, Allan M. Gordon wrote, "I think there are definite African elements in the work of Gilliam, Loving, Overstreet, and [Barbara] Chase-Riboud in the improvisatory quality, the sense of transformation that occurs; the element of chance, the sense of extemporizing, the deviation and arbitrariness with the hanging construction of those artists, for example."

Some went further, connecting the legacy of African art both to the ability to improvise and, in turn, to art's revolutionary potential. Melvin Edwards, for instance, in addition to writing about the "survivals" from African cultures that existed in African American art ("Survivals are positive examples of the strength of our traditional art systems"), stated in 1969 that "it is necessary to be free enough to create beyond the boundaries of any esthetic and make that freedom plastically manifest. To improvise is the only real and constantly dynamic revolutionary way to be." James T. Stewart, a critic, made a related argument in his 1968 essay "The Development of the Black Revolutionary Artist." For Stewart, whereas White culture privileged permanence and White institutions were built to preserve artworks in perpetuity, "Black culture" acknowledged impermanence and change. He cited the mud temples of Nigeria that were built as temporary structures. Black artists knew that "Art goes. Art is not fixed. Art can not be fixed. Art is change."

Jack Whitten made yet another argument for a Black aesthetic that drew on African art. While most viewers would have placed Whitten's work in the context of process-based abstract painting by the likes of Robert Ryman, Brice Marden, and David Reed, Whitten, in his studio notes of the mid-1970s, claimed special access to "African sculpture" and its "spiritual force" as well as a special understanding of the deep structures underlying it. For Whitten, the grids at work in his paintings were connected to those found in African

wood sculptures. These links were not apparent to all viewers, however: "While it's evident for me to sit here and say that that painting has a source in Africa, it is not evident to the average viewer." This semi-secrecy, and the references to African art presumably available only to Black members of his audience, were precisely what gave his work its Trojan horse–like power. As he wrote in 1976, again in his studio notes, "My paintings are designed as weapons. Their objective is to penetrate and destroy the Western aesthetic."

Literary theorists such as Houston A. Baker Jr. have discussed the generational shifts that may account for the replacement of an earlier formulation of the Black aesthetic in literature with a later one.[13] Yet, in the visual arts, as we are seeing, different positions were adopted simultaneously rather than in sequence. Hence, another influential concept of Black art was articulated by the artist Noah Purifoy. Like Charles White's, Purifoy's statements were not lengthy, but his ideas, first expressed when discussing his exhibition 66 Signs of Neon in 1966 and next in connection with Eleven from California, held at the Studio Museum in Harlem in 1972, were succinct and original. Purifoy believed that Black art was assembled from the rubble of everyday Black life, and in Los Angeles in the late 1960s, that meant the debris of the Watts Rebellion as well as its less physical residue: emotions such as the "flaming anger" he describes in his text for the Studio Museum show. Black art would rise like a phoenix and, reborn, abandon what Purifoy saw as a White concept, namely, "art for art's sake." Black art was "for the sake of something." To Purifoy, this did not mean political mobilization in the manner of Emory Douglas, or even uplift in the manner of Jeff Donaldson. His idea was that in recycling debris, the Black artist modeled a kind of "creativity" that countered the "materialistic world" of postwar America, whose consumer culture Purifoy would presumably have connected to the history of colonialism and slavery. Although he did not write about it, Purifoy seems to have associated a Black aesthetic of antimaterialistic creative recycling with certain aspects of African art. Several of his works of this time alluded to African cultures, such as Zulu #4, which incorporated old sneakers, and his untitled 1970 work shown at the Whitney in Contemporary Black Artists in America, which included old wooden spoons and resembled the fertility figures of the Asante people known as akua'ba.

So, a contemporary Black aesthetic could be derived from African art and culture in terms of form, or improvisation, or impermanence, or antimaterialism, or spiritual power and secrecy. This last pair of ideas developed through the 1970s. Black artists began to emphasize the importance of mysticism and spiritualism in their art, making work that related to altars and charms and sometimes staging ritual-like performances. In a text of 1969, Joe Overstreet anticipated this direction very clearly: "Black art is a spiritual movement like black magic, or witchcraft. Magic has always been used and probably will always be used. Black people in America are superstitious; that is why a voodoo art is necessary." Overstreet, at this point, had abandoned

overtly political figurative works such as 1964's *The New Jemima* for abstract constructions inspired by West African shields, such as *Ungawa—Black Power* of 1968. A related turn occurred in Betye Saar's work a few years later, when she moved from *The Liberation of Aunt Jemima* (1972), in which she repurposed racist objects in a Joseph Cornell–like vitrine, to *Mti* (1973), an assemblage consisting of palm fronds, candles, shells, bones, mirrors, and dolls that she later displayed as an altar, inviting viewers to leave offerings beside it.[14] In her 1975 interview with Cindy Nemser for the *Feminist Art Journal*, Saar described her move away from the "black movement" toward a "concern with black history going back to Africa and other darker civilizations such as Egypt or Oceania. I was interested in the kinds of mystical things that are part of non-European religion and culture." In the same year, interviewed by Benny Andrews, she explained that whereas "in my previous work my message was very clear," now her messages were "more subtle. There is more secretiveness about them because I think this represents the way Black people feel about the movement today. They've got over the violent pain and have become more introspective and are doing more thinking and plotting. Blacks are dealing with their enemy on a secret level. The political messages are still in my work, but one has to think harder to find them."

Like Emory Douglas, Saar did not use the term "Black aesthetic," but, clearly, what it meant in her work had changed, and her points about secretiveness and mysticism spoke to a new generation of artists who looked up to her at this point, among them David Hammons, Senga Nengudi, and Houston Conwill ("Spirits is the subject I am working with," Nengudi wrote in a 1972 artist's statement). This group's work of the mid-1970s onward prompted key texts by other artists, such as Dawoud Bey's 1982 piece on Hammons, in which Bey claimed that "all art carries with it an aura of magic if it is truly doing its job. Or if the artist is truly a magician. Or a shaman. David Hammons is." The most sustained account of these artists' work, however, was the essay their gallerist Linda Goode Bryant penned for her 1977 catalogue *Contextures*, which was the last major theorization of the Black aesthetic in the period covered by this anthology. What she called "contexturalism" did not pertain just to Black artists, but their contributions were at its core. Bryant showed that, as opposed to earlier nonfigurative sculptural artists, who had been concerned with processes and forms for their own sake, these artists used materials and rituals to make allusions to everyday life, and that meant Black life. They incorporated "remains" into their sculptures and installations. "Contextural" art developed new ideas of "energy, mysticism, automatism and ritualistic process."

INTO THE 1980S

This anthology cuts off in the early 1980s, which was around the time curators began to see the period it covers as a distinct era, as shown by retrospective exhibitions such as *Tradition and Conflict: Images of a Turbulent Decade,*

1963–1973, curated by Mary Schmidt Campbell for the Studio Museum in Harlem in 1985. Some later catalogue texts, such as the interviews given by artists for the 1984 exhibition *Since the Harlem Renaissance: 50 Years of Afro-American Art*, staged at Bucknell University in Lewisburg, Pennsylvania, are included in the anthology because those interviews look back to the 1960s and 1970s. But the primary reason for the mid-1980s end date is the important shifts in artistic practice and the discourse surrounding it that took place at that time. The kinds of debates covered in this anthology made way for very different discussions.

Many of these shifts were prompted by the contributions of feminist and queer critics such as bell hooks and Barbara Smith, who would have felt that much of the writing around "Black art" and the "Black aesthetic" was too totalizing, making no space for difference within Black identities. Queer Black artists looked back to important figures—James Baldwin, in particular—who, in the 1960s, were often attacked by influential Black nationalists. Meanwhile, the emphasis placed on the Black family in the writing of some artists closely associated with the Black Arts Movement (for instance, members of AfriCOBRA) was alienating to many of those who were attempting to theorize queer Black practices. By the early 1980s, feminist Black artists also formed alliances with other artists of color, not only to think about their situation vis-à-vis the art world's sexism but also to consider the exclusions of White feminist organizations. When such artists edited journals or exhibition catalogues, the pressures to define Black art or the role of the Black artist were no longer felt to be relevant. We see this in Ana Mendieta's foreword to the catalogue for *Dialectics of Isolation: An Exhibition of Third World Women Artists of the United States*, the show she curated at the New York gallery A.I.R. in 1980 that included work by Howardena Pindell and Senga Nengudi. Cornell West's 1990 essay "The New Cultural Politics of Difference" sums these shifts up well: "The new cultural politics of difference [trashes] the monolithic and homogenous in the name of diversity, multiplicity and heterogeneity."[15]

Meanwhile, other Black scholars in university literature departments began to produce new theoretical material about Black aesthetics, history, and gender that influenced the ways artists made and discussed their works. Often, such scholars took issue with Black Arts Movement theorists such as Larry Neal and Amiri Baraka. Houston A. Baker Jr., for example, as we have seen, published texts about the successive stages of thinking about the Black aesthetic. Informed by poststructuralism, he began to analyze Black culture through semiotics, anthropology, and social history. Hortense J. Spillers's essay "Mama's Baby, Papa's Maybe: An American Grammar Book," published in 1987 in the journal *Diacritics*, shifted understandings of slavery, family, and gender. Henry Louis Gates Jr.'s book *The Signifying Monkey: A Theory of African-American Literary Criticism* came out the following year and attempted to formulate a theory of the Black aesthetic based on the idea

of "signifying" in Yoruban and African American cultures. Just as writers like Neal and Baraka had impacted Black visual arts in the 1960s, so these scholars changed the way artists of the 1980s understood their art.

The shift away from the discussions of the 1960s and 1970s was also attributable to changes in art education. Those studying in many MFA programs and in the Whitney Museum's Independent Study Program encountered different kinds of theoretical writing in addition to literary theory. Poststructuralism, while encouraging artists to think about Blackness in new ways, was problematic at the same time, seen as being too disconnected from everyday Black life. The artist Charles Gaines's introductory essay for his 1992 exhibition *The Theater of Refusal: Black Art and Mainstream Criticism* gives a sense of the range of theories available to artists studying in the 1980s. Gaines posited that postmodernism's critique of the centered White male subject enshrined by modernism, while necessary, did not serve the political interests of those who had much to lose if critical art practice made no place for subjectivity. Gaines warned that a dialectical understanding of Blackness that always positions it as the marginal position in relation to the mainstream was also problematic. Instead, taking cues from the writing of Gilles Deleuze and Félix Guattari, he argued for a concept of "becoming-Black" that always required a related change in the majority's position, concluding that "identity that is deterritorialized produces a dynamic marginality that constantly seeks to define itself."[16]

Another, related shift in the early 1980s involved the impact of artists working from some of these same theoretical positions who viewed identity not as fixed but as constructed by representations and images from advertising, journalism, television, film, and art history. Members of the "Pictures Generation" such as Cindy Sherman and Barbara Kruger rose to prominence at this time, while Allan Sekula and Martha Rosler, in San Diego, published important critiques of documentary photography. African American artists working at the same moment, including Adrian Piper, Lorraine O'Grady, Lorna Simpson, Carrie Mae Weems, and Kerry James Marshall—though less celebrated in those years than their White peers—took a related but distinct approach to appropriation and the complex interplay of text and image. All these new theoretical positions and practices informed the work of emerging artists such as Renée Green, Fred Wilson, Glenn Ligon, Lyle Ashton Harris, and Gary Simmons as well as the curators and critics who supported them: Thelma Golden, Greg Tate, Kellie Jones, Lowery Stokes Sims, Beryl Wright, and Hilton Als, among them.

TODAY

How do the contents of *The "Soul of a Nation" Reader* appear from the perspective of today? One observation is that the polemical, sometimes outright aggressive tone of debate *between* Black artists that we see in the 1968 exchanges between Tom Lloyd and Jacob Lawrence, or in Frank Bowling's

1971 comments on Benny Andrews's work, seems to have disappeared, along with the kinds of manifestos penned by collectives such as AfriCOBRA. This is, in part, because artists have become more accepting of a diversity of practices and more understanding that art might be political whether or not it includes overt content. But it is also because of the new ways success is defined in the art world. Individualism and career progress are valued so highly that collective statements and polemical disagreements seem almost unimaginable. Black artists have become more recognized and rewarded by institutions and the market, and with this visibility, there is more at stake in attacking other living Black artists in print. This is not a situation that affects just African American artists, of course; it accounts for the general politeness that pervades discourse between artists, at least most of the time.

Since *Soul of a Nation* opened in 2017, Mark Bradford and Martin Puryear have represented the United States at the Venice Biennial, Arthur Jafa has won the Golden Lion, Adrian Piper has had a retrospective at the Museum of Modern Art, Kerry James Marshall's acclaimed exhibition toured from the Museum of Contemporary Art, Chicago, to New York and Los Angeles, and Julie Mehretu's retrospective opened at LACMA. Major museums have hosted exhibitions by artists who were in the show, from Charles White to Dawoud Bey, and works that were in the exhibition have entered major collections—most famously, Faith Ringgold's *Die*, now at MoMA. The contrast is great to the situation in the 1960s and 1970s, when major institutions rarely supported Black artists in a sustained and prominent way. But the battles fought by the artists of the 1960s and 1970s are far from won. Just as Benny Andrews once responded to Hilton Kramer, Black artists still need to publish texts condemning art critics unaware of the thinking that informs their art, although this tends to happen on social media rather than in print—Simone Leigh's response to a complaint that the 2019 Whitney Biennial had no "radical" art in it being a case in point.[17] And as bigotry continues to blight the United States, as innocent Black Americans continue to be murdered by police and take to the streets to protest, and find ways to reflect on all this in their art, artists and their allies continue to pressure museums to respond to the historical and current institutional racism that seems so far from being eradicated.

March–July 2020

NOTES

1 Kellie Jones discusses Bowling's text in her essay "It's Not Enough to Say 'Black Is Beautiful': Abstraction at the Whitney, 1969–1974," in Kobena Mercer, ed., *Discrepant Abstraction* (London: Institute of International Visual Arts; Cambridge, MA: MIT Press, 2006), 154–82.

2 The exhibition was on view at Tate Modern, London, from July 12 to October 22, 2017, and has since toured to Crystal Bridges Museum of American Art, Bentonville, Arkansas; the Brooklyn Museum, New York; the Broad, Los Angeles; the de Young, San Francisco; and the Museum of Fine Arts, Houston.

3 Jack Whitten, studio note, April 20, 1976, in Katy Siegel, ed., *Jack Whitten: Notes from the Woodshed* ([New York]: Hauser & Wirth Publishers, 2018), 113.

4 Robert Farris Thompson, "African Influence on the Art of the United States," in Armstead L. Robinson, Craig C. Foster, and Donald H. Ogilvie, eds., *Black Studies in the University: A Symposium* (New Haven: Yale University Press, 1969), 122, 163.

5 Arnold Rubin, "Accumulation: Power and Display in African Sculpture," *Artforum* 13, no. 9 (May 1975): 35–47.

6 For example, Romare Bearden, "The Negro Artist and Modern Art," *Journal of Negro Life*, December 1934: 371–72.

7 The members of OBAC coauthored many other statements, but they have not been included here because they were not widely circulated at the time. They can be found in Abdul Alkalimat, Romi Crawford, and Rebecca Zorach's book *The Wall of Respect: Public Art and Black Liberation in 1960s Chicago* (Evanston, IL: Northwestern University Press, 2017).

8 For a summary of such writing from the 1920s to the 1940s, see the section "The Evolution of a Black Aesthetic, 1920–1950" in David C. Driskell's catalogue *Two Centuries of Black American Art* (Los Angeles: Los Angeles County Museum of Art, 1976), 59–79.

9 It should be noted that David C. Driskell was also an artist, and his work was included in exhibitions such as the Whitney's *Contemporary Black Artists in America*.

10 Margo Natalie Crawford, *Black Post-Blackness: The Black Arts Movement and Twenty-First-Century Aesthetics* (Urbana: University of Illinois Press, 2017).

11 Sam Durant, "Introduction," in Sam Durant, ed., *Black Panther: The Revolutionary Art of Emory Douglas* (New York: Rizzoli, 2007), 25.

12 Alain Locke, "The African Legacy and the Negro Artist," quoted in Driskell, *Two Centuries of Black American Art*, 59.

13 Houston A. Baker Jr., "Generational Shifts and the Recent Criticism of Afro-American Literature," in Winston Napier, ed., *African American Literary Theory: A Reader* (New York: New York University Press, 2000), 179–217.

14 Saar had always been interested in the "mystic image," as she called it in the first volume of Samella S. Lewis and Ruth G. Waddy's *Black Artists on Art* (1969), but in 1973, she made a clear shift away from overtly political works.

15 Cornel West, "The New Cultural Politics of Difference," *October*, no. 53 (Summer 1990): 93.

16 Charles Gaines, "The Theater of Refusal: Black Art and Mainstream Criticism," in Charles Gaines and Catherine Lord, eds., *The Theater of Refusal: Black Art and Mainstream Criticism* (Irvine, CA: Fine Arts Gallery, University of California, Irvine, 1993), 16.

17 In response to reviews criticizing the 2019 Whitney Biennial for lacking "radical" art, despite all the controversy surrounding the museum trustee Warren Kanders, and in particular to Linda Yablonsky's piece "Everything Is Good at the Whitney Biennial but Nothing Makes a Difference" in the *Art Newspaper* (May 14, 2019), the artist Simone Leigh published an incredible text on Instagram, accusing critics of "lack[ing] the knowledge to recognize the radical gestures in my work" (May 16, 2019).

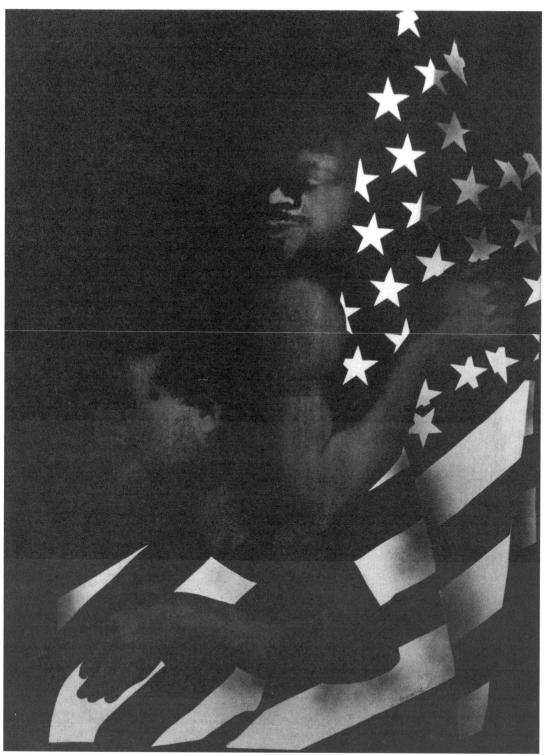

David Hammons. *Black First, America Second*, 1970. Body print and screenprint on paper, 41¼ × 31¼ in. (104.8 × 79.4 cm). Tilton Family Collection

THE READER

INTRODUCTORY TEXTS BY ALLIE BISWAS

1959

Marion Perkins, "Problems of the Negro Artist," keynote address delivered at first National Conference of Negro Artists, Atlanta, Georgia, March 28–29, 1959; first published as Marion Perkins, *Problems of the Black Artist* (Chicago: Free Black Press, 1971)

The artist Marion Perkins was born in Arkansas in 1908. Following the death of his parents, he moved to Chicago's South Side, where he was raised by an aunt. Largely self-taught, he started making sculptures in the 1930s. His figurative works drew on African, ancient Greek, and Meso-american art and were regularly exhibited at the Art Institute of Chicago. An outspoken advocate for social reform and racial equality, Perkins estab-lished himself as a prominent figure at the South Side Community Art Center—the sole venue where Black artists in Chicago could exhibit their work. Perkins delivered this text as a lecture at the first National Confer-ence of Negro Artists, which he had cofounded with the writer Margaret G. Burroughs (also known as Margaret Taylor-Burroughs). It outlines his con-cerns about the discrimination faced by Black artists in the United States and proposes ways for their art to flourish, independent of mainstream Western standards. Perkins's argument can be considered a precursor to the rhetoric used by the Black Arts Movement, which emerged just a few years later.

MARION PERKINS, "PROBLEMS OF THE NEGRO ARTIST"

All of you know the title for the subject of my talk tonight—Problems of the Negro Artist. Unfortunately—this word "problem" arouses unpleasant reactions among many of us. It is a word that is kind of worn and battered and one wishes at times that it could be completely abolished and something more inspiring substituted. But this in itself becomes a problem. But to heap injury on to insult—it's the last two words in the title which affect some like a red rag waved in the face of a bull—and that's the expression—"Negro Artist." At times I am inclined to sympathize with them because of the manner in which it has been used by our avowed enemies and a few of our patronizing friends. Nevertheless, to be an artist and a Negro presupposes problems whether one likes it or not. In fact, just to be a Negro in America creates a problem, and from what one can glean from the press, quite a serious one. Well, we are assembled here, the first national gathering of Negro artists to my knowledge to take place in this country. And I am sure we all are looking forward to the hope that at the conclusion of this conference, the problems, through our collective exchange of experience and ideas, will become more sharply defined and put in proper focus so that we can take constructive measures to overcome many of them.

It is very fitting that this historic gathering should take place here at Atlanta University, prior to the opening of its 18th anniversary All-Negro Art Show, where in its repository there exists, without doubt, one of the most notable collections of Art created by Negro artists within this country. There may be some who have reservations as to the wisdom of such a show, and think in terms of the opposition that existed at its very beginning. But I wonder if they can deny that within the eighteen years of its existence, it still offers the greatest opportunity of any other Art Show in the country to be accepted and exhibited. When I speak these words, I feel that I can speak with some authority having achieved some modest recognition as an artist nationally. But we have not met here to belabor this question,

but to explore ways and means of opening up more opportunities to our aspiring artists.

We are not alone in taking some collective efforts to examine our position in today's troubled world. A few weeks ago another historic conference of Negro writers, sponsored by the American Society of African Culture, met in New York to exchange and evaluate their experiences on the problems of being writers in addition to being Negroes. There is an added significance—that this conference of Negro writers which met there—obtained their cue from the "International Conference of Negro Writers and Artists" held in Paris in 1956 under the leadership of African intellectuals. This contagious spiritual renaissance of Black, Yellow, and Brown intellectual and cultural forces throughout the world, to meet to discuss and examine their common problems, evidently points to some great inherent need.

Today the subject races and nations of Africa and Asia are beginning to awaken to the fact that their own culture, a knowledge of its origin, and its contribution to human development is one of the essential ingredients to give a race or nation a cohesiveness and a definite feeling of self respect. Western culture, in spite of its tremendous material achievements, stands at the crossroads where the questions of human relations are concerned, and finds it difficult to translate its moral concept of the brotherhood of man into a living reality. So we find those intellectuals within these groups, dominated by European and American civilization, beginning to free themselves from the hypnotic spell of its self acclaimed superiority.

I know everyone here would like to know some of the results of the New York conference. I understand that Mrs. Burroughs contacted the chairman of the conference and invited him to send an observer to our proceedings. If that representative is here, I am sure we would welcome a short report on the results of the conference. In the meantime I would like briefly to report some of the results as reported by the press. Speaking of the press and the news worthiness of this unique event, it is amusing to note that the American Press, with few exceptions, failed to even give it a byline; and the Negro Press, also

American, devoted a few begrudging inches to this, in its estimation, not so momentous event.

I have no desire to quarrel with the brethrens who are dispensers of our daily or weekly news. They know their public and it is common knowledge that intellectual and cultural gatherings do not rate headlines or sub-headlines in American life. Anyway, the final aims of this conference, to me, appear very gratifying from what I could see—plans for a quarterly publication, for a Negro Theatre, an award for the best Negro writer, grants to send Negro writers to Africa, and the final plan to give the conference a permanency. All these aims I subscribe to wholeheartedly. It is my hope that out of this conference we can establish a closer liaison with them. A united cultural movement of all the arts would be a healthy thing. Let us not forget that we are all in the same boat with all the Negro people piloting through the storm toward the same cherished goal—full democratic rights and first class American citizenship.

I would like now to get down to the nub of the question as to why we are assembled here this evening. All of us are interested in the shop-talk, the specific questions confronting every creative artist within his particular field. Much of what I have to say comes out of personal experiences as one who has made an attempt to do some serious creative work, along with the experience and ideas of others in the field of the plastic arts, and along with numerous books and periodicals which I try to keep up with in order to stay abreast of the development of art in American life. The fact has to be faced that art, like any other commodity in American life, is subject to the instability of the craze, the trend, the change, a pathological kind of attitude into which the American people have become so conditioned to until nearly everybody is looking forward to tomorrow's model before yesterday's has been tested out thoroughly and probably could serve just as well. If some of the old masters, developed in the Western world's traditional concepts of art, should return today and attend an exhibition of art such as the recent Carnegie show, I am certain they would become completely bewildered by what they were seeing. Yet, it becomes necessary to keep up with viewing what others are doing, for always there is something one may learn which may help one's own development.

There are three major problems that I want to briefly explore: namely, becoming an artist, which consists of that inner urge to seriously express one's self in one of the varied cultural media used in communicating with our fellow men. In order to communicate successfully in one's chosen media, one must achieve a reasonable knowledge and mastery of one's craft. Secondly, content—the very essence of any art in which one can become engaged in such an endless controversy and speculation, until one becomes so bogged down until nothing is accomplished. Then thirdly—how to reach the spectator, whether it be one or many. (Personally, I say, the more the merrier, in spite of those snobbish creatures who pride themselves that their creations can be understood by the selected few, or claim that they are only indulging in the creative process as an outlet for their frustrations.)

The three problems enumerated are ones which every creative person has to face regardless of race or nationality. But where the Negro is concerned, they take on a special connotation, and involve special difficulties as in the matter of preparation for one's career—obtaining adequate training—so one can successfully accomplish one's objective. This is the number one problem in the mind of every intelligent Negro. Those who seek to throw up the smoke screen that the Negro is seeking integration in the school merely for the sake of integration falsifies the real issue. What Negroes seek is equal education and opportunities and to obtain the best regardless of which side of the track the best is located on. The Negro artist is especially handicapped in certain sections of the country where there is a dearth of art schools or art departments with adequate facilities and competent instructors.

On the question of content, its treatment, its purpose—what to paint, what to sculpt, these are the problems which plague every artist. But the social milieu in which the Negro artist is condemned to reside plays a dominant role in conditioning his outlook and reactions. Carl Milton

Hughes in his book *The Negro Novelist* sums this situation up accurately when he states, "But there are numerous factors in the environment which operate against the Negro, and as such must be carefully documented and projected in narrative form for the sake of advocating change. Negro novelists stress the role of the underprivileged and the dispossessed Negro inhabitant of America. There is an indictment of society in the novel of protest because the society in which the Negro lives permits vice and corruption to undermine basic personality growth. Environmental factors pave the way for the demoralization of the character of many Negroes. These problems arise from wrongs in American society which the Negro novelist considers too urgent to by-pass." The Negro artist finds the same factors operative in dictating his attitude toward his material. The vogue of abstract expressionism and similar abstract theories which are being loudly acclaimed by the guardians of the art world in America today has small attraction to the Negro artists confronted with harsh human realities and impelled with the desire to uplift his people, to portray them in dignity in the manner of the old masters, and to seek to demolish the stereotype which persists in being cherished in the minds of white America. If this is true, it will account for the unacceptance of works by Negro artists at many of the major shows. This fact holds true in so far as many white artists are concerned who persist in retaining the realistic image upon their canvas. The biased dictators of The Academy of Modern Art insist on using their narrow conception as to the worthiness of a picture or piece of sculpture. If it lacks ambiguity, a favorite word cherished in the vocabulary of the extreme moderns, or if it is not something novel with a shock value to hit the spectator between the eyes, they refuse to label it as art. There are some who may question my assertion. I ask, if it is not true, why is it that not one of the national art magazines in America consider this unique collection here in Atlanta worthy of a critical article. Surely these gentlemen cannot be unaware of this collection and the yearly annual art show. It becomes increasingly clear that the Negro artist can look for few laurels from the lords of the modern academy. A few pass the test for one reason or another, probably at times only because of expediency. In the effort to sell American democracy to the world, how can the happy successful face of the darker brother be omitted as a commodity.

Friends and fellow artists, I think this situation highlights one undeniable fact. The time has come when we have to evaluate our own endeavors, when we must separate the men from the boys among ourselves, when we must turn to the spirit of Alain Locke and to the still living courage of Du Bois and Paul Robeson. Let's honor those among us who give wings to our spirit, who create an art to sustain the bitter defeats and celebrate the hard won victories. It is true that the depressing, the ridiculous, and the ribald comic spirit exist among us. But the down to earth and sympathetic image of a Langston Hughes' *Simple* has far greater artistic validity than the so called representative samples of Negro life such as *Porgy and Bess*, which was the arbitrary choice of the white hierarchy for a trip abroad. Unquestionably, it was amusing and entertaining to the European brethren, but one wonders about the reaction of our African and Asian brothers. For the fifth time, the beloved play of a large section of white America, *Green Pastures*, with its wonderful odors of fish frys in heaven is nationally televised with fanfare and with acclaims. And let us not forget the greatest example of the debased mentality of certain sections of the American public with its tolerant support of an outmoded black face minstrel program on radio and television for nearly three decades such as *Amos and Andy*. I often marvel why it has not been awarded the Pulitzer Prize. Unquestionably, our own indifference and lack of social alertness has contributed much to the continued existence of such caricatures of Negro life. And we should resolve from this day on that we will collectively combat with every means at our disposal this blot on our cultural life. And I would like to point out that our artists and sculptors can play a major role in replacing the stereotype with the true image of Negroes and Negro life. To my mind, a dedicated artist like Charlie White, portraying his people with love, with sympathy, with dignity, exemplifies the desire and creative efforts of most Negro artists.

So much for content. What about the audience? Who must the Negro artist paint for? I say if he creates with integrity, seeks to communicate with legible images, takes his wares to the outdoor shows, he will find the people receiving his works with admiring eyes. For the people everywhere, whether white or black, view the artist as a miracle worker. Of course, they will hesitate to ask the price, for they have been taught that works of art are usually beyond the ordinary man's means, which they usually are. But if you assure them that you will make an exception in their case, and since they appreciate it so much, you want them to have it if they will pay a bit from time to time, as they pay for many other things in our time-payment economy, you will be surprised at the result. In my estimation, the open outdoor art shows in the public squares and shopping centers in many sections of America is one of the healthiest developments in our national life today. Many people who would not dare to put a foot in the museums come out, and for the first time look at pictures and sculpture and see a living artist in the bargain.

Of course I do not mean that the artist should let up in his struggle to make some of the shows in his region and nationally if he can and seek to obtain the recognition that is his due. After all, we cannot afford to abdicate to the abstract academicians who rule the roost in the art world today. I say to every Negro artist—work diligently to master your craft, explore all the avenues for the direction in which you can express your talent more effectively. In case there has been some mistaken impression that I am unilaterally opposed to certain modern manifestations in the art world today, allow me to clear the record. I am opposed to the tyrannical dictation of those who seek to narrow the concept of the function of art: who seek to brand efforts at social and moral comment as irrelevant or propaganda; who decry realism as illustration; and in the name of freedom, uphold the anarchistic license that prevails today. Is it not enough that there are dangerous war-minded men with unimaginable instruments of destruction wrestling on the brink of chaos, without an art that is only adding to the confusion. Never before has mankind been faced with a greater need for expressions of clarity to arouse his sense of humanity, which only those who command the language of the arts are able to give. There is no denying the fantastic miracles accomplished by science today, with its promises of unlimited blessings. But only the men with minds bathed in the light of the humanities will be able to help translate it into reality.

In regards to some of the specific tasks I feel that we must tackle at this conference, first, there is the Atlanta Art Show here in the heart of the South, where numbers of our white brethren are painfully engaged in a struggle to make a moral reassessment of a conditioned immoral attitude toward their darker brother. In my estimation the show must continue and we must help it grow. We must build it collectively with the loving hands of master craftsmen, until, like one of the mighty Gothic cathedrals, the spires of our endeavor will tower to the heavens as a special testimony of our faith in the South and in America. There are some who feel that the show must be broadened to include white artists. Certainly this idea merits discussion. There is a second task that we are faced with, though some may be unaware of it. 1963 will be the century mark since the signing of the Proclamation of Emancipation. A while back in idealistic fervor a slogan was formulated, "Free by '63," to cap anticipated celebration of this coming important event. With enthusiasm I subscribe to such a celebration, though I feel somewhat dubious that the slogan can become a complete reality. But I feel it devolves upon us, the Negro artists, the writers, the musicians, the actors, along with all the progressive forces in America to begin now laying the foundation for such a celebration which will symbolize the ending of an era and the beginning of a new one. We must begin now to intensify our creative efforts in order at that time to have the books and plays written, the pictures painted, the sculptures made that will be worthy of this great occasion, in which we shall be the arbiters, to present to the world the American Negro's real cultural contribution. We should begin now to marshal our supporters; progressive labor, the liberals in deeds instead of words, the Christians who practice their religion instead of just preaching

it, and the mass of our struggling people who toil daily to provide their children with an opportunity for a better life. Friends, before I conclude my talk, I would like to read to you two quotations, one by a now deceased, eminent American Negro poet, Countee P. Cullen, and the other by a living African intellectual, Keita Fodéba, born in French Guinea and the organizer and director of the African Ballet Company and an acknowledged authority on the African Dance. Permit me to read to you one of Mr. Cullen's memorable poems.[1]

I feel sure that had Countee P. Cullen been fortunate enough to be alive today he would have greeted the almighty African liberation movement with fitting verse. But we cannot deny that at the time he wrote this beautiful poem, it reflected the attitude of most of our people who were enslaved and spirited thousands of miles from the land of their heritage, and their culture ridiculed and nearly erased from their consciousness.

Now for this remarkable insight into the dilemma of his American darker brother by Keita Fodéba, I quote:

Our transplanted brothers have generally been placed in such political, moral, and material conditions, that as a result of retiring within themselves, so often they have reinforced their psychic bonds with our continent. Owing to the dominating effect of conditions of environment upon the individual, it would seem difficult to speak of a culture of the Negro World. Yet, to the best of our knowledge, nowhere in the world during the long years of their tragic expatriation have the Black races enjoyed social and economic conditions which were sufficient to destroy utterly their original ties.

On the one hand, Africa being the land of origin of the Negroes, we can probably deduce that for a long time, and wherever they are, they will retain something ancestral which will link them to their African brothers. On the other hand, when considering the fate reserved, generally speaking for the Black man in the so-called "civilized" world, we are obliged in the present circumstances, to recognize and wish

for a certain identity of aim in culture. "Every culture worthy of the name must be able to give and receive" it is said. And the added merit of the Black cultures will be that they all have the same legitimate desire to defend the cause of an unjustly used race.

Thus our African brother expresses an implicit faith in the oneness of our spirit, that the symbols of our heritage still live within us. Surely it is our task to acknowledge, and seek to renew those ancestral ties. We must begin to see that the African liberation struggle aids our struggle. It is time that we should begin to drink at the fountain of African culture in order to better know our brother. It is my hope that we can establish a cultural link with rising Africa, and that we darker people marching toward the goal of freedom will trample in the dust the legacy of arrogant superiority, prejudice, and race hate bequested by certain exponents in the Western World. And in our march lift our voices and sing the prophetic hymn by the poet, Margaret Walker.

Let a new earth rise. Let another world be born. Let a bloody peace be written in the sky. Let a second generation full of courage issue forth. Let a peoples' freedom come to growth. Let a beauty full of healing and a strength of final clenching be the pulsing in our spirits and our blood. Let the martial songs be written, let the dirges disappear. Let a race of men now rise and take control.[2]

NOTES

1 Countee Cullen's poem "Heritage," recited.
2 Taken from the poem "For My People" by Margaret Walker. [The fifth sentence of Walker's poem actually reads: "Let a people loving freedom come to growth." —Eds.]

1964

Clebert Ford, "Black Nationalism and the Arts," *Liberator* 4, no. 2 (February 1964)

Liberator was a radical magazine founded in New York by the architect–turned–full-time activist Daniel H. Watts in direct response to the assassination of the Congolese prime minister Patrice Lumumba in January 1961. Published by the American Negro Labor Congress, a Communist Party initiative that sought to advance the rights of African Americans, the magazine ran monthly from 1961 to 1971, foregrounding explicitly political opinion pieces but also including cultural criticism. Clebert Ford was a staff writer at the magazine, known for his social commentary and art reviews. He was one of the earliest critics to discuss the significance of the theater for Black artists and, unlike most other commentators, had a direct relationship with the stage and cinema through his career as an actor. Ford's article is indicative of a growing awareness of the Black nationalist impulse in the early to mid-1960s.

CLEBERT FORD, "BLACK NATIONALISM AND THE ARTS"

Any discussion of the concept of "nationalism" with respect to the black American must be preceded by a definition of Nationalism in the American context and an evaluation at the current status of the Afro-American in American society.

What *is* Nationalism? Recently someone mentioned to this writer that the *Liberator* was the first magazine specifically concerned with an honest examination of the black American's life in American society. Nationalism as used in this context means just that. It is a truthful and sincere involvement by black people with the total experience of black people in American culture. This "soul syndrome" or "black syndrome" entails a commitment to the total black experience in all of its aspects, from fried chicken and watermelon to the assimilationist aspirations of the black bourgeoisie; from African Black Nationalism to hair processing and skin whiteners; from chitlins' to sit-ins; the entire Afro-American experience . . . switch blades, clabber bread and rice and peas, white women and red Cadillacs, Paul Robeson and Jackie Robinson, Martin Luther King and Malcolm X. Nationalism is not proscribed by "Africanist" or "separatist" philosophy. It is a realization and expression of "blackness" or American "negritude" in the totality of the American experience with all of its varied ramifications and peculiarities.

The freedom struggle is at this point in American history at somewhat of a standstill. James Baldwin likens this lull of activity to a football huddle: "People are reassessing. They are planning. We will flush the villain out." (*Time* magazine, 1/3/64). In this writer's opinion what will emerge will be a program much more nationalistically oriented than at any time in the past. Black youth has rapidly been assuming the reins of leadership in the freedom struggle, having been influenced by several parallel forces in the current American scene. Briefly, they include such factors as:

1. The myth of assimilation, i.e. the growing realization that the attainment of true integration (hard core schoolroom and bedroom integration) is an impossibility. White America has given very little indication that she is yet willing to accept her black step-children into the family of man. Any "black" acceptance is going to be on his (the white man's terms.

2. The failure of Negro leadership to develop a program encompassing the needs and aspirations of most black people.

3. Disillusionment with Black Nationalist and Black Muslim philosophies which, in spite of their great initial influence on nationalist thought, have also failed to come forth with a meaningful program.

4. The realization that the establishment (the white power structure) maintains its position solely by force of its own power and only respects power. Afro-Americans are beginning to understand that in "blackness" there is power.

5. The myth of African black brotherhood; or the realization that although some relationship exists with the African freedom struggle, the black American problem is just that, i.e. an American problem.

[*Here, Ford discusses specific examples of Black nationalism in theater, music, dance, and poetry.*]

The experience of the black man in the American society must be given continuing expression in all forms of our culture. Unfortunately, the white establishment has not shown that it is truly interested in this aspect of American development. The white liberal now calls for an involvement with the "Americanness" of all things while the white power structure only sees the "whiteness" of all things. Let us as black people begin to concern ourselves with the "blackness" of some things. Integrationist, or assimilationist philosophy, has too long clouded the basic issue, and that is the issue of color. In short, let's see what it feels like to be black for a while.

1965

Unsigned statement in *Spiral: First Group Showing (Works in Black and White)*, pamphlet for exhibition held at 147 Christopher Street, New York, May 14–June 4, 1965

Spiral, a New York–based group of fourteen African American artists, came together in 1963, shortly before Dr. Martin Luther King Jr.'s March on Washington, with the premise of exploring what artists' role should be during this time of racial upheaval. Members of the group were at varying stages in their careers and worked in diverse styles, and some held opposing opinions about the merging of art with activism. This text is from the catalogue that accompanied the group's only exhibition, *First Group Showing (Works in Black and White)*. It opened in May 1965 at the group's headquarters on Christopher Street in Manhattan, where the members held weekly meetings. It had been agreed that only works executed in black and white would be presented, perhaps in a symbolic reference to contemporary life in the United States. Spiral disbanded in 1966.

SPIRAL: FIRST GROUP SHOWING (WORKS IN BLACK AND WHITE)

During the summer of 1963, at a time of crucial metamorphosis just before the now historic March on Washington, a group of Negro artists met to discuss their position in American society and to explore other common problems. One of those present, the distinguished painter Hale Woodruff, asked the question, "Why are we here?" He suggested, in answering his own question, that we, as Negroes, could not fail to be touched by the outrage of segregation, or fail to relate to the self-reliance, hope, and courage of those persons who were marching in the interest of man's dignity.

In examining ourselves, we soon realized we were also examining the present health of a wounded American society, as well as much of Western culture. Despite many varying viewpoints, the members of the group felt they had something definitive and positive to affirm. If possible, in these times, we hoped with our art to justify life. In time we came to depend upon one another, and perceived that talent and aptitude were not the only means needed for creativity, since creativity is an aspect of human behavior, comprehensible only in terms of a dynamic social relationship.

As a symbol for the group we chose the spiral—a particular kind of spiral, the Archimedian one; because, from a starting point, it moves outward embracing all directions, yet constantly upward.

Now, after nearly two years of having been together, we have decided for our first public exhibition to use only black and white and eschew other coloration. This consideration, or limitation, was conceived from technical concerns; although deeper motivations may have been involved.

It will be apparent that the works do reflect varying feelings and approaches to art: several reveal that the artist's eyes were fed by nature; another, the painter's basically emotional response; works of Reginald Gammon and Merton Simpson are configured with violent images of conflict; in contrast, the graphics of Bill Majors are lyrical and richly textured; Hale Woodruff's painting, despite a surface freedom, has deliberate exactitude and design.

Time, and judicious judgment, will determine the lasting merit of the work on exhibit. What is most important now, and what has great portent for the future, is that Negro artists, of divergent backgrounds and interests, have come together on terms of mutual respect. It is to their credit that they were able to fashion art works lit by beauty, and of such diversity.

1965

Lawrence [Larry] Neal, "The Black Revolution in Art: A Conversation with Joe Overstreet," *Liberator* 5, no. 10 (October 1965)

The painter Joe Overstreet was born in Mississippi in 1908, grew up in the Bay Area, and in the late 1950s moved to New York, where he became involved with the Black Arts Repertory Theater in Harlem. In October 1965, provoked by Malcolm X's recent assassination, LeRoi Jones (later Amiri Baraka), Askia Touré (born Roland Snelling), Charles Patterson, William Patterson, and Steve Young established the theater with the intention of advocating for the Black community through their productions. The theater directly aligned itself with the militant politics of Black nationalism and, though short-lived, is often acknowledged as the earliest manifestation of the Black Arts Movement. Overstreet's paintings became overtly political in the mid-1960s, when he started to challenge stereotypical images of African American culture. His comments in this profile underline his belief that Black artists needed to take a revolutionary stance and connect their art to the reality of how Black people lived; doing so, he posited, would create representational methods and values that could be understood only by African Americans. The author of the profile, Larry Neal, was a highly influential figure of the period, recognized primarily for his essays and poems. After completing his postgraduate studies at the University of Pennsylvania, Neal moved to New York, where he became involved with the Revolutionary Action Movement (RAM). He was the arts editor of *Liberator* from 1963 to 1965 and later served as the Black Panther Party's education director.

LAWRENCE [LARRY] NEAL, "THE BLACK REVOLUTION IN ART: A CONVERSATION WITH JOE OVERSTREET"

" . . . We must understand what kind of pictures we must paint."

Overstreet's statement is plain enough on the surface. But close examination of the facts behind it leads us to be more aware of the problems confronting Black artists today. These problems result from attitudes and values learned in white schools which, for the most part, are not suited to the needs of Black people, particularly artists. Outside of the school, there is white society which essentially has no room for the Black artist. Note the number of Afro-American musicians out of work; while those that are working are barely squeezing out a living. As if these problems were not enough, the artist is confronted with a changing world; his people are demanding better, more human images of themselves; some conscious elements even questioned the necessity of art at this time. Finally, as an extension of the latter statement; the artist is confronted with the necessary and painful knowledge that often his work is directed at other than his own people. These are generally some of the topics that we covered with Joe Overstreet.

We asked Overstreet about the situation of Black painters with a revolutionary idea. "What do we mean when we say 'revolutionary'?" He countered, "Revolutionary painters have always been Black painters in America; right now, I guess Jacob Lawrence is an exceptionally revolutionary painter. I don't know how painters will support the movement. I think that painters can and should support a Black revolutionary movement in America." What about the other arts, we asked. "They all should, and take an active interest in our struggle here, and elsewhere. For example, I'm pretty disturbed about this Vietnam thing. I feel that the artist should act and speak about everything that they feel about Black people going to war and fighting non-white people, like the Vietcong and the Chinese."

He went on to discuss the nature of white oppression, and the necessity of the Black artist understanding what his *own problem* is. What I was interested in was the degree to which painting could be of importance to the struggle. Joe's answer saw painting as another way of "getting to the people." "A painting is important to people, and people who understand a picture will understand life in that sense. I think that a really great revolution will have a great picture; but one thing that we must get to—we must understand *what kind* of pictures we must paint."

One problem the Black artist faces is that of evolving new uses of Western forms. Many of them are working within frameworks that are particularly limiting and have little to do with the manner in which Black people experience life. Joe approached this problem by asserting: "Aesthetic studies in art are all right for art school, ofay schools, but for an artist who feels that he has something to say about the people, he must find that something, and it is that which is going to help move Black people and Black artists."

But what about these Western forms *per se*? Painting, sculpture, vocal expression, and drum rhythms, all of these were a part of us, he said. "They are what was taken from us . . . and we have adopted European ways of doing things; but we must develop our own values, our own concepts." Overstreet feels that there is a definite tendency among certain Black painters in this direction: Romare Bearden, the Yoruba painters, in Uptown, New York; and of course Jacob Lawrence who, Overstreet feels, is one of the outstanding Black painters.

Overstreet would like to see the artist take a more active part in seeing that his art is displayed. Essentially, he suggests that the setting up of Black-operated galleries, like the Afra-Arts gallery on Convent Avenue, New York City: or painting on billboards and fences where building construction is going up. "We need space and area; if we can get it, we can really do something." We did not comment on the political overtones implied in this statement. But the problem is just that. Which led to the final question: What about nationalism? "That's a word . . . it doesn't necessarily mean anything. We are a people and our art will come from accepting this in ourselves; I don't have to say, or *talk* about

killing whitey to know that I love myself and my brothers. Our art is going to be about the fact that we are a people." We interjected, it will be about love, and what it means to be a people, and to have undergone certain things. Joe: "If it's not about that, then it's not art."

Joe Overstreet is attempting to practice his ideas in a setting that allows full expression for the creative ideas of Black artists. He teaches a course in painting at the Black Arts Theatre/School in Harlem.

1966

Jeanne Siegel, "Why Spiral?" *ARTnews* 65, no. 5 (September 1966)

Three years after forming, the group of artists who called themselves Spiral reflected on their aims in this conversation with the writer Jeanne Siegel. The interview, which was published after the collective had dissolved, explores subjects critical to Spiral's ethos, such as civil rights and the "Negro Image." It also recounts the personal aspirations of each of the fourteen artists. At the time of the interview, Siegel was completing her master's thesis ("Four American Negro Painters, 1940–1965: Their Choice and Treatment of Themes") in the Department of Art History at Columbia University. She was also known for her interviews with artists for the local radio station WBAI. *ARTnews*, a popular monthly magazine covering the visual arts, had been founded in New York in 1902.

JEANNE SIEGEL, "WHY SPIRAL?"

Negro artists, well known and neophyte, meet as a group in New York to discuss the contradictions facing them in modern America.

When I asked each of the 13 men and one woman that make up the present membership of the Spiral group what Spiral stands for, I got 14 conflicting answers. One of the reasons for the disparity is that unlike most artists' circles, its raison-d'etre was not primarily an esthetic one, nor was it formed for the traditional purpose of exhibiting together and making public statements. As if the problems that confront all modern artists are not enough, Charles Alston, Romare Bearden, Felrath Hines, Norman Lewis, Alvin Hollingsworth, Merton Simpson, Earl Miller, William Majors, Reggie Gammon, Hale Woodruff, Perry Ferguson, Calvin Douglass, James Yeargans and Emma Amos—a dynamic and totally divergent group ranging in age from 28 to 65, that includes a court clerk, art dealer, floorwaxer, Ph.D. candidate and restorer of old masters—first began meeting three years ago to discuss what they considered a far more vital issue: what should be their attitudes and commitments as Negro artists in the present struggle for Civil Rights.

At a glance the issue seemed clear enough, but it provoked many searching questions. Should you participate directly in the activities of the Movement? Do you have special qualities to express as a Negro artist? What is your value as an artist who is both an American and a Negro? What do you have in common with other Negro painters? What should your role be in the mainstream of art?

In other words, they felt an urge to say something, but they didn't know what, how or where to say it. They also knew that something set them apart from other painters, but they weren't sure if that "something" had a tangible form that could be transmitted through art. They referred to this possibility as "the Negro Image," and they suspected that, although unquestionably intertwined with other issues, it had to be clarified before other problems could fall into place.

NORMAN LEWIS: I am not interested in an illustrative statement that merely mirrors some of the social conditions, but in my work I am for something of deeper artistic and philosophic content.

HALE WOODRUFF: I agree with Norman Lewis. I am not interested in some "gimmick" that will pander to an interest in things Negroid.

JAMES YEARGANS: We should look to our past for a distinct identity. The Negro artist should take something out of the present upheaval as part of his expression. The Negro has a deep cultural heritage to be explored.

CHARLES ALSTON: I have come to the point where I wonder whether most of the expression I observe in Negro painting might not be only reflections of a dominant culture and not truly indigenous. The Negro artist might have a more personal "thumbprint."

ROMARE BEARDEN: I suggest that Western society, and particularly that of America, is gravely ill and a major symptom is the American treatment of the Negro. The artistic expression of this culture concentrates on themes of "absurdity" and "anti-art" which provide further evidence of its ill health. It is the right of everyone now to re-examine history to see if Western culture offers the only solutions to man's purpose on this earth.

NORMAN LEWIS: Our group should always point to a broader purpose and never be led down an alley of frustration. Political and social aspects should not be the primary concern; esthetic ideas should have preference. Is there a Negro Image?

FELRATH HINES: There is no Negro Image in the twentieth century—in the 1960s. There are only prevailing ideas that influence everyone all over the world, to which the Negro has been, and is, contributing. Each person paints out of the life he lives.

JAMES YEARGANS: Is there a White Image?

FELRATH HINES: There is not. There are just varying means of expression.

NORMAN LEWIS: If we had been allowed to pursue our own image historically, it would have been a Negro Image.

FELRATH HINES: There are Jewish painters who, like Chagall, paint Jewish subject matter, and some who don't.

JAMES YEARGANS: The word "image" is ambiguous. I would like some explanation of it. . . . I have brought one of my paintings that I feel was inspired by certain rhythms that are peculiar to my experience as a Negro.

NORMAN LEWIS: I feel that Franz Kline in his paintings with large contrasts of black against white and Ad Reinhardt in his all-black painting might represent something more Negroid than work done by Negro painters.

PERRY FERGUSON: I suggest that there is no such thing in America as a Negro Art.

JAMES YEARGANS: I prefer the word "Afro" to Negro. We can speak of an Afro-American Art.

ALVIN HOLLINGSWORTH: I wonder why it should be necessary to seek one particular image. Even the exponents of Pop Art paint in divergent ways. When I was a child I used to think Bob Gwathmey was a Negro.

ROMARE BEARDEN: You can't speak as a Negro if you haven't had the experience.

In spite of their doubts and different opinions, they still hoped to evoke in their paintings the "signature," the personal "thumbprint" that they had talked so much about. This was not merely a concept of subject matter, but closer to the formal quality that is found in jazz. Jazz, they feel, grew out of the grassroots of Negro culture. In a concerted effort to bring out this "Negro-ness" they tried to eliminate traditional Western ideas from their minds. Romare Bearden suggested that certain new esthetic ideas of such African writers as Diop and Senghor should be discussed. Merton Simpson, a dealer in primitive art, lectured on African sculpture. They studied geometric tribal designs found on huts, textile patterns, Zulu shields.

In the spring of 1964, for their first group exhibition, they flirted with the idea of "Mississippi, 1964" as a theme and then rejected it as too pointedly "social protest." In its place, they chose an esthetic limitation—to restrict their palettes to black and white—which, they felt, carried symbolic overtones. Bearden created a group of collages that drew on his memories of the South, Harlem, ritual jazz. "I use subject matter," he said, "to bring something to it as a Negro—another sensibility—give it an identity." Giant faces were faceted into abstractions that left no doubt about the artist's desire to depict the nobility of the Negro in a fractured society.

Although Bearden returned after 20 years to the Negro image, themes of the human condition had never ceased to concern him. If we compare the recent collages to his paintings of the 1940s, the difference lies in a certain spirit of detachment that the artist has achieved since the era when "social protest" was current. A product of the W.P.A., he speaks nostalgically of the days when all the Negro artists lived in Harlem and he and Jake Lawrence had studios next door to each other on 125th Street. Today Bearden, a social case-worker when he isn't painting, worries about the fact that the Negro artist has so little rapport with his own community.

Charles Alston, a cousin of Bearden, who also got his start with the W.P.A., says, "Bourgeois Negroes have always striven to participate in the mainstream, always tried to achieve the mainstream's values, a car, a fur coat. . . ."

Although in the heat of the moment he has created paintings like *Starved People*, of Klansmen and poor whites—"those people," according to the artist, "who make the rules, the victims"—such canvases are not typical. "The themes that I am working on today," Alston says, "for example, *The Family*, a mural for the lobby of the Harlem Hospital, or *Nobody Knows*, a portrait of a blues singer, have concerned me throughout my career." He feels now, "Spiral was too weighted on the side of the Cause . . . too involved in self-conscious themes."

Perhaps most deeply affected was the sensitive and talented Norman Lewis. His subject, tiny forms in clusters that suggest migrations of people or birds in space, hasn't changed, but what was

delicate and diffuse became sharpened, in a painting like *Procession*, into a definable object with direction and power. Feeling the frustration that is common to many Abstract-Expressionists at the moment, Lewis had looked to Spiral as a solution to his problem which he interprets largely as a Negro one. Having exhibited alongside the most famous Abstract-Expressionists throughout his career, he says, "in Spiral, we made no attempt to exclude white artists, but what would be the advantage to Ad Reinhardt or de Kooning to join?"

Alvin Hollingsworth, Phi Beta Kappa, teacher, occasional poet, anxious participator, thinks of Spiral as a form of group therapy. "It's a place for Negroes to air their own prejudices and see each other in realistic terms and realize that we have the same concerns as most bourgeois white painters." Although for the Spiral exhibition he created a group of violently Expressionistic oils that depict the isolation of the contemporary urban Negro, he, too, feels that his themes haven't changed. "They've always revolved around the city. For me it was always a question of escape. A series on *Exodus* was my fantasizing about faraway places. In the '50s I painted *The Beat Scene* that depicted bohemian life in the Village. . . . I was always doing backyards."

Of a more esoteric nature, soft-spoken, Indianapolis-born William Majors wants to go to Europe where he feels more like a human being. Rather pessimistic in his prognosis for the future of Spiral, he is not quite certain of his role in it. "I'm a loner. . . . I don't ask any opinions. The problem with Spiral is that we can't criticize each other's work. We can't talk about esthetics because the work is on too many levels. If the educators who haven't painted for years would paint instead of giving advice, there wouldn't be any Spiral. White painters don't need advice; they just paint. I don't care about going to Africa. . . . I just work." Confining himself to print-making, he has devoted a year to a portfolio, *Etchings from Ecclesiastes*, that suggests, through abstraction, time and motion, trees, water, air and sky, the spirituality of man.

Other younger members, including Reggie Gammon, Emma Amos and Earl Miller, who have looked to the old guard as mentors (Miller studied with Alston; Miss Amos has been in awe of Hale Woodruff since she was a child in Atlanta), feel they have gained something through the social contact. "We really got to know them as people," said Gammon, the most sharply diverted by the black-and-white experiment. Prior to the exhibition, he had concentrated on nudes and traditional portraits (he is the only one to paint white figures), but made an abrupt shift to Action-Paintings in which Negro heads (reminiscent of Charles Alston's of the same period) barely emerge from the ground. Gammon, however, like Felrath Hines and Calvin Douglass, seems to be more interested in pictorial problems than making any social statement. Hines, who never deviated from a landscape motif, felt that the black-and-white experiment was valuable esthetic discipline. On the other hand, Calvin Douglass, who tried to express himself more volubly about "the Cause," returned after the exhibition to the "environmental expansions" that he had been working on before.

If in most instances the experiment in black and white did not change any individual artist's conceptions, it did bring certain facts to light. They shared the discovery that, in general, the attempt to express their feelings as Negroes through an art of "social protest" was ineffective if not impossible. They also recognized that, at least in this one effort, there was no evidence of any such thing as a Negro quality or a Negro art. The lack of a quick and ready thematic solution to their dilemma was, I believe, a disappointment to them.

Just as significant is the fact that a diversity of esthetic levels had been brought to light. Their original motive for banding together was not, as has been said, an esthetic one, and it is this ambiguity of goals that creates problems. If they plan to express themselves as a group through their pictures, discrepancies will continue to cause conflict and frustration. This limitation, coupled with the lack of any collective "image," leaves only the Civil Rights issue as a common pivot. When the members decide whether they are a group of Negroes fighting for a particular cause or a group of artists, the necessity for Spiral, at least in its present form, will be over. There are still basic questions to probe, however, before they can reach any conclusions.

HALE WOODRUFF: Should Spiral continue? Is the purpose of Spiral to exploit the fact that we are Negroes—in order to get shows? Or do we believe as artists that we have something valid, together, as a group? We come together, after all, because we see conditions and we face problems.

REGGIE GAMMON: Spiral should begin, not continue.

EMMA AMOS: We never let white folks in. I don't believe there is such a thing as a Negro artist. Why don't we let white folks in?

ALVIN HOLLINGSWORTH: We blackballed all the Colored folks too.

ROMARE BEARDEN: The Negro artist is unknown to America.

Noah Purifoy, "The Art of Communication as a Creative Act," in Noah Purifoy (as told to Ted Michel), *Junk Art: 66 Signs of Neon*, catalogue for *66 Signs of Neon*, exhibition held at Markham Junior High School, Watts, Los Angeles, June 20–29, 1966

"Signposts That Point the Way" (unsigned review), *Los Angeles Times Home*, October 9, 1966

66 Signs of Neon was initially mounted at Markham Junior High School in South Los Angeles as part of the First Annual Watts Art Festival in 1966 and toured various venues through 1969. (For the exhibition catalogue, "Junk Art" was added to the title.) Noah Purifoy had moved to California in 1950 after receiving a master's degree in social work from Atlanta University. He was the first African American to enroll at Chouinard Art Institute (now CalArts), receiving his BFA in 1954, and became an important mentor figure for other artists and young people in Los Angeles. Purifoy and Judson Powell, also an artist, conceived *66 Signs of Neon* when they were both teachers at Watts Towers Arts Center, the organization they had cofounded in 1964 with another local artist, Sue Welsh. The center, one of the first of its kind in California, provided the impoverished community of Watts with a diverse range of art classes. The sixty-six works in the exhibition were created by Purifoy, Powell, and other members of the organization from vast amounts of burned and melted debris collected after the Watts Rebellion of August 1965, which had led Purifoy to change paths in his art. The collective reconstitution of salvaged materials signaled a spirit of defiance. As Purifoy points out, *66 Signs of Neon* functioned as a powerful form of self-expression for the afflicted community while simultaneously asserting the importance of public art education.

NOAH PURIFOY, "THE ART OF COMMUNICATION AS A CREATIVE ACT"

66 Signs of Neon exists on several levels: as an art exhibition dominated by assemblages of artifacts of the Watts riots; as a one-to-one format of communication between individuals who otherwise would not or could not communicate; as an evolving system of philosophy.

For *66 Signs of Neon*, the time of conception was the Watts holocaust of August, 1965. *Sixty-six* was born nearly 12 months later, in a labor of 30 days immediately preceding the First Annual Watts Art Festival, where the collection initially was exhibited. The festival, expected to be the Life span of *66 Signs*, became instead merely its infancy.

The objects of art jabbed the viewer low in the abdomen, squeezed his heart, pricked his mind. It communicated with those blind to its artistic excellence, as well as with those who saw. Unsolicited invitations for showings began to trickle in, then cascade, as further exhibits expanded its circle of advocates. This child of the Watts tragedy now is traveling through major California cities, and as it evolves and matures—new pieces are continually added—there is hope that it will tour the nation, if not beyond. Funds raised by the exhibitions will be partially used to build a permanent gallery to house the collection.

Here briefly then is the story of *66 Signs of Neon*, told primarily in the words of Noah Purifoy, who with Judson Powell, another artist, created the first of the art works and formed the nucleus of the dedicated group now involved:

"Judson and I, while teaching at the Watts Tower Art Center, watched aghast the rioting, looting and burning during the August happening. And while the debris was still smouldering, we ventured into the rubble like other junkers of the community, digging and searching, but unlike others, obsessed without quite knowing why.

"By September, working during lunch time and after teaching hours, we had collected three tons of charred wood and fire-moulded debris. Despite the involvement of running an art school, we gave much thought to the oddity of our found things. Often the smell of the debris, as our work brought us into the vicinity of the storage area, turned our thoughts to what were and were not tragic times in Watts: and to what to do with the junk we had collected, which had begun to haunt our dreams."

The two artists at last decided to build with the found objects "a sculptured garden" around the Tower Art Center, but before they had completed their plans, they learned that due to lack of funds the school would be closed in March, leaving them "among the community of the unemployed." Their thoughts then turned to the impending first art festival, formally titled "The Simon Rodia Commemorative Watts Renaissance of the Arts," scheduled for Easter Vacation week. Noah and Judson were already committed to participate in some fashion, but their role had not yet been delineated.

"It dawned upon us that unemployment for the month of March gave us the time to do something worthwhile for the Festival. Naturally the junk we had collected came to mind. But the validity of its use as an art expression did not occur to us until we came across the McCone Report, the findings of the Governor's Commission on the causes of the riots. We thought it a good report—that it advocated most things necessary for the betterment of the community. However, we observed that there was no mention of art education. Education, yes, but not art education.

"This was our cue. We decided that *66 Signs* could establish its validity by becoming an addition to the McCone Report. We could become that ingredient which had been omitted. . . . It is not unreasonable to state that everyone is creative, that creativity ranks alongside food and shelter as absolute necessities. But art education in most public schools is seen as mere recreation. Yet in reality it is that aspect of education which stimulates the whole process of learning. We recognize that to rediscover himself, each person need not become a graphic artist. But we are certain that, child or adult, whatever one's potential is, it should be given the opportunity to express itself."

Thus *66 Signs* began as an expression of the necessity for art education, affirming the importance of this avenue of self-expression to individuals in the community of Watts.

Noah and Judson began with six assemblages created from the lead drippings of melted neon signs, artifacts of the riots. As their work continued they recruited six other professionals skilled in the plastic and graphic arts. In concert, the group set out to create 66 separate works of art for the festival, in the incredibly brief period of 30 days. They labored literally night and day, groping through "the glittering, twisted, grotesquely formed materials, each interpreting in his own way the August happening"; and they achieved their goal.

"The ultimate purpose of this effort, as we conceived it then, was to demonstrate to the community of Watts, to Los Angeles, and to the world at large, that education through creativity is the only way left for a person to find himself in this materialistic world."

Junk was chosen as the medium for a variety of reasons, in addition to its obvious impact as the artifacts of tragedy. "Watts finds itself virtually set down in the center of junk piled high on all sides. Its main industry is junk! The essential question being posed to the community by the exhibit was, what is the true value of these materials over and above sale to the junkyards for a few cents?"

On another level, the assemblage of junk illustrated for the artists the imposition of order on disorder, the creation of beauty from ugliness. Its analog was the essence of communication, for the placing of unrelated objects in a pattern conceived by intellect and emotion made them speak coherently, much as the juxtaposition of two persons in a certain context permits them to converse in a way that would be impossible under so-called normal circumstances.

The group does not now see 66 Signs of Neon as an "art show as such, nor as a mere adjunct to the McCone Report." Rather "it is a feeling or sensing of something difficult to describe. It is evident that it is a utilization of the August 11th event, but that it transcends it, and rises above social protest. It seems to be saying that there is some uncertainty about our direction. That we all take equal responsibility for the Wattses of the world, and that only we can prevent their happening again.

"The art works of 66 should be looked at, not as particular things in themselves, but for the sake of establishing conversation and communication, involvement in the act of living. The reason for being in our universe is to establish communication with others, one to one. And communication is not possible without the establishment of equality, one to one.

"If junk art in general, and 66 in particular, enable us only to see and love the many simple things which previously escaped the eye, then we miss the point. For we here experience mere sensation, leaving us in time precisely where we were, being but not becoming. We wish to establish that there must be more to art than the creative act, more than the sensation of beauty, ugliness, color, form, light, sound, darkness, intrigue, wonderment, uncanniness, bitter, sweet, black, white, life and death. There must be therein a ME and a YOU, who is affected permanently. Art of itself is of little or no value if in its relatedness it does not effect change. We do not mean change in the physical appearance of things, but a change in the behavior of human beings. And changes in behavior are effected through communication."

The philosophy of 66 Signs postulates that the activities of each and every human being are attempts to dispel his peculiar anxieties. If the outlet chosen is creative, then the nature of the individual experiences change, evolves with this activity. If the outlet is materialistic, then the dispelling of anxiety is purely transient, and without permanent benefit. But the common denominator of all humans is the absolute necessity to dispel anxiety. This means that any human action, no matter how reprehensible by civilized or personal standards, stems from the same motivation. Therefore, we all are brothers, and the possibility of mutual understanding, as well as communication, exists.

The distilled spirit of 66 Signs of Neon tells us that the world is a confused and fearful place, that God is difficult to find, that our philosophic systems are imperfect, that the only hope is communication between individuals: "I DON'T HAVE ANYBODY BUT YOU!"

"SIGNPOSTS THAT POINT THE WAY"

Sixty-Six Signs of Neon are signposts pointing the way from the wasteland of fury and disorder to the gateway of constructive accomplishment and fulfilment. The *66 Signs* consist of melted and twisted ruins of neon and metal, as well as other findings, from Watts riot country, transfigured into works of art by a group of local artists. The transfiguration represents what the group hopes eventually to accomplish in Watts: out of former nothingness, an art education program for the community and a gallery where the art can be exhibited. The group believes that a creative seed exists in every person; encouraged to grow, it can make possible a personal affirmation that might not otherwise develop. Further, such a project could apply to everyone—the child in the streets, the potentially delinquent youth, the barely literate man in a wheelchair not only to those with a secure education. The *66 Signs* are on public exhibit at the AID and Furniture Fashions Show now at the Sports Arena. The artists, who believe that a constructive program can arise from a negative outcry such as the riots, are Noah Purifoy, Max Neufeldt, Leon Saulter, Deborah Brewer, Ruth Saturensky, Frank Anthony, Davis Mann, Judson Powell and Roy Johnson.

The flames and rubble of the August Watts riots left masses of junk smouldering on the streets and in the rectangles once occupied by stores. Through this post-havoc labyrinth two artists saw the fire-molded debris as more than junk.

To Judson Powell and Noah Purifoy the hunks of melted neon signs and twisted spoons were "little jewels. Nobody had ever seen shapes and forms quite like these before," Purifoy said.

Powell, 32, and Purifoy, 48, recruited six other professional craftsmen to mold a show which not only serves as an expressive effort but as a format for interpersonal exchanges among the show's spectators.

The resultant display, *66 Signs of Neon*, composed of the "junk art" will be exhibited from 10 a.m. to 8 p.m. Monday, June 20, through Wednesday, June 29, in the Student Union Men's Lounge.

The motivation for assembling the junk art was the artists' belief that education through creativity is the only possibility left to enable a person to find the "self" in a materialistic world. *66 Signs of Neon* is a show that is only incidentally related to art, however. Viewers are encouraged not to stop at description because the show is also a feeling, sometimes obscure and incapable of analysis, but it is a feeling which is in the twisted, broken forms which were the Watts Riot.

The pieces are the expression of the rioting citizens explaining that they are not prepared to totally accept white values or to dismiss all of theirs. *66 Signs of Neon* declares that "the last try at togetherness wasn't the answer—the Watts Riots said 'NO'—now let's try again."

The exhibit reflects the tragic destruction that occurred in Watts, but also expresses the hope of creation of new understanding and communication.

Proceeds from purchases made during the show will go toward establishing a gallery and contributing to workshops for the graphic, plastic, and performing arts in Watts.

66 Signs is part of JOINED FOR THE ARTS IN WATTS, an organization composed of groups of individuals and organizations devoted to promoting creative activity and stimulating a deeper awareness of life and self through the medium of the arts.

1967

Ishmael Reed, "The Black Artist: Calling a Spade a Spade," *Arts Magazine* 41, no. 7 (May 1967)

Ishmael Reed became a dynamic figure in New York's literary scene after moving to the city in 1962. He cofounded the countercultural newspaper the *East Village Other* and was a member of the Umbra collective, a group of young Black writers who met from 1962 to 1965 on Manhattan's Lower East Side. The group launched its magazine, *Umbra*, in 1963. Reed was greatly influenced by Black nationalism. He saw activism as an essential component in the establishment of a Black artistic identity that could stand apart from the White mainstream. In this article for the monthly *Arts Magazine* (previously known as the *Art Digest* and *Arts*), Reed singled out the visual artists Joe Overstreet and Chester Wilson for their politically focused works. A poem by LeRoi Jones (who changed his name to Amiri Baraka in 1968) is also featured in the article. Following his studies at Columbia University and the New School for Social Research, both in New York, Jones had established himself through influential writings such as "The Myth of a 'Negro Literature'" (1962) and *Blues People: Negro Music in White America* (1963). His 1964 play *Dutchman* established his reputation as a playwright. Ensuing works conveyed his increasing disappointment with White America and growing need to separate from it. The Black artist's role, Jones wrote in *Home: Social Essays* (1966), was to "aid in the destruction of America as he knows it."

ISHMAEL REED, "THE BLACK ARTIST: CALLING A SPADE A SPADE"

Since the "ghostpeople" punk-troops padlocked the Black Arts Repertory Theater two summers back, there has been a lull in "Black Arts" activity—"Black Arts" simply meaning painting, poetry, novels, and music written and performed by black people.

You couldn't run it down front like that when Mrs. Eleanor Roosevelt reigned, but now that America's hypocrisy is hitting the fan and the youth are halfway hip (*EVO*)[1] and even Jack Newfield is playing Virgil to wire-tappers and slick equivocating rappers, people are beginning to cut through all the b.s. by calling a spade a spade. There are black artists and white artists, and this skin thing is bound to leave imprints in poetry, painting, etc., even though the artist might deny it, coming on like a buck-toothed and retired humanist. You know— the "we is all 'mericans" bit.

Black Arts uptown was busted by black "fat cats" who run a monopoly on all things "colud" for dozens of publishing companies, art galleries, foundations. They saw their "pension punch" in LeRoi Jones' own brand of soul-sorcery—so they had one of the State Department's colored literary gentlemen put the Black Arts movement down in the C.I.A.-funded *African Forum* magazine.

Later on after the literary gambit didn't come off they sent in the bruisers and fuzz (and believe you me these cats don't play; break your fuckin' knuckles for fish-sandwich).

The resulting explosion sent the Black Arts movement to sections of New York and Newark where they've been woodshedding ever since. Now some of the results of this silent period of reflection and "getting one's s— together" are beginning to surface. Luther went to Wittenberg, J/C went into the wilderness where he played "chicken" with the devil and LeRoi Jones went to Newark, New Jersey, a city presided over by a Petrocelli suit named Hugh Addonizio. Black gloves and shades peeping from behind newspapers abound in his excellency's outer office.

Nightly bearded men in beaded hats—writers, poets, musicians—board the Hudson tubes and the Port Authority buses to make their pilgrimage to that underdeveloped town which is sorely in need of the Peace Corps and an armada of care packages.

Surrounded by loved ones, the leader is in magnificent exile as he pounds out mimeographed position papers on local political corruption, composes rock-and-roll music (first album *Black and Beautiful*, Jihad Records), directs movies, plays and of course as always writes poems:

PART OF THE DOCTRINE
By LeRoi Jones

RAISE THE RACE RAISE THE RAYS
THE RAZE RAISE IT RACE RAISE
ITSELF RAISE THE RAYS OF THE
SUNS RACE TO RAISE IN THE RAZE
OF THIS TIME AND THIS PLACE FOR
THE NEXT, AND THE NEXT RACE
OURSELVES TO EMERGE BURNING
ALL INERT GASES GASSED AT THE
GOD OF GUARDING THE GUAR-
DIANS OF GOD WHO WE ARE GOD
IS WHO WE ARE RAISE OUR SELVES
WHO WE HOVER IN AND ARE
RAISED ABOVE OUR BODIES AND
MACHINES THOSE WHO ARE WITH-
OUT GOD WHO HAVE LOST THE
SPIRITUAL PRINCIPLE OF THEIR
LIVES ARE NOT RAISED AND THEIR
RACE IS TO THEIR NATURAL
DEATHS NO MATTER HOW UN
NATURAL, WITHOUT SPIRIT WITH-
OUT THE CLIMB THROUGH SPACE
TO THE SEVENTH PRINCIPLE WITH-
OUT THE PURE AND THE PURITY
OF THE SPIRIT. TO RAISE THE EYES
TO RAISE THE RACE AND THE
RAYS OF OUR HOT SAVAGE GODS
WHO DISAPPEARED TO REAPPEAR
IN THE BODY IN THE ARM MOVE
THROUGH THE GOD OF THE
HEAVEN OF GOD WHERE WE
RAISE THE RACE AND THE FACE
THROUGH THE EYE OF SPACE TO
RAISE AND THE RAYS OF THE RACE

WILL RETURN THROUGH ALL SPACE
TO GOD TO GOD TO GOD TO GOD
TO GOD TO GOD TO GOD TO GOD
GOD GOD GOD GOD GOD GOD
GOD GOD GOD GOD GOD GOD
GOD GOD GOD GOD GOD GOD
GODGODGODGODGODGODGODGOD
GODGODGODGODGODGODGODGOD
GODGODGODGODGODGODGODGOD

Others from the Black Arts movement have set-tled on the Lower East Side where they congre-gate in Pee Wee's Other Side, a popular soul food restaurant-bar replete with a lowdown snatch-it-back-and-hold-it jook box. No long haired little chil-dren here with a rocket full of money orders from Westchester. No madrigal singers who are trying to make Elizabethan music sound funky—but strong Motown marches by serious grown people and blues screamers, stone taking care of business with bombastic boo-ga-loo stomps which ignite the ceil-ing of this little room located at Avenue A between 12th and 13th Streets.

Archie Shepp, who has always been on the periphery of the Black Arts movement rejecting the Noble Negro vs. the Beast view of history espoused by some of its more orthodox members, staged his Jazz allegory *Junebug Graduates Tonight* before an enthusiastic and friendly audience in a Chel-sea church. *Junebug* was a hilarious debunking of Marxist clichés, Negroes who would lead other Negro baggy pants into the ninth century and the American Right Wing (here a white boy with Wag-nerian locks who makes with "gallows humor" and wisecracks about lampshades). Much of the play recalled those scripts submitted to 'thirties Fed-eral Arts Projects and although Archie is a leading avant-garde jazz musician and composer the songs were heavily Cole Porter. Nevertheless in content, language and movement the play stands up favor-ably next to, say, the work of Edward Albee who says about the same three things over and over again (women are dikes, men are fags and grand-mothers have "soul"). Makes you want to "die stand-ing on your feet," as LeRoi Jones recently said about reading Robert Creeley's poems.

Meanwhile Sun Ra continues his interstel-lar hopping ("We're traveling through space—the next stop Mars . . . JOOPITER!"). He mans a well-disciplined group (disciples?) replete with stam-peding saxophones and instruments invented by their leader—odd-shaped horns and percussion instruments which give off that eerie, wiry sound one associates with Gustav Holtz in *The Planets* or the TV show *The Invaders*. Sun Ra can be seen on Mondays at Slugs and his not-to-be-believed the-ater: costume changes, monologues, poetry, mad-ness and spell-weaving, should not be missed.

Then there's Albert Ayler whose band sounds like a psychedelic Salvation Army troupe. But they ain't begging for nickels or brandishing no tin cups baby, 'cause them cats is hard. Got blood in their eyes as they "spit up craziness," honk eschatologi-cally and do the hymnal violin sawing of American broadside music. Their music signals the smoke of eastern cities, the last days of the American empire with freakish Fourth of July sounds and scatological street madness.

Two leading black painters are Joe Overstreet and Chester Wilson, both of whom reside on the Lower East Side.

Recently interviewed in his loft on the Bowery where he lives with his wife and child, Joe pitched a fit about what he deems the shabby treatment of the black artist in America. He complained, pacing up and down, about the lack of opportunity to compete "toe to toe" with what he considers the lily-white Anglo-Jewish art scene in New York. That fancy ad placed in *The New York Times* during Angry Arts Week seems to bear him out. Glamorous names—some of them on government payroll sheets—were hustling napalm victims a month ago. They romped around town, knocking over aspirin heads in Grand Central station. The list of names included many pimps of misery who although publicly "crying the blues" about Vietnam have never given a black art-ist a Hershey bar let alone invite him to set up his work in a gallery. I happen to know that some of the poets on that lily-white Angry Arts list consider black poetry to be so much "coon talk." When you get them drunk on Dr. Pepper fizzle juice they will tell you so.

Other black painters insist that art transcends whatever credentials one might wear on his skin or name or coatsleeve. Such an artist is Chester Wilson, a slim, bouncing original hippie whose canvases deal with funny colored fish, ocean floors spinning with ferris wheels and subterranean fun houses.

So there they are—individualists who want no part of the before-the-battle dracula trumpets, as well as visionaries whose screams see Gov. Reagan's elite boots marching into the ghettos. They are the authentic "others" who tell it like it is. Uncompromising and mean they are peeping America's hold card with the no-nonsense glare of stud poker. Quietly they plot the day when their genius will find the slots of those museums uptown where guards stand gray-buttoned and unsmiling. Maybe they will liberate those museums and America will swing once more.

NOTE

1 [*EVO* stands for the *East Village Other*, the countercultural newspaper Ishmael Reed cofounded in 1965. —Eds.]

**Raymond Saunders, *Black Is a Color*, self-published
pamphlet, June 1967**

The artist Raymond Saunders was born in Pennsylvania in 1934. After grad-
uating from the California College of Arts and Crafts in 1961, he remained
in Oakland and embarked on his artistic career, becoming known for
mixed-media abstract paintings that constructed social narratives through
the use of collage, drawing, and found objects. Saunders conceived this
pamphlet as a direct response to Ishmael Reed's article in *Arts Magazine*,
which had been published just a month earlier (see pp. 64–67). Saunders
based his counterargument on his belief that art should not be limited or
categorized by an artist's race. Refuting the proposition that Black artists
must produce forms that can be uniquely labeled as "Black art," he appeals
for a more race-neutral approach to art making. For Saunders, black was
simply a color—one that should not be burdened by politics.

RAYMOND SAUNDERS, *BLACK IS A COLOR*

arts magazine published an article (may, 1967) in which it claims that poet-novelist ishmael reed has "documented" the "explosive black arts moment." mr. reed himself, if the title he chose denotes his aim, assumed the heroic role of black artist's champion, hipping it through the musty debris of hypocrisy and lies, into the clear light of newly-daring truth, where a spade can at last be called a spade.

yet, after this one man takes it upon himself to call it a fucking shovel, we know nothing more about the spade of the end of his tirade than we did at the outset.

what's he trying to prove? all he says has been said before, with the same pitiful and dangerous inadequacy. on the one hand, he seems to be trying to support the black artist's cause, while on the other he lumps black artists, of which he means a mere handful, into one bag and throttles them with a string of almost incoherent hippishness.

more flip than hip, his diatribe may have been meant to give the black artist a lift, but glib and shallow as it is the net result is far more degrading of the black man and artist than any mute rejection by a museum selection board (one of mr. reed's bones of contention).

using hip-talk as a kind of tribal mumbo-jumbo, he sets the black arts outside the current of art as a whole, and in so doing he does the black artist a grave injustice.

hip-talk is a language, effective when it illustrates something of human substance, but where is the substance of this subjective, emotional outburst, it all seems as futile and paradoxical as the demonstrations of those "halfway" young hippies who advance on their opponents shouting: "love, love, love!" while pelting them with rotten eggs.

who's supposed to be saving who? mr. reed appears to propose that the black arts should save america, as though the act of salvation were a function of some rarefied preservation hall, and the black artist a species of new orisons entertainer, who can "make america swing again." but let's face it—when has america ever swung? and why should it be the black man's responsibility?

this is a pseudo-messianic concept that mr. reed is free to subscribe to, but what makes him think he qualifies as a spokesman for black artists? is it because he's black—or because he's an artist? he doesn't seem at all sure in what measure the two are one, and the ambivalence of his approach renders his spade calling curiously unconvincing.

apart from a disproportionate quotation from leroi jones, mr. reed's "documentation" of black arts is famishingly sparse. black music is harnessed to archie shepp, albert ayler and sun ra, latching on to examples of certain discernible success, but what of the countless unsung but brilliant black musicians whom mr. reed blithely, and, though he uses an interesting photograph of sun ra to illustrate his article, mr. reed gives mere caption-mention to the photographer himself, and focuses no attention whatever on the growing band of vital black photographic artists in america, of whom charles shabacon is just one member, albeit a highly creative one.

in approaching so vast a subject as the black arts, whose scope far outreaches the limits imposed upon him by the editorial requirements of *arts magazine*, it would appear that mr. reed bit off more than he could chew. but this is no excuse for launching into so sadly haphazard and scrappy an exposition, while still retaining an ambitious title-promise beyond his capacity to fulfill.

what is more disturbing, however, is mr. reed's assumption that success must be equated with material gain; that uptown and money spell success for all. uptown is no "open-sesame" to artistic fulfillment, nor is money, as mr. reed appears to believe. uptown is the art marketplace, but who says it's the art scene? what are we dealing with here, anyway—art or a popularity contest?

material success is extremely desirable, but it's a dangerous criterion by which to measure artistic achievement. mr. reed seems to have fallen into the trap, adding insult to injury by dragging art through the mud of sociopolitical antagonism. the "we is all 'mericans" bit, to which he so strongly objects, is beside the point. "we is all artists" seems more akin to the subject.

i am an artist; examples of my work can be seen in american museums; i have been the recipient of

national awards; i have just enjoyed the "privilege" of my fourth one-man show at an uptown gallery (reviewed p. 60 of *arts magazine*, may, 1967); and i also happen to be black. i fail to see any profound significance in the mere conjunction of these circumstances. yet, if one is to take mr. reed's sweeping statements as criteria, it must be assumed that i am a phenomenal success. bullshit!

what are the true criteria for success, in terms of the individual artist's aspirations? is he committed merely to the realization of stereotyped image of the artist who's "arrived," crowned with the laurels of popular acclaim; assured of a constantly re-plumped bankroll and entree into the inner sanctums of madison avenue (which seems to be mr. reed's contention), or is it rather that the artist is committed to respond to the unending challenge of his very nature as a creative person, and to discover the depth, width, range of his own unique vision as an artist, and hopefully, as a human being?

i'm not here to play to the gallery. i am not responsible for anyone's entertainment. i am responsible for being as fully myself, as man and artist, as i possibly can be, while allowing myself to hope that in the effort some light, some love, some beauty may be shed upon the world, and perhaps some inequities put right.

every creative person is subject to periods of profound discouragement, when denied recognition of the vision he embodies in his work. the denial seems to constitute a rejection not only of his work but of all he is striving to be. in his angry rebellion, he may well lash out at the first apparent obstacle—which can easily take the form of some highly publicized social or political defect in his environment. it's a plausible explanation for some deadlock in his progress. it can be a very real one too, in which case his anger is perfectly valid. but when anger, a human reaction, gets syphoned off into serving merely as a political expedient, it is robbed of genuine humanity, and is useless as inspiration to the artist as a man.

some angry artists are using their arts as political tools, instead of vehicles of free expression. using his art and his anger in such a way, the artist makes himself a mere peddler, when he might be a prophet.

every artist, regardless of his skin color, may suffer from the vagaries of museum selection boards. confusing this age-old problem with questions of race is just casting about for a scapegoat, when the real culprit—the dragging, grinding mechanism of american social and cultural awareness gets clean away, unchallenged. all americans are culturally deprived, not just black americans.

the prevailing system repeats its sartorial term of reference for success (to which mr. reed himself, oddly enough, seems to subscribe). the image that fits into those terms may not easily be stretched to include the black artist, particularly if he claims his blackness as the reason for his achievement. but the basic question is, does the black artist, or any other artist for that matter, want to hold himself to this prescribed, but worn and shabby image in any case?

the image itself is the result of distortions in human society, stemming from deprivation, but this is the plight of every man. the underdog, the low man on the totem pole in this society, will continue to suffer because of the blindness and selfishness of society's leaders. this is nothing new, and what has this got to do with art itself or the real quality of the artist?

art projects beyond race and color; beyond america. it is universal, and americans—black, white or whatever—have no exclusive rights on it.

when are americans going to wake up to the fact that america is not the world, nor the cultural center of it. there's a big, big world out there, where people of all colors are living; yearning, competing, suffering, reaching out (and some succeeding) with every turn of the earth.

no one can honestly deny the existence of discrimination and oppression against black people (and black artist, by extension) in america, but the black man is not the only human being ever to have suffered these ills. counter-racism, hyperawareness of difference or separateness arising within the black artist himself, is just as destructive to his work—and his life—as the threat of white prejudice coming at him from outside.

pessimism is fatal to artistic development. perpetual anger deprives it of movement. an artist who is always harping upon resistance, discrimination, opposition, besides being a drag, eventually plays

right into the hands of the politicians he claims to despite—and is held there, unwittingly (and witlessly) reviving slavery in another form. For the artist this is aesthetic atrophy.

certainly the american black artist is in a unique position to express certain aspects of the current american scene, both negative, but if he restricts to these alone, he may risk becoming a mere cypher, a walking protest, a politically stereotype, negating his own mystery, and allowing himself to be shuffled off into an arid overall mystique. the indiscriminate association of race with art, on any level—social or imaginative—is destructive.

isolationism: us-against-the-world, is stultifying. it undermines the very emancipation the black man so deeply desires, and to which he is entitled. us-coming-out-into and becoming-a-part-of a wider reality—becoming what we really are—is what will truly free us.

in america, black is bound to black not so much by color or racial characteristics, as by shared experience, social and cultural. this is the same in any rarefied social (or racial) enclave, but "no man an island, entire of itself." the artist deals with the human condition, he is "involved in mankind." this is as valid for the black artist as any other. he uses his heart, his eyes, his mind as interpreters of his own deep vision of himself, and the world as it is reflected in those depths.

if he wants to get out there; if he really wants to know, there is nothing that can stop him. a hell of a lot depends upon his curiosity and his own determination. the artist can only realize himself though active effort to be what he really is.

both as artist and as human being he can learn to channel his energy, rather than expand it in futile protest. he has to learn the lie of the land around him, and where he can cut through. he has to send his mind, his emotions, his eyes ranging across the whole field of vision open to him, probing its boundaries to find where he can push them further and further out.

the creative imagination is his channel, but it has to be dug (painfully slowly sometimes, as it has been throughout history) through the resisting barriers of established convention; then it can bring its new, irrigating force to the parched and thirsting desert of cultural and spiritual backwardness.

but the artist doesn't exist for the sole purpose of changing the world. each artist has to do for himself what is necessary for his own development, fulfilling himself as an individual, not as one of a herd. he has to enter into the total experience of himself and his vision, which transcends the cramped boundaries of any stereotypes—angry or otherwise. it is a risk, but life is full of risks, if you're going to live at all. living is being hurt, happy, sad.

humility is frowned upon these days, yet the very immensity, complexity and universality of art should be a reminder to the artist that he cannot be the be-all-end-all. the pressures and apparitions the black man has so triumphantly endured could be translated into positive strength that will persist in the teeth of rejection, refusing to be eliminated. this goes for the black artist too.

in order to be recognized and accepted, does the black artist have to depend upon the uptown critic or the politics-sociologist to define the meaning of his own experience? it is high time that the black artist make his own rejection of misguided, inadequate—if not out-and-out dishonest—interpreters of his condition. from the depths of his own integrity he has to believe in his capacity to distinguish the real from the false—and to recognize manipulators when they try to use him.

racial hang-ups are extraneous to art. no artist can afford to let them obscure what runs through all art—the living root and the ever-growing aesthetic record of human spiritual and intellectual experience. can't we get clear of these degrading limitations, and recognize the wider reality of art, where color is the means and not the end?

raymond saunders

exhibiting artist,
terry dintenfass gallery, new york city

professor
california state college at hayward

1967

Organization of Black American Culture (OBAC), "Black Heroes" (statement on the *Wall of Respect*), August 1967

Gwendolyn Brooks, "The Wall," read at opening of the *Wall of Respect* on August 27, 1967; first published as part of "Two Dedications" in Gwendolyn Brooks, *In the Mecca* (New York: Harper and Row, 1968)

Don L. Lee, "The Wall," read at opening of the *Wall of Respect* on August 27, 1967; first published on August 29, 1967, in *Chicago Daily Defender*; published in slightly revised form in Don L. Lee, *Black Pride* (Detroit: Broadside Press, 1968)

The Organization of Black American Culture (OBAC) was a Chicago-based collective of academics, artists, and writers founded by Hoyt Fuller, editor of *Negro Digest*; the poet Conrad Kent Rivers; and the writer Gerald McWorter (also known as Abdul Alkalimat), who, at the time, was studying sociology at the University of Chicago. Jeff Donaldson was a key participant. One of the organization's first enterprises was the painting of a mural on a derelict building in the city's South Side neighborhood. The artist William Walker, who directed OBAC's visual arts workshop, led the project, and Donaldson, as well as fellow future members of AfriCOBRA Barbara Jones-Hogu, Wadsworth Jarrell, and Carolyn Lawrence, all participated. "Black Heroes" lays out OBAC's purpose, introduces its important definition of the "Black hero," and enumerates the heroic names to be painted on the wall. The importance of the mural to the local community, as well as more widely, is reflected in the poems Gwendolyn Brooks and Don L. Lee recited at the opening of the *Wall of Respect* on August 27, 1967.

ORGANIZATION OF BLACK AMERICAN CULTURE (OBAC), "BLACK HEROES"

O B A C
(Ob-bah-see)

• OBAC is organized to enhance the spirit and vigor of culture in the Black community.
• OBAC seeks to involve the total Black community in every aspect of its undertakings.
• OBAC conducts a series of creative workshops in music, art, dance, drama oratory, and literature.
• OBAC will showcase the products of these workshops in a Festival of Black Art in the fall of 1967.
• OBAC seeks themes, attitudes and values which will unite Black artists and Beautiful Black people around heroic self-images and standards of beauty relevant to the Black experience in America.

OBAC needs your participation in the realization of these objectives.

OBAC declares that a Black hero is any Black person who:
1. honestly reflects the beauty of Black life and genius in his or her style.
2. does not forget his Black brothers and sisters who are less fortunate.
3. does what he does in such an outstanding manner that he or she cannot be imitated or replaced.

Therefore, the following list of persons and groups are heroic to us, Black people. This WALL is a celebration. We pay respect to our heroes, we are proud of them, we are proud of you, we are proud of ourselves.

BLACK HEROES

LAYOUT AND DESIGN: Sylvia Abernathy

NEWSSTAND ARTIST: Carolyn Lawrence

RHYTHM AND BLUES Artist: Wadsworth Jarrell

Billie Holiday—all pain and suffering joined with beauty and strength
Aretha Franklin—deserves respect
Dinah Washington—the Queen
Muddy Waters—tells it like it is
Smokey Robinson and the Miracles—Soul Spokesman
The Marvelettes
James Brown—Mr Dynamite
Ray Charles—don't it make you feel alright

JAZZ Artists: Elliott Hunter, Jeff Donaldson
Photographer: Billy Abernathy

Charles Parker—prophet of the modern age
Ornette Coleman—shape of things to come
Nina Simone—Mississippi goddess
Sarah Vaughan—sweet, sassy and soulful
Max Roach—the talking drum
Miles Davis—the master of mood
Thelonious Monk—new pianistic expression
Charlie Mingus—melodic anger
John Coltrane
Eric Dolphy—out there
Lester Young—the "Pres" of modern music
Sonny Rollins

THEATER Artist: Barbara Jones
Photographer: Roy Lewis

Claudia McNeil—evokes the eternal struggle of Black motherhood
Ruby Dee—celebrates the sensitivity of Black womanhood
Cicely Tyson—natural, modern and Black
Sidney Poitier—Black dignified genius
Ossie Davis—victorious and glorious
Oscar Brown, Jr.—minstrel of the Black experience
James Earl Jones
Dick Gregory

STATESMAN Artist: Norman Parrish
Photographer: Roy Lewis

Malcolm
Stokely—the power dimension

Rap Brown—with Black in his rap
Marcus Garvey—a man whose version is still
 relevant
Adam Clayton Powell, Jr.—Faith and Force
Paul Robeson—dares to deny America's gift
Floyd McKissick

RELIGION Artist: Bill Walker
Photographer: Bobby Sengstacke

Elijah—the Prophet of things now and things
 to come
Albert Cleage—an honest Black Christian
Nat Turner—made a meaningful protest

LITERATURE Artist: Edward Christmas
Photographer: Darryl Cowherd

W. E. B. Du Bois—scientist of the Black Revolution
Gwendolyn Brooks—she celebrates sensitivity and
 Black Life-styles
Ronald Fair—butchers stereotypes
LeRoi Jones—"that bad cat from Newark"
Lerone Bennett—historian of every Black man

SPORTS Artist: Mirna Weaver

Wilt Chamberlain—the man who made them
 change the rules
Jim Brown—new grid iron records, then
 economics for his people
Lew Alcindor—young, talented and hip
Bill Russell—angry, Black and greatest defensive
 genius that basketball has ever known
Muhammad Ali—the undefeated and unbeatable
 heavyweight Boxing Champion of the World

We in OBAC wish to thank all of the beautiful Black people of this neighborhood for their protection of the WALL and our equipment, for their generous aid in moving the scaffolding, and their sincere criticism and general appreciation of the project. Special thanks to Brother Baker for making the WALL available, to Brother Johnny Ray for the electronic hospitality, Brother Charles, Brother Herbert and the Young Militants and to all the other sisters and brothers, young and old. We further wish to add that this project was financed entirely by the members of the OBAC visual arts workshop whose works are on this WALL. The organization is not sponsored by, affiliated with, or in any way connected with any political organization, community group, or any other type (of) organization.

GWENDOLYN BROOKS, "THE WALL"

August 27, 1967
(the day of its dedication)

 A drumdrumdrum.
 Humbly we come.
South of success and east of gloss and glass are
sandals;
flowercloth;
grave hoops of wood or gold, pendant
from black ears, brown ears, reddish-brown
and ivory ears;

black boy-men.
Black
boy-men on roofs fist out "Black Power!" Val,
a little black stampede
in African images of brass and flowerswirl,
fist out "Black Power!"—tightens pretty eyes,
leans back on mothercountry and is tract,
is treatise through her perfect and tight teeth.
Women in wool hair chant their poetry.
Phil Cohran gives us messages and music
made of developed bone and polished and
 honed cult.
It is the Hour of tribe and of vibration,
the day-long Hour. It is the Hour
of ringing, rouse, of ferment-festival.

On Forty-third and Langley
black furnaces resent ancient
legislatures
of ploy and scruple and practical gelatin.
They keep the fever in,
fondle the fever.

All
worship the Wall.
I mount the rattling wood. Walter
says, "She is good." Says, "She
our Sister is." In front of me
hundreds of faces, red-brown, brown, black, ivory,
yield me hot trust, their yea and their
 Announcement
that they are ready to rile the high-flung ground.
Behind me. Paint.
Heroes.
No child has defiled
the Heroes of this Wall this serious Appointment
this still Wing
this Scald this Flute this heavy Light this Hinge.

An emphasis is paroled.
The old decapitations are revised,
the dispossessions beakless.

And we sing

DON L. LEE, "THE WALL"

sending their negro
toms into the ghetto
at all hours of the day
(disguised as black people)
to dig
the wall, (the weapon)
the mighty black wall (we chase them out—kill if
 necessary)

whi-te [*sic*] people can't stand
the wall,
killed their eyes, (they cry)
black beauty hurts them—
they thought black beauty was a horse—
stupid muthafuckas, they run from
the mighty black wall
brothers & sisters screaming
"picasso ain't got shit on us.
send him back to art school."
we got black artists
who paint black art

the mighty black wall
negroes from south shore &
hyde park coming to check out
a black creation
black art, of the people,
for the people,
art for people's sake
black people
the mighty black wall

black photographers
who take black pictures
can you dig,
 blackburn
 le roi,
 muslim sisters,
 black on gray it's hip
they deal, black photographers deal blackness for
the mighty black wall
black artists paint
 du bois / garvey / gwen brooks
 stokely / rap / james brown
 trane / miracles / ray charles
 baldwin / killens / muhammad ali
 alcindor / blackness / revolution
our heroes, we pick them, for the wall
the mighty black wall / about our business, blackness
 can you dig?
if you can't you ain't black / some other color
negro maybe??

the wall the mighty black wall,
"ain't the muthafucka layen there?"

1967

"Wall of Respect" (unsigned article), *Ebony* 23, no. 2 (December 1967)

Ebony was founded in 1945 as a monthly magazine. Although it covered primarily lifestyle and entertainment, the publication also had a remit to offer an authoritative perspective on Black culture and discuss topical issues in an affirmative manner. Like *Negro Digest* (later renamed *Black World*), which had been founded three years earlier and was also published by the pioneering African American businessman John H. Johnson, *Ebony* played a critical role in the cultural production of Chicago's Black Arts Movement. This article celebrates the *Wall of Respect*, which depicted actors, statesmen, religious and literary figures, musicians, and athletes on a building on the city's South Side (see pp. 72–75). The mural turned an ordinary public space into a visible celebration of Black achievement. Although the *Wall of Respect* was destroyed in 1971, the considerable attention it garnered during its existence prompted the creation of other murals in the same vein throughout the United States.

"WALL OF RESPECT"

Artists paint images of black dignity in heart of city ghetto

Forty-Third Street and Langley Avenue on Chicago's near South Side, an area where storefront churches outnumber laundromats, is a corner whose beauty is largely unseen and too often unspoken. Marcus Garvey proclaimed that beauty, "Bird" celebrated it, and Malcolm dared to believe in its possibilities. But none of them lived to see The Wall.

However, when the side wall of a typical slum building on the corner of 43rd and Langley became a mural communicating black dignity this summer, the faces of those three giants were joined with others to remind a people that the blackness and beauty that is their own has always been one. A group of black men and women—painters and photographers from the Organization of Black American Culture (OBAC)—in creating this newest of Chicago's landmarks, chose as their heroes persons who had incurred both the plaudits and scorn of the world of whiteness, but who, in their relation to black people, could by no account be considered other than images of dignity.

Rising two-stories above ground long grown barren, the mural depicts the intense intellectualism of W. E. B. Du Bois who was a black prophet; the rare physique of Muhammad Ali who *is* a black champion; the folksiness of Nina Simone who signs with black simplicity; and the gentle rage of LeRoi Jones who writes poems about black love. The names seem endless—John Coltrane, Stokely Carmichael, Sarah Vaughan, Thelonious Monk, Gwendolyn Brooks, Wilt Chamberlain, Max Roach, John Oliver Killens, Ornette Coleman, and Rap Brown among them—and at the end of the names and the painting, the artists were perhaps left no choice but to call their work the *Wall of Respect*.

In this era of the "happening," The Wall just might be called a "black-hap." OBAC, which includes writes and community workshops as well as an artists workshop, was formed early this year to enhance the spirit and vigor of culture in the black community of Chicago. Bill Walker, a member of the artists workshops, was given permission by the owner to paint on the wall. Walker introduced the idea to his workshop fellows, and history evolved.

"Because the Black Artist and the creative portrayal of the Black Experience have been consciously excluded from the total spectrum of American arts, we want to provide a new context for the Black Artist in which he can work out his problems and pursue his aims unhampered and uninhibited by the prejudices and dictates of the 'mainstream,'" concludes the OBAC statement of purposes. Thus black artists whose particular talents and skills might have, in another time, taken them far away from 43rd and Langley, directed their genius to the community of their roots. In essence they told a community: "Our art is yours, you are us, and we are you."

Lerone Bennett Jr., who confides that he has received no honor as meaningful as being portrayed on The Wall, believes that the event marks a significant breakthrough in terms of black people, instead of white people, legitimizing black culture and black history. He notes, moreover, that The Wall is where it should be—in the midst of the people—as opposed to being in a museum or a special, out-of-the-way place. Adds Bennett: "For a long time now it has been obvious that Black Art and Black Culture would have to go home. The Wall is Home and a way *Home*."

In their initial venture towards the objective of seeking themes, attitudes and values that will unite black artists and the masses of black people, OBAC inspires reciprocal identification. The people of the community surrounding The Wall have become not only its praisers, but also its protectors. Novelists James Baldwin and Ronald L. Fair, viewing in appreciation this monument which includes them in its tribute, were taken aback by a youngster who asked: "How do you like our Wall?"

The creation, finally, is an authentic landmark signifying a specific development in the experience—"Black Experimentalism," in the words of OBAC—of a people. The Wall, as young Don L. Lee ended his poem of the same name, is "layen there." Which in the idiomatic language of the poet, and the black life style, means something more than simply standing there.

1967

Robert Newman, "*American People*: Faith Ringgold at Spectrum," press release for exhibition held at Spectrum Gallery, New York, December 19, 1967–January 6, 1968

Faith Ringgold was born in Harlem in 1930. After receiving an MFA from the City College of New York in 1959, she began to pursue opportunities to exhibit. In 1963, she met Ruth White, the director of a gallery space on Fifty-Seventh Street. White's bewildered response to her apolitical still lifes and landscapes sparked Ringgold's reconsideration of what she was really trying to achieve through her art. As the civil rights movement intensified, she realized that the pictures she was producing were not adequate, and the subject of race relations in the United States consequently became her focal point. After a failed attempt to join the recently formed Spiral collective—Romare Bearden turned her down—Ringgold landed her first major opportunity through LeRoi Jones (later Amiri Baraka), who included her political paintings in a 1966 exhibition at the Black Arts Repertory Theater. Soon after, she was offered representation by Spectrum Gallery, a large cooperative in Manhattan's commercial art district. Ringgold's first solo show, *American People*, opened at Spectrum in December 1967. The show included three mural-style paintings, *American People Series #18: The Flag Is Bleeding*, *American People Series #19: Postage Stamp Commemorating the Advent of Black Power*, and *American People Series #20: Die*, each an unapologetically stark portrayal of the brutality of contemporary American society and the relentlessness of interracial tensions. As Spectrum's director, Robert Newman, commented in the press release, the images provided "revelatory truths."

ROBERT NEWMAN, *"AMERICAN PEOPLE*: FAITH RINGGOLD AT SPECTRUM"

Categories and labels will always be used to help people evaluate certain realities, and with justice it can be said that Faith Ringgold, in her dramatic first major exhibition, emerges as the major American Negro artist, an essential American artist. Her three great mural paintings are unique and unforgettable. They have a special beauty that comes from the revelatory truths of the images, and what the paintings embody in implication couldn't be more important. The great *Postage Stamp Commemorating The Advent Of Black Power* is an American classic; in it there are 100 fully painted faces, locked together in a subtle and mysterious structure, and the faces show every gradation of skin color, people together in the historical and constitutional reality of it being this way. Faith Ringgold's irony and humor about interracial relations is the essential intelligence needed to create communication. And her deep emotion about the terrible incommunications is unforgettably vivid in her stunning mural of the riots, *Die*.

1968

Jay Jacobs, "Two Afro-American Artists in an Interview with Jay Jacobs," in "The Afro-American Issue," special issue, *Art Gallery* 11, no. 7 (April 1968)

Art Gallery, founded in 1957, is often referred to as the United States' first gallery guide. In addition to listing national exhibition calendars, it featured articles and commentaries and soon became recognized internationally as an authoritative journal. This article draws on interviews with two artists conducted by Jay Jacobs, the notable New York–based writer who was the magazine's editor. Seeking to decipher the reasons behind the absence of African American artists from the mainstream art world, the text outlines the social and economic difficulties faced by artists in pursuing their careers. Born in North Carolina in 1911, Romare Bearden graduated from New York University in 1935 and, in the early 1950s, studied art history and philosophy in Paris. He worked in several media, including cartooning and oils, but became especially known for his collages. While his early imagery centered on scenes of the American South, he shifted his focus to depictions of life in Harlem. Four years younger than Bearden, Hughie Lee-Smith was known for his paintings of desolate urban landscapes. He received a scholarship to the Cleveland School of Art, where he studied painting, and in 1967 became the first African American to be granted full membership in the National Academy of Design since Henry Ossawa Tanner's induction forty years earlier.

JAY JACOBS, "TWO AFRO-AMERICAN ARTISTS IN AN INTERVIEW WITH JAY JACOBS"

Although Romare Bearden and Hughie Lee-Smith are both respected artists of the same generation (they are in their fifties), they have little else but an ethnic heritage in common. A product of the Harlem ghetto and an alumnus of the W.P.A. art project, Bearden currently is enjoying a sudden, spectacular popularity as a result of his much-talked-about one-man show at Cordier & Ekstrom last fall. His work has been selling well; he is constantly besieged by importunate impresarios; *Fortune*, a magazine ultra-sensitive to the sweet smell of success commissioned a Bearden cover for one of its recent issues. A big, shambling, heavy-set man with a fleshy face, Bearden could easily, as they say, "pass." He dresses (in his studio anyway) casually and comfortably and seems somewhat disinclined to rock the boat by dwelling much on the most disturbing social issue of the day.

Lee-Smith was born in the south, received most of his training in the midwest on a series of scholarships, and while his work sells with reasonable steadiness (he is represented by the Grand Central Galleries), he has never made it big. He supplements a meager income derived from the sale of his enigmatic, symbol-caged canvases by teaching and lecturing, and his last commission for a magazine cover was from an obscure university journal. Smallish, slight and dark-complected, he is dapper, conservative, almost formal in his dress, and speaks gently a cultivated, more or less British accent—the accent perhaps of the dance and theatrical groups he belonged to in his youth. He is not at all reticent on the subject of racial equality.

Romare Bearden received me in the living room of his Canal Street loft. I asked him why there seemed to be—or at least why I'd heard of—so few Negro painters and sculptors; so few, at any rate, in comparison to the number of Negro writers and performing artists. "There are a number of reasons" Bearden said. "It wasn't until the thirties that Negroes in appreciable numbers began to enter the fine arts field. The W.P.A. made it possible by supporting painters and enabling them to meet other artists and learn the rudiments of their craft. It's largely an economic thing. There are—and have been—very few Negro patrons. Furthermore, a Negro family—at least until very lately wasn't likely to encourage artistic talent. The Negro family prefers a doctor or lawyer to an artist with no prospect of earning a livelihood. The case with the Negro performing artist was different. The understanding was more immediate, and he could be supported within the Negro community."

Bearden got up to answer the phone. The call was from a prominent, museum official. "It's been like that ever since my last show," Bearden said, leaning back in an easy chair. "Interest in the arts in the Negro community is now beginning to come alive," he continued. "A quarter of a million people, most of them Negroes, came in three weeks to last October's show [*The Evolution of Afro-American Artists: 1800–1950*] at the university [The City University of New York]. The number of Negroes going into the field is increasing each year, and the last time I was down at Hampton [Hampton Institute, a Negro school in Virginia] I found three hundred students in the art department alone."

I mentioned that I hadn't noticed many Negroes around the New York galleries and asked what sort of Negro turnout his show at Cordier & Ekstrom had produced. "Oh they came to the gallery," he said, "but the economic support isn't there. They can't afford to buy."

I asked Bearden whether he had encountered much in the way of prejudice in trying to show and sell his work to a white market. "That's a difficult question," he said, "and one that every artist would answer differently. To me, so much of the gallery scene has to do with social things. For instance, a lot of artists used to go to the Cedar Bar, you know, to meet Kline or de Kooning, and a lot of them were helped in that way. If the Negro artist isn't involved in that sort of thing. . . ."

Bearden's voice trailed off. I broke the silence by asking whether the Negro artist still wasn't involved in that sort of thing. "Oh, there's some association now between Negro and white artists in the studios and lofts. A lot of Negroes live in the vicinity now. I think, on the other hand, that the Negro artists who

emerged in the thirties were thrown more together. We all lived in Harlem then and met all the time in one or two places. I didn't know any downtown artists [somehow, although Bearden gave it no special emphasis, the word "downtown" suddenly seemed to have become synonymous with "ofay"] until a model I knew introduced me to people like Rattner and Stuart Davis." What sort of future, I asked, had Bearden envisioned for himself at that time. Was he looking forward, for example, to his first one-man show? "I never even thought of a one-man show back then," he replied. "None of us did. It wasn't really a racial thing, though. It was the time of the Depression. Nobody was buying, and there was no concern with selling, but only with the social use of painting. Today, it's different. Most of the older Negro artists are still concerned with Negro subject matter, but not the younger people. Despite Black Power and all the rest, they're working in the international mainstream. When I was down at Hampton, the students kept asking, 'Does our work look Negro?' and I said 'No.' Of course, there's still some social protest work, but most artists who think that way go into other media—motion pictures."

Bearden reflected for a moment, then continued. "You have to remember," he said, "that Negro subject matter in itself doesn't make the work Negro. There are certain experiences within the Negro life style that are similar to all the great and common experiences of art. When I was a boy in Harlem, there was no Diaghilev Ballet, but there was a great basketball team, and they were as graceful on the floor as any group of ballet dancers. As Booker T. Washington said, 'Cast your buckets where they are.'"

I began my interview with Hughie Lee-Smith with the same opening question I had put to Bearden: Why were there so few Negroes in the visual arts? "It's largely economic," he answered. "Quite obviously, it was an economic problem for the artists of my generation. My own experience is hardly typical, however. My parents just happened to be very interested in this sort of thing—creativity, I mean—and I had quite a bit of encouragement. Theatre training as a youngster, quite a bit of modern dance in the thirties. Then I won a scholarship to the Cleveland School of Art. Most Black artists of my generation got started through the W.P.A., but I was lucky enough to have interested parents and to win several scholarships. Then, later, I took my B.S. at Wayne University on the G.I. Bill. But getting back to the racial question, during those years, when my generation was getting started, everything looked rather bright in terms of racial progress, and we artists felt sure color would be no problem. After all, we were in a field made up of intellectuals and liberals. In my own case, there was an exceptional set of circumstances in Cleveland at that time, and it just never occurred to me to think in terms of obstacles. There's been a rude awakening since however or I suppose one might say a new awareness of the depth of the problems facing us as a group in this country."

Did that mean active resistance toward Negro artists on the part of the white art world? "Resistance is still very real," Lee-Smith said. "There's no sort of stable patronage of the Negro artist, although that's partly due to the inability of the black community to play its part. But the Negro is not yet considered—in the white or black community—on his merits as an artist. As far as the whites are concerned, he is an *exotique*, and he has to paint like one or he's not even considered. And for the blacks, if he's had any kind of success at all, he's held up as a model. Not as an artist, but as a model Negro. One might say there's really not a great deal of difference between the present and the nineteenth century as far as black artists are concerned."

I asked Lee-Smith whether he had seen much in the way of a rapport—or even simple socializing— between Negro and white artists. "Oh, there isn't much camaraderie between us within the art society," he said. "It's not necessarily deliberate exclusion. It's just that you've got too different realities at work here. The black artists see the world differently. Their values and realities are altogether different. This business of trying to measure the degree of deliberate segregation is ticklish. It's not a black-and-white (no pun intended) sort of thing. The black artist, because he doesn't socialize much with the white establishment, just isn't around when the deals are made. We don't get into shows, and we

don't get grants and scholarships because of a lack of contacts. We just don't know the right people. And they don't know us. Or maybe they don't want to know us. When the Museum of Modern Art put together a print show for American embassies in Africa—in Africa mind you—no Negro artists were included. When the Negroes began to complain, the museum pleaded ignorance, said it didn't know any Negroes were working in the print media. Then Romare Bearden sent them a letter pointing out that a number of Negroes were represented in the museum's own print collection."

Lee-Smith lighted a thin cigar, drew on it, and said, "The black painter is in a bind every way he can be. I've been extremely fortunate myself patronage-wise—especially, I want to emphasize, in the middle west—and I've had a certain modest success, but I'm still not making much of a living although a number of comparable white artists are doing quite well for themselves. And most of us aren't getting any patronage at all. Not from the white or the black community." I remarked that the black community was hardly in a position, economically, to provide patronage. Lee-Smith waved the observation aside. "The Negro can afford art," he said. "He's buying Cadillac cars and mink coats, but he's just not at the point where he considers art important. Not in terms of art or collecting art, anyway, but only in terms of racial pride—what our boys are doing. I get practically no patronage from the black community, and this raises the question, Who do you paint for? It really puts the Negro painter in a terrible bind. I'm sure many of us would like to become immersed in the Negro liberation struggle, but nobody wants to buy that sort of thing. Certainly, the white community isn't going to buy it—or much else, if a Negro paints it. The mere fact that Negroes increasingly are forming their own galleries speaks for itself. They form them because they say they have no opportunities in the white establishment galleries."

I asked whether this might at least in part be because many Negroes were not working in the popular styles of the moment. "Well," Lee-Smith said, "at least some of them are not terribly taken with way-out methods. They feel that establishment art is not speaking to them or for them. It's operating in an entirely different world. Of course, I don't say that the black artist, by and large, meets the highest standards, but how much better he would have been with better opportunities! Without encouragement we have perforce not been able to do as well as we might have done. Think of the sort of encouragement and patronage some white artists are getting. Take a painter like Gottlieb. Big country house and all that. The Negro gets a look at that and says, 'What the hell's happening? We're not getting cut in on the pie.' A measure of the integrity of the white liberal will be his ability to accept and encourage the black artist. And he'll have to meet him at least part of the way. Truth is what art is about, but truth as a black artist sees it is entirely different."

I asked Lee-Smith what his opinion was of those white artists (Thomas Hart Benton, to name one) who tried to paint black truth. "I don't hold white painters of Negro subjects in very high esteem," he said. "For them, the Negro is still an *exotique*. Benton made Negro life look like. . . ." He couldn't seem to find just the word he wanted. "Like Catfish Row?" I suggested. "Exactly," he said. "Joseph Hirsch is the only white painter I can think of who is sympathetic from our point of view. There's no reason, though, for whites to paint—or try to paint—Negro life. The white's job is to include Negroes in white activities. And he must try not only to clean up the slums, but to accept the Negro in all his activities—including art."

Larry Neal, "The Black Arts Movement," in "Black Theatre," special issue, *TDR: The Drama Review* 12, no. 4 (Summer 1968)

TDR: The Drama Review was founded in 1955 by the scholar Richard W. Corrigan. The academic journal covered a broad range of performance genres and aimed to situate such practices within a social and political context. This essay by Larry Neal discusses a number of plays that were first showcased by the Black Arts Repertory Theater in Harlem, of which he was a principal member. Neal's text was one of the earliest to define the role of the Black Arts Movement, connecting the movement's aims to Black Power ideologies. By 1968, Neal had established himself as a prolific essayist, contributing regularly to periodicals such as *Negro Digest*. His writings advocated for art forms that would promote autonomy for the African American community. At the time this piece was published, Neal had recently cofounded a magazine, *The Cricket: Black Music in Evolution*, and he would soon publish his first collection of poetry, *Black Boogaloo: Notes on Black Liberation*. Later in 1968, the author gained further prominence for *Black Fire*, a landmark anthology of contemporary Black writers, coedited with LeRoi Jones (later Amiri Baraka; see p. 111).

LARRY NEAL, "THE BLACK ARTS MOVEMENT"

The Black Arts Movement is radically opposed to any concept of the artist that alienates him from his community. Black Art is the aesthetic and spiritual sister of the Black Power concept. As such, it envisions an art that speaks directly to the needs and aspirations of Black America. In order to perform this task, the Black Arts Movement proposes a radical reordering of the western cultural aesthetic. It proposes a separate symbolism, mythology, critique, and iconology. The Black Arts and the Black Power concept both relate broadly to the Afro-American's desire for self-determination and nationhood. Both concepts are nationalistic. One is concerned with the relationship between art and politics; the other with the art of politics.

Recently, these two movements have begun to merge: the political values inherent in the Black Power concept are now finding concrete expression in the aesthetics of Afro-American dramatists, poets, choreographers, musicians, and novelists. A main tenet of Black Power is the necessity for Black people to define the world in their own terms. The Black artist has made the same point in the context of aesthetics. The two movements postulate that there are in fact and in spirit two Americas—one Black, one white. The Black artist takes this to mean that his primary duty is to speak to the spiritual and cultural needs of Black people. Therefore, the main thrust of this new breed of contemporary writers is to confront the contradictions arising out of the Black man's experience in the racist West. Currently, these writers are re-evaluating Western aesthetics, the traditional role of the writer, and the social function of art. Implicit in this re-evaluation is the need to develop a "Black aesthetic." It is the opinion of many Black writers, I among them, that the Western aesthetic has run its course: it is impossible to construct anything meaningful within its decaying structure. We advocate a cultural revolution in art and ideas. The cultural values inherent in western history must either be radicalized or destroyed, and we will probably find that even radicalization is impossible. In fact, what is needed is a whole new system of ideas. Poet Don L. Lee expresses it:

. . . We must destroy Faulkner, dick, jane, and other perpetrators of evil. It's time for Du Bois, Nat Turner, and Kwame Nkrumah. As Frantz Fanon points out: destroy the culture and you destroy the people. This must not happen. Black artists are culture stabilizers; bringing back old values, and introducing new ones. Black Art will talk to the people and with the will of the people stop impending "protective custody."

The Black Arts Movement eschews "protest" literature. It speaks directly to Black people. Implicit in the concept of "protest" literature, as Brother Knight[1] has made clear, is an appeal to white morality:

Now any Black man who masters the technique of his particular art form, who adheres to the white aesthetic, and who directs his work toward a white audience is, in one sense, protesting. And implicit in the act of protest is the belief that a change will be forthcoming once the masters are aware of the protestor's "grievance" (the very word connotes begging, supplications to the gods). Only when that belief has faded and protestings end, will Black art begin.

Brother Knight also has some interesting statements about the development of a "Black aesthetic":

Unless the Black artist establishes a "Black aesthetic" he will have no future at all. To accept the white aesthetic is to accept and validate a society that will not allow him to live. The Black artist must create new forms and new values, sing new songs (or purify old ones); and along with other Black authorities, he must create a new history, new symbols, myths and legends (and purify old ones by fire). And the Black artist, in creating his own aesthetic, must be accountable for it only to the Black people. Further, he must hasten his own dissolution as an individual (in the Western sense)—painful though the process may be, having been breast-fed the poison of "individual experience."

When we speak of a "Black aesthetic" several things are meant. First, we assume that there is already in existence the basis for such an aesthetic.

Essentially, it consists of an African-American cultural tradition. But this aesthetic is finally, by implication, broader than that tradition. It encompasses most of the usable elements of Third World culture. The motive behind the Black aesthetic is the destruction of the white thing, the destruction of white ideas, and white ways of looking at the world. The new aesthetic is mostly predicated on an Ethics which asks the question: whose vision of the world is finally more meaningful, ours or the white oppressors'? What is truth? Or more precisely, whose truth shall we express, that of the oppressed or of the oppressors? These are basic questions. Black intellectuals of previous decades failed to ask them. Further, national and international affairs demand that we appraise the world in terms of our own interests. It is clear that the question of human survival is at the core of contemporary experience. The Black artist must address himself to this reality in the strongest terms possible. In a context of world upheaval, ethics and aesthetics must interact positively and be consistent with the demands for a more spiritual world. Consequently, the Black Arts Movement is an ethical movement. Ethical, that is, from the viewpoint of the oppressed. And much of the oppression confronting the Third World and Black America is directly traceable to the Euro-American cultural sensibility. This sensibility, anti-human in nature, has, until recently, dominated the psyches of most Black artists and intellectuals; it must be destroyed before the Black creative artist can have a meaningful role in the transformation of society.

It is this natural reaction to an alien sensibility that informs the cultural attitudes of the Black Arts and the Black Power movement. It is a profound ethical sense that makes a Black artist question a society in which art is one thing and the actions of men another. The Black Arts Movement believes that your ethics and your aesthetics are one. That the contradictions between ethics and aesthetics in western society is symptomatic of a dying culture.

The term "Black Arts" is of ancient origin, but it was first used in a positive sense by LeRoi Jones:

> We are unfair
> And unfair

> We are Black magicians
> Black arts we make
> in Black labs of the heart

> The fair are fair
> and deathly white

> The day will not save them
> And we own the night

There is also a section of the poem "Black Dada Nihilismus" that carries the same motif. But a fuller amplification of the nature of the new aesthetics appears in the poem "Black Art":

> Poems are bullshit unless they are
> teeth or trees or lemons piled
> on a step. Or Black ladies dying
> of men leaving nickel hearts
> beating them down. Fuck poems
> and they are useful, would they shoot
> come at you, love what you are,
> breathe like wrestlers, or shudder
> strangely after peeing. We want live
> words of the hip world, live flesh &
> coursing blood. Hearts and Brains
> Souls splintering fire. We want poems
> like fists beating niggers out of Jocks
> or dagger poems in the slimy bellies
> of the owner-jews . . .[2]

Poetry is a concrete function, an action. No more abstractions. Poems are physical entities: fists, daggers, airplane poems, and poems that shoot guns. Poems are transformed from physical objects into personal forces:

> . . . Put it on him poem. Strip him naked
> to the world. Another bad poem cracking
> steel knuckles in a jewlady's mouth
> Poem scream poison gas on breasts in green
> berets . . .

Then the poem affirms the integral relationship between Black Art and Black people:

> . . . Let Black people understand
> that they are the lovers and the sons
> of lovers and warriors and sons

of warriors Are poems & poets &
all the loveliness here in the world

It ends with the following lines, a central assertion in both the Black Arts Movement and the philosophy of Black Power:

We want a Black poem. And a
Black World.
Let the world be a Black Poem
And let All Black People Speak This Poem
Silently
Or LOUD

The poem comes to stand for the collective conscious and unconscious of Black America—the real impulse in back of the Black Power movement, which is the will toward self-determination and nationhood, a radical reordering of the nature and function of both art and the artist.

[*Here, Neal outlines the history of the Black Arts Repertory Theater School and discusses several plays by Black Arts Movement playwrights.*]

The Black Arts Movement represents the flowering of a cultural nationalism that has been suppressed since the 1920's. I mean the "Harlem Renaissance"—which was essentially a failure. It did not address itself to the mythology and the life-styles of the Black community. It failed to take roots, to link itself concretely to the struggles of that community, to become its voice and spirit. Implicit in the Black Arts Movement is the idea that Black people, however dispersed, constitute a nation within the belly of white America. This is not a new idea. Garvey said it and the Honorable Elijah Muhammad says it now. And it is on this idea that the concept of Black Power is predicated.

Afro-American life and history is full of creative possibilities, and the movement is just beginning to perceive them. Just beginning to understand that the most meaningful statements about the nature of Western society must come from the Third World of which Black America is a part. The thematic material is broad, ranging from folk heroes like Shine and Stagolee to historical figures like Marcus Garvey and Malcolm X. And then there is

the struggle for Black survival, the coming confrontation between white America and Black America. If art is the harbinger of future possibilities, what does the future of Black America portend?

NOTES

1 [Etheridge Knight (1931–1991) was a poet who, after serving in Korea in the U.S. Army, spent most of the 1960s in prison, where he began writing and was encouraged by established African American writers such as Gwendolyn Brooks. His first collection, *Poems from Prison*, was published the year before he was released, in 1968. Subsequently, he became a fixture in the Black Arts Movement. —Eds.]

2 [Baraka later addressed the "Anti-Semitism {that} grew in the Black Liberation Movement" in his article "Confessions of a Former Anti-Semite," published in the *Village Voice* on December 17, 1980. —Eds.]

1968

Evangeline J. Montgomery, "Why New Perspectives in Black Art?" and Paul Mills, untitled text, in *New Perspectives: Black Art*, catalogue for exhibition held at the Kaiser Center Gallery, Oakland Museum (Art Division), Oakland, California, October 5–26, 1968

Paul Mills was the curator of the Art Division of the Oakland Museum and a champion of local art and culture. He coorganized this show with Evangeline J. Montgomery, who, in 1967, had founded an organization for Black artists in San Francisco called Art West Associated North (AWAN)—an offshoot of Art West Associated, formed five years earlier in Los Angeles by the artist Ruth G. Waddy (see p. 176). The objective of both groups was to make the work of Black artists on the West Coast visible to the public through exhibitions and printed materials. Members fought against the tendency on the part of well-known museums in the region to exclude African Americans from their programming. The Oakland exhibition presented thirty-six artists in total, including Waddy, Arthur Carraway, Frances Dunham Catlett, Marie Johnson, and Mary Parks Washington.

EVANGELINE J. MONTGOMERY, "WHY NEW PERSPECTIVES IN BLACK ART?"

Black people want to know their artists. They want us to record events ourselves. This presupposes a group effort wherein Black artists combine their intellectual, physical and material resources in an immediate response to their Black community. The Black artist depicts the perseverance—the deprivation—the anger—the very "souls of Black folks." If something has to be said, he says it—without deliberation—but in a spirit which reflects the blood of the Black community. Thus, in the midst of a stagnant but affluent society, new perspectives are developed.

Therefore, AWAN, a new perspective in Black Art was founded. I felt the need for Black artists to get together and to make a group statement concerning the role of the Black artist in his community. AWAN responded by exhibiting their art in a total Black community—Hunter's Point. We took our work to one of the colleges in the Black community. We tried to establish a rapport with the areas in the Bay Area having a large percentage of Black people. We participated in regular art festivals in the Bay Area. From there we have come to the Kaiser Center Gallery of the Oakland Museum.

At present, AWAN membership includes Black artists in Northern California. Some artists are self-taught: some are professional artists. We would like to express our appreciation to Kaiser Industries and to the Oakland Museum who have recognized the need and have given us a start. We hope that this exhibit will be viewed in the spirit in which we have sought to present it—*A NEW PERSPECTIVE IN Black ART*.

PAUL MILLS

The Oakland Museum and its Art Division are honored to be hosts to Art-West Associated North and to their exhibition, *NEW PERSPECTIVES IN Black ART*. It is one of the largest and finest regional exhibitions of Black art yet held in this country. It is also the fulfillment of a dream which began in 1967. Then, the Museum and Kaiser Industries exhibited *The Negro in American Art*, organized by U.C.L.A. We were able to add a small section of work by local Black artists to this show. All of us hoped the day would come when the Black artists of the Bay Area could have their own show; thanks to AWAN and to its friends, that day is here. We look forward to future Museum exhibitions of the work of contemporary Black artists.

1968

Earl Roger Mandle, "Introduction," in Earl Roger Mandle, ed., *30 Contemporary Black Artists*, catalogue for exhibition held at the Minneapolis Institute of Arts, Minneapolis, Minnesota, October 17–November 24, 1968

30 Contemporary Black Artists was curated by Earl Roger Mandle, associate director of the Minneapolis Institute of Arts. Having recently completed his postgraduate studies at New York University, Mandle conceived the show to promote the work of African American artists who were, one by one, starting to receive acclaim in the United States. As well as being one of the first presentations of work by notable Black artists in an art museum, the exhibition was also the earliest national touring show devoted to contemporary Black artists. Following its run in Minneapolis, the exhibition traveled to Atlanta; Flint, Michigan; Syracuse, New York; and San Francisco. Participating artists included Emma Amos, Benny Andrews, Romare Bearden, Melvin Edwards, Sam Gilliam, Richard Hunt, Daniel LaRue Johnson, Norman Lewis, Tom Lloyd, Richard Mayhew, Betye Saar, and Raymond Saunders.

EARL ROGER MANDLE, "INTRODUCTION"

One important aspect, tragic in its implications, of the Black American's place in society is that he has inherited a vantage point from which he can make unique observations about the American scene. Yet, it is curious that the Black artist has remained virtually unknown in American culture, while Black writers and musicians have made significant contributions in music and literature. Separation from a visual heritage, the denial of educational opportunities that would afford sophisticated artistic training and the opportunity for little more than a craft tradition have prevented natural artistic development. The Black artist, therefore, has been considered somewhat of a phenomenon, endowed with his unique vantage point, but denied his cultural history and any promise for the future. Nevertheless, he has persisted. "While many other aspects of our society pose great threats and promises for me," says Benny Andrews. "I never lose sight of my one aim, to be an artist first and always."

This desire is perhaps the only characteristic common to the thirty Black artists in the exhibition. From divergent backgrounds, with varying talents and opportunities, each artist has developed his own style, reflecting not so much his ethnic background, but his personal direction as an artist. As Mahler Ryder stated, his work "is like most art, the sum total of borrowed experiences, altered by personal indulgence." Several artists in this exhibition, however, do make strong statements about the condition of the Black American, and others draw upon African art as a source of inspiration. Generally, the artists are responding to the crosscurrents of contemporary art, and are primarily concerned with recent experiments in form and technique.

This exhibition offers three challenges: it challenges the viewer to judge and enjoy the works of art on their own merit, not measuring his response by sympathy with the artists. Secondly, the special nature of this exhibition challenges the establishment, by recognizing the achievement of these artists, to acknowledge the potential and desire for quality urgently developing in our communities.

Finally, this exhibition serves as an encouragement to the Black youth of America. Black youth, vitally aware of its potential, can find art a powerful vehicle not only to express its history, but to project its destiny.

Emory Douglas, "Position Paper 1 on Revolutionary Art," *The Black Panther*, October 20, 1968

The Black Panther Party (BPP) was established in October 1966 by the Oakland-based political activists Huey P. Newton and Bobby Seale. On April 25, 1967, the first issue of the weekly newspaper the *Black Panther* was released, and the paper would eventually be distributed nationally and internationally. Emory Douglas, the BPP's Minister of Culture, was the publication's art director. Trained as a graphic designer, he created bold illustrations that powerfully communicated a message of cultural resistance and had an immediate impact on the paper's mass readership. Douglas's authoritative images of empowerment forcefully redefined notions of African American identity in the public realm. In this text, Douglas explains what "revolutionary art" means and how it activates oppressed people, insisting that, for the revolutionary artist, "the Ghetto itself is the gallery." His "position paper" was featured in the paper twice more, with slight revisions, in January and June 1970.

EMORY DOUGLAS, "POSITION PAPER 1 ON REVOLUTIONARY ART"

REVOLUTIONARY ART DOES NOT DEMAND ANYMORE SACRIFICE FROM THE REVOLUTIONARY ARTIST THAN WHAT IS DEMANDED FROM A TRAITOR (NEGRO) WHO DRAWS FOR THE OPPRESSOR. THEREFORE, THE CREATION OF REVOLUTIONARY ART IS NOT A TRAGEDY BUT AN HONOR AND DUTY THAT WILL NEVER BE REFUSED—EMORY

REVOLUTIONARY ART begins with the program that Huey P. Newton instituted with the Black PANTHER PARTY. REVOLUTIONARY ART, like the Party, is for the whole community and its total problems. It gives the people the correct political understanding of our struggle.

Before a correct visual interpretation of the struggle can be given, we must recognize that Revolutionary Art is an art that flows from the people. It must be a whole and living part of the people's lives their daily struggle to survive. To draw about revolutionary things, we must shoot and/or be ready to shoot when the times comes. In order to draw about the people who are shooting, we must capture the true revolution in a pictorial fashion. We must feel what the people feel who throw rocks and bottles at the oppressor so that when we draw about it—so we can raise their level of consciousness to hand-grenades and dynamite to be launched at the oppressor. Revolutionary Art gives a physical confrontation with tyrants, and also enlightens the people to continue their vigorous attack by educating the masses through participation and observation.

Through the Revolutionary Artist's observation of the people, we can picture the territory on which we live (as slaves): project maximum damage to the people, and come out victorious.

The Revolutionary Artist's talents are just one of the weapons he uses in the struggle for Black People. His art becomes a tool for liberation. Revolutionary Art can thereby progress as the people progresses, because the People are the backbone to the Artist and not the Artist to the People.

To conceive any type of visual interpretations of the struggle, the Revolutionary Artist must constantly be agitating the people, but before one agitates the people or progress as the struggle progresses one must make strong roots among the masses of the people. Then and only then can a Revolutionary Artist renew this visual interpretation of Revolutionary Art indefinitely until liberation. By making these strong roots among the masses of the Black People, the Revolutionary Artist rises above the confusion that the oppressor has brought on the colonized people, because all of us (as slaves) from the Christian to the brother on the block, the College student and the high school drop out, the street walker and the secretary, the pimp and the preacher, the domestic and the gangster; all the elements of the ghetto can understand Revolutionary Art.

The Ghetto itself is the Gallery for the Revolutionary Artist's drawings. His work is pasted on the walls of the ghetto, in stores' front windows, fences, doorways, telephone poles and booths, passing buses, alleyways, gas stations, barber shops, beauty parlors, laundry mats, liquor stores, as well as the huts of the ghettos.

This way the Revolutionary Artist educates the people as they go through their daily routine, from day to day, week to week, and month to month. This way the Revolutionary Artist cuts through the smokescreens of the oppressor and creates brand new images of Revolutionary action—for the total community.

Revolutionary Art is an extension and interpretation to the masses in the most simplest and obvious form. Without being a revolutionary and committed to the struggle for liberation the artist could not express revolutionary at all. Revolutionary Art is learned in the ghetto from the rat avaricious businessman, the demagogic politician and the pig cops on the beat, not in the schools of fine art.[1] The Revolutionary Artist hears the people screams when they are being attacked by the pigs. They share their curses when they feel like killing the pigs but are unequipped. He watches and hears the sounds of foot steps of Black people trampling the ghetto streets and translates them into

pictures of slow revolts against the slave-masters, stomping them in their brains with bullets—that we can have power and freedom to determine the destiny of our community and help to build "our world."

Revolutionary Art is a returning from the blind whereas we no longer let the oppressor lead us around like watchdogs.

NOTE

1 [The typesetting of this sentence is garbled in the October 1968 version, so the wording from the January 1970 version has been substituted. —Eds.]

1968

Edward Clark, "Un musée pour Harlem" [A Museum for Harlem], *Chroniques de l'art vivant*, no. 1 (November 1968)

The painter Edward Clark was born in New Orleans in 1926 and studied in Chicago. After living in Paris for a few years in the 1950s, Clark returned to the United States and, in 1957, cofounded the cooperative Brata Gallery in New York. That year, at Brata, he showed a work now believed to have been the first shaped canvas in American art. In 1966, Clark moved back to Paris, where he made his first oval paintings, and remained there until 1969. Looking at the debates among African American artists from a distance, he wrote this article about the beginnings of the Studio Museum in Harlem for *Chroniques de l'art vivant*, a new journal published by the French art dealer and collector Aimé Maeght. Clark could not decide how to react to the Studio Museum's founding. However, concerned by what he felt was the mediocre quality of many exhibitions of Black art, he made the important point that Black artists were more likely to be free and daring in their work once they had greater financial security and institutional support. The Studio Museum could help with the latter, and, indeed, in 1980, Clark was given a solo show there.

This essay was published in French and is translated here for the first time. Clark sometimes capitalized "Noir" (Black) in the original and sometimes left the word in lowercase; we have followed his variable usage here.

EDWARD CLARK, "UN MUSÉE POUR HARLEM" [A MUSEUM FOR HARLEM]

A new museum opened in New York. It is dedicated to modern art, with one slight difference: located in the heart of the black ghetto, the Studio Museum in Harlem intends to present mainly exhibitions by non-whites. Should we rejoice in this new opportunity offered to modern art? It is not clear. The fact that such an initiative seems to be necessary reveals, above all, that racial inequity also holds sway in a domain where the spirit of segregation is, by definition, inconceivable.

Applied to certain artists mentioned here, the expression "Black American artists" is regrettable, while perhaps necessary (in this article). In fact, at this time, ten years since "Black Power" became the rallying cry and "Black Pride" the catchword, we feel constrained to treat these Black Americans as a whole, without taking account of the individuals they are. The expression is justified by the specific different nature of the Black American's cultural heritage, and we know very well that his cultural work (that of the Black American) differs from that of other black people in the world.

It is undeniable that music has been the most accomplished artistic expression of Black Americans. Jazz, the only original art form that America has produced, had a profound impact on American painting, from black as well as white artists, in the '40s and '50s, especially on the Abstract Expressionist movement.

—But, how is it that every time a large number of black artists have had a group exhibition, the results have been rather mediocre?

—Why has the Black American artist not achieved a higher level in the plastic arts?

In the course of this year, two of the most celebrated black American artists were interviewed by an American art magazine. The journalist asked them the latter of the two questions above. He implied that that this failure or lack of artistic activity was due to a certain underdeveloped intellectual capacity. The causes of that situation go much deeper. First of all, I would have responded to that question with another question: why has

America—with an impressive population of one hundred million people in the 1930s and 1940s—not been able to produce one single artist with an international reputation? In fact, it is only within the past ten years that White Anglo-Saxon America has disengaged itself from European references in order to come up with an authentically white expression, which is, in my view, Pop art.

The essential part, for me, lies in the fact that black American artists have been directly excluded from the main currents of the plastic arts. For example, white artists have at least two advantages over black artists. Aided by talent and luck, they have been encouraged by other people, who have thereby stimulated them to persevere; and, once they have achieved financial success or a reputation, they can be more free and daring in their work, which is practically impossible for Black American artists.

Certain people say that the Black Americans are aesthetically blind, that their originality can be found in other realms. The plastic arts, they say, require greater intellectual capacity. It may be that this is true in certain aspects. Few Black Americans, for example, see the beauty of the "Deep South," because the concepts of injustice and cruelty are too deeply associated with this part of the country. In that sense, it could be said that many blacks are "blind" to the beauty before their eyes.

Even if they hardly receive more encouragement in Europe, at least black artists are not restricted and have more freedom to progress there; this becomes evident in the remarkable work of non-American black artists working in Europe, including the sculptor Cárdenas,[1] Patrick Betaudier, and the famous Wifredo Lam.

I have tried to provide some answers to the following question: why have Black American artists as a group fallen behind their white counterparts?

I will admit that I do not know all the answers. For example, while leafing through recent catalogues of exhibitions featuring black artists, I see many works attempting to describe the beauty or despair of the black world. But the feeling there is never violent or even filled with anger. The clear lack of anger remains a mystery to me in view of the current situation.

I will conclude by saying that art is not subject to political games. Its importance rises far above racial differences. Any man with talent and a noble spirit can produce it.

NOTE

1 [Agustín Cárdenas (1927–2001), a Cuban sculptor associated with André Breton and the Surrealists, was active in Paris from 1955 to 1994. —Eds.]

1968

Ralph Ellison, "Introduction," in *Romare Bearden: Paintings and Projections*, catalogue for exhibition held at the Art Gallery of the State University of New York at Albany, November 25–December 22, 1968

Romare Bearden's series of photostats called *Projections* was first displayed in 1964 at the Cordier and Ekstrom Gallery in Manhattan and soon after was reviewed by Dore Ashton in the journal *Quadrum*. The SUNY–Albany exhibition included some of these acclaimed works as well as new pictures. The African American novelist Ralph Ellison, best known for his 1952 novel *Invisible Man*, was a friend of Bearden's and authored this essay for the exhibition catalogue. Emphasizing the ways in which Bearden's fragmented compositions contrasted with stereotypical portrayals of African American communities in the mass media, Ellison argued that Bearden's technical mastery and stylistic innovations in fact represented the complexity of the Black experience in the United States.

RALPH ELLISON, "INTRODUCTION"

> I regard the weakening of the importance given to objects as the capital transformation of western art. In painting, it is clear that a painting of Picasso's is less and less a "canvas," and more and more the mark of some discovery, a stake left to indicate the place through which a restless genius has passed . . .[1]

This series of collages and projections by Romare Bearden represent a triumph of a special order. Springing from a dedicated painter's unending efforts to master the techniques of illusion and revelation which are so important to the craft of painting, they are also the result of Bearden's search for fresh methods to explore the plastic possibilities of Negro American experience. What is special about Bearden's achievement is, it seems to me, the manner in which he has made his dual explorations serve one another, the way in which his technique has been used to discover and transfigure its object. For in keeping with the special nature of his search and by the self-imposed "rules of the game," it was necessary that the methods arrived at be such as would allow him to express the tragic predicament of his people without violating his passionate dedication to art as a fundamental and transcendent agency for confronting and revealing the world.

To have done this successfully is not only to have added a dimension to the technical resourcefulness of art, but to have modified our way of experiencing reality. It is also to have had a most successful encounter with a troublesome social anachronism which, while finding its existence in areas lying beyond the special providence of the artist, has nevertheless caused great confusion among many painters of Bearden's social background. I say social, for although Bearden is by self-affirmation no less than by public identification a Negro American, the quality of his artistic culture can by no means be conveyed by that term. Nor does it help to apply the designation "Black" (even more amorphous for conveying a sense of cultural complexity) and since such terms tell us little about the unique individuality of the artist or anyone else, it is well to have them out in the open where they can cause the least confusion.

What, then, do I mean by anachronism? I refer to that imbalance in American society which leads to a distorted perception of social reality, to a stubborn blindness to the creative possibilities of cultural diversity, to the prevalence of negative myths, racial stereotypes and dangerous illusions about art, humanity and society. Arising from an initial failure of social justice, this anachronism divides social groups along lines that are no longer tenable while fostering hostility, anxiety and fear; and in the area to which we now address ourselves it has had the damaging effect of alienating many Negro artists from the traditions, techniques and theories indigenous to the arts through which they aspire to achieve themselves.

Thus in the field of culture, where their freedom of self-definition is at a maximum, and where the techniques of artistic self-expression are most abundantly available, they are so fascinated by the power of their anachronistic social imbalance as to limit their efforts to describing its manifold dimensions and its apparent invincibility against change. Indeed, they take it as a major theme and focus for their attention, they allow it to dominate their thinking about themselves, their people, their country and their art. And while many are convinced that simply to recognize social imbalance is enough to put it to riot, few achieve anything like artistic mastery, and most fail miserably through a single-minded effort to "tell it like it is."

Sadly however, the problem for the plastic artist is not one of "telling" at all, but of revealing that which has been concealed by time, by custom, and by our trained incapacity to perceive the truth. Thus it is a matter of destroying moribund images of reality and creating the new. Further, for the true artist, working from the top of his times and out of a conscious concern with the most challenging possibilities of his form, the unassimilated and anachronistic—whether in the shape of motif, technique or image—is abhorrent, an evidence of conceptual and/or technical failure, of challenges unmet. And although he may ignore the anachronistic through a preoccupation with other pressing details, he can never be satisfied simply by placing it within a frame. For once there, it becomes the

symbol of all that is not art and a mockery of his powers of creation. So at his best he struggles to banish the anachronistic element from his canvas by converting it into an element of style, a device of his personal vision.

For as Bearden demonstrated here so powerfully, it is of the true artist's nature and mode of action to dominate all the world and time through technique and vision. His mission is to bring a new visual order into the world, and through his art he seeks to reset society's clock by imposing upon it his own method of defining the times. The urge to do this determines the form and character of his social responsibility, it spurs his restless exploration for plastic possibilities, and it accounts to a large extent for his creative aggressiveness.

But it is here precisely that the aspiring Negro painter so often falters. Trained by the circumstances of his social predicament to a habit (no matter how reluctant) of accommodation, such an attitude toward the world seems quite quixotic. He is, he feels, only one man, and the conditions which thwart his freedom are of such enormous dimensions as to appear unconquerable by purely plastic means—even at the hands of the most highly trained, gifted and arrogant artist.

"Turn Picasso into a Negro and then let me see how far he can go," he will tell you, because he feels an irremediable conflict between his identity as a member of an embattled social minority and his freedom as an artist. He cannot avoid—nor should he wish to avoid the scene; a self-assertive and irreverent art which abandoned long ago the task of mere representation to photography and the role of story-telling to the masters of the comic strip and the cinema. Nor can he draw upon his folk tradition for a simple answer. For praise and admiration. And unfortunately there seems to be (the African past notwithstanding) no specifically Negro American tradition of plastic design to offer him support.

How then, he asks himself, does even an artist steeped in the most advanced lore of his craft and most passionately concerned with solving the more advanced problems of painting as painting address himself to the perplexing question of bringing his art to bear upon the task (never so urgent as now)

of defining Negro American identity, of pressing its claims for recognition and for justice? He feels, in brief, a near-unresolvable conflict between his urge to leave his mark upon the world through art and his ties to his group and its claims upon him.

Fortunately for them and for us, Romare Bearden has faced these questions for himself, and since he is an artist whose social consciousness is no less intense than his dedication to art, his example is of utmost importance for all who are concerned with grasping something of the complex interrelations between race, culture and the individual artist as they exist in the United States. Bearden is aware that for Negro Americans these are times of eloquent protest and intense struggle, times of rejection and redefinition—but he also knows that all this does little to make the question of the relation of the Negro artist to painting any less difficult. And if the cries in the street are to find effective statement on canvas they must undergo a metamorphosis. For in painting, Bearden has recently observed, there is little room for the lachrymose, for self-pity or raw complaint; and if they are to find a place in painting this can only be accomplished by infusing them with the freshest sensibility of the times as it finds existence in the elements of painting.

It would seem that for many Negro painters even the possibility of translating Negro American experience into the modes and conventions of modern painting went unrecognized. This was, in part, the result of an agonizing fixation upon the racial mysteries and social realities dramatized by color, facial structure, and the texture of Negro skin and hair. And again, many aspiring artists clung with protective compulsiveness to the myth of the Negro American's total alienation from the larger American culture—a culture which he helped to create in the areas of music and literature, and where in the area of painting he has appeared from the earliest days of the nation as symbolic figure—and allowed the realities of their social and political situation to determine their conception of their role and freedom as artists.

To accept this form of the myth was to accept its twin variants, one of which holds that there is a pure mainstream of American culture which is

"unpolluted" by any trace of Negro American style or idiom, and the other (propagated currently by the exponents of Negritude) which holds that Western art is basically racist and thus anything more than a cursory knowledge of its techniques and history is to the Negro artist irrelevant. In other words, the Negro American who aspired to the title "Artist" was too often restricted by sociological notions of racial separatism, and these appear not only to have restricted his use of artistic freedom, but to have limited his curiosity as to the abundant resources made available to him by those restless and assertive agencies of the artistic imagination which we call technique and conscious culture.

Indeed, it has been said that these disturbing works of Bearden's (which virtually erupted during a tranquil period of abstract painting) began quite innocently as a demonstration to a group of Negro painters. He was suggesting some of the possibilities through which common-place materials could be forced to undergo a creative metamorphosis when manipulated by some of the non-representational techniques available to the resourceful craftsman. The step from collage to projection followed naturally since Bearden had used it during the early Forties as a means of studying the works of such early masters as Giotto and de Hooch. That he went on to become fascinated with the possibilities lying in such "found" materials is both an important illustrative instance for younger painters and a source for our delight and wonder.

Bearden knows that regardless of the individual painter's personal history, taste or point of view, he must, nevertheless, pay his materials the respect of approaching them through a highly conscious awareness of the resources and limitations of the form to which he has dedicated his creative energies. One suspects also that as an artist possessing a marked gift for pedagogy, he has sought here to reveal a world long hidden by the clichés of sociology and rendered cloudy by the distortions of newsprint and the false continuity imposed upon our conception of Negro life by television and much documentary photography. Therefore, as he delights us with the magic of design and teaches us the ambiguity of vision, Bearden insists that we see

and that we see in depth and by the fresh light of the creative vision. Bearden knows that the true complexity of the slum dweller and the tenant farmer require a release from the prison our media-dulled perception and a reassembling in forms which would convey something of the depth and wonder of the Negro American's stubborn humanity.

Being aware that the true artist destroys the accepted world by way of revealing the unseen, and creating that which is new and uniquely his own, Bearden has used cubist techniques to his own ingenious effect. His mask-faced Harlemites and tenant farmers set in their mysterious familiar but emphatically abstract scenes are nevetheless resonant of artistic and social history. Without compromising their integrity as elements in plastic compositions his figures are eloquent of a complex reality lying beyond their frames. While functioning as integral elements of design they serve simultaneously as signs and symbols of a humanity which has struggled to survive the decimating and fragmentizing effects of American social processes. Here faces which draw upon the abstract character of African sculpture for their composition are made to focus our attention upon the far from abstract reality of a people. Here abstract interiors are presented in which concrete life is acted out under repressive conditions. Here, too, the poetry of the blues is projected through synthetic forms which, visually, are in themselves tragi-comic and eloquently poetic.

A harsh poetry this, but poetry nevertheless; with the nostalgic imagery of the blues conceived as visual form, image, pattern and symbol—including the familiar trains (evoking partings and reconciliations), and the conjur women (who appear in these works with the ubiquity of the witches who haunt the drawing of Goya) who evoke the abiding mystery of the enigmatic women who people the blues. And here, too, are renderings of those rituals of rebirth and dying, of baptism and sorcery which give ceremonial continuity to the Negro American community.

By imposing his vision upon scenes familiar to us all Bearden reveals much of the universally human which they conceal. Through his creative assemblage he makes complex comments upon

history, upon society and upon the nature of art. Indeed, his Harlem becomes a place inhabited by people who have in fact been resurrected, re-created by art, a place composed of visual puns and artistic allusions and where the sacred and profane, reality and dream are ambiguously mingled. And resurrected with them in the guise of fragmented ancestral figures and forgotten gods (really masks of the instincts, hopes, emotions, aspirations and dreams) are those powers that now surge in our land with a potentially destructive force which springs from the very fact of their having for so long gone unrecognized, unseen. Bearden doesn't impose these powers upon us by explicit comment, but his ability to make the unseen manifest allows us some insight into the forces which now clash and rage as Negro Americans seek self-definition in the slums of our cities. There is a beauty here, a harsh beauty which asserts itself out of the horrible fragmentation which Bearden's subjects and their environment have undergone. But, as I have said, there is no preaching; these forces have been brought to eye by formal art.

These works take us from Harlem through the south of tenant farms and northward-bound trains to tribal Africa; our mode of conveyance consists of every device which has claimed Bearden's artistic attention, from the oversimplified and scanty images of Negroes that appear in our ads and photo-journalism, to the discoveries of the School of Paris and the Bauhaus. He has used the discoveries of Giotto and Pieter de Hooch no less than those of Juan Gris, Picasso, Schwitters and Mondrian (who was no less fascinated by the visual possibilities of jazz than by the compositional rhythms of the early Dutch masters), and has discovered his own uses for the metaphysical richness of African sculptural forms.

In brief, Bearden has used (and most playfully) all of his artistic knowledge and skill to create a curve of plastic vision which reveals to us something of the mysterious complexity of those who dwell in our urban slums. But his is the eye of a painter, not that of a sociologist and here the elegant architectural details which exist in a setting of gracious but neglected streets and the buildings in which the hopeful and the hopeless live cheek by jowl, where failed human wrecks and the confidently expectant explorers of the frontiers of human possibility are crowded together as incongruously as the explosive details in a Bearden canvas—all this comes across plastically and with a freshness of impact that is impossible for sociological cliché or raw protest.

Where any number of painters have tried to project the "prose" of Harlem—a task performed more successfully by photographers—Bearden has concentrated upon releasing its poetry, its abiding rituals and ceremonies of affirmation—creating a surreal poetry compounded of vitality and powerlessness, destructive impulse and the all-pervading and enduring faith in their own style of American humanity.

Through his faith in the powers of art to reveal the unseen through the seen his collages have transcended their immaculateness as plastic constructions. Or to put it another way, Bearden's meaning is identical with his method. His combination of technique is in itself eloquent of the sharp breaks, leaps in consciousness, distortions, paradoxes, reversals, telescoping of time and surreal blending of styles, values, hopes and dreams which characterize much of Negro American history. Through an act of creative will, he has blended strange visual harmonies out of the shrill, indigenous dichotomies of American life and in doing so reflected the irrepressible thrust of a people to endure and keep its intimate sense of its own identity.

Bearden seems to have told himself that in order to possess the meaning of his southern childhood and northern upbringing, that in order to keep his memories, dreams and values whole, he would have to recreate them, humanize them by reducing them to artistic style.

Thus in the poetic sense these works give plastic expression to a vision in which the socially grotesque conceals a tragic beauty, and they embody Bearden's interrogation of the empirical values of a society which mocks its own ideals through a blindness induced by its myth of race. All this, ironically, by a man who visually at least (he is light-skinned and perhaps more Russian than "Black" in

appearance) need never have been restricted to the social limitations imposed upon easily identified Negroes.

Bearden's art is thus not only an affirmation of his own freedom and responsibility as an individual and artist, it is an affirmation of the irrelevance of the notion of race as a limiting force in the arts. These are works of a man possessing a rare lucidity of vision.

NOTE

1 [Ellison's epigraph is from André Malraux's preface to the French translation of William Faulkner's 1931 novel *Sanctuary* (Gallimard, 1933), also published in *La nouvelle revue française* on November 1, 1933. —Eds.]

1968

Frederick Fiske, "Reflections from Within-Without: The Black Artist," and Victoria Rosenwald, "The Black Murals of Boston," in "Art in the Ghetto," special issue, *Harvard Art Review* 3, no. 1 (Winter 1968–69)

In winter 1968–69, the quarterly magazine *Harvard Art Review* published an issue devoted to "Art in the Ghetto." Articles detailed the severe poverty faced by Black artists working in Boston and documented the art that was nevertheless being made around the city. The writer Frederick Fiske interviewed a group of local artists, the most prominent of whom was Dana C. Chandler Jr. Born in Massachusetts in 1941, Chandler had grown up in Boston's Roxbury neighborhood and joined the National Association for the Advancement of Colored People (NAACP) while still in high school. He was a well-known community activist by the time he graduated with a degree in education from the Massachusetts College of Art in 1967. The outspoken artist's intention with his work was to convey a message of protest. Victoria Rosenwald's piece examines the mural movement that flourished in the Boston area from 1968 until 1974, largely inspired by the *Wall of Respect* in Chicago (see pp. 72–75). Shedding light on the phenomenon, she discusses murals created by Chandler, Gary Rickson, and Roy Cato.

FREDERICK FISKE, "REFLECTIONS FROM WITHIN-WITHOUT: THE BLACK ARTIST"

The most pressing problem facing Black artists in Boston is simply how to make a living. Most of them have secondary jobs, such as teaching, social work, even odd jobs. Roger Beattie, a soft-spoken and articulate volunteer instructor of the BNAA (Boston Negro Artists' Association), described the split personality of the black artist. On the one hand, many feel the need to express a social message through their paintings, a "social realism," for which there has been and remains no market in the art world. On the other hand, in order to support their families (and most of them have large ones), they must compromise their integrity by teaching. They lack the training and experience necessary to work in the more advanced and creative art schools; the only positions they can take are in public schools and small social programs. Teaching jobs of this sort demand more time and effort unrelated to painting itself than an art school, and they tend to stifle the urge to paint "on the side." If, however, the artist were determined to make painting his career, in order to eat he would have to further compromise himself in painting "to order," creating work that would sell.

Roger Beattie tried to make a living by painting according to consumer demands for a while, but soon gave up: "I used to have this problem, but I got sick of doing views of the Charles; I couldn't justify it to myself. I've had terrific financial difficulties that only a painting could get me out of; these were the things you had to do." He is now teaching art at a girls' high school and has little time, and less inclination, to paint.

Government sponsorship has traditionally been a method of alleviating the financial worries of the artist. The earliest large-scale subsidizing began in the 1930s during Roosevelt's New Deal, in the form of WPA sponsored murals; the majority of these murals were done by Charles White in and on buildings in New York City. In Massachusetts, the Boston municipal government has sponsored block art exhibits, such as last summer's *Sunday in the Park* in Roxbury. Also last summer, the locally organized "Summerthing" commissioned the famous outdoor wall murals which are fast becoming the social landmarks of Roxbury and the South End. Unfortunately, subsidies are scattered and irregular, and although they give the artist the chance to express himself, they cannot create the recognition and respect he needs and deserves.

Sam Greene faced the same problem of the artist having no time to paint. Now forty years old, he has experienced all the hardships of the Depression and its consequences. For him, time to paint was provided ultimately by the courts; for the last twenty years he has been in and out of prison for the use and possession of drugs. Prison served as a retreat for him. "Art has to be full-time, but it's difficult to become a painter without money; the writer goes off to a cottage to write and find himself, I got that time in prison. We ate, slept, and lived art."

Painting is for Sam Greene more than a means of self-expression. It served as a centralizing force in his character, a rallying point throughout his period of drug addiction, and a therapeutic release during the agonies of withdrawal. "Painting was something for ego-strength through it all. It remained a vehicle for self-expression, but my primary concern was with keeping myself together."

II

Closely related to the problem of income is the more personal one of developing a unique style. For the black artists I talked to, with the possible exception of Dana Chandler, this problem was complicated by an ambiguous relationship to "social realism." Starting from the assumption that black artists by definition include a social message in their work, at least implicitly, these artists proceeded to defend positions at some distance from social realism.

Roger Beattie states the obvious relation of black social realism to the tradition which is born in Goya's anti-war etchings, grows through Daumier, and spreads even to proletariat painting of post-revolutionary Russia. (He said he'd discovered this tradition during his one year at the Boston Museum School). The WPA-sponsored murals of the Depression contained at least an undercurrent of protest by portraying the wretched living conditions of the

American Negro and his place in American history; in this the murals were quite similar to the contemporary Mexican murals. The "Summerthing" murals of last summer are outspokenly social, even political, statements.

After describing the movement, however, Roger Beattie qualifies his endorsement of the social function of art. "All black artists are social realists, yet I'm somewhat suspicious. You're using the art form as a vehicle, there's a sort of vengeance, an emptiness; it left me feeling flat, as if I'd missed the art form."

The social function, if there, should be "unintentional"; that is, implicit and understated, as a secondary function of the visual form. Here he again admits the influence of academic training.

Sam Greene has reasons for being both sympathetic to and isolated from social realism. His large range of experience built up through his earlier connections with the drug underworld, has been recorded in an evocative series of sketches and portraits; his drawings, often of himself, reveal a great deal of the pain and excruciating self-analysis of the addict. Most of his faces are reflective, pre-occupied studies; but he has also burst into outspoken protest, principally through the theme of the Black Christ. In Virgil Wood's Blue Hill Christian Center, Sam Greene painted a mural in which the black body on the cross forms the central element around which are ranged the faces of the most recent black martyrs, Malcolm X and Martin Luther King, in the setting of symbolized police brutality.

Despite his impulsive anger, Sam Greene freely admits that he is the most interested in the face, black and white, for its inherent expressiveness, not the message it conveys. In the majority of his work, the message comes through "unintentionally." He showed me a painting of an old woman and a child, and said that he had originally entitled it *My Country 'tis of Thee*, but later dropped the title. It is really the complexity, the mystery of the black woman's expression he wished to convey in all its connotations, not the juxtaposed irony of her poor living conditions and the American Ideal. "Like the melody of a song, I get captivated by a face, and have to express it with the instrument of paint; I need to share the pleasure."

He goes even further into his "own thing" and away from social realism in his self-portraits. Drawn throughout his life as an addict, they show a withdrawal deep into his own character, and remain emotional indicators of his post mental states. He said he drew many of them staring at himself in the empty screen of a television; there are titles under each one, *A Lonely Man*, *Someday I'll Come Back*, *That Other World*, *This is Probably the Most Difficult Period of My Life . . . So Far*. He calls them his diary.

In the mid-fifties Sam Greene went to the Vesper George Art School in Boston for a year, and his style developed considerably. He speaks enthusiastically of his debt to Thomas Hart Benton, not for his social realism, but for his genius of composition and the way he activates common objects; "He was really down with the nitty-gritty of life. His paintings are moving: the hand, the folds in the cloth, even an old boot are alive."

Sam Greene won first prize in the Harris Park Art Exhibit, *Sunday in the Park*, last summer, for a painting entitled *The Rice Pickers*. The second prize went to a young friend of his, Terry Yancey, 23 years old, for *Coming Home from the Rice Paddies*. The obvious connection is illusory; Sam Greene got his idea from a magazine photograph (Once again, he said he was most interested in the faces and the movement). Terry Yancey, however, had just returned from active duty in Korea, where he participated in the recent border conflict. He had painted his picture outdoors, next to the rice paddies. In addition, he brought back with him charcoal drawings of scenes from towns and marketplaces, done with the rounded forms, smooth surfaces and precise detail of contemporary oriental styles. In Korea, he taught art as a volunteer at a vocational school and an orphanage and was selected soldier of the month. He spoke angrily of the racial prejudice within the army and the pressure he felt his fellow soldiers exerted to keep him from making a good impression. He chose his own way through community service and pointing, "and I made it." For him, the social message is contained in the very act of pointing.

The difficulty for Terry Yancey will be to define his position in relation to the problems facing

all black artists. Perhaps he can strike a balance between the oriental style and more relevant, personal subjects. He is teaching at a boys club, and last summer was art director for "Summerthing." His current work, he says, contains a little of everything.

He is not alone in this struggle for maturity. Roy Cato is still at the first stages of artistic development. On the corner of Shawmut Avenue and West Canton Street, in the South End, the mural reaches across the side of an apartment building. Roy Cato is 18 years old, a senior at Jamaica Plain High School. His mural, which he calls *Yesterday, Today and Tomorrow*, is a clearly symbolic, stylized social realism. Yet outside of this one public statement, his work is decidedly non-controversial. He is strongly influenced by Africa: in his drawings and sketches, he often uses the African as his subject; in his wood-carving, he uses African masks as models for the small lacquered heads he calls "Tikis."

Roy Cato has lived in the South End all his life and doesn't plan to leave it. He said he has never felt discriminated against: "I have no reason to be angry. . . . My two best friends at school are white and Chinese." His mother works next door at the Boston Educational Service, and he himself has taught at St. Stephens Church, a few blocks up the street. Through these channels he has made connections within the area which enabled him to be selected as a mural painter by "Summerthing" (he knows the program's director), an honor which should be a good introduction to art schools. He still seems very unsure of the relation between his work and social realism. Speaking of his mural, he said, "I definitely wanted to paint a picture first, then a message." I asked if Dana Chandler had influenced his choice of a mural subject, and he answered that he had talked to several of the muralists, and several similar ideas were suggested to him. The implication of this mural is that the magnitude and placement of the work demand more than purely visual expression, that "art for art's sake" is not enough here. Roy Cato seems to oscillate between the two functions of art, social and visual; perhaps it is too early to look for more.

Dana Chandler, 27 years old, has no doubts about the function of art. One of the most publicized of Boston's black artists, he believes in art only in so far as it contains a social or political message. The visual aspect is secondary at best; remove the message, and art becomes little more than decoration. "I believe in relevant art. If it's going to be for decoration, it should be purely functional (i.e. architecture, furniture). I want to make the black people remember they're black, to define their black heritage." Although he is himself an extremely articulate defender of his beliefs, his paintings speak for themselves. In a sense, every work is a self-portrait; every one is an angry and highly personal call to arms. Since he has four children to support, he does paint non-social pictures, for which there is a market. This work he considers "commercial art"; what he really feels is felt by everyone who sees his mural at the intersection of Massachusetts and Columbus Avenues. Behind the glittering Citgo gasoline station, he and Gary Rickson have shared the side of a building to express their pride in the new black identity and their disgust with the ruling power structure. The colors clash violently, Dana Chandler's crude realism contradicts Gary Rickson's cold surrealism, yet the message comes across all the more strongly: Revolution!

Sam Greene sees protest art as a process of emotional de-escalation, a de-fusing of the explosive threat of physical violence. He observed that most of the Boston wall-murals are already dotted and defaced by the paint "bombs" thrown at them. Certainly no harm has come to the painters of the murals; likewise, the possibility of actually inciting black people to revolt through the inflammatory painting seems quite remote. Instead, the murals affect the mental attitudes of the Negro toward himself; a more genuine cry from the wall than "Revolution!" is "Black is Beautiful!" The two messages in the mural support one another to strengthen the sense of a proud black identity.

III

More generally, Sam Greene feels that through the preceding process of reducing social conflicts to a cultural level, hostile aggressions can ultimately be eliminated from society. The result would be a complete metamorphosis: the energy that had once

been prejudice would lose its bitterness and be directed by the will toward more productive ends. "The struggle would become a human struggle, not pitting race against race, but—a people thing: not 'black struggle against' but 'equality among.'" The world of the arts would remain sovereign in its sphere of the visual and emotional, and any interaction between painting and politics would become secondary; to use a metaphor, art would act as a thermostat maintaining a safe social temperature.

Another striking theory of the development of the negro identity was presented by Joseph Martin of FIRST (the initials of For Individuals Recovering Sound Thinking, a halfway house for drug users in Roxbury). Historically, he sees the black man as deprived of culture. When white immigrants originally settled in North America, they formed their own economic and social structure. The black people, degraded and suppressed from the start, developed a different value system, based entirely upon material possession. Their system was logical: They were held in physical bondage; break the bonds, gain material equality, and domination would cease. Their ambition was directed toward getting something, not doing something. The negro was willing to make compromises and be subservient in order to gain material wealth. "It wasn't 'Hi, Bill, how are you?,' but 'Master, are you all right?'" The negro was then emancipated and made equal before the law, yet the mental attitudes could not be legislated upon; and one sees vestiges of this value system today in the "Cadillac mentality."

These distorted values have resulted in a lack of responsibility and discipline, which in turn has alienated whites even further. "We committed crimes against ourselves, how could we expect sympathy?" Joseph Martin sees self-help as the only effective way of dissolving material consciousness. FIRST subscribes to this method, and it is working; the Blue Hill Christian Center does also. "Virgil Wood is a real 'Positive Thinker' (cf. Ayn Rand). He thinks our destiny can be controlled by rebuilding the community, and with it our local economy. We must concentrate on what we need, not what we want." To Joseph Martin, Africa remains a fertile area to study. Artistically, it is a rich field, both for its subjects and traditions; ideologically it is perhaps even more important: its peoples possessed independent disciplines and beliefs, not based on material acquisition. "Africa was a very holy land, not by any means ignorant; perhaps we're moving back in that direction, but first our material comforts must be sacrificed." Joseph Martin himself grew up in an orphanage, and left school to work after finishing eighth grade. His life has been further complicated by drug addiction, but that is all over now.

Roy Cato defined his conception of the negro's place in America by describing his mural: "On one side, the slave is developing in the darkness; where dark meets light, he is realizing his identity as an African, and on the other side, in the foreground, stands the black man of the future, dressed in a business suit, where he can take his place mentally as well as legally in the rest of the world." The moment of recognition is the main lever of progress toward a positive identity, as for Freud the realization of the problem in its complexity brought its cure as a consequence. Roy Cato has placed the burden squarely on the shoulders of the artist: he must bring about this realization.

The problem of the black artist thus becomes one of defining his role within the larger concept of a new black identity. In this limited context, a final comparison can be made between Sam Greene and Dana Chandler. They both want to foster and strengthen an awareness of this identity. For Sam Greene (as for Terry Yancey in Korea) this awareness is implicitly stated in the action of painting. "I want to let all people, especially black people, know that we have culture in our race." Dana Chandler assumes this function as a starting point and goes a step further: after creating this awareness, the artist must mobilize it. "I want to make them remember their blackness, because when the ship goes down, we're going to need everybody."

IV

The only safe inference to draw from the variety of attitudes among Boston's black artists is that the idea of a "black arts movement" is an oversimplification. Steps in the direction of a community have been taken: Alma Lewis's school, widely

publicized, has classes taught by and for black artists; the BNAA under the direction of Marcus Mitchell is trying to institute an artists' workshop and seminar program. However, these institutions are little more than tentative suggestions of a future community. As of now, the artists are still anxious to remain individuals, and they have been slow to respond to the idea of workshops and seminars at the Artists' Association. More exhibits of black art, and the accompanying publicity would provide a further stimulus toward unity. John Wilson, a well-established Boston-born black artist, is organizing a permanent exhibit of black painting, and there are rumors that a gallery is being formed.

The variety and complexity of viewpoints, even among the few black artists I could talk to, makes generalization nearly impossible. The artists are interesting in themselves and do have points in common: they are neglected by the art world, identify at least in part with the aims of social realism, but they must often sacrifice their integrity to the business of living; they are unified in the struggle to define their individual artistic identities at a time when black people are beginning to define their own larger identity. Beyond these common bonds, black artists vary widely in their conceptions of black cultural development and its implications for the present and the future. The variables of education, acquaintance, and family life create distinct environments which are central to their styles and theories of art and society. Given time and means, individual security might develop, and black artists would then feel comfortable in a community, an association recognized and respected primarily for its variety. A bold manifesto for such a community is written on the wall of the halfway house For Individuals Recovering Sound Thinking:

We're alive . . .
Respect us
We're beautiful . . .
Enjoy us
We're good . . .
Love us
Self-respect—dignity—wonderment
—reconciliation—life

VICTORIA ROSENWALD, "THE BLACK MURALS OF BOSTON"

Walking down Massachusetts Avenue, past career girl Back Bay and Symphony Hall, you come to Boston's South End, a polyglot area of once fashionable row houses where restaurants called Fish 'n Chips advertise soul food not far from their Greek and Irish counterparts. Just before the Dudley Street MBTA station, on the corner of Columbus Avenue, is an empty lot that has been made into a basketball court. The lot is backed by a four story brick building; looking up, you can see a city landscape painted on it in browns and dull greens, and below a geometrical pattern of bands of the same colors. The whole thing is dominated by an enormous eye crying a red, white, and blue tear onto the small figure of a white man hanging from a stylized gallows. Below this is a portrait of Stokely Carmichael in bright reds and greens, the rays of energy emanating from his outstretched hands striking off the chains which bind two black figures. On the right of this is a portrait of Rap Brown carrying a torch, the colors so bright that it is painful to look. These murals are by Gary Rickson and Dana C. Chandler, Jr. A few blocks away on Shawmut Avenue is another empty lot whose back wall, painted purple and yellow, depicts the rise of the black man in three stages with three different figures. This mural is by Roy Cato.

These three men are black artists, instead of artists who happen to be black, and they work in the Negro ghettos of Boston. They work in the streets on scaffolds hung from city roofs, leaving imprints of their blackness on the urban landscape. This genre of folk art began in the summer of 1967, when a group of black artists in Chicago created the *Wall of Respect*, an outdoor wall covered with portraits of Negro leaders with the inscription, "This wall was created to honor our black heroes and to beautify our community." Four similar murals have been painted in Boston. Two have been defaced by paint bombs hurled by Puerto Rican gangs, and one disappeared when urban renewal tore down a building.

For some artists in the ghetto, the mere creation of art is enough; they are content to know

that their work is making the slums more beautiful. David Bromberg, the head of the Lower East Side Beautification Committee in New York, sponsored several purely decorative murals on the back walls of parking lots during the summer of 1967. During the same summer, however, on the upper west side of Manhattan, another mural painter told the *New York Times* "People say to me 'Hey, Pepe, what color you going to put on the next building?,' and I say, 'Puerto Rican colors, man.'"

Like Pepe, most of the black artists in Boston have a purpose beyond beautification. Stokely Carmichael has said that before a separate black society can be formed, a black consciousness must be created. Dana Chandler agrees; he wants his murals to awaken a feeling for the cultural heritage of the Negro race, to strike a chord of blackness. He does not seek black-white reconciliation; instead like Carmichael, he wants to define and glorify a separate black culture.

A brightly colored painting that is five stories high can hardly be ignored, and simple unavoidability is one reason the city streets have become the artist's studio. Negroes who do not want to be reminded of their blackness are confronted by it nevertheless every time they walk down Massachusetts Avenue. Also, like street theater, which reaches people who cannot or will not pay to see legitimate drama, the murals reach those outside the usual artistic channels.

The murals also share the problems of street theater. Outdoor art plays to a non-captive audience; it must grab the eye's attention and hold it. The emphasis is on immediate comprehension; thus one finds the bright colors, simple forms, and over powering size. These are the techniques of billboard advertising, from which the mural painters have learned the method of making a quick point. As with much of outdoor advertising, the Boston murals may be termed "bad art"; yet, to do this is, in a sense, missing their authors' point. The muralist is not necessarily aiming for aesthetic excellence; he is working for a social purpose. He does not have to sell to a market or please the experts; his work is for the street, and the very fact that murals bring art to the empty lots is enough.

Every culture develops a unique visual vocabulary; every chair, building, and painting it produces becomes a manifestation of that culture. Non-representational art is not always mere decoration; when James Brown sings "Say it loud, I'm black and I'm proud!," he makes his point through the nature of the music, the use of African rhythms, and the Motown sound. The lyrics are secondary; the medium is the message. Similarly, an African sculpture may not outwardly carry a political message, but it will strike an emotional chord in blacks and if well executed, show them the beauty of their heritage. The poetry of the Black Nationalist movement is the work of the artists; the politicians will look after the prose. If a black artist wants to create a separate black nation, he must create a separate visual vocabulary of form and color. Dana Chandler cannot paint an effective Black Power mural using the forms of the white art tradition. Creating a black visual language is difficult, for a Negro tradition of painting does not now exist. African art is primarily sculptural, and the black artist who looks back to his African heritage must derive his two-dimensional forms from three-dimensional primitive sculpture.

1968

James T. Stewart, "The Development of the Black Revolutionary Artist," in LeRoi Jones [Amiri Baraka] and Larry Neal, eds., *Black Fire: An Anthology of Afro-American Writing* (New York: William Morrow, 1968)

This groundbreaking book comprises more than 180 texts: essays, poems, fiction, and drama. While it was not the first anthology of its kind, it was unique in its inclusion of new and previously unrecognized contemporary Black writers. Providing standpoints on an assortment of topics, including Black nationalism, White supremacy, Afrocentrism, and Black liberation, the anthology was seen as capturing the essence of the Black Arts Movement. James T. Stewart argues here that while Western culture values fixity, wanting artworks to be preserved in perpetuity, Black artists recognized that "man cannot create *a* forever; but he can create forever." Change, fragility, and malleability had always been valued by Black artists and needed to be central to revolutionary Black aesthetics. Although Stewart was particularly concerned with avant-garde jazz, his ideas also speak to some tendencies in abstract visual art by Black practitioners.

JAMES T. STEWART, "THE DEVELOPMENT OF THE BLACK REVOLUTIONARY ARTIST"

Cosmology is that branch of physics that studies the universe. It then proceeds to make certain assumptions, and from these, construct "models." If the model corresponds to reality, and certain factors are predictable, then it can be presumed to substantiate the observable phenomena in the universe. This essay is an attempt to construct a model; a particular way of looking at the world. This is necessary because existing white paradigms or models do not correspond to the realities of black existence. It is imperative that we construct models with different basic assumptions.

The dilemma of the "negro" artist is that he makes assumptions based on the wrong models. He makes assumptions based on white models. These assumptions are not only wrong, they are even antithetical to his existence. The black artist must construct models which correspond to his own reality. The models must be non-white. Our models must be consistent with a black style, our natural aesthetic styles, and our moral and spiritual styles. In doing so, we will be merely following the natural demands of our culture. These demands are suppressed in the larger (white) culture, but, nonetheless, are found in our music and in our spiritual and moral philosophy. Particularly in music, which happens to be the purest expression of the black man in America.

In Jahn Janheinz's *Muntu*, he tells us about temples made of mud that vanish in the rainy seasons and are erected elsewhere. They are never made of much sturdier material. The buildings and the statues in them are always made of mud. And when the rains come the buildings and the statues are washed away. Likewise, most of the great Japanese artists of the eighteenth and nineteenth centuries did their exquisite drawings on rice paper. With black ink and spit. These were then reproduced by master engravers on fragile newssheets that were distributed to the people for next to nothing. These sheets were often used for wrapping fish. They were a people's newssheet. Very much like the sheets circulated in our bars today.

My point is this: that in both of the examples just given, there is little concept of fixity. The work is fragile, destructible; in other words, there is a total disregard for the perpetuation of the product, the picture, the statue, and the temple. Is this ignorance? According to Western culture evaluations, we are led to believe so. The white researcher, the white scholar, would have us believe that he "rescues" these "valuable" pieces. He "saves" them from their creators, those "ignorant" colored peoples who would merely destroy them. Those people who do not know their value. What an audacious presumption!

The fact is that *these* people did know their value. But the premises and values of their creation are of another order, of another cosmology, constructed in terms agreeing with their own particular models of existence. Perpetuation, as the white culture understands it, simply does not exist in the black culture. We know, all non-whites know, that man can not create *a* forever; but he can create forever. But he can only create if he creates as change. Creation is itself perpetuation and change is being.

In this dialectical apprehension of reality it is the act of creation of a work as it comes into existence that is its only being. The operation of art is dialectical. Art goes. Art is not fixed. Art can not be fixed. Art is change, like music, poetry, and writing are, when conceived. They must move (swing). Not necessarily as physical properties, as music and poetry do; but intrinsically: by their very nature. But they must go spiritually, noumenally. This is what makes those mud temples in Nigeria go. Those prints in Japan. This is what makes black culture go.

All white Western art forms, up to and including those of this century, were matrixed. They all had a womb, the germinative idea out of which the work evolved, or as in the tactile forms (sculpture and painting, for instance), unifying factors that welded the work together, e.g. the plot of a play, the theme of a musical composition, and the figure. The trend in contemporary white forms is toward the elimination of the matrix, in the play "happenings," and in music, aleatory or random techniques. All of these are influenced by Eastern traditions. It

is curious and sometimes amusing to see the directions that these forms take.

The music that black people in this country created was matrixed to some degree; but it was largely improvisational also, and that aspect of it was non-matrixed. The music of Ornette Coleman.

The sense in which "revolutionary" is understood is that a revolutionary is against the established order, regime, or culture. The bourgeoisie calls him a revolutionary because he threatens the established way of life—things as they are. They cannot accept change, though change is inevitable. The revolutionary understands change. Change is what it is all about. He is not a revolutionary to his people, to his compatriots, to his comrades. He is instead, a brother. He is a son. She is a sister, a daughter.

The dialectical method is the best instrument we have for comprehending physical and spiritual phenomena. It is the essential nature of being, existence; it is the property of being and the "feel" of being; it is the implicit *sense* of it.

This sense, black people have. And the revolutionary artist must understand this sense of reality, this philosophy of reality which exists in all non-white cultures. We need our own conventions, a convention of procedural elements, a kind of stylization, a sort of insistency which leads inevitably to a certain kind of methodology—a methodology affirmed by the spirit.

That spirit is black.
That spirit is non-white.
That spirit is patois.
That spirit is Samba.
Voodoo.
The black Baptist church in the South.

We are, in essence, the ingredients that will create the future. For this reason, we are misfits, estranged from the white cultural present. This is our position as black artists in these times. Historically and sociologically we are the rejected. Therefore, we must know that we are the building stones for the New Era. In our movement toward the future "ineptitude" and "unfitness" will be an aspect of what we do. These are the words of the established order—the middleclass value judgments. We must turn these values in on themselves. Turn them inside out and make ineptitude and unfitness desirable, even mandatory. We must even, ultimately, be estranged from the dominant culture. This estrangement must be nurtured in order to generate and energize our black artists. This means that he can not be "successful" in any sense that has meaning in white critical evaluations. Nor can his work ever be called "good" in any context or meaning that could make sense to that traditional critique.

Revolution is fluidity. What are the criteria in times of social change? Whose criteria are they, in the first place? Are they ours or the oppressors? If being is change, and the sense of change is the time of change—and what is, is about to end, or is over—where are the criteria?

Romare Bearden, Sam Gilliam, Richard Hunt, Jacob
Lawrence, Tom Lloyd, William T. Williams, and Hale
Woodruff, "The Black Artist in America: A Symposium,"
The Metropolitan Museum of Art Bulletin 27, no. 5
(January 1969)

On January 18, 1969, the exhibition *Harlem on My Mind: Cultural Capital
of Black America, 1900–1968* opened at the Metropolitan Museum of Art in
New York. The curator was Allon Schoener, director of the Visual Arts Pro-
gram of the New York State Council on the Arts. The show did not include
any works by contemporary artists. Instead, it treated African American
culture in sociological terms, through documentary-style displays and
photomurals. Schoener's curatorial approach caused an uproar: Artists boy-
cotted the show before it even opened. Institutional change was demanded
throughout the city's major museums. This symposium, moderated by
Romare Bearden, took place in summer 1968, in the run-up to the show.
The artists Sam Gilliam, Richard Hunt, Jacob Lawrence, Tom Lloyd, Wil-
liam T. Williams, and Hale Woodruff convened with Bearden to discuss the
problems faced by Black artists, the category "Black art," and the possibil-
ity of a Black aesthetic. Lloyd, who was preparing *Electronic Refractions
II*, a solo presentation of his work that would be the inaugural exhibition at
the Studio Museum in Harlem, was committed to Black nationalism and
upheld a concept of Black art that the other panelists found hard to accept.

ROMARE BEARDEN, SAM GILLIAM, RICHARD HUNT, JACOB LAWRENCE, TOM LLOYD, WILLIAM T. WILLIAMS, AND HALE WOODRUFF, "THE BLACK ARTIST IN AMERICA: A SYMPOSIUM"

MR. BEARDEN: We are here to discuss some of the problems of the Black artist in America. I think one of the most perplexing is the problem of making a living. During the last two or three years this problem has been met to some degree by more teaching jobs being made available to us, but it's still hard for the Black artist to support himself. I'd like to hear some of the members of the panel respond to this question.

MR. LLOYD: Many Black artists can't support themselves through their art—there may be one or two, but it's most difficult. First of all because the Black artist's very existence has been denied so long that people don't know of him—even in the Black community. Therefore his struggle to reach the top has been a great one, and I envy three gentlemen who are sitting here—Mr. Bearden, Mr. Lawrence, Mr. Woodruff—who have made it. I know what kind of struggle any Black artist who's made it has gone through, and therefore I bear a great deal of respect for you gentlemen.

MR. BEARDEN: Well, Tom, would you like to explore that a little further? You said that the Black artist is unknown in the Black community. What could be done to have him better known? Within his own community and within the mainstream of American art?

MR. LLOYD: First, I think he has to be accepted in the galleries; the museums have to recognize that he has something to contribute to his own culture, to the Black communities, and I think they have failed miserably to do this. Sure, within the last couple of years I've heard about exhibitions dedicated to show the accomplishment of the Black artist and I've been in some, but what has happened for the two hundred years before that? What has happened with some three hundred, four hundred art galleries in greater New York? What has happened with the museums?

MR. BEARDEN: Maybe Hale Woodruff can reply to these questions, because he has a great knowledge of art history and has lived through some of these problems.

MR. WOODRUFF: Well, I agree that it's very tough for the Black artist not only to make a living but even, first, to make anything out of his art. I think this is also true of the white artist. I suspect the economic problem varies for all artists, and each must come to grips with it, somehow, in his own way. Of course the ideal solution would be the ongoing sale of his art product. This opportunity has come to a few artists and will doubtless come to others, although slowly, in the future. Scholarships and grants have been awarded to a few Black artists, but such grants are usually of short duration and therefore do not meet the long-term needs of artists in general. The majority of artists, Black and white, resort to teaching as a means of meeting economic needs, while some artists engage in other types of employment.

Generally speaking, the Black artist has not had the same opportunities to exhibit in the big national annuals and biennials as other artists have. A number of galleries exhibit the works of a few leading Black artists, but by and large the Black artist has not come before a very large public through gallery shows, which could open up to him channels of purchase and public recognition. Support from the Black community for the Black artist is gradually developing, but it seems that the real job still remains in the hands of the art institutions—galleries and museums—to provide the Black artist with that kind of professional and prestigious support he needs for his continued development on both the economic and aesthetic levels.

MR. BEARDEN: In writing about this once I said that the best-known Black artist since Henry O. Tanner was certainly Jacob Lawrence. Jacob has been one of the artists who has been in shows and represented us through the years, and I'd like Jake to give us his thoughts on the economic problems of the Black artist.

MR. LAWRENCE: I surely agree with Mr. Lloyd and Mr. Woodruff, but I think it takes on another dimension than just the economic. I think it's a psychological one. Mr. Lloyd asked what can be done, what can help. I think one thing we can do is just what we're doing now, and more of it. It's going to take education—educating the white community to respect and to recognize the intellectual capacity of Black artists. We've been accepted in the theater to a greater degree than we have in the fine arts. Why is this so? I think it's because in this area we are recognized to have a natural ability. But still, there's a psychological problem. You take a man like Bill Robinson, who never attains the same kind of recognition as a Gene Kelly. They say we're supposed to be good cooks, but we've never been made chefs in the Waldorf-Astoria, we've never been asked to give cooking lessons on television. Why? Because this calls for a certain recognition on the part of the white community that you have an intellectual capacity that either they don't want to recognize or are so brainwashed that they can't accept.

On the other hand, none of us wants to be selected as "the one and only" or "one of the few." Mr. Bearden and Mr. Woodruff and I have been participating in shows for a number of years, and the rest of you have come along—I've seen your names. But none of us appreciates the idea of "We'll accept *you* and this is it." It's going to take just what we're doing now to educate the white community. I think they must have a psychological block because they refuse to see and refuse to recognize what we can do. The mere fact that we're here, having this discussion, indicates this. We're always in *Negro* shows, not just shows. I don't know of any other ethnic group that has been given so much attention but ultimately forgotten. You take a man like Horace Pippin, who I'm sure was a greater "primitive" than Grandma Moses. But compare the amount of recognition the two have received.

MR. WILLIAMS: It seems that one of the underlying things we're talking about is that basically we come from a non-visual culture or people. There haven't been that many visual arts—paintings, sculpture—exposed to the Black community itself. I think that one of the mechanisms that helps a young person decide to be an artist is what resources there are for him to go to. One of the things I'm interested in, one of the necessities, is to provide facilities. Provide a situation where these young people can come and be helped in a constructive manner, not just in the usual superficial art-school methods.

Getting back to shows, one of the things that's happening is that every show that concerns Black artists is really a sociological show. The *Harlem on My Mind* show is a pointing example of total rejection on the part of the establishment, of saying "Well, you're really not doing art," or of not dealing with the artists that may exist or do exist in Harlem. These shows deal with the sociological aspects of a community, a historical thing. I think the nature of this panel is just that again—another sociological thing, instead of dealing with pressing issues. The question is "You're a Black artist; what are you doing, what do you want to do, where do you want to go?" instead of saying "You are in it, you're an artist who has been suppressed, how can we help you?" I'm somewhat irritated by and somewhat opposed to the nature of this panel, especially when you attach the "Black artist" thing to it, because I think we're perpetuating the ideas that we're trying to get away from. There are two different questions about Black identity. Black *men* and Black *artists*—they're different questions and somehow they seem to be thrown together as one that can be answered with some simple statement. There are as many answers to that question as there are people sitting here.

MR. BEARDEN: Bill, we're going to discuss some of these questions of identity later, so at this point I'd like you to develop some of the programs you have in mind for the community and, to use an old cliché, for the economic betterment of the artist.

MR. WILLIAMS: One of the things that we've thought and talked about was an artist-in-residence program. The nature of this program would be that we ask an artist or group of artists, as

professional people, to serve as artists in residence in a particular community. They would be totally supported; that is, their studio bills and living expenses would be paid. We're not talking about the usual grant level of two or three thousand dollars; we're talking about ten or fifteen thousand dollars. What they would be asked to do in return would be to produce their own work, produce it on a serious, aggressive level, and also to act as male images, symbols of attainment for the community. An aspiring artist could come to them—they could be almost apprentices—and could be supported, that is, provided with a studio and materials or with minimum living expenses. This is kind of an idealistic proposal, but I'm sure if we can have this panel, if we can have fifty Black shows, we can have this idealistic proposal.

MR. HUNT: There are things like that in operation in other cities, in St. Louis, for example. They have a grant from the Rockefeller Foundation and from the Danforth Foundation to set up this kind of artist-in-residence program, with apprentices and studio space, and something like a ten-thousand-dollar-a-year stipend. I don't see why it couldn't be done in New York, because there are even more resources here, certainly in terms of artists available. That sort of thing has been developed in Illinois, too; I've been involved with the Illinois Arts Council. They've started an artist-in-residence program that doesn't deal specifically with Negro communities, but with a number of outlying communities that for one reason or another don't have access to this cultural enrichment type of program.

MR. GILLIAM: A similar kind of artist-in-residence program is going on in Washington, in which I'm a participant. The stipend is five thousand dollars and studio facilities are provided. It's not specifically directed toward the Black community, but the majority of Washington's population is Black.

Since I'm from Washington my experiences have been totally different, and that leads me to raise another question in relation to the problem of economics, and this is about the extent that the Black artist has been recognized by the Black community. The answer might be what Mr. Williams has suggested, a matter of sociology or a matter of economics on a greater scale. We've been prevented from being visually minded because we've had to be so industrially minded. This economic factor would probably prevent someone like myself from a southern community from coming to school in New York, as opposed to staying in my own community and going to school. How are you going to think about things like art when it's all you can do to get any kind of job? These kinds of things have been prevalent issues.

MR. BEARDEN: Hale, perhaps you could sum up some of these economic problems in relation to the future. Do you think a young man like Williams will have a better prospect of making a living as an artist than you had?

MR. WOODRUFF: First, I'd like to say that I don't agree entirely with Williams and Gilliam on the notion that we are not visually minded. I'm older than anybody here and I've lived long enough to see scores of Black artists, who never really made it, come and go. They didn't make it for many of these economic reasons, but basically I think they didn't make it because there was no kind of world for them, either in the Black community or the white community. I don't want to sound chauvinistic, but I think every Black man has certain sensitivities and sensibilities that come out in various art forms. The fact that music is one of our strengths probably is no accident. The fact that we don't have a visual history or a history of creating visual works in this country is a fact of circumstance, and doesn't mean that the visual world was never open to us or that we never opened our eyes to it. I think it's chiefly economic. In the twenties and thirties there were many Black artists. Read some books about it: you'll see name after name of artists who have since disappeared from the scene. They simply could not make it in the so-called fine arts, but many of these fellows got into the non-fine-arts areas, like illustration, design, teaching. You rarely, if ever, hear about them, but they are there. What we're discussing now is the so-called fine arts area. When you ask me what's

going to come—we don't know. But here is a practical point: I believe that in the visual arts there's something more than just painting for Madison Avenue or a gallery show or a museum show. I know of many young Black artists who are successful designers—TV designers, industrial designers, and so on. This is a very real and practical world.

The American has a notion that fine arts are the greatest thing that ever existed, and he may very well be right. I don't know that you've got to worry too much about that youngster who's going to be an artist, whether he's in the ghetto or in Nob Hill or wherever. Circumstances are going to lead him into it, and I think just about every man at this table has come into art in that way. The establishment of centers in the ghetto and elsewhere, available to all people as well as the people who live there, will be a way of not only discovering talent but also of encouraging it and helping it to develop. But I'm very wary of urging these fourteen- and fifteen-year-olds to go into art as a profession. Let them make up their own minds. I think the whole world of art should be open to them and made available for them to become involved, either as active participants or appreciator-consumers of art.

MR. LLOYD: But is that world open to them?

MR. WOODRUFF: In terms of what it has been and is now for a lot of people, I don't know. It's hard enough for the best to make it in the fine arts area. I see the future as being one where there are conducive atmospheres, facilities, and people to work with these youngsters. There might be no teaching in the sense of having classes, but simply every facility imaginable, and guides and teachers to work with them. If a youngster wants to throw some clay around, let him do it: if he gets sick of that and wants to carve some wood, that's fine. This is the kind of orientation I think would be helpful in developing interest, activity, and participation.

MR. LLOYD: I think there needs to be a gigantic effort to bring art to young Black kids in an enormous project. I don't think they have anywhere near the same opportunity as anyone else. I think young white kids are exposed to art at a very early age; their mothers go to museums and drag the kids along and they get a look at art when they're three or four. This doesn't happen with Black kids.

MR. WOODRUFF: When I said the visual world was open to Black kids, I meant things that every man sees, even if it's an old back fence. I certainly agree that they need art brought to them.

MR. LLOYD: This is one of my pet things: it's very important to bring art to Black people. Right now, we're not going to museums and to art galleries. I've been going to them for something like twenty-five years and I could count the Black people I've seen. We have to bring art to the Black communities. We should have things like the "wall of pride." We have to beautify the Black communities, with trees or whatever; we have to have monuments to Black heroes, right on Seventh Avenue. It's important for Black people to have this identity. They have to feel this pride. It's our responsibility to bring it to them. We can begin by using posters, by using existing billboards, and we have to get the money to do this. A group of Black artists should get together and do these posters and put them up and let people see them. Perhaps a place like the Metropolitan should finance something like that.

MR. GILLIAM: Up to now our major interest hasn't been in promoting culture, in promoting awareness of Black art and artists. We do have to begin to make the Black community more aware, more visually oriented.

MR. BEARDEN: It seems to me that a big problem confronts the Black artist after he decides to become a professional artist. He's twenty-five, or twenty-six, or twenty-seven. He's married. He has one or two children. It's difficult getting a foothold into the art world; trying to have his work exposed; trying to make a living, probably by having another job—teaching or something. I'd like Mr. Hunt, Mr. Gilliam, Mr. Lloyd, and Mr. Williams to begin this discussion on professional problems they

themselves are probably dealing with. How does the young Black artist make a living? What are some of the things that are wrong? What would you like to see done?

MR. LLOYD: There should be many more opportunities open to the young Black artist. It's a peculiar thing: I teach painting and sculpture in a program called the Adult Creative Arts Workshop, sponsored by the Department of Parks: a ceramics class was introduced and I went around looking for a potter, a Black potter. I searched the whole of New York and I found three. There might be more, but I only found three and they were already employed. I really thought about that. Here in New York, with millions of people, how is it that there are only two or three Black potters? There's something wrong here; someone has perpetrated some kind of evil on the Black race that's unbelievable.

MR. GILLIAM: Why is the issue finding a Black potter to teach a Black child as opposed to finding a potter?

MR. LLOYD: Oh, I think that's very important. We were talking about Black art: I think there's going to be Black art, I think there's going to be a separate Black community. If there is separate Black art it might be a good thing, because what's gone before hasn't been a good thing.

MR. WILLIAMS: How would this Black art be different from white art?

MR. LLOYD: Well, it would be different inasmuch as one of our main aims should be relating to Black people. Black artists should be working in Black communities.

MR. WILLIAMS: The question I'm really posing is how does one make art relevant to its community?

MR. LLOYD: I think the artist is more than just someone who paints or someone who makes sculpture. I think he has a compact, a relationship with the people that the ordinary person doesn't have. I think he can bring about changes.

MR. BEARDEN: Well, let me ask you a question, Tom. You're going to have a show shortly at the Studio Museum in Harlem. Tell us how you feel what you have done relates to the Harlem community. Do you wish to direct your art to the community?

MR. LLOYD: Yes. I hope my show will make Black people aware of what's happening in art today. A lot of Black people are involved in helping me form that show, in helping me make my sculptures; that's part of the museum idea, and I don't think this has happened before. But mainly I think Black people can relate to my work—it's a visual thing. When I was working in my studio little Black kids would come up to my door and just look at my light sculpture and they'd like it and somehow relate to it.

MR. WILLIAMS: Yes, but would a white kid do the same thing, though?

MR. LAWRENCE: Yes.

MR. LLOYD: But I'm interested in a Black kid.

MR. WILLIAMS: And if so, if a white kid would do the same thing, what makes it Black art then? Beyond that you did it?

MR. LLOYD: I don't know what makes it Black art except that it exists in the Black community.

MR. WILLIAMS: Yes, but you could have made the same forms on 10th Street as well, so it's not uniquely related to that particular community.

MR. LLOYD: It's related because I'm Black, and I know where my feelings lie.

MR. WILLIAMS: Yes, but see, what I'm trying to get at is that we talk about making Black art. And if we're really talking about Black art, we're talking about something in which the forms are uniquely Black.

MR. LLOYD: We're talking about communication. I don't even know that we're talking about *forms* necessarily. It's like how you feel and what you're doing. I mean, with the kind of thing I do, most people don't even associate me with being Black, and when they see me they're rather shocked and in some cases rather hurt and I don't know why.

MR. GILLIAM: Is there a specific form of art that a Black artist does that should be immediately identifiable?

MR. LLOYD: There has been in the past—Black artists were primarily known as social painters. But that's not what I mean: I know that it's very important for me to relate to Black people with my work, and I have to tag myself as being Black and being interested in the Black man. This is part of my very existence. It's important to somehow relate to our own people.

MR. WOODRUFF: What you're supporting and asserting then is the Black *artist*, not Black *art*.

MR. LLOYD: Yeah, I'm supporting the Black artist, but by supporting the Black artist, naturally I'm also supporting the Black community. I think that this is so important.

MR. WOODRUFF: It is.

MR. WILLIAMS: Maybe I'm dwelling on a point, but "Black art" is kind of a touchy thing with me . . .

MR. LLOYD: No, don't you see? Black art can be any kind of art, it can be anything. It can be a painting of a little Black child or a laser beam running around the room. We have to project that the artist is Black.

MR. WILLIAMS: My point is that it *can* be a laser beam or a de Kooning drawing or a number of other things. It seems to me that we're belaboring the label of Black art for nothing. What you're saying is that you should have a commitment to the Black community, to educate them to the visual world. We're not talking about Black art per se.

MR. LLOYD: Not in that sense, no. But only in the sense that the Black artist hasn't ever been publicized. He doesn't exist. I'm with a group called Black Visual Environments, and we're a group of professional artists who hope to bring a big, big change about in New York through various means—putting pressure on people if we have to, but mainly by working in the Black communities. We're not going to teach art, we're going to get involved in the whole political structure.

MR. WILLIAMS: It seems to me that you couldn't really make art as we know it now welcome or relevant to the Black community.

MR. LLOYD: Why not? You mean to say if there was a statue of Martin Luther King on Seventh Avenue . . .

MR. WILLIAMS: We're not talking about statues. There's a difference.

MR. LLOYD: But we're talking about art.

MR. WILLIAMS: Yeah, but statues aren't necessarily art. What I'm trying to say is that if you took your light pieces and put them on 125th Street there would be a certain amount of exposure to your community, but would that exposure make the pieces *relevant* to the community—the total Black community and not just the kids you're working with?

MR. LLOYD: It's relevant to the Black community if they can identify with it. If I put up a statue of Stokely Carmichael, like, people are going to identify with that.

MR. WILLIAMS: But then by the same token I can take a newspaper clipping of Martin Luther King and blow it up and everyone will identify, but I can't necessarily call that art.

MR. LLOYD: No, I wouldn't call that art either.

MR. WILLIAMS: It's a higher aesthetic that we're talking about.

MR. LLOYD: Of course it is—I'm a professional artist, you know. I'm talking about a certain form of art that's meaningful.

MR. BEARDEN: Tom, in other words, you're saying that you want to direct your efforts toward the Black community, and the mere fact that you are there and making your work accessible and in a certain sense directing it to them would classify the work as Black art. This work could take any form?

MR. LLOYD: Yes. It could be kinetic or light sculpture, it could be painting, it could be anything, if the person who does it has these things in mind.

MR. LAWRENCE: We're involved in many problems here. I agree with Mr. Bearden that economic problems lead into the professional ones. Somehow we've missed one very important thing—government involvement in art. If we go back about thirty years we'll find that some of the greatest progress, economic, professional, and so on, was made then, by the greatest number of artists—not only Negro artists but white ones as well. The greatest exposure for the greatest number of people came during this period of government involvement in the arts. That is what many professional organizations like Artists Equity, the theater groups, and so on, have been trying to do. The government has made stabs at it—you've got various committees and they've given stipends, but nothing massive like the thing thirty years ago. I think what we need is a massive government involvement in the arts—by municipal groups or by the state or by private organizations or by museums like the Metropolitan. What we need is more concern with the philosophy of socialism—that's the only way we're going to achieve this sort of progress, and we, the Negro artists, are going to benefit by this.

That leads me into another thing. I think we must be very careful not to isolate ourselves, because many of the things we're talking about not only pertain to the Negro artist but pertain to the artist generally. If they're accomplished we will all benefit by them.

I also think that many of these problems we're mentioning have to be solved individually. You may feel, Mr. Lloyd, and I may feel that we have to work in a community that's predominately Negro, like Harlem. Others may feel that we will benefit to a greater degree by working outside of the community and being (this is an unfortunate term) "integrated into the mainstream" of the overall national community.

MR. LLOYD: Yeah, but haven't we been integrated for so long? I mean, where are we now? We're here, you know, talking about the bad situation we're in because we've been integrated.

MR. LAWRENCE: Who's been integrated? We've never been integrated.

MR. LLOYD: There's never been any real unity amongst the Black artists.

MR. LAWRENCE: Oh sure there's been, man, you don't know your history. I think Black artists had a greater degree of unity when I was a youngster than they have now. Probably Mr. Woodruff can give you a better account of this since he's older than I am, but at any rate, right after the Reconstruction and maybe before, you had various art communities among your Negro artists. You had your Walker group, your Darktowers group, you had your Negro Renaissance, which was a very tight organization. There were cultural groups—maybe too isolated, but you did have them, even more than you do now. I'm not saying this was a totally good thing, but it had its good aspects.

MR. LLOYD: What were some of the good aspects and what were some of the bad?

MR. LAWRENCE: One of the good things was that there was a community of artists who had a spiritual relationship, I guess you'd call it. And there were a few paternal organizations like the Harmon Foundation that would help the Negro artist. One of the bad aspects was that maybe we never attained the top degree of professional status because of the economic aspects of the situation. There was no way for artists to make a living except for a few people who were teaching in Negro colleges, and artists could never get into the economic mainstream. But aside from that, this community relationship was very good, and it existed then more than it does now.

MR. LLOYD: Well, I haven't heard about it. I never read about it in school or anywhere.

MR. LAWRENCE: I think the young people today don't know these things because there isn't that kind of interest.

MR. LLOYD: It's not there isn't an interest—the material's not available to them. How could one hear about this group you're talking about? How could one learn about it? Certainly not by coming in this museum and buying a book.

MR. HUNT: I've seen this material in the Schomburg Collection [the branch of the New York Public Library on 135th Street].

MR. LLOYD: Even that collection is not that publicized.

MR. HUNT: Well, I must say you sort of want everybody to bring it and put it in your lap.

MR. LLOYD: I want it to be where I'm at.

MR. HUNT: The kind of thing Jake Lawrence is talking about was going on in Chicago during the WPA days. There was the South Side Community Art Center, for instance.

It's interesting to see how things have gone one way at one point and another way at another point. After the war a few Negro artists were more integrated in the larger scene, and now things are sort of going backward—Tom Lloyd is getting more and more identified with the Negro community, he's sort of going back into it. The kind of history that Jake Lawrence is outlining gives you a kind of perspective, something that you can start from—like maybe not making the mistakes of the past and helping you develop this idea of making your art relevant to the Negro community.

I must say I think you're talking about two different things. Okay, you're a Black artist and living in a Black community. That's fine. Whether your art is Black or not doesn't make any difference. I think you needlessly confuse the issues by insisting that there's something about living in a Black community that makes your art Black. That's just not true.

MR. LLOYD: I'm not just talking about me. The white community hasn't accepted Black artists for years and years, and they're not even ready to now, really. And so I'm not just an artist. Therefore I'm a Black artist. If white society is not going to accept my work, I'm a Black artist. I'm not a white artist.

MR. LAWRENCE: I've seen a couple of your pieces and I would put it this way: I think you are an artist who happens to be Black, but you're not a Black artist. See, that's the difference.

MR. LLOYD: No, I'm a Black artist who has refused to be conditioned . . .

MR. LAWRENCE: Wait a minute. From what I've seen of your work—although you may be a terrific artist—there's no possible way that I can see anyone in the Black community *relating* to your work. They may respond to it aesthetically, they may feel that it's a terrific piece—but I can't see how anyone would *relate* to it, and I don't see why they should.

MR. LLOYD: They would relate to it if they knew that I am Black. That's very important.

MR. LAWRENCE: That's not important in a work of art.

MR. LLOYD: It's important to Black people, you know. I'm not only concerned with art. With me art is a secondary thing.

MR. LAWRENCE: I think you're begging the question here and you're making an excuse that you don't have to make. You can be a very fine artist and I think you'll be contributing. There's no reason why you have to paint or work in a certain way, and have the image of Blackness written on your work to be a fine artist.

MR. LLOYD: It doesn't have to be written on. But don't tell me that Black people can't relate to my work. When they see me and they see my work, I know what they say. They say, "Dig it, a Black cat did that." And that means something to them, I know it does.

MR. WILLIAMS: But what happens when you're not there?

MR. LLOYD: I'm talking about my work being meaningful to Black people, and that's very important.

MR. BEARDEN: Suppose the Black community didn't accept your work and the white community did. Suppose you had been accepted by the white

community, fully accepted. Would you have gone to the Black community to show your work if you had that kind of acceptance? Think about it.

MR. LLOYD: I've thought about that before. I've made it—I'm making a living off my art, a pretty good living. I can just keep my mouth shut and go ahead and make nice constructions for people to buy. But I'm not talking about me. I'm talking about Black artists. I'm talking about Black artists in the past, Black artists in the future. Simply because they're Black, there are millions of roadblocks in front of them.

MR. GILLIAM: I think I worry more about the quality of the experience coming to the Black community. And I think there is a need to raise the visual orientation of the Black community. During the riots in Washington, when the whites didn't come in from the suburbs, gallery attendance fell way off. If Washington has a sixty per cent majority of Black people, why does museum attendance fall down when something happens so the whites don't go? It's easy to see that we could easily hustle up to Harlem or over to 14th Street and put up a lot of structures that would be meaningful. But instead, isn't it that museums as such have not served the total community? Why can't museums really emphasize the kind of programs that will bring a person from where he is to where the better facility is? And when he's there why can't you make him actually welcome? This is the kind of point we should pursue, not dwell on "art meaningful to Black people." What we should be talking about is the quality of aesthetic experiences available to persons within the Black community, and raising the level of this quality. But let's not forget about what has gone before, let's not forget about Black history. In fact, let's emphasize this more.

MR. BEARDEN: I think that's very true. And I think what Jake was saying about the community spirit of the Harlem Artists Guild was true. This is what it did for me: I went to the first meeting: I was surprised to see fifty or sixty people there. I hadn't known there were that many Negro artists in New York!

When they did the news release on Tom for his show, it was stated that the Harlem Studio Museum is the first museum in Harlem. That's not true! There was one on 125th Street and Lenox Avenue all during the thirties—Jake and I showed at it. It wasn't only a museum, but they had teaching there, workshops, textile weaving, lithography.

MR. LLOYD: That's what we need now.

MR. LAWRENCE: I can appreciate what you say, but I think you're going to fall into a trap if you pursue this to the degree to which you are pursuing it. Because you're going to have people from downtown saying, "Well, let's give these people uptown a little something and we can forget about them for a couple of years." We *are* more involved now—it may not be to the degree that we think ideal, but we are more involved now in the total community structure than we've ever been. I think all of us will agree with that. But I think the thing for us to pursue—and I repeat this—is not only to get massive aid and help within the Negro community, but not to tear us away from the main community, not allowing people downtown to say, as I said before, "Well, let's give them a little something and we can forget about them."

MR. LLOYD: I'm not interested in what they think. No, *they* haven't done anything up to this point. And you say that we're involved. I don't think we are involved. I think there are a lot of Black artists that aren't making a living and that are not communicating with the people in the ghetto. I mean like nothing's happening. So if some form of separatism is going to make things happen, I'm all for it. And I think it will.

I like the things you were saying about the various programs in the thirties, Blacks being together. I don't know what came of it, but I'm sure some good things came of it. And I'm all for that again.

MR. BEARDEN: What came of it was . . .

MR. LAWRENCE: People were involved. It brought a camaraderie . . .

MR. WOODRUFF: It brought a greater degree of professionalism.

MR. BEARDEN: Jake was about the first artist who got out of the Harlem community, who got a one-man show *down*town. But before that, our minds didn't think past 110th Street. This was like a customs barrier back then.

MR. LLOYD: What I'm after is having my little Black girl exposed to art. And if she wants to be a potter I don't want her to be in that one-to-three ratio. There may be just three Black potters here in New York. I want to improve on that. Like a whole lot.

MR. WILLIAMS: It seems to me that you haven't really touched on one of the points Mr. Gilliam brought up—the quality of that pottery or the quality of that sculpture or the quality . . .

MR. LLOYD: What do you mean, "quality!" They have to be exposed. What makes you think that the quality is going to be any less because they're Black?

MR. WILLIAMS: I don't think I'm implying that. I think what I'm trying to say is that the nationalism you're talking about is a very dangerous thing.

MR. GILLIAM: I would say that before I looked all over New York for Black potters and could find only three—and before I kept somebody from making pots and being turned on by it—is that I'd find me a potter first. I don't think I'd worry about his color; I think I'd worry more about the quality of the experience.

MR. LLOYD: Look, I'm worried about the quality too, but I am worried about the fact that there's only three Black potters here in New York. That has a lot of implications, and I don't think you're facing up to them.

MR. HUNT: Well, you know, you could do something else. You could hire a white potter while you looked for another Black potter, and then fire the white potter and hire the Black. Then you would show your people something about you.

MR. LLOYD: Perhaps it would, and perhaps that might have been like an idea I had. But I'm more interested in young Black kids having an opportunity just to be a potter.

MR. GILLIAM: What you may be running into is the same difficulty they had in one of the summer programs in Washington, looking for a Black sculptor. You can name a number of them, but they'd already be doing something beside practicing sculpture. I think whenever you look for Black potters, Black painters, Black artists, they'll already be doing something else.

MR. LLOYD: At the same time there are a lot of programs here in New York, and even if you're a professional, capable Black artist you can't even get a job in the program. Because, number one, most of the cultural programs aren't run by Black people. I think that's very important. I think Black people and Black communities should control Black programs. They're the only people that can really, really relate to Black people.

MR. WILLIAMS: We're getting involved in sociology again, aren't we?

MR. LLOYD: Well, so what?

MR. GILLIAM: I think it's pretty hard to keep the whole question away from sociology.

MR. BEARDEN: Let me sum up. Tom feels that a lot of the professional problems of the Black artist have to do with his relation to the community. And he feels that his, and a number of Black artists', work should be directed to making the Black community more art-conscious. He feels, also, by the mere fact of his being a Black artist working in the Black community, he could refer to his work—or work done by anyone of a similar mind—as Black art. Now Mr. Williams has challenged that. He feels that the Black artist shouldn't limit his horizon to just one particular community, but should try to expose his work to a greater audience. I think we all have come to the conclusion, however, that there are dire economic and professional problems hindering the Black artist in the full expression of his potential. These problems stem from

social conditions, from the fact that the Black artist is not completely involved in the mainstream. He doesn't go to East Hampton, and he's not around the rest of the artists. It was brought out that the few people who buy don't always consider him, and he has not been able to get his work up to higher monetary levels.

Unless someone has anything to add to this discussion of economic and professional questions, I think we can go on to our third point—the aesthetic problem. I think some of the things that you were talking about, Tom, also involved questions of craft and identity. I throw the discussion open.

MR. WOODRUFF: This is one of the most important and probably one of the most difficult to solve. I think we should clarify what we mean by aesthetic problems, and problems of self-image or identity in terms of the topic we are working with—"Black art." We've been told that a recognizably Black uniqueness in the art product is not necessarily essential. There is such a thing as a "Black Anglo-Saxon," and then there are those who champion the notion of the Black heritage—who think that the Negroes' aesthetic image should come from his Black African ancestry. I don't think there's anything wrong with this, because we who are taking the traditional forms of Western art as a starting point are doing the same thing—we are beginning with a form from which we may create a form. There is also the idea of substantially good art—and this is what Sam has been talking about—coming from the soil. But the soil of the Black community must not only be productive and rich in its resources, but those who till that soil and try to raise a harvest—and that is the artist—must come in there with some real artistic insights. I don't believe that the subject matter, the hot-headed art of the moment, is of any consequence: the fact that the artists get a kind of frustration or anger off their chest is fine. But the creation of art is something else again. And we may be quite prone to accept anything that is enjoyed, in any kind of sense, regardless of its qualities, as Black art. But it is not. As I see it, you start with a concept, a thematic idea. And out of that you've got to create a form. And I believe the form must embody and convey that idea visually, physically. Above all, the sensibility of the artist, his beliefs and his convictions and his aspirations, must come through and control it. This is how any art is produced, be it black, white, green, or blue. If there is to be a *Black art*—not just something made by a Black artist—there must be certain outer manifestations so it can be identified, as you can identify Oriental art or pre-Columbian art or Eskimo art. (But I don't mean in any sense a primitive art: right here I reject the term "primitive" in referring to African art or any such ethnic form.)

More important to the work of art are the energies, the efforts, and the deep insights that come from the artist as he works through what he has experienced in life.

In the musical world there is Leontyne Price, who sings like a bird. And this has nothing to do with her color. There are others, like Mahalia Jackson—whose singing you would call Black singing. I do think there is a something found in the works of the Black artist that is absent in the art of other people. Langston Hughes used to define this as coming from the folkways, from the special quality that we as Black people have. But I think that, in the final analysis, you've got to create art—art of the highest possible aesthetic level, in which your means are what your goals are. They are very highly personal.

We have a young man here, Richard Hunt, who I think is a great sculptor. This man is an artist. It has nothing to do with race; it is that real spark, unfathomable, and unidentifiable, that is deeply felt. The power of his sculpture is unassailable. Is this Negro art? Is it done by a Negro? It may very well be. Who knows? It's powerful, convincing, compelling art. And this is what I mean. It isn't black, white, green, or blue, but it's great art.

I think the Black artist is faced with the problem of almost working from scratch. If he doesn't resort to the traditional sources that are available, he's got to start from scratch. And this is

tough. If he wants to produce a unique art form, he's got to ignore every other art form that has been used as a springboard for other art forms. This is a tough job.

I haven't answered any questions. My question has never been solved throughout my life and never will be. It's a continuous and ongoing search. But the search must be qualified by this constant and ongoing emphasis on quality, of the highest possible level that you can achieve.

MR. BEARDEN: They say that abstract expression-ism—action painting—is the first indigenous American art exported, and imitated by artists all around the world. No critic that I have read has ever aligned this spark with jazz music. But that's the feeling you get from it: involvement, personal-ity, improvisation, rhythm, color. What I'm trying to point out is that Black culture is involved far more into the whole fabric of American life than we realize. But it is up to us to find out the contribu-tion that we have made to the whole cultural fabric of American life. No one else is going to do it. I look at baseball a lot; I see a man hit a home run—he comes in and slaps the hand of the other fellow who's waiting at the plate. This started with Negro ballplayers, and everybody does it now.

MR. WOODRUFF: I've had lots of arguments on the parallel aesthetics of music and of art. I asked one of my friends, "Just what is so Negroid about this Black, so-called Negro music?" And he said that it's the little dissonant note at the end of each piece that makes the uniqueness of Negro music. When a band winds up a piece, they always wind up on a minor note, even if they're playing in a major key. They leave you there. That sustained, suspended moment is in the musical style, in the literary style, it's in the drama certainly—their timing in dramatic action is just terrific. This is a quality that is almost unexplainable, but it's always identifiable. It's not something that a critic can point out—"That's it, right there." It's the total—the total sensation that you get.

MR. LLOYD: The thing that worries me, Mr. Wood-ruff, is that you seem to single out individuals. You talk about a few Black artists who have made it and so I get the idea that they're some sort of Abraham Lincolns. Perhaps they are. But I don't think that's anything to point with any great pride about. I still maintain that Black art should be separate. I feel like this is the only way for us to make it.

We were talking before about institutions, and someone mentioned this institution. I feel that the Metropolitan is an institution for white people, not for Black people. So therefore, if we're going to be equal with the white artist, where are we going to show? Where have we shown? What kind of facilities are open to us? What galleries will accept us? There are none that will and none that have. Don't mention one or two people—I'm not interested in one or two people. I'm interested in the millions of Black people who want to be artists. Therefore I maintain that there has to be a Black art. This is what we need, if it would pull us out of this thing here. We haven't got it from the white cultural power structure. They haven't given it to us.

MR. WOODRUFF: Well, when I mention a man like Richard Hunt it's not to put him on a pedestal . . .

MR. LLOYD: We don't want a pedestal. He's one man.

MR. WOODRUFF: I'm a visual man, not a verbal person, and when I mentioned Hunt's sculpture I wanted to suggest a visual image, to make my task a little easier because I cannot explain in words that which I always see.

MR. LLOYD: What I want to know is if there are two hundred Richard Hunts, where are they going to show their work?

MR. LAWRENCE: Well, I'll go halfway with you, Tom. I will say that I'd like to have the opportunity for a person with talent to make himself into an artist as successful as Richard Hunt. But I don't think you'll ever have two hundred Richard Hunts or two hundred Thomas Lloyds, because everyone is just not that talented.

MR. LLOYD: No, I mean to equate them with the two hundred white artists who have the opportunity.

MR. WOODRUFF: That I'll buy.

MR. GILLIAM: We're necessarily speaking of a job for the future. We've been few in number; the injustice of the whole social situation has made it so that we are few in number. We need not only to develop Black craftsmen, but also Black historians, Black critics. We need more Black-owned art galleries: let's talk about moving into business—art is a business. This is a thing that concerns us. If we're looking for ways art—or Black art—can be developed within a community, then let's talk about all the things that are really necessary to develop it. Why is it that there aren't Black historians or Black aestheticians, aside from people like Hale who have had to double to do the job? Why aren't these professions being encouraged at Black colleges? Why can't places like that make their special responsibility taking care of the Black heritage? They should investigate exactly what the facts are: what we have accomplished, and whether or not we're going forward from where we are now.

MR. LLOYD: I think that sort of program would be very important. I mentioned an organization called Black Visual Environments, and part of the thing we want to do is to bring Black art—and I mean *Black art*—into the public schools, for these young Black kids to talk to the Black artists, to try to form some sort of dialogue, to be there and be seen, to show that he's Black. This is important to the young Black kids. It's never happened before and I think that it's important that it does happen. These Black artists should be paid for it. I'd also like to see Black art shows traveling to the South, to Black colleges, to make these people aware of what's happening in Black art today—okay, I'll say art today.

MR. GILLIAM: I'd equally like to see some of those Black colleges having an artist-in-residence program. This kind of program would be terrifically important, because often a person suffers because his experiences and information are locked into his regional environment.

We're really talking about an uplifting, about providing us with a base of freedom in general. We can take care of business. The impact of our times makes it individually important that we don't go back an inch, a centimeter, but that we move on. These are the kinds of things that should be part of our experiences, and that should indicate the paths we should take.

MR. BEARDEN: I understand there's going to be a big show of Black artists opening in Minneapolis. William, if you went to this show, could you look at the paintings and the sculpture and find something that identified the artists as Black?

MR. WILLIAMS: I've never seen a piece that I could say that about positively. I've seen a great many pieces I think are commendable by Black artists, but I didn't attach that special title or special category to them, and I don't think I ever will.

It seems to me that it would be fine if an art form or a thing could be created that was so uniquely Black that it wasn't necessary to have Tom's picture in front of it. But it hasn't been done. You talk about the need for a Black male image: what you're really talking about is this sociological thing. The Black male image is one thing, but I wonder what happens to his work—or any work—ten, fifteen, years from now when the Black male images aren't standing in front of it and giving a whole rundown about what it's about, why I'm doing it, why I'm participating in the community. If we're going to build a cultural basis that is relevant to the Black community, it should be a cultural basis that's relevant when Tom is gone, when we're all gone, something that's so embedded in quality that it not only stands in Harlem but stands any place. That's a goal to shoot for.

One of the things that Tom's addressing himself to is the necessity, in terms of the social strife that we're in now, to assert a lot of Black things. I can agree with that on one level, but on another I must talk about quality as Mr. Gilliam has, and what the level of the experience of "Black art" will be, and what exposure to it will do ten or fifteen years from now. If I expose five hundred or six hundred kids to Black art now, my hope is that the Black art will be of such a level that I will be instilling some type of aesthetic or

values within those kids that they can draw on years from now.

MR. LLOYD: That's good, but you see it hasn't happened. If we're going to accelerate that kind of thing we have to do it now.

Being separate and making Black art might possibly be the answer. I'm not saying for sure it is, but I believe it is. All I know is that nothing has happened in the past. It's a change that has got to happen.

MR. BEARDEN: I can't agree with your argument that nothing has happened in the past, Tom. Two years ago I went to the Grand Central Galleries because I had heard so much about the works of this man Henry O. Tanner. I looked at his pictures and I must conclude he is one of the three or four great painters of America, the only religious painter who in my judgment compares with Rouault. This museum had two of his pictures, but they sold them.

The reason you can have a place like the Metropolitan is that you can bring art into this country duty free. It was a Black woman, Edmonia Lewis, who went to Congress with W. W. Story and a few other artists, to have the law changed so artworks could come in without duty.

I could go on and tell you the things that Black artists have done; so don't say nothing's happened—it's just been obscured.

MR. LLOYD: The fact about this Black woman is fine, but this is still a white museum, Black people still don't come here. Don't mention individuals, like Tanner. I'd like to know more about him, but I haven't had the opportunity to learn about him. I'm not alone in this. Don't tell me progress has been made because of Tanner. Sure, there has been some progress, but I want to know about twenty Tanners. We're a whole race of people, and you know, when you talk about one, I know there's something wrong.

MR. WOODRUFF: Tom, why don't Black people come to this museum?

MR. LLOYD: They haven't been exposed to art. That's the number one thing: they haven't been exposed

to art. They don't know about Black art, and if they did know about it, people in the streets would know that Black artists are showing here or at any other museum. That's our fault, and part of society's fault.

MR. LAWRENCE: You know, there's something I can't understand here, and it keeps bothering me. It's a term that's been used over and over again, "Black art." I don't understand that. I think we may as well cut out the sentimental slush. "Black art" means maybe something like "Black art of Africa" or something produced in some of the earlier days of America, in some of the ironworks throughout the South or things like that, which came out of the experience of a cultural group of people who happen to have been Africans. Here it would be more correct for us to say "art by Black people," but not "Black art."

MR. LLOYD: When I say "Black art" I mean the Black experience on a total scale: being Black, our heritage, Africa, living in the Black community.

MR. GILLIAM: It *is* a total experience. We've been talking about the visual arts because we're painters and sculptors, but we must realize that there are other forms of art—theater and music—that are much more capable of having a definite "Black" personality. We have to recognize that it's his total experience that influences what a person does. And it may not affect only him, but some other person regardless of skin color: think of the influence of African art on Picasso, for instance, or on Modigliani.

We artists should discuss art, and not leave it to the civil rights workers or politicians. We have a feeling for it, and we don't belittle it.

MR. LLOYD: Well, being Black . . .

MR. GILLIAM: Is great.

MR. LLOYD: I can't imagine an artist—a Black artist—functioning without knowing he's Black, without being concerned about what's happening to us, without being concerned about our very lives. We're Black. No matter what kind of work you do, you're influenced by all these things.

MR. LAWRENCE: Is this always evident looking at the person's work?

MR. LLOYD: Maybe not. I never said it's evident looking at someone's work. I'm just saying it's Black art.

MR. WOODRUFF: I can't agree with that.

MR. BEARDEN: He's calling "Black art" anything done by Black artists.

MR. LAWRENCE: I just can't see how something is "Black art." What you find are shows that deal with some philosophy of art—minimal art or this art or that art—and the artists in each of those shows will belong to many ethnic groups, Black artists among them.

MR. GILLIAM: By giving a show a kind of sociological title, you know, or a political theme, you can make it a community expression. Look at the *Sixty-six Signs of Neon*, a show brought from Watts, done by people in Watts. Even there the reigning influence was someone like Ed Kienholz, because this is something that's part of the Los Angeles scene. I think that in certain areas you can say that art can coexist with the social problems.

MR. LLOYD: Has it? I mean, what's happened in the past?

MR. GILLIAM: I think the past is perhaps much more important than what is going on now. Number one is the fact that every Black artist that painted has been involved with my situation in America—me and what's happening and concern for the Negro. This was the overriding consideration: what the artist was concerned with, and what I looked for as a kid, and what I dealt with when I was painting figuratively. But later on, you're a mature artist, maybe a great one, if you can personalize yourself, move from identification with something outside yourself to your own thing.

MR. BEARDEN: A lot of this experience is knit with identity, isn't it? For instance, you were saying in the prospectus for your show that the artist that turns you on is Agostini.[1] Every artist that you mentioned was a white artist. Now if you are this

concerned, why didn't you say that Jake Lawrence turned you on?

MR. LLOYD: But Jake Lawrence didn't turn me on. . . . He didn't turn me off either.

MR. BEARDEN: No, I'm not saying that. I would expect that when the young kid who worked with you has an exhibit, say four or five years from now, if you've done your work right, he's going to say that the thing that turned him on was the experience he had working with Tom Lloyd. This is different from the stand you take now, because everyone you studied with, the people who turned you on, are all white.

MR. LLOYD: Yes, that's just the point—that's the thing that bothers me: that there weren't any Black Agostinis around. Part of my function is concern for my people, not just getting in a little corner and painting a little picture.

MR. BEARDEN: That's what we are saying, but we've moved back into the question of identity. It all has to do with the artist.

MR. LLOYD: Yes, Black identity, Black art. That's why I say "Black art."

MR. GILLIAM: The Frederick Douglass Art Institute in Washington, which started out as the Museum of African Art, puts African sculpture side by side with German expressionist paintings, prints by Modigliani and Picasso, and things like that, and brings out a sense of identity very strongly. I want to know how Tom feels about this kind of thing.

MR. LLOYD: That's fine with me.

You know, so much needs to be done. There has to be such a tremendous effort on the part of the Black artist, on the part of the cultural power structure. I'm not too sure, Mr. Lawrence, that the government is going to get involved with the Black artist; the government isn't going to give you something when you're going to turn around and hurt them with what we create.

MR. WOODRUFF: I think the real thing that's bugging Tom is very evident. We want these doors open so that the Negro, the Black man, can move in

and share and share alike. But the topic we're discussing is the aesthetic problems that the Black artist faces.

MR. LAWRENCE: I think we need a definition of aesthetics. Are we talking about space, line, form, or something much more broad and abstract—"experience" or something like that?

MR. WOODRUFF: Well, I used the term because the phrase "Black art" seems to suggest something that is different in its structure and its formal manifestation. We've been making differentiations in terms of economics, social impact, gallery facilities, museums being closed to Black art, and so forth, and I think this should be considered in terms of whether the art really does have some particular, special form.

MR. HUNT: Well, "the aesthetics of Black art" is a problem I really don't address myself to, in either my work or my thinking. The problem of the Negro in terms of the contemporary situation in art—showing in museums and galleries and all those things—seems to be more or less tied up with the prevailing currents in art itself. For instance, an artist who's working with kinetic, light, or minimal things might have a better chance of breaking into the scene than somebody who's painting figuratively. All these things don't really seem that much different from the problems that white artists or any other kinds of artists have. There are certain kinds of social biases on the part of some of the establishment people that you mentioned that might influence things, but you know, I really don't think those things are all that important. I don't really like to go into definitions, but in terms of my feeling about my relationship to my art I sort of separate it from my life as a Black man in America. Given I'm a Black man in America, I live from day to day and take things as they come. In terms of my work, I have a certain kind of ideal that I want to attain and I find myself being able to do that as a Black man in America living in a Black community.

As Hale was talking about things that characterize Black art, and art growing out of the soil, it came to my mind that I'm kind of regionalist. I come from Chicago and I like living there. Listening to Tom's description of life here, I feel lucky that I was born in Chicago and haven't had to contend with the sort of problems that exist here. I come from a rural background: my father's from the rural South, my mother's from the rural Midwest. I remember the thing that impressed me about visiting my father's relatives in Georgia, one time when I was a kid, was that they had some land that they cleared, and they took the logs to the sawmill and built their house out of them. It's kind of nice thinking about how my uncle could do all that stuff; I think about things like that—and maybe this is what Tom is talking about, being able to identify with positive male images. It's like the things you read about pioneers doing. Of course they were living in Georgia, segregated and all, but at the same time they could exercise this ability to make things. I see myself as a sculptor as being a person making things. I may not make as good a sculpture as I want to make, but those are my limitations, nothing ever comes out exactly the way you want it. At the same time I feel like I can do anything I want to do. That has to do with family experiences and school experiences. I had Negro art teachers—Mr. Johnson, Mrs. Currin—who encouraged me and urged me to go on to the Chicago Art Institute. Then I had other instructors who were white and they encouraged me too.

It's a combination of things. I don't see how a Negro in America, even with segregated situations, can escape having influences that come from his family, from his background in the ghetto or wherever he happens to be, from his formal education, from his exposure to the arts. The thing gets pretty much mixed up, and the idea of separating out these experiences, good or bad, Black or not, seems sometimes rather useless and sometimes rather tiresome.

MR. LLOYD: Well, I don't think so. You know what I think, Mr. Hunt, is that you are a conditioned Black man. I think you are oblivious to what's happening.

MR. GILLIAM: Tom, I think *you're* acting more for the conditions . . .

MR. LLOYD: That may be so, but I've got to say what I think.

MR. HUNT: That's perfectly all right.

MR. LLOYD: To me you don't seem like a man concerned with Black people, with Black kids, with Black culture. I don't think that enters into your feelings. And that bothers me, that bothers the hell out of me. You know, when I think of an artist, I think of a Black artist, not a Black white artist or someone who has given in to this kind of conditioning that the white people have put us in. I have children and I want the best for them, and if they want to be artists, I want them to have the same kind of exposure any other kid has. They don't have it now, so I'm going to make sure mine do. I care, I care about my people and I think this is what every Black artist has got to do.

MR. GILLIAM: It's erroneous to presuppose that a person who doesn't follow a certain philosophy all the way doesn't care about his race or his kids. We're all badgered by these things . . .

MR. LLOYD: But this is the time for us to jump in and bring changes about, make things happen. And have some identity with our own doggone people.

MR. WILLIAMS: It's also the time to distinguish rhetoric from real facts.

MR. LLOYD: I know what real facts are, I know what's happened in two hundred years.

MR. WILLIAMS: I think that we're all too sophisticated to accept easily everything you're saying, but I assume those faults are your own, your own way of going about what you're doing.

I assume that's the way he—Mr. Hunt—should go about it, and that it's worked very well—he's created a thing that is uniquely beautiful. But in my own case, I find it very hard indeed to think of myself in terms of doing Black art, because it becomes such an anonymous thing. I find that I'm more hung up in my own frustrations and my own ego than anything else. When I'm doing my own thing, I kind of go about doing what I'm doing, and hopefully I can separate my daily frustrations on the surface level from what I'm doing. Obviously you're doing it, Tom, or else you wouldn't be working with lights. What I'm trying to say is that there are two levels that any man thinks on, whether black, green, or otherwise. If an artist—a sculptor, musician, or whatever—if an artist gets so hung up in social conditions and in what's happening to him, he winds up in something I call rhetoric.

MR. LLOYD: That's nonsense.

MR. WILLIAMS: Rhetoric to me is a point where one gets so involved that he's not going forward, he's standing still. I'm not condemning what you're doing; I'm saying that we're at a very dangerous point. It seems to me that the work of the artist at this point is to distinguish what's rhetoric and what's progress and what's fact.

Art by nature is an aristocratic thing . . .

MR. LLOYD: What?

MR. WILLIAMS: Art has been historically—historically in the Western sense—aristocratic.

MR. LLOYD: That's been the trouble with our culture.

MR. WILLIAMS: If you're talking about bringing in an Eastern kind of philosophy of art, then it does become kind of an anonymous thing. But I don't think any of us are willing to do that. We're still dealing with art in a Western sense; we're not willing to give it up and go into a special thing. So I think you have to keep that in mind when you condemn someone.

MR. LLOYD: I'm condemning a whole lot of people.

MR. BEARDEN: I want to sum this up. Tom, what I think you're saying is that you feel the entire tradition of Western art is kind of empty now; you think we must develop a certain cultural philosophy for the Black artist. Things, as they exist now, must be attacked on different levels—economic, social, perhaps even political. Now, in this struggle, in the civil rights movement, very little attention has been given to the cultural needs of the people. So now let's consider how the Black artist relates to the civil rights movement. How does he, or his

work, or his philosophy, relate to these pressing problems of the Black people in this country?

MR. LAWRENCE: Well, I think you can relate in any number of ways, and the individual artist has to solve it in his own way. He may participate through the content of his work, or by donating a piece that has no specifically relevant content. I know that we all relate to the civil rights movement, and we all make contributions. We give because we want to give. It's an obvious way of helping, not a spiritual one, but it's a way that has an immediate, definite benefit.

MR. WOODRUFF: Let me say that I've always felt that one of the things that we lack in the Black world generally, not only in the visual arts, is critical scholarship. That could do so much for the situation Tom is talking about. Clement Greenberg, for instance, just about made Jackson Pollock, and there are many other such instances. We need a writer to make us known. We have no one who can use the written word except yourself, Romie, and you're a painter basically. Scholarship from our college men and others has gone into the social movement and civil rights. Look at your jazz critics, they're white, and most of your drama critics are white. Even your writers, like Baldwin and so on, aren't concerned with us. Some years ago these Black writers were in Paris and the Paris press went to them and said, "Now, we know about your writers; what is the Negro artist doing?" And those fellows couldn't say anything—"I don't know any Negro artists"—and they couldn't answer the question. I believe that we need someone to critically and knowledgeably assess our combined artistic efforts. There are few Negroes who do this, but that scholarship is what we need.

And I do think there should be a communal feeling among the Black artists, whether or not we paint or think alike, or whether we sit down and beef like we're doing today. Whether we meet regularly or whether we just bump into each other in a bar, I think this is necessary, in order to present what I would call a kind of united front. When we try to fight this battle singlehandedly we're lost, we're not even up to bat. You know, you need a team to win a ball game; you can't do it with sandlot techniques.

This has to do in a very oblique way with the so-called cultural movement, because until the Negro in Harlem finally gets a decent place to live and food in his belly, maybe he'll have no time to go look at our pictures. So therefore the whole revolution is intertwined.

But what I sense is the great need is to have a man who points out to galleries and museums that this artist is a good one and you should have his work.

MR. WILLIAMS: After that, I don't know if there's anything I can say. I totally agree with the idea of uniting efforts with other artists, which is really, really necessary. I don't know about other cities, but in New York I feel an enormous separation between the writers and the poets and the painters—people are kind of isolated in their own corners.

As for the civil rights struggle, it's very hard to distinguish what you, on a personal level, can do. My feeling is "different strokes for different folks." I kind of take it as it comes and hope that I'm doing the proper thing at the proper time.

MR. GILLIAM: Of course there are "different strokes for different folks"—some are revolutionists, some are social changers, some are politicians. I would say that what we should help develop is an awareness of history and a broad cultural exchange, and set up the kind of institutions that would provide the kind of educational experiences that would visually orient people and make us aware of our total role.

MR. HUNT: I can only second that.

MR. WILLIAMS: Can we add, also, that there should be some intercity communication as well.

MR. LLOYD: I'm just a little shocked because I think our role as Black artists is right up there in the front line and we haven't been there, we haven't even been heard of.

MR. LAWRENCE: Now, you speak for yourself, not for me—I've been there thirty years, you know.

MR. LLOYD: I'm talking about unity, I'm not talking about one artist going that way and doing his thing. I think we should be marching, I think we should do anything. This is part of our life; this civil rights thing is a struggle that has a lot to do with us, and we haven't participated in it at all. I think that's shameful. We're not interested in the political life in the city, the civil rights struggle. We're just dead and you know we're not moving.

MR. LAWRENCE: Maybe *you're* not moving.

MR. LLOYD: Well, I'm glad you're moving.

MR. BEARDEN: I feel that the artist has to serve a movement the best way he can do it. Now we have a man here, oldest among us; I don't think anyone has done more than he and he's done it with his work. I'm not saying this is the only way you can do it, but his works inspired me as a kid. This was a contribution, and all of us around this table hope we are making a contribution. Maybe we can't all go out and make posters, but we can develop our talents in the best way we can.

MR. LLOYD: I just say get out and be concerned, and we're not concerned. If we are, we haven't let our concern be known.

MR. BEARDEN: Let's sum this up. Jacob indicated that in the civil rights movement the artist should do all he could, in his way, to assist the development and liberation of the people. Hale indicated criticism and scholarship, to further what the Black artist was trying to do, was something which had been lacking. I think both Sam and William felt that each artist had a commitment to the struggle, but this was something he had to do in the best way he could. I think Richard agreed to that too. Tom felt that the struggle for Black liberation was all-embracing and that we all had to get in there and pitch, do whatever was necessary to advance the struggle.

In the discussion we've had today we've covered many problems. We've posed problems. Only time and history will offer a solution. I think we have made a valuable contribution here. It's something that more artists everywhere need to do.

NOTE

1 [Peter Agostini (1913–1993) was an American sculptor who, in the 1960s, worked primarily in plaster. —Eds.]

Benny Andrews and Cliff Joseph for the Black Emergency Cultural Coalition (BECC), untitled statement, early 1969

Benny Andrews was born in Plainview, Georgia, in 1930 and moved to New York in 1958 after graduating from the School of the Art Institute of Chicago. He became recognized for figurative paintings incorporating paper and fabric cutouts. In 1968, Andrews and his fellow painter Cliff Joseph founded the Black Emergency Cultural Coalition (BECC). Joseph, born in Panama in 1922, had grown up in Harlem and graduated from Brooklyn's Pratt Institute in 1953. Describing itself as "an action-oriented and watchdog group," the BECC was formed to confront racism in the arts sector. It demanded that Black artists be included in major museum exhibitions held in New York City and that African Americans be hired as curators and directors by mainstream institutions. Known for taking to the streets with placards and staging protests at museum entrances, the BECC first congregated to oppose the Whitney Museum of American Art's 1968 show *The 1930s: Painting and Sculpture in America*, which did not include a single African American artist. Less than two months later, having already built considerable momentum, members of the BECC gathered at the Metropolitan Museum of Art on the occasion of the *Harlem on My Mind* exhibition (see p. 223). As outlined in the statement here, the BECC deemed the exhibition "a travesty of the cultural ethic." The outcry at the Met introduced the group as a powerful force in New York's art scene.

BENNY ANDREWS AND CLIFF JOSEPH FOR THE BLACK EMERGENCY CULTURAL COALITION (BECC)

A group of
Concerned Black artists
Wish to announce
The birth of a movement

The Black Emergency Cultural Coalition came into being in response to what its founders deemed a travesty of the cultural ethic. An institution invested with the guardianship of our society's cultural integrity, on January 18th 1969, presented an exhibition entitled, "Harlem On My Mind." That institution, The Metropolitan Museum of Art, hired Allon Schoener as the exhibition coordinator. He sought to, "prove that the black community in Harlem is a major cultural environment with enormous strength and potential and that this community has made major contributions to the mainstream of American culture in music, theater and literature." The museum's director, Thomas P. Hoving, stated that the purpose of the exhibition was, "a sincere effort to increase the knowledge and understanding of the cultural history of Harlem." Both the exhibition coordinator and the museum director failed to meet their stated objectives.

They failed because they omitted painters and sculptors who also contributed to the cultural development of Harlem, misused and otherwise ignored the body of black advisors to the exhibition, so that their own ignorance assisted by their arrogance, became their only guidelines, imported people from outside the Harlem Community to work on the exhibition and ended up producing an audiovisual exposition with neither logical sequence nor adequate explanatory information.

The Artists who responded to these gross failures with placards and leaflets of protest, stand together now as the Black Emergency Cultural Coalition dedicated to the principles of creative responsibility and cultural integrity. The Black Emergency Cultural Coalition is constituted as an action-oriented and watchdog group to implement the legitimate rights and aspirations of individual artists and the total art community. It is founded on the belief that those persons most intimately related to and profoundly influenced by relevant problems affecting the art community should have the ultimate responsibility for the establishment and execution of policies to deal with these problems.

The Black Emergency Cultural Coalition adheres to the principle of direct action, to be taken whenever and wherever necessary. To effect changes in any and all policies and practices which are alien to art and to artists. One must only comprehend the power inherent in art to motivate the human spirit toward social change and freedom. To grasp the desperation with which the system works to obscure the beauty of blackness in art in these revolutionary times.

Overcoming present and future obstacles to truly significant recognition of the Black artist's serious involvement in and valuable contributions to the world art community will require the active and often sacrificial participation of fellow artists; supported by the concern and cooperation of less active contributors.

The Black Emergency Cultural Coalition wishes therefore to invite you to participate as an active member or as a committed supporter.

Please indicate your interest by completing the form enclosed.

ALL POWER TO ART and THE PEOPLE

THE BLACK EMERGENCY CULTURAL
COALITION
Benny Andrews
Cliff Joseph / Co-Chairman

1969

Roy Wilkins, "Preface," and Carroll Greene, "1969: Twelve Afro-American Artists in Perspective," in 1969: Twelve Afro-American Artists, catalogue for exhibition held at Lee Nordness Galleries, New York, January 22– February 8, 1969

Established in 1909, the National Association for the Advancement of Colored People (NAACP) consistently strove for equality through legislative means rather than an activist approach. By the 1960s, the NAACP, led by its executive director, Roy Wilkins, was carrying out important work in the civil rights movement. In this text, Wilkins discusses *1969: Twelve Afro-American Artists*, an exhibition commissioned by the NAACP in its sixtieth-anniversary year. The show, which included works by Alma W. Thomas, Norman Lewis, and Noah Purifoy, was curated by the prolific art historian Carroll Greene Jr. and the art dealer Lee Nordness, who owned the gallery on Madison Avenue in New York where the exhibition was presented. Greene, born in Washington, DC, in 1931, was a highly accomplished scholar who had published widely on African American artists. After studying at Columbia University and New York University, he co-curated *The Evolution of Afro-American Artists, 1800–1959* with Romare Bearden at the City College of New York in 1967. The following year, he began a fellowship at the Smithsonian Institution, where he developed the museum's collection of African American artifacts and organized a comprehensive retrospective of the work of Henry Ossawa Tanner. *1969: Twelve Afro-American Artists* was one of the first shows to present Black artists in a prominent commercial venue in uptown Manhattan. As Wilkins explains, although his motivation for mounting the show had been apolitical—wanting the works to be considered for their aesthetic qualities rather than with the artists' race in mind—he had also intended it as a response to the distinct lack of representation of Black artists at other galleries in the city.

ROY WILKINS, "PREFACE"

On January 22, 1969, the exhibition of *12 Afro-American Artists—1969* opened at a gala benefit attended by many of New York's prominent art collectors and distinguished community and civil rights leaders. It marked the first major exhibition of Negro artists in a major New York midtown commercial gallery in many years. Critically, the show was well-received. However, the concept of an exhibition of black artists failed to satisfy those in the black community who reject any association with white Americans, as well as those—white and black—who refuse to acknowledge the special nature of the black experience in art or any other cultural endeavor.

The initiative for this show originated with the NAACP's Special Contribution Fund, under whose auspices the Lee Nordness Galleries and art historian Carroll Greene, Jr. selected the works to be exhibited. Our only limitation was that all of the artists be black Americans. Messrs. Nordness and Greene, each uniquely qualified, were the sole judges of the technique, talent and ability of the selected artists.

Nobody associated with this show sought to categorize the works of art according to the artists' racial origins. This is not Negro, black or Afro-American art. It is a show comprised of American artists who *happen* to be black.

Our motive in grouping these twelve artists was to make a simple statement: here are a dozen living, contemporary American artists who happen to be black. Notice that although they share several experiences in common—notably being black, American and contemporary—their styles are as varied as any twelve other American artists might be. Indeed, most of those who have viewed the show seem surprised that so few of the artists are concerned with Negro, or Afro-American, subjects.

Underlying this premise is another: that there are far more talented and highly developed American artists who are black than one might be led to believe from an intensive survey of New York galleries.

This "discovery" leads one inevitably to the larger social and economic problems which all Negroes confront, but which are even more pressing for artists who are also Negroes. Few black artists have access to New York City's commercial galleries, especially those in the midtown and Madison Avenue complex. Few Negroes move in the social circles which can lead to the patronage and museum "entree" that is afforded to many white artists. Most artists must find other forms of work to support themselves while they gain experience in their art and develop their reputations. If this is difficult enough for unknown white artists, it is even more difficult for Negroes whose access to the job market is still half that of the white with equal qualifications.

Yes, artists figuratively starve, which is a sad enough commentary on American life; but Negroes who are artists literally starve with far too few exceptions.

Thus, it was the NAACP's hope, in urging this show upon one gallery, to demonstrate to other galleries, museums and collectors that there are many talented artists who are black in this nation. But things being what they are in America, they have to be sought out systematically to be "discovered" and exhibited. Hopefully, many of the artists exhibited will, for the first time, find New York representation—the first step toward independence as an artist. Perhaps, too, a few noted collectors will find enough merit in the paintings and sculpture to make purchases which will initiate a vogue in this direction.

Finally, a noted art critic has observed that "no doubt there are legitimate political reasons for imposing such racial categories on the public consumers these days, but esthetically they make no sense at all."[1] I believe this critic was saying, "That is the way it *should* be," because in his field he is devoid of racial consideration. That, we of the NAACP believe, *is* the way it should be; but it is not that way yet.

We are working toward that goal, in part by showing white Americans what Negroes have already achieved as a measure of their potential. In the same way, we are trying to demonstrate to our fellow Negroes their indisputable achievements by appreciating the contributions of Negroes in

all fields—thus, the unquestioned anthologies of Negro literature, poetry and music; the recent rise of "black theatre"; the new consciousness of Afro-American history. For it is only on the basis of achievement that meaningful pride can be based; and only upon such pride as men and women that we can take our place as equal Americans.

CARROLL GREENE, "1969: TWELVE AFRO-AMERICAN ARTISTS IN PERSPECTIVE"

The works of these twelve artists represent an American treasure trove of artistic achievement too splendid to remain obscure. And yet, the art appearing in this exhibit is a fortuitous bellwether of a cultural renaissance developing in black communities across the land. No "school of art" is reflected here. What is revealed are the individual artists' pursuit of excellence and faithfulness to rich and personal esthetic expressions. In many ways this exhibit represents a coming of age of black American artists as well as a coming of age of American culture. Hopefully, this renaissance will be significantly encouraged by the American public.

With all too few exceptions, black American artists have remained cut off from the mainstream of American culture. As one artist recently put it: "The black artist's very existence has been denied so long that people don't know of him—even in the Black community."[2] The trend towards greater democracy in the arts—this trend needs active support—and the new impetus being generated in Afro-American communities are beginning to make more black artists visible. If strengthened and continued, this trend will move the black American artist into the mainstream of the culture where his works can be given an ample viewing by peoples of all hues. Further, he may at long last be enabled to compete not only esthetically but economically.

As this venturesome generation races toward the new frontiers of the planets and penetrates the depths of the sea, we may need to take especial care to discover and nurture our vast untapped human resources, particularly those of our neglected minority groups. The cherished American ideal of equal opportunity demands it, even as practicality requires it. No nation can afford to blithely jettison its most precious possession—the creative abilities of its people, all of its people.

[*Here, Greene provides a short history of African American art, beginning with "craftsmen" working in "colonial days" and continuing through to Robert S. Duncanson, Henry Ossawa Tanner, and various artists associated with the Harlem Renaissance.*]

Since World War II the vogues in the visual arts have changed with increasing rapidity. The new spirit of Internationalism following World War II in the wake of the rejection of the traditional has caused artists to continuously seek new forms of expression first through abstract art, abstract expressionism, pop, op, assemblage. You name it. With better training and growing opportunities, black American artists have been finding their way into the mainstream movements of the larger art community and the tradition of isolationism is slowly yielding.

NOTES

1 [The "noted art critic" was Hilton Kramer. The quotation (which, presumably accidentally, replaces the original term "public consciousness" with "public consumers") is from Kramer's review of the exhibition ("Art: Imposition of a Racial Category; *12 Afro-Americans* at the Nordness Gallery") published in the *New York Times* on January 25, 1969. —Eds.]

2 [Here, Greene is quoting Tom Lloyd. See p. 115 in the present volume. —Eds.]

1969

Frank Bowling, "Discussion on Black Art," *Arts Magazine* 43, no. 6 (April 1969)

Frank Bowling, "Discussion on Black Art—II," *Arts Magazine* 43, no. 7 (May 1969)

Frank Bowling, "Black Arts III," *Arts Magazine* 44, no. 3 (December 1969–January 1970)

Frank Bowling was born in British Guiana (now the Cooperative Republic of Guyana) in 1934. After moving to London as a teenager, he attended the Royal College of Art, graduating in 1962. A few years later, he received a Guggenheim Fellowship and relocated to New York. During this time, he encountered the work of American abstract painters and began to explore abstraction while also experimenting with silkscreen and stencils of maps. In addition, he became known for his criticism. From 1969 to 1972, Bowling was a contributing editor at *Arts Magazine*. These essays were published shortly after he became affiliated with the title. Like his other criticism, the texts are polemical in nature and address the current state of Black art. Ignoring categories of figuration and abstraction, Bowling finds Black expression and attitude in the works of artists as disparate as Bob Thompson, Jack Whitten, Melvin Edwards, and Daniel LaRue Johnson.

FRANK BOWLING, "DISCUSSION ON BLACK ART"

The art scene is full of things that everyone knows about: grapevine truths that people carry around (rather in the manner of beasts of burden) like guilty secrets. "Guilty" because, although everyone is free to air these general truths, they are only tempted to do so under duress or in instances of extreme passion—offensively or defensively. One of these guilty secrets is the neglect of the black artist. By a rare piece of luck (perhaps it's an historical imperative) we have had a spate of black shows: individual, collective, old, new. But it is neither possible nor desirable to separate this sudden appearance of black shows from the extant political mood. And since art and politics are, in this case, inseparable, there is no better time than now to create standards.

In this connection, one detects a number of things flashing about like quick-silver. For instance, there is the intense conflict going on between the older black artists and the younger ones. It is fugitive and unexplained, funny and sad; in short, like life itself. The survival of the older artists, which was in a large part dependent on their "keeping their place," is a demonstration of the stigma that affects everyone. But that code for survival has not deterred the young black artist. One would think that the "achievements" of the older artists would have been enough testimony to discourage the young ones. But no; the young ones do make the sort of demands for showing, criticism, and so on, that the older ones didn't. The present attitude reflects "a wind of change." Frequently these young black artists insist that they are not "painting black." In a sense, this is an escape from reality. Any black artist who does not want to be identified by the color of his skin could be indulging in a subtle new form of "passing." There is a paradox here and the inconsistency is partly the reason why certain questions must be asked: why have black artists, given their historical role in art, contributed so little to the great body of modern works? Or, more loaded still, is there a separate black art? Is black art simply an eruption of passion (black) or a subtle turn-off (white)? One starts to mention a few names

but one is stopped by another question: "Well! Who are these artists? Are they any good? Where do they show?" What one is really concerned with, when posing those latter questions, is *not* the relative merit of these people as artists (their work) but the curious fact that black artists exist—either isolated in pockets or in groups.

To forestall potential detractors who might throw up their hands I want, at this stage to state that unless this publication gets bored with the idea, I am going to weave a broadly based explanation of why the black artist has contributed so little to the mainstream, or to the most relevant aspects of contemporary art. Let me say at once that a recognition of just how loaded the subject of black art is has got to be faced. Otherwise we are wasting time. I have questioned black Brazilians, black Africans, black West Indians, recording their answers on tape. I always end up in a rage, frustrated by a general inability to separate the meanings or explanations from the fact. Even the most cantankerous black blowhard in the art bars will shift ground in the manner of an "uncle" on the topic of black art. I lay myself open to criticism writing about it, since such matters as accuracy of dates and the like are of cardinal importance. Such an undertaking takes time and I could be asked why I am rushing into print. In answer, I point to the urgency of the situation: it can't wait. Furthermore, there are ideas in print worth discussing.

First I would like to cite *Encounter*, an entire issue of which was devoted to Latin America (September, 1965). It contains a moving piece called "The International Style," by Lawrence Alloway, who states: "When a block of artists from an area regarded as artistically underprivileged moves into wider recognition, a general problem is precipitated for both the movers and the witnesses." This is unlike the Negro Renaissance of the twenties in which there were problems for the "movers" but not for the "witnesses." Now there is a genuine black revolution which affects everyone. In this same issues of *Encounter*, Emanuel de Kadt writes: "The impasse in which Brazil is caught has its roots deep in structural and mental rigidities formed during a long experience of slavery and economic

marginality. . . ." It would be interesting to hear what Lawrence Alloway would say in the face of the observations of Abdias do Nascimento, a black Brazilian painter, writer and theater man with whom I have been having long talks. We noted that none of the artists Alloway mentions has, or claims to have, a black heritage or influence. There is no use denying that Abdias do Nascimento is right when he argues that much of the work done by black people (in Brazil) cannot be completely understood in critical terms without careful attention being paid to the attitude which produced it. There can be no doubt that this is exactly what people like Frank O'Hara did for a master like Jackson Pollock. And say what one likes about the recent book, *David Smith on David Smith*, it seeks to define Smith's art as coming out of a deliberate, intelligent mind, conscious of a socio-cultural philosophy. It is not just an autobiography.

There are moments in history when the time seems ripe for an attempt at defining terms. One such moment is now. The weight of exposure being given black people in all walks of life is second to none in Western history of which they are now firmly a part, the Third World notwithstanding. We recall James Baldwin's remark about being "born about the time of the so-called Negro Renaissance." Despite this kind of observation, we are witnessing a revolution, a black revolution of unmanageable scale and what is imperative is that out of it, some standards must emerge. Otherwise, we will find ourselves in a situation similar to that which Mr. Baldwin describes. The one area being significantly ignored in discussions is art. So the question comes up again. "Is there a separate black art, as opposed to white art?" The fact that the question is asked puts in doubt the existence of black art. Yet, on a universal level the answer has got to be yes. There has always been black art. If LeRoi Jones can claim in his book, *Black Music*, that white jazz is different from black jazz and if one can make a distinction between black and white writing on the basis of the completely different, yet related, experiences of these two sets of people, then the claim can certainly be extended to art by stating this simple fact: what distinguishes or creates the uniqueness of the black artist is not only the color of his skin, but the experience he brings to his art that forge, inform, and feed it and link him essentially to the rest of the black people. It is astonishing, ironic, but, on reflection, very predictable that black artists everywhere are making the same observations about their relationship to the world. Say what one likes about LeRoi Jones, he talks quite clearly about the socio-cultural philosophy of the Negro.

Let me clarify this by an example: Bob Thompson's work.

I had been waiting for his exhibition for some time. I had heard rumours—was told it was on. I called the sort of people whom I thought would know only to find that they didn't. I rang the New School and was told by the switchboard that there was no such exhibition. Finally I went to the Martha Jackson Gallery. The girl at the front desk had never heard of Bob Thompson. She referred me to someone in the back—another girl. We joked about it: was it or wasn't it there? I left. The whole thing was inconclusive and disturbing. A short time after I came back from England, I ran into Jack Whitten who asked: "Are you going to the Bob Thompson show?"

When I saw the exhibition I was overwhelmed. I desperately wanted to write about this artist. I was given the go ahead to review the show. It occurred to me that objectivity was imperative. Toward that end, I took the people I teach at Columbia to see the exhibition and afterwards assigned them a paper. My class at Columbia consists of about 25 people, only one of whom could answer to the current description of Black. Now the point I'm trying to make is that even considering that Thompson was born a year or so after I was, as a figure he was a legend—a hero, a tragedy, an artist by the standards of the people I admire. It quickly became evident that the assignment I made to the students was not going to help. One had to be initiated in order to understand this work. A confrontation on purely aesthetic terms could not be avoided.

The Jewishness of a Jewish novel can be controversial, polemical, attractive, and embraced. However, it remains valid and establishes itself continuously as such. So with Chinese-ness or Japanese-ness. In art, this is not so. In the hierarchy

we are led by, art doesn't allow the color or ethnic lines except at its peril. This is clearly a questionable position in the changing, fermenting world in which we live. Black art is done by black people and Thompson's work is not only idiosyncratic and personal, but black. The structures in Bob Thompson's work are explainable within the framework of an historical context which includes a psychological release which is traceable to Eastern Europe before Hitler's war in much the same way as the complete shift in Modernism. (The New American Painting: Pollock, Motherwell, Kline, de Kooning et al can be traced via André Masson and the Surrealists to what, for want of a more precise description, I must term Western Europe.) Thompson's work comes out of influences from German Romanticism (David Casper Friedrich), Die Bruecke and painters, writers, and intellectuals who gathered in art colonies (Worpswede) and cities (Berlin and Munich) and spread to painters now scattered all over the globe. What removes Thompson completely, yet entrenches him deeply is his experience as a Black.

Thompson's is a stunning and revealing exhibition: the genesis of black art. He has used European masters in much the same way as during the ferment and rumblings after Cezanne and Monet, artists used everything from Japanese prints to African sculpture. The works have a sneaky look, a feel, stamp, and, finally, a quality about them. One might say "This painting reminds me of that Piero— God! Which one is it?" *The Nativity*? But then one looks hard and it doesn't at all. What we thought was Piero disappears and we have a Thompson. A rich, sumptuous, and undeniably complex painting generating its own personal heat, comparable only to a Picasso's use of tribal sculpture or a Van Gogh's use of Japanese prints. We had to wait for a Bob Thompson to understand more clearly.

Consider further. The Museum of Modern Art puts on a show called *Homage to Martin Luther King*. Danny Johnson has a piece of sculpture in this exhibition called *Homage to René d'Harnoncourt*. Mr. d'Harnoncourt was not only an admirer of Johnson's but an important curatorial official at the museum and had recently been tragically killed, rather in the manner of Frank O'Hara. Johnson,

I would venture to say, was not just indulging in subtle counterpoint, nor for that matter really playing art politics. (It is sheer cant to deny that politics play an important part in the lives of all members in all communities. Art, even in its grand estate, does not escape this.)

The advent of Martin Luther King as a cultural, not folk, hero, parallels artists having become very much a part of the scene—intertwined irrevocably in the socio-cultural fabric. But, while in this country Martin Luther King is a public figure and black artists are called upon to pay homage to him, the situation is entirely different for black artists elsewhere. The disappearance of Dennis Williams from the London scene came shortly after the *This Is Tomorrow* exhibition in the late fifties. His most ambitious picture publicly seen for the first time at this exhibition, was described by a fellow artist as "Mau Mau Mondrian." Along with Patrick Betaudier, there were several West African and Indian painters who were forced to emigrate. The token appreciation that these painters received before they emigrated is similar to Tanner's reception before he emigrated to Europe.

In summation, black art is being done by black people. It is too simplistic to say that it is solely pigment oriented. Some of the people jiving around with their Afros are on the "side of a whiter shade of pale." What informs black artist's works is the black experience, which is global.

The dilemma of the black artist reaches into every sphere. Since the public is unfamiliar with his work, he is at a disadvantage from the outset. With known artists, through reproductions and photographs, one can quickly grasp the essence of what an artist is getting at. Consider the Francis Bacon painting called *Man Getting Up From A Chair*, reproduced in the catalogue of the recent New York showing of his work. The thing hits you with such rapidity and power you know what the artist meant. Or a Jackson Pollock in one of his overall paintings. But the work of an artist like Jack Whitten, for instance, has to be experienced directly. No black and white photo or color reproduction is going to give his "feeling" (from seeing) that this is a world of demanding urgency. There is

no separation between abstraction and figuration for Whitten. As with Pollock, the artist whose work Whitten's most resembles, the molecular structure of the canvas material, the way it accommodates paint, holds it, sucks it, bleeds, rejects, moves on, builds, stops at the boundaries of the supports, creates newer more surprising areas, is much the same. Different from Pollock is what informs this activity. What coalesces in Whitten's gripping, varied, and rich paintings is an individual experience. The time is different; the tempo is different. We had to wait for an artist like Whitten to make us understand that remark about Pollock painting the way Ornette Coleman plays the saxophone.

Incidentally, Jack Whitten had a beautiful painting in his New York show entitled *Martin Luther King's Dream*. Yet the show was almost completely ignored. Whitten's exuberant handling of an "all over the spectrum" coloring produce an enigmatic, quiet and almost impersonal quality. Although I doubt whether Whitten had anything of the sort in mind, there was the remarkable counterpoint to King himself. If Whitten was trying to present the "one-of-us-ness" and at the same time the "public property" aspect of Dr. King, he was successful.

Whitten's style is not mysterious except in the sense that a magic man and paint have come together to create a real world, a black world. It's just that no one (except a chosen few) seeks to know about this world.

FRANK BOWLING, "DISCUSSION ON BLACK ART—II"

The question remains: Why have black artists, given their historical role in art, contributed so little to the mainstream of contemporary styles or better still, why have they contributed so little to the great body of modern or modernist works? Left at sea, as I indicated in my last effort, I have been groping madly for answers. To such a fundamentally obvious question there can't be any easy answers, and it's surely simplistic to state—as William Williams did in a taped interview at the Metropolitan Museum and reproduced in the Met's bulletin in time for the *Harlem on My Mind* show—that "we don't have a visual tradition. . . ." Even given what was being discussed, the American Northern big city scene, this is a rather narrow and flabby declaration. However I have to come back to this as I want to deal with where *it's at* and that is America. The confrontation of Black or in this specialized case Black Art is American. One could go further and say New York but that would be overstating it. One of the points I made last was the relative economic positions black people held within the structures: Here I want to emphasize the economic structure of America. The Blacks were first "no-citizens," then rural near chattels and lower class "ghetto" citizens. This is the straight line of interpretation and my recent readings and planned trip to the South do not put me in the category of "expert." However what *is* hard to define is the inexplicable bombing of a black middle class. The explanation is that there never was a Black idea here. There always was (and perhaps still is) The American Dream: which is white. See James Baldwin's essay on being an American. Your black middle class of which so many of us boast in all the right publications and places were European geared. Whiteness was its essence. Black middle class people were either European trained, versed or loaded toward.

The standards were measured by the same ones articulated in a brochure put out by the Center of Inter-American Relations (an institution to which I want to return) which states "the purpose of the center is to strengthen understanding between the people of the U.S. and of other nations in the Western Hemisphere . . ." and then goes on to state its visual arts programme " . . . the one area of hemispheric culture most easily communicated to U.S. audiences is the visual arts. It transcends language barriers, its origins trace back to *our common European cultural heritage.*"

The class system in America cannot really be evaluated in as easy terms as the class system in England. The constant shifting, renewing and changing lifestyle pertaining in this country makes analysis part of that complex. However, a large part of the reason for why there is no tradition of Black preoccupation with advanced works of art lies with

the sort of people who at one time were the essence (apotheosis, apogee?) of that milieu: namely the light skinned Mulatto. The fact is that "their" middle class was a slavish harking back, or seeking of the past (white). This left only cul-de-sacs. For fuller discussion of this see Cedric Dover's largely stodgily put together but otherwise excellent book, *Negro Art*. My esteemed friend and coworker William Williams notwithstanding, the explanation can only marginally, if at all, be blamed on ". . . no visual tradition. . . ." Almost without exception the black middle class, now vocal and militant, profoundly uneducated and (in many instances) ". . . can't spare the time . . ." for high art and plastic values. Bob Thompson's "instinctive" reaching for total expression in this area is rather like those throw-ups who underline a rule.

Reading and looking at a lot of what was, and is, popular Negro art prompted me to go back to Clement Greenberg's essay "Avant Garde and Kitsch." Negro art up until recently was a perverse kind of Kitsch, rather in the order of slavery. Greenberg has a lot to say about Kitsch which applies to Negro art and now to Black art. (I suggest the term is interchangeable.) We know from the middle class bit that Jazz wasn't music, nor dancing, nor for that matter singing. By the same token Picasso's use of Negro sculpture (Primitive Sculpture and the like . . .) was not painting and the lesson of him and his cronies in the Bohemian coteries was not to be tolerated. I find a real equivalence in all that Greenberg talks about when quoting Dwight McDonald on Russian films and his subsequent discourse and see no point in either quoting or stating bits. I refer the reader to this essay in toto. Incidentally there is a recent piece by Harold Rosenberg in the *New Yorker* which is a journal Greenberg cites. Doesn't McDonald write for this—I recommend it to my readers—there's not a single nigger mentioned.

The bombing-out of the black middle class and the subsequent challenging of all old and largely outmoded concepts being harassed by the young give a great deal of moment to the multilayered, fraught, and essentially self-defeating attitudes the young are involved with. It's not a question of who admires who, and hence gives underlying fore to who, but of standards in terms of that wonderful phrase Life-Style. I hope I have given at least an indication as to why Black artists have contributed *so* little to the Mainstream. My next point is that now they definitely are, which is inherently part of why they have not before.

The new middle class black product is as alienated from society as the white: the American dream has failed and all these badly misled people are not so much wrecking as getting together: hence questioning and feeding off each other. It's a great revolutionary moment but it still has its roots in what feeds it. Black art is still being done by black people only now it isn't Kitsch; it's the real thing. Take an artist like William Williams. It has been said that Williams's work is rather like Noland's (that school) but these paintings, although painted in that no nonsense flat masking tape and all process are so "irrational." One thinks of multiple swing rest points. . . . One thinks of single swing rest points / stable, rigid (dead) as, say, in the construction of a quadrant arch with a brittle instrument. Or multiple swing rest points as say when describing a circle by the "primitive" method of string and any kind of mark-making tool (brush, pencil, charcoal) the maximum of one's natural reach: regular and irregular heart-beats. But nothing holds; these paintings are articulated in such an anxious "slipping-n'-sliding" fashion as to be eminently "niggerish" in content and it's no use confusing this work with some sort of influence by Frank Stella. The off-hand nature in the order of a Stella is very much a shrug. In Williams it's a "holler."

Again an artist like Mel Edwards could be superficially confused with David Smith except that Edwards produces a kind of ambivalence unknown in Smith. The calibration of weights is a basic generation (rather like "red" in the spectrum of theoretical "white" light). Since the weight of an object is determined from the sum of the masses of small weights which just balance the object, it is essential in exact work that the masses of the individual weights be accurately known: Impossible! Those Mel Edwards works posed alongside architecture are not a challenge or an education—it's very much

a love thing. I suspect Edwards is much closer to Caro than Smith, in that what furnishes the passion and informs the forms is a love—a nigger love—where humor is something like flying in the face of death.

Walking into Danny Johnson's studio was like walking into a death house, not, mind you, a morgue, but a mausoleum; but gay, man, gay. The light. The color. Those beautiful, decorated coffins were so sunny, pretentious, and healthy in a completely unhealthy way. It dawned on me that Johnson's recent discovery of African sculpture has engendered an uncanny expression of the Californian death thing now common currency via Waugh books and films: those streamlined funeral parlours and arty graveyards. Johnson's earlier work used to involve smashed dolls painted black and other kinds of urban ghetto debris rather in the manner of the so-called "Funk" school but he was never in anybody's book on Pop Art or group show involving that. Johnson's instinctive understanding of the linear aspects of certain African sculptures locked in an intense marriage with current "striped paintings" a rebirth completely fresh and triumphant. Yet on a knife edge and troubled with questioning. What was once an almost academic tyranny is now a flowering of possibilities. With all the attendant risk. The irony is what came out is not African but "Black" Californian. Johnson's use of the source material is like and at the same time totally unlike Picasso's whose work from an authority like Rosenblum to *Life* magazine sets up only generalizations, or better still confusion. The sculptures that were supposed to have influenced *Demoiselles d'Avignon* are so different and from tribes (African tribes) so far apart as to annul or frustrate checking. Picasso's use of this material is completely original and remains mysterious (perhaps even ironic, frustrating, and amusing) in much the same way, in this area as Johnson. And there is an irony in that from "Nothing" we went straight into Kitsch and from Kitsch to this splendid flowering; one wonders if it is going to happen now so suddenly: Integration. It would be awful, wouldn't it. I hope that I may discuss why it isn't desirable or possible in the Arts next time.

FRANK BOWLING, "BLACK ART III"

Current art criticism is developing an attitude which threatens to consign the idea and fact of Black Art to the periphery of artistic events. This establishment criticism hides behind useful political terms "revolution," "pragmatism," "Marxism," and sociology. It is a form of cultural myopia, malignant in its approach to Black art; for Black art, like any art, is art. The difference is that it is done by a special kind of people.

Threatening through "anarchism," which someone defined as "permanent revolution," may sound it defines Black existence—not Black struggles, but Black existence itself. Black life has had the spirit of anarchism as its content for centuries. Our history (this "historylessness") within a framework of degradation and oppression is a creative self-perpetuating process of anarchist, pro-life zeal. This perennially underground concept is in peril of being destroyed by assimilation, fragmenting, and watering down. The total thrust of the establishment is toward annihilation by ignoring contemporary black existence in the light of history.

Earlier criticism, in every book and article, confirmed a deeply held opinion that, in the plastic arts, Black endeavor didn't exist or, when it did, was "lesser." At present there is no support for any such prejudice, suggested or real, for no contemporary art criticism deals with Black history or experience with the indelible anarchist content. Of the new criticism, Gregory Battcock in *The New Art* says, "If our response to the present is inadequate and outmoded what of the future and the 'new' awareness of the non-white peoples? . . . The new criticism presents not only a direct confrontation with the new art in question, but also a 'confrontation' with its cultural, moral and social logic." Those were the dark romantic days of 1966 for subsequently, Mr. Battcock has evoked that well-known, itinerant Marxist-humanist-theorist Professor Marcuse, so often called upon to diagnose society's ills. But even with Professor Marcuse's aid, Mr. Battcock was not able to increase our understanding.

Miss Barbara Rose, with a nod or two in the past at individual artists who happen to be Black,

sets out in the new criticism (*Artforum*, last season) and delivers a labyrinth of learned name dropping, concluding with a totally White, controlled, pragmatic plug for her favorite young White exponents of the American dream. Miss Rose contends that "younger artists are responding to a new world view which holds far more in common with pragmatism than idealism. . . ." This observation may be the case in the narrow White American sense but it is too late to disguise the fact that what may have started out as pioneering and pragmatic has revealed itself as arrogant, colonialist and greedy, with an idealist zeal somewhat unprecedented in history. Pragma might be Greek for action, only, when this turns out to be brutal and domineering it leaves open for question whether Miss Rose's suggested distillation, via her learned peers of the ". . . function for art, placing us back again on a favorite terrain of American artists, who have felt so often that art must transcend the 'merely' aesthetic to inform experience more directly . . ." isn't essentially a plea to perpetuate a rather abnormal and now notorious situation where a people have to let themselves be hypnotized into believing a huge section of their population were not simply irrelevant but virtually didn't exist. If one can have "world view" without local perspective it is plain we are dealing with the cyclops, regardless of John Dewey, Morse Peckham et al. . . .

Of the "sociologists" writing in the *New York Times*, Peter Schjeldahl, on August 31, 1969, praised two recent art shows of low calibre—both organized by Black people. Of *Afro-American Artists* at Brooklyn College, he observed it was a painstaking selection of the best available recent work by Black Americans, but wondered whether "Black viewers were universally pleased with its fastidious elegance. . . ." Of the *Harlem Artists 69* exhibition, he says, "The Studio Museum has evidently opted to survey the actual state of art in its community. The decision was not to 'educate' the taste of the community (though the Museum is heavily funded from outside), but rather to convey to the people of Harlem a sense that Black Art is worthy of their pride. *Harlem Artists 69* obviously did apply minimum standards. . . ." Whose minimum standards?

Part of the function of any Museum in any community is to educate by survey. If Mr. Schjeldahl's conviction is that this is what the Studio Museum in Harlem could not do then the clear implication is that this must be the freak Museum in the history of Museums: its function being only to instill pride. Again, much as one can come to art through sensitivity and intelligence; which, one must assume, is what "the guy off the street" brings with his "natural gifts" as a maker of art works; art cannot sustain itself without "education" (this much maligned activity)—the swop, exchange, cross-splicing, this necessary growth-process of ideas—which is true of all people in the history of the world, whether the means is the apprentice system, art schools, or enclosed societies of long ago where there was "appreciation of its own art by a people for whom it is not a luxury but an integral part of life. . . ." These words by William Fagg, in a symposium on "Tribality" at the First World Festival of Negro Arts, refer, as he said, to "the ideal relationship between art and society . . . enjoyed for some centuries in Christian Europe before the Renaissance." But we are not pre-Christian Renaissance Europeans. We are Black people in the Western world. To lower standards for our benefit is condescending and insulting to art.

Mr. Schjeldahl's patronizing progress report finds artists influenced by the look of 50s Abstract Expressionism and even 30s and 40s realism. "Black artists, who are automatically participants in the turmoil of our current history, would not seem quite ready to submit to the cool reductionisms and esthetic ploys of fashion. . . ." Were Black artists left out of history's turmoil before? This patently contradictory nonsense is anti-life and uninformed. Let it suffice to say if Mr. Schjeldahl found no connection between the contemporary life-style of the people uptown—which is the hippest and most modishly influential there is—and their art (which he documents and dates by identifying it with the 30s and 50s) then the educative function of the Museum has capitulated to something of which neither it or he approves: insidious racism.

It is hardly surprising then that museum people of various persuasions have been revealed as not

believing their own publicity. Two prime examples are *Harlem On My Mind* and the *X to the 4th Power* exhibition at the Studio Museum in Harlem. The fact that the former exhibition was a disaster and the latter praised does not disguise the flaw in both; neither believed in Black artistic effort; both merely tried it on. If he really believed that museums had a function outside the limits of their constitution, Mr. Hoving would have let the Blacks turn the place on its head; he had nothing of the sort on his mind. He would have had nothing to fear for Blacks have always "re-routed" without destroying. Good as the *X to the 4th* exhibition was, it contained a similar lack of conviction—the inclusion of a White artist being a fruitless gesture of politicizing by pointing up how equal, or as-good-as-White the Black majority was. In whose opinion?

The net result of the publicity for the Black Revolution spilling over into art is the fact that in all of the more unfortunate displays it hasn't mattered whether the art was good or not—a testimony to the sadly overwhelming and burdening concentration on politics and sociology. There *are* good works, as demonstrated by the *X to the 4th* show, but mediocre, ethnic, amateurish, irrelevant stuff is also being touted in the name of Black endeavor. As long ago as 1934, Romy Bearden was protesting against an "attitude . . . of a coddling and patronizing nature." Have things really changed? Except for the greater viciousness of the surrounding misunderstandings?

James R. Mellow, "The Black Artist, the Black Community, the White Art World," *New York Times*, June 26, 1969

In September 1968, the Studio Museum in Harlem was founded to support the work of African American artists. The museum took its name and ethos from a proposal written by William T. Williams. At the time, the painter, who had grown up in New York and received a BFA from Brooklyn's Pratt Institute in 1966, was pursuing an MFA at the Yale School of Art. This text is a review of the museum's second exhibition, *X to the 4th Power*, which took place in June 1969. It was the first of several shows staged during this period that focused on African American artists who were making abstract work. It was also an early example of a racially integrated exhibition of contemporary artists: A White artist, Stephan Kelsey, was included alongside Williams, Melvin Edwards, and Sam Gilliam. The *New York Times* and *New Leader* critic James R. Mellow acknowledges the divided views Black artists held toward abstraction as exhibitions of this kind grew.

JAMES R. MELLOW, "THE BLACK ARTIST, THE BLACK COMMUNITY, THE WHITE ART WORLD"

The politicalization of art—the attempt to bend art to the service of political objectives, however far-reaching or short-sighted—has established a number of unhappy precedents in modern times. The brief history of vanguard art in Russia following the Revolution, when artists like Malevich, El Lissitzky and Tatlin attempted to promote their radical new abstract forms of art as the official style of an equally radical political regime, represents one of the ironic failures of modernist art. By the late 1920's, in a climate of distrust and suspicion and as a result of political and international events, the brave and optimistic program of the vanguardists was completely suppressed, replaced by a more manageable esthetic doctrine—that of Socialist Realism. Official Russian art became a species of propaganda, full of heroically illustrational pictures of smiling, valiant farm and factory workers exemplifying the virtues of the Soviet state.

The politicalization of art in Nazi Germany was equally disastrous. Under the directives of the Third Reich, all forms of modernism—from the pure abstractions of Kandinsky to the figurative expressionism of Barlach—were branded as "decadent" and outlawed as examples of "cultural Bolshevism." The official art style of Hitler's regime consisted of banal glorifications of full-blooded Aryan types and super-patriots. In both cases, artists of modernist convictions—if they did not meet death in concentration camps—were either forced into political exile or obliged to withdraw from the cultural scene altogether, practicing their art in secret.

It is against this perspective, I think, that one ought to consider an admirable and interesting exhibition of four contemporary artists—three painters and one sculptor—now installed at the Studio Museum in Harlem, 2033 Fifth Avenue. For the exhibition raises a number of pertinent questions—political as well as esthetic—concerning the role of the black artist in his relationship to both the black community and its ambitions and the predominantly white art world and its opportunities. Although three of the artists in the show are black and one is white,

the paintings and sculptures exhibited are of an order of abstraction that makes the particularities of the artists' lives irrelevant to an evaluation of the work. Commendably, the artists involved—William T. Williams, Stephan Kelsey, Sam Gilliam and Melvin Edwards—ask to be judged on no other basis than that of the work on view and the degree of its accomplishment. To a large extent, the exhibition succeeds in making its point that art is art—whether the artist is black or white, whether the work is exhibited in Harlem or in a posh downtown establishment.

But while biography has little relevance to the work in question—except in the subtle and undefinable ways in which an artist's life always informs his work—it is not always the case that an artist's experiences can be so conveniently divorced from the forms he creates. In more literal and representational forms of painting and sculpture, for example, the fact that an artist is black, that he has lived through the disadvantages of that heritage in a white society, could—but not necessarily must—have a legitimate and important bearing upon the themes and subject-matter of his art.

The polarization of black culture as a political issue of some consequence is having widespread effects. It casts even an exhibition such as the current Studio Museum show—an exhibition which seeks to establish its value on esthetic merits alone—into a broader, more troublesome context. One of the odd facets of the current controversy is that it reactivates what was previously considered (by a major portion of the established art world, at least) a dead issue—the conflict over purely abstract forms of art as against art of a representational order. For the attempt to create and promote a specifically black art, as opposed to art created by black artists, underscores the disadvantages—and the radical integrity—of abstraction. Confronted by social and political pressures from groups that feel art should convey a recognizable message, should espouse and promote a political program, abstract art must invariably seem a failure. And if the polarization of black culture should harden completely, it can only produce—in the visual arts of painting and sculpture, especially—a crisis of divided loyalties among black artists themselves. It would be too

bad, then, if art of the order of the present Studio Museum show should fall into limbo, lacking support from the black community and recognition from the white.

The four artists in the show share a number or common ambitions—an imposing sense of scale being the most obvious (the paintings, for example, range from 9 to 26 feet in width). And it is evident that they are determined to enter the field at the highest and most contemporary levels of style. In that respect, the show is an up-to-the-minute affair. It displays, to be sure, the failures that one expects from ambitious work by relatively new talents, but it is possible to single out a number of clear successes—William T. Williams' *Big Red for N.C.*, a brassy precisionist canvas full of bright ribbons of staccato color, and Sam Gilliam's *Green Sheet*, with its handsome phasings of color and its rigorous attempt to bring an essentially lyrical sensibility to order. One of the more impressive canvases on view is Stephan Kelsey's *Pearl of a Girl*, which makes an improbable game of playing off geometric motifs against cloudy and expressionistic expanses of beautiful pastel color. Kelsey's work in a more doctrinaire style, deploying colored circles against flat white grounds, however, seems too much like a decorative exercise in a thoroughly assimilated mode.

The work of the one sculptor in the show, Melvin Edwards, is particularly notable. Not in the case of the "floor pieces," heaps of steel chain that can be drawn out and strewn around the gallery: like much current anti-formalist work, the ideas behind the work invariably prove more interesting than the work itself. But in at least two examples—a graceful, suspended linear structure, *Con Allma*, consisting of bent lengths of metal tubing and chain, and in two versions of a belligerent triangle formed by horizontal lengths of barbed wire stretched across corners of the gallery—Edwards manages to imbue an otherwise cool minimalist style with some strikingly brutalist connotations.

One hopes that viewers at the Studio Museum show will recognize that art at this level of complexity, art in which formal considerations count as heavily, cannot be drafted into political service without damage to its basic intentions. It is art that must make its way through a world of fine gray formal distinctions: it does not lend itself readily to the usual black and white arguments or political rhetoric. As examples of art in an age of risk, then, the work now at the Studio Museum may be risking a good deal more than appears on the surface.

1969

Dana Chandler Jr., untitled text, in *12 Black Artists from Boston*, catalogue for exhibition held at the Rose Art Museum, Brandeis University, Waltham, Massachusetts, July 20–August 31, 1969

12 Black Artists from Boston grew out of the show *Local Afro-American Artists*, which had been mounted at the Elma Lewis School of Fine Arts in the Roxbury neighborhood of Boston. Lewis was an influential art teacher in the region and the founder, in 1968, of the National Center of Afro-American Artists (NCAAA), the first institution of its kind to preserve African diasporic cultural practices through teaching and exhibitions. William C. Seitz, director of the Rose Art Museum and a former curator at the Museum of Modern Art, New York, was a well-known advocate for contemporary artists, having championed the Abstract Expressionists. Dana C. Chandler Jr. was one of the twelve artists in the show as well as the essayist. The other participating artists were Calvin Burnett, Babaluaiye S. Dele, Henry de Leon, Jerry Pinkney, Gary Rickson, Leo Robinson, Al Smith, Richard Stroud, Lovett Thompson, John Wilson, and Richard Yarde. As an ardent Black Power advocate and a professor at Boston's Simmons College, Chandler used his art to protest against the inequalities faced by the African American community. Addressing the persistent, and historical, racism faced by Black artists, Chandler's essay in the catalogue is an outright denunciation of the contemporary situation in the United States.

DANA CHANDLER JR.

I can't claim any great pleasure in being involved in, and serving as catalyst for, this art show at this point in Black history. It unfortunately seems like too little, too late. Perhaps this appears as a harsh statement, but when one considers the caliber of some of the contributing artists, such a show is recognized as long overdue. I do not take issue with the Rose Art Museum, but with the American white art world in toto. The Rose Art Museum at least has understood that such a show is about fifty years overdue (if you don't think we had great Black artists then, look at the work of Henry Ossawa Tanner and compare him with Sargent!) and acted upon this knowledge.

It is sad that this country is going into another era of oppression, especially of new voices for change relevant to poor Blacks and Whites. But it's a fact. Artists generally have never received their proper due in this country. Perhaps that is why so many resort to sensationalism and irrelevance to make a name for themselves. Black artists, no matter what they have accomplished, still do not receive their due in recognition of their major contribution to the Black arts. The greats like Charles White, Jacob Lawrence and Romare Bearden, and local greats like John Wilson and Calvin Burnett still have not attained the stature of a Ben Shahn, Leonard Baskin or, locally, a Jack Wolfe. Why? Racism, and racism alone. Someone is perpetuating the myth that Black art is not a saleable commodity: thus we Blacks are forced to work in other areas, often for far less than we're worth, in order to get the materials for the survival of our families and our art. Because we must often work forty or fifty hours in other capacities, we can put only a part-time effort into our art, and then when we are too overtired to give it proper attention. What a loss this has been for our people! And the system which miseducates our children into thinking that art is a craft, a hobby, a plaything, deprives us of value to our community and makes our loss double—no time to work and few to respect what we do create. How long can this go on?

Whites do not know that there are brilliant Black artists. Blacks never receive the education in the Black arts to know that we exist at all, let alone are brilliant. The time we must spend in educating them is an additional drain from our work. But at least it's worth it to see a Black child's eyes light up when he or she discovers a new reason for pride in Blackness.

I deeply believe that for our four hundred years of suppression of mind and body we are owed any monies necessary to pursue our chosen profession, without having to worry about our bills or measuring up to white aesthetic values. We should be able to do our own thing for our people or for all people if that is our need. Black artists, as you can see, generally produce functional art: art with a message. I guess it's a part of our African heritage. I believe that Black art should reflect the needs of the community and be an integral part of the day-to-day existence of our people, relating to life in the way our African heritage in art does. When we as Black artists can continue that which our ancestors began for us in Africa, when "good-hearted white liberals" understand that our need as a people is not for love, compassion, friendship or other intangibles, but for all of the food, education, money, land, power and machinery that we are owed, then we will have the kind of progress that will enable me to exhibit at the Rose Art Museum and others with a good deal of pride.

Yours in Black Power,
Dana Chandler, Jr., Black Artist

1969

Larry Neal, "Any Day Now: Black Art and Black Liberation," *Ebony* 24, no. 10 (August 1969)

A year after the publication of the *Black Fire* anthology (see p. 111), Larry Neal resumed his examination of the Black Arts Movement in this essay for *Ebony*. His text discusses the movement's evolution, which he closely aligns with the principles of Black Power. As Neal saw it, the foundation of each was a desire to achieve self-determination. His thoughts here touch on the potential of Black art to liberate—to express "the Soul of the Black Nation." While acknowledging the profound changes already under way, he was insistent that Black artists no longer be forced to look at themselves "through white eyes." His assertion that African Americans needed to rethink their place in the cultural sphere was rooted in the belief that Western art was a stale, decaying system that did not speak to the realities of life. Consequently, to Neal, a Black aesthetic was not simply about art making but was equally concerned with rebelling against White sensibilities.

LARRY NEAL, "ANY DAY NOW: BLACK ART AND BLACK LIBERATION"

I was born by the river in a little old tent,
and just like the river, I've been running ever
 since.
It's been a long time, but I know change is
 gonna come . . .

—Sam Cooke

We bear witness to a profound change in the way we now see ourselves and the world. And this has been an ongoing change. A steady, certain march toward a collective sense of who we are, and what we must now be about to liberate ourselves. Liberation is impossible if we fail to see ourselves in more positive terms. For without a change of vision, we are slaves to the oppressor's ideas and values—ideas and values that finally attack the very core of our existence. Therefore, we must see the world in terms of our own realities.

Black Power, in its most fundamental sense, stands for the principle of Self-Definition and Self-Determination. Black Power teaches us that we must have ultimate control over our own lives. It teaches us that we must make a place on this Earth for ourselves, and that we must construct, through struggle, a world that is compatible with our highest visions.

This was the gut essence of the Black Power philosophy before the political butchers and the civil rights hustlers got into the game, confusing everybody and the issues. Black Power is essentially a nationalistic concept; it speaks to the suppressed need of Afro-Americans for true liberation, for Nationhood. The forerunners of the current movement were such 19th century thinkers as David Walker, Edward Blyden and Martin Delaney. The movement takes its revolutionary zeal from Gabriel Prosser and Nat Turner. It takes its Third World outlook from W. E. B. Du Bois, Marcus Garvey, Malcolm X and Frantz Fanon. And on its weaker side, it takes its economic and institutional philosophy from Booker T. Washington. Therefore, when Brother Stokely Carmichael invoked the slogan "Black Power" on the Meredith March, it was these voices speaking through him.

Now along with the Black Power movement, there has been developing a movement among Black artists. This movement we call the Black Arts. This movement, in many ways, is older than the current Black Power movement. It is primarily concerned with the cultural and spiritual liberation of Black America. It takes upon itself the task of expressing, through various art forms, the Soul of the Black Nation. And like the Black Power Movement, it seeks to define the world of art and culture in its own terms. The Black Arts movement seeks to link, in a highly conscious manner, art and politics in order to assist in the liberation of Black people. The Black Arts movement, therefore, reasons that this linking must take place along lines that are rooted in an Afro-American and Third World historical and cultural sensibility. By "Third World," we mean that we see our struggle in the context of the global confrontations occurring in Africa, Asia and Latin America. We identify with all of the righteous forces in those places which are struggling for human dignity.

Lately, Black artists have been concerned with the development, for lack of a better term, of a "Black Esthetic." Esthetic sounds like some kind of medical term. It might just as well be for all that its dictionary definition tells us: "Esthetic: 1) A branch of philosophy relating to the nature of forms of beauty, especially found in the fine arts. 2) Study of the mental and emotional responses to the beauty in art, nature, etc." —*Standard College Dictionary*.

For the most part, this definition is worthless. What the Western white man calls an "esthetic" is fundamentally a dry assembly of dead ideas based on a dead people; a people whose ideas have been found meaningless in light of contemporary history. We need new values, new ways of living. We need a new system of moral and philosophical thought. Dig: There is nothing in the above quoted definition about *people*. It is a cold, lifeless corpse they speak of; the emanations of a dead world trying to define and justify itself.

Therefore, today we bear witness to the moral and philosophical decay of a corrupt civilization. Europe and America are the new Babylons. Today, we see white artists wallowing in the sudden

discovery of the body, of sex. These hypocritical puritans now play with themselves like new-born babies. They have suddenly discovered the body which, for centuries, they denied existed. Sexploitation. Andy Warhol madness. America has become one great big dirty movie. Like suddenly sex, one of man's most natural urges, has become controversial; or at least, they would have us believe so. What's so controversial about sex? Nothing, we know.

I raise these questions to illustrate the impasse that Western art has reached. They fall back on the sex thing because they are unable to deal with the political, spiritual and cultural liberation of Man. They are unable within the confines of even their idea of art to deal with the real issues confronting Man today. And the most important of which is the liberation of the majority of Mankind. So they steal and suck Black energy, an energy which in the slop jars of their minds they distort and corrupt in their own sick images.

And backed up by a powerful and oppressive political system, he tries to force Black people to measure up to his standards. Thus, we are constantly forced to see ourselves through white eyes. We are made to evaluate our innermost impulses against his. And in the process, we do ourselves great spiritual and psychological harm. The Black Arts movement seeks to give a total vision of ourselves. Not the split vision that Du Bois called the "Double Consciousness": ". . . this of always looking at one's self through the eyes of others, of measuring one's soul by the tape of a world that looks on in amused contempt and pity. One ever feels his two-ness—an American, a Negro—two souls, two thoughts, two unreconciled strivings; two warring ideals in one dark body, whose dogged strength alone keeps it from being torn asunder. . . ."

These words are from *The Souls of Black Folk* which was published in 1903. Now, in 1969, Du Bois' sons and daughters in the Black Arts movement go forth to destroy the Double Consciousness, go forth to merge these "warring ideals" into One Committed Soul integrated with itself and taking its own place in the world. Can you dig it?

But this is no new thing. It is the road that all oppressed peoples take enroute to total liberation.

In the history of Black America, the current ideas of the Black Arts movement can be said to have their roots in the so-called Negro Renaissance of the 1920s. The '20s was a key period in the rising historical and cultural consciousness of Black people. This period grooved with the rise of Garvey's Black Nationalism, danced and made love to the music of Louis Armstrong, Bessie Smith, Jelly Roll Morton, King Oliver, Perry Bradford, Fats Waller and the Holy Father, Duke Ellington. There was a flowering of black poets, writers and artists. And there was the ascendancy of hip, blues-talking Langston Hughes who came on singing songs about Africa, Haiti, and Harlem:

> Droning a drowsy syncopated tune,
> Rocking back and forth to a mellow croon,
> I heard a Negro play.
> Dover on Lenox Avenue the other night
> by the pale dull pallor of an old gas light
> He did a lazy sway . . .
> He did a lazy sway . . .
> To the tune o' those weary Blues . . .

There were other writers of that period: Claude McKay, Jean Toomer, James Weldon Johnson, Countee Cullen. . . . But Langston best personifies the Black artist who is clearly intent upon developing a style of poetry which sings forcefully and recognizably from a Black life style; a poetry whose very tone and concrete points of reference is informed by the feelings of the people as expressed in the gospel and blues songs.

It is here that any discussion of a Black esthetic must begin. Because Black music, in all of its forms, represents the highest artistic achievement of the race. It is memory of Africa that we hear in the churning energy of the gospels. The memory of the Motherland that lingers behind the Christian references to Moses, Jesus and Daniel. The Black Holy Ghost roaring into some shack of a church in the South, seizing the congregation with an ancient energy and power. The Black Church, therefore, represents and embodies the transplanted African memory. The Black Church is the Keeper of that Memory, the spiritual bank of our almost forgotten visions of the Homeland. The Black Church was

the institutionalized form that Black people used to protect themselves from the spiritual and psychological brutality of the slave-masters. She gave us a music, a literature and a very valid and essential poetry. And when she ceased to be relevant, for some of us, we sang the blues: "They call it stormy Monday, but Tuesday's just as bad; call it stormy Monday, but Tuesday's just as bad, Wednesday's worse, but Thursday's also sad. . . ."

At the pulsating core of their emotional center, the blues are the spiritual and ritual energy of the church thrust into eyes of life's raw realities. Even though they appear to primarily concern themselves with the secular experience, the relationships between males and females, between boss and worker, between nature and Man, they are, in fact, extensions of the deepest most pragmatic spiritual and moral realities. Even though they primarily deal with the world as flesh, they are essentially religious. Because they finally celebrate life and the ability of man to control and shape his destiny. The blues don't jive. They reach way down into the maw of the individual and collective experience. Sonny Terry and Brownie McGhee sing: "If you lose your money, please don't lose your mind; If you lose your woman, please don't mess with mine."

Taken together, the blues represent an epic cycle of awesome propositions—one song (poem) after the other expressing the daily confrontations of Black people with themselves and the world. They are not merely entertainment. They act to clarify and make more bearable the human experience, especially when the context of that experience is oppressive. A man that doesn't watch his "happy home" is in a whole world of trouble. Therefore, the blues singer is teaching an ethical standard in much the same way as the poet. Only the psychic strength of most of the blues singers is often times more intensely focused than that of the poet's. We must often strain for images like: "I walked out in the Milky Way and I reached for a star. I looked across the cosmic way and my lover, she wasn't very far. . . ."

That's Jimmy Reed. As poetry, the blues act to link Man to a past informed by the Spirit. A past in which art served as a means of connecting our ancestors with the Unknown psychic forces which they knew to exist in the Universe. Yeah. Forces which they somehow felt were related to the natural operation of the Universe. (*He's a deep Sea Diver with a stroke that can't go wrong.*) The blues are a deep down thing, always trying to get to the nitty-gritty of human experience.

Therefore, no matter how you cut it, the blues and the people who create them are the Soul Force of the race, the emotional current of the Nation. And that is why Langston Hughes and Ralph Ellison based their esthetic on them. The Black Arts movement strives for the same kind of intimacy with the people. It strives to be a movement that is rooted in the fundamental experiences of the Nation.

The blues singer is not an alienated artist moaning songs of self-pity and defeat to an infidel mob. He is the voice of the community, its historian, and one of the shapers of its morality. He may claim to speak for himself only, but his ideas and values are, in fact, merely expressions of the general psychology of his people. He is the bearer of the group's working myths, aspirations, and values. And like the preacher, he has been called on by the Spirit to rap about life in the sharpest, the harshest terms possible. Also like the preacher, he may have gotten the calling early in life. He may have even sung in the church like Ray Charles and James Brown.

It is the ultimate urge to communicate the private pain to the collective that drives and pushes the blues singer from place to place to place, from job to job, from one fast moving freight train to the other. All kinds of cities and people moving through the blues experience. All kinds of human tragedies and circumstances find their way into the blues singer's repertoire. It is all about feeling. All about people. All about Truth.

Contemporary Black music and the living folklore of the people are, therefore, the most obvious examples of the Black aesthetic. Because these forms are the truest expressions of our pain aspirations, and group wisdom. These elements decidedly constitute a culture. And a culture expresses a definite feeling about the world. Otis Redding, Sam Cooke, Little Willie John, Blind Lemon, Bessie Smith, Billie Holiday, Charlie Parker, Coleman

Hawkins, Eric Dolphy and John Coltrane are, in the minds of Black people, more than entertainers. They are the poets and philosophers of Black America. Each of these artists devoted his life to expressing what Du Bois referred to as the "Souls of Black Folk." They along with the Black church are the keepers of our memory, the tribal historians, soothsayers, and poets. In them, more so than in literature, we find the purest and most powerful expression of the Black experience in America. These artists have set the standards, and the current movement attempts to meet them and, where possible, to create new and more demanding ones.

So when *we* speak of an aesthetic, we mean *more* than the process of making art, of telling stories, of writing poems, of performing plays. We also mean the destruction of the white thing. We mean the destruction of white ways of looking at the world. For surely, if we assert that Black people are fighting for liberation, then everything that we are about, as people, somehow relates to it.

Let me be more precise: When artists like LeRoi Jones, Quincy Troupe, Stanley Crouch, Joe Goncalves, Etheridge Knight, Sonia Sanchez, Ed Spriggs, Carolyn Rodgers, Don L. Lee, Sun Ra, Max Roach, Abby Lincoln, Willie Kgositsile, Arthur Pfister . . . assert that Black Art must speak to the lives and the psychic survival of Black People, they are not speaking of "protest" art. They are not speaking of an art that screams and masturbates before white audiences. That is the path of Negro literature and civil rights literature. No, they are not speaking about that kind of thing, even though that is what some Negro writers of the past have done. Instead, they are speaking of an art that addresses itself directly to Black people; an art that speaks to us in terms of our feelings and ideas about the world; an art that validates the positive aspects of our life style. Dig: An art that opens us up to the beauty and ugliness within us; that makes us understand our condition and each other in a more profound manner; that unites us, exposing us to our painful weaknesses and strengths; and finally, an art that posits for us the Vision of a Liberated Future.

So the function of artistic technique and a Black esthetic is to make the goal of communication and liberation more possible. Therefore, Black poets dig the blues and Black music in order to find in them the means of making their address to Black America more understandable. The Black artist studies Afro-American culture, history, and politics and uses their secrets to open the way for the brothers with the heavy and necessary political rap. We know that art alone will not liberate us. We know that culture as an abstract thing within itself will not give us Self-Determination and Nationhood. And that is really what we all want, even though we fail often to admit it openly. We want to rule ourselves. Can you dig it? I know you can.

But a cultureless revolution is a bullcrap tip. It means that in the process of making the revolution, we lose our vision. We lose the soft, undulating side of ourselves—those unknown beauties lurking rhythmically below the level of material needs. In short, a revolution without a culture would destroy the very thing that now unites us; the very thing we are trying to save along with our lives. That is, the *feeling* and *love-sense* of the blues and other forms of Black music. The *feeling* of a James Brown or an Aretha Franklin. That is the *feeling* that unites us and makes it more possible for us to move and groove together, to do whatever is necessary to liberate ourselves. John Coltrane's music must unquestionably be a part of any future revolutionary society, or something is diabolically wrong with the fools who make the revolution. A revolution that would have Leonard Bernstein, Bobby Dylan or the Beatles at the top of its cultural hierarchy would mean that in the process of making the revolution, the so-called revolutionaries had spiritually murdered Black people. (Bobby Seale are you listening?) A future society without the implied force and memory of Bessie Smith, Charlie Parker, Sun Ra, Cecil Taylor, Pharoah Sanders and Charlie Mingus is almost inconceivable.

The artists carry the past and the future memory of the race, of the Nation. They represent our various identities. They link us to the deepest, most profound aspects of our ancestry. [. . .]

The Black Arts movement is rooted in a spiritual ethic. In saying that the function of art is to liberate Man, we propose a function for art which is

now dead in the West and which is in keeping with our most ancient traditions and with our needs. Because, at base, art is religious and ritualistic; and ritual moves to liberate Man and to connect him to the Greater Forces. Thus Man becomes stronger psychically, and is thus more able to create a world that is an extension of his spirituality—his positive humanity. We say that the function of art is to liberate Man. And we only have to look out of the window to see that we need liberation. Right on, Brothers. And God Shango, help us!

This is what's on Ameer Baraka's (LeRoi Jones) mind. He could have been the pawed-over genius of the white literary establishment. But he peeped that they were dead, and that they finally had nothing to give—the future ultimately did not include them. It was LeRoi who first used the term "Black Art" in a positive sense. In the Western world view, it is connected with the "evil," "dark" forces of witchcraft and demonology. It was LeRoi who first shifted and elevated its meaning, giving it new significance in the context of a Black esthetic.

In a poem entitled "Black Art" he sings that Poem is the Black nation: ". . . We want a black poem. And a Black world. Let the world be a Black Poem. . . ."

Therefore, the Poem comes to stand for the collective consciousness of Black America—the will toward Nationhood which is the unconscious motivation in back of the Black Power movement. It comes to stand for a radical reordering of the nature and function of both art and the artist.

[. . .]

The Black Arts movement preaches that liberation is inextricably bound up with politics and culture. The culture gives us a revolutionary moral vision and a system of values and a methodology around which to shape the political movement. When we say "culture," we do not merely mean artistic forms. We mean, instead, the values, the life styles, and the feelings of the people as expressed in everyday life. The total liberation of Blues People can not be affected if we do not have a value system, a point of reference, a way of understanding what we see and hear every day around us. If we do not have a value system that is, in reality, more moral than the oppressor's, then we can not hope to change society. We will end up taking each other off, and in our confusion and ignorance, calling the murders of each other revolutionary. A value system helps us to establish models for Black people to emulate; makes it more possible for us to deeply understand our people, and to be understood by them.

Further, the Black Arts movement proposes a new "mythology." What musician-poet Jimmy Stewart calls a "Black Cosmology," a Black World-View that is informed by the living Spirit. According to Stewart, such a world view would make easier and more natural the shaping of the Black artistic, cultural and political forms. This idea has fantastic implications for religion, as the Hon. Elijah Muhammad and Detroit's Rev. Albert Cleage have demonstrated.

Like can you dig it: We have been praying to the wrong God. And who is God anyway but the awesomely beautiful forces of the Universe? The Black Sun exploding semen into Her dark body. Your ancestors are the Gods who have actually walked this planet. Those who have tried to liberate us. Nat Turner, Harriet Tubman, Malcolm X, they are surely Gods. They preached Black Liberation. And Black Liberation is far more important than some Alice-in-Wonderland Heaven. Black Art must sing the praises of the true gods of the planet. We don't need any soulless Hebrew God. We need to see ourselves reflected in our religions. For prayer is poetry; and like poetry it acts to reinforce the group's vision of itself. If that vision is rooted in an hypocritical alien force, we do ourselves great psychic and psychological harm by adhering to it. For example, one of the first things the Algerians did when they began to fight the French was to cease allowing the colonial authorities to conduct their marriage ceremonies.

Like Black Art, Black religion should be about strengthening group unity and making radical change. If your minister is not, in some way, engaged in the job of achieving Black freedom, he is a con man. Cut him loose quick.

[. . .]

Religion, therefore, like politics, can embrace all of the ideological features of the liberation struggle. What is needed, however, is a change of

references. A hippy Jesus won't do. A change of references is needed in black popular music also. Like: We can't go into the future singing: *Who's Making Love to Your Old Lady* or *It's Your Thang, Do With It What You Wanna Do.*"

It is the task of the Black artist to place before his people images and references that go beyond merely reflecting the oppression and the conditions engendered by the oppression. Don't condemn the people for singing the blues. Write a blues that takes us to a more meaningful level of consciousness and aspiration. But also understand the realities of the human condition that are posed by the blues. Take the energy and the feeling of the blues, the man-gled bodies, the broken marriages, the moaning nights, the shouting, the violence, the love cheating, the lonely sounding train whistles, and shape these into an art that stands for the spiritual helpmate of the Black Nation. Make a form that uses the Soul Force of Black culture, its life styles, its rhythms, its energy, and direct that form toward the liberation of Black people. Don't go off playing Jimi Hendrix or something like that. Respect and understand the culture. Don't exploit it.

Put it into meaningful institutions that are run and controlled by Black People with a vision. What Ameer is trying to do in Newark. What Clarence Reed and the beautiful young Brothers of the Har-lem Youth Federation are trying to do at the Black Mind in Harlem. What Jacques and Cecilia and the other Liberators of the National Black Theatre work hard at daily. Give to the culture temples like the East Wind where you can see the Last Poets. Build something like Gaston Neal's school in Washing-ton, D.C. Let us see theaters like the new Lafayette springing up wherever Black people live and work. Construct Black Universities like Abdul,[1] A. B. Spell-man and Vincent Harding are trying to do. Because these attempts at building Black Institutions are not merely *cultural* in the narrow sense of that word. They are finally about the physical and spiritual sur-vival of Black America. In the context of our struggle *here*, they are as important as the gun. [. . .]

The Black Arts movement supplies the political brothers with an arsenal of feelings, images, and myths. [. . .]

NOTE

1 [Abdul Alkalimat (born Gerald A. McWorter in 1942) is a professor emeritus at the University of Illinois at Urbana-Champaign. See Gerald McWorter, "The Nature and Needs of the Black University," in "The Black University: A Revolutionary Educational Concept Designed to Serve the Total Black Community," special issue, *Negro Digest* 17, no. 5 (March 1968): 4–13. —Eds.]

Elsa Honig Fine, "The Afro-American Artist: A Search for Identity," *Art Journal* 29, no. 1 (Fall 1969)

Elsa Honig Fine was born in Bayonne, New Jersey, in 1930. This essay was published in the periodical *Art Journal* shortly before Fine received her doctoral degree in art history from the University of Tennessee in 1970. Her dissertation, "Education and the Afro-American Artist," surveyed the role Black artists could play in society as equals to their White counterparts. Fine became interested in researching African American artists, recognizing their absence from art history, after applying for a teaching position at a college in Knoxville whose student population was primarily Black. In this text, she outlines the recent trajectory of the African American artist in the United States. In 1973, she followed up her essay with a book of the same title, published by Holt, Rinehart and Winston.

ELSA HONIG FINE, "THE AFRO-AMERICAN ARTIST: A SEARCH FOR IDENTITY"

Today the black militant is trying to forge his image on the American cultural scene. Not content to be a pale imitation of white middle class society, all too frequently the goal of his brethren in the earlier decades of this century, he wants to be judged on his own terms, by his own values and standards. He no longer feels inadequate because of his peculiar speech patterns, hair texture or body structure. He is forcing additions and changes in the curriculum in the high schools and universities. Refusing the role of the "invisible American," the black is demanding recognition and compensation for centuries of subjugation and discrimination.

The black musician has left his imprint on the American culture. The black painter is trying to do the same. These questions are often asked: Why is there not a black visual art tradition comparable to the black musical tradition? And what is the role of the black visual artist? Where do his traditions lie, with the American culture or with his African heritage? And what should be the unique contribution of the black artist? Should he express his inner emotions in his art, or does his responsibility rest with his people? These are not new concerns. They are questions that have troubled black intellectuals for nearly a century, reaching their climax during the Negro Renaissance of the 1920's, and reemerging with the militancy of the sixties.

[In the next few paragraphs, Fine outlines the history of African American art from slavery to Spiral, with a focus on the debates around the theories espoused by the Harlem Renaissance philosopher Alain Locke (1885–1954).]

A visitor from a foreign country sees the Afro-American as American. His attitudes and values, his goals and ideals, are all shaped by the American environment. His dream has been the American dream. Yet his experience in this country has been unique. Snatched from his ancestral home, denied any cultural continuity, he was forced to absorb the life he saw, but was never allowed to become part of the great American "melting pot." He has been an alien in his own land. Yet this situation can be used advantageously. The creative artist, in order to be free to explore new worlds, must remain separate from, or alienated from the larger culture. Being outside the culture, he is free to mold it, shape it, and lead it to higher ideals, without fearing the judgment of the larger society. This is both the tragedy and the opportunity of the black artist. Shaped by his environment, trained by its institutions, he has an addendum, a deeper and richer, though often tragic, experience from which to draw his inspirations.

Returning to Africa for roots and tradition is not the answer. The Afro-American seeking solace in black Africa has found that he is a stranger in a distant land. By taking advantage of the opportunities offered by both American societies, black and white, separate yet similar, the Negro artist will be free to create. The bloodshed and hostility engendered by the battle with the larger group can only lead to creative impotence. This is not to say that he should submit to oppressive situations. Where there is discrimination, the battle should be fought. But to destroy a society is not a creative act.

Perhaps Edward Wilson, a sculptor at the State University of New York at Binghamton, has the solution. Rather than committing himself exclusively to the fight for equality, the black artist should "commit himself to seeking humanistic values."

To seek the universal in the specific, to transform the Negro experience into "universally understood terms," this is the role of the Afro-American artist. The Negro jazz musician has done this, and of all the black artists, Jacob Lawrence comes closest to realizing this fulfillment.

Ameer [Amiri] Baraka, "The Black Aesthetic," *Negro Digest* 18, no. 11 (September 1969)

Negro Digest was launched in 1942 as a serious outlet for discussion of the African American experience. It featured writing by leading intellectuals of the day and became a key publication of the Black Arts Movement. Hoyt Fuller, previously an associate editor at *Ebony*, edited the magazine from 1961 until the final issue in 1976, transforming it into a vital and thoughtful forum for Pan-Africanism. Amiri Baraka's article was published in the annual poetry issue, the cover of which featured Mari Evans's poem "I Am a Black Woman." The issue was dedicated to Gwendolyn Brooks, who, in 1950, had become the first African American to win the Pulitzer Prize for poetry. By the late 1960s, Baraka had established himself as a pioneering and highly influential figure. After working early in the decade as an author, publisher, and playwright on the Lower East Side, where he became a fixture at workshops and events and a mentor to other writers, Baraka moved to Harlem a month after the assassination of Malcolm X, in February 1965, and helped to make Harlem a hub for artists of the African diaspora. As this essay outlines, the concept of a single Black nationhood was at the heart of Baraka's project. To him, the Black aesthetic was grounded in the collective efforts of all African American artists—whether writers, painters, or dramatists—to make art that underlined a "commitment to revolution" with the intention of creating "the nation."

AMEER [AMIRI] BARAKA, "THE BLACK AESTHETIC"

We are clawing for life. The forms will run and sing and thump and make war too. We are "poets" because someone has used that word to describe us. What we are our children will have to define.[1]

What does aesthetic mean? A theory in the ether. Shdn't it mean for us Feelings about reality! The degrees of in to self registration Intuit [*sic*]. About REality. In to selves. Many levels of feeling comprehension. About reality.

We are our feeling. We are our feelings ourselves. Our selves are our feelings.

Not a theory in the ether. But feelings are central and genuine and descriptive. Life's supremest resolution is based on wisdom and love.

How is a description of Who. So a way of feeling or the description of the process of is what an aesthetic wd be.

Our selves are revealed in whatever we do. Our art shd be our selves as self-conscious with a commitment to revolution. Which is enlightenment. Revolution is Enlightenment.

The purpose of our writing is to create the nation. (The advanced state of creation. Create an individual ego, that is one measure. . . . Create the nation and the muscle of that work is, you see?, a gigantic vision . . . the difference between building a model airplane and the luftwaffe). In this grand creation is all creation and the total light of man in heaven—himself realized—as the expanded vision of the angel.

We want a nation of angels. The illuminated. We are trying to create in the same wilderness, against the same resistance. The fire is hot. Let it burn more brightly. Let it light up all creation.

The intent is the guide, the direction. (As Maulana Karenga has said, all that we do as black artists must commit us collectively to revolution.) "Collective and committing." The purpose itself is the spirit path. Without the spirit, the "blackness" is a mask of minor interest. A stutter or a note. Light is the answer, and to understand this is to be committed, through faith, to its existence. Poetry is jingling lace without *purpose*.

Light has a style. Blackness is a force. All the power must be summoned from everywhere it exists as real power.

Its criticism will be its absence, its failure to exist. Re: SoCalled "LiteraryNegroes"/

There is still an entrail, an inside navel connection with the bodies of the dead. The dead white bodies puked out in a slow trickle and researched and sprayed, for life, and stood up and made to curtsy, an agonizing computerized boogaloo going for straighten up and be intelligent.

We are clawing for life. The forms will run and sing and thump and make war too. We are "poets" because someone has used that word to describe us. What we are our children will have to define. We are creators and destroyers—firemakers, Bomb throwers and takers of heads.

Let the fire burn higher, and the heat rage outta sight.

Can you define this mad beauty now at its crazy summit. Can you Pipsqueak a form when it is more energy that is needed. More Energy! The combinations exist and will exist. The double clutching triple stopping fipple tonguing intelligence is evolving and learning and meditating at incredible speeds.

The new poetry is structures of government and shapes of cities. The boomaloom of words will shape a vision scattered from Johnny Boy's mouth and carry all the street noise as Mass Music and Sphere Image. To Destroy and Survive and Defend and Build.

We do not worry about anything but dullness, flatness and worship of texts which are rubberbanded to plain death.

The breakthru the break out the move New ness New forms Explorations Departures all with the responsibility to force and be change all with the committment to Black Revolution, utilizing the collective spirit of Blackness.

(I say another time, The harmonics in James Brown's voice are more "complicated," if that's what you dig, than Ornette Coleman will ever be. Altho,

and here's the cold part, there was a time, when Ornette cdda gone straight out past Lama city, and the pyramids of black gold. His tune was that hip . . . once!!! It was his life, and his commitment, as path, that changed it.)

Revolution, will provide the fire in your loins, them hot rhythms, jim. Work is the spirit of rhythm. Carry yr book with you. Hard work. Brutal work. (Sing sing, song in yr back pocket.[2] Build a house, man. Build a city. A Nation. This is the heaviest work. A poem? One page? Ahhhh man, consider 200,000,000 people, feed and clothe them, in the beauty of god. That is where it's at. And yeh, man, do it well. Incredibly Well.

NOTES

1 [This is a pull quote from the article itself. —Eds.]
2 [There is no closing parenthesis in the original text. —Eds.]

1969

Roy DeCarava: *Thru Black Eyes* (unsigned text), pamphlet for exhibition held at the Studio Museum in Harlem, New York, September 14–October 26, 1969

Roy DeCarava was born in Harlem in 1919. In 1952, with the encouragement of the photographer Edward Steichen, who was then director of the Museum of Modern Art's Department of Photography, he was awarded a Guggenheim Fellowship. Shortly after, he founded a gallery in his own apartment—one of the first spaces in New York dedicated to selling photographs. His book *The Sweet Flypaper of Life*, a collaboration with the poet Langston Hughes, was published by Simon and Schuster in 1955, and in the mid-1960s, DeCarava served as the first director of the Kamoinge Workshop in New York, a collective of African American photographers. In 1969, he refused to participate in the Metropolitan Museum of Art's *Harlem on My Mind* exhibition (see pp. 134–35, 201n2, 223). Later that year, the Studio Museum in Harlem recognized DeCarava's contributions by giving him his first major solo exhibition. Reviews of the show by Larry Neal and A. D. Coleman appeared in 1970 in the *New York Times* and *Popular Photography*, respectively (see pp. 195–201).

ROY DECARAVA: THRU BLACK EYES

He began a new tradition in the art of photography, and his works are in the permanent collections of major museums. Yet Roy DeCarava, at 49, remains a photographer's photographer, profoundly respected within his profession, relatively unknown outside of it.

According to James Hinton, a leading young black photographer and film maker, "DeCarava was the first black man who chose by intent to document the black and human experience in America, and he has never wavered from that commitment. He was the first to devote serious attention to the black aesthetic as it relates to photography and the black experience in America. For those of us who knew his work at first hand, he set a unique example. His influence today extends throughout the field." The photographs in *Thru Black Eyes* are concerned with the human experience, especially as it relates to black people. They are characterized by an extraordinary directness, a deceptively simple immediacy, and they reveal an underlying optimism about people and about life that belies the artist's childhood in Harlem.

Roy DeCarava became a photographer because he wanted no dichotomy between what he is and what he does. He had started out to be a painter, but he is black and he discovered he could survive in this art form only by denying spiritual values fundamental to his identity as a black man. "You should be able to look at me and see my work. You should be able to look at my work and see me," he says. "A black painter to be an artist had to join the white world or not function—had to accept the values of white culture, like emphasizing technique in painting rather than what the artist feels. Black people have a spiritualism, maybe because for so long they had nothing else."

1969

Edward K. Taylor, "Foreword," and Joe Overstreet, untitled statement, in *New Black Artists*, catalogue for exhibition held at the Brooklyn Museum, October 7– November 9, 1969

The exhibition *New Black Artists* featured twelve painters and sculptors, including Joe Overstreet. It was organized by the Harlem Cultural Council, a prominent Black advocacy group, in conjunction with the School of the Arts and the Urban Center at Columbia University, where the exhibition later traveled. In his introduction to the exhibition catalogue, Edward K. Taylor, the council's executive director, discussed the role of "Black feeling and experience in shaping the expression of Black artists." The show was a key turning point for Overstreet, who, in his artist's statement, began to for-mulate ideas of a Black aesthetic connected to his new work. Having pre-viously worked figuratively, the artist, in new abstract works such as *Alpha and Omega* and *Ungawa—Black Power*, created shaped canvases relating to forms from Benin, ancient Egypt, and other cultures. These later led to his unstretched canvases of the early 1970s, which had ropes threaded through them by which they were attached to the ceiling, walls, and floor (see pp. 174–75).

EDWARD K. TAYLOR, "FOREWORD"

It is hoped that this exhibition will serve the dual purpose of introducing to a wider public the work of twelve serious Afro-American artists, and of raising the question—as a question—of the role of Black feeling and experience in shaping the expression of Black artists.

This is not the place to rehearse all the circumstances of the historical exclusion of Black artists from the mainstream of American art. These things are well known. Let it suffice to say that this adverse pressure has meant a denial to Afro-American artists of precisely that creative freedom which is essential to any artist—the freedom to dream with one's own vision in a context where that vision is taken seriously. The matter of making a living professionally is only a part of the problem; the larger problem is that of, quite literally, our culture—that medium which will permit a gifted artist to grow and flourish. These problems, never easy for the artist in America, have been doubly compounded for the Black artist by the white world's ignorance of his culture and indifference to his serious intent.

The question of the relation of Black identity to works of art is complex and bound to be controversial. One reason for the sharp division of opinion lies in the understandable reluctance of the art world to deal in categories other than those established in the Western art-historical continuum. I can only suggest that there may be room for another category of interest; that there are certain qualities which, to my eye, create significant relationships among Black artists. Some of these qualities are: a need for immediate communication, a concern for getting a message across; the necessity for a dramatic posture, for "soul"; a desire to protest the racial condition; a sense of color related to black skin and the bright sun of the South and of the jungle; a sense of form which is deliberately simple and straightforward and often has a primitive, rough or unfinished feeling; and, finally, a certain involvement with the world of Ju-Ju, of ritual and witchcraft.

Of more concern to me in this controversy than the interpretation of Black Art is the expressed fear of some Afro-American artists that any serious presentation of Black Art as such will create too rigid a category—a "bag" into which the establishment may be only too happy to put all Black artists, no matter what the character of their work or of their intent. The white art world could so easily reject their already proven abilities to work in past and current modes and decide to consider all Afro-American artists in terms of Black Art alone—a prime example of "the American cultural cotton fields." I would like to believe that in America in 1969 we no longer have to think in terms of such basic ignorance and prejudice. I would like to believe that each Afro-American artist should be able to work in his own personal style, whether it be more related to a Black esthetic or to an international esthetic, and be accepted according to the quality of his work. After all, in music we do not perform spirituals or "soul" works alone, but also opera and lieder. In the dance we are not simply primitive and modern dancers, but ballet dancers as well.

[Here, Taylor describes how the Harlem Cultural Council began organizing the exhibition.]

It seems only right, at a moment when there is at once such a deliberate avoidance of and so much about "Black Art" that we should give some of these artists a chance to be seen and discussed in their own right.

Nonetheless, this exhibition does not purport to make a doctrinaire statement about Black Art. It is really only a beginning, a hint of uncovered ground and a new area of exploration. The simple fact is that most of the artists represented here are not just incidentally Black, but have Blackness as an important element of their work. We have tried to present an exhibition of Black artists, in which the word Black has meaning.

JOE OVERSTREET

I like to think of black as being infinity and not as having a scientific scale. Black art is a spiritual movement like black magic, or witchcraft. Magic has always been used and probably will always be used.

Black people in America are superstitious; that is why a voodoo art is necessary. Infinity does not reason with reality nor do black people . . . the only thing that is real is time and space. Power changes hands, but time and space remain the same. America has created a new form of the supernatural, one of a class struggle. (The American dream in black and white.) The spiritual magic that motivates black art is in direct contact with a master sun that controls our universe and is in every man. Black art like mortality is a very superstitious consciousness of time and space.

NIGHT IS FALLING UPON US!

**Lawrence Alloway and Sam Hunter, "Introduction";
Frank Bowling, "Notes from a Work in Progress"; and
William T. Williams, Jack Whitten, Melvin Edwards,
Al Loving, Daniel LaRue Johnson, and Frank Bowling,
untitled statements, in *5+1*, pamphlet for exhibition held
at the Art Gallery of the State University of New York at
Stony Brook, November 12–23, 1969**

The exhibition *5+1*, which was, in some ways, a continuation of the curatorial approach of the Studio Museum in Harlem's summer 1969 show *X to the 4th Power*, was organized by Frank Bowling in conjunction with Lawrence Alloway and Sam Hunter. Then professors at SUNY–Stony Brook and Princeton University, respectively, the two men had previously worked at the Solomon R. Guggenheim Museum and the Jewish Museum, New York. The title made reference to the number of artists included in the exhibition: Melvin Edwards, Daniel LaRue Johnson, Al Loving, Jack Whitten, and William T. Williams were the five, and Bowling was the "+1" of the group, as he was not American and was also a critic. The exhibition pamphlet includes a central text by Bowling as well as statements by each of the artists, some of whom seem to be joking at the convention of the artist's statement itself.

LAWRENCE ALLOWAY AND SAM HUNTER, "INTRODUCTION"

The way in which this exhibition came about should be recorded, as it is the only way to express our gratitude to its organizer, Frank Bowling.

Frank Bowling was uniquely able to surmount the divisive cultural problems involved. Mr. Bowling is a Black artist living in the United States, but not of American birth; the other five artists are American by birth and, like him, now live in New York City. (In this respect all six artists are like most artists in New York, out-of-towners by birth.) Mr. Bowling's position as part of the Black community is complemented, as a result of his different background, by the knowledge of detachment as well as of participation. He is the only artist at present in a position to act as a critic, a man able to speak to two different groups—the artists and their audience (an audience that is still mostly White).[1]

The situation of Black artists is ambiguous: there is considerable use of the idea of art as an instrument to advance Black identity, Black rights; there is, also, clearly and successfully, an impulse towards the making of art as art. In the artists' statements in this catalogue, both possibilities oscillate. One attitude shared by the present artists is worth isolating. Edwards' desire for an art beyond aesthetics, Loving's view of the "artist as part-prophet," Williams' "we are action painters," Bowling's relevant-irrelevant account of the genesis of his present paintings, are pungently mid-century in ideas and style (another name for mid-century is "Art Since 1945").

This is the period of existentialist criticism, of Abstract Expressionist attitudes; thus the language of the present artists is not specifically their own, but a shared language of post-war art. The alienation, the floating revolutionary impulses, the epistemological doubts, are not racial in origin but professional. Viewed in this way, the two themes of aesthetics and protest can be joined. The Black artist has a social framework in which to enact artistic problems; protest serves as a metaphor of the alienation felt by all Abstract Expressionist artists. Hence the fact of making art becomes its social significance.

FRANK BOWLING, "NOTES FROM A WORK IN PROGRESS"

In a lecture on *Liberation from the Affluent Society*, Professor Herbert Marcuse names several philosophers, none of whom deal with Black existence. Marcuse, an eminent thinker on the contemporary scene, is often called upon to pronounce on current issues. When he talks about a "society which develops to a great extent the cultural needs of man, a society which delivers the goods to an ever larger part of the population," does he mean to include Blacks? In reference to the title of his lecture: Blacks have always been "liberated" from the affluent society.

From masks to funeral jazz, from politically subversive spirituals to the work of present Black artists and writers, the relationship between aesthetics and reality is binding, deliberate, and harmonious.

Black artistic endeavour has never been accommodated in the dialectic. In fact, one might say that in the socio-cultural contract an "exclusion" clause was written in for Blacks.

Blacks are, with few exceptions, equivalent to the Masses.

It is certain that Black as art is not as readily available as Black as militant. Black, aspirationally, politically, sociologically. Black art demands the same learning, knowledge, in-touch-withness as any art. Black art is not isolated by Africanisation with its implied stagnation.

Two positive virtues of Black art: (i) an awareness of the solid canons of traditional African artistic expression and thought (which have contributed to 20th century western art); and (ii) that powerful, instinctive, and intelligent ability which Blacks have shown time and again, despite inflicted degradations, to rearrange found things, redirecting the "things" of whatever environment in which Blacks are thrown, placed, or trapped.

The late Bob Thompson and his work is an example of great significance. Dead, tragically, before he was thirty, he managed nevertheless to bring an intuitive, sneaky cognizance of European master-works to his own art, very like the edgy

and complicated existence of Blacks in the United States. It is an understanding which is not merely instinctive, but rich in the studied variety of a people who live an utterly ambivalent interior life in complete contrast to the smiling and dancing stereotype.

The work of Mel Edwards has Black content: the way chains, barbed wire, trusses, and the like are put together has a kind of high-spirited canter, a humour, the equivalent of which can only be found in all that "rapping" and palm-slapping and carrying-on when Black cats meet.

Frontally, "uptown" William T. Williams' paintings seem dead-pan, unsmiling, and precise. From the side all the "flawa" appear: the dragging of a paint-clogged brush creates a zig-zag pattern like the charting of a breathless pulse-beat. This surface is Black in so far as this seemingly logical concept (I do not mean simply the way the paint is brushed on, but the way the wide bands of color collide and disperse) is achieved by the most irrational of means. Jack Whitten's paintings are the intense end-product of a running, jumping, and standing-still mind not afraid to re-open the argument about, and add a new twist to, gesture as content. Al Loving's intricate and delicately balanced color sense reveals even more than Williams', that rank expressiveness one finds so clearly defined in the dress style of certain uptown types, that preference for gingery and cheekily-designed "ice-cream" suits. The clothes and their demanding subtlety function rather like peacock feathers. Loving's paintings, with their near-sweet color avoid being confections by his thorough understanding and natural use of geometric structures. Dan Johnson's head-on clash with certain linear aspects of traditional African sculpture has enabled him to produce sunny and original work. Avoiding the Minimalist dilemma (from the same pod surely grew this pure shoot, as the other half of a dicotyledon plant), Johnson's work has a distinct Californian flavour.

The structure of Black life has revealed, over centuries, a creative, self-perpetuating process of anarchist, pro-life zeal which a study of the fine arts and history alone, though helpful, can never fully define. That all-embracing and strange power of Black people, their rugged individualism, dignity, and strength: it is with these values that the exquisitely dressed corner boys must identify, if only in terms of Black pride that some of the Brothers are "out there" doing it, rather than with the current abstractions of politics and sociology.

MELVIN EDWARDS

It is necessary to be free enough to create beyond the boundaries of any esthetic and make that freedom plastically manifest. To improvise is the only real and constantly dynamic revolutionary way to be. I have known for thirty years that the color of the first earthman to visit the moon would be "White." I have taken the stand that I can deal with perception from any angle or as directly as I choose. The time is a choice, the place is a choice, and the act or object is a choice in time which I often choose to syncopate. To put some English on the ball is a choice of moves and weapons in the middle of the struggle's circle of stainless steel. Black and white, red, yellow and azul, are necessary angles and rattles modifying the connections of the cosmos. It is murderously masochistic and sadistic to put art before man. All formal values are rhetoric and at this time real beauty is the knowledge that I would burn, slash, trample, and destroy all of the objects in the world in order to create a better time and place. 9/20/69

AL LOVING

To me the wall is the painting. I am tired of objects on walls. The wall must be pierced, brought forward, pushed back. The hexagon is capable of expanding, of occupying a given space. I am a universalist. I see the role of the artist as part-prophet, one who creates a visual reaction to possible projected changes. Being black at the expense of all other things is capitulation. Most viewers either like a thing or they don't. Explaining the reasons for their feelings doesn't change their view very much. The social-political perceptions I have which motivated my particular approach I can only speak about personally. I have been asked how my

isometric cubic or septehedrons could possibly be of any relevance to present social political ideals. The truth is that there is none. I say "prepare the senses" as opposed to informing the senses, as the media says.

JACK WHITTEN

My vision of art is that of Pinkism. Pinkism is the personality of the world expressed in pure plastic symbols. Pinkism combines all the isms of art history, especially those of contemporary times. At present I am the only true believer in Pinkism, but like all isms when introduced to the mass media it establishes instant followers. The creation of a pink world became evident to me when I started seeing pink angels on my canvas, pink horses, pink women with pink *blip*, pink cats that *blip* pink *blip*, and big pink elephants with tiny pink *blip*. I have seen pink mountains where pink stinky goats grazed upon pink grass placed within a pink holy sky. I have seen pink pigs and pink dollars . . .

DANIEL JOHNSON

I will bless the Lord who hath given me understanding: I set God always in my sight; for He is at my hand that I be not moved.

WILLIAM T. WILLIAMS

Myth of Revolution . . . this community of culture will not depend upon geographical confines, especially when these confines are destructive to dreams. The dreams of dreamers are directly related to the system which suppresses them . . . blackness is always the subject matter in the mind of the insane . . . so complex as to define description. The future of the unreal is the life line of Blackness . . . do not look for stylist directions. Blackness itself is a movement. Far greater . . . more profound, than any neo-plasticism, constructivism, fagism, could ever aspire to be. What movements give, Blackness has taken for granted . . .

We are surrealists (or we could not have survived).
 We are primitives.
We are humanists.
We are hard edge.
We are earth people.
We are action painters.
WE ARE BLACK.

Black artists should sell their egos by the yard, pound, or inch . . . store them in reachable plastic cocoons to await metamorphosis. Black artists should see space and dreams. Black artists will see love and lust. Field painting is a term used to describe egotistical racist ideas. Earth works were done by slaves who later became Baptist ministers and wrote essays about numerical symmetry.

 Winds and rumors destroy work by Black artists . . . later to be rediscovered by French moralists and homosexual hounds.

a, a, a, a, a, a, a, a,
a, a, a, a, a, a, a, a,
a, a, a, a, a, a, a, a,
X, X, X, X, X, X, X,
X, X, X, X, X, X, X,
X, X, X, X, X,
X, X, X, X, X,

FRANK BOWLING

The works in this show are a direct result of a rejected book jacket I did for the English edition of LeRoi Jones' *Black Music*. I say "rejected"; it might be more correct to say the publishers and I had a disagreement. As the only Black artist on the English scene, it was natural for my friend Martin Green to offer me the cover. The disagreement was over how much a publisher could expect to get for £25. The result was that my rough was never returned. In many ways the present work has nothing to do with the earlier episode.

NOTE

1 During 1969 Bowling has published criticism in *Arts*, Vol. 43, February, March, April, May, Summer.

Frank Bowling, "Joe Overstreet," *Arts Magazine* 44, no. 3 (December 1969–January 1970)

Joe Overstreet received his first major solo exhibition in winter 1969–70. The show, mounted at the Studio Museum in Harlem, included several intensely hued, hard-edged, curved canvases. In Bowling's opinion, Overstreet possessed an "unusual and bold understanding" of color, shape, space, and geometry. He also identified Overstreet's interest in the artistic traditions of Africa. However, as Bowling made clear, such curiosity on the artist's part arose from a preoccupation with form rather than from any historical or spiritual concerns.

FRANK BOWLING, "JOE OVERSTREET"

Joe Overstreet's first, comprehensive one man show is this season at the Studio Museum in Harlem. It is the most challenging pictorial confrontation in my recent experience. This show is a triumph!

Much of the work through aesthetic aspirations ends up with a certain academic rigidness. But Overstreet, along with all other major painters, is exploring painting as a first-order activity. He is unique in that with all the rhetoric, his efforts in breadth and detail provides us with an unusual and bold understanding. Color resonance for emotion, shape for edgy understanding of protection. Space for essential change. The wall is not dealt with formally, but with utter distrust: first tentatively. Formal (western) geometry plays an ever increasing part in Overstreet's work. The most distinguished is *Tribal Chieftain* which looks like a big kite. Four equi-v's isosceles triangles[1]—juxtaposed to asymmetrical triangles are constructed freehand; they rotate in a circular motion, becoming the straight-lined edges of this shaped canvas. They ripple over and under, now concave, now convex, leaving slightly optical rectangles partly through the choice of color (these areas are painted red and black) but very much through their irregular freehand placing. The whole primary structure and primary color field oscillates between the complementaries—yellow/blue, red/green—setting up a resonance lateritious in content and firm in delivery. All of these elements tend to aid the lucre of visual knowledge, the illusion of a stuttered, vibrant, indefinite, yet unequivocal color flow.

The geometrical discontinuity and sectional structure disengage the optical flow to leave a fictile arena flat in color resonance unlike what one finds in large, single color field paintings, like Rothko's where the subtle changes billow like a heart pumping warm blood. "All pervading, as if internalized [is the] sensation of dominant color . . ." is an observation made by Professor Meyer Shapiro. Mr. Overstreet has managed to hold down this busy flutter—the seen image—by a process, in the studio, of heightening and slackening to give full vent to a personal morphology. He tightens up the painted surface as a whole to prevent complementary color from interfering with the sinuosity of an open, accommodating, spatial illusion. This space integrity is countenanced by the almost compulsive maintenance of a map-structured African experience. The almost abstract (in a western sense) structures of shields and other African utility are designs which preoccupy Mr. Overstreet; but he is not involved with them in any but an anterior frontal sense, once removed from the spiritual fatherland.

He-She, a work of two six-sided figures strutted together, is built up from a beginning base of two casually constructed rectangles shifting left to right, right to left—dominant red into orange, yellow into green. It reaches out somewhere to the borders of being the completely successful pictorial statement. All in all one can choose any of the paintings, even the ones that failed, to demonstrate the arrival of a truly striking new talent on the scene.

NOTE

1 [This is to be read as "Four equilateral versus isosceles triangles. . . ." —Eds.]

1969

Samella S. Lewis, "Introduction"; Ruth G. Waddy, "Introduction"; and Gary Rickson, David Hammons, John Outterbridge, Betye Saar, Dana Chandler, Cliff Joseph, Marie Johnson, David Bradford, David Driskell, Phillip Mason, Samella Lewis, and Robert Sengstacke, untitled statements, in Samella S. Lewis and Ruth G. Waddy, eds., *Black Artists on Art* (Los Angeles: Contemporary Crafts, 1969)

The artists Samella S. Lewis and Ruth G. Waddy were pivotal figures in the Los Angeles art scene of the 1960s and 1970s. Both became known for powerfully graphic prints and lithographs. They were also influential activists, setting out to raise awareness of Black artists in California. In 1962, Waddy, who had studied at Los Angeles City College and the Otis Art Institute, founded Art West Associated, the first large-scale organization to support African American artists in the region. As a student, Lewis had met Elizabeth Catlett and Charles White, who became her mentors, and in 1951, she received a doctorate in art history from Ohio State University. In 1969, she accepted the position of education coordinator at the Los Angeles County Museum of Art (LACMA) to help create exhibition opportunities for African American artists. During this time, Lewis helped to initiate Concerned Citizens for Black Art, an advisory group that made recommendations to the museum about meaningful educational programming. Lewis established three galleries in the Los Angeles area and, in 1976, founded the city's Museum of African American Art. With the actor Bernie Casey, she also cofounded Contemporary Crafts, which began as a gallery before starting to publish books. It was the first African American–owned art-book publishing house, and it also provided an exhibition space for non-White artists (*Benny, Bernie, Betye, Noah and John: 5 Black Artists*, staged in 1970, was one of many prominent shows at the gallery). After receiving an award of fifteen thousand dollars from the National Endowment for the Arts, Lewis and Waddy researched and published the first edition of *Black Artists on Art*, a compendium of images and statements by more than eighty African American artists, in 1969. A second volume followed in 1971 (see pp. 381–84). The texts reproduced here appeared in a revised edition of the first volume, issued in 1976.

SAMELLA S. LEWIS, "INTRODUCTION"

Black Artists on Art is intended to introduce the works and thoughts of a selected number of producing Afro-American artists.

Traditionally it is customary to approach a subject of this nature with some historical justification. I have, however, decided to depart from tradition because I feel that honest creative expression needs no history or justification.

Many will be surprised to discover the large number of truly creative individuals who are participants outside of the mainstream of art in the United States and the Western world. The fact that these artists are generally unrecognized is not because they are ignored but because they are seldom observed.

The aesthetics of a people is directly tied to the mainstream of their existence. This assumption is a natural consequence which could give rise to resourceful creativeness . . . resourceful creativeness that could provide for differences that might serve as vital accents in the total human scheme. However, one finds that in the United States the "European style aesthetics" commands the art world. Most other cultural orientations are deemed "primitive," quaint or suspect.

The adaptation of this European-imposed style of aesthetics may be regarded more as ancestor worship rather than as a valid system of aesthetics. A truly valid system of aesthetics should be derived from the culture of its inhabitants and should reflect the prevailing spirit of the times in a manner that involves all groups residing within the society. This direction would provide for a concept of relationship that would include both commonalities and differences. Since it is the differences that sharpen or give vitality to the commonalities, it would seem that the necessity of a culture to accept and respond to such diversities is a requisite to creative production.

Many pages could be written concerning art and its relative importance from a cultural standpoint. It can be briefly stated, however, that the control of this cultural empire is ninety-nine and one-hundred percent from the white group. This is not because whites are more "cultured" but because they control the economy and consequently dictate the specific aesthetic standards.

This condition will persist so long as we continue to follow the prevailing archaic, computerized style of aesthetics insisted upon by those in command. It is without question that the present operations of the "world of art" function in the manner of a closed society.

It is long past time for us to fully realize that artists are really different from each other—just as people are different from each other. One might venture to say that artists are people.

There are artists and men of science of varying capabilities in all cultures. In this book we lay no claim that a man's ethnic origin makes him better or worse. It is felt that a man's ethnic origin gives him license to be different in matters related to creativeness.

Black Artists on Art presents the work of some of the many individuals who deserve to be called artist. They are individuals of varying degrees of interests and abilities. They are individuals who have continued as active producing artists in spite of the many obstacles that confront all artists. Many of the artists featured in *Black Artists on Art* are as yet unrecognized as artists. They have, however, through art found a means of expression which confirms them as individuals.

Black Artists on Art is a book to promote change—change in order that art might function as expression rather than as an institution. It could open many doors and many minds for it is varied enough in its orientation to serve as a point of departure for many avenues of expression.

This book is not limited to the area of art but rather it could easily be considered as a vital contribution to comparative studies. *Black Artists on Art* is not intended to be a book with answers but one with ideas—ideas that could serve to stimulate men's minds in order that they might broaden their scope and thereby reflect in a "timeless" sense the differences in orientation of a truly creative society.

RUTH G. WADDY, "INTRODUCTION"

Art critics are going to have to expand their minds and concepts in order to evaluate this publication in its entirety. True, a line is still a line and composition is still composition but there are different kinds of lines and compositions, and these kinds are going to continue and grow whether or no.

Art is not an intellectual exercise, approached through structured learning, emotions, styles, and practiced in museums, galleries, and private "collections." Art is spiritual, the primary function of which is for the benefit, growth and improvement of the human animal. The artists and craftsmen were left out of the social revolution that attended the industrial revolution. Today we are on the threshold of another revolution: technocracy, computation. The social revolution which will attend it leaves us no choice but to undergo deep, psychological change in our instinctive attitudes toward the world and its peoples.

Artists and craftsmen will lead the way and the black artist will be at the head of the procession because he has never been permitted substitution of "things" for human values. From whatever point of view, aesthetic or social, he has always had to tell it "like it is."

GARY RICKSON

Truth and the reality of truth is always in constant study. This study is for me a science that relates to my art and to me . . . a confirmation of my emotional existence.

[*The following text is accompanied by a photograph of Rickson's mural in Boston.*]

The mural, done in what I call black expressionist technique. It is there to counteract the lack of black art in the Museum of Fine Arts in Boston and to create an out-door museum of functional art. The mural is further used by the children of the area as a backdrop for their playground.

DAVID HAMMONS

I feel it my moral obligation as a black artist, to try to graphically document what I feel socially.

JOHN OUTTERBRIDGE

I paint, draw and carve not beauty, for beauty you can see all around you, and it is forever made so obvious as in super department stores and other such places. But I rather like the effort to understand the ordinary things, people and places that stand close by, not readily seen by many and seldom heard. Get to know these things, for they are complete and very much a part of us. Then go beyond that which is normally referred to as beauty.

Presently my professor is love and life, my school is dedication to truth of expression. I am deeply involved with humanity and much less sacred subjects in an attempt to create an art that is a kind of deity. I work hard because I care hard, with the hope of someday becoming a total artist.

BETYE SAAR

I have been involved with the mystic image for some time. In my search to produce a graphic sensation, I have used my prints or portions of prints combined them with drawings, and framed them in windows with many small panes. The window is a symbolic structure, which allows the viewer to look into it to gain insight and to traverse the threshold of the mystic world.

My graphic interpretation is to create an occult atmosphere which will leave a strong impression of the vague and unexplained in the mind of the viewer and to give his imagination free rein to explore the mystery of human destiny, of change, of fate and of the quest of knowledge of the future.

DANA CHANDLER

I am a black artist whose work is directed expressly toward the education of blacks as to their true position of oppression in a White Racist Society, and to the development of a new third world concept

in black art. We must develop our standards concerning black art and move away from past identification with, and adherence to, castrating white standards. Black art is a tremendous force for education and political development which we have ignored. I mean to tell it like it is. I "ain't" subtle and I don't intend to become subtle so long as America remains the great white destroyer.

As to my style, it's black expressionism, done in vivid colors, raw, earthy, much use of Day-glo. If the system does not destroy me, I will move into plastics and do with plastic sculpture what I've done in acrylics and tempera. I use all kinds of surfaces, whatever I can get my hands on. Obviously, I do not make a great deal of money with my works; in fact, my works have been defaced and destroyed, 11 major pieces at last count. But I will not stop painting . . . only death can stop me, as it does everyone.

Peace and Black Power, Brothers and Sisters.

[*The following text is accompanied by an image of Chandler's 1967 work* Land of the Free #2.]

We are imprisoned by American Democracy; democratic principles do apply to us. And now that we've discovered that black is beautiful, and all civilization comes from us, we can expect greater repression.

[*The following text is accompanied by an image of Chandler's work* Nigger . . . You Are a Four Hundred Year Prisoner!]

We are not free! The constant persecution of all our heroes proves this! We are still being lynched, raped, brutalized, and I'm not going to forget it. Sure, we've made progress, but only that which we've died for.

[*The following text is accompanied by an image of Chandler's 1967 work* Moses Brings the Word to His People.]

My way of saying black is beautiful. This work tells the pride of black America in its own power and genius, and is an example of my belief that black Americans who survive to the age of twenty-one, still retain their manhood and pride must be geniuses, since America tries so desperately to destroy all our heroes and all our men.

[*The following text is accompanied by an image of Chandler's 1968 work* Rebellion.]

It's my belief that this kind of confrontation will happen during the next decade. Things will get very bloody.

CLIFF JOSEPH

My art is a confrontation. Among the many realities of art expression, this remains the most constant purpose of my aesthetic.

MARIE JOHNSON

In a country where human values are constantly being raped and murdered in the name of technological and economic progress, black art must deal with the common humanity which unites all mankind. Black art's function is the rediscovery of its own roots, and the examining of the depths of the beauty, poignancy, and the humor of the souls of black people. We are a people who protest, pray, curse and preach, sing, moan, grunt and scream, laugh, cry, live and love. I am to produce a portrait of a people: the reservoir of images is unlimited.

DAVID BRADFORD

Just as jazz evolved out of black people in America, so shall black art. It is a difficult task to be sure, because we as black artists must unlearn all that we have been taught that art should be, and at the same time maintain very high standards for black art.

By a black art, I do not mean a painting of a black woman with a rag on her head. A black art must have the rhythm, freedom and excitement of a John Coltrane solo as well as make a statement to its viewer. Also black art must be folksy and natural. By this I mean it must derive from pure talent and not from the arrangement of light bulbs and tin foil; for the experience of black people in America have been a folksy experience and black people the world over are close to nature and the natural process of things in nature.

I think the times we live in now demand that the black artist produce what the Mexicans call "popular" art. That is, we must make statements to and for black people. It is foolish for black artists to think in terms of "art for art's sake," for the experiences of black people (and any art produced by black people must derive from black experience) in America has been and continues to be a struggle against racism, injustice and induced cultural defecation.

Only when we omit the desire to make it in the white man's art world, only when we omit the desire to place the making of money first with our art, can we produce a popular art, a black art, an art that speaks to and for black people. Until we as black artists realize these things, we shall continue to lay in the dark of the white man's shadow.

I hope my work evolves to the things I have just spoken of. . . . I want to show the inner beauty and strength of black Americans and glorify those black people who have contributed so much to our people.

DAVID DRISKELL

I am concerned with what medium can best say the things I want to get across to my viewers. Therefore, I have selected several to help toward accomplishing this goal. Art, for me, remains a personal reaction to the world of experiences but I am equally interested in others sharing the final statement that I make in painted form. In this way I am able to reach to different things through many approaches to the medium.

As an artist, I feel deeply committed to the idea of shaping content the way I like it. I am seldom at home imitating form as I see it in the natural order.

PHILLIP MASON

My work is concerned with universal equivalents:
 the social phenomena of life on earth. Black
 life. Images. Black images. Dream images.
My work is concerned with the calling of one's
 bluff with one's self.
Nitty gritty. Bugaloo.
And outer space too.
My work is concerned with what black people

have been. What they are now. And what they could be. My work is concerned with the blues and paying dues. My work is concerned with the cliché and the unknown for life is both a mixture of the cliché and the unknown.
My work is concerned with me doing my thing.
Growing
Sowing my seeds
Producing flowers/weeds in the soil of this land.
My work is concerned with "the man" No! Not that
 man! Black, beautiful (enigmatic) man.
My work is concerned with loud colors, new
 rhythms New/old things.
Circles, rings.
My work is concerned with how we love
How we lie
How we smile
How we cry
How we move
Be still
Until . . .
See?
My work is concerned with Me.

SAMELLA LEWIS

Art offers avenues for exploring ideas and human experiences. It is important to Black people because it adds to the enrichment and understanding of our ancient past and provides a significant source for documenting our contemporary present.

ROBERT SENGSTACKE

I see my surroundings in a positive light. I am involved in expressing the true image of what being Black is.

1969

Claude Booker for the Black Arts Council (BAC), letter soliciting members, undated (ca. 1969)

Charles White, "Art and Soul," lecture delivered at the Los Angeles County Museum of Art, October 27, 1969

Charles White, untitled statement, in *Wanted Poster Series*, catalogue for exhibition held at the Heritage Gallery, Los Angeles, January 1970

The art preparators Claude Booker and Cecil Fergerson established the Black Arts Council (BAC) at the Los Angeles County Museum of Art (LACMA) in autumn 1968 to ensure that African American artists and audiences were welcomed and visible within the museum. Booker and Fergerson had been inspired by the popularity of a one-day festival held at the museum that September, which had been organized entirely by LACMA's Black security officers. The BAC was the driving force behind African American programming at the museum, and its activities paved the way for the seminal 1976 exhibition *Two Centuries of Black American Art* (see pp. 533–35). In 1969, the council proposed a three-part series of artist's talks, which LACMA approved. Charles White was invited to give a lecture as part of the program. The Chicago-born artist had been based in Los Angeles since the late 1950s and was an influential teacher at the Otis Art Institute, acting as a mentor to younger Black artists such as Alonzo Davis, David Hammons, and Kerry James Marshall. Celebrated for his powerful and dignified images of African American historical and contemporary figures, White was a key figure in Chicago's Black Renaissance of the 1930s and had exhibited throughout the United States. For White, the formation of the BAC was of "historical significance," signaling progress for artists and museums alike. His LACMA lecture is published here for the first time.

CLAUDE BOOKER FOR THE BLACK ARTS COUNCIL (BAC), LETTER SOLICITING MEMBERS

Dear Friend:

The Black Arts Council is an organization composed of concerned individuals who have had some experience in various cultural affairs in the Los Angeles area. The purpose of this group coincides with the more general, current desire of the black community to organize itself at all levels—economic, political and social, and specifically to create in the community an awareness of the important role all the arts have played in establishing the identity of black people, both from an historical and contemporary point of view. The citizens of the black community have an obligation to themselves to be involved in and informed of its unique achievement in all cultural activities and its past and present contribution to American Society.

The Black Arts Council intends to reach out to the community to establish this awareness through numerous educational means. Our primary goal is to enable the people to discover for themselves what the arts are all about, how they reveal our historical identity and how they relate to our lives today.

The Black Arts Council has begun orientating the black community through a series of lectures, slides, and films which will be presented at various community centers such as schools, churches, social clubs, and other public or private institutions. These lectures and films will cover all types of cultural achievements, both historical and contemporary. The lecturers are qualified individuals, professionals in these fields. The Black Arts Council also wants to go into the schools all over the Los Angeles area to organize activities such as, field trips to relevant exhibitions at art museums, theatrical performances, or other cultural activities of special interest to our people.

As a body, the Black Arts Council feels the absolute necessity for this kind of organization. Until the American educational system has instituted sufficient means and methods of including the historical contribution of all its citizens, then black people must take the responsibility to shape and direct themselves in the areas where that educational system fails.

If we are to succeed in this endeavor, we must have your support. Therefore, the Black Arts Council wishes to take this opportunity to extend an invitation to the citizens of the entire community to become members of the Black Arts Council. The annual fees for membership are one dollar for students, ten dollars for associate members, ten dollars for participating members, and fifty dollars for sponsoring patron membership, which will include an original print by one of the black artists represented in the Black Arts Council. You may indicate by return mail either individual or organizational interest in regular activities of the Black Arts Council.

We earnestly solicit your support.

Very truly yours,
Claude Booker
Chairman, Black Arts Council

CHARLES WHITE, "ART AND SOUL"

I want to thank the Black Arts Council for inviting me here. I think this is a beautiful and very significant occasion. I don't know whether you really dig the significance of this—I hope you do—what the Black Arts Council represents. Men who work at this museum, interested in art. I don't know of another museum in this whole country, be he black brother or white, where these kinds of events are taking place, and are the initiative of people who work for a museum. I don't know of any other place. I think this has historical significance.

While I did come through the back door, to get to this institution [*laughter*], through no fault of the brother, I am here. The brother is here. I think the museum needs to be commended for their cooperation. I think they have done themselves a great honor. This will grow, and once the initial step is taken, it's very difficult to take two steps backward. One step forward sometimes is all we need—all we need. We will make the other steps, we will take them.

In a sense, the museum, Los Angeles County, is beginning to take on a wee bit of soul. A wee bit. Soul is hard to come by, because you can't learn it

at school, and you can't acquire it, really. Soul is almost something you have to be born with. Museums, all institutions, have an aura of coldness to them. I guess it's supposedly because a certain bureaucracy prevails. There's a certain austerity in an institution that makes it difficult for people to embrace with warmth. It's an impossible dream, but what a great thing it would be to have a soul museum! Do you think how swinging that would be? Nothing but soul. Might be too much—might blow everybody's mind! [*Laughter and applause.*] We may reach that point—let's hope, let's dream. I'm a romanticist, I dream. I can see the day when the brother might be even the head of the museum. [*Applause.*]

I'm here by invitation of the brother and through the cooperation of the museum. Hopefully, that time to come, that will be even a representation on a more significant level for all my black artists throughout this country. That we don't necessarily have to have a special event for the brother to enter. It becomes a part of the whole structure. That's the dream.

I know a great deal about culture, and therefore I guess I'm quite an educated man. I learned very early to dig people. I learned very early to feel in a family situation, even to feel in a neighborhood situation, the warmth, the security, of love for one another. I learned what it was to have hope; I learned very early to dream. That's a rare commodity, to dream and to hope. So, when I decided that art was to be my way of life, was to be my media to which I was to try to find a one-to-one relationship with people, I had no other choice but to put these ingredients into my work. They couldn't be left out. That was true not only of myself but my contemporaries who, in Chicago, were interested in art. These contemporaries were Katherine Dunham, Richard Wright, Willard Motley, Gwendolyn Brooks, Margaret Walker, and many other blacks striving to say something and to establish a one-to-one relationship.

[*Here, White begins to speak in reference to projected slides of his works, including his 1965 drawing* General Moses (Harriet Tubman), *and then describes his reaction to the bombing of the 16th Street Baptist Church in 1963 and the work he made in response,* Birmingham Totem *(1964).*]

Not too long ago, three little kids were killed.[1] The idea for this picture [*Birmingham Totem*] came as I was sat there contemplating this monstrous act by some perverted, degenerate minds. And I began to think beyond the locale of Birmingham. And it was at the time that many new African nations were being born. It's almost an incredible thing for me to conceive a new nation being born. And as I related it to this question of what happened to these kids and what was taking place throughout the South, I said, by God, a new nation has to be born out of all this rubble. Maybe this has been predestined. Maybe the black is a catalytic symbol. Maybe history has placed him in the position of being the architect of a new nation. So, he sits amidst the rubble with a plumb line, and somehow he's going to put all this rubble together and build anew for all. . . . We will fight a magnificent fight, and the blacks will fight. We will fight the good fight.

It seems that every place in the world that people rise up against oppression they are celebrated, except here. What is it about us? I look at myself sometime in the morning and I say, my God, that color! It's so powerful! My God! It's amazing! It's only pigmentation, but yet that damned color can make people tremble, run—they move out of neighborhoods. I don't know what it is but it must be something! [*Laughter.*]

When [Eldridge] Cleaver got out, and a couple of other people have been moving around a bit, it felt like back to slavery times—fugitive, wanted posters were sent out—and I began the *Wanted Poster Series.* . . . What I've done is taken heads and [made] them feel like they're both part of the crumpled poster and also three-dimensional, or real. They're both part of it and not a part of it. I've brought them up to today. We're all fugitives—it ain't just Cleaver. Who knows what tomorrow . . . you know . . . all these names and prices [on the *Wanted* posters] I got off original posters.

I don't know where all of this is in relation to art. I have the slightest idea—that is, today,

prevailing attitudes about art through the institutions, through the people who are in control, the power structure of the art world, says that art has nothing to do with people, by and large. It has to do now with technology. This is where it's at. Maybe it is. I don't know whether I'll ever come to be in this museum. I don't [know] whether there is a place for a John Riddle or a Charlie White or a Jacob Lawrence. I do know that, for the first time in my life, I am the most excited, turned-on cat you will ever meet, because my brother is doing more art than he has ever done. You stumble over artists in Watts; man, you can't even cross the street without bumping into a cat getting themselves together with either poetry, drama, painting, or something. The very interesting thing is that it took a Watts to make people conscious of the fact that the brother was out here painting and acting and had all these great talents going for him. It took that little incident. Maybe it will take another incident to build a museum to house the brother's work. I hope not.

I don't know whether what I do is art. I could care less whether [my work receives] this label from any of the prominent critics in town—"art"—or whether they miss the point of what I'm trying to say. Or whether their criteria for good art or great art [are] so above dealing with life, dealing with emotion, dealing with people, either sentimentally or romantically, as I deal with it. Maybe there is no place for this stuff now. If it is, it is a sad commentary. I think the archives will, one of these days, will house this great feeling that is being expressed by black artists, as well as white artists, about people. I have faith. I think they will learn. I think soul will prevail. It is in each of you. Each of you have soul. Each of you have the capacity to love. Each of you have the capacity to override your prejudices. Each of you have the capacity to build a better world, to establish peace. Are you ready to ensure your artists are going to survive, as well as yourselves? Are you ready to ensure that they believe in people as expressed through their art—that they will find a place? Are you ready to support it? Is this museum ready?

I want to thank you for permitting me to address you. It has been a pleasure.

CHARLES WHITE, *WANTED POSTER SERIES STATEMENT*

The substance of man is such that he has to satisfy the needs of life with all his senses. His very being cries out for these senses to appropriate the true riches of life:

The beauty of human relationships and dignity, of nature and art, realized in striding toward a bright tomorrow. . . . Without a history, a culture, without creative art inspiring to these senses, mankind stumbles in a chasm of despair and pessimism.

My work takes shape around images and ideas that are centered within the vortex of a black life experience. A nitty-gritty ghetto experience—resulting in contradictory emotions. Anguish—hope—love—despair—happiness—faith—lack of faith—dreams. Stubbornly holding on to an elusive romantic belief that the people of this land cannot always be insensible to the dictates of justice or deaf to the voice of humanity.[2]

NOTES

1 [In fact, four girls—Addie Mae Collins, Denise McNair, Carole Robinson, and Cynthia Wesley—were killed in the bombing of the 16th Street Baptist Church in Birmingham on September 15, 1963. —Eds.]

2 [The second half of this sentence alludes to Frederick Douglass's January 1, 1846, letter to William Lloyd Garrison from Belfast, published in the *Liberator* and quoted in Douglass's autobiography: "May God give her {America} repentance, before it is too late, is the ardent prayer of my heart. I will continue to pray, labor, and wait, believing that she cannot always be insensible to the dictates of justice, or deaf to the voice of humanity." —Eds.]

1969

Al Loving, untitled statement, in *Al Loving*, pamphlet for exhibition held at the Whitney Museum of American Art, New York, December 19, 1969–January 25, 1970

Al Loving was born in Detroit in 1935 and studied at the University of Michigan, receiving his MFA in 1965. After arriving in New York, he became known for geometric, hard-edged paintings employing hexagonal shapes that sometimes contained illusions of three-dimensional structures. Loving was featured in the SUNY–Stony Brook exhibition *5+1* (see pp. 170–73) and, later in 1969, was the first African American artist to be given a solo show at the Whitney Museum of American Art, in the small gallery off the lobby on the museum's ground floor. Loving's statement in the exhibition pamphlet steers clear of questions of Black identity and insists on the artist's right to approach color as other modernist artists did. By 1971, however—as he later told an interviewer for the journal *Artist and Influence*—he had developed what he called a "violent hatred of hard-edged painting" and began to think that "geometric art conflicted with civil rights." He cut up geometric paintings and collaged the fragments together. As he said, "The decision to move away from that kind of rigid formalist view had to do with whether there is a black art and what it looks like."

AL LOVING

I would like to offer a few random thoughts that pass through my mind as I work. I like the idea of being subtly aware of something obvious.

Color—I'm not interested in color as a science. I'm interested in using the science of color. Prisms. Colors are not always intuitive but are used intuitively. Multiplicities of color to make one color feeling. Varied. Color is already drama; we only impose the degree.

Form—It tends to reduce the importance of color. I use it to articulate compositional positions. Composition = the position of a reality.

Space—Shaping the canvas became a convenience to the form. When the form of any potential interest to me has been exhausted, the shape will be of no use. My interest in composition: composing a wall finds more options with the use of a shape. Repetition of that shape breaks the horizontality, rectangularity, verticality and depth of normal confines. The cube is permanent and universal. It concerns the beginning of intellect. A sort of building block: making things out of ideas that are already present.

Light—Another interest in conflict. Surfaces of forms collecting light or projecting it.

Time—I like the repetition of a form, the variety in it and the element of accident. The notion of an expanded concept: each form as a whole, sometimes added together.

Reality—I'm no longer interested in "new" ideas. What is relevant to the artist today is what contemporary events will mean to the state of reality twenty-five years from now.

1970

Robert Newman, "*America Black*: Faith Ringgold at Spectrum," press release for exhibition held at Spectrum Gallery, New York, January 27–February 14, 1970

For *America Black*, her second exhibition at Spectrum Gallery, Faith Ringgold presented new paintings later known as the *Black Light* series. Made between 1967 and 1969, these works coincided with the period of her steadfast involvement in the Black Emergency Cultural Coalition (BECC) and Women Students and Artists for Black Art Liberation (WSABAL). Ringgold began to mix black pigment into all her paints, later saying that "black art must use its own color black to create its light" (see p. 215). Through bold depictions of men and women, paintings such as *Big Black* (1967) and *Soul Sister* (1967) sought to address "Blackness" as both a color and a social identity. The paintings also manifested Ringgold's interest in African design, which she had begun to study in the late 1960s.

ROBERT NEWMAN, *"AMERICA BLACK*: FAITH RINGGOLD AT SPECTRUM"

The key painting to Faith Ringgold's development since her last exhibition, *American People*, was the widely shown mural painting, *Postage Stamp of the Advent of Black Power*. The use of words in that painting works with the images of human faces to speak of national and social structures the faces were locked in. In the recent paintings, as always in her work, the human image is studied for its human values, but this exhibition limits itself to the study of "Black" values. In *America Black*, the image statements and word painting statements research the positive values of a race in the nation it needs to come to terms with, in the sense that its people must make its life better, must find its creative strength in all the difficulties still endured. Probably the most single element in these paintings is their resolved search for unique color and light. In the word paintings, valuable American posters, the colors evolved describe a creative direction in the search for the color-light of her race. And the light tone the faces are seen through, the warm brown "Black" faces, is the work of an intelligence seeking a new kind of light, with an extremely human need.

1970

Debbie Butterfield, "Contemporary Black Art," and Samella Lewis, "Epilogue," in Jehanne Teilhet, ed., *Dimensions of Black*, catalogue for exhibition held at the La Jolla Museum of Art, San Diego, California, February 15–March 29, 1970

Dimensions of Black was an exhibition of more than three hundred works organized by Jehanne Teilhet, a professor at the University of California, San Diego, together with more than one hundred students. It was the largest display of its kind to have been mounted on the West Coast, and loans came from around the country. Artists from California were shown alongside those who had established themselves on the East Coast. The essay by Debbie Butterfield, which appeared in the substantial catalogue, examines the growing influence of the Black Arts Movement; Samella S. Lewis penned the epilogue. After the negative critical response to the Metropolitan Museum of Art's *Harlem on My Mind* exhibition the year before, *Dimensions of Black* was an example of authentic institutional engagement. The show drew record-breaking attendance figures and received nationwide attention. Its opening alone saw nearly two thousand visitors.

DEBBIE BUTTERFIELD, "CONTEMPORARY BLACK ART"

Black art today embraces an enormous range of attitudes and styles and reflects the diversity and the explosion of individual awareness within the Negro race. The African culture with its intuitively abstract and sophisticated form and its action-oriented view of creativity has provided the continuum, the life source, for today's Afro-American art. [. . .]

While in the past black artists wrote and painted not as much to their own people as to the white critics, they no longer need to draw inspiration or approval from the white art world. A developing racial pride and consciousness is the product of painful racial experience and self-realization; black people are freeing themselves to accept and express their *own* beauty and are rediscovering the cultural, mythical wealth of their collective past. With this new-found freedom, black artists are faced with new responsibility and power. The black artist can express attitudes that no one else can express and with a feeling that is his own, and today he is in a position to be seen and heard.

One of the most aggressive and demanding facets within the realm of black art is the Black Arts Movement which has been embraced by the Black Power Movement as its spiritual sister. The sociopolitical movements have recognized the power generated from the artist's redefinition of himself and the world and his ever changing reality. The Black Arts Movement calls for this definition in black terms: it proposes a new black esthetic and symbolism as well as critique. It demands that art be for and by the people and calls for popular art directed to the community and its needs. The Movement denounces protest art because of its dependence on the very values it condemns. Protest art could not exist without these negative values and is an important but temporary step to the "new esthetic." The Black Arts Movement calls artists to nourish their own culture and to stop merely reacting to white culture. It is this looking beyond, the seeking of an elemental cultural awareness, that has the potential for development of a new esthetic. A new esthetic arises not because of a conscious need or demand but through a gradual building upon heritage and attitude. In this sense the Black Power struggle with its basis of self-conscious and cultural awareness is preparing the ground for a new environment and nourishment of black culture and nationalism. The new black art, with its emphasis on function and change, is vitally connected to African art and demonstrates the continuity of black art throughout the ages and an alliance against the "art for art's sake" attitude of Western art.

The Black Arts Movement bases itself on the defining and exalting of black culture and emphasizes social reality. Its goal is to establish the identity of the nation of blacks within the "white belly" of America, and many black artists direct themselves to creating black images and a sort of social realism aimed at producing change and revolution. Ben Hazard's *Self Portrait* and Philip Lindsay Mason's *The Deathmakers* are hard-edged, hard-cut expressions of black men in America. Both men work in almost pop and poster art styles with obvious symbolism directed to evoke emotional response. Perhaps this politicalization of art is temporary, but it is, nonetheless, an important insight into what many blacks demand from art right now. Elizabeth Catlett develops a powerful sense of racial pride and unity in her print *Malcolm X Speaks for Us*, which is a more stylistically traditional expression of her deep commitment to the movement. Other artists comment with a more personal viewpoint, such as Raymond Saunders and his figurative series which attacks the values of American society, John Outterbridge with his *Great American Bird* which rocks to the right and left but never gets off the ground, Bernie Casey's *White Bird*, and Dan Johnson's assemblage series *Trek*.

The call of the Black Arts Movement for political, involved art is more easily manifested in literature, poetry and drama than in the visual arts. To take its directives literally would imply that all black visual art must be some form of social realism. Past experience with Russia's vanguard art and the censorship of Nazi Germany only repressed exploratory, non-objective art and inhibited such creative men as Kandinsky, Malevich and Barlach. The Black Arts Movement can't expect to dictate

style and subject, but it demands unity of consciousness, that is, art and artists that reflect the human condition and involvement with more than plastic, visual tension. The question must not be *how* an artist will create art, but *who* will he reach? Who will he bring up? Artists who are involved in many different styles, political as well as abstract are working to bring art into the street and the ghetto. They approach this goal by teaching, through black art councils and associations, by starting neighborhood workshops or by taking apprentices, offering advice and criticism to young artists, or simply lending money for materials. The means and style of individual expression does not conflict with community involvement—one need not make political statements to involve people in art and in change.

Like all artists, black artists are concerned with change and exhibit this change in many dimensions. Within the realm of black art there are as many approaches as there are artists: some draw from their African heritage; some express an ethnic consciousness of the American experience, some are involved in totally personal statements which may or may not reflect their racial background.

Among the black artists who seem especially drawn to Africa and her art, both philosophically and visually, are Dan Concholar, Eugene Grigsby, Arthur Carraway and David Driskell. They have all drawn visual imagery from the African heritage and incorporated it into their own experience. John Biggers has become even more involved in the study of African cultures as is evident in his highly realist drawings of a Nigerian *Queen Mother* and *Timi of Ede, Nigeria*.

The approach of such artists as Richard Hunt, Fred Eversley and Sam Gilliam could also be compared with non-object oriented values in African art and its emphasis on the creative *process*. Gilliam's *Carousel III* corresponds to the African attitude that an "art" object has no value, is just a thing until or unless it has been designated to have certain meanings or powers. His canvas is 75 feet long and is hung each time to relate to the specific space in which it exists. It must be confronted and the space problem resolved each time and offers infinite possibilities and solutions. Gilliam's work directly involves the canvas, the space and the viewer and establishes a tension between them. Eversley's pieces in cast resin reveal total involvement in the media and in the process of creation. The precision of the concentric color rings and the clarity of casting seen in his finished pieces are the result of lengthy controlled process and technical orientation. The processes are removed from the piece itself because you can't tell what it will look like until it is completely done. The creation is almost an act of faith reminiscent of the bronze-casting processes of Ife and Benin. Eversley is concerned with internal space and the change resulting from varying the light source and viewer's point of view, and the exterior shape of each piece exists only to enhance and project the effect of the internal color forms.

Many of the black artists speak directly to their communities with ethnic statements, such as Cleveland Bellow's photo-silkscreen portraits, David Hammons' body print, Charles McGee's *Despondence*, and Samella Lewis' *Royal Sacrifice*. Mel Edwards, Bob Thompson, Merton Simpson and William Majors are currently involved in more nonobjective or expressionists pieces and constructions. Noah Purifoy has been interested, as have Betye Saar and John Outterbridge, in making art from the waste and destruction of our society, basing attention on the rebirth of useless objects into forms which convey message and beauty.

Current black art projects wealth and diversity and a tremendous range of direction and relevance. Artists are exploring all dimensions of form, technique and message. Some of the art produced coincides with current international trends, some is directed more specifically to the black community, but all of it is creating and contributing to a new attitude and possibly a totally new art form born of the black experience and which contains the freshness, power and rhythm of jazz and modern black poetry and drama.

SAMELLA LEWIS, "EPILOGUE"

Art can perform a significant function for man and, no matter what the culture, it has succeeded in assisting him in finding, shaping, and securing his

place in the world. For creative expression covers a range of activities as wide as the basic experiences of life itself. And man desires to recreate and share these experiences with others because they are emotionally significant and intellectually meaningful to him.

In contemporary American culture, however, there is an "established" way of viewing art that gives rise to a sameness and a standard of esthetic absolutism. This prevailing concept leaves little or no room for the appreciation of expressive and serious indigenous creativity which is based on an art form differing from the traditional norm.

Since the art of black Americans is related in the deepest sense to daily experiences, it is more often viewed by critics from without as insignificant and irrelevant. This assumption is a natural one when art is viewed from a form and not a content perspective. Similar states of confusion occur whenever one views the art of any unfamiliar culture.

But the question is—"irrelevant" to whom? Black artists today are looking to their own experiences and environments for sources of inspiration and motivation. They have ceased accepting the evaluation of the Black Cultures of the past as being "primitive" and without sophistication. Many black artists are also refusing to be dominated by an imposed esthetic standard—one that denies the existence of their basic way of life. They believe that the act of creation should be directly related to their own expressive needs.

To some, art is important as a product—a luxury product—a prestige-enhancing product. To others of us, art is important as the carrier of the ideas of the past civilizations, and as an antenna which keeps us in touch with the undercurrents of our own time. It can make us conscious of our own experiences and strivings, and link us to the most human depths of others.

Through the utilization of ideas, thoughts, feelings and emotions in terms that are individual— and yet universally meaningful—art reflects man's desire to express his reactions to life. . . . And life itself is what black art is about.

1970

Melvin Edwards, untitled statement, and William T. Williams, "William T. on M.E.," in *Melvin Edwards: Works*, pamphlet for exhibition held at the Whitney Museum of American Art, New York, March 2–29, 1970

In 1969, the Whitney Museum of American Art began to mount a series of small solo exhibitions by African American artists in its lobby gallery. Al Loving's show (see pp. 185–86) was followed by exhibitions of the work of Frank Bowling, Alma W. Thomas, Jack Whitten, Betye Saar, and others. Robert M. Doty, a curator at the Whitney, asked Melvin Edwards to show works from his *Lynch Fragments* series there. The sculptor, who grew up in Houston, Texas, had begun working on this series of wall-mounted metal reliefs based on found objects while living in Los Angeles. He had learned how to weld as an art student at the University of Southern California and was given his first solo show by the Santa Barbara Museum of Art in 1965. After the artist moved to New York, in 1967, his work was exhibited at the Studio Museum in Harlem. For the Whitney show, Edwards told Doty that, rather than his *Lynch Fragments*, he would prefer to showcase his newer barbed-wire sculptures. The statements reproduced here, by Edwards and his friend the painter William T. Williams, outline the role of materiality in the artist's practice and allude to the historical and social associations Edwards was making to various industrial objects. The artist David Hammons would later say that one work in the show, *Curtain (for William and Peter)*, was "the first piece of abstract art that I saw that had cultural value in it for Black people."[1]

MELVIN EDWARDS

My first ideas for connections were formed in about 1963. I was at a place involved in cinematic visual and physical explorations in outer space. I picked my own head for possibilities and came through with a chain, rod and welded steel combination that connected the corner of a room and the ceiling. This piece was included in a one man show at the Santa Barbara museum in 1965. I have always understood the brutalist connotations inherent in materials like barbed wire and links of chain and my creative thoughts have always anticipated the beauty of utilizing that necessary complexity which arises from the use of these materials in what could be called straight ahead formal works. Linear geometry having its purity complicated because one chooses to exploit the flexibility of the wire. A geometric organization appearing to be something else now you see it now you don't.

The modifier, the changer, the move, the column of barbwire. The connections on the floor were shown before with the back to back *Pyramid Up and Down Pyramid* at the Studio Museum in 1969, modifying floor and corner in order to corner concepts before I passed them without making them real.

How long is a chain? How long is a change?
How heavy is a chain? How heavy is a change?
How long is a heavy connection?
Is a connection as flexible as a chain?
Is a connection as flexible as a change?

B.wire has a long history in war both as obstacle and enclosure. B.wire has a long history in agricultural life both as obstacle and as enclosure. Wire like most linear materials has a history both as obstacle and enclosure but barbwire has the added capacity of painfully dynamic and aggressive resistance if contacted unintelligently. To use this chain with all its kinetic parts criss-crossing the line as invader and potent container.

This line wire barb thing changing perception
This line wire barb thing changing definition
This line wire barbed thing having connotations

Changing chains having weight having graphic connotations making definite forms having history contained in this place now pulling walls together being lit by the spirit of those who are with me and the quarter of a quadrilateral pyramid shadowing other possibilities.

My use of art as a life to work past the confines of any set of classifications and conditions is a critical attempt at this point in history, for all systems have proven to be inadequate. I am now assuming that there are no limits and even if there are I can give no guarantees that they will contain my spirit and its search for a way to modify the spaces and predicaments in which I find myself.

WILLIAM T. WILLIAMS, "WILLIAM T. ON M.E."

(Barbwire) A linear movement with a secondary rotational symmetrical movement and counter perpendicular rotational wrap module. With every linear descriptive, massless drawing there is a simultaneous symmetrical modular movement. (S.M.M.)
a, S.M.M.—Nonsymmetrical linear descriptive mass (Non S.L.D.M.)
b, S.M.M.—Symmetrical linear descriptive mass (S.L.D.M.)

Therefore:

S.M.M.—Non-S.L.D.M.
Or
S.M.M.—S.L.D.M.

NOTE
1 [Quoted in Kellie Jones, "David Hammons," *REAL LIFE Magazine*, no. 16 (Fall 1986): 4. —Eds.]

1970

A. D. Coleman, "Roy DeCarava: *Thru Black Eyes*," *Popular Photography* 66, no. 4 (April 1970)

This article was the first attempt to outline Roy DeCarava's career to date. At this point, the photographer had been working for some two decades and had recently received his first major solo show at the Studio Museum in Harlem. A. D. Coleman, the inaugural photography critic for the *Village Voice* (1968–73) and the *New York Times* (1970–74), was an early advocate of DeCarava's work and had already reviewed the exhibition in his "Latent Image" column in the *Voice*. In this profile, he positions DeCarava "in the ranks of the master photographers" and highlights the aesthetic qualities of the artist's pictures, which by now had entered the collections of many institutions, including the Museum of Modern Art, New York, and the Art Institute of Chicago. Despite these accolades, DeCarava was still largely unknown to the wider world. Coleman attributed this to the "long, punishing battle for creative survival" the photographer had endured—a battle that, for Black artists, was especially unsparing. Speaking of "a tacit form of racism" that was "still, conveniently, being overlooked," the author was amazed that a Black photographic aesthetic, spearheaded by DeCarava, had been able to evolve at all.

A. D. COLEMAN, "ROY DECARAVA: *THRU BLACK EYES"*

Rising in a high, fluid arc of melody, the piercing cry of a soprano sax skirls and soars through the spacious gallery, echoing off the white, sun-warmed walls. An almost unbearable passion—more simultaneous ecstasy and anguish than most of us allow ourselves in a lifetime—surges through the horn, filling the room with its energy.

In one shadowed corner of the gallery, the creator of this music—John Coltrane, dead (so very much too soon) these three years—leans brooding against a wall between sets, hunches his huge form over his instruments, and then, drained utterly in the ugly pre-dawn city grayness, rests his head on a luncheonette table. These images are only photographs, of course; but in them, for anyone blessed with the memory of having seen him perform, Coltrane is alive. The music, as well as the man, can be felt in them.

Other famous faces dot the walls: Lester Young, Billie Holiday, Langston Hughes. But unfamiliar faces outnumber them by far: children, young men and women, adults, the old, caught in all kinds of activity—laboring, playing, at home, on the streets. Just people, involved in the process of living, unusual only in that most of them are black and have been brilliantly photographed—as the exhibit's title makes explicit—*Thru Black Eyes*.

Those three small words define the show perfectly. As they imply, the people portrayed therein have not been seen as specimens, symbols, or social phenomena, but as distinct, unique human beings—a rare and momentous achievement. And, as the title also suggests (through an apropos, probably intentional, pun), these images were made by an artist who has fought a long, punishing battle for creative survival—and who has, at great cost, won.

In a peculiarly American perversion, our society delights in taking credit for the success of artists who manage to overcome the endless obstacles we place in their path. It may be gratifying to think of ourselves as an aesthetic boot-camp, and in some instances not entirely inaccurate; most often, though, all that is accomplished by this enforced hurdling of nonsensical barriers is the dissipation of creative energy, the frustration of wasted time. For black artists, needless to say, these problems are so compounded that superhuman efforts are required merely to retain enough sanity to go on.

I state this deliberately and bluntly, to forestall anyone (myself, white as I am, included) from rationalizing himself into the mistaken belief that the triumph of this exhibit belongs to anyone save the man who made it—Roy DeCarava. This was his show, his alone; and, quiet as it may be kept, I do not think that Edward Spriggs—executive director of the Studio Museum in Harlem, where *Thru Black Eyes* was mounted—exaggerated too much when he called it "one of the most important photo shows of our time."

It's a three-flight walk up to the heavy metal door bearing the name DeCarava in thin, elegant letters. If the light is right in the dim hallway, you can just make out the word "photographer" beneath the name, painted over but still faintly visible. Inside the studio there is space, light, and order.

Row on row of carefully labelled boxes of prints line the shelves, along with books, magazines, and records. The furnishings are sparse: a neatly made bed, several chairs. A saxophone rests on its stand, gleaming in the noon light which streams into the front room from windows which look out on Sixth Avenue in the upper 30s, near the heart of the garment district in midtown Manhattan.

The studio's tenant must be numbered among the eminent contemporary photographers. One of that handful of men who have been awarded Guggenheim Fellowships for photography, he is represented in the permanent collections of many institutions, including the Museum of Modern Art, the Chicago Art Institute, and the Metropolitan Museum of Art. He ran one of the first exclusively photographic galleries in the city, and organized a workshop which, though currently defunct, continues to be highly influential. He has participated in numerous important group exhibitions, including *The Photographer's Eye*, *Always the Young Stranger*, and Steichen's *Family of Man*. (Steichen, incidentally, is a particular admirer of his.)

In collaboration with a renowned American writer, he produced a book that won two awards, received critical plaudits from the *New York Times Book Review* and sold out its first edition.[1] Additionally, as his superb one-man show proved, he is capable of sustaining an exhibit almost 200 prints long—which, in my book at least, places him in the ranks of the master photographers.

Yet Roy DeCarava is almost as unknown to the outside world as are the men who push racks of clothing through the streets below his windows. His name is hardly recommended for dropping; it rings no bells with most people. While it is tempting to call him a "photographer's photographer," that would be evading the issue, since only a small number of photographers are aware of his work.

Most of those who recognize his name do so with raised eyebrows and a strange expression—as though the photographic world were a frontier town, and they had just heard tell of some trouble-making lawman hellbent on a showdown with the local gunslingers. Not only do such words as "difficult" and "intransigent" crop up continually in the ensuing discussions; at times, incredibly, there is even a faint aura of danger, much like that which hangs over the marked man in a gangster flick.

All of which is curious indeed, because Roy DeCarava does little more than tell the truth as he sees it and insist on his rights as an artist and as a man. It would be even curiouser—incomprehensible, in fact—were he not black.

Though unacknowledged and unmentionable—photographers, after all, pride themselves on belonging to a hip, pace-setting profession—there is as much de facto segregation in the photographic field as in any other. Less blatant, perhaps, because it is less an act of commission (it's hard to stop a man from taking pictures) than of omission (it's easy to prevent him from making a living at it), discrimination is nevertheless common practice. Excepting Gordon Parks, the industry's carefully selected token Negro and the only one yet permitted to reach the top, the facts speak eloquently for themselves.

Aside from those employed by the black press, only a handful of black photographers have been able to earn a living as photojournalists. Despite the dramatic increase in coverage of black-oriented material and news events over the past decade, this situation has not noticeably improved. Ironically, the assignments for these stories have almost invariably gone to white photographers. Intent as we are on preserving our distorted vision of black reality, we have insured that it reaches us only after filtration through white eyes.

Similarly, blacks have been unable to break into fashion and/or advertising photography. Indeed, until a few years ago there was segregation on both ends of the lens: the models, as well as the photographers, were exclusively white. That could hardly have escaped the discerning eyes of the fashion and advertising photographers: but, though it was certainly within their power to do so, I don't recall the top men in the field banding together and refusing to shoot a racially unbalanced session. Nor, for that matter, have the leading models exerted any corresponding pressure for integration of the studios. A tacit form of racism is still, conveniently, being overlooked.

The same bias prevails in the area of creative photography. Not many "pure" photographers, black or white, are able to support themselves through their art, so the criteria are different. But the clues are there: the established galleries do not exhibit the prints of many non-whites, while museums have for the most part ignored them completely. Thus, the black artist is cut off from his potential public and from his peers, forced to work in a vacuum and go unnoticed.

Under these circumstances, it is little short of amazing that a black photographic aesthetic has evolved and that a black school of photographers can be identified. Both of these developments can be attributed directly to Roy DeCarava, who has bucked the system and worked towards these goals for over 20 years.

DeCarava's contribution to modern photography is two-fold, and both facets merit consideration in depth. First, he is—as photographer James Hinton wrote in the exhibit brochure—"the first black man who chose by intent to document the black and human experience in America, and he has never

wavered from that commitment. He was the first to devote serious attention to the black aesthetic, as it relates to photography and the black experience in America."

Consequently, DeCarava's body of work, taken as a whole, provides what is undoubtedly the most thorough and profound record we have of black life over the last two decades, invaluable precisely because it was made from within the black culture rather than from without. His unswerving dedication to this task has made him the spiritual father of all black photographers. To quote Hinton, "For those of us who knew his work at first hand, he set a unique example. His influence today extends throughout the field."

Much of that influence can be traced back to the Kamoinge Workshop, which DeCarava founded and ran from 1963 through 1966. Organized by him at the request of numerous black photographers, Kamoinge (the word, Kikuyu in origin, translates roughly as "group effort") was, according to DeCarava, "an attempt to develop a conscious awareness of being black, in order to say things about ourselves as black people that only we could say. A black man," he continues, "sees the world through black eyes, and it's this blackness that shapes his world. The black man—and, of course, this means the black photographer too—tends to see the world in a more truthful, realistic way; he must, to survive. And, because of the immediacy of the medium, this is very important."

He is not involved in the planned revival of Kamoinge. "It was a very fruitful experience for me," he explains, "but I've done what I could: I don't think there's anything I could add at this stage of my life." The workshop's impact has continued to be felt since its demise, not only directly—in the work of such former members as Lou Draper, Beuford Smith, and Ray Francis—but also at one remove from the group itself. As James Hinton (another former member) pointed out in a telephone conversation, "The younger black photographers have been influenced by Roy without knowing it, through the few black photographers who do know his work. Black photographers—and black subjects—used to be afraid to be black. Roy broke that down, and he

was doing that in the late '40s and early '50s—20 years ahead of his time."

The second part of his contribution, inherent in his work, is an approach to the medium, to the act of photography, that makes his images extraordinarily compelling.

We are accustomed to defining maturity in a photographer as the ability to confront honestly and express clearly his own deepest feelings. This is a valid standard, as far as it goes (though there are precious few who meet it: too often, in its guise, we are offered pictures which, by pleasing the eye and titillating the intellect, camouflage their failure to affect the heart.) Beyond the self-knowledge which introspection brings, however, there is an even higher level of photographic maturity: the ability to use that self-knowledge for the purpose of confronting honestly and expressing the deepest emotions of others.

For any photographer whose primary subject is people, this is treacherous ground to tread. Pitfalls abound: sentimentality is one, formlessness another—and, even if these are avoided, success is never guaranteed. Yet, eschewing sentiment, and without in the least sacrificing formal considerations, Roy DeCarava has charged all his images with the emotional gestalt of the moment in which the camera seized them.

If this sounds somewhat reminiscent of the "decisive moment," that is not accidental: Cartier-Bresson was DeCarava's greatest initial influence (though, like many others, DeCarava finds in the French photographer's later work a decided falling-off in quality). But DeCarava does not share Cartier-Bresson's detachment: his personal involvement in the moment—best described as subjective objectivity—produces pictures in which self and subject are perfectly merged. Because it is purely visual, this effect is difficult to describe (though such words as love, soul, and compassion—especially compassion—come to mind), but it results in unutterably moving photographs.

Given all this, it is hardly surprising that DeCarava should have elected to work within the boundaries of the realistic tradition, unquestionably the ideal framework for his vision. However,

it is not only surprising but grimly ironic to hear the curator of a leading photographic collection dismiss him—regretfully, it should be noted in all fairness—as being, "after all, rather old-fashioned." That DeCarava has remained true to his vision, even at the price of being bypassed by the waves of fashion, is one of his greatest victories.

For, far from stagnating, his work has become richer and more passionate. Straightforward and ungimmicked as always, his style has acquired a flowing tenderness rare in any medium. His formal sense is sure but deceptively simple: only as an afterthought does the viewer realize the strength of his compositions. His prints, unusually sensitive to subtle tonal gradations, are never harsh or exaggerated, filled instead with the delicate interplay of dark and light.

One is conscious of him not as a photographer but as a perceiver, focusing himself on the world, forcing the viewer to experience it with him, up to the hilt. Discipline and freedom, eloquence and understatement, in exactly the right proportions—the hallmarks of the consummate artist.

> You should be able to look at me and see my work. You should be able to look at my work and see me.
>
> —Roy DeCarava

Portraits of him—even one he took himself—fail to capture the controlled intensity of his presence. In them, his eyes seem vaguely troubled, and there is a guarded quality, as though he did not entirely trust the instrument to which he has devoted his life. In person, what appears at first to be an impossibility—the absence of bitterness—is in fact something more dynamic, the presence of an internalized anger that must daily be reconquered.

"I am bitter," he said quietly, "but that's a safety valve, a self-indulgence. Either you believe that life in all its manifold horrors is basically and essentially good, or you don't." A pause. "What I try to say in my work is that I believe in life. I can't create out of bitterness. It undermines my creativity."

As we sat talking, at the tail end of September, *Thru Black Eyes*—his first one-man show in several years—was entering the third week of its run at the Studio Museum. It had taken him only three days to assemble: "I knew what I wanted to include," he told me, "and I had the prints on hand. I always make up several as I go along—I hate printing old negatives."

Attendance was high, resulting in part from DeCarava's reputation and in part from the unanimous critical acclaim accorded the exhibit. While obviously pleased with the show and its reception, he was anxious that it be understood. "I wanted to show in the community," he said, explaining his acceptance of the Studio Museum's invitation: the Studio Museum, a nonprofit gallery/showcase for black artists, is located just off 125th Street on Fifth Avenue in Harlem.

"This is not a retrospective," he also insisted. "I'm not nearly finished—I'm not even ready for a summation." To emphasize the exhibit's non-retrospective nature, none of the pictures from *The Sweet Flypaper of Life*—published by Simon and Schuster in 1955—were included.

Unready for a summation he may be, but Roy DeCarava has been at it for a long time. Born in New York City in 1919, he was brought up in Harlem, and began his creative life as a painter, studying at Cooper Union and elsewhere. "My mother always had a Brownie and took pictures all the time," he recalls, "but I never thought of it as a serious medium." However, like many other painters, he began taking pictures himself in lieu of making laborious sketches, and eventually gave up painting for good.

He gives two reasons for his switch to photography. First, "a black painter to be an artist had to join the white world or not function—had to accept the values of white culture, like emphasizing technique in painting rather than what the artist feels. Black people have a spiritualism, maybe because for so long they had nothing else." Second, he found himself devoting more and more time to photography.

He started to photograph seriously in the late '40s, and received his Guggenheim—the first ever awarded to a black artist—shortly thereafter, in 1952. The pictures that he took on his Guggenheim—all studies of life in Harlem at that period—became *The Sweet Flypaper of Life*, to date the only

collection of his work in book form. This slim volume (still available in a Hill and Wang 1967 reprint edition)—which Gilbert Millstein described in the Times as "a delicate and lovely fiction-document"—was the brainchild of Langston Hughes, author of the tender, lyrical text.

"Nobody wanted the pictures," DeCarava remembers, "so I took them to Langston. I never said a word to him about those photographs; I just handed them over to him." Hughes assembled DeCarava's images into a visual narrative, a counterpoint to the bittersweet story he wrote to accompany them in the book.

As Millstein pointed out in his review of the end product, "Mr. DeCarava's photographs are peculiarly apposite, without being merely a collaborative effort. In this book, the story and the pictures are not so much dependent on each other as they are justifications of each other."

(Since then, the photographer has produced another book, *The Sound I Saw: Improvisations on a Jazz Theme*, but "nobody wanted that either. I did all the work—writing, editing, designing. It's been to all the publishers, but they all turned it down. They say it's too pretentious. . . ." Much larger and more complete than his first book, *The Sound I Saw*—which contains many of the pictures from *Thru Black Eyes*—is an exciting attempt to capture the spirit of jazz and its close relationship to the black experience, interweaving photographs and a long poem in free verse.) Until 1958 he supported himself and his family by working as a commercial artist, shooting in his spare time. Then he decided to try freelancing: his two children were of age, and he was financially free.

But breaking into the field was next to impossible, because he was black. "It was a horrible experience. I had won a Guggenheim, I had published a book, I had run a gallery, but I couldn't get any assignments. It was a hand-to-mouth existence. Harry Belafonte gave me several jobs, and that helped to pull me through."

Even so, it is only recently that he has enjoyed any measure of financial security. (He has been under contract to *Sports Illustrated* for the past three years: this provides a stable income, and he enjoys the job: "I wouldn't want to work for anyone else right now." He also teaches a course in photography—beginner-level, one class a week—at Cooper Union, his alma mater.) Fame has, so far, eluded him—or vice-versa.

Yet it is to be hoped that *Thru Black Eyes* will mark a turning point in his career, and engender a greater public awareness of his talent. A tour de force despite itself, the show only hinted at the breadth of DeCarava's accomplishments.

Though one would tend to assume that such a large collection of prints—roughly 180—must represent the absolute cream of his visual crop, this is not the case. Indeed, according to a photographer who knows DeCarava's work well, "Roy could have put together 10 shows this size. Some of his strongest pictures are missing—things I kept expecting to see just never turned up. But that's the way Roy wanted it." Rather than a self-glorifying, virtuoso display, DeCarava chose instead to offer a carefully planned, thematically structured exploration of black life.

Sections were devoted to such subjects as family life, music, civil rights demonstrations, work, and the white world: the exhibit probed the ghetto's subsurface far more exhaustively than the Metropolitan Museum of Art's monumental disaster, *Harlem On My Mind*, from which DeCarava was conspicuous by his absence.

Thru Black Eyes more than justified DeCarava's "intransigent" insistence on an entire room for himself as the price for his participation in the Met's fiasco. No one, black or white, has photographed New York's black ghetto more truthfully or in greater detail over the past two decades, so it hardly seems out of line for him to have asked for one room—which, not altogether coincidentally, is exactly the space *Thru Black Eyes* occupied.

But his conditions were not accepted, and—unlike Bruce Davidson, who at first made the same demand—DeCarava refused to compromise. Opening night of *Harlem On My Mind* found him on the picket line outside, dressed for the icy January weather and bearing an angry placard ("the foreigners reveal the real nitty-gritty"): no pictures of his graced the walls of the Met's galleries.[2]

And shortly thereafter, he stated the motives for his protest in these pages (May, 1969). His biting critique of the exhibit's technical flaws concluded with these words: "It is evident from the physical makeup of the show that Schoener and company have no respect for or understanding of photography, or, for that matter, any of the other media that they employed." Then, exercising considerable restraint, he added, "I would also say that they have no great love for or understanding of Harlem, black people, or History."

Obviously, this sort of frankness has not endeared him to the photographic establishment, and he has ended up in a semi-exile which is only partially self-imposed. During his membership in ASMP (the American Society of Magazine Photographers), for instance, he formed a committee to combat discrimination in the field. But, as he notes, "doing something fundamental was a different question entirely." At one meeting of the organization, he rose to inform the assembled members that "there are two societies—one white, one black."

No one today would question that statement of fact, but he was denounced as a racist and promptly resigned. "They give you a promise like a carrot on a stick—and you wind up without any balls, grinning. No, I'm not loved by the white photographic community," he says wryly, "but I am loved by the black photographic community, and that's what really matters to me."

He recounts these and countless similar incidents reluctantly, though with calm objectivity; he would obviously much prefer to discuss his work. Yet his struggles are so intertwined with his imagery that it would be hypocritical of him to avoid mentioning them.

Always, though, he comes back to his art. "Photography is an intransigent medium," he believes, "and it's very hard to express yourself. After you get a certain technical facility—and from the very first I took 'good' pictures—you've got to get at what you feel." Describing his own approach, he says, "I want to reach people inside, way down—to give them a quiver in their stomach. I've reached a certain plateau at this point, where I can sense an even greater intensity in a situation than I'm able to get on film.

That's what I've got to learn to capture, even if it takes the rest of my life." It is little short of tragic that our prejudices should have deprived Roy DeCarava of the wide audience he deserves, and deprived that audience of an artist with so much to reveal that they desperately need to know. As Edward Spriggs commented, in soft indignation, "Roy was way overdue for something like *Thru Black Eyes*. He should have been exposed on this scale 15 years ago. He's 49, and this is the biggest show he's ever had." It is high time for Roy DeCarava, black photographer, to begin receiving that recognition rightfully due him.

NOTES

1 [The collaboration with Langston Hughes, *The Sweet Flypaper of Life*, was published in 1955 by Simon and Schuster. —Eds.]

2 Subsequent to publishing this profile I learned that Roy had been roped into joining that picket line, hadn't bothered to read the placard handed to him, and didn't realize what it said till a photo of him carrying it appeared in the *New York Post* the next day.

A. D. COLEMAN

1970

"Object: Diversity" (unsigned article), in "Black America: 1970," special issue, *Time* 95, no. 14 (April 6, 1970)

Taking "Black America: 1970" as its theme, this special issue of the long-standing American weekly magazine *Time* was published two years to the week after the assassination of Dr. Martin Luther King Jr. The cover bore a portrait by Jacob Lawrence of the civil rights activist Jesse Jackson, who, at the time, was the national director of Operation Breadbasket, a project dedicated to improving economic conditions in Black communities across the United States. The unsigned article provided the context in which African American artists were working at the beginning of the 1970s. Facing it was a full-page photograph of Dana C. Chandler Jr. in his studio. After a spread of images of murals in Chicago and Detroit, more photographs of artists (all, unapologetically, male)—Sam Gilliam, Melvin Edwards, David Hammons, Malcolm Bailey, Richard Hunt, Joe Overstreet, and Daniel LaRue Johnson—appeared.

"OBJECT: DIVERSITY"

Is there such a thing as black art? Museums and gallery owners across the country seem to think so, and are rushing to mount shows. But as in other such efforts, earnest, liberal Whitey does not seem to have got it just right.

Some angry young black artists consciously paint black. Others of the generation that came of artistic age during the time of the new black militancy are painting and sculpting in styles ranging from expressionist to minimal, and they resist being classified racially. All these artists generally resent white sponsorship, even while recognizing that they have to deal with the white Establishment. As black men, they must approve the new recognition won by black artists. But as artists, they dislike the white man's current celebration of them merely because they are black. As one artist put it: "The black artist is a man, baby, not some kind of plastic superman you can make tap dance to Whitey's tune." Said another scornfully: "If they want black art, just take a canvas, paint it black, call it *Nigger Number One*, and they'll eat it up."

YOUNG AND ANGRY. The youngest and angriest care neither about what Whitey thinks nor about what they call the "white man's aesthetic." Their sole interest is to create a black art to which the black community can respond.

A good example is Boston's Dana Chandler Jr., a product of the tough Roxbury ghetto. At 28 he is a painter whom few in Boston can ignore, since his huge, bright Black Power murals glare from the sides of buildings that people pass by every day. Chandler's avowed intent is to "create a black museum in the inner city." His scorn for the white art world is complete. "Frank Stella? So much crap! It's decorative and costs lots of money and doesn't say anything. Earthworks? What the hell does it mean to black people if you get bulldozers and dig holes in the ground? All this stuff whites are buying tells the black man a lot about where the white community is at, namely, nowhere." His easel works are as bold and simple as his walls. In *The Golden Prison*, he shows a black man behind bars

beneath a flag with yellow and red stripes. "Why yellow? That's because America has been yellow and cowardly in dealing with the black man." In *Freddie Hampton's Door*, a rendition of the Panther leader's bullet-splintered door bears a stamp of U.S. Government approval.

INTO THE STREET. Some 20 other muralists, with encouragement and materials supplied by the city of Boston, have splashed their pride and sometimes anger on public walls. They are not subtle, nor are they meant to be. Among the most skilled is Charles Milles' mural painted on a handball wall in Orchard Park, in the primarily black Roxbury neighborhood. It proudly depicts black aspirations in dance, theater and music—and brings a spot of color to an otherwise dismal playground.

Elsewhere, notably Washington, Detroit and Chicago, black artists have also taken to walls. "People decorate the street because that's where their life is," says Artist Don McIlvaine, whose *Into the Mainstream* enlivens the rear wall of a store in Chicago's Lawndale ghetto. On *The Wall of Respect*, at the corner of 43rd St. and Langley Ave. in a desperately depressed part of Chicago's South Side, new scenes are frequently added to reflect changes in ghetto feelings. Originally it was dominated by athletes, peaceful marchers and popular heroes, including Malcolm X and Martin Luther King Jr. Now some of these have vanished beneath a wave of red paint, and in their place is a huge, malevolent Ku Klux Klansman under whose baleful eyes policemen are beating black youths.

By comparison, Detroit's *Wall of Dignity* is calm and restrained. Painted primarily by Chicago Artist Bill Walker, it faces a rubble-strewn lot on Mack Avenue in Detroit's East Side slums, and brings to the residents a saga of the black man's history from ancient Egypt to LeRoi Jones' exhortation: "Calling all black people. Calling you urgent."

FLAGS AND CHAINS. Though less overt than Chandler and the muralists, other young artists are painting or sculpting out of their sense of black identity. David Hammons, 26, of Los Angeles, well remembers his childhood in Springfield, Ill. The

youngest of ten children of a welfare mother, he passed Lincoln's house every day on his way to school, which somehow relates to his fascination with the American flag. "I don't know whether it's the black skin against the bright colors or the irony of the flag being held by an oppressed people. I do use the flag for some kind of shock value."

Also aimed at shock, but much cooler, is the work of New York's Malcolm Bailey, 22. In *Hold (Separate but Equal)*, a group of black and white figures are lined up on opposite sides of the canvas, but both races are in the same boat—a slave ship. "Real revolution won't occur until poor whites as well as poor blacks realize they are oppressed," Bailey explains. Bailey's career is typical of the new opportunities opening for talented young blacks. Born in Harlem, he got scholarship funds to Pratt Institute. He appeared in the Whitney Annual show this year, and is now living in the artists' community of Yaddo in Saratoga Springs, N.Y.

Barbed wire and chains are the materials of Melvin Edwards, 32, who was born in Texas. He has received seven grants, studied at both U.C.L.A. and U.S.C., is currently teaching at the University of Connecticut at Storrs, and has recently had a show at Manhattan's Whitney Museum. He disclaims any polemic intent. Still, a fellow sculptor remembers that when they tramped the streets of Watts together and Edwards started collecting bits of wire and jagged metal among the rubble of back lots, he called them "lynch fragments."

SHAPED AND DRAPED. Those artists for whom the question of blackness seems irrelevant—they are probably the large majority—are busy establishing their own kind of individuality. Some have handsomely succeeded, and in an extraordinary diversity of styles. Take Sam Gilliam, who was born in Mississippi 37 years ago, took an M.A. from the University of Louisville, and now teaches at the Maryland Institute of Art in Baltimore. His canvases are not so much shaped as draped—in drooping paint-spattered bunches, like clothes drying on a line. He had one on view in this year's Whitney Annual, has had shows at Washington's Jefferson Place Gallery and the Phillips Collection. The only

hint of racial origin on the guy-roped canvases of Joe Overstreet is his use of African and, most lately, American Indian colors.

Daniel LaRue Johnson came out of Los Angeles' Watts ghetto, but no one would ever know it from his works. He made his way via a scholarship and gumption to New York (where he made friends with Larry Rivers and Willem de Kooning) and Paris (where he met Riopelle and worked with Giacometti). Manhattan's prestigious French & Co. gallery gave him a show last month, where his slab-sided totems sold briskly for upwards of $3,500 apiece. As for being a black artist, he snaps: "Such questions are frivolous. They have nothing to do with the consciousness of people who attempt to make art."

Outside of their art, these men are often as passionately involved with the black predicament as any of their more graphically explicit colleagues. Chicago's Richard Hunt, 34, makes welded sculptures out of old automobile parts, and has had no complaint of studied neglect—he has been shown in museums from New York to Milwaukee to Pittsburgh to Houston. "But I'm not running away from being black," he insists. "I live in a ghetto-type situation now, and I'm involved with trying to get new low-cost housing in this neighborhood. It's different from painting pictures about it, and that is why I like it—because it's a different area of involvement."

COCKTAIL SALES. Whether their work is polemical or not, most black artists feel that the art world is controlled by whites and still largely closed to them. True, such artists as Horace Pippin, Jacob Lawrence and Romare Bearden have been widely recognized on their merits. Moreover, despite the efforts of the newly zealous black historians, no neglected genius has been turned up, though figures like Robert Duncanson, Edward Bannister and Henry O. Tanner have been given refurbished status. The past lack of major black painters is not due to any inherent lack of artistic talent on the part of black men—African sculpture disproves that. It is largely a function of the economic fact that in the U.S. few black men could afford to launch into careers as artists, or were encouraged to do so by their society.

Today, black artists are still sparsely represented in museums and private collections. Henri Ghent, who as Director of the Brooklyn Museum's Community Gallery is one of the few blacks to hold a job at the decision-making level in any U.S. museum, admits: "Everyone today will swear on a Bible that there is no discrimination in art. But it is still a fact that more paintings are sold over cocktails at private parties—from which blacks are excluded—than at the galleries."

All that black artists are demanding, or so they say, is fair exposure. It looks as if they are in the process of getting it. Then they will be on their own—both as blacks and as individuals. They say, properly, that they want it that way.

Walter Jones, "Critique to Black Artists," *Arts Magazine* 44, no. 6 (April 1970)

Walter Jones, an actor, playwright, and figure of note on New York's down-town scene, lived in the same building as the renowned jazz musician Charles Mingus. He had performed in *The Toilet*, a play by LeRoi Jones (later Amiri Baraka), and in 1969, he played the role of Sweets Crane in Charles Gordone's Pulitzer Prize–winning *No Place to Be Somebody*. The following year, his own play *Jazznite*, which he had written in the studio of William T. Williams, a childhood friend from North Carolina, was staged. Jones was skeptical about Frank Bowling's *Arts Magazine* articles—formal-ist accounts of the group of abstract artists that included Williams (see pp. 139–47)—and wanted to provide a different perspective in the same pub-lication, one that focused on social ties and conditions. This piece (which was illustrated with Williams's painting *Sweets Crane*) addresses the accusations Williams received of selling out after the Museum of Modern Art acquired his 1969 painting *Elbert Jackson L.A.M.F. Part II*. The artist Jones mentions who was "kicked out" of an Ivy League school is Peter Bradley; the artist from Detroit is Al Loving; Joe Blow is Joe Overstreet; Ed Lem is Melvin Edwards; and Larry Ocean is Larry Rivers. Jones refers to Rivers's controversial plans to curate an exhibition about slavery, *Some American History*, for the Menil Foundation in Houston (see pp. 309–14) and to involve artists such as Williams and Overstreet.

WALTER JONES, "CRITIQUE TO BLACK ARTISTS"

Hey, hey, read all about it. Niggers can't paint. They can sing and dance, man, and act the fool, that's for sure. Black painter growing up in America. Trying to identify with blackness, being forced by the establishment to stand up and be counted one by one.

Making you inferior before the start by labeling you a black artist because really, man, in their eyes, in this western world, the word black is number 2 in line: There's no place for number two in this Society. O.IC, black artists you want us to be, black artists we'll be, O.K?[1]

William Williams, ageless, growing up in North Carolina around a lot of long-needle pine trees, plowing a mule, living in a cinder block house without paint of any kind on any part of the interior, just gray flat walls. He used to steal a lot of watermelon as a kid with Dudder, Perry and me. As a kid, we stole a whole lot of things cause we were poor people. Never really had a whole lot of food to eat sometimes so we stole watermelon and apple and corn from some of the rich farmers that lived near us out in the countryside of North Carolina, the hill, the sticks, the swamp, the beauty of nature. All in North Carolina. Two-thirds of the state was then, and still is probably now, woodland.

Leaving North Carolina because of certain economic problems or reasons, going to New York, going way up the road to New York the city, which is a city. And the country, which is a country. What a big difference, man, what a contrast. Blending them both together to make what is a whole, ain't it man?

Living in Harlem for a while. Then he with ma and pa moving out to Far Rockaway to live in a project. You know, man. Them big tall square-looking buildings, looking like a box. Just sitting there doing nothing but holding back the wind from flowing smoothly. He being depressed most of the time.

Having to join a gang to survive in the project.

Fighting the white boys that lived down the beach a little ways. They living in nice little white homes with a little green grass growing out in the front lawn. With a little black samba standing out there smiling at everybody passing by. Sneaking girls on the rooftop of the project and fucking them was a big thing in the project, or on the stairway which no one used much. Niggers fuck, fight, and drink a lot of whiskey for the typical American escape into nothingness. Being lonely most of the time. Not able to communicate to his parents too tough. Beginning to withdraw from things and people around him. Not able to completely understand the entrapment in which black people find themselves.

Within this society that they have here for us. Not being able to escape enough with fucking, fighting and drinking, he made the turn to drawing things. Painting he picked up later on.

For the first time in his life he had found something that would keep him ultimately contented, as long as he wanted to draw, to paint out all of his frustration, disappointment, hatred, fears. And then to try and give something to the universe. To give humanity a long good look at itself, through artistic abstraction. Going to an art kind of high school, which was good for him. (Man, that cat's lucky he didn't grow up in North Carolina, no art high school is there for him). During that high school through two terms in college his work was hate, hate and emasculation. Coming out of that period he decided to go into something of his own. Him. The black man waking up finding himself trapped in white America. Screaming. He's trying desperately to be heard, to be part of the whole. Just to belong to something. To be seen as something, not seen just as a shadow lurking behind in the second spot, which means nothing in this world. Number two don't mean anything.

He decided to assimilate some of the whiteness that was around him and that he had been affected by. And with his black soul he feels that he will push aside and knock down if he has to, to surpass any white thing that might be there at the time to compete with him. He has a fantastic chance of doing it. He's off to a great start.

There's a little short cat around the corner and across the street that l-o-v-e-s the hell out of him some white girls. Now this little short nigger was kicked out of a big ivy league school for driving a watermelon truck on the campus and wearing

Mellondonnen suits. Nigger coming from Detroit saying he can paint. No Nigger from Detroit can paint. Damn, don't he know dat? They can't even hold a brush in their hands properly. One thing they're good with is gasoline, matches and a little gun play. Summer of 1967 they created one of the greatest art forms, or movements, or whatever artistic venture you would like to call it, in all of the twentieth century. Coming in a close second was Watts. Finishing third, strong with more gas to burn, was Newark.

My little short man don't dig this kind of art movement. He says it ain't gonna get us nowhere, but I notice that he's been able to get two grants that he wasn't able to get before 1965. He's in demand to teach art almost any place he wants. Can't handle all the lecturing jobs offered him. Was able to buy him a new sports car. Hey, how are you able to get into all them things now, man. A few years ago you couldn't have done it. I don't know, do you know? Does he know? Maybe.

This lil short nigger feels the only way to make it with all the odds against him is to fuck a lotta rich old women that have money. And maybe they'll keep him up with ah lil money in your pocket, or maybe they'll turn you on to some of their rich friends. And if you screw them maybe they'll buy a painting from you. He's a stereotype black painter. If you can get to fuck the rich white ladies you don't have to worry about a thing. Mr. B.T. dies overseas a few years ago proving that route was a failure. Dying so young, somebody else other than his immediate family is making money off his shit now. There must be another way out.

Joe Blow, living in Harlem painting his beautiful blackfaces and ugly black faces and mean black faces, hating everything that's white. Getting mad with my main man, telling him that he shouldn't have sold a painting to Modern Museum of Art because he didn't help to put pressure on the museum. Saying that it should have been one of the guys in the group who put the pressure on. And also that he didn't think his work represented black folk anyway. All them stripes that he is painting.

One afternoon Joe Blow, that cat tried to go in the museum without paying, in fact he did, but a

friend of his was billed later for it. He told the guard that he didn't believe in paying to see art, that rich people should pay for him.

Now dig this. The weirdest thing that I've seen happen was one day I was over at my main man's loft, and Joe Blow, my lil short nigger and this big dude named Ed Lem we were all sitting around bull shittin' each other. So Joe Blow had been smoking some shit and he had gotten a lil stoned. He started talking about how much money he had gotten from this deal that had gone down. That he'd gotten less money than anybody. He wanted to know why. Now dig this shit. My main man had gotten $5,000, my lil short nigger had gotten $4,000, Ed Lem $3,000 and brother Joe Blow fifteen hundred dollars. You hear me talking to you? $1,500. I can understand why he was mad, can't you? So Joe Blow thinks my main man was the cause of him getting so little. So they started arguing. Joe Blow stands up quickly, goes in his pocket, pulls out a long switch-blade knife and he's getting ready to do my main man in, but ol big Ed Lem saves him by grabbing Joe Blow's hand quickly, putting a karate chop on his hand, forcing him to drop the knife. Then explaining to Joe Blow that it's not my main man that did it, but the Great White Father Larry Ocean, who got $100,000 for the show.

Now if you want to hear some way-out shit, listen to this. There's a white boy going around here making black art. The first time I saw some of his work I thought he was black. Beautiful black girls that he paints. A hungry child in the streets of Harlem. A tall black man blowing a soprano saxophone while riding on a warm train way, way outta sight. Then it blew my mind when I found out this dude was white. *Black art, Black art, black art.* But to get to the roof of the story—this dude Larry Ocean got some money from a rich dude who lives out there where they shoot Presidents at. He asked Larry Ocean to do a show on niggerism as represented by the arts. All these cats are in the show, you dig, and about to whip each other's ass over a lil money. Larry Ocean did what he was supposed to do, putting one against the other. All the time man they do it.

After everybody cooled down a bit and Joe Blow put his knife back in his pocket, I felt that I

should say a lil something. Me being a actor, coming from another direction. So I stood up and said listen, man, you cats better get your shit together. It's getting late, man. This is the last gravy train. If you miss this one, forget it baby. There won't be another no more never no more. The man has given you a chance to express yourselves.

Don't fuck up and fall in the trap, which was put there when he gave you a little money, you understand? His plan is not about you succeeding, but falling in the trap and him saying I told you so. So don't let him fool you man, because dig it, if you succeed where does it put him? There's no fun being second best. You know that shit for yourself. Look around you, man. Dig on what the other brother is trying to say. He might be way-out.

But listen anyway. To be an individual and black is a lonesome, long, hard, difficult trip through this madness, man. I personally don't know of any black painter whom I can think of that honestly made it through this shit, man. Man, do you know that you are the last pure resource on this planet that hasn't been totally devoured? There's still a mystique about you that hasn't been opened yet. You are the one that could help save them. They know it, but they don't want you to know that they know it. Most of them are still pretending that they don't know. And they just might be stubborn enough to continue to ignore you and send this planet to the bottom of the sea to join Atlantis. I wonder what happened to that planet? Nobody knows really, but there were some black cats on it, that's for sure. Man, you cats can create something that will be greater than anything he has ever seen if you pool all of your knowledge together. You dig? You could save yourself and maybe him if he wants to be saved. I kinda doubt it. But you gotta save yourselves, man. You cats didn't come from a suicidal background. So I leave you with this: No man can play baseball better than Willie Mays. Ruth? You must be kidding. Who could beat Muhammad Ali? Marciano? Be real, man. Who can outplay Oscar Robertson? Cousey? Aw, come on, man, be serious. Who was a better football player than Jim Brown? Red Grange? Oh, man, are you crazy? Who can act better than Walter Jones? Marlon Brando? You kidding? He acts like

me. And Janis Joplin imitates Bessie Smith. You understand what I'm trying to say, brother? It has come to that, man. You cats will have to make your stand. You're dealing with the most difficult art to do it with though.

In the course of human events, when one reaches his fullest of evolution, in a given time of history when the last one is over-ripe and the juices are slowly flowing out of him and the flies and the bugs begin to tell him that he is decaying, he will almost always somehow close his eyes and ears and make believe that he's not listening or looking and sometimes convince himself that he's not decaying all although the handwriting is clearly written on the wall that the one is ready spiritually, culturally, emotionally, aesthetically to somehow reshape and revitalize the over-ripe plum that is slowly beginning to roll down the hill. Because the one, sweet juices inside resting beneath the skin that has never been sucked and eaten, knows that he is pure and stands alone as being the only one.

Peace.

NOTE

1 ["O.IC" is presumably meant to be read as "Oh, I see." —Eds.]

1970

Carroll Greene, "Perspective: The Black Artist in America," and "Black Art: What Is It?" (questionnaire), *Art Gallery* 13, no. 7 (April 1970)

In its April 1970 issue, *Art Gallery* offered what its editor called "the most comprehensive representation of Afro-American art ever published in a national magazine." Carroll Greene Jr.'s richly illustrated survey was followed by a questionnaire answered by a number of artists, including Romare Bearden and Faith Ringgold.

CARROLL GREENE, "PERSPECTIVE: THE BLACK ARTIST IN AMERICA"

"Every time I turn around nowadays there is a black art show," comments a gallery owner. "What's all this fuss and flurry about black artists all of a sudden?" The same bewilderment, infused with varying degrees of pique, seems prevalent among gallery and museum professionals and art critics. Public response generally can be judged on the basis of attendance, and it is precisely on that basis that these shows continue to be organized. Indeed, the group show of black artists has become the "in thing" in certain parts of the country.

What do the black artists themselves hope to derive from these exhibitions? Although it would be presumptuous for an individual to speak for all black artists, certain factors loom quite clear. Perhaps the whole matter can be summed up in the statement delivered by a black artist during a 1968 symposium at the Metropolitan Museum of Art: "The black artist's very existence has been denied so long that people don't know of him—even in the black community."[1]

Until quite recently, a group show of works by black artists was a rarity. The black artists themselves were reluctant to be "lumped together" on an ethnic basis, and there was little, if any, interest in their works. Individually, a few black artists were represented in urban museums and galleries but the representation was, and continues to be, minimal. I am aware that in some places this pattern is being altered, but only after confrontation between organized groups of black artists and museum officials. But whether there has been direct confrontation or not, a whole society is now being confronted.

It is true that the black artist often has been hesitant to expose himself to possible rejection. History supports his pessimism. The recent spate of group exhibitions, aside from creating mere awareness that these artists exist, serves other purposes: mutual support, the stimulation of public interest, and response by the critics. One-man shows of black artists' works might be quietly ignored, but put those same artists in group shows these days and the critics can hardly ignore them. Two other questions which these group exhibitions put to the galleries and museums are: (1) "Are there any black American artists on your roster and if not, why not?" And (2)—for those institutions which have several paintings or one or two prints by black artists—"How can we open up channels of communication between this gallery or museum and the black artists to ensure that they, who have been traditionally ignored or excluded, can now be given a fair chance of representation on the same basis as that accorded non-black artists?"

The day this last question is answered, more black artists will begin to function as individuals (that's where it ought to be) and there will be no need to confront the private gallery or good gray institution—private or public—with group exhibitions which have race as their *raison d'etre*, and, like the monotonous repetition of an African drum, "We remind you, you left us out again" as their message.

The situation of the black American in American society is, of course, reflected in the art community. It has been accurately observed that few American blacks visit the museums and galleries, although many might if they could discover something in those institutions which constructively relates to the one-tenth of our population comprised of black Americans. It may very well be too late to make museum and gallery-goers of the over-thirty generation of Afro-Americans, but what about the unprecedented numbers of blacks now in colleges and secondary and elementary schools? More of them are being exposed to the museums than ever before, but will they be sufficiently motivated to return on their own later on? Of course, no one need literally label a painting as the work of Joe Jones, Negro. Adequate and equitable representation of black artists will not go unrecognized in the black community.

[*The next few paragraphs of Greene's article present a history of African American art until 1970.*]

"The winds of change" which had been felt in Africa's new nation states began to be felt here, and

by the mid-1950s the Black Revolt had its painful birth. Inevitably the Black Revolution is having its effect on the work of black artists. Social commentary, once used sparingly, is becoming more prevalent in the work of today's artists. These works are often bitter, ironical or sarcastic as they attach the various hangups of our times. . . .

I do not wish to suggest that the gallery or museum professional should not be concerned with those black artists who eschew "art for art's sake" and in essence are challenging most of Western art theory. Frequently, they are admirers of the muralists Rivera and Orozco. Certainly, they are at home with the functionalism of African art—an art in which aesthetics *per se* seldom existed. The objects which we call "African art" were an integral part of their cultural milieu, reflecting its values, revering tribal ancestors, propitiating the necessary gods, and serving to coalesce the social fabric of the community—a community which so clearly understood its "art" that a more exacting critic than the average villager scarcely could have been found.

Even as increasing numbers of black artists entered (or tried to enter) the mainstream of American art, social, economic and political developments in the country at large and in the black ghettos gave birth to a new breed of black artists. Often they were young, but young or not, the concerns of these artists were conceptual, didactic and idealistic, not primarily aesthetic. Disdaining the "art Establishment," these artists attempted to communicate with their "sisters and brothers" left behind in the ghetto. Unlike so many of the middle-class-oriented black artists of other generations, these artists were often themselves "of the ghetto" and their major concern has been to inspire black unity, black dignity and respect as the first steps in a long march toward social, economic and political goals. There is no trace of *noblesse oblige* here, but a genuine desire to stand shoulder-to-shoulder with the "sisters and brothers" of the ghetto because "that's where it's at."

Elementary facts similar to American blacks from the beginning have begun to be recognized by all Americans in recent years: we live in two Americas, the one white and affluent and the other poor and black. Clearly, the value system that operates for the advantaged group cannot function for the disadvantaged. These younger artists are concentrating on this problem and even though more of them are educated, they prefer to "walk that walk" and "talk that talk"—i.e. identify completely with the people of the ghetto.

"You can't always make the other man's statement," observed one prominent black artist who is all too familiar with the necessity for artistic individualism. His observation reflects the crisis in values that our nation now faces. It is expressed variously: the black-white confrontation, the generation gap, the poor versus the affluent (irrespective of color)—in short, the powerful versus the weak.

These advocates and creators of "black art" and street art may be against many things, but they are pro-people—the poor disinherited black people of the urban jungle who have been imprisoned in ghettos by a society in which caste and credit still determine one's life chances to a preponderant degree. These dissident black artists are affirming an as yet unarticulated new humanism. They are offering, as did their African ancestors before them, an art based on communal values. Such an African "art" must have had crude beginnings also, but the best of it has taken its place as part of humanity's cultural heritage. We have an old and revered American tradition of art in which concepts triumphed over aesthetic means of expression. Admittedly some of these younger black artists have not yet "gotten their thing together"—but can you blame them for trying?

EDITOR'S NOTE—Although we have illustrated Mr. Greene's article with as many plates as space and availability have permitted, our pictorial survey is necessarily incomplete. We believe it to be the most comprehensive representation of Afro-American art ever published in a national magazine, however, and while we regret the omission of many deserving artists' works, we hope that future books on the subject will cover it with the exhaustiveness for which no magazine has the physical capabilities.

"BLACK ART: WHAT IS IT?" (QUESTIONNAIRE)

There has been much debate of late over the question of "black art." Both within and outside of the black community there are those who maintain there is no such thing (or shouldn't be), that art transcends ethnic distinctions. Others clearly recognize the existence and usefulness of art that is, in one way or another, identifiably black. The editors invited a number of black artists and white art authorities to air their views on the subject. White response was disappointingly scarce and except for Mr. van der Marck (whose views most closely parallel those of the editors), all the participants in this symposium are black.

BENNY ANDREWS

That question requires an answer that is much more than anything I shall be able to write, say or even put in a painting. The answer has to be more than today, yesterday or even . . . ever.

For this moment let it suffice for me to say:
To be black is to feel it
To be white is to need it
And since all should know it
Get busy showing it
Then we can share it
Who knows, maybe that's it

MALCOLM BAILEY

In my opinion there is no definition of black art. It is absurd to take a group of painters, whose various works and concepts differ, and categorize this group as exponents of black art just because of their skin color. There is however a definite black political experience in America. I feel that too many black artists believe that by depicting an African design motif or painting an enraged black man with a raised clenched fist they are really saying something. It is a much more dynamic experience to see a live black cat raising his fist than it is to see a painting of one. Therefore an artist's job should be more than one of just mirroring life; he must instead interpret life in a very subjective abstract way.

ROMARE BEARDEN

In most instances when I create a picture, I use many disparate elements to form a figure, or part of a background. I rarely use an actual photograph, for instance, of a face, but build faces from parts of African masks, animal eyes, strips of colored paper, mossy vegetation, or whatever else I feel suits my purpose. In such a process, often something specific and particular can have its meaning extended toward what is more general and universal, but never at the expense of the total structure.

In this connection, in the work of mine portrayed on page 27,[2] the hand of the man on the far right has as much to do with integrating the painting as a whole as with representing the "handness" of hands. I also try to show that an interior of a southern home was as important to the life of this country as it was in the Holland of de Hooch, Terborch and Vermeer.

Also involved in this process is the purpose of extending the larger rhythms of the picture. For instance, the man on the right is structured to correspond to the horizontal and vertical rhythms that tie the collage together.

I feel a quality of artificiality must be retained in a work of art, since, after all, the reality of art is not to be confused with that of the outer world. Art, it must be remembered, is artifice, a creative undertaking the primary function of which is to add to our existing conception of reality. Moreover, such devices of artificiality as distortion of scale and proportion and abstract coloration are the very means whereby I try to achieve a more personal expression.

Although the initial public reaction to my work has been one of shock, which appears to arise out of a confrontation with subject matter unfamiliar to most persons, it is my intention to reveal through pictorial complexities the richness of a life I know.

LOIS MAILOU JONES

My appearances on television this past year and just recently in Charleston, W. Virginia have dealt with the controversial subject: "Black Art." On each appearance I have been confronted with the questions—"What is black art?" "Does black art exist?"

In response I have explained that I consider "black art" a name or a title given to works done by black artists in an effort to bring about an awareness that black artists exist. It establishes for them "black identity."

This designation of works produced by black artists (whether it be good protest art or meritorious abstract works) has resulted in the fostering and presentation of numerous black art shows, stimulated recognition of the value of these works as a force in the development of America and encouraged black artists to exploit these opportunities in an effort to establish their place in American art on an equality basis.

PAUL KEENE

Black art is a visual attempt to find a viable form which relates directly to the black experience. We are understanding in a very precise way that we are a people of a unique and tragic experience—people of a particular race and culture. It is the graphic language of the self-assertion and imminent maturation of black people living in a degrading and oppressive society that offers little liberation of the black potential. It is an attempt to impress in black terms the sense of who and what we were, what we are now, and what we can be.

JACOB LAWRENCE

Black art is that art which has a particular form that is recognized as "BLACK"—regardless of content.

TOM LLOYD

To the question What is black art? I usually reply with a question: What is white art? My question always stuns my adversary, who, while regaining his composure, thinks, "Oh hell, what is he asking? Doesn't he know what white culture is? Doesn't he know how long it's been around? Can't he see the relevancy of Noland's stripes? Or the beauty of Warhol's Brillo boxes? Certainly, he must know the validity of Oppenheim's earthworks. Damned black militant extremists! Black aesthetic—bah!"

HUGHIE LEE-SMITH

My observations have led me to conclude that a growing number of today's young black artists are showing signs of increasing disaffection for what has been for them a frustrating, unproductive courtship with the art Establishment, and Establishment art. Unlike most earlier Afro-American artists who sought in vain to enter the portals of the white art palace by way of diligent and often brilliant emulation of prevailing stylistic modes, many contemporary blacks are rejecting officially sanctioned art, and are turning to their own communities as a source of stimulus of a different order.

In their view the mainstream art scene, replete with a diversity of aesthetic alternatives, most of which are concerned with gross trivialities, is entirely irrelevant to the cultural needs of black people who have been denied the "pseudosophistication" required to "appreciate" most current art and its anti-humanist philosophy.

The new work of black artists who have returned to the grassroots is often rough-hewn and vigorous, but most importantly it is affirmative of life. This robust "unsophistication" seems to be an essential characteristic of black art at this early stage of its development.

So, although we are a long way from a consensus on the question What Is Black Art? I would venture to define it tentatively as that art which derives its inspiration and sustenance from the struggle of black people for economic, social, and cultural power; an art which reflects, celebrates, and interprets that struggle in a stylistic manner which is meaningful to the Afro-American community and members of other oppressed minorities.

This is not to advocate the imposition on black artists of a specific set of values, or a prescribed manner of working. That sort of thing can be done only at great peril to artistic freedom. But, given the current social/political climate, it is to be hoped that they will develop a new intellectual posture which will lead to a re-examination of favored assumptions, and inspire a search for new values; new art forms that can be appropriated to the cultural needs of the black community and the black human rights struggle.

FAITH RINGGOLD

If black art is art at all, it must be expressive of some deep and pervasive truth; and for the black artist in America the most pervasive truth, the one with which he must daily contend, is the unmovable reality that he or she is black in America. To deny this reality, consciously or unconsciously, is to indulge one's self in dangerous, pathological fantasy; and if there is one thing that black people and black art have had absolutely enough of, it is fantasy of any kind.

Truth is too difficult for most people to deal with. Artists exist as the only element within society which can actually afford to tell the truth about it. Telling is not only in the "what," but also in the "way." Black artists must refer to the black experience for the "way," if they are to tell the truth as blacks; which is to say, if they are really to be black artists.

Specifically black art must use its own color black to create its light, since that color is the most immediate black truth. Generally, black art must not depend upon lights or light contrasts in order to express its blackness, either in principle or fact.

All "black" artists are aware of this blackness I speak of, and with more black, black art to attest to it, white artists will also know what blackness and black truth is about. At present, I am sorry to say, the *truth* is that most black art is really brown.

THOMAS SILLS

Black art? I don't know. I'm just painting the way I paint. There's nothing in my *work* that's black. *I* know that I'm black. Black men wear the colors I use, but so do whites. We were in Uganda a couple of years ago and I saw them tall black women in the sunshine wearing their costumes and they were beautiful. I said to my wife: "A lot of these colors are my colors." But you know, a lot of white painters use the same colors. I just feel I'm a painter.

JAN VAN DER MARCK, DIRECTOR, MUSEUM OF CONTEMPORARY ART, CHICAGO

A misnomer, but who cares. Ten years ago it might have been applied to Ad Reinhardt or considered the pictorial counterpart to black humor and black comedy. Today it is more than art made by black people—it is a battle cry. Black art stands outside of and is, in fact, scornful of the arena of international art with its carefully controlled codes of rules and conventions—an art that admittedly serves art rather than people. Ignoring rather than flouting international tradition, young black artists develop their own style from scratch. Their art serves the black liberation, it denotes black pride, it is a weapon of propaganda and it is an art of the streets, not of museums. Black art is epic, popular and for mass consumption. It is an important means for young and militant talents to link heritage and background with the furthering of the black cause and the destiny of the black race. For whites to demand that black art comply with current international esthetics is unreasonable and shortsighted. The revolution will have to be fought before art by black people becomes another strand in the fabric of international art and the term "black art" is recognized as a misnomer. Until then, the art world has to accept black art on its own terms—or turn away from it, at a loss!

NOTES

1 [The artist in question was Tom Lloyd; see p. 115 in the present volume. —Eds.]

2 [The illustrated work was Bearden's screenprint-collage *Carolina Blue* (1970), now in the Museum of Modern Art, New York. —Eds.]

1970

Dore Ashton, "Introduction," and Smokehouse Associates, "Smokehouse," in *Using Walls (Outdoors)*, catalogue for exhibition held at the Jewish Museum, New York, May 13– June 21, 1970

In 1967, the artists William T. Williams, Melvin Edwards, Guy Ciarcia, and Billy Rose initiated a project, separate from their individual studio practices, to paint murals on various buildings in Harlem and place sculptures in empty lots. They called their group Smokehouse Associates, thinking of the buildings used to prepare meats and store them during the winter. Previous murals in Black neighborhoods tended to be image-based and narrative-led, most famously the *Wall of Respect* in Chicago (see pp. 72–75), but Smokehouse worked with abstract designs, hoping to improve the surrounding environment through color and shape. "We saw the work itself as being the actual change," Edwards recalled in 1999. "You don't tell people to make things better, you make things better and people join you in making them better. I think the general idea of improving things was what we wanted to happen."[1] Smokehouse's projects received some exposure outside Harlem when the Jewish Museum organized *Using Walls (Outdoors)* in 1970. The exhibition had two parts: Inside the museum, artists such as Mel Bochner, Sol LeWitt, and Lawrence Weiner made works directly on the walls, while visitors were also directed to various works dispersed throughout the city, including Smokehouse's wall paintings. The critic Dore Ashton introduced the catalogue, and in the second volume (with one of its paintings on the cover), Smokehouse published its only statement of the period, keeping its members' names anonymous.

DORE ASHTON, "INTRODUCTION"

All over the world people are moving to signal their presence as thinking, feeling, and, above all, concerned individuals. They are concerned about the quality of their increasingly sordid, shared public spaces. And about the undeniable alienation sponsored by chaotic, ugly and crowded urban situations. From the urchin who signs his name on the wall, to the professional who projects his image large, the impetus is the same: change these public spaces at all costs into habitable places that console and inspire the urban dweller; into places that remind him that no man is an island.

The urge to move into public spaces has a history in the United States. It was never, historically, related to the superficial notion of "beautifying" America. It emerged, during the 1930s, as a dynamic movement to change not only the facades and interiors of public architecture, but to change the values of the citizens sharing the spaces. Those American artists who watched Rivera doing his Rockefeller Center murals, who assisted Siqueiros when he was in New York, and who keenly appreciated Orozco, were not interested in embellishment alone. They wished to assert the value of community. They were motivated by a deep, ethical commitment. That tradition has now been extended in many directions.

[. . .]

The rectification of initial planning blunders is no small part of the movement towards walls. Since New York is condemned to live in a rigid grid formation, with few open spaces and fewer pleasing vistas, the artist must step in, with his magic bag of tricks, altering and annulling whenever possible.

[. . .]

The members of the other professional group most active in New York City, Smokehouse Associates, are avowedly opposed to rectification. Their goal is to change the society, beginning with its living spaces. The anonymous members of this interracial group attempt to alert the community to its own possibilities. They roam the alleys, garbage lots and abandoned spaces in the most crowded areas of Harlem, staking out the most despised spaces for their efforts. But they don't stop with the realization of painted walls. They approach the life of the community from every direction, carefully documenting the results of past activities, and building toward a totally integrated social scheme. The tremendous ambition evidenced by the Smokehouse group may be measured by their frequent references to other cultures (African, Oriental, and pre-Columbian) which they feel successfully created habitable environments in every sense—physical as well as spiritual. Such broad thought is increasingly apparent all over the United States where survival has suddenly appeared to be a local affair of urgent importance.

SMOKEHOUSE ASSOCIATES, "SMOKEHOUSE"

It is both encouraging and heart warming that artists have decided to venture into public forms of art. Thus, the restricted boundaries of museum and gallery walls are being opened to the public.

But . . .

But . . .

It is our belief that all city wall paintings executed thus far are decorative, lacking in scale and irrelevant as a public art form. These projects do not have the power, scale or conviction that commercial billboards have. They have in essence been studio problems which were inadequate in the studio, and become visual atrocities as public forms. One cannot bring formalist problems to a public audience and expect meaningful participation.

Most city wall paintings have not understood the difference between scale and size. They have relied on color intensity and sheer mass for impact. It should be apparent that the city environment itself is a great deal more powerful than the isolated wall paintings.

We, the Smokehouse Associates, believe that there is a necessity to separate one's studio ego from public forms. Meaningful public environmental solutions will come from collective efforts on the part of painters, sculptors, architects, writers, planners, etc. Those persons who have expertise in many interrelated fields must be called upon to resolve a total urban condition.

Smokehouse Associates was originally formed in 1967, as a means to deal with a gap between art and audience. Our original membership was limited to painters and sculptors, but it quickly became apparent that we had to expand our membership to include other related expertise. Our composition now includes architects, writers, actors, photographers, graphic designers, community workers, city planners, lawyers, and poets. We admit that the projects we have completed are by no means an answer but a qualitative possibility.

NOTE

1 [Melvin Edwards, "Statement on Smokehouse (1999)," in James Prigoff and Robin J. Dunitz, *Walls of Heritage, Walls of Pride: African American Murals* (San Francisco: Pomegranate, 2000), 127. —Eds.]

1970

Unsigned statement on poster for *AFRICOBRA 1: Ten in Search of a Nation*, exhibition held at the Studio Museum in Harlem, New York, June 21–August 30, 1970

In summer 1970, AfriCOBRA's first institutional show was mounted at the Studio Museum in Harlem. Although no catalogue was produced for the occasion, a poster featuring a photograph of the ten artists in the group and a selection of their works, all superimposed over a collaged silhouette of Africa, accompanied the show. The exhibition traveled to a number of venues: The first stop after the Studio Museum was the Museum of the National Center of Afro-American Artists (NCAAA) in Boston. A couple of months after the show closed in Harlem, AfriCOBRA's objectives were published as a manifesto in the October issue of *Black World* (see pp. 263–65). The article set out the group's goals while underlining the importance of making accessible images for all to enjoy.

AFRICOBRA 1: TEN IN SEARCH OF A NATION

AFRICOBRA—AFRICAN COMMUNE OF BAD
RELEVANT ARTISTS

It is Nation Time and we are searching. In the spirit of Nation-ness we are examining the roots and branches of our African Family Tree for the seeable which is most expressive of our people/art. We are trying to make images inspired by sublimely SuPer-real African people/experience in the U.S.A. Images that all African people can dig on directly. Images that jar the senses and cause movement. Poster art. Images designed for mass production. Inexpensive. We want everybody to have some. All the SuPerreal people.

We invite you to view our work. You, SuPerreal African People, are our standard for excellence. Only you can determine the hipness of our observation/vibrations. We invite you to judge our efforts. If we are moving in the right direction we would appreciate hearing from you. If we are moving in the wrong direction, a coat-pull would likewise be appreciated.

Come see us. Got something for you.

1970

Benny Andrews, "The Black Emergency Cultural Coalition," *Arts Magazine* **44, no. 8 (Summer 1970)**

This text is the artist Benny Andrews's personal account of attending a "preview reception" for *Harlem on My Mind: Cultural Capital of Black America, 1900–1968* at the Metropolitan Museum of Art and of forming the Black Emergency Cultural Coalition (BECC; see pp. 134–35).

BENNY ANDREWS, "THE BLACK EMERGENCY CULTURAL COALITION"

On the night of June 4, 1968, I attended the preview reception for the *Harlem on my Mind* exhibition at the Metropolitan Museum of Art, little knowing that I was starting out on a completely new adventure in both the art and the black world. The night of festivities marked the commencement of an event embodying Tom Hoving's publicly avowed intentions of including the public in a more active role in the everyday existence of the Museum. To quote Hoving, ". . . our charter, which is almost a hundred years old, enjoined the Museum to apply itself vigorously not only to the study of the fine arts but to relate them to practical life as well. Practical life in this day can mean nothing less than involvement, and active participation in the events of our time. For too long museums have drifted passively away from the center of things, out to the periphery where they play an often brilliant but usually tangential role in the multiple lives of the nation. Speaking for this museum, we have by and large been unresponsive to social and political events. Perhaps, given our own struggle to grow, it couldn't have been otherwise. But to continue to do so would be irresponsible. *Harlem on my Mind* signals the turning point."

The above generous statement by Thomas P. F. Hoving, Director of the Metropolitan Museum is the rallying cry of all individuals and organizations involved in the cultural and social upheavals that are now taking form—erupting in the daily war between the keepers of the American heritage and the public cultural archives.

Enough has been written about the reason Hoving agreed to let Allon Schoener mount the *Harlem on my Mind* exhibition to satisfy any questions anyone should have on the subject. I will say, as a complete outsider, that I personally feel Hoving really thought there was political gold in including something "black" in the overall plans he had for the Museum and that his advisors were simply too ill-informed about the nature of the black community to advise him wisely as to what kind of inclusion of "black" would enable him to: 1. make a public gesture to the black community in a way that would help him politically (should he need it), 2. put on an exhibition that would not make inroads into the sacred and non-black areas of "high culture." Even taking into account such selfish motivations, however, I must say that Thomas P. F. Hoving probably ventured more towards carrying out the mandate of the Museum's charter to involve itself with the public than anyone else in the city's museum structure.

I was struck by the ignorance of the Museum's advisors when, on arriving at the opening preview, I found that many of the best known black artists, who had lived in Harlem for years—Norman Lewis, for example—were not invited; the precious and chic advisors who had scurried about never heard of them. On the other hand, artists like myself, whose names had recently appeared in the *New York Times* regarding an exhibition of black artists (*New Voices—15 Black Artists*, sponsored by Ruder and Finn at the American Greeting gallery in the Pan American building), were invited.

The preview was held in the medieval section behind the Museum's prized Spanish Gate, on the first floor. There was a band playing, waitresses rushing across the floor with dishes of little tastes, and a improvised bar lavishly pouring out drinks as if they had a private tap on an endless distillery. People of all shades were "sassafrassing" back and forth, and smiles were in abundance everywhere one turned. The Museum had removed all the breakable, or turn-overable art objects that usually adorn the space for that particular night. Black and white people mingled together freely with a lots of elbow room but except for that there was no physical presence of anything pertaining to the forthcoming exhibition, *Harlem on my Mind*. I looked for other clues, asked various people and, finally spotting Mr. Thomas P. F. Hoving, surrounded by clever and smartly dressed men and women, decided to express my dismay over the omission of certain artists. I broke into the discussion to say, "Mr. Hoving, I'd like to say that somehow this whole idea of an exhibition pertaining to the black man seems to have already gotten off on the wrong foot." I was interrupted by a young man who pushed himself

between Hoving and me (My wife whispered in my ear to forget it. Besides, she said, "they will just think that you are drunk"), but Hoving pushed the Tuxedo man aside and said, "let him finish." So I said I felt that their advisors were too uninformed about who the real people of Harlem were to be trusted with putting on a exhibition such as the one they suggested they were going to do. Well, just at that time a young lady piped in that she would be willing to contact me, and listen to any suggestions I or anyone else might have regarding the Harlem community. I gave her my phone number and address, and that was sufficient to get rid of me forever as far as they were concerned. Incidentally, the only reference to the exhibition (except us), was a little hastily put-up board that had the invitation brochure tacked up showing the back, front and inside of the brochure (an obvious last minute effort to give some semblance of an active and on-going effort in getting the exhibition started). No one seemed to have any idea of what the exhibition would really be about; and one of the Museum's clever people told me that the reason we were invited was for them to get our ideas. Well, from the way the reception went, I would venture to say that scheme was a total failure. Everyone looked completely baffled, and I couldn't fail to notice how easily the Museum would be able to erase the fact of our having being there, in their "Gilded Cage" of culture, by just taking down the little board with the skimpy views of the brochure; tomorrow no one need be the wiser.

I thought about that strange event called the "Preview Reception for the *Harlem on my Mind* Exhibition," and what really stuck in my throat was the flippant and superficial attitude of the people I'd met there who were connected with the show. I remember how helpless I felt as an artist and as an individual. That episode was to enable me to sustain a sense of indignation that will be with me as long as I live.

The indignation that I felt was shared by many others too; its physical expression was first manifested in a visible form in the establishment of the Black Emergency Cultural Coalition. The B.E.C.C. was formed by a group of black artists for the purpose of making sure there would be no more *Harlem on my Mind* exhibitions foisted on the public, both black and white.

On a cold day—January 12, 1969, to be exact—at one p.m., the Metropolitan Museum of Art witnessed a strange and foreign assemblage parading around and around the oval in front of the Museum on Fifth Avenue. Some of the people present on that now-historic occasion were Reginald Gammon, Norman Lewis, Ray Saunders, Henri Ghent, Vivian Browne, Calvin Douglass, Cliff Joseph, Russ Thompson, Felrath Hines, Mahler Ryder, Roy DeCarava, Ed Taylor, Raymond Andrews, Barbara Carter, Romare Bearden, Benny and Mary Ellen Andrews and children, John Dobbs, Alice Neel, Tecla, Zeb and Francesca,[1] and others who joined in from the streets. From that expression of disgust by a collection of black and white people evolved the B.E.C.C. which took it upon itself to carry on the fight against racism in the cultural area of American society.

After the protests at the Metropolitan Museum of Art, we (the B.E.C.C.) set up a permanent organization headed by three co chairmen, and a executive board of artists, with the goal of serving as a watchdog group for the black community in the graphic arts. On April 24, 1969 the B.E.C.C. opened up talks with the Whitney Museum of Art over its policies of omission regarding the black community; and for the first time in the history of that museum of American art, black people sat across the table from its representatives and demanded tangible evidence of the museum's claims of concern regarding a fair and equitable representation of art works by all people regardless of race. It was a unique experience in the history of this country's museums. We of the B.E.C.C. are far from pleased with the results, to date, of the meetings with the Whitney Museum of Art; but we know that we did provide a push in the right direction—as far as it was possible for us at that time and under the prevailing circumstances.

Specifically, the Whitney Museum of Art agreed, as a result of our meeting with them, to: 1. stage a major exhibition of "Black Art Works," 2. establish a fund to buy more works by black artists, 3. show at least five annual one man exhibitions, in the small gallery off the lobby, of black

artists, 4. have more black artists represented in the "Whitney Annual," 5. consult with black art experts.

It is up to the Whitney Museum to show good faith in implementing the above promises in order to prove their contentions of impartiality. We of the B.E.C.C. will remain on the alert for any subtle deviations on their part.

We cut our teeth in the talks with the Whitney Museum; and we learned a lot about the upper stratum of American cultural society. The B.E.C.C. set out in the talks with the Whitney Museum to show that we could sit down with "them" and deal in measured tones with the inequities accorded the black man in this society—and dammit we did. We called our points out straight and clear; and we made no deals. We listened to their side; and we presented ours. We were not wiped out by their niceties; and we never forgot who we were, where we came from and where we were to return to. When we ended that phase of the talks there were no misunderstandings left between "them" and us; the lines were clear and distinct.

We folded up our tents and left the Whitney Museum of Art, its grand boardroom and thick carpets, carrying a memory of the two or three paintings by black artists they had up for our benefit in the boardroom (they probably followed us down the steps and into the basement). We left no promises, and made no requests, but we know we'll be back to the Whitney Museum of Art someday—as painters and sculptors, we hope; not as stand-in curators and vocal spokesmen for the black man.

Since then the B.E.C.C. has continued its pioneering movements into alien and sometimes hostile inner sancta. We have met with representatives of the Museum of Modern Art and, recently, the Metropolitan Museum of Art. Other art groups are emulating our approach and already we are seeing the influence of our initial efforts in actions taken by different museums in their dealings with black artists and black art experts. With the great number of black art exhibitions taking place across the country, it is no longer necessary for the B.E.C.C. to demand that black art work be shown or for a black art exhibition to take place; instead we have moved into the area of the employment of black art expertise.

This is the area that is least occupied by the black man now; the selection and exhibiting of works by black artists should justify the use of good qualified black minds. One of the few major exhibitions to do this is being staged by the Boston Museum of Fine Arts and will be on view through June 23rd. This exhibition, titled *Afro-American Artists: New York and Boston*, has the necessary ingredients for the successful projection of a qualified black art expert into a meaningful curatorial role as a valid representative of the show's historical and ethnic background, and to insure a superior exhibition. Edmund B. Gaither, Director of the Elmer Lewis Art School in Dorchester, Massachusetts, and presently holding a curatorial position at the Boston Museum of Art, comes completely prepared to sensitively coordinate the accomplishments of the formally trained black artists and the more socially and politically aroused, untrained black artists into a unified exhibition. He brings two critical requisites to an exhibition of this kind: 1. a life-long identification with the entire spectrum of the "black experience," 2. a well-rounded formalized study of all the available historical data on the history of the black artist in America. He is ably assisted by Barney Rubenstein (artist and teacher, and white).

Mr. Rubenstein will contribute (with all due respect to his avowed intentions of objectivity) all the doubts, conscious and unconscious, that are naturally present in a non-black mind confronted with the concept of an all-black exhibition. This conflict can help to insure a strong effort on the part of Mr. Gaither; for it will be up to him to be forceful in his convictions and feelings concerning the validity of the "black experience." All in all, this exhibition stands to be the major all-black one to date. I might add that it is ironic that the Boston Museum of Fine Arts should be the first such institution to actually make use of a qualified and young black art expert to organize this major exhibition (a centerpiece for its centennial year). One used to the proud claims of New York City's cultural bastions can only be dismayed at their lag in this area—in which the Boston Museum has demonstrated such enlightenment. In fact, members of the B.E.C.C. are painfully aware of the Whitney Museum's failure to emulate this type

of appointment—which would serve a positive indication of faith in a black man to coordinate a major exhibition for them. So for anyone who is tempted to underestimate the validity of the B.E.C.C.'s exposure of deep-seated racism in our country's cultural institutions, he has only to look at the records of the local museums to grasp our point.

The B.E.C.C. has proven and will continue to prove that unless the black people solidify their strength in a pointed and direct way, as far as the cultural institutions of this country are concerned they can only expect token representation in America's art. It should be underscored time and again that it is easy to have two or three well established black representatives in any professional endeavor, with the solid backing of the society, because they can serve to "cool the situation." It is when a fair and large contingent of black people demand that they be accorded their just dues in the cultural arena that the society rises up and becomes hostile—in this case, by means of its insulated museum structure. It is to this very area of operations that the B.E.C.C. chose to direct its main thrust.

The recent and brief history of this thrust has shown tremendous gains—which are not being attributed to the B.E.C.C.—but we can live with that. What we cannot live with is the foot-dragging on the part of some key people in this noble struggle. If the all-black exhibitions are to be eliminated from our daily fare, then a fair and impartial representation of the black artist's work must be included in museums, galleries, and homes. So the exhibition *Afro-American Artists: New York and Boston* signals another forward step in the struggle being fought by the B.E.C.C., and its particular artistic merits I leave to the critics; for the present, its mere existence is a triumph of artistic morality over entrenched cultural racism.

NOTE

1 [Tecla Selnick (1909–1983) was an artist. Francesca Burgess, a graphic designer, and Zeb Burgess, a sales representative for the publisher Harper and Row, were supporters of Benny Andrews and the B.E.C.C. —Eds.]

Edmund B. Gaither, "Introduction," in *Afro-American Artists: New York and Boston*, catalogue for exhibition held at the Museum of Fine Arts, Boston, May 19–June 23, 1970

Hilton Kramer, "Black Artists' Show on View in Boston," *New York Times*, May 22, 1970

Hilton Kramer, "Trying to Define 'Black Art': Must We Go Back to Social Realism?" *New York Times*, May 31, 1970

Hilton Kramer, "'Black Art' and Expedient Politics," *New York Times*, June 7, 1970

Benny Andrews, "On Understanding Black Art," *New York Times*, June 21, 1970

Douglas Davis, "What Is Black Art?" *Newsweek* 75, no. 25 (June 22, 1970)

Henri Ghent, "Black Creativity in Quest of an Audience," *Art in America* 58, no. 3 (May–June 1970)

Afro-American Artists: New York and Boston was an exhibition of seventy artists held at the Museum of Fine Arts (MFA), Boston. It was the largest exhibition of work by Black artists in the United States to date and consequently garnered nationwide attention. The show was organized by Edmund Barry Gaither, curator of the recently established Museum of the National Center of Afro-American Artists (NCAAA), which Gaither had helped to spearhead; he had also recently been appointed as an adjunct curator at the MFA. A joint effort between the two institutions, the exhibition reflected the pressure felt by museums to display the work of Black artists in the aftermath of the Metropolitan Museum of Art's controversial *Harlem on My Mind* exhibition (see pp. 134–35). Specifically, artists including

Emma Amos, Dana C. Chandler Jr., Tom Lloyd, and Lois Mailou Jones had demanded change from the MFA, and this exhibition was the most visible result.

Hilton Kramer, art critic at the *New York Times*, devoted three weekly columns to the Boston show. He felt that political concerns had taken precedence over "rigorous artistic standards"—standards that he thought would allow Black art to truly evolve. Following Kramer's critiques, the *Times* published a response by Benny Andrews, who offered an account of his involvement with the exhibition. Andrews took issue with Kramer's view of the show and argued that the critic did not have the correct criteria to judge its importance.

Douglas Davis, a video artist who also worked as a critic, published his review of the Boston show in *Newsweek*. Amos complained to Davis about the art establishment's expectation that Black artists always address politics, which meant that work like hers was often ignored. Lloyd, also in conversation with Davis, defined his light sculptures as "black art . . . a black expression" and claimed that the flashing bulbs evoked "the rhythms of our African past." Despite these artists' ideas, Davis proposed that an "authentic black school" was most likely to arise from the figurative, political work of artists such as Andrews and Chandler, particularly because "white critical opinion" was "least comfortable" with their kind of art.

Finally, coinciding with these articles was a piece in *Art in America* by the curator Henri Ghent. Born in 1926 in Atlanta, Ghent studied at Boston's New England Conservatory and at the Longy School of Music in Cambridge, Massachusetts. After initially forging a career as a concert singer, he became a prominent art critic. As the inaugural director of the Brooklyn Museum's Community Gallery, from 1968 to 1972, Ghent was the first African American to occupy a senior post in a major arts institution in the United States. In Brooklyn, he advocated for the work of local, underrepresented artists. He was also an important figure in the Black Emergency Cultural Coalition (BECC), responsible for directing discussions with the Whitney Museum of American Art in 1971 (see pp. 223–24). Ghent's argument here functions as an institutional critique, holding museums, in their role as "tastemakers," responsible for the "'invisible' status" of Black artists in cultural programming.

EDMUND B. GAITHER, "INTRODUCTION"

Afro-American Artists: New York and Boston is the largest and most concentrated exhibition of the work of contemporary Afro-American artists presented to the American public. It is the most recent addition to the group of so-called "black shows." Yet it is not enough to simply state these facts, pay compliments to the artists and wait for the next such show. Indeed, part of the obligation of understanding such a project is to help you—the viewer—gain a perspective on the world, the artists, the nomenclature and the circumstances which have led to the necessity for "black shows."

To meet this obligation, let us focus our attention on the important terms "black show" and "black art."

At its simplest, a "black show" is an exhibition of work produced by artists whose skins are black. The term seldom connotes the presence of properties or qualities intrinsic in the work and therefore it does not act as an art historical definition. A "black show" does not belong to the same order as a "cubist show." The "black show" is a yoking together of a variety of works which are, for social and political reasons, presented under the labels "black" or "Afro-American." Such a show is thus a response to pressures growing out of racial stresses in America. At the same time, "black shows" attempt to introduce a body of material to a race-conscious public in order to force that public to recognize its existence and its quality. And like most socially motivated devices, the "black show" has its strengths and weaknesses.

The "black show" as a serious exhibition is a twentieth century invention. It began in the dual system which characterized American life early in the century, and it has continued because social and political factors still make black people a special group in the national population.

[Here, Gaither charts the history of "black shows" until the 1960s.]

"Black shows" of the sixties differed in two important respects from earlier ones: they were usually hosted by major museums and universities and they were of much higher quality. The increased involvement with major art institutions reflects the pressure of militant black arts organizations and the heightened demands for relevancy. Higher quality shows result from the enlarged pool from which the art is selected. Serious critical standards can be observed because one no longer grabs everything possible for a "black show." Instead, one carefully picks and chooses.

A second factor contributing to the improved "black show" is the introduction of black organizers who have shown a greater sympathy and understanding of their fellows and have thus prevented faux pas such as *Harlem on My Mind*.

Irrespective of how one regards the "black show," it still has certain points in its favor, at least for the rest of this decade. It begins to meet the need for real involvement between the black community and the professional art world. It begins to attack the ignorance which still clouds the culture of black people. It provokes people, black and white, to look, and it precipitates benefits for the artists.

The "new black show" is a valuable educational and cultural experience for both black and white viewers and artists.

It will remain so as long as the racial attitudes out of which it grew remain, although it will no longer be the black artist's only outlet.

The social meaning of the "black show" is, and has always been, clear to the astute observer. The foggy area has been the seeming inability of its organizers to move beyond simply pulling together works by artists who are black and to begin to create meaningful definitions of the work. That thirty artists have black skins and produce art is an observation of no artistic consequence. Unless they have some shared property in their art, there is no reason to group them together in an art show and label it "black art." After all, what does that mean?

It is absolutely essential to recognize that even though the groupings which make "black shows" have a social imperative, the art nevertheless has properties which lend themselves to definition. It is possible for those much over-used terms "Afro-American art" and "black art" to have meaning.

However, as critical terms, their meaning must derive from the study of the works.

Perhaps a fruitful way to approach the term "black art" is by reviewing its background. In the era of the "New Negro" (1920–5), a number of black intellectuals and artists came to feel that the American black man had an honorable and rich heritage, and that by drawing upon it he could create an art uniquely expressive of himself. This idea was early suggested in "The Negro Artists and the Racial Mountain" published in 1927 by Langston Hughes. A more developed statement of the position was advanced by Dr. Alain Locke, professor of philosophy at Howard University and a Rhodes scholar. Locke stated that the black American had an artistic genius derived from his African past, but that the institution of slavery had broken his plastic traditions and had reversed his artistic temperament. He advocated the study of African art in order to rediscover its sense of subtlety and discipline. The artist was to learn African aesthetics. Out of this study would come, he felt, a school of Negro Art which would employ creatively the formal lessons which African art had taught the western world and interpret sympathetically the life and story of black people here and abroad.

Locke did not regard the creation of a school of Negro Art as a retreat from the mainstream art world, but he saw it as providing a foundation for the production of great Negro art which would be the equal of French or Italian art. The result of Locke's efforts was the appearance of a short-lived movement based directly on African art. He also contributed to the growing concern for black subjects by black artists, but his influence at this level is probably secondary to the prevailing taste for realism and genre work. Nevertheless, Locke's ideas have continued and have taken on new dimensions with the rebirth of cultural and political nationalism among black people.

While there is a continuing interest in ideas akin to those of Locke, not every artist who is black can be called a black artist if that term is to be meaningful. Although at its broadest "black artist" may mean simply an artist whose formative experience was in the black community, it is clear that as an artist he may choose to work outside of the traditions of that community. He may regard himself as a cosmopolitan artist. Depending on his political and social ideas, he may wish to cut all ties with the group. The group may pose a threat to his freedom and may reject his chosen style. The work of such artists may be most fruitfully discussed in terms of generally recognized styles and tendencies rather than as "black" or "Afro-American."

By contrast, there are artists who knowingly and intentionally base their art on peculiarly black experiences, on the history of blacks and on a view of Africa. Their work must be considered within legitimate art historical groupings which may be characterized by specific and observable traits.

Perhaps there is no better expression than "Afro-American shows" for these new and diverse exhibitions of the work of artists who are black. In this case, however, the term is used for sociological reasons rather than art historical ones. "Afro-American" does not describe the work but states a fact about the artists which is of interest to the public at this moment in history. Thus under the umbrella of a sociological description may be found several styles, each of which belongs to the discussion of other works of similar character. Afro-American art exhibitions may therefore include hard-edge painting, color-field art, minimal, kinetic or figurative art and even some varieties of social realism.

Black art, on the other hand, is one of two movements in the work of younger blacks which is subject to critical definition. Black art is a didactic art form arising from a strong nationalistic base and characterized by its commitment to a) use the past and its heroes to inspire heroic and revolutionary ideals, b) use recent political and social events to teach recognition, control and extermination of the "enemy" and c) to project the future which the nation can anticipate after the struggle is won.

In his visual language the black artist is basically a realist. Black art is a social art and it must be communicative. And realism is generally accepted as the most common visual denominator and therefore the most communicative art language.

A related but distinctly different movement in the work of black artists is Neo-Africanism. This

direction is rooted in the study of traditional African art, its formal organization and its palette. Neo-Africanists do not attempt to copy or translate African art, they attempt to fathom its aesthetic, to get at its essence. The ideas thus extracted from African art are used to create art forms reminiscent of African art but at the same time peculiarly modern. Such works may seem superficially based on the shaped-canvas idea, but they are in fact resonant with deeper meaning. The palette of the painted masks and house decorations of West Africa finds a new home on stretched canvas or burlap. The shapes of Dogon headdresses and ritual objects reappear in Harlem with freshened memories of their historical significance in the African experience. The viewer of Neo-African work will be struck by the African qualities of the work which account for its consistency as a group Neo-Africanists share with black artists proper a nationalist basis and, like black artists, they are associated with a syndrome of essentially nationalistic political views.

Afro-American Artists: New York and Boston presents a rich, high quality selection of works representing all of the directions which Afro-American artists are presently exploring. A great deal of the art belongs to the body of mainstream American art and therefore does not demand special explanation. Its strengths are its imaginative power, its subtlety and its fine execution. Into this group fall the kinetic work of Tom Lloyd, the stripes of Daniel Johnson, the nudes of Zell Ingram, the women of Emma Amos and the excellent father-son group of John Wilson. Other works belong to the category of black art proper; for example, the political art of Dana Chandler. Still other works such as the masks of Ben Jones and the sculptures of Tonnie Jones belong to the Neo-Africanist tendency.

Altogether, the exhibition underscores the vitality and diversity of the work of the American artist who is black, whether he embraces prevailing styles or makes new departures on his own. I am persuaded that, if the younger artists can retain their energy and direction, they may hold the key to the most vital art of the second half of the twentieth century.

HILTON KRAMER, "BLACK ARTISTS' SHOW ON VIEW IN BOSTON"

[*Kramer begins by explaining the size of the show and where it was staged.*]

The exhibition itself brings together a wide variety of visual styles, from the most elegantly executed color abstraction to the most crudely conceived social realism. Behind this stylistic variety, however, there is one basic line of division in the exhibition— the division separating works of art that are conceived as an esthetic end in themselves and those that are conceived as a medium of social criticism and political action. There are works of compelling interest of each side of this basic division in artistic outlook, but for the most part—in my view, at least— the real quality of the exhibition is to be found in a handful of paintings and sculpture that belong to the so-called "mainstream" of modern art.

Among these I would include the shaped canvas of Alvin D. Loving Jr., the heavily impastoed abstractions of Bill Rivers, the abstract expressionist canvases of Norman Lewis, the sculpture of Jack White, the color abstractions of Alma Thomas, and the lyric abstraction of Felrath Hines. Also in this category are works by Marvin Brown, Thomas Sills, Frank Bowling, Ellen Banks, and the late Bob Thompson.

Among the paintings and graphic work that undertake to impart a more explicit social or political message, most are of a vehement illustrational character. They are either expressions of community solidarity or outright protest art. Often these works are very affecting, but not in esthetic terms.

To approve or disapprove of such work in esthetic terms seems somehow inappropriate, however. Whether an art museum is the most appropriate place to display such work is also a question, at least for me. One cannot help noting, in any case, that black artists seem to be no more successful than their white contemporaries in finding a fresh stylistic expression for their social and political grievances. The crisis through which our society is now passing has caught the artist, black and white, without a vocabulary adequate to the occasion, and the results are all too evident in the exhibition.

I hope to be able to discuss this exhibition in more detail on a later occasion, however. Its principal value, in my view, lies precisely in the important questions it raises—questions about art, but also questions about the relation of art to social values and of the museum to the community at large.

HILTON KRAMER, "TRYING TO DEFINE 'BLACK ART': MUST WE GO BACK TO SOCIAL REALISM?"

What is "black art"? Is there a "black esthetic" discernible in the visual expression of black American artists that distinguishes it from the work of their white contemporaries? If so, what are its characteristics? If not, are there nonetheless sufficiently compelling social reasons why segregated exhibitions of art by black artists should now be encouraged?

Picking one's way through these questions in the current political atmosphere in this country is a little like picking one's way through a minefield. Only an incurable innocent could expect to come through the experience unscathed. Yet it is imperative, I believe, that such questions be debated, and not merely buried under ritual responses and demagogic rhetoric. The conflicts that arise whenever and wherever these questions are seriously entertained—conflicts between esthetic standards and radical social aspirations—may not be the most fateful that now confront American society in its present crisis, but they are of great importance all the same. For the answers we give to these questions may very well determine the character of the culture that will emerge from the present turmoil—assuming (if one may) that culture itself will not simply be dissolved in the political miasma.

The exhibition called *Afro-American Artists: New York and Boston*, which Edmund B. Gaither and Barney Rubenstein have organized for the Museum of Fine Arts in Boston, has the virtue of providing some tentative answers to these difficult questions—or, if not precisely answers, then at least some visual evidence on the basis of which the beginning of some answers can be broached. For this is the largest exhibition of black artists in America ever organized. Moreover, it inaugurates a

new program of collaboration between the Museum of Fine Arts and Boston's National Center of Afro-American Artists—a program designed to encourage the creation as well as the collection and exhibition of black art.

But what, alas, is "black art"? The difficulty of defining this term is the principal issue, to which Mr. Gaither, who is both the Curator of the Museum of the National Center of Afro-American Artists and a staff member of the Museum of Fine Arts, addresses himself in his Introduction to the catalogue of the show. He distinguishes straightaway between a "black show" and "black art." "At its simplest," he writes, "a 'black show' is an exhibition of work produced by artists whose skins are black. The term seldom connotes the presence of properties or qualities intrinsic in the work and therefore it does not act as an art historical definition. A 'black show' does not belong to the same order as a 'cubist show.'"

Mr. Gaither continues: "The 'black show' is a yoking together of a variety of works which are, for social and political reasons, presented under the labels 'black' or 'Afro-American.' Such a show is thus a response to pressures growing out of racial stresses in America. At the same time, 'black shows' attempt to introduce a body of material to a race conscious public in order to force that public to recognize its existence and its quality. And like most socially motivated devices, the 'black show' has its strengths and weaknesses."

This definition is, I think, admirable in its candor and precision. But in attempting to define "black art," Mr. Gaither is less successful. He speaks of "artists who knowingly and intentionally base their art on peculiarly black experiences, on the history of blacks and on a view of Africa." He then adds: "Their work must be considered within legitimate art historical groupings which may be characterized by specific and observable traits." The "traits" in question are not, however, esthetic or stylistic traits. They are, if I understand Mr. Gaither's account correctly, political.

For this is as close to a workable definition of "black art" as Mr. Gaither can come: "Black art is a didactic art form arising from a strong nationalistic

base and characterized by its commitment to: a) use the past and its heroes to inspire heroic and revolutionary ideals; b) use recent political and social events to teach recognition, control and extermination of the 'enemy'; and c) to project the future which the nation can anticipate after the struggle is won." To this political definition Mr. Gaither adds a comment on style: "In his visual language the black artist is basically realist. Black art is a social art and it must be communicative. And realism is generally accepted as the most common visual denominator and therefore the most communicative art language." So we are back in the realm of social realism. Interestingly enough, there is no mention here of "quality" or "strengths and weaknesses." These (essentially esthetic) terms are reserved for "art [that] belongs to the body of mainstream American art." Of the latter Mr. Gaither observes: "Its strengths are its imaginative power, its subtlety and its fine imaginative power." But how are we to judge the "strengths" of "black art"? Only in terms of political ideology, apparently. Implicit in the distinctions Mr. Gaither has drawn in his Introduction to the catalogue of this show is an assumption that "black art" is to be exempted from the customary application of critical discriminations based on purely artistic values.

The exhibition that Mr. Gaither and Mr. Rubenstein have organized at the Museum of Fine Arts faithfully reflects the divisions to be found in this important essay. This is certainly a "black show." But whatever stringent critical discrimination has been brought to bear on the selection of works for the show has been limited to "mainstream" expression—to works of art that observe, with varying degrees of success, the established stylistic conventions of modernist esthetics. In the selection of "black art" for the show, the criteria are patently ideological, and esthetic quality suffers accordingly. There are some compelling images of social horror in the show, but almost without exception they rely on a visual language of outworn devices and established clichés. These images address themselves to emotions already rubbed raw by the march of events. They deal in practiced responses, and add

little or nothing to the true language of feeling—which, after all, it is the function of art to modify and enlarge.

HILTON KRAMER, "'BLACK ART' AND EXPEDIENT POLITICS"

Writing last Sunday about the exhibition called *Afro-American Artists: New York and Boston*, I suggested that the concept of "black art" put forth by Edmund B. Gaither, the black organizer of the exhibition, was fundamentally a political conception. The Boston exhibition is not, to be sure, entirely devoted to "black art." Much of the work here belongs to what Mr. Gaither himself characterizes as "mainstream American art." The best of these "mainstream" artists are, in my opinion, the painters Norman Lewis, Alvin D. Loving Jr., Bill Rivers, Alma Thomas, and Felrath Hines—all abstractionists of various persuasions—and the sculptor Jack White. Others who are represented by work of notable "mainstream" quality are Marvin Brown, Thomas Sills, Frank Bowling, Ellen Banks, and the late Bob Thompson. There is also a fine drawing by Ronald Boutte.

Two of the best-known New York artists in the show—Romare Bearden and Benny Andrews—work in styles which seem to derive their energy and expressiveness from a double commitment. On the one hand, they exhibit a very canny awareness of "mainstream" modernist esthetics. On the other, they very consciously seek to utilize a "black" subject matter. In theory, an art that draws its inspiration from this double commitment would seem to constitute an ideal synthesis. Yet in practice such an art seems to be extremely difficult to realize. The artist's loyalties remain divided. One term or the other in this double commitment is always gaining the upper hand, disturbing the balance that is sought. In Mr. Bearden's work, it is always the Cubist structure that dominates. The "black" motif is relegated to a secondary, epiphenomenal status. In Mr. Andrews's work, the real power lies in its vehement depictions, and he has yet to find a form really equal to the emotions his work is designed to

convey. Still, the work of these two artists defines, if only in principle, a possible direction for a "black art" that refuses to surrender itself entirely to the well-worn clichés of social realism.

There is another artist in the Boston show—Mahler B. Ryder—whose work embodies this division between esthetic and politico-ethnic loyalties in the most poignant and and explicit way. Mr. Ryder shows a group of tiny collages more or less in the manner of Kurt Schwitters, a handsome painted wall sculpture reminiscent of Arp (his best work, I think), and two political drawings that are little more than crass illustrations. Mr. Ryder is an artist of real gifts, and the division that is so dramatically evident in his work is, in some respects, the most important "message" which this exhibition discloses.

With the bulk of the "black art" in the Boston show, we are in the presence of political propaganda pure and simple. For the most part, this art displays a vivid, highly exacerbated black awareness of social problems and social aspirations, but an altogether depressing lack of awareness of artistic problems. Such art undoubtedly has its purposes—for the white public as well as for the black—but they are not artistic purposes. With the purposes of art, such work is not really concerned. No discernible artistic standards obtain in its creation. One is left with the unhappy impression that the practitioners of "black art" have been very largely content to draw upon the most moribund visual conventions of the white art world for the expression of black social grievances. Perhaps such work will serve, in Mr. Gaither's words, "to project the future which the nation can anticipate after the struggle is won," but I frankly doubt it. Its very style—and lack of style—looks to the past rather than the future. The only thing such work signifies about the future is a permanent division between artistic excellence and politics.

What role, you may wonder, has the Museum of Fine Arts played in mounting this exhibition, which is only in part an exhibition that speaks in the name of disinterested artistic accomplishment? *Afro-American Artists: New York and Boston* is, as I reported last week, the joint effort of the Museum of Fine Arts and Boston's National Center of Afro-American Artists, and the exhibition marks the beginning of what is said to be a new program of collaboration between these two institutions. I have no idea what this collaboration will produce in the future, but in the organization of the present exhibition the role of the Museum of Fine Arts is pretty clear. The museum raised the money for the show, lent its facilities and extended its hospitality to it, but otherwise had little voice in determining its nature or quality. There is no mistaking the fact that the exhibition is the result of community political pressure.

The irony, in the case of the Museum of Fine Arts, is particularly striking. For the museum has a poor record so far as organizing exhibitions of contemporary art is concerned—in fact, hardly any record at all. It has no curator charged with this for such exhibitions. Mr. Gaither, who holds a double appointment with both the Museum of Fine Arts and the National Center of Afro-American Artists, is, in effect, the only museum staff member who specializes in contemporary exhibitions, and his responsibility (as I understand it) is limited to "black shows." Thus, *Afro-American Artists: New York and Boston* is not just the largest but the only survey of contemporary American art the Museum of Fine Arts has initiated in many years.

Would a museum with a healthier, more knowledgeable and sympathetic interest in contemporary art have been in a position to handle the complex problems of a "black show" differently? I don't really know. For so long as political criteria are insisted upon in the selection of "black shows," and the imposition of rigorous artistic standards is regarded as simply one more form of white racism, I am not sure that any art institution—no matter what its past history may be—can deal with the "black" problem any other way. Yet I see no point in pretending that an exhibition such as the present one in Boston is anything but what it actually is: an art exhibition mounted under the pressures of political expediency that fails, by and large, to justify itself in terms of artistic accomplishment.

BENNY ANDREWS, "ON UNDERSTANDING BLACK ART"

The shuttle plane from New York made its last run around the greater Boston area, then locked itself into a straight line and, for what seemed like hours, flew lower and lower toward Logan Field. The scrunch of the tires brought me back to the reality of my sitting on that plane at this time, and in this place. I was to give two gallery talks at the Boston Museum of Fine Arts, in relationship with the recently opened *Afro-American Artists: New York and Boston*. Edmund Barry Gaither, curator of the exhibition (in conjunction with Barney Rubenstein, art teacher in the Boston Museum's art school), was at the airport in no time to pick me up, and we were heading for the museum to see the "newborn baby of Boston," the first major exhibition of Black artists in the area.

While it is true that these all-Black art exhibitions are a recent happening on the American scene, somehow I feel that they are old hat, I suppose because I have been so deeply involved in the whole question about them in so many ways. So as Barry and I drove along the expressway, I pumped him with questions about the reactions of the People, our people, to be specific. Questions like "Did a lot of Black people show up? How did they react? What did they say?" Finally, in a kind of desperation to make sure that our people really responded positively, I turned to Barry and said, "Look man, you and I both know how our people can look and act about public things, and no one is the wiser. It's been our thing to maintain those poker faces throughout distasteful history. So I am asking you as Barry, the black cat that can read our people even when they are keeping their cool, were they proud of the exhibition?" Barry hesitated for a moment and said, "Yes, they felt all those things that should be felt. But remember that you will be facing them in the gallery talks, and you'll get the answers for yourself."

I had never been to Boston before, and upon entering the museum, I took quick note of the many cherished masterpieces that stood atop marble stands, peered from behind thick glass cases and hung from the ceilings in ornate frames. I caught the names of famous Americans, old families, both as the subjects of the art works and as donors to the museum. All in all, I could have been in any major museum in the United States—the National Gallery in Washington, the Philadelphia Museum or the Metropolitan Museum—and seen the same cultural exhibition of America. So far there was nothing to forewarn the new visitor that a few feet ahead in the main galleries of this 100-year-old edifice of American culture, one would see a total victory of a people from the streets of America being accorded a long overdue right and honor.

The first glimpse I got of this Black exhibition was Dana Chandler's *Bobby Seale, Prisoner of War*, and then I entered into the galaxy of the "American Innards," the Black man's artists expressing themselves in all forms, shapes and colors. On first seeing, they are too diversified to detail, much less describe. I saw two beautiful paintings by Romare Bearden, two pieces of sculpture by Barbara Chase-Riboud, *Monument to Malcolm X No. 2* and *No. 4*, and the overpowering painting by Edward Clark, *The Big Egg*, that just seems to hang there, suspended. This was only the first of many galleries to see, and already I was full, but hungry because from the corners of my eyes even more individual and varied expressions were beckoning me to come and stand before or above or beneath but just come.

This was and is the kind of exhibition that I experienced every time I walked through it. The only work that I did not react to was my own work. I'd reacted to that when I was doing it, and that was the last time ever; from then on, it would be on its own. I could look at it, but I could only see it from the outside, too, and whatever it was that we shared in those moments in my studio are only secret memories between us, lost forever to the public.

One piece literally grabbed me, and that's the sculpture, *The Junkie*, by Lovett Thompson, a Boston artist. I stood there with a chill running down to my toes as I experienced the grip . . . aaaach!!! Who in the hell can put it into words or art what it must be like to be *The Junkie*? Thompson must

have because hard-nosed me felt all welled up and twisted inside while I stood there transfixed by the artistic transference of this pathetic and tragic figure, and I relaxed on my haunches and remembered the putrid and inappropriate review I'd read in *The New York Times*, by its art critic, Hilton Kramer, on Friday, May 22, 1970. On first reading it, I was disturbed but I told myself to leave my mind open until I saw the exhibition, then I would re-read his report. As I stood there, I began to get his inability to mentally penetrate the main essence of an exhibition of this kind.

[*Here, Andrews quotes from Kramer's article.*]

It goes without saying that Kramer is unqualified to honestly evaluate this kind of exhibition and, by his own admission, he is unable to bring the mind or the tools to see a piece of work such as *The Junkie*, or the painting by Dana Chandler, *Fred Hampton's Door*, riddled with bullet holes, as anything more than, to quote him, "paintings and graphic work of a vehement illustrational character . . . either expressions of community solidarity or outright protest art. Often these works are very affecting, but not in esthetic terms."

Kramer continues on to make clear that he is ill-prepared to adequately review the exhibition in the first place by saying, "To approve or disapprove of such work in esthetic terms seems somehow inappropriate, however." One can immediately ask why in the hell is it so damn confusing to see the Black artist expressing his feeling about his people, his environment and life as something unfathomable, if artists like Goya, Picasso (his *Guernica*, for example, and his long *political* battles with Franco of Spain), and Dürer, George Grosz, Ben Shahn, etc., can be dealt with critically? I would be the first to say to hell with sentiment if I didn't feel it, and if it was not ever-present in *my* everyday existence. There are artists who can and do paint in the so-called "mainstream" of art and they express political, social and personal views, and they are *praised* and *criticized* for their works.

Those were some of the galling thoughts that interrupted my viewing of the exhibition. When my mind returned to *The Junkie*, they were all erased, and I went on to look at works by Lynn Bowers, *Barbara In Three Parts*, Jack White's beautiful and elegant sculptures, Russ Thompson's poetic *My Breath Is One With The Clouds*, Gary Rickson's *Capitalism In Organic Brown*, Reginald Gammon's homages to Henry O. Tanner and Paul Robeson, and Norman Lewis's solid and exquisite *Heroic Evening*. There were others of great merit and substance to make this exhibition a landmark in the history of America's culture.

At two o'clock the people began to gather, both white and black, for the gallery talk that I was scheduled to give. We started out. I would comment on the impressions I received from certain pieces in the exhibition, and different individuals in the audience would ask questions. One man asked: "What did the exhibition intend to do, did it intend to show that there's a 'Black' Art and if so, what do the Black artists intend to do about future exhibitions?"

I found the answer in the introduction to the catalogue written by Edmund Gaither, curator of the Museum of the National Center of Afro-American Artists, when he states, "At its simplest, a 'black show' is an exhibition of work produced by artists whose skins are black. The term seldom connotes the presence of properties or qualities intrinsic in the work and therefore it does not act as an art historical definition. A 'black show' does not belong to the same order as a 'cubist show.' The 'black show' is a yoking together of a variety of works which are, for social and political reasons, presented under the labels 'black' or 'Afro-American.' Such a show is thus a response to pressures growing out of racial stresses in America."

When one accepts that explanation for this type of exhibition, and I feel that most black people do, then it is easy to see the impossible task a critic like Kramer has when he is faced with a body of work like that in *Afro-American Artists: New York and Boston*.

The gallery tour came to a halt in front of my painting, titled *The Champion*, and a black person from the audience asked me to comment on it. I felt obligated to say something, and my response went

something like this: "I wanted to show the strength of the black man, the ability to persevere in the face of overwhelming odds, and I have used the symbol of the prizefighter.[1] I remember the fights of Joe Louis and how his strength carried us through so damn much, and today I think of the strength that Muhammad Ali has shown in his battles for his principles, so when I was working on the *The Champion* I was trying to capture the essence of that thing, whatever it was that the black man has and is able to muster in the face of so damn much adverse odds. If people can only see a prizefighter, then okay for them, but for those who are able to fathom something more meaningful than just a fighter, then more power to those perceptive people.

Also, I cannot fail to relate my sense of indignation over the fate that has befallen the black man's Thors, and it is in this sense of indignation I tried to paint my heart out in *The Champion*. The epitome of the sad fate that has engulfed our Thors came to surface a few weeks ago when it was reported that an official at the Colorado Psychiatric Hospital said that former world champion Joe Louis, 56, had been admitted on a "hold for treatment" order.

When I finished talking about my feelings and my reasons for painting, I looked into the crowd, and as I looked from one black face to another, I knew that they felt in their way the way I felt in mine, and that it was no longer a question, "Did the folks feel the exhibition?" I had those beautiful and soulful faces nodding and silently saying, "Yes, yes, indeed we understand."

The fact of the matter is this—just because the bulk of the art does not fit into a tidy little outline of art criticism does not mean that there are not people capable of getting to what there is to say and explain about this body of work that makes it valid and artistic. For that reason, even though I am not an art critic, I cannot in clear conscience let the slighting remarks made by Kramer go unchallenged. There are times in one's life when one must step forward and direct the light of knowledge and wisdom in the right direction.

One of the works of art that abstractly suggests grappling with the essence of any struggle is James Denmark's huge black wood sculpture, *The Struggle*, and if there is anything to the feeling that the artist actually transfers some of his inner emotions into his work, then, to me, *The Struggle* is a beautiful example of that. On and on the works of art go, and they serve as a continuation of the still unresolved and unanswered question of the status of the black man in American society. Few informed people would deny that there is no definite answer to just what the final answer will be in the streets, but I feel that those same people will not deny that that society cannot remain exactly the way it is now. If that be the case, then neither will the artistic expressions of black people follow the status quo. This crucial, and maybe in some minds, fine point, is the area in which the present work of black artists and the present status quo or "mainstream of modern art" critic are at odds. I personally feel that it is an exercise in futility to attempt to change these particular "dyed-in-the-wool" individuals. I am encouraged to feel okay in this belief when whenever I go to an exhibition like the *Afro-American Artists: New York and Boston* and see all those people, black and white, looking and being so damn involved. I can compare that sight to the one of the bored and indifferent people, mostly white, that I see at the major exhibitions of "mainstream in modern art." Like the *Spaces* exhibition at the Museum of Modem Art, *New York Painting and Sculpture: 1940–1970* at the Metropolitan Museum, and the *22 Realists* at the Whitney Museum of American Art.

My Boston experience came to an end; I caught the shuttle plane back to New York. The trip was in every way almost a re-run of the other, yet in between I had witnessed something that at least one other person had missed on his round trip to the Boston Museum of Fine Art's *Afro-American Artists: New York and Boston*. If I had any hopes that Kramer would eventually comprehend the artistic quality of the exhibition, they were shattered when he wrote his "in depth" two-part Sunday article, "'Trying to Define 'Black Art': Must We Go Back to Social Realism?" Here, he proceeded to tear the exhibition apart as being political and, for the most part, non-artistic. Establishing in his own mind that Gaither had implied in his introduction in the catalogue that "black art" was fundamentally a political

conception, Kramer asked this question: "Are artistic standards simply a form of white racism?" My answer to that question could very well be yes, if the white mainstream art oriented critic persists in the following:

1. Not being able to see a black figure done by a black artist without automatically assuming that the work is propagandistic, or politicizing.

2. Being unable to look at an all-black art exhibition with the same impartiality that he brings to an all-white exhibition.

3. Not criticizing curators or museums for putting on all-white exhibitions.

4. Giving the impression that art exhibitions are dropped down from heaven.

5. Not re-examining his attitudes about black people in general, and black artists in particular, before assuming so much knowledge about what blacks think or do not think.

6. Forgetting how easily he has lived with past discrimination against black artists.

7. Last, but not least, not asking himself, "How many great all-white art exhibitions have I seen lately?" For example, the Metropolitan's white *New York Painting and Sculpture: 1940–1970* and the Modern's white *Spaces* exhibition, and all those white bombs staged by the Whitney over the years.

There will be many more Boston experiences, and they won't necessarily take place in Boston, and there will be more people to grasp the true and full meaning of those experiences. I honestly want to believe that statement, because if I ever fail to believe that, then I shall have to believe that not only will the Boston experience cease to exist, but also that the Bostons of this country will cease to exist.

DOUGLAS DAVIS, "WHAT IS BLACK ART?"

Climb to the top of the stairs at the Museum of Fine Arts in Boston and you will find four brightly painted columns about 7 feet high with thin pinstripes taped to their canvas surfaces. Facing each other in a tiny circle, the columns create a carefully structured environmental space all their own; the colors echo and re-echo each other, from stripe to stripe, from column to column. This is neat, precise, intelligent art, the kind the American art establishment has been promoting and collecting for a decade. Yet the man who painted these columns—Daniel Johnson—is black and his work is standing at the top of the stairs to introduce the largest exhibition of black art ever assembled in this country, *Afro-American Artists: New York and Boston*.

At a time when racial rhetoric is militantly separatist, artists like Johnson, working in "white," "mainstream" idioms, present an uncomfortable paradox for white liberals as well as black militants. Ellen Banks, who is one of them, a painter devoted to pure, almost geometric abstraction, puts it this way. "If you paint the way I do, you used to be looked upon as a traitor." And Emma Amos, a painter and printmaker who uses the figure as a vehicle for color, not to transmit a political message, says: "All some white curators can see in black art is political significance."

GUT: Should art consciously reflect the specific social and political life from which it comes? For the emerging black art, this is a gut question, not easily resolved. Edmund B. Gaither, the young and articulate curator (of the Museum of the National Center of Afro-American Artists in Roxbury, Mass.) who organized this exhibition, thinks the time has not yet come for black art to be fully itself—or fully realized. "We are moving toward a singular language, partly through this attention and exposure," he says. "It is allowing us to discover certain qualities in each other. We haven't seen a school of black art yet, but by the end of the century it will have emerged to interpret what it was like to experience living in this time and in this place."

Gaither also believes that this is the last of the "black shows," the last major exhibition, that is, to announce the supremely obvious fact—that serious black artists, like serious black musicians and writers, are alive and working. What he has wrought in Boston has established that fact in overwhelming quantity. There are 158 works on display, the product of 70 artists, covering a vast gamut of styles and media. The mere thought of one more black show, after this, ought to embarrass any curator, white or black. "It is about time," says Miss Amos. "I am

sick of black shows. I am annoyed with the way the press tries to make all our art political, when it isn't."

PARADE: There is a deeper objection than this to the idea of the black show. While the black artist will seize any chance to exhibit, after so many years of invisibility, he by and large wants his art to be seen for what it is, not because it was made by an abstract "black man." Gaither's survey, though sold as a black show, points in another direction. Its size consciously demonstrates the diversity of black art, the presence of rich and deeply contrasting families. "From now on," Gaither predicts, "the museums will have to deal with sub-sets of black art, not the whole parade."

There are three pointedly clear sets at Boston, none fully developed but each rich in promise. There is first the kind of mainstream art produced by Daniel Johnson, Ellen Banks and Emma Amos, by kineticist Tom Lloyd, by the late Bob Thompson, whose expressionist figure compositions dance with vibrant color, by the cool, tricky, geometric compositions of Alvin Loving, by Romare Bearden and Hughie Lee-Smith, old masters of a figure painting that borders in its taut elegance upon abstraction. This work is closely allied to all those modes of sophisticated Western and predominantly white art that divorce form from content or message of any kind—so closely, in fact, that militants like Lloyd turn inside out justifying themselves. "The lights in my work are black art," he maintains, "a black expression. One student told me they reminded her of doors opening and closing, of the rhythms of our African past."

Second among the sub-sets is what Gaither calls "Neo-African," a concerted effort to invoke images based in tribal African culture. The fluorescent acrylic face masks of Ben Jones, the *Duocoin Tapestry* of Gerald Jackson, filled with frozen, silhouette figures, the sinuous tubular carvings of Tonnie Jones, which create a mosaic of African imagery, both human and animal, are all examples. There is a paradoxical cultural overlap here, too. John Rhoden's *Paytoemahtamo*, an 8½-foot tower of bronze, silver and copper, resembles nothing so much as the early cubist sculpture of Pablo Picasso—who learned himself from African art.

Finally, there is the patently political art, the stuff that draws both the headlines and the television cameras, led by Dana Chandler's cartoon-like paintings showing Panther Fred Hampton's bullet-riddled door (emblazoned with the sign: "U.S.A. GOVERNMENT APPROVED") and Lovett Thompson's *The Junkie*, a dark wooden head pierced viciously through by a nail. Far more effective and moving is the work of Milton Johnson and Benny Andrews. Johnson's *Another Birthday* presents a wearied black face drenched in ironically bright streaks of color—to the point where it becomes a brooding presence rather than one more fact on canvas. Andrews's ironic *Champion* is limned by rags and rope as well as paint. His face sags out from the canvas, torn and smeared, as he sits in the corner of a boxing ring, awaiting the bell. The ropes behind him, thick, strong and knotted, stand out from the surface and surround their battered subject, imprisoning him.

PRIDE: It is somewhere in this last group, grounded in representation, that the authentic black school seems likely to flourish—precisely where white critical opinion is least comfortable. This is true despite the fact that these politically oriented works are relatively crude in execution and smack of social realism—that dread enemy of contemporary abstraction, castigated in every sophomore survey of American art. Like the political art of the 1930s, the polemic paintings of Chandler, Milton Johnson and Andrews care more for message than form. The more abstract and conceptual work—by Lloyd, Daniel Johnson, Bearden and others—is much more sophisticated and professional, but it is redolent of the past rather than the future or even the present. "We are concerned with communications," says Hughie Lee-Smith, who has become an elder statesman of black art, "with glorifying our heroes, contributing to black pride. We look upon this as our historical mission."

This mission is largely unfulfilled, but Lee-Smith's words have the ring of inevitability all the same. The black American came much more slowly

to painting and sculpture than he did to music or literature for a complex of reasons, many of them social. "The fine arts," Gaither points out, "have involved a presumption to class." Art as communication involves the very opposite: the emphasis in artists like Chandler and Andrews on message, celebration, and the figure is thus based on forces and attitudes than run deeper than either political fashion or the appeal of ancient Africa.

This is not to say that Daniel Johnson's proud, formal columns are irrelevant to the future of black art. They are as much a part of it as fluorescent acrylic is now, or African masks an ingredient in Picasso. Neither black nor white art can escape the other.

HENRI GHENT, "BLACK CREATIVITY IN QUEST OF AN AUDIENCE"

A basic understanding of modern art, in its entirety, necessarily includes an appreciation of African art. It is common knowledge that African art was instrumental in helping to shape the course of modern art. How can one appreciate Picasso and Modigliani without understanding the derivation of their forms? One would naturally assume that art historians in particular—as well as art connoisseurs—would curiously look to Afro-American artists, as direct descendants of this African heritage, for an extension of this *vitality* in art.

In trying to discover a possible link between African art and art created by Afro-Americans, one should not look to find these artists repeating traditional African art forms simply because of their ancestral bond. The very lack of contact with Africa—together with centuries of forced acculturation has indeed served to weaken the Afro-American's knowledge of and freedom to exercise those skills requisite to creative continuity of traditional African art. What should be discerned is the marriage of this *African spirit* and a temperament that has been shaped out of the *blacks' unique experience in America.*

Contrary to the uncritical myth that blacks are of a uni-life style, they are very much a diverse people. A careful examination of blacks representing various socio-economic, educational and political strata will reveal that this diversity of life style does not alter the basic existence of their common consciousness. Black artists are as diverse as the black populace in general. Their creativity clearly reflects the difference in the conditions and circumstances out of which it grew.

One divergent aspect of black creativity is the current black "nationalist" art movement. The principal objective of the "nationalists," they claim, is to elevate the status of "Negritude." What particularly distresses this writer is the fact that their credo is based on a policy of reverse racism. Their nonthinking attitude reveals that they are willing to perpetuate an ideology as venomous as the one that has victimized them over the centuries! Aside from displaying their vulnerability as human beings, they, as artists, suffer doubly when they abandon an essential concern for esthetic criteria for the sake of politicizing. What results are feeble works of art that fall far short of communicating their message, thereby rendering a gross disservice to their cause. In other words, black artists who are "nationalist"-inclined are much too preoccupied with what they have to say rather than how well it should be said.

On the other hand, there are many black artists who are very concerned with organizing their personal statements, regardless of subject matter or stylistic preference, in accord with the best-known and agreed-upon esthetic criteria. It is to these black artists, who adhere to flexible universal artistic standards, that the writer addresses himself. Even so, these artists, along with their radical counterparts, are unceremoniously relegated to obscurity by the white "art establishment."

The art establishment is primarily to blame for the black artist's "invisible" status in this country. The directors of these public and private institutions continue to operate as the "artistic tastemakers of America." They have excluded black creativity from public exposure because it is the establishment's belief that black artists are creatively bankrupt. Black artists are judged by double standards.

A *classic* example of an exercise of this double standard is evidenced in the review by John Canaday (*The New York Times*, October 8, 1969) of the

New Black Artists exhibit at the Brooklyn Museum (under the aegis of the Urban Center of Columbia University, and organized by the American Federation of Arts and Ed Taylor of the Harlem Cultural Council). Mr. Canaday's so-called review was downright perverse. For one of New York's leading art critics to falsely praise work that was obviously inferior is proof positive that, in his mind, a double art standard was operative; to gush out gratuitous statements for poor work that was exhibited on a "professional" plane (for which he apologized in each subsequent sentence) was nothing more than a hypocritical expression of a kind of racist condescension on Mr. Canaday's part. The exhibit in question was, in the opinion of many knowledgeable people (and in the opinion of this gallery director of color), one of the most horrendous and embarrassing showings of painting and sculpture that ever purported to embrace the "black spirit," a criterion which *quality* black artists hold so dear!

The black artist is further maligned by virtue of his repeated exclusion from significant surveys of American art. Although black artists began to emerge in appreciable numbers in the thirties, not one was included in the Whitney Museum's 1969 survey of American art of that period. Still another case in point is the Metropolitan Museum's recent centennial exhibition *New York Painting and Sculpture: 1940–1970*. This show was the brainchild of Henry Geldzahler, that hallowed crypt's curator of contemporary art. As is his wont, Geldzahler went to great lengths to pay homage to his coterie of intimates, while flagrantly ignoring the towering contributions of such "deflectors," black and white, as Louise Nevelson, Larry Rivers, Marisol, Romare Bearden, Eldzier Cortor, Felrath Hines—to name only a few. His highly questionable taste, integrity and intellectual capacity, as a curator, were never more in doubt than when he unveiled his choices. Black artists, radical and moderate alike, were overwhelmed by the fact that Geldzahler's manner of selection for the show eliminated so many really strong talents. They were, understandably, most critical of the *total* exclusion of the many significant works created by blacks. Such blatant racism causes *all* black artists to distrust the integrity of the white art establishment. Geldzahler's imprudent omission of art created by blacks merely adds fuel to the black separatists' call for a complete separation of the races; after such an insult, they ask why they should acknowledge white art standards, white institutions, white creativity. One certainly cannot expect a reversal in racist practices at the Metropolitan as long as a curator such as Mr. Geldzahler continues to operate on a policy of anointing his circle of friends with celebrity. Mr. Geldzahler will definitely not be able to echo the "liberal's" refrain, "One of my best friends is a Negro artist!"

What all this points to is the fact that black artists of quality lack an appreciative audience for their unique manner of creative expression. The art establishment must bear its share of the criticism for the existing attitude that, in essence, implies that the blacks' potential for enriching the American cultural scene is nil. If the art establishment is sincerely interested in reaffirming the depth and quality and variety in American art, it must reverse its racist practices and cull talent from all segments of society. Until this ideal is achieved, it is incumbent upon the black community—particularly its affluent members—to lend support to its innovators. Most important, black artists themselves must utilize their inherited vitality to sustain their positive orientation during the bleak hours and, at the same time, dedicate themselves to creating the finest possible art.

NOTE

1 [There are no closing quotation marks in the original, so it is unclear where Andrews's comments to the museum visitor end and his general discussion resumes. —Eds.]

1970

Margaret G. Burroughs, "To Make a Painter Black," in Floyd B. Barbour, ed., *The Black 70's* (New York: Porter Sargent, 1970)

Margaret G. Burroughs (also known as Margaret Taylor-Burroughs) was born in Saint Rose, Louisiana, in 1914. She began her career as an artist and teacher and was also a prolific writer. After earning a master's degree in art education from the School of the Art Institute of Chicago, Burroughs, along with Margaret Danner, Archibald Motley Jr., and Marion Perkins, helped to form the South Side Community Art Center. In 1961, also in Chicago, she and her husband, Charles Burroughs, founded the Ebony Museum of Negro History (later renamed DuSable Museum of African American History), one of the first museums devoted to Black culture in the United States. Burroughs's primary objective was to celebrate the achievements of Black Americans and encourage an awareness of African American identity. In this essay, Burroughs criticizes Black abstract artists while setting out a vision for what she believes artists should be creating instead.

MARGARET G. BURROUGHS, "TO MAKE A PAINTER BLACK"

Yet do I marvel at this curious thing: To make a poet black, and bid him sing!

Thus wrote our black bard, Countee Cullen, some years ago in a poem which gently questions the wisdom of the Almighty when He created black poets and did not consider the vicissitudes of racism. In this essay, I shall substitute artists for poets since they are cut from similar cloth. I marvel that in spite of the lack of fulfillment that comes to the black artist, we continue to create. As truly creative human beings, we can do nothing else. Yet, it is obvious to all who are sensitive that racism permeates all fields of American life. It certainly has not taken a holiday in the area of the arts. Racism operates more subtly, but its spectre is there none the less!

Racism has not, however, stopped our creativity, for it is conceded that without the creativity of blacks, American culture would indeed be greatly deprived. Racism has, however, been a discouraging factor to hundreds of us who have chosen art as a lifework and thousands more who would be potential artists. Until quite recently, fine black artists have not been able to look forward to the normal rewards which are taken for granted by even the most mediocre white artists. For the most part, black artists in this country have been overlooked, if not downright ignored. It is only in very recent years that galleries and critics have been shocked into realizing that there are black artists, too.

Until recently, few major museums have shown the works of black artists. Even fewer top commercial art galleries handled the works of black artists. (Well, it just wasn't done.)

Occasionally the art establishment has singled out those it deemed to be our "great" artists by placing the white "stamp of approval" on them. In this way, a small number of our artists have been rewarded with crumbs, while numerous other superb black artists have been left out in the cold.

Nor has the black artist been able to look to the black art patron for support; generally, the black art patron does not exist. There are some among the black bourgeoisie who could be potential patrons for black artists, but they have yet to arrive at the art patron stage. Unfortunately, our black bourgeoisie often tend to ape the pattern of the establishment in all respects except one: the buying, collecting, and acquiring of art.

[Here, Burroughs discusses the problematic lack of Black patronage for Black artists.]

Accordingly, the success of a black artist has been based on how many "white" shows he has made or how many awards he has received or how many paintings or sculptures the white world has purchased from him; not by the acclamation of our own people.

It was the white man who approved or disapproved of our subject matter or technique. If the white man said it was good, it was thought so and accepted by us as good. If the white man didn't recognize the work of a black artist, blacks considered the work to be of no significance. We are not yet quite free of this brainwashing. How can we be? The white man has the money, Honey, and he who pays the piper calls the tune. Furthermore, this approach has sown disunity and mistrust among our artists, one for the other. Each has been a "loner," trying to make it on his own. If he happens to make it, he slams the door shut on others who are struggling upward.

Now, some of our artists mistakenly operate from the view that success is a broad plateau with plenty of room at the top. They soon find this is a fallacy. There is generally room for only one black artist at the top, if there is room at all. Many black artists have felt that they can make it by being as non-black as possible. They are not black artists. They are not African American artists. They do not handle "black" subject matter. They do not even paint or sculpt black people or anything of an ethnic nature. They are one hundred percent American artists and their works are no different from the mainstream of white American art or non-art. They have become masters of the non-humanist techniques. In some cases they have surpassed their white counterparts and painted themselves into a corner away from their black soul people. They have carried this meaningless non-objectivism to a

fine point and often are touted and lauded by the "establishment" for this nonsense. Unfortunately, they have influenced many younger artists who follow their model, not because it is what their soul dictates but because of the material rewards to be gained from doing so.

Happily this is not the case in general. There are black artists all over the country, many more unknown than known, who have not "copped out," who realize that to be a black artist is to be one who is close to and deeply involved with life and humanity, and who express themselves creatively within this framework.

In considering racism's effect on the economy of the black artist, we find that racism has consistently deprived the black artist of an opportunity to make a living from his art. There are a few exceptions in recent years, due, we suspect, to the current demand for instant black Exhibit A.

Yet, despite the problems of the black artist caused by the hostility of a racist society, there is today a lively ferment. All over the country, black artists, young and old, are painting and sculpting as never before. They are seeking to reaffirm themselves and their black culture, to rescue American culture from an artistic decadence void of human emotions and full of junkyard sculpture, paintings shot from pistols and flung from stepladders. Again the creativity of the blacks arises to save and revitalize American culture.

[...]

And so it is today. Black artists once again exert their creative influence over a decadent culture. A group of young black Chicago artists decided that art should be brought to the people. They combined their talents to depict black heroes and heroines on the wall of a tenement in the heart of their community. They called it the *Wall of Pride and Respect*. The idea has spread to black artists in other urban communities, and has inspired many other exciting black art movements.

The desire to make significant contributions to the "movement" and rights "revolution" has highlighted the expression of black subject matter. Demonstrations, riots, and confrontation are depicted often with more passion than technique.

Lively dialogue has precipitated the search to define black art and the black esthetic. There are as many points of view on the subject as there are schools of artists. I have had the opportunity to discuss the matter informally with several artists. A few comments selected at random from those I respect can serve to bring my paper into contemporary focus.

Lois Pierre Noel of Howard University, Washington, D.C., expressed a dilemma which is perhaps confronting many teachers of art, black and white. She stated at a recent National Conference of Artists meeting:

> There's really black art going on at Howard. The students are very strong. They have identified themselves as artists. Many of their subjects have to do with social change, movements, the riots, Africa. When I give my criticism based in my training, what do I get? "Well, I like it like that; I don't agree with you!"

There is a growth of independence of spirit on the part of the students. How can I carry them on to the point where they will do good art? The question is, yes, this is black art but is it good to train them to be good artists in all they do, or do we just let them paint black art, the expression of subjects, emotions and colors, and set that up—this black esthetic—as the best?

Artist Eugene O. White of Los Angeles favored a black esthetic. He stated:

> I traveled a lot and I didn't see exactly what I wanted to see, so I decided to do what I see in the way I felt. The way I felt would link into the Revolution. Yes, there is a difference between a work done by a black hand and a white hand. I feel you have to be black to do the work I am doing. According to the feeling I get, you have to be part of what you are involved in.

Selma Burke has been active on the art scene more years than many of today's "New Breed" black artists are old. When asked about this question, she said:

> There is no such thing as black art. My work is done by a black artist. I paint a leaf. It is green. It is not black art. My influence of geometric

forms, etc., was inspired from African sculpture that my uncle brought over from Africa. There are black artists and black subject matter.

By the same token, there is no such thing as white art. Much bad art is being passed off as "black" art. Is there a black esthetic? Yes. But in this sense: take, for example, the dance. It is what the Negro puts into it, his heritage. I am not denying whatever school he chooses to express himself in. Our contribution must ultimately be the rejection of racism. Art in Africa is not a thing apart, but a way of life. Africans created things of beauty which had meaning and significance to them.

There is a black esthetic in the sense that black folk are the true creative forces in America. So much of what is creative in western culture comes straight from us, black folk.

Ernest Crichlow of New York told me:

Yes, there is a black esthetic. However, not every black intellectual has to adhere to it. The black artist or intellectual has a dual personality. This may not be so noticeable among all blacks. We are taught the technique and history of our craft from the viewpoint of the white establishment (white, western, Anglo-Saxon European) culture. The purpose of this is to ignore, deny, to wipe out any positive aspects of black culture—to deny its validity and to force the black to accept the established form of esthetic, of culture, or ways of doing things.

The black intellectual or artist in his training period goes off into that realm of white-oriented western esthetic for a time or perhaps during the whole of his schooling. He is on the other side of the tracks, as it were, but he has to come home sooner or later, if only to sleep or to get his battery recharged. When he comes back home, he is forced to deal with his own personal esthetics, even if he is determinedly non-black in all aspects and paints abstract expressionism in white-on-white!

The black artist therefore develops a dual personality and dual ability to express both esthetics, white and black. He may work in the white,

but he cannot avoid the black experience. It is the nature of American society to try and hide what you are. A black painter cannot hide it. He may paint white, he may disassociate himself from any recognizable, identifiable subject matter totally, but deep down inside himself, he hears a small voice telling him, and he knows, that he is a black artist.

Some have tried to ignore and stifle this voice, but it still persists, and in some black artists, if ignored over a period of time, the personality of the artist can be affected. Yet, a black artist has a right to express himself as he sees fit. If he sees the world as cold and mechanistic, it is his prerogative to paint the world that way. That is the way he sees it. However, the black artist must realize that his is not the only and the most important expression of what he is. It is only a part of the expression of what he is.

Romare Bearden takes abstraction and makes it serve him meaningfully as a black artist. He incorporates African sculpture and familiar symbols into his work which his black audience is able to note and appreciate. While speaking with Charles White, I asked whether he felt "content" alone was enough to legitimize black art. His comments are well worth passing on to the young, aspiring black artist:

Anything you do, if you don't do it well, it is not going to have the impact. It's kind of lost. Take Miles Davis or Cannonball Adderley or Max Roach; just name it in terms of music. None of them would be the great artist he is if he hadn't studied and mastered his instrument and gone through all the academic problems dealing with his music. The same thing applies to dance and to literature. A book that is badly written, no matter what the intent of its author—if the form is bad, if it doesn't have too much sophistication of style, if the structure is bad, who in hell is going to read it?

The same thing applies to art. If you don't take the time to master your craft, your statement is going

to be lost and the impact is going to be lost. It's as simple as that.

Evangeline Montgomery of Oakland said:

> In dealing with the whole universal humanity, I feel that black people are leading the way and that one of the causes for alienation among many of the young white artists in this country is because they do not want to be identified with the major society as they know it. This has resulted in a kind of alienation which has been reflected in their paintings of non-art for material aggrandizement. The black artist through his art may even be leading America toward a more human world.

The debate may go deep into the seventies; the black artist, young and old, will continue to create.

For it is the artists who have ushered us into the era of a new black renaissance. All that they are doing may not be excellent, but much of what they are doing is honest. They have again given American culture that needed shot in the arm. And just think, all of this comes from a people who are called culturally deprived, who have been cordoned off into compounds and denied their basic human rights.

I like to imagine what American art and culture would be like if black folk were granted all the rights and privileges of citizens of this country. How the art and culture would flourish in such a free society! What a great, rich culture would be ours! But this cannot happen under a system infected with racism. Cannot and will not.

1970

Bayard Rustin, "The Role of the Artist in the Freedom Struggle," and Jacob Lawrence, "The Artist Responds," *The Crisis* 77, no. 7 (August–September 1970)

Bayard Rustin was born in 1912 in West Chester, Pennsylvania. A close advisor to Dr. Martin Luther King Jr., he was one of the most dynamic leaders of the civil rights movement and the strategic force behind the unprecedented March on Washington in 1963. He went on to direct the A. Philip Randolph Institute, from 1966 to 1979, which advocated for African American trade unionists. In 2013, Rustin was posthumously awarded the Presidential Medal of Freedom. A supporter of nonseparatist ideals, Rustin was firmly opposed to Black cultural nationalism and concerned by the ideology of exceptionalism he felt had come to dominate discussions about Black culture. "There is no such thing as a 'black artist,'" he wrote, and he considered any effort to use art as a vehicle for scoring social or political points to be "a vulgarity." He was instead committed to art's universal humanism: Whether Black or White, artists were to be held to the same artistic standards. Rustin originally delivered this text as a lecture in June 1970 at the sixty-first annual convention of the National Association for the Advancement of Colored People (NAACP), which honored the artist Jacob Lawrence with a medal. Shortly thereafter, the text appeared in *The Crisis,* founded in 1910 by the pioneering African American intellectual and activist W. E. B. Du Bois, who edited the publication for almost twenty-five years. Lawrence's acceptance speech was also included in the issue.

BAYARD RUSTIN, "THE ROLE OF THE ARTIST IN THE FREEDOM STRUGGLE"

The black people in this nation have never been in graver danger than they are today. Even greater danger I believe than when, as part of the Compromise of 1876, the Union Army was withdrawn from the South, and former slaves were made into secondary citizens. It is significant and important that on the occasion of the Spingarn Award this year, this medal is not being given to anyone who is related directly to that political struggle, but the medal goes to Jacob Lawrence, a man who has achieved distinction, not in the political sphere, but as a painter, as an artist. And rather than talk about Jacob Lawrence tonight, which would be of considerable embarrassment to him, I should like to relate the importance of the artistic man or woman to the struggle for freedom.

I noticed something very interesting in the booklet on the Spingarn Award and that is that more than one-third of the persons who have received this award were in fact artistic people—writers, poets, composers, singers, architects, actors, and now a painter. Men and women who have devoted their lives to the imaginative re-creation of the human experience. There is none more important than the man who gives imaginative re-creation to the human spirit for, ultimately, that is all there is of man. And since these artists, like Jacob Lawrence, have been black, their work represents an interpretation of the experience of the Negro in this country. But, as I shall later point out, there are no "black artists." There is no such thing as a "black artist," or an "Italian artist," and there is no "Italian art" or "Greek art," and no "black art." And no black man in this nation does his cause good by referring to "black art" because he reveals not only that he is ignorant of what art is, but he will also do a disservice to the artistic process.

The black artist, whether or not he considers himself as such, is an essential member and a most important member of the freedom struggle. In saying this, I do not want to imply that the Negro artist should resemble in any way the social artist. The very concept of a social artist, an artist whose objective is to sell a cause or to sell a political party or even to sell Negroes, is a vulgarity and would be a misunderstanding of the nature of art and of the Negro struggle.

What we have, therefore, is that the black artist is a part of the very struggle for justice and freedom by the fact that he paints or creates a poem because, by so doing, he is expressing the imaginative creativity and creation, and every time our recipient tonight paints a great picture, he automatically adorns the struggle. Young James Joyce, as an Irishman, put it very well. He defined his role as encouraging the reality of experience in order, and I quote him, ". . . to forge in the smithy of my soul uncreative conscience of my race." And that is precisely what the black artist is to do. Now, this role imposes no limitations upon his freedom as an artist since the black struggle of which he is a part is, in its very essence, a struggle for freedom.

It is interesting to note that art which is in fact great art undergirds the movement and tends to create a consciousness amongst men. For example, we created, our grandfathers created, the spirituals. It could be said that the spirituals were, in part, an escape from religious and other oppressions. But I want to point out that the spirituals also were used for purposes of political revolt. The song "Steal Away to Jesus," for example, was a password for slaves to go out and meet to discuss revolution. "Let us steal away to Jesus . . ." they sang as an escape from white oppression. Here we see the convergence of art and politics in the black experience, but I want you to note, and it is most important to note, that the spiritual came first of all out of their own religious experience, and the convergence with politics was secondary.

This is important for our young people to understand today, particularly when great numbers of young black people are attempting to be artists without having any discipline, and are accepting inferior art on the basis that it is "black art." There is no such thing as "black art," independent of artistic standards. An inferior drawing is inferior no matter who did it, now matter how black the creator is, no matter how long his hair, no matter how he dresses.

One of the fundamental reasons that the artist is always a forerunner in the movement for freedom among oppressed people is that all men, including black men, judge a society or an ethnic group or a nation on the basis of their artistic creativity. One respects the Greeks and the Italians precisely because of their tremendous artists. To look at a work of Michelangelo immediately gives you respect, not only for him, but for the society which spawned him.

We ought to salute the black artists. For example, when it was not possible for a black man to sing on the great stages of America, Roland Hayes went to Europe and was commanded to sing for the King of England. Roland Hayes sang beautifully, he was an artist. But a by-product of that art was to shame America and, when he returned, he had opened the concert stage for all aspiring young black artists. Whether or not he knew that he was the forerunner of the civil rights movement, whether or not he liked the NAACP, which, of course, he did, would not have made any difference. It is an automatic process. Fisk University was built by young black artists who went across the country singing the songs of their fathers. Jubilee Hall came, and then hall after hall until Fisk University was founded. This has been another function of the black artist.

There is the example of the painter, Henry O. Tanner. The world is still marveling at the ability of this man to produce blues and greens that almost never had been produced by any artist before nor since. When Henry O. Tanner could not make a living in this country, he went to France. By 1900 he was one of the world's most renowned painters, a black man. And his art did much to proclaim the humanity of black men to Europeans and to shame Americans who had scorned his work earlier. Thus, we begin to see the basic duality of life for the black artist and, by extension, for all blacks.

The black artist is at once a Negro and a human being, a member of a particular race and part of that vast community which comprises all mankind. It is only by maintaining that tension between our blackness and our humanity that we can live a decent life either as an artist or as a person. The Negro artist is the ultimate and the only unfettered, clear voice of the aspiration of the black community. The painter, the writer, the singer, and the dancer ultimately reflect the way in which our people live. And to the degree that they are good artists, they do not lie. To the degree that they set up an ideology, an apologia for the black experience and distort that black experience into their own preconceived notions, to that degree do they destroy us all.

The true artist avoids five dangers. Every young black must learn from such artists that these dangers are death. The first is that the artist will not engage in stereotypes. He is consistently seeking new ground to explore to explain an experience. Even "Cotton Comes to Harlem," done by sincere black people, has in it almost every stereotype that white people visited upon us. The scene in which black people are diverted from what they think is an honest protest at the police station by two Negro detectives who throw chickens to them is no less a stereotype or dangerous because black people wrote it. This is not art, and the reason this must be said is that somebody began with the production of a "black thing." If they had begun with the production of a human thing, that mistake would not have been made.

The second thing the artist will avoid is ideological constraints. A good example of that is in regard to black studies. The courses are not, in many places, being built on the basis of truth. People begin with an ideology, first "Black is Beautiful," and proceed from there. They will not get good courses under those circumstances because that's ideological constraint.

The third thing to avoid is praising something because it was made by Negroes, in other words, black standards. Our job as the artist is to reveal irrationality, not to play into it. And so if a picture is bad, if it is badly constructed, it is bad; it's not good art. If the black man who painted it has just joined the NAACP and brought in fifteen life members, the art is still bad.

The fourth thing which the artist must avoid, and we must learn with the black artist to avoid it, is that all over the country today people are saying if the painting about a black man is not done by a black man, there's something wrong. He can't

understand us. If the book that was written about a black man was written by a white man, automatically it's bad because he doesn't know "our thing." Or if an essay is in any way critical of, or insightful into, the nature of blackness, there are all kinds of people excluding it from consideration. Now the artist knows that exclusiveness in art is death. A white man who is a great artist with great insight can write, paint, and do anything artistic about blacks and what will be revealed will be his insight, not his whiteness. Otherwise, Alan Paton could never have written the most important novel to have come out of South Africa, a work which sensitized us all to the horror of South Africa, *Cry, The Beloved Country*. It was not written by a black man.

The fifth problem that the artist rejects as an artist, and which we in our movement must reject, is rigidity. One of the most marvellous things about Picasso is that almost every three or four years, his style changes so that it is hard to believe that the same man did these paintings over the years. That is the highest tribute of art. The eternal search, the fluidity, the flexibility as against rigidity.

Now in conclusion, I would like to point out what are the artists' tools. The real tools of the artist are not the piano on which he plays or the paintbrushes, sir, which you manipulate. You know, in a sense, no painting in the world, even the ones done by Rembrandt, are objectively worth more than twenty dollars. You can buy a piece of canvas fairly cheap, and all the paints might not cost twenty bucks. Did you ever think of that? A hunk of stone by Michelangelo called "Pietà"—I'm sure if you wanted to go and buy some marble for two hundred bucks you could get a bigger hunk. What is the reality?

And I think here again we can learn something from the movement as to what reality is. The artist's real tools are internal. He first of all knows that life is dialectical. Here is his palette and on it he has eight colors, and he selects red for the canvas. What the artist knows is that every creative act is negative because he has had to reject seven colors as he selected the red. And he knows that every negative act is positive because in rejecting seven, he did in fact select the red. He knows that that which seems opposite may not necessarily be and that his energy

is to probe that contradiction. And we must probe it. Almost like saying that in the movement some of the people we don't like may make a contribution in their own strange way. Because sometimes you have to have a nincompoop over there in order that they understand how profoundly sensible the NAACP is.

Second of all, the artist is not fooled by talk of separation. The artist again knows that man is one. I am in humanity with white people not only because there are some good white people and NAACP people are good. I am in humanity with white people because they have bastards and so have we. It is in fact that man is one in his beauty and in his depravity. That is what the artist continually tells us.

Finally, the artist knows that he cannot speak only for himself or for his kind. When you go to most of the important museums in this nation and around the world, and look at some of the paintings that Jacob Lawrence has done, you know that even when he paints something specifically concerned with the black experience, he is doing it for all to appreciate because all men need the truth which he professes. Furthermore, anything that we produce creatively is no longer ours. Do you think jazz is ours anymore? Thank God, it has become part of American culture. You know, we started wearing our hair "natural," and now the fashion industry's taken it. In New York City you can see many white women wearing natural wigs. Everything beautiful we produced—the spirituals, our dancing—became part of America. Thank God that we have contributed to the human spirit as an artistic people.

Now the artist has three things which give him the ability to carry on. I don't think most people really understand the discouragement of an artist. The very painting that causes one to say, "My God. How could you have done it? It is so beautiful." The true artist is saying to himself, "This is a failure and next time I must dig more deeply." And he is sustained by three things. Humility, in that he never believes that he has done well. When someone said to Rembrandt "What is your greatest painting?" Rembrandt said, "The one I'm going to start next week." Secondly, he is dedicated to simplicity. In

the great artists, things are simplified for the few of us who are stupid and non-artistic to understand the complexities of life. That is what he is dedicated to. No highfalutin foolishness. And, finally, like the great Langston Hughes, he is dedicated to a sense of humor. The thing which disturbs me more than anything else about young Negroes today is that so many of them have lost a sense of humor and the ability to play Simple for a moment and look at themselves as Langston Hughes looked at our condition.

It is in this way of looking at reality, I think, that Ralph Ellison was trying to tell us when he said, "The artist is preserving those human values which can endure by confronting change." Which is to say that the artist must perceive and somehow try to relate to all others the human core of their experience. The black artist's role is to reveal to all the human core of the human experience as seen through the black experience. It is because Jacob Lawrence, with his beautiful canvases, has done precisely that, that we honor him. Not because he is hung in the great galleries, or not because he paints black, but because he presents the human core of the human experience through the black experience.

JACOB LAWRENCE, "THE ARTIST RESPONDS"

I am highly honored this evening to have been chosen as the 55th recipient of the Spingarn Medal. To have been selected to receive the Spingarn Medal by the National Association for the Advancement of Colored People, an organization which has for many years been in the vanguard of the black struggle, is recognition of the highest order.

[. . .]

If I have achieved a degree of success as a creative artist, it is mainly due to that black experience which is our heritage—an experience which gives inspiration, motivation, and stimulation. I was inspired by the black esthetic by which we are surrounded, motivated to manipulate form, color, space, line and texture to depict our life, and stimulated by the beauty and poignancy of our environment.

If, at times, my productions do not express the conventionally beautiful, there is always an effort to express the universal beauty of man's continuous struggle to lift his social position and to add dimension to his spiritual being.

We, the black artists, express ourselves in numerous ways. We range in philosophy from the figurative to the non-figurative. From the perceptual to the conceptual. We are both hard-edge and soft-edge. But through all of our various forms of expression, we hope to make a contribution in the field of the plastic arts. As is true with artists generally, our sources are the African, Oriental, and European esthetics. But, above all, we continue to learn from and to appreciate the talents of our fellow black artists.

[Here, Lawrence thanks the Black community for its patronage of Black artists and its organization of exhibitions.]

Now the practicing black artist is being joined by other black estheticians, who are most important to the development and support of the black artists. These young people are entering into the fields of art criticism, art history, gallery management and various museum specialties. I know that they can count on your encouragement and help in the further realization of their careers.

Between us all—the black community, the black scholar and the practicing black artist—let us hope to keep alive a vital art practiced by black artists.

1970

LeGrace G. Benson, "Sam Gilliam: Certain Attitudes," *Artforum* 9, no. 1 (September 1970)

Sam Gilliam was born in Mississippi in 1933 and grew up in Louisville, Kentucky. He received an MFA in painting from the University of Louisville in 1961 and, the following year, moved to Washington, DC. Gilliam began painting geometric abstractions in the mid-1960s and exhibited with artists associated with the Washington Color School. These abstract works soon led to his breakthrough "drape" paintings. LeGrace G. Benson's profile of Gilliam was the first monographic article on an African American artist to appear in *Artforum* since the magazine's beginnings in 1962. Largely consisting of quotations from an interview with the artist about his experimental and improvisational approach to painting, the article appeared a year after the group exhibition at the Corcoran Gallery in which Gilliam first dispensed with stretcher bars, instead "draping" his expansive and brightly painted canvases from various fixtures. In 1969, Gilliam had also painted *April 4*, the first in a series of paintings he would make in memory of Dr. Martin Luther King Jr., but he was not asked to discuss that aspect of his work in this interview. Benson, who was teaching at Cornell University at the time, later became a leading scholar of Haitian art.

LEGRACE G. BENSON, "SAM GILLIAM: CERTAIN ATTITUDES"

The presumptive categories "painting" and "sculpture" do not apply to the recent works of Sam Gilliam; nor do such otherwise useful hybrid terms as "shaped canvas," or "combines." The word "situation" seems appropriate, carrying as it does connotations of place or locality and also of conditions and circumstances that are only metaphorically spatial. Draping painted canvas out into the space of a room came out of necessity and after a long period of experimentation. The form did not arise from the desire to devise a new type of art object, but out of the pressures of deeply felt visual, kinetic, tactile emotional experience. For a time, Gilliam actually seems to have resisted the urge to let the paintings move:

"... but the point was that there is a tradition involved that you could not [ignore]. You know it's hard for a painter to think in terms of sculpture. And after pushing it back and forth, I got very romantic about Baroque, you know, you think about Rubens' S-curves . . . and the structural problems. But then this whole thing just does not matter—I don't really think about it that way. I didn't really want to be a sculptor. [He didn't wish to look at sculpture or painting in terms of translating one into the other.] . . . but it I could just stay with it, and just be very thoughtful and let it happen, let it come kind of new, then I wouldn't have to worry. A sculptor was in here one day and he said, 'Well, all bad painters eventually become sculptors,' and that really made me mad. But it was good kidding. It was good in the sense that then I began to discuss it more."

He had experimented with the color and space effects of folding and rolling small watercolors for several years, then "... the idea just occurred to me as I was finding with the watercolors, . . . why not just remove the support, why don't I use the form, let the form. This in the sense of trying to believe in the materials or the kind of tools that I actually use and let them excite the kinds of possibilities, and not to get too mental, you know, about what's really going on. Just to sort of sit back and observe what you're doing as much as you can, you know—just work and let things go. So that I got this whole kind of idea of really sitting back and looking at curtains . . . and with the one here [one of the large Carousels] of actually going to the top [of the painting] and kind of breaking the frame and [thus] getting into the shape. Suddenly I felt myself constructing kinds of traverse rods and actually hanging the paintings, so that all these problems of trying to structure and of letting them move and create the kind of forms I really wanted [could be worked out that way]."

The process became too cumbersome with its pieces of wood, hardware, etc., and in order to get past those limitations he began to hang the fabric from nails driven into the studio wall and from beams and posts, eventually utilizing all the space of the studio. Once with canvas not yet stretched he went into Rock Creek Park and experimented with situating fifteen foot lengths of painted canvas in meadows or unfurling them down rock faces.

The painting process established several years ago continues to be employed, that is, pouring, soaking, mopping, scrubbing fluid paint onto and into the surface of the canvas. With any one canvas this is apt to take several days with the fabric allowed to dry, to be folded and wet down again, to be rolled, to be folded again, to be rolled out and more paint worked into it, sometimes from close to the floor, sometimes from various heights on a ten foot ladder.

"I made some little kind of cut out things that sort of draped and began to do [other] kinds of things, so that I said if I can try to do simply what my real instincts in terms of painting really are then this is what the vocabulary is. That possibly some kind of sculpture, you know, is important to this— the fold in the beginning, for example, to transform something into planes, into a dimensional kind of thing and then to flatten it out, and really stretch it, wet it down and get it tight and to establish that kind of illusion that artists have always been able to visualize—that kind of shadow world, the kind of space that you understand distinctly that you can't walk into. But here [with the draped works] is something that you can walk into if you know how to present it."

When there had been about thirty experiments worked out in the studio, each one photographed in each of its manifold states with an old Polaroid camera, and each the result not only of action but

also of long periods of contemplation and "just looking," Walter Hopps saw them and thought it was time for Gilliam to start working the ideas out directly in the space of the Corcoran where they were to be shown last fall. There were three large spaces allotted and of these the most exciting and challenging to Gilliam was the atrium.

"I really had a room that was like no other room—a kind of transparent room, so that I had to offer it on all four sides and it was also possible to be above and see that, and below and see that. I worried about that, you know, really just how it was going to be. And I had them slowly raise it from the bottom, and I got underneath it and looked, then had them bring it down again and begin to tie the bottom and do other things with it. Then I had the idea of actually involving two paintings, one of them a Carousel *and the other a kind of Baroque cascade. I began to tie them in, and letting things develop so that going down one plane you would look down into this open kind of thing, actually operating with the whole space, keeping it all going, creating the same kind of diagonal pass and movement that I'd thought of earlier."*

The result with the atrium situation as well as with works in the other rooms of the Corcoran was astounding. The ceilings in that Greek temple of art are some 30 feet high and when the walls are hung with easel paintings, even large ones, one tends to move slowly from one work to the next, the perception of the space horse-blindered to the shape of the work one happens to be seeing now. But Gilliam's "Baroque" assertions staked out a claim on the entire territory in such a fashion that every visible and tactile and kinetic element was drawn into an ensemble of compelling force. The classic vastness of the Corcoran galleries and corridors functioned as a positive architectonic structure rather than as a recessive, relegated background. This effect did not simply have to do with scale, though that was bold enough; between monumentality and bombast lies the world of meanings. It had to do with the use of color, of shape, of optical space and tactile space, and above all with the reciprocity of these with one another and with the introspected color and space these gave rise to.

Reciprocity seems to be a key not only to the works but to the processes by which they come into being. "Let it happen," and "allow this thing to work," are Gilliam's most reiterated phrases. It is clear also from conversation and from observation of the artist at work that all of it is allowed at the same time—that at any given moment the work is full in its present state, and redolent with future possibilities. Every ensemble is understood to be one of many optional situations. What was in the Corcoran, what was in the Baltimore Museum was one situation for each fabric, which with (not *in, with*) other spaces will become another situation, having in common the native shape and color of the fabric.

I watched him working in the studio with a piece just returned from a museum show:

"I dropped it back of the wall there and I'm planning to come out just a little bit somehow over here if I can. What I really want to do is shift back and contrast. It's easy to see a crossover, this is back here, and go back behind that and establish another kind of relationship with the plane—and that's something that just occurred to me, so I think I'll do it just to see it. Then once I get through the whole top kind of thing, I'll want to come back and re-examine some things in terms of the floor and some way, very much the way that it's painted. I have to start over again here in the studio [as in contrast to the space in Chicago where the work had formerly been displayed] *and move around here. And what I really do is to say that I'll start with the yellow paint here and I'll walk around and like actually through that painting, and over here I'll stop and then establish another level of contrast starting over here. And that somehow these kinds of movements are still involved as I've seen the painting, as I painted it, and, you know, that I've seen it on the floor. And I'll think about that, because there is a familiar kind of space there, and it's just a matter of finding ways to reintroduce these kinds of things. That since I'm going around, and that I'm remembering how I really painted it or thought about it is that there are these kinds of movements here, . . . the skips, the hit and miss and actually pulling the lines out. And once this is done, I know it's not going to be on the floor; it's going to be suspended, so that I relate to certain kinds of movements by pulling up*

and even possibly taking some of the painting over on the pulley at the right point and pulling up and climbing up on the ladder and pouring [paint] down, and that's one kind of movement, then contrasting this because of the floor. [It's] parallel to a kind of floor plane here, and that since [the painting] is mostly going to fall is that . . . these points here are actually pouring down. An interesting thing I'd like to see is where I re-establish other kinds of points as opposed to seeing these angle out [the ones just completed at the top], is to see them just kind of glide along here, which very much reminds me of the thing that happens along the bottom where you're working with a kind of linear thing that goes on through the entire canvas. Then I'd like to establish kinds of counter-relationships to that so that you have a kind of abundance of things you could possibly do, if it occurs to you, in the sense of working with it. But the idea is that in terms of playing with it is actually to become as descriptive as possible about how I see.[1] I mean this is how I conceive of making this work. . . ." [I had the impression that both senses of the phrase "making this work" were intended.]

There is an intimate acquaintance worked out between the artist and his fabric, in which the nature of the cloth becomes known to him—he continually experiments with linens, silks, cottons—how a fabric takes color, how it expands and contracts, how it behaves wet, how it looks dry, how the texture affects the tonal values, how the weight prescribes forms, and what mechanical operations can be worked upon it.

"I have an idea of taking the paintings down and painting them on both sides, of doing one series of color possibilities here and one there, so that when this [surface] comes over there where it is now blank in a kind of shallow fold like that, there's a different altitude offered altogether. . . . I had to find out how tough a surface I really had to have in order not to get some kind of bleeding or discoloring . . . and it becomes descriptive even in the way that the nails are placed. . . . And I would conceive of transferring some of this into other pieces of material that I can sew and tie and actually make this thing work in terms of color. And there's another kind of thing: to use actual points of color [attachment points with

colored heads]—make a real mark [at those points] that would call attention to certain other kinds of things, like this variation that is going on all over here—to contrast or to pull in other elements. . . . And I want to try to continue to get the kinds of lines that are in the paintings, cutting into them [with scissors] and getting a kind of action along that edge. To use the knots, to draw on the wall and to take in a bigger kind of contrast now that these are all soft and kind of floppy and anti-form to find out some ways of getting a hard quality. That's why to concentrate on sewing and cutting. That's one way to go back and actually to put a line in here.

"It's so surprising—one of the students . . . in my class really made things with a sewing machine . . . but I was too busy to sew and besides, 'That's a sissy occupation,' I thought. But I did get interested. . . . Ed [the student] was willing to sew and we'd get together and sew, and you know the thread would break. We didn't have enough tension on the thread, and I said, 'Forget it, we're painters anyway,' and I said, 'If I could only hire a seamstress or relate to them freely.' So I went to the library and got a lot of old kind of Baroque drapery patterns. And I thought it would be kind of interesting to give it to a guy, if he thought I wasn't kidding, and let him sew all this kind of beautiful lacy thing, and that kind of good structure. But I thought I would have to establish more of a reference, because that's such an expense to pay some guy to make a pair of curtains of a painting. . . . I'm basically looking for a good craftsman, but it'll come in time. It becomes quite interesting as a possibility, as a hard line, and I repeat, that's the reason for a kind of stitch, to have that possibility of seeing it just really stay there and work as a painting and also to have this kind of [spatial] advance and to be able to consider it from both points of view, and it's just an idea that works of having the actual weight of the fabric itself establish a point. . . . And if it is well placed, it always falls back. It's been changed, it's been moved, it's been, you know, observed in those other ways, but then it falls back because it's flexible in the beginning, it's changeable, and that becomes important. . . . If there is something I am positive about it is the fact that once it's de-stretched or unstretched it has its own variability, which is one of

the reasons then for exploring not one kind of constant, dramatic rhythmic structure, but of actually establishing the possibilities for a number of effects, then to see how that something, although it is one kind of thing, that definitely it establishes its own kind of unlimited, universal qualities depending on how I address myself to the problem."

Gilliam has been interested in variation of natural and artificial light as affecting both the apparent forms and the color, of the way lighting systems in various spaces will affect the total situation.

"You learn a lot about museum spaces. It is a real kind of contrast to see a painting like this hanging in a kind of domed place or anything that establishes an architectural contrast. This is interesting. . . . In the Baltimore Museum which is a much shallower space than the Corcoran I want to get it high so that even basketball players can walk under it, but it's going to be close, and I still want to have it look deep. I want to get it as close to the floor as possible and then to have channels that you can look up into. There's the possibility of coming from the top of the pillars in this kind of colonnade structure and then to really blast light up there. And the point of playing with that, of lighting it up and seeing it in some kind of show—the forms I've been exploring—is that later on it becomes a part of the artistic thing that I want to do. . . . And I'd like to see—to do—a dance with them. There's this guy I know who started out as a painter but he says he'd like to [help me] do that. And I said to him, 'That's interesting,' because one of the things, say, in looking at the old kind of African dances was to watch how that the mask was simply a kind of relationship, say, to a kind of structure. And this again comes back to a kind of reference to a wet garment [referring to an earlier discussion about the "wet drapery" technique of the last century] and that it's exciting to build from both sides. This kind of mask flopping up and down and seeing what would happen if you put fans on to lighten up the drapery, and to have them work either independently or with the dancers. But I don't know if I want to think that way. It may be the same kind of thing . . . as . . . [the decision] of whether or not to make the paintings on stretchers or to unstretch them. Maybe in time, maybe if I get enough work done in a certain direction it may be nice to do it even just once."

Color may be the most intuitive aspect of the process and the work considered as a whole. While there is apt to be competent technical discussion of pigments and vehicles and further of the discoveries of such men as Albers, Itten, Noland, and Davis, the best clue to implications beyond this is found chiefly in Gilliam's phrase, ". . . to establish certain kinds of attitudes. . . ." This suggests that effects of simultaneous contrast, density, sheen, transparency, optically effected "space " and temperature are used to bear meaning and to evoke meaningful response. To be simpler: the color is employed expressionistically. Whatever purely formal merit the fabrics have (and that is considerable) is secondary to the direct fundamental metaphors which elude verbal translation.

To apprehend Gilliam's "certain attitudes" is to effect what may be the most crucial juncture and the most resonant union between the exterior situation and the "real" object, and the introspected or "ideal" object. It is to realize these as contrasting positions of a continuum rather than as contrasts of "real" and "unreal." The experience reinforces the sense of the realness of the imagination. Although in one sense Gilliam's situations are re-presentations of "certain attitudes" they are not vicarious symbols only, but material information highly correspondent to the state of awareness of the artist—a state whose intensity, intimacy and complexity necessitates an extended vocabulary of color, shape, texture, brightness, motion and place.

NOTE

1 Merleau-Ponty, "painting celebrates no other enigma but that of visibility. It can be said that the human being is born at the instant when some thing that was only virtually visible, inside the mother's body, becomes at one and the same time visible both for itself and for us. The painter's vision is a continued birth." [Maurice Merleau-Ponty, "Eye and Mind," trans. Carleton Dallery, in The Primacy of Perception and Other Essays on Phenomenological Psychology, the Philosophy of Art, History, and Politics, ed. James M. Edie (Evanston, IL: Northwestern University Press, 1964), 166–68. —Eds.]

1970

Barbara Rose, "Black Art in America," *Art in America* 58, no. 5 (September–October 1970)

Barbara Rose was born in Washington, DC, in 1938. In 1962, she began working as a correspondent for *Art International* and went on to be a contributing editor at *Art in America* and *Artforum*. In this feature for *Art in America*, published in autumn 1970, she considers "Black art" and its potential for rejuvenating American culture. For Rose, the notion of "Black art" was a political one, related to cultural and political integration in the United States. Nevertheless, her text also discusses the diversity of contemporary styles. A "drape" painting by Sam Gilliam was featured on the cover of the issue.

BARBARA ROSE, "BLACK ART IN AMERICA"

What is black art? For some, "black art" refers to a specific subject matter or content relating to the black experience. Others define it as a rejection of the forms of European art in favor of primitive African forms. In researching this article, I found that definitions of black art varied from generalizations as broad as art made by painters and sculptors of Afro-American descent, to art made in imitation of primitive styles. Indeed, the heterogeneity of activity among black artists has already led to a certain factionalism. Extending from the black nationalist artists exhibiting crude expressionist works in storefront cooperative galleries in Harlem, the range broadens to include thoroughly Europeanized black painters and sculptors living as expatriates in Paris.

Because of the differences of personality and background, not to mention tastes and politics, there are a variety of attitudes the contemporary black artist may have toward the concept of black art. Reviewing the material I was able to gather— and there was a large quantity, since black people are becoming increasingly active as artists in America—I found essentially four attitudes developing among black artists toward the predominantly white American culture in which they are forced to function. Most extreme was the position of artists like James Sneed of the Harlem Art Gallery and Dr. Ademola Olugebefola of the Countee Cullen Library Community Gallery. Such artists wish to establish an autonomous black art movement closely linked with black separatist politics. Working within black communities like Watts and Harlem, directing their art exclusively to the needs of a black public, they reject the modern European tradition as a decadent style serving a white bourgeois Establishment. Many are self-taught, and most paint in neo-primitive or expressionist styles that deliberately evoke the bold patterning and bright colors of African textiles. Their themes stress values basic to the black social struggle: they paint families united or idealized workers and leaders of the black community like Malcolm X and Martin Luther King.

Other black social-protest artists like Dana Chandler, William Curtis, and David Hammons, to name but a few, have had extended formal art training. Like social-protest art in general, the work of black social realists is basically illustrational and hortatory. Both stylistically and thematically, it has a great deal in common with the social realism of the thirties, which stressed poster-like clarity, the better to deliver a message which was often a call to action.

Although black separatists and social-protest artists use specifically black subject matter, others, while employing the forms and techniques of modern art, refer either implicitly or explicitly to the black experience as content. In deliberately "funky" idioms, they allude, in forms, materials, techniques or images, to an environment different in many respects from that of white America.

Black and white sociologists recently have argued that Afro-Americans have created a distinctive culture-within-a-culture in America. Up until this point, however, the black cultural contribution has been more acceptable in the popular arts and as entertainment. Now, however, the black artist wishes to make his contribution to what have formerly been considered the "high" arts: painting, sculpture, theater, poetry, etc.—that is to say, the elite arts of the museum and the university. His attacks on these institutions are part of the complex process of cultural democratization that this country is now undergoing. Developing a far more ambitious concept of himself as a cultural as well as a political force in America, the black artist today does not aspire to become a tap dancer, but an architect.

The major source of conflict between black artists and white institutions is that the former feel they are being discriminated against by the latter because their art is being judged exclusively by white European esthetic standards. Establishment tastemakers for their part reject much, if not all, black art on the grounds that it falls short of their esthetic standards. The question of an absolute scale of critical values is being debated today on many grounds. The problem in this context is whether such absolutes as "significant form" exist, and whether art being made by black artists qualifies in terms of a hierarchy of such established

values. My own experience with black art causes me to conclude that its quality today is largely on a level with what was produced in America during the thirties. Many of the characteristics of prewar American art—social, protest, illustration, deliberate or unconscious primitivism, work derivative of established artists—exist among black artists.

Like the precisionists, realists and American-scene painters who tried to find dignity in native American themes and authenticity in native American forms, many contemporary black artists are attempting to reclaim their own heretofore repressed cultural heritage.

Whether one recognizes the possibility of a uniquely black art depends on one's recognition of black culture as distinct and separate from white American culture. How much of an African heritage has actually been preserved by black Americans, however, is debatable. Yet many black artists understandably feel that their dignity depends on redeeming their own cultural traditions. Within the black community as well as within universities and museums, new attention is being paid to African art. Exhibitions like the recent *Impact Africa* at the Harlem Studio Museum are presented now with regularity.

The direct influence of African art on contemporary black artists is an incredibly complicated matter, since African art was, in the beginning of the century, one of the most important sources for the whole modern movement. Without African prototypes neither Picasso's nor Brancusi's break with the academic tradition is imaginable. The question is: can a contemporary black artist forget Picasso and Brancusi, turn directly to African sources, and produce anything of consequence in terms of world art?

There is a lesson here, I believe, to be learned from the recent history of American art. American art rose above a provincial level mainly for two reasons: the W.P.A. provided work and exhibition possibilities for thousands of unknown artists (some of whom turned out to be Pollock, Gottlieb, Gorky, Rothko, and Reinhardt); later the influx of European artists allowed firsthand experience with the most advanced art. Today the black artist faces a situation analogous to what faced the majority of American artists in the thirties: lack of funds and patronage, lack of exposure and criticism, lack of opportunity to practice technique and to experience the quality of masterpieces, not only of African art, but of all world art. Black artists today need and deserve time and space to work, patronage, encouragement and exhibitions. Wrongs are beginning to be righted, and museums are beginning to acquire works by neglected but genuinely gifted black artists of the past like the Colonial limner Joshua Johnston, and Eakins' pupil, the genre and landscape painter Henry O. Tanner.[1]

Today the white Establishment is suffering from a healthy collective guilt complex toward black artists. Even though many would prefer the term "black art" to recede from memory as black artists are allowed more opportunities to participate in American culture at all levels, for the present they will use it to attract attention from the media and museums, which need labels in order to operate. Obviously, "black art" is a meaningless term if it encompasses everything from the unconscious surrealism of Minnie Evans to the academic landscapes of Richard Mayhew, to the sophisticated collages of Romare Bearden and the elegant welded sculpture of Richard Hunt.

For the first time, the black artist is in a position to keep pace with if not outstrip the innovations of advanced art. Essential to this development are the community art programs sponsored by institutions like the Brooklyn Museum, the Walker Art Center, the Corcoran Gallery and the Whitney Museum. Providing materials, instruction and field trips, these programs introduce ghetto youths to esthetic experiences closed off to them in the past. Uninhibited by any feelings of cultural inferiority, these young people are at last beginning to find outlets for their creative potential. Their work, with its boldness and directness, and its powerful imagery and expression, points to what black artists might contribute if allowed the opportunity.

My purpose in assembling the photographs on the following pages is to show the great range of work being done by black artists today in painting, sculpture, architecture, graphics and photography.

Another article could easily be done illustrating the exceptional work in the minor arts and crafts such as jewelry, ceramics and textiles now coming out of the black community. The diversity and vitality of the work indicate to me the immense contribution black artists have to offer. Whether "black art" exists is basically a political question whose answer depends on the ability of America to become a genuinely integrated nation, both of culturally and politically. For the present, however, one thing is manifestly clear: American culture desperately needs the infusion of fresh energy and creativity that black artists are in a unique position to contribute today.

NOTE

1 [The spelling of the last name of the Baltimore-based African American artist Joshua Johnson (ca. 1763–ca. 1824) varies between "Johnson" and "Johnston." —Eds.]

Joseph E. Young, "Los Angeles" (interview with David Hammons), *Art International* 14, no. 8 (October 1970)

In 1962, David Hammons left his hometown of Springfield, Illinois, to study art in Los Angeles. He enrolled at the Chouinard Art Institute (now CalArts) in 1966, then attended the Otis Art Institute, where Charles White, whom he held in high regard, was one of his teachers. Hammons's own socially committed practice was grounded in found objects and materials. In the late 1960s, he began to use his own body as a tool in itself. In this interview conducted by the curator Joseph E. Young, who would include Hammons's work in the exhibition *Three Graphic Artists* at the Los Angeles County Museum of Art the following year (see pp. 272–78), the artist offers his thoughts on the current state of "Black art." The text largely centers on the "body prints" in which Hammons pressed parts of his own, grease-covered body against paper, then sprinkled powdered pigment over the greasy areas to complete the image. A number of these works had been shown in two recent exhibitions in Los Angeles: *Two Generations of Black Artists* at the Fine Arts Gallery at California State College and a solo exhibition at the Brockman Gallery.

JOSEPH E. YOUNG, "LOS ANGELES"

Two Generations of Black Artists was presented at the California State College in Los Angeles, where thirty artists were represented from throughout the United States, and judging from this exhibition and others at such "black" galleries in town as Gallery 32 and the Brockman Gallery, one is hard pressed to find a common characteristic which might conceivably be labelled as Black Art.

If we limit the term Black Art to the art works produced by artists of Negro descent, we are left with a hodgepodge of aesthetic persuasions ranging from the purely abstract to the figurative. One can readily appreciate the black community's wanting to recognize Negro artists of merit, especially when a significant younger artist like David Hammons, in a May 1970 interview with this writer, stated that he took a drawing class with Charles White, an instructor at the Otis Art Institute, because, "I never knew there were 'black' painters or artists or anything until I found out about him—which was maybe three years ago. There's no way I could have got the information in my art history classes. It's like I just found out a couple of years ago about Negro cowboys, and I was shocked about that."

When asked how he felt about being a "black" artist, Hammons stated to the author, "I think that you're really holding yourself back if you get totally hung up in being a 'black' artist. I feel that my early things were related to the 'black' cause, but now I'm outgrowing that. Now I want to branch out and, hopefully, be more worldly instead of putting those reins on myself. I think there should be a 'black' awareness, however, but what I really "enjoy doing most is something without any kind of message, and then everyone says, 'What are you going to title it?' and I say, 'Forget about it needing a title; just let it stand as it is.'"

It may be that certain aspirations and ills in our turbulent society will continue to provide the grist for future art productions, as in the recent past when we viewed Roy Lichtenstein's Pop Art painting of the hydrogen bomb, Andy Warhol's silk-screened paintings of race riots, and numerous other examples which one could readily cite, but whether or not American Negroes will produce a body of works which we can justifiably call Black Art must be determined at some future date when possibly more evidence is available for an objective evaluation. At this moment in history, however, we can readily understand a desire in the "black" community to have superior Negro artists recognized; and in this regard *Two Generations of Black Artists* was most successful, especially with the presentation of works by Charles White, who has long been a distinguished member of the international art community; Betye Saar, whose enigmatic prints are inspired by astrological signs; Ron Moore, whose intimate drawings were discussed by this author in an earlier review in *Art International*; and David Hammons, whose "body prints" already seem significant far beyond the immediate circle of the "black" community.

David Hammons was simultaneously represented in both *Two Generations of Black Artists* and in his own one-man exhibition at the Brockman Gallery where he displayed what he has designated as "body prints." These pictures which look as though they were photographically derived, but in fact are not, seem midway between printing and painting. To create his representations, Hammons often uses his own body which he first covers with margarine. Hammons then presses his body against an illustration board, which may be placed either on the floor or on a wall, depending on how dark an "impression" he desires. Powdered pigment is then sprinkled over the "printed" image and then, according to Hammons, "The surprising thing is that when I first make the print you can't see anything, and once the powder flows over it—it just 'blooms.'" The resultant "body prints" exhibited were visually arresting, especially the works which appeared to be derived from recent, political events as in his *Injustice Case* which was inspired by the "Chicago Conspiracy" trial in which Bobby Seale, the Defense Minister of the Black Panthers, was gagged and tied to a chair on several occasions in a court of law. As a result of these incidents, *Injustice Case* depicts a man in profile, seated on a chair with his feet tied together, his mouth gagged, and his hands tied behind the back of the chair. The frame

for this "body print" is made from an American flag, and the red, white and blue design contrasts strikingly with the subdued almost photographic quality of the represented figure. This picture, however, is only part of a larger setting which consists of a seven-foot-tall lighted case which has been lined with black velvet and which acts as a setting for the framed image. On a slightly elevated section in front of the picture rests a gavel, presumably the sort a judge would use to call a court of law to order. Possibly to create an "aesthetic distance" for the viewer, the case has two sliding glass doors, complete with a lock, and the total *ensemble* appears at the very least to equal some of the tableaux by Edward Kienholz. Another work by Hammons, *Black First, America Second*,[1] is a picture which is executed in such close tonal values of black, white, and gray that from a distance the gray areas of the picture appear to be silver. Depicted in the oval composition in *Prayer for America*[2] is a bearded figure which is wrapped in the familiar red, white and blue American flag that may easily become Hammons' special trademark since it often appears to good advantage in his works. David Hammons in his "body prints" unhesitatingly combines formal and technical innovations in order to produce evocative images of unusual power and strength.

NOTES

1 [This work is illustrated on p. 40 and on the cover of the present volume. —Eds.]

2 [The work, now titled *Pray for America*, is in the collection of the Museum of Modern Art, New York. —Eds.]

1970

Jeff Donaldson, "AFRICOBRA 1: *10 in Search of a Nation,*"
Black World 19, no. 12 (October 1970)

The Chicago-based artist Jeff Donaldson had raised the possibility of start-
ing a "Negro" art movement based on a "common aesthetic creed" with
Wadsworth Jarrell as early as 1962. Five years later, both men worked on
the *Wall of Respect* (see pp. 72–75). After the loosely formed group that had
produced the South Side mural parted ways, Donaldson sought to create
a more unified collective, with shared ideals. By the end of 1967, COBRA
(Coalition of Black Revolutionary Artists) had been established. Its mem-
bers were Donaldson, Jarrell, Jae Jarrell, Barbara J. Jones (better known
by her married name, Barbara Jones-Hogu), and Gerald Williams. Soon,
the group changed its name to AfriCOBRA (African Commune of Bad Rel-
evant Artists). AfriCOBRA's first major show was mounted at the Studio
Museum in Harlem from June 21 to August 30, 1970 (see pp. 219–20).

JEFF DONALDSON, "AFRICOBRA 1: *10 IN SEARCH OF A NATION*"

The whole thing started slow, real slow . . . suffering through an outdoor art fair in a wealthier Chicago suburb one hot July day in 1962, I asked Wadsworth Jarrell if he thought it would be possible to start a "negro" art movement based on a common aesthetic creed. And having little else to do—the wealthy anglos were not buying that day—we rapped about the hip aesthetic things that a "negro" group could do. When the sun went down, we packed up our jive, drove home to Chicago and the lake breeze cooled the idea from our minds. But that was cool, it was only a daydream balloon ethered by ennui and the hot sun—we let it float. They were buoyant times. The "negro" sky was pregnant with optimistic fantasy bubbles in those days. Education. Integration. Accommodation. Assimilation. Overcomation. Mainstreamation. THE PROMISE OF AMERICA. We would be freed.

But this was before the Washington picnic, its eloquent dream and its dynamite reality at the church in Birmingham. This was before the very real physical end of Malcolm. And the end of the "negro" in many of us. And it was before James Chaney. Afro-American. Before Lumumba. Before Jimmie Lee Jackson. Before Selma. Black. Before the Meredith March. Black Power. Before Luthuli. Sammy Younge, Jr. and the others. Before Watts and Detroit, Chicago, Harlem and Newark. Black Nationalism. More Balloons. Separation. Self-determination. We would be free.

And the atmosphere of America became more electrically charged, the balloons jarringly shaken, many destroyed by the thunder and by the lightning of the real Amerika. And we (Jarrell, Barbara Jones, Carolyn Lawrence, me and other artists) bestirred ourselves, formed the OBAC (Organization of Black American Culture) artists workshop and following Bill Walker's lead, painted the *Wall of Respect* in Chicago. Black History. And thinking that we had done a revolutionary thing we rested and nodded anew, among the few remaining balloons. And then the dreamer's dreamer had his balloon busted on a Memphis motel balcony. And that was the last

balloon. And it was Chicago again and Harlem again, and San Francisco and D.C. and Cleveland and everywhere. And COBRA was born. And Law and Order. And off the pig. And we angrily realized that sleepers can die that way. Like Fred and Mark and very legally. And COBRA coiled angrily. Our coats were pulled. And the anger is gone. And yes, Imamu, it's Nation Time.

We are a family—COBRA, the Coalition of Black Revolutionary Artists, is now AFRICOBRA—African Commune of Bad Relevant Artists. It's NATION TIME and we are searching. Our guidelines are our people—the whole family of African People, the African family tree. And in this spirit of familyhood, we have carefully examined our roots and searched our branches for those visual qualities that are most expressive of our people/art. Our people are our standard for excellence. We strive for images inspired by African people/experience and images which African people can relate to directly without formal art training and/or experience. Art for people and not for critics whose peopleness is questionable. We try to create images that appeal to the senses—not to the intellect. The images you see here may be placed in three categories:

1. definition—images that deal with the past
2. identification—images that relate to the present
3. direction—images that look into the future

It is our hope that intelligent definition of the past, and perceptive identification in the present will project nationfull direction in the future—look for us there, because that's where we're at.

This is "poster art"—images which deal with concepts that offer positive and feasible solutions to our individual, local, national, international, and cosmic problems. The images are designed with the idea of mass production. An image that is valuable because it is an original or unique is not art—it is economics, and we are not economists. We want everybody to have some.

Among our roots and branches we have selected these qualities to emphasize in our image making:

(a) the expressive awesomeness that one experiences in African Art and life in the U.S.A. like the Holiness church (which is about as close to home

as we are in this country) and the daemon that is the blues, Alcindor's dunk and Sayer's cut, the Hip walk and the Together talk.

(c) symmetry that is free, repetition with change, based on African music and African movement. The rhythm that is easy syncopation and very very human. Uncontracted. The rhythm the rhythm the rhythm rhythm rhythm.

(f) Images that mark the spot where the real and the overreal, the plus and the minus, the abstract and the concrete—the reet and the replete meet. Mimesis.

(g) organic looking, feeling forms. Machines are made for each other like we are made for each other. We want the work to look like the creator made it through us.

(B) This is a big one . . . Shine—a major quality. We want the things to shine, to have the rich lustre of a just-washed 'fro, of spit-shined shoes, of de-ashened elbows and knees and noses. The Shine who escaped the Titanic, the "li'l light of mine," patent leather. Dixie Peach. Bar BQ. fried fish, cars, ad shineum!

(z) color color Color color that shines, color that is free of rules and regulations. Color that shines. color that is expressively awesome. color that defines, identifies and directs. Superreal color for Superreal images. The superreality that is our everyday all day thang. color as bright and as real as the color dealing on the streets of Watts and the Southside and 4th street and in Roxbury and in Harlem, in Abidjan, in Port au Prince, Bahia and Ibadan, in Dakar and Johannesburg and everywhere we are. Coolade colors for coolade images for the superreal people. Superreal images for the SUPERREAL people. Words can do no more with the laws—the form and content of our images. We are a family. Check the unity. All the rest must be sensed directly. Check out the image. The words are an attempt to posit where we are coming from and to introduce how we are going where we are going. Check out the image. Words do not define/describe relevant images. Relevant images define/describe themselves. dig on the image. We are a family of image-makers and each member of the family is free to relate to and to express our laws in her/his individual way. dig the diversity in unity. We can be ourselves and be together, too. Check.

We hope you can dig it, it's about you and like Marvin Gaye says, "You're what's happening in the world today, baby."

Robert H. Glauber, "Introduction," and Ralph Arnold, Sam Gilliam, and Joseph B. Ross Jr., untitled statements, in *Black American Artists/1971*, catalogue for exhibition held at the Illinois Bell Telephone Company Lobby Gallery, Chicago, January 13–February 5, 1971

Robert H. Glauber's exhibition featured 136 works by 59 artists, including Romare Bearden, David Hammons, Faith Ringgold, Raymond Saunders, and Charles White. In the catalogue, Glauber underlines that he had not set out to examine the notion of "Black art." Rather, the exhibition's intent was to highlight the work of American artists who happened to be Black, promoting new and unfamiliar names that had, until recently, been denied mainstream opportunities in American institutions. The catalogue also included statements by exhibited artists Ralph Arnold, Sam Gilliam, and Joseph B. Ross Jr. The exhibition traveled to four other locations in Illinois, then to venues in Indiana and Iowa.

ROBERT H. GLAUBER, "INTRODUCTION"

It is sociologically and artistically regrettable that at this late date in American history it is still necessary—or even practical—to have exhibitions solely devoted to the works of Black Artists. But the inescapable truth is that up to recently Blacks have been virtually excluded from the mainstream of American artistic life. To most viewers, Black and white alike, the serious work of contemporary Black artists is new and unknown.

This has now, at least in part, been rectified by a rash of all-Black shows held all over the country. Unfortunately, the vast majority of them have been quite ordinary. They have been geographically too limited or stylistically too parochial or dealt too exclusively with single aspects of the art of Black Americans. (One, for instance, concerned itself only with Black artists who live or have lived abroad.) Since its inception, the Lobby Gallery has maintained a policy of mounting a major survey exhibition annually.[1] Early last year our committee decided that the time had come for someone (i.e., us) to try for a nation-wide, broad-based, truly representative sampling of the best that is being painted, sculpted, drawn and printed by Black artists in this country at this time. The result is *Black American Artists/1971*.

The idea of choosing an art exhibition based on the color of the participants' skin is logically not a very satisfying one. It can too easily smack of further tokenism. Yet, beyond the general public, there remain three important groups of people who must be made more aware of the immense amount of Black talent and artistic power that still lies virtually hidden and untapped.

Those three groups are: 1) the established gallery owners who tend to work almost entirely with their own (closed) stables; 2) the serious collectors who follow the gallery dealers they trust; and 3) the museum directors and curators who understandably take their cues for action from the collector-patrons who give them the greatest support.

Thus, the artists who are pushed by the established galleries are bought by the established collectors and, eventually, wind up in the established museums. It is a world largely closed to outsiders—

white and Black alike. But even a mediocre white artist can much more easily survive the exclusion than a good Black one.

Perhaps *Black American Artists/1971* will help break that chain reaction.

But there is another group—perhaps the most important of all—who must be made more aware of what the most talented Black artists in this country are producing. That group is the young Black art student.

This is an emotionally trying and financially difficult period for many of them. They are not sure of themselves as artists.

We would like this exhibition to help prove to such young doubtfuls that they can make it and that the collection itself is the prime evidence. Art is what matters. If *some* with talent can make it, *all* with talent have a chance. And making it, in the long run, means making good art—satisfying to viewer and creator alike. Perhaps the show will help some young Black students say along with the sculptor Richard Hunt: "In terms of my work, I have a certain kind of ideal that I want to attain and I find myself being able to do that as a Black man in America living in a Black community."[2]

The method of assembling the exhibition was simple but exhaustive. Contact was made with all the cities in the country where there are major centers of Black artists: Boston, New York, Washington, D.C., Atlanta, Nashville, Detroit, Los Angeles and the San Francisco Bay Area. In places where no formal centers exist, or where artists are few, or where we had no known informants (St. Louis, New Orleans, Phoenix, etc.), we contacted artists on an individual basis.

Most of the pieces in this exhibition came to us through the organizing efforts, the publicity, the pre-screening and the patient studio and gallery guiding done by people all over the country—painters, sculptors, critics, teachers, museum personnel, social workers. The vast majority is Black and they are all experts on their own scene, personal friends or long-term observers of the artists they have suggested. In virtually every choice in this show, I have been guided by the recommendations of local Black art experts.

We have made some exciting discoveries together. Yet responsibility for the overall look and balance of the show—for all inclusions and some omissions—must remain mine.

It must be made perfectly clear at the outset that this exhibition is not meant to deal specifically with "Black Art." It is a collection of works drawn from all over the country by American artists who happen to be Black. Their common bond, however, is not primarily their race (which they look upon from widely differing viewpoints) but their talent. Being Black could not automatically get one into the show, but being white kept one out.

What you had to be, in the view of the people who made the initial suggestions and in mine as I made the final selections, was a good artist. Our main guideline came from the painter Frank Bowling's flat statement: "Quality is the only criterion from which to judge."[3]

The show is not a complete survey of all major Black artists in America. It could not conceivably be so for reasons of space; but also for reasons of the artists' choices. Some artists we wanted do not wish to be associated with racially segregated shows; some deal with forms too large or too heavy to be practical for travel; some did not now have available works of the quality and date we required; some did not have the capital to tie up works for the length of the tour; some simply wanted no part of another "token gesture."

But an exhibition must logically and ultimately be judged on what it includes rather than what has been left out—for whatever reasons.

Though this is not a show specifically of "Black Art" (the title was carefully selected to make that distinction clear) this is not to imply that in gathering the show it did not become clear that—at least in a great many cases—there is a difference between the art of white and Black Americans. The difference stems, I should say from their differing life attitudes.

Cedric Dover summed up the divergence succinctly. "They do not think of themselves 'simply as American artists,' whose primary tasks are to seek fuller 'integration in American life' and identification with 'mid-twentieth century internationalism.' They regard themselves as Negro artists who are also American artists. They intend to rise with their people, not away from them."[4]

There is a wide diversity of artistic style, intent and content displayed here. Yet, as the works were being collected, three general classifications emerged rather neatly.

First (and most readily accessible to whites, I expect) are the artists who work within one or another of the definable "international schools." These include, as instances, the abstract expressionist, color field, surrealist, hard edge, new realist, and Pop pieces in the show. These are works by Black artists who have not allowed their racial feeling (which may be profound indeed) to obtrude into their art. They have accommodated to a dichotomy in their lives that is very personal.

The second general classification involves works with marked African influences. Edmund B. Gaither has termed this "Neo-Africanism" and describes it as a tendency "rooted in the study of traditional African art, its formal organization and its palette. Neo-Africanists do not attempt to copy or translate African art, they attempt to fathom its aesthetic, to get at its essence."[5]

This interest and concern with African art on the part of Black artists in this country is understandable and logical. Africa is at the roots of much art by Blacks and "represents a heritage that merits the most careful and enthusiastic study."[6]

Neo-Africanism will be quickly apparent in many of the works of the exhibition. Yet a word of caution is necessary to the casual viewer. There is considerable danger in using vague terms like "African influence" to describe what you see. It seems to imply that Africa has a single or unified style, aesthetic or essence to offer. This is not the case. The term "African style" carries no more definite artistic meaning than would "European style."

Ngere, Bakwele, Makonde, Bakota, Yoruba, Ndebele, Shilluk—these and many others are all African *tribal* styles: distinctive, sharply individual, often mutually exclusive. Their examples differ from one another as much as many Greek, French, Russian and Spanish pieces differ.

What is present in the works of Black American Neo-Africanists is a seeking for past identity of

a general but compelling visual nature; an amalgam of African tribal influences that suggests half-dozen styles simultaneously but that looks like no single one. It is not an attempt to synthesize a "universal" style for Black Africa. Such an attempt would be fruitless because "when we examine the tribal arts in themselves, we find that every tribe is, from the point of view of art, a universe to itself; and this great paradox is the central fact about African art."[7]

The third group of works are most obviously concerned with social commentary (which, by the way, does not exclude touches of Neo-Africanism). It is natural enough that Black painters wish to express their emotional, economic and political concerns in their art. Western artists have always done so in one form or another.

But a great and present danger emerges just as soon as social concern takes over as an artistic motivation. This danger was stated at its bluntest by the French critic Gérald Gassiot-Talabot: "The artist who wants to make his convictions and his art coincide tries to use the latter as a weapon. There remains the problem of discovering if this weapon is an artistic act and reciprocally, if this act is an effective weapon."[8]

The most skillful Black artists have treated social commentary in a manner so individual that it has given rise to what may be a genuinely self-contained style—something that has been termed Black Art. This is a fairly easy style to recognize, to feel, to assimilate, but, because it is so eclectic, Black Art becomes very elusive if you attempt an academic definition.

Edward Taylor has listed its main qualities as these: "a need for immediate communication, a concern for getting a message across; the necessity for dramatic posture, for 'soul'; a desire to protest the racial condition; a sense of color related to black skin and the bright sun of the South and of the jungle; a sense of form which is deliberately simple and straightforward and often has a primitive, rough or unfinished feeling; and, finally, a certain involvement with the world of Ju-Ju, of ritual and witchcraft."[9]

This definition puts an enormous extra-artistic burden on artists who wish to paint Black. Sensibly, most of the best ones steer clear of complex theory

and create out of their hearts and their experience in the traditionally accepted techniques of painting or sculpture. Yet there is a strong, sometimes almost shocking communication of their emotional reactions to being Black, to being the underdog that makes us recognize the best of Black Art as something special and respond to it—one human being understanding the tormented cry of another, the bravado and the hopes.

Basically, all artists share the same problem: they wish to express their view of the world in terms of their visual preferences and in keeping with their times as they understand them. The creation of art is a solitary affair—an artist wrestling with his medium and his muse. But he works to be seen, to be understood, to be appreciated.

The painter David Driskell has summed up the idea nicely. "Art, for me, remains a personal reaction to the world of experiences but I am equally interested in others sharing the final statement that I make in painted form."[10]

What the organizers of this exhibition hope to show through the wide variety and high quality of the works on display is that Black American artists now fully have the techniques to sustain their imaginings. They have style and styles. And that at their most militant, they can transcend personal prejudice with fine art—the highest human effort to achieve sense, order and compassion.

RALPH ARNOLD

In the last few years, interest in art created by American Blacks has soared to unprecedented heights. Artists previously unheard of except within their own environs are being sought after as prize fish in a big pond. The fishermen are the museum directors, curators, and gallery owners, both Black and white: the pond—the entirety of the United States. It is unfortunate that such has been the case. It has created and is continuing an unfair and artificial situation for many Black artists, and for the community in general.

The goal of most artists both Black and white is to be allowed the freedom to create as they wish and to receive some kind of fair recognition and/

or reward for their efforts. Today, these rewards are becoming too unrealistically tainted with such multi-purpose overtones that some Black artists, I feel, are becoming disgusted with the whole scene.

There are those who would rather be left alone to seek recognition and reward from other than the traditionally established art community. Many artists feel that they are being used in some way to help soothe the ills of years of obvious neglect. Some feel that the established art community cannot understand nor is it willing to understand their work. Still others, like myself, feel that their work will be judged as examples of "Black Art" rather than ART. The "Let's all go down to the Museum and see the Big Black Art Show" era has evoked such adverse criticism from critics, both local and national, that few artists come out unscathed. Perhaps it has been those artists whose works fall into the mainstream of established artistic values or those whose iconography falls into the proper shade of blackness that have been favorably mentioned. In addition, I feel that many younger artists want no part of the phoniness that shines so brightly in the established art world. Recognition by being included in museum shows because of the color of the artist's skin somehow does not seem any more honest than a national art exhibit comprised of artists from only the New York and West Coast areas.

Many of the Black Art exhibits of the past few years, while well-meaning in concept, have done as much harm as they have done good to the Black artist and his image. He is judged by his own community on the basis of his personality and the degree of his militancy in the current Black revolution. His work is judged as to whether or not it relates to this revolution. Sometimes the artistic quality is not given too much consideration. He is also judged by the established, recognized art critic by his ability to "fit in" and his ability to do "something new." The criticism of the art work has been on so many and varied levels that no matter what the artist produces the camps are so divided that perhaps only history will adequately judge.

The exclusion of Blacks from the mainstream of American art has had its effect on the current art scramble in that a good painting or piece of sculpture by them in many instances reaches only as far as the 1930s in its degree of "newness." If there can be any ray of hope in all of this, it is the fact that young Blacks are going to see these exhibits, and they will know that there are artists who are Black. This might be the meaningful event that will encourage the beginning of that something we call "new," that something some call "relevant."

SAM GILLIAM

As an artist, I have always looked beyond the medium into life. In the earlier days as an art student, the "civil rights movement" was my principal concern outside the college classroom and formed a backdrop for personal based paintings. Along with contemporaries in Louisville, Ky., we formed a group through which many of the perplexities of a social/artistic existence could be resolved. There, through conversation, "listening to sounds (music)," and dwelling upon the experiences of those in whose footsteps we followed, we established a means of working, a mode of sharing and a way of being to ourselves. As Black artists, as Black men, critical self projection is important. I have always felt that the act commits the aesthetics. I still believe in looking beyond the medium into the whole of life from both a personal and universal stance. In this way I get a feeling for being myself. Only then can I listen, live, and work.

JOSEPH B. ROSS, JR.

It is significant that today Black art is being discovered and sought after. But not to the benefit of the Black artist. It seems to me that the Black artist is being taken advantage of and not supported by the white establishment. The Black artist does not find his work being collected by major collectors nor does he find his work in major museums in the country. Therefore, he finds himself in a predicament. He cannot work as fully as he would like because of monetary needs. There is no one beating down his door to buy his work. So ultimately the Black artist works mainly for himself and his few friends. His outlook on life is very bleak.

NOTES

1 *A Decade of Accomplishment: American Drawings and Prints of the 1960's* (1970); "The Art of New Guinea" (1969); "30 Mexican Printmakers" (1968), etc.

2 *Metropolitan Museum of Art Bulletin*, January 1969. p. 258. [See p. 130 in the present volume. —Eds.]

3 *Arts Magazine*, Summer, 1970. p. 31.

4 Dover, Cedric, *American Negro Art*. p. 44.

5 Gaither, Edmund B., Introduction. Catalogue for: *Afro-American Artists: New York and Boston*. [See p. 230 in the present volume. —Eds.]

6 Murray, Albert, *The Omni-Americans*. p. 179.

7 Fagg, William, *Tribes and Forms in African Art*. p. 11.

8 Gassiot-Talabot, Gérald, "Is Confrontation Possible?" An essay in *Art and Confrontation*. p. 96.

9 Taylor, Edward K., Foreword. Catalogue for: *New Black Artists*. [See p. 168 in the present volume. —Eds.]

10 Lewis, Samella S., and Waddy, Ruth G., *Black Artists on Art*. p. 95. [See p. 180 in the present volume. —Eds.]

1971

Joseph E. Young, *Three Graphic Artists: Charles White, David Hammons, Timothy Washington*, catalogue for exhibition held at the Los Angeles County Museum of Art, January 26–March 7, 1971

Three Graphic Artists: Charles White, David Hammons, Timothy Washington was the first exhibition to be initiated through the efforts of the Black Arts Council (BAC), which had been formed at the Los Angeles County Museum of Art (LACMA) three years earlier. Joseph E. Young, an assistant in the Department of Prints and Drawings, took on the role of curator and wrote the accompanying catalogue. Charles White was the most established artist of the group, with a national reputation, while David Hammons, who had studied under White, and Timothy Washington, a recent art-school graduate, were still emerging. Although the exhibition marked a new direction for the museum, its organization was controversial. The show's placement in a small gallery space was seen as disparaging; the BAC, arguing that White was noteworthy enough to be given a solo exhibition in a central gallery, picketed the opening in protest. Nonetheless, *Three Graphic Artists* provided an important reference point for LACMA as it continued to work with African American artists, and the BAC was instrumental in cultivating *Two Centuries of Black American Art*, which was mounted at the museum a few years later, in 1976 (see pp. 531–33).

JOSEPH E. YOUNG, *THREE GRAPHIC ARTISTS: CHARLES WHITE, DAVID HAMMONS, TIMOTHY WASHINGTON*

Three Graphic Artists is an exhibition of prints and drawings by contemporary Los Angeles artists whose productions are often of a public rather than a private nature and whose effectiveness in appealing to a large audience is increased by their utilization of the human figure in their compositions. In spite of their many thematic affinities, each artist has produced works that are easily distinguishable and that bear the unmistakable stamp of but one person. It is this impressive mark of originality which imparts to this exhibition so much of its stirring vitality.

A decisive factor contributing to the selection of these works was their technical and aesthetic excellence. [. . .] Another hallmark of this exhibition is the degree to which each artist acknowledges his awareness of man in relation to society and the role of the community in relation to man himself. Although occasionally the traditional device of using a particular contemporary incident to imply the general dilemma confronting mankind is employed, for the most part the prints and drawings exhibited are not specifically derived from the events of contemporary society. All of the works displayed are intended by the artists subtly to invite the viewer into a thoughtful, contemplative state of awareness—of himself and the larger role he plays as a social creature. Indeed, it is the universal expression of man's basic humanity which makes this exhibition significant for all persons who are genuinely interested in the continuing expansion of Western art.

CHARLES WHITE

My work takes shape around images and ideas that are centered within the vortex of a black life experience, a nitty-gritty ghetto experience resulting in contradictory emotions: anguish, hope, love, despair, happiness, faith, lack of faith, dreams. Yet stubbornly holding on to an elusive romantic belief that the people of this land cannot always be insensible to the dictates of justice or deaf to the voice of humanity.[1]

[*Young starts with biographical information and describes the different ways White uses lithography, drypoint, charcoal, and oils.*]

Because graphic images are more easily reproduced than paintings and, therefore, can more easily be disseminated to the public, Charles White, who has a profound respect and admiration for the human race, increasingly has turned to drawing as a means of communication. This desire to produce an art which the many rather than the few can enjoy also stems from the influence of another culture to the south of the United States, a culture which has deeply influenced the heritage of California in the past and is once again through Charles White transmitting its message of life and man.

[*Here, Young discusses the importance for White of the work of Diego Rivera, David Siqueiros, and other Mexican muralists.*]

Back in the United States White began to realize that most of the people who had purchased his art had been either upper middle class individuals or museums and that this had not been his intention:

The primary audience that I was addressing myself to was really the masses of black people, and they were not turning out in hundreds to see my shows, and I had to find some way of reaching them, since my subject matter was related to them and should be made available to them, particularly in a national way.

Later, when White was approached to have a portfolio of his drawings reproduced, he immediately recognized the offer as the opportunity he had been looking for. Consequently he created a suite of drawings especially for his 1953 *Portfolio of Six Drawings—The Art of Charles White.* This was followed by the 1961 *Portfolio 10/Charles White* and the 1964 *Portfolio 6/Charles White.*

The themes that Mr. White explores center about the universal conflicts that involve all mankind. They include, among others, the relationship of man to man, social or economic dislocations, the

opposition of love and hate, and the never-ending problems of justice and injustice. For, as the artist stated:

> I deal with ideas as an educator or a philosopher. This is my life's work, and I treat this responsibility very seriously. Consequently, I don't release works that I am not comfortable with myself, in the sense that I have fulfilled my responsibility of having dealt with an idea.

> I am concerned about my fellow man. I am concerned with the survival of man. I am concerned with the progress that man has made in relation to his fellow man, in relation to nature, in trying to find a more beautiful way of life. . . . I am trying to fulfill my responsibility to myself and to express my gratitude for the privilege that I've had of living with my fellow man. I want to pour something into life—perhaps a little bit more than I've gotten out of it. Now that sounds awfully platitudinous, but that's really the way I feel about it.

DAVID HAMMONS

> I feel that my art relates to my total environment—my being a black, political, and social human being. Although I am involved with communicating with others, I believe that my art itself is really my statement. For me it has to be.[2]

[*Young begins with biographical information and a description of Hammons's arrival in Los Angeles.*]

> I had my first commercial art job, and this blew my head off. I couldn't believe it—those deadlines and everything. Like, every job I did you had to put down the starting time and the ending time too. So I dropped out of that and went to Chouinard.

When asked about those artists whom he considered as an influence on his own work, Hammons replied that he had taken a drawing class with Charles White at the Otis Art Institute in Los Angeles because:

> I never knew there were "black" painters or artists or anything until I found out about him—which was maybe three years ago. There's no way I could have got the information in my art history classes. It's like I just found out a couple of years ago about Negro cowboys, and I was shocked about that.[3]

In a more recent interview, Hammons stated of White:

> He's the only artist that I really related to because he is black and I am black, plus physically seeing him and knowing him. Like, he's the first and only artist that I've ever really met who had any real stature. And just being in the same room with someone like that you'd have to be directly influenced.[4]

Before he studied with Charles White, David Hammons had become familiar with the senior artist's work through exhibitions and reproductions. He was especially drawn to White's figures with their exaggerated gestures, often enlarged hands, and generally unsmiling visages which, for Hammons, possess an "agonized" look:

> In most of Charles White's art there aren't too many people smiling, and I like that in his things. There's always an agonized kind of look, I think, because there aren't many pleasant things in his past. He's gone through a lot of Hell. I know he has.

Unlike White's pictures, which over the years have presented an heroic, idealized, and seemingly timeless panorama of humanity, the images in David Hammons' "body prints" appear to capture a single moment in time, as if, in many instances, they have been frozen in actual movement. Hammons has stated that he prefers to create his art without any message at all, feeling that messages are aesthetically restrictive.[5]

Nevertheless, he is deeply affected by the events of our times:

> I just can't sit down with something political in mind and try to make something. I can't work

*like that. . . . I'm still political at times, but I
don't want to be; but there are so many political
issues that come up, and . . . they bother me.*

Contemporary events have already influenced
Hammons' art which, on occasion, does seem to
have political and/or social overtones. An example
is *Black First, America Second* which results from
the artist's belief that an American Negro for the
sake of personal survival must consider himself
first as a Negro and second as an American.[6] Other
works by Hammons, such as *Injustice Case*, refer to
civil liberties abuses and political injustices. More
often, however, Hammons' pictures border on the
surreal. This is true of *Close Your Eyes and See
Black* where various imprints of the artist's body
are repeated and formally integrated to create
a new vision which seems to inhabit the world of
art alone.

The monotype technique, originated by G. B.
Castiglione in the seventeenth century, was widely
employed during the nineteenth century by many
notable artists including Whistler, Gauguin,
Toulouse-Lautrec, and Degas. A traditional mono-
type or monoprint is a single, unique impression
made from an image which has been painted or
drawn, often with printer's ink or oil paint, on a hard
surface such as glass, wood, or metal. The actual
print is achieved by placing a sheet of paper on the
drawn image and then either running the paper
and the "plate" through a press or, as one does for
a woodblock print, rubbing the paper from behind
to print the image. Like monoprints, Hammons' pic-
tures are unique works of art. But, contrary to the
traditional monotype technique, his "body prints"
employ powdered pigments rather than oil paint
or printer's ink, and the actual "plate" from which
the artist prints is his own pliable body instead of
a hard surface.

"I draw a lot from live models," Hammons
recently stated, "because I'm really surprised how
much it helps when I make 'body prints.' That's
what I really love—drawing the nude, and I've been
doing this for about eight years now." Even so, he
does not make a preliminary sketch for his prints,
preferring to work directly on the smooth surface of

illustration board which he finds especially respon-
sive. As a preliminary step to "printing," the artist
lightly coats his body, his clothing, and even his hair
with margarine, having first selected the fabrics
that he wears according to their physical structure:

*I generally try to use corduroy in all of my things
because of the textures it produces. That's why
I like to use my wife's lace tablecloths, since the
"body print" technique seems to recreate every
thread.*

The artist has stated that in some of his pictures
he has been able to reproduce even the veins in his
body and the texture of his skin.

Having first coated with margarine those sur-
faces that he will "print," Hammons next presses
his clothing and his body against the illustration
board which he places either on the floor or on the
wall depending on the intensity of the image he
desires. A lighter impression is produced when the
paper support is placed against the wall since this
position enables Hammons to more easily control
the pressure of his margarine-coated surfaces. One
of the many difficulties involved in the production
of "body prints" is the hazard of smudging the pic-
ture while it is being produced. This is especially
the case when Hammons creates his images on
the floor:

*When I lie down on the paper which is first
placed on the floor, I have to carefully decide
how to get up after I have made the impression
that I want. Sometimes I lie there for perhaps
three minutes or even longer just figuring out
how I can get off the paper without smudging
the image that I'm trying to print.*

Once he has physically disentangled himself from
the illustration board, Hammons sifts powdered
pigments through a strainer to make a fine mist that
completely covers the work still in process. As the
fine pigment slowly descends like a cloud of dust,
the color is captured more intensely in those areas
of the paper which have absorbed the "printed"
margarine film. Simultaneously, the "unprinted"
background of the paper often acquires a slight haze
of color. This situation occurred in *Injustice Case*

where the artist chose to erase the background around the "printed" image. However, when Hammons employs certain types of illustration board, such as the black board used in *Stars on Sleeve* and *Black First, America Second*, the white powdered pigment does not adhere to the background to any noticeable degree, and, therefore, it is not necessary for him to erase the background.

Like the pastel drawings of other artists, Hammons' "body prints" are sprayed with a fixative. But, unlike most pastel drawings which have a tendency to become less brilliant after being so treated, the colors of Hammons' prints, when sprayed with a fixative, tend to become more intense, especially when he uses oil-base rather than water-based pigments.

In many of his pictures, particularly those in which he utilizes the image of the American flag, Hammons combines "body printing" and the silk-screen technique:

> I always do the "body print" first. Then I decide where the image of the flag will be. I must print in this sequence because the "body print" technique is so uncertain as to how it will actually turn out.

What is remarkable in his works is the superior formal and aesthetic unity that he is able to achieve while integrating two techniques. From a distance such works as *Stars on Sleeve* and *Black First, America Second* appear to have been produced by a single method of printmaking.

For David Hammons one of the main enjoyments of his craft is the element of "surprise":

> That's why I love printing, because there's a surprise. You really can't tell what you've got until you lift up the paper. You know, in painting you work with it, and you see the results as you are working so that you can't really see the picture when you're finished with it unless you put it away for a month or so. Then you can look at your painting again and see it from a different angle. And "body printing" is no different as far as the element of surprise is concerned. Especially when I use cloth that I have wrapped

> around myself. I had no idea originally that all those wrinkles and all those folds would actually turn out like that. I just couldn't believe it. I still can't believe what I see sometimes.

Hammons is constantly impelled to seek new means of expression. His most recent works have begun the rather complex investigations of multiple colors in a single "body print"; and he is, at present, considering working on a grand scale "where the artist is so small in relation to his work—like an architect looking up at a huge building that he designed." It was originally this same sort of adventurous search for new imagery that led David Hammons to develop the "body print" into a significant graphic expression.

TIMOTHY WASHINGTON

> I am dealing with message art: it is informative and relates to a poster in that it gives information. However, I want the information to be discovered; therefore the message is subtle. I try to ask questions and make the viewer think and in turn look closer.

> I feel that there are no shortcuts in life. We have to stop and gather up bits of knowledge as we go along, to form a total. My separate, direct strokes—each line is an effort to form a whole.

> I am not trying to change society but create an awareness, because awareness can curb or change reactions in the future.

> I am also concerned with bringing people back to nature. I try to make people aware of plant and animal life.

> I use simple shapes because modern society trends deal toward simplicity. The oval [circular] eyes are because they can capture several goals, beliefs, norms, and mysteries. They have a tendency to leave an imprint on your brain, or an after image. I am concerned with the effect my work leaves on people and their reactions. Each piece says something, whether for or against the establishment.

Technology has advanced, and I want to work with a material that says "today." I started working with aluminum because I wanted to work on a cold material. It is a challenge to create warmth from a cold, hard material.[7]

[*Young begins by tracing Washington's trajectory from his upbringing in Watts to his enrollment at Chouinard.*]

While the artist was still attending Chouinard, his style was rapidly acquiring its now distinctive mark. He was even then "redesigning" the human figure. "I would change the way I saw things," he related, "to give the picture more visual impact." And, in the latter part of 1967 a class assignment was given that was to change the course of Washington's future:

I was in class, and our problem was to do something that we would consider very personal. And I think it was the very same day that I went home and found that I was reclassified for the draft as 1-A. So, I knew that I was going to make something relating to the army or war. I wanted to work on a substance that was cold and hard, and I thought of aluminum as a material that I would like to work on. The first piece that I did on aluminum was a triptych which was a social commentary against wars.

A technique present in the artist's first aluminum picture is still found in his later works. Washington initially sprays a sheet of aluminum with enamel paint and then carefully scratches the plate with an etching needle. Most artists would consider this a "dry-point" technique, would ink the resultant plate, and would print from it. This, however, is not the case for Timothy Washington though he is fully aware that he could print from many of these engraved plates:

But I also feel that if I tried to print from them they would lose a great deal. I like them as they exist right now without trying to print from them, because paper says a certain thing to me, and aluminum says another, and to print on paper would take away from the luminous quality you have in aluminum.

Washington is no stranger to traditional printmaking, having practiced etching, dry-point, and silkscreen techniques, but even as a student he discovered:

When I had an etching class, the plate seemed much more fascinating to me than the print itself. And I wondered about boundaries in art. Why should the plate be considered something to use to make a paper print when I loved the plate so much more? The plate said so much more to me because it had me within it.

Ignoring artificial boundaries in art, Washington has created many recent dry-point engravings on aluminum panels which combine with other materials to create complex pictorial collages. *Raw Truth*, *Why Poverty?* and *Ghetto* are all examples of his efforts to combine various media. *Raw Truth* integrates a sculptural section of a wooden yoke for cattle into a composition of a standing figure and an exquisitely drawn cow. *Why Poverty?* incorporates an actual wheel of a child's wagon into the physical structure of the picture. *Ghetto* is still another example of the artist's juxtaposition of different materials—in this case leather against metal. The figure in this picture is that of a woman whose extended left arm holds a rat and from whose neck protrudes the head of a cat. The woman's hair is made from a ragged leather baseball mitt. In talking about his mixed-media pieces, Washington stated:

In these works there's a large amount of hand sanding and construction. In some pieces like "Exist" I have formed the metal itself. That whole piece was aluminum, and I sanded and worked back and forth and shaped the breasts with a hammer. And in much of my work there are some areas that are often painted on, and there are also so many applications of other materials that I don't think they can really be called drawings or even given a specific label because they seem to go so much beyond any specific category.

Even when Washington's dry-point engravings incorporate sculptural elements, they remain unquestionably pictorial because there is always

a sense of containment. This stems largely from the artist's respect for the framing edge of his pictures. In describing his collage-approach to his metal engravings, Washington said:

> It seems to me that if you incorporate different media into one work, the visual impact will be greater because you begin to see form. Also, I can incorporate the differences of the cold metal and the warmth of leather. I feel that by using all of these materials it will, hopefully, "pull the viewer in." Just as there are differences in life today, I feel that some of these differences can be applied to art.

This artist has chosen to work with the figure because it allows him to communicate more easily with his audience. He considers his role as a creator to require him to comment on issues and events of the present and the past. This he does as gently as possible because one of his basic premises is that most people "resent being told anything" and have a better chance of re-examining their thinking if they can make their own discoveries. He believes that by referring subtly in his pictures to present and past events he will create messages with a timeless quality:

> Often, I comment about things of the past, but I try to bring things up to date in a manner which will be significant for today, although the event itself may have occurred in the past. I believe that something like the Bible may talk about things of the past, but it also has messages that can be related to today.

Washington's pictures also employ highly personal symbols. For example, the cattle yoke incorporated into *Raw Truth* represents to him an aspect of the past which can be re-interpreted in our own time. Contemporary society is represented in this work by a figure which is bending a stick:

> I feel that a given society or the system that we live in can only bear a certain amount of pressure before it breaks down. That's why in "Raw Truth" there is the bending of the stick. The cow in relation to the figure applies to life

> itself and its relationship to knowledge. The cow demands a certain amount of responsibility, and in return we get milk from it. This is a give-and-take situation which I feel should be applied to life.

That the highly personal content of Washington's works is somewhat elusive does not disturb the artist who feels that if his work stimulates thought of any kind, it has succeeded. For those persons who know and love the graphic arts—especially when they utilize highly accomplished and sophisticated draftsmanship—Timothy Washington's enigmatic pictures should easily provide the aesthetic stimulation and enjoyment which we experience from much of the significant graphic art of the past.

NOTES

1 Charles White, "Wanted Poster Series," portfolio of drawings (Los Angeles: Heritage Gallery, 1970). [The wording and punctuation here vary slightly from White's original statement. See p. 184 in the present volume. —Eds.]

2 Statement prepared by David Hammons especially for this catalog.

3 Joseph E. Young, "Los Angeles," *Art International,* XIV (October 20, 1970), p. 74.

4 All statements by David Hammons in this essay are taken from interviews the artist granted the author on May 2, 1970, and December 28, 1970. Portions of the first interview have been published in "Los Angeles," *Art International,* IV (October 20, 1970), p. 74.

5 Ibid.

6 [This work is illustrated on p. 40 and on the cover of the present volume. —Eds.]

7 Statement prepared by Timothy Washington especially for this catalog.

1971

Edward Spriggs, "Preface," and David Driskell, "Introduction," in J. Edward Atkinson, ed., *Black Dimensions in Contemporary American Art* (New York: New American Library, 1971)

Black Dimensions in Contemporary American Art consists of profiles of forty-nine African American artists, including Benny Andrews, Margaret G. Burroughs (also known as Margaret Taylor-Burroughs), David Hammons, Richard Hunt, Lois Mailou Jones, Raymond Saunders, and Alma W. Thomas. Edward Spriggs was the second director of the Studio Museum in Harlem; the artist and academic David C. Driskell was head of the art department at Fisk University in Nashville, Tennessee. The publication was commissioned by the Carnation Milk Company as part of an audience outreach program that sought to engage with the company's substantial African American customer base and was edited by Carnation's senior public relations supervisor, J. Edward Atkinson.

EDWARD SPRIGGS, "PREFACE"

Many of you reading this book for the first time will be seeking the answers to questions such as, "What is 'black art?'" and, "What is meant by the term a 'black aesthetic?'" If you expect to find in this visual survey a representative style that can be designated "black art," you will be disappointed. If you want to discern within these pages an aesthetic that is something other than the Europo-American one referred to in art texts and journals, again, you are searching in the wrong place.

This collection presents the forms and styles operative in the works of artists who have been assembled together, not because their creations are related by styles or form some kind of school, but because they happen to be Afro-American or artists of African descent. This is a visual survey. The point is worth repeating. The attempt is to give a general idea of the kinds of expressions that have emerged in contemporary black America. This book does not attempt to present one trend, one style of school: It is an arbitrary and fairly broad survey. In one sense this book is already obsolete because it is a survey.

Instead of trying to fit all of the art by those who happen to be black into one category or another, we need systematically to isolate those works that fall into one category from those that fit into another. In other words, we need to examine the kind of "trees" that are growing in the "forest" in order to assign proper names to all the various types represented and to determine whether there is an unclassified or new type present. The kind of voluminous approach that is being suggested has yet to be undertaken. Few non-blacks have either the historical vision or the intellectual appetite to deal seriously with the art of the American black in this way. Perhaps, and if for no other reason, it is because of the fantasy of an unrealized egalitarian ethic that haunts the American imagination.

But when we ask, "What is the black aesthetic?" and, "What is black art?" we are talking about something other than what most art critics are prepared to deal with honestly at this point. The possibility of a black art/aesthetic is not a mainstream idea. It is not something non-blacks consider seriously. It is not something that is generally desired. It is a different and separate thing.

We are living, I believe, in a time when non-white people all over the globe are striving to develop and project an honest vision of their present collective conditions—spiritual, physical, and mental—and what they want their future to be. I see this as a transitional period in the development of an art and an aesthetic for black people. It is a period when absolutes seem impossible. It is a period in which the art of black people is usually described as "protest," "propaganda," "sociological," "diverse," and "emotional" notwithstanding the fact that these terms can be applied to Western art as well. All of these terms help to form the shield that hides the undercurrent of a different standard—a standard that is evolving among a large but scattered number of creators who may or may not be presented here.

These artists and thinkers are interested in the relationship between aesthetics and ideology. Aesthetics and ideology seem to have converged at much the same time in the current works of many black artists. How do/should we account for this? It is because a profound social consciousness has now been released in the black kind that different ideas about art and life are emerging. By briefly recalling some of the dynamics of the last twenty years, we can see that it is in the context of militant social developments in the United States and the world that we find the immediate sociopolitical roots of these surfacing ideas.

With the advent of the civil rights movement in the early fifties and the simultaneous drive for independence being made by Africans on the international stage, some black American artists began to focus (in their works as well as their thoughts and actions) on the position of black people internationally as well as domestically. The new confidence and pride that they expressed went much deeper and was more sustained than even that expressed by their predecessors—the Negro artists of the twenties and those of "The Harlem Renaissance." These younger artists had gotten even closer to their subjects and were on the move in step with the people as they marched through the streets

of the fifties. This newfound social awareness led some artists to re-think the function of art in life. Some began to see art as functional in their lives and as a tool for physical and mental liberation. Others began seriously to explore the question of our relationship to Africa and the possibilities of residual African sensibilities. We must also recall that during this same period there was a great proliferation of historical, sociological, and cultural literature concerning the affairs of the black man and that bold new areas of political and social confrontations molded the realities of the sixties. Indeed, the new consciousness took a firm hold. Its artistic and social manifestations closed out the sixties and has opened the new decade with a heightened sense of political and social consciousness and commitment. If one doubts that broad movement has evolved (one that is both aesthetic and ideological in nature) note how Larry Neal, a leading black poet-critic, recently announced the presence of a new art for his people:

> The Black Arts movement is rooted in a spiritual ethic. In saying that the function of art is to liberate Man, we propose a function for art . . . which is in keeping with our most ancient traditions and with our [contemporary] needs. Because, at base, art is religious and ritualistic; and ritual moves to liberate Man and to connect him to the Greater Forces. Thus Man becomes stronger physically, and is thus more able to create a world that is an extension of his spirituality—his positive humanity.

> The Black Arts movement preaches that liberation is inextricably bound up with politics and culture. The culture gives us a revolutionary moral vision and a system of values and a methodology around which to shape the political movement. When we say "culture," we do not merely mean artistic forms. We mean, instead, the values, the life styles, and the feelings of the people as expressed in everyday life.[1]

The need for new values and systems of thought is a foregone conclusion in the sub basement of America. Afro-American students, artists, writer-critics are excited about the possibilities of a systemized study of art and aesthetics from their own points of reference. They understand that it is in their own interest to lay the foundations for new and subjective impulses and interpretations of their art and life. They are focused upon and concerned with priorities of curricula, definitions, aesthetic theory, and revisionism. They see revisionism as part of the life blood of change as men have gone to the moon and 1984 is upon us! They are sending forth artist-liberators who are expounded the necessity to reduce the distance between art and life—artists and people, aesthetics and ideology—between themselves and their native vision.

DAVID DRISKELL, "INTRODUCTION"

During the years prior to 1960 few writers, critics, or students of art history bothered to consider the role of the black artist in American culture a subject worthy of scholarship. However, in 1936 Alain Locke's book *Negro Art: Past and Present* was published as a follow-up to his earlier book *The New Negro*, which had been published in 1925. Locke was looked upon as the spiritual father of the new invigorating movement later to be called "The Negro Renaissance." In both books his tone and spirit for the times mirrored his interest in a new appreciation for Africa and a return to what he referred to as the "ancestral arts." He strongly believed that knowledge of an African past would enhance the Afro-American's cultural literacy and awaken in him a sense of pride for his own cultural heritage.

Dr. Locke did not attempt to set forth in his new book, *Negro Art: Past and Present*, an ethos which enunciated the functional aesthetics of what he called Negro art. Instead, he was more interested in the general public being made aware of the role the black artist had played in the making of American art. *Negro Art: Past and Present* was followed in 1940 by a book by the same author designed to show pictorially the black artist's perspective in world art. It is called *The Negro in Art* and describes black imagery, symbols, and content by artists of various ethnic origin.

The late James V. Herring, former chairman of the Department of Art, Howard University, also wrote enlightening articles attesting to the skills and craftsmanship of the black artist in the colonial period. But the most scholarly of such books on the subject of the black artist's contribution to American culture Is *Modern Negro Art* written by James A. Porter in 1943. Porter was at that time a professor in the Department of Art at Howard University and is still regarded as the most authoritative spokesman on the subject of Afro-American art. Cedric Dover published *American Negro Art* in 1960 and made a contemporary evaluation of the black artist's work in the twentieth century.

The scholarly work of Alain Locke and James A. Porter was not continued until the year 1967 when black students began demanding changes in course curricula with specific reflections on the contributions of black Americans in the visual arts and in other areas of fine arts. It is against this background of interest and concern for the black man's cultural history in America that this summary of paintings is presented.

The intention of this publication is twofold. First, it attempts to show that a relevant number of black artists have always been conscious of their being apart from the mainstream of American art and have worked toward the creation of symbols that reflect the aesthetic needs of black Americans. This may be argued to be the closest manifestation toward the establishment of an ethos in black art. Secondly, it calls to our attention some of the problems generated by the attempts of contemporary philosophical thought to classify the art of black people in America without looking at the social, economic, and political conditions that have helped to make it a particular cultural entity to itself.

The verbal ethos which delineates black art from any other form of expression was established in the philosophy of Alain Locke. However, the black public, specifically an impatient young public, has turned to the artist and asked for signs and symbols in his work that reflect the specifics of Afro-American culture. A symbol is an accepted abbreviation of form which points beyond the ordinary perceptual world. With it, the viewer is made to understand an abstract form which is capable of transcending reality.

The artists whose works appear in this publication represent all sections of the United States. Their works show a variety of styles that are based in the various movements reflective of general trends in modern American art. These artists have a common history. Many of them have been exposed to the same life-styles and general cultural patterns, which cause the form and content of their work to be much the same. They have all been looked upon by sociologists as misfits in a technological society which emphasizes materialism instead of humanism. American artists have been traditionally viewed by a segment of the general public as visionary misfits endowed with magical intuition, capable of issuing forth talent at will. The black artist has not been exempted from this misconception.

It is still assumed by many people that the fine arts are forms which reflect man's leisure and consequently are synonymous with wealth. Since wealth in America is controlled by the white majority, one could readily assume that black artists do not participate in the creative process in the visual arts. But they do. The systematic denial of black artists' participation in the mainstream of American culture has been a deliberate act by art historians to affirm the black man's nonpresence or invisibility in American society. For this reason, one is often surprised to know that the history of the black man's participation in American culture as an artist goes back to colonial times.

The attitude concerning the black man as artist in American society is a sociological phenomenon based on the general desire to classify everything that involves human behavior. Since sociology is always mentioned in the context of the black man's survival as artist in the United States, one can narrowly escape the burden of a sociological perspective being imposed on the art of the American of African descent. Some observers believe that an artist's race or ethnic origin gives special meaning to the characteristics of his art. It is in this context that the recent use of the term "black art" is applicable to contemporary Afro-American art.

It is further necessary to mention sociology here in connection with art since in discussing the meaning of black art, the question of identity and aesthetics are often unknowingly combined. There is the sociological question, "What is it to be a black man in America?" and also the distinctly separate question, "What is it to be a black artist?" Making this distinction is a great help in understanding the meaning of the category "black art." It is likely within this context that the artist of the street, sometimes called "The black funky militant," feels that his art should be rightly termed "black art." His work, committed to propaganda and visual literacy, shows a literal interpretation of contemporary black life in America. This artist, unfortunately omitted from this publication, usually paints on walls, fences, and pavements. He does not feel the need for academic orientation and critical aesthetics that are bound within the western tradition of "good standards" in art. He is creating his "own thing" within the bounds of his own needs and is not asking for upper-societal judgments that are based in the aesthetics of western art. For this reason, we are unable to pass judgment on the value of his work as it is mentioned, this artist himself has exempted it from general aesthetics. He further argues that those artists and art historians who were trained prior to 1960 have a built-in aesthetic which creates a bias toward works that reflect a nonwestern tradition.

Perhaps this new form is being based in an ethos reflective of what is considered to be a societal need. Thus, the validity of the term "black art" as rightly argued by Jeff Donaldson, an articulate young spokesman for the black artists of the street, is not to be seen in the traditional concept of spiritual satisfaction through the experience of the symbol and what it means when viewed.

There exist perhaps two basic conflicting views concerning the creation of symbols and the purpose of art: one being that art's only commitment is to the form or symbol itself and that a work of art is an object to be perceived as a thing in itself, with little or no reference to other areas of experience. The other point of view being that art primarily is a means of expressing and communicating ideas and emotions.

Each of these perceptions has an inherent danger implied within it. The first perhaps promises to turn out cold and unfeeling art, completely divorced from any social reality even though symbols may be present. The second threatens to produce an art that must meet certain social needs. And, with the latter definition of art, people can too easily begin to dictate specific ideas and emotions that are to be expressed.

Both opinions have relevance to the black artist. It is clear that the artist must have a defined role as participant in his culture. In the African past, his art was in the service of the ruling family or was the basis for providing symbolic forms for ceremonial use.

But defining that role leads to definite difficulties. His role should not be so sterile as the first definition suggests, causing him to devote his entire life to the pursuit of an abstraction called "form," and completely divorcing himself from urgent social needs. But each artist must decide this for himself and plot his own role of involvement beyond form. Neither can one expect the Afro-American artist to become so involved in the social definition of being black in America that he allows his art to become a political tool. If a role for the artist is to be determined and if some effective guidelines are to be drawn up for art, then surely the only people qualified to do so are black artists. The two opposing views are implied in the question: How does one reconcile externally imposed artistic purposes with a complete internal freedom, when the social situation points up a definite need for some type of control?

Perhaps the best synthesis of the two opposing points of view must come from within each individual artist. Surely, no rigid external controls can be placed upon his creativity. He must be led by an intrinsic and internal force to create. But perhaps the difference in the art produced will come with a personal feeling of responsibility and commitment on the part of the artist as to his function and role within the society.

The black man's art in America, like his music, cannot be separated from his life. His art has evolved from his life-style and his will to survive.

All that he perceives and makes with a medium will have his stamp on it. And for this reason, it may be argued that the art of the twentieth-century black artist is one which shows forms based on the expression of experiences that reflect a realistic portrayal of certain aspects of American life.

The dynamics of social protest and propaganda have played a vital role in twentieth-century Afro-American art. It is in this context that the black artist's work becomes a subcategory of American art taking into account like characteristics that reflect the state of being black in America in the twentieth century. If the experience of being black in America determines a black artistic style at all, it does not control the artistic expression in a restricted way. The variety of styles represented in this publication is a witness to this fact. An appreciation of the variety of styles found here is a prerequisite for examining the popular notion that the black experience in America by its very uniqueness produces a special art.

The diversity of styles presented in this publication does not dictate a homogeneous grouping; however, there is a unifying bond running through all of the works. The bond is formed by the emotional mood of many of the works presented as well as the common expression of experiences relating to the need to be expressive with a medium such as paint. A number of the artists represented are nationally known. Others less well known are seeing their work published for the first time. The styles represented range from the traditional portrait mastery of Aaron Douglas to the West African vignettes of John Biggers.

Since the black man in the United States is still in search of his identity as it relates to his cultural heritage, the absence of a distinct style of black art cannot be looked upon as a weakness of his culture. Instead one must realize that distinct symbolic forms are created out of societal needs that are acceptable for mass communication. In order to establish an acceptable style, forms must be created and used by the black community. This idea may account for the contention of some blacks that the only proper way to think about black art is to start from an altogether new base.

While the mainstream of contemporary American art has become progressively more concerned with form to the exclusion of objective content, art created by black Americans has tended to hold on to content as a vital part of its format. Content is a concept which is related to subject matter but different from it in that form in a work of art gives visual description to the object being depicted. Thus, content in the context of a black artist's work can be tied to a specific experience consistent with the uniqueness of being black in America. Since the artist's style determines and to a certain extent controls the form his art will take, style is an important factor in the art of the black American. It is surprising to some people to note the absence of the dynamic characteristics of African art in the art of the black American. Yet, to force the iconography of African art on black artists would presuppose that their art is derived from art rather than from life itself. The black artist believes that the state of being black in America helps to create a unifying characteristic in his work that is based in the experiences of life instead of the systematic exploration of stylistic form.

The diversity of styles in this publication is unified by one factor, and it is this which further justifies bringing all of the works together in one book: all of the artists are black, living in America in the twentieth century, and feel the urge to be creative painters.

There is precedence for discussing contemporary black art in one of two ways: It can be looked upon as a separate form developed independently and distinctly apart from the larger context of twentieth-century American art or it can be looked upon as having derived its impetus directly from the study of American art. Neither of these points of view places contemporary art by black Americans in a proper perspective. It should not be denied that ethnic identification can play an important role in the making of artistic style. The Mexican muralists of this century have proven this point well. It is obvious that every aspect of an artist's background—his race, nationality, religion, family, and education—plays an important part in the formation of his art just as it helps in the shaping of his personality and

expectations in life. What one is and what he has experienced in life will help to shape the form of his art as much as it will determine his life-style.

Twentieth-century American art has been characterized by a general move away from academic realism and social concern to abstract and non-objective form. The same cannot be said of Afro-American art. While contemporary American art has become progressively more concerned with form to the exclusion of emotional or objective content, works created by black artists have generally emphasized content and are labeled by the critics as social realism. The emotional content of a painting results from the transformation of experiences into subject matter which becomes stable form. However, form can be created without emotional overtones being added. Such a tradition of painting devoid of content can be traced in this country. It is exemplified by the artist who paints in the tradition of the cubist and by the recent devotees of post-painterly abstractionism. This trend in America, art which comes from art rather than from life, can be seen in the works of some of the artists represented in this collection. The artists who follow this trend, however, are the exception rather than the rule in this regard.

The fact that most paintings by black artists do have emotional content is one aspect that forms an aesthetic bond linking them together. This shared characteristic helps unify the collection and shows that the significance of the black experience and all that it implies is the most likely explanation for the emotion which fills each canvas.

The whole argument of what black art is rests on the matter of the creation of black forms. Only those forms which by their very appearance are immediately identifiable as the products of the black artist clarify the symbolic meaning of black art. Hale Woodruff, respected black artist, historian, and critic, expressed the dilemma in this manner:

> If there is to be a Black Art, which is something made by a black artist, there must be certain outer manifestations so it can be identified as you can identify Oriental art or Pre-Columbian art or Eskimo art. I think the black artist is

faced with the problem of almost working from scratch. If he doesn't resort to the traditional sources that are available he has got to start from scratch. If he wants to produce a unique art form, he has got to ignore every other art form that has been used as a springboard. This is a tough job.[2]

There are qualities which define the American experience. Conflict and violence are notable among these. Naturally these qualities are reflective in the nation's art. The black experience is defined by these and by other special qualities unique to its suppression, struggle, passion, and soul force of revival and existence. These special qualities coupled with the artist's personal history and sensitivity to form are reflected in his paintings. There are works in this collection which illustrate this point. Lois Jones Pierre-Noël has been profoundly influenced by the surrounding tempo and the mood of Haiti. The voodoo motifs, bright colors, and lively spirit of her works are directly derived from an enchantment with that area. Other artists were deeply moved by a trip to Africa and have expressed an interest in the life and forms in African culture. John Biggers and Lucille Roberts are among these. Both artists have responded to the forms in African life which appealed to their stylistic interests. Lucille Roberts treats a traditional theme "Black Madonna" expressionistically, echoing a poetic rhythm of color and shapes that speak of the dynamics of semi-abstract form. There are times when an artist wishes to respond to what he calls "universal conditions" without localizing his art on the basis of his own race. In this case, style may be so personal as to discredit an ethnic label, but this does not destroy the relevant issues involved in the ultimate concern that the artist creates forms out of the depth of his personal experiences.

Charles White, one of the great voices among those black Americans who have for many years been the real interpreters of the Afro-American scene, in an interview appearing in the *Los Angeles Times*, said the following concerning his involvement with black imagery: ". . . I use Negro subject matter because Negroes are closest to me. But, I

am trying to express a universal feeling through them, a meaning for all men. . . . All my life, I have been painting a single painting. This does not mean that I am a man without anger . . . but what I pour into my work is a challenge of how beautiful life can be."[3]

Charles White's understanding of art goes beyond mere philosophy which takes into consideration man's benevolence or man's inhumanity to man. He is more concerned with the physical translation of form into spiritual matter which is meaningful to all who see it and to all who embrace the unity of life. Black life is closest to him, and he has responded warmly. It is in this sense that the artist's individuality comes forth when he shows his ability to create a physical embodiment of what is inside him.

This writer does not contend that all black artists have embraced a common ethos which is reflective of a unified symbolic form. But it is safe to say that some have attempted it. There are those who feel that a black ethos in art is one which binds the spirit and dictates a common style which stifles individuality. Some artists feel that they are able to personalize their content beyond recognition and toward a visual iconography unrelated to ethnic or racial characteristics.

Recognition of the dilemma faced by the black artist in his attempt to define himself in American society helps us to understand the problem of isolating black art from general American art. Since he has been the victim of discrimination in all aspects of life, the black artist is forced to make a choice or strike a balance between two modes of expression: Is he to be first an artist and secondly a black American; or is he to be a black American responsive in his painting to the injustices, hypocrisies, and indignities suffered by the black man as a second-class citizen? Each artist responds to this dilemma in his own way depending on his own personal concerns and goals. The choice to be made is related to the artist's ability to personalize his own work. If he feels compelled to remove it from socially oriented issues, he is at liberty to do so. If he feels that he best represents himself through the portrayal of a sociopolitical literal orientation, then the propaganda of his work is his response as well as his motive expression.

This confrontation with artistic choice seems particularly important to black artists in the United States who are in the midst of a cultural revolution. In a trend following the general pattern of the Negro Renaissance, there is a great interest among the black population proclaiming black values in issues which tend to establish a social aesthetic that relies heavily on propaganda. There are those artists from the black community who have personalized their work so that one is not so much concerned about the color of the creative hand as he is about the symbol which provides inspiration for the observer.

Jacob Lawrence is probably the best known of all living black artists. Lawrence has searched for an African-based inspiration in his art, and his systematic use of what Professor Porter refers to as the "Negro theme" points to the fact that some artists are able to commit themselves to a personal graphic style which contains symbols distinctly racial in character and at the same time embrace the broad problems of humanity. For this reason, his work, though literally filled with black subjects, transcends the boundaries of time and place and puts black subjects in the category of universals.

Lawrence is more concerned with creating visual records which touch upon our ancestral interests. He is equally concerned with black history and the vital symbols that can be extracted from it. Many of his paintings contain some of the visual symbols associated with man's protest against the intolerable conditions that he faces from day to day, but they also reflect a segment of reality which ties our lives to history in a meaningful way. He distinguishes himself as an artist who is highly sensitive to the conditions of life that all mankind faces. He, like many other artists represented here, weathered the experience of growing up in a large city where social injustices were heaped upon him without any explanation as to why. These things contributed to his life-style, which became a determining factor in the life of a black man who wanted to become an artist. Consequently, here is a man whose tough times have contributed to his own salvation.

Professor Porter commented recently on the programmatic stylism that social realism embodies when he talked about the possibility of the black artist returning to social realism as a means of translating those themes in his works that are necessarily black. It has been argued that Afro-American art, which has borne the label of social realism for a long period of time, has forced its own exclusion from shows which feature the most avant-garde methods in art. But all art that has been created by black artists has not fitted into the category of social realism. There are examples in this collection which present a concept of abstraction which is based in the contemporary feel for space and motion in a unique way. These works show the power of art in the universal sense.

There have been times when the black artist has been called upon to turn to Africa for those values which would stylistically cause his work to be set apart with a certain relevant meaning. After having been chosen the decided leader of the Negro Renaissance, Dr. Alain Locke wrote the following in an essay called *The African Legacy and the Negro Artist*:

The constructive lessons of African Art are among the soundest and most needed of art today. They offset with equal force, the banalities of sterile imitative classicism and superficialities of literal realism. They emphasize intellectually significant form, abstract the balanced design, formal simplicity, the strained dignity and unsentimental emotional appeal. Moreover, Africa's art creed is beauty in use, vitally rooted in the crafts and uncontaminated with the blight of the machine. Surely the liberating example of such art will be as marked an influence in the contemporary work of Negro artists as it has been in that of the leading modernists: Picasso, Modigliani, Matisse, Epstein, Lipchitz, Brancusi, and others too numerous to mention. Indeed we may expect even more of an influence because of the deeper and closer appeal of African art to the artist who feels an historical and racial bond between himself and it. For him, it should not function as a novel pattern of eccentricity or an exotic idiom for clever yet imitative adaptation. It should act with all the force of a sound folk art, as a challenging lesson of independent originality or as clues to the re-expression of a half-submerged race soul. African art, therefore, presents to the Negro artist in the New World a challenge to recapture this heritage of creative originality, and to carry it to distinctive new achievement in a vital, new and racially expressive art.[4]

Those artists who have directed their work toward themes which echo an African heritage are responding to the sounds of cultural history. Others have chosen to concern themselves with the job of painting in abstract and expressionistic styles. Each artist has attempted to express in his own way a basic identity with the peculiar experiences of his life within the American complex. Many artists have argued in the tradition of Dr. Alain Locke that a real and vital racialism in art is a sign of objectivity and independence. Aaron Douglas found within the black experience a form of racial identity which communicates the historical meaning of Africa in the new world and strengthens its evolutionary consequences for world history. He was able to give stylistic meaning to forms in his work that were derivative of the African posture. His famous murals painted for the New York Public Library in Harlem and for the Fisk University Library illustrate this point. It was through no stroke of luck that Douglas found himself involved in the execution of murals which tended to show the dignity of blackness as early as the 1920s. Instead, it was the genius of a bright young man who felt a close kinship to those neglected "primitive" forms which were still an obviously vital aspect of black life in America and particularly in the South. As a result of Douglas' keen sense of observation, a thorough knowledge of black history, and a steady hand of prophecy, a new way of seeing was opened up to black artists. The freshness of Douglas' approach to the question of a special black imagery substantiates the fact that an ethos is not a recent development.

The recent murals of the streets and the community wall projects show the desire by the black

masses to have a special form in the visual arts peculiar to their own life-style. It can be rightly argued that music has fulfilled this vacuum in the Afro-American scene by synthesizing indigenous African folk elements with the sophisticated sounds of black life in America. But art is not a medium which survives the physical presence of body and soul. It is generally done with media that do not rely on one's physical body.

The art of black America has been a varied conglomeration of many interests, schools of thought, and modes of expression. However, the activism of the new generation of artists prophesies the beginning of a "grass roots" art which may be embedded in the soil of discontent with social injustice and deprivation, and it also speaks of an oncoming sign that black people in America no longer accept the idea that they must look to whites to be the interpreters of a culture in which they have only participated as observers.

Whereas it may rightly be argued that all black artists have not responded to a unifying symbol that sets their work apart from any other kind of art, it must be admitted that these artists have consistently been aware of the possible consequences of an aesthetic which would define their position of being black artists in a white racist society. Throughout the years, many well-known black artists have found it politically expedient to bind together to form organizations of unity to assure their own survival in the art world. As late as 1962 a group called Spiral, made up of black artists, functioned in New York City. Art critics and historians would argue that the ideal for art in America is "good art" just as there is the ideal for American citizenship to be comprehensive and bring into the fold all minority groups on the same respectful level of participation in society. But the general public must be made aware of the fact that the black artist has not thrust the burden of the new aesthetics upon himself. He was forced to take action on his own to see to it that the survival of his own art took place. Langston Hughes, poet laureate of black America, spoke succinctly to the point when he said in "Note on Commercial Theatre":

> . . . But someday somebody'll stand up and talk about me and write about me—Black and beautiful—and sing about me and put on plays about me! I reckon it'll be me myself yes, it'll be me.[5]

Many artists have begun to "sing" of themselves. Many others will come later. But their forms may be as varied in style and content as those we see represented here.

NOTES

1 Larry Neal, "Any Day Now: Black Art and Black Liberation," *Ebony* (August 1969), 54–55. Used by permission of the author. [See pp. 153–59 in the present volume. —Eds.]

2 "The Black Artist in America: A Symposium," *Metropolitan Museum of Art Bulletin* (January 1969), 253–254. [The quoted passage takes some minor liberties with the original text. See pp. 125–26 in the present volume. —Eds.]

3 James A. Porter, "Charles White" (catalogue of the artist's works), The Art Gallery, Fisk University (1967), 9.

4 Alain L. Locke, "The African Legacy and the Negro Artist" (exhibition of works of Negro artists), the Harmon Foundation, New York (1931), 11–12.

5 Langston Hughes, "Note on Commercial Theatre," in *Selected Poems of Langston Hughes*, 4th ed. (New York: Alfred A. Knopf, 1968), 190. [In Driskell's quotation, there are some slight differences in punctuation and capitalization from the original. —Eds.]

Cover of **Junk Art: 66 Signs of Neon** (Los Angeles: 66 Signs of Neon, 1966), catalogue for *66 Signs of Neon*, with photography by Harry Drinkwater, design by Al Khanasa, and graphics by Debby Brewer

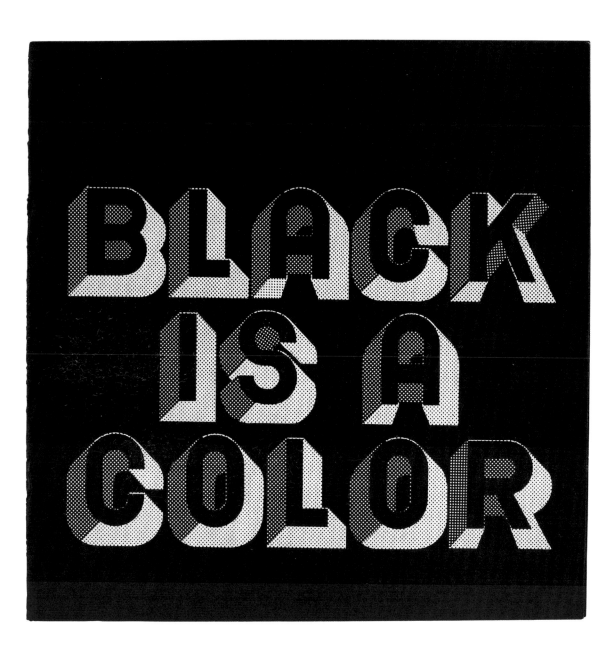

Cover of **Black Is a Color,** by Raymond Saunders (self-published, 1967), with design by E. Marc Treib

30

contemporary black artists

Cover of catalogue for **30 Contemporary Black Artists,** edited by Earl Roger Mandle (Minneapolis, MN: Minneapolis Institute of Arts, 1968)

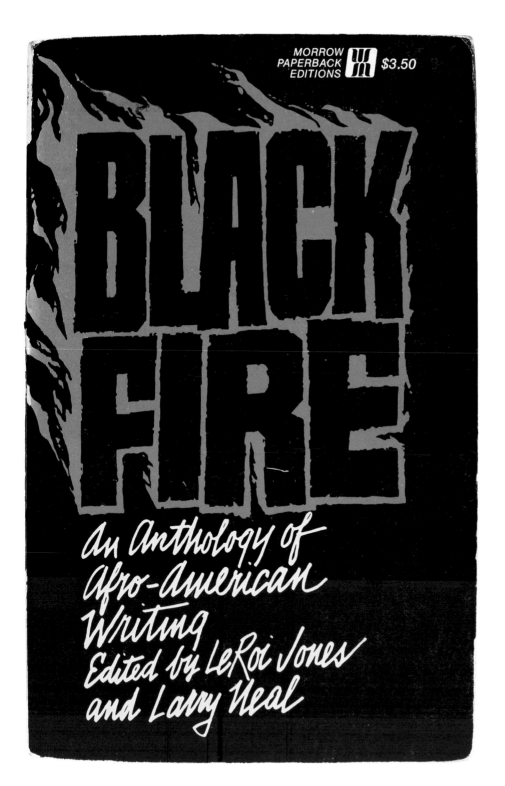

Cover of **Black Fire: An Anthology of Afro-American Writing,** edited by LeRoi Jones
[Amiri Baraka] and Larry Neal (New York: William Morrow, 1968)

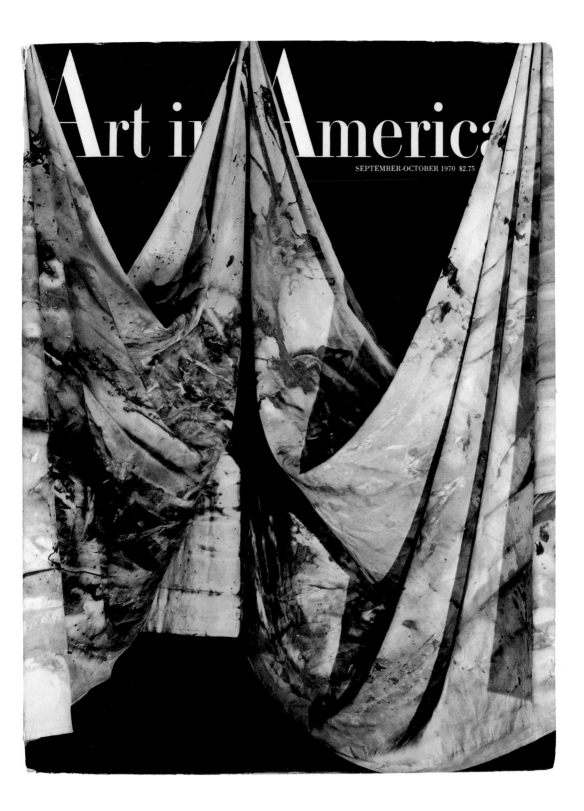

Cover of **Art in America** (September–October 1970), showing detail of Sam Gilliam's *Carousel Form II* (1969)

Cover of pamphlet for **5+1** (Stony Brook: Art Gallery of the State University of New York at Stony Brook, 1969)

Cover of catalogue for **Afro-American Artists: New York and Boston** (Boston: Museum of the National Center of Afro-American Artists; Museum of Fine Arts; School of the Museum of Fine Arts, 1970), with partial photograph by Rob Howard (cover unfolds to show a dab of black paint emerging from a tube of Rembrandt-brand oil color)

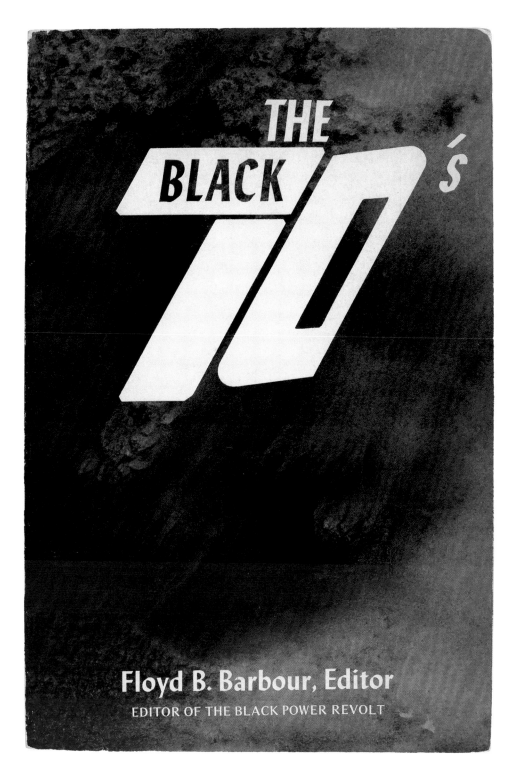

Cover of **The Black 70's,** edited by Floyd B. Barbour (Boston: Porter Sargent, 1970), with design by Raymond Parks

Three Graphic Artists

Charles White

David Hammons

Timothy Washington

Cover of catalogue for ***Three Graphic Artists: Charles White, David Hammons, Timothy Washington,*** by Joseph E. Young (Los Angeles: Los Angeles County Museum of Art, 1971)

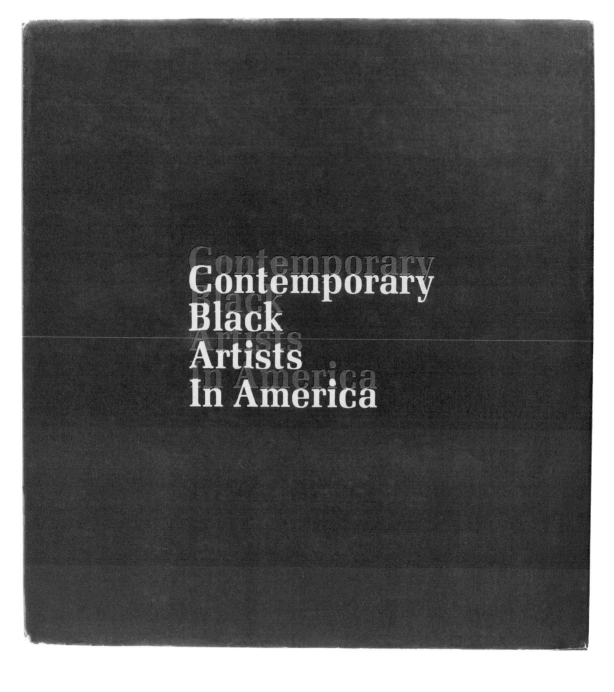

Cover of catalogue for **Contemporary Black Artists in America** (New York: Whitney Museum of American Art, 1971), with design by Joseph Bourke Del Valle

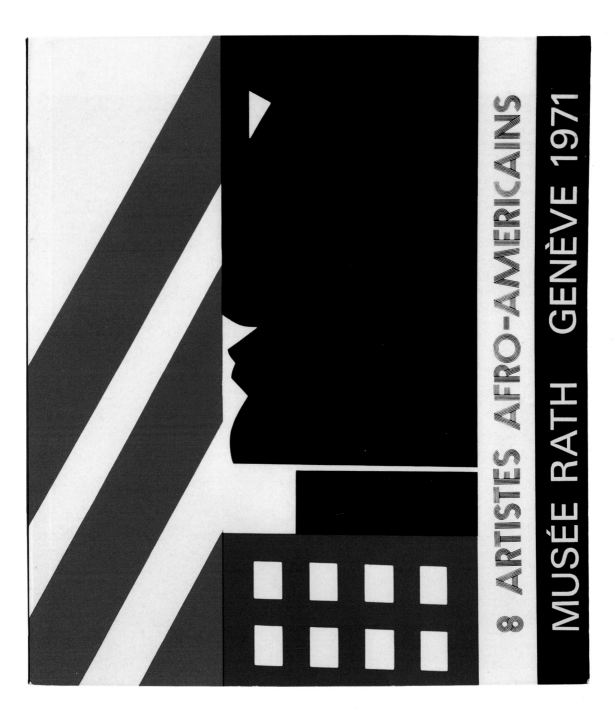

Cover of catalogue for **8 artistes afro-américains** (Geneva: Musée Rath, 1971), with illustration by Romare Bearden and design by Andréa Marquez

the de luxe show

Cover of catalogue for ***The De Luxe Show*** (Houston, TX: The Menil Foundation, 1971), with design by Penny Johnson

Cover of catalogue for ***AFRICOBRA II*** (New York: The Studio Museum in Harlem, 1971), showing detail of Wadsworth A. Jarrell's *Revolutionary (Angela Davis)* (1971)

A JOURNAL OF AFFAIRS OF BLACK ARTISTS

**Where has the Black Artist in America
been all this time?
He's been in the streets in Watts,
in Roxbury and Chicago.
He's been in his body. In hard times.
He's been in the eyes of people who love him
and in the eyes of people who hate him.
And he's been putting it all down.
On canvas. In stone. Out of wood.
Affairs of Black Artists
a new journal devoted to the life
and times of Black Artists, takes a good look
at where the Black Artist in America has been,
where he is, and where he's going.
It's beautiful. It's enlightening.
It's about time.**

Cover of ***ABA: A Journal of Affairs of Black Artists*** (1971), with statement by the journal's editors

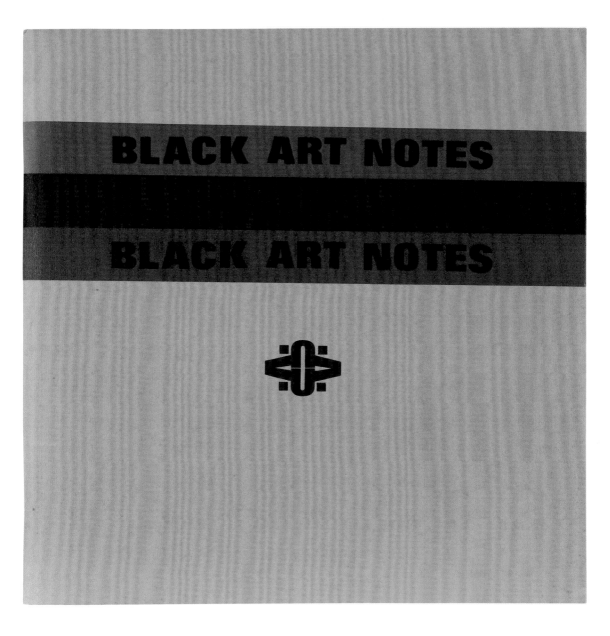

Cover of **Black Art Notes,** edited by Tom Lloyd (self-published, 1971)

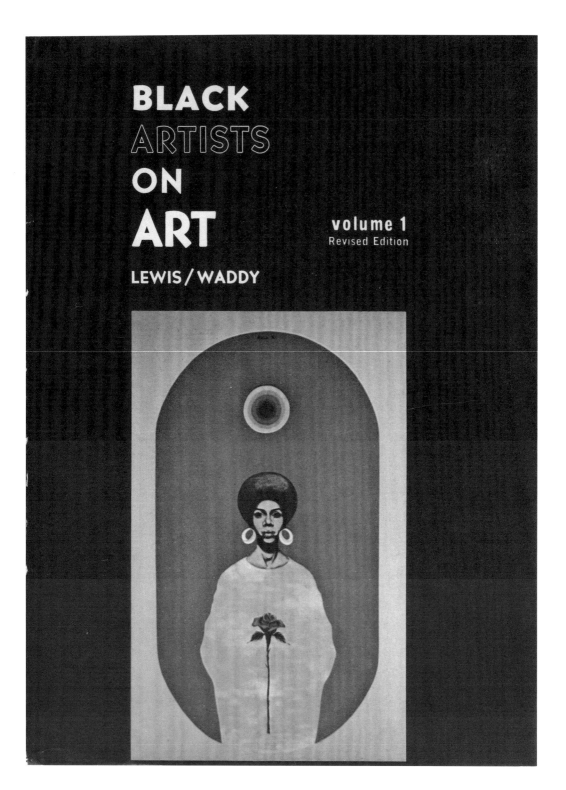

Cover of **Black Artists on Art, Volume 1,** edited by Samella S. Lewis and Ruth G. Waddy (Los Angeles: Contemporary Crafts, 1971; rev. ed., 1976), showing Phillip Lindsay Mason's *Woman as Body Spirit* (1969)

Cover of catalogue for **AFRI-COBRA III** (Amherst, MA: University Art Gallery, University of Massachusetts at Amherst, 1973), showing members of AfriCOBRA, summer 1970

Cover of catalogue for **Blacks: USA: 1973** (New York: New York Cultural Center; Madison, NJ: Fairleigh Dickinson University, 1973), showing Raymond Saunders's *Jack Johnson* (1971)

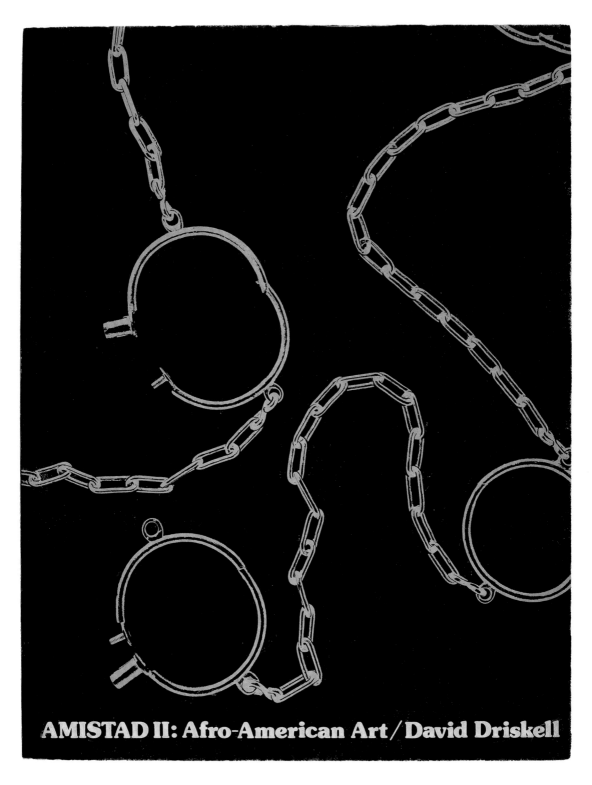

AMISTAD II: Afro-American Art / David Driskell

Cover of catalogue for ***Amistad II: Afro-American Art,*** edited by David C. Driskell (Nashville, TN: Department of Art, Fisk University, 1975), showing image of 18th-century iron shackles in Fisk University's collection

Cover of **Contextures**, by Linda Goode Bryant and Marcy S. Philips (New York: Just Above Midtown, 1978), showing Senga Nengudi's *Study for "Mesh Mirage"* (1977)

Charles Childs, "Larry Ocean Swims the Nile, Mississippi and Other Rivers," in Larry Rivers, *Some American History*, catalogue for exhibition held at the Institute for the Arts, Rice University, Houston, Texas, February 1–April 30, 1971

Dominique and John de Menil, important patrons of the arts in Houston, commissioned an installation from the New York–based artist Larry Rivers that Rivers then developed into a comprehensive exhibition, inviting Ellsworth Ausby, Peter Bradley, Frank Bowling, Daniel LaRue Johnson, Joe Overstreet, and William T. Williams to contribute work. *Some American History* examined the history of slavery in the United States and its impact on contemporary Black life. Rivers was already known for his paintings exploring African American history, but his position as a White artist at the center of this project was considered problematic by critics and audiences alike. Charles Childs defends Rivers in this text. Despite Rivers's intentions, the other artists in the show were dissatisfied with their treatment, and the ensuing negative reception convinced the de Menils to organize a follow-up exhibition. *The De Luxe Show* opened six months later (see pp. 366–72).

CHARLES CHILDS, "LARRY OCEAN SWIMS THE NILE, MISSISSIPPI AND OTHER RIVERS"

In the turbulent dialectic of black peoples' drive to assign their own cultural identity, the idea of having a white artist comment on black subject matter, on first glance, seems unacceptable.

Yet, one of the most famous artists of this generation, Larry Rivers, has pursued just this sort of endeavor and questions as to his intent and motivation say more about the "hang ups" in all of us than they do about just what, precisely, Larry Rivers is up to.

Basically separatist in its challenge, the whole idea of race purity and more qualified knowledge is just one more entrapment out of which the limitlessness of art will once again have to escape.

Nevertheless, the arrogance of artistic freedom, to someone who has yet to achieve equality, may be what prompted one black critic to hurl the slur "Great White Father Larry Ocean" at Rivers in an article that raised, as a result of its undiscerning narrowness, serious questions about "cultural privacy" and the new rule of "Apartheid" that says only blacks can interpret blackness.[1]

That such ideas are understandable in view of the inaccurate projection of black identity in American history is obvious. Still, the arbitrary nature of ignorance so characteristic of white oppression, turned back on whites, in no way can be interpreted as black perception or intelligence, much less black pride.

On the contrary, throughout all the levels of black life in America, despite the rhetoric of "nationhood" and "self-determination," much to the credit and subtlety of black understanding, there have been certain exceptional whites who have been accepted. These whites, some of whom have walked in the footprints of John Brown, who have died beside black brothers in the struggle for human dignity, find acceptance not out of a feeling that they are "special" but rather out of an awareness that distinguishes individuals on merit and the deeper knowledge that sympathetic and constructive work by whites, ready to correct the record and reveal the truth about history, can complement black aspirations.

All this, of course, brings us to the case in point: Larry Rivers, a sort of peg in a square hole, who is neither as lily white, say, as Norman Rockwell nor as wasp-like as Andrew Wyeth . . . but who really in full measure has his own thing going for him.

Curiously enough, being neither lily white nor lamp black, but between two worlds, is the merit of Larry Rivers. In a certain way, it means he can be anything, assimilate anything. Consequently, if his curiosity about the energy and vitality of another culture has made him a trespasser, it is because he sees racial boundaries as essentially contrived and ultimately untenable and, being true to his unbridled spirit, he wants to leap over walls, especially those that separate men from each other.

Actually, Rivers, who in 1967 traveled 10,000 miles throughout Africa, is a seasoned traveler, not a first time-tourist; and now his exhibition *Some American History*, with all its concentration on the one theme of race, is really only one of a series of glimpses into black experience that Rivers has taken over the years that span, incredibly enough, nearly a quarter of a century of art production.

Take for example a painting commissioned by the Container Corporation of America in 1964. Here, Rivers ventured into the black world with courage and candor. Juxtaposing a black woman against the idealized image of the *Ebony* magazine skin-lightened example, Rivers, in his *The Identification Manual*, took on the ghastly and incriminating subject of false beauty standards as imposed by a self-denigrating black mass media magazine. Shocking and revealing in its directness, *The Identification Manual*, coming at a time when "black is beautiful" had not surfaced, was forcefully remarkable in both its perception and accuracy.

Here in this early show of brilliance, Rivers goes beyond identification with blacks on a compassionate and liberal level. Instead, he enters the alien world with an integrity that gets to the "nitty grit" of an issue where the truth can sometimes be as embarrassing and as penetrating as an unbridled fart, blurted out into the open.

Historically, other white artists trespassing the boundaries of black life through art have not been as accurate.

[*Here, Childs discusses aspects of the work of Harriet Beecher Stowe, Mark Twain, George Bellows, Winslow Homer, and others.*]

In tackling the vastness of black life and history in this tradition, Larry Rivers brings to the subject his unique proximity to the black community, and his tendency to draw on this "intimacy" to make art of his own life.

"Black life to me is a whole spectrum of people I've met and come to know at various times," Rivers admits. "It is a perception of race and culture with as many variables and dimensions as people are variable. Because of some of these people, I think I've become sensitized, enriched and broadened. After all," Rivers continues, "more than being an artist, I am a political man. I am affected by what other men do and say and think and what I have produced as an artist is my relationship to other men which points out our differences and our similarities."

Consequently, Rivers, always social, never closes himself off from new contacts and new experiences. His life is the happening of a dozen or more important chance occurrences that would not have flowered had he not been open to assimilation.

[*Here, Childs discusses Rivers's interest in jazz.*]

It was really this appetite for another culture that lured him beyond the confines of his middle class Bronx, New York Jewish family.

A roustabout hipster, Rivers gravitated to the opposite of "square" Bar-Mitzvah-type upbringing, not out of disrespect for his own Jewishness, but, here again, because of his insatiable curiosity concerning the world around him. Like the white prototype of Norman Mailer's "white-negro," Rivers paid his acculturation clues in all night rent parties in Harlem and got his first short-sighted impressions of black life through intimate associations with pimps, street hustlers and one special whore who took him home to meet her family.

But there were other more devastating, less romanticized insights into the inequities that exist for those who are black in America.

"My father had this business," Rivers remembers, "he had black guys working for him and one day it suddenly hit me that he was paying them peanuts. When he would meet any of the men on the street, I noticed that he would act kind of slap happy, in a way that he wasn't prior to that moment . . . you know, like they were children. Once all hell broke loose because my sister brought this black guy home. My mother made a fuss and it struck me as the biggest contradiction in the world that a Jewish lady should make a fuss, since that was precisely the kind of shit we put Hitler down for."

These are the sort of contradictions against which Larry Rivers has used his art. His frankness has always verged on the edge of rebellion, simply because he hates hypocrisy.

[*Here, Childs discusses the controversies surrounding some of Rivers's earlier works.*]

Larry Rivers is constantly being accused of not taking art seriously, of being capricious. His tendency to unvarnish and disembody hallowed images is more a part of his inheritance than he is willing to admit. A significant remnant of his Jewishness, this tendency toward wit and humor in his work is a particular view of reality that has historical roots in the treadmill and banana peel of minority group status. In Jewish wit, it is the ability to be uncompromising, to laugh at oneself sympathetically, through the pathos of the "meshuggana" and the "schlemiel," in much the same way as Langston Hughes' character "Simple" analyzes the futility and irony that come from carrying an oppressor's burden.

In *Some American History*, however, Rivers was careful not to give the wide range of his comic tendency irresponsible freedom. "You can make fun about something which is already established, an institution or a fact in past history," Rivers acknowledged, "but here with this exhibition, I had to take into account that black history is still being made, and rather than evaluate that history, I wanted to simply reveal some of the conditions out of which it is still evolving."

Such an ambitious notion seemed overwhelming to Rivers at the outset. He knew he wanted to set out on a journey into blackness, but it was territory he had only partially charted. For this reason, he was not averse to accepting instruction. Unlike

the questionable exhibit *Harlem On My Mind*, with its Cotton Club title, presented in 1969 at New York's Metropolitan Museum of Art over the protest of blacks who wanted some say in the exhibition's production, Rivers sought and received help and contributions from black artists.

True to his tradition that subjectifies and personalizes everything, Rivers ignored the more established black artists, collaborating only with "cats," as he calls them, who were friends and whose work he knew and admired. "My decisions and choices come out of a combination of laziness, social contacts, accidents and what I'm impressed by," he admits. "I knew this girl who worked at the Schomburg Collection in Harlem. Together we went to bookshops, gathering a lot of material on black history. As I digested this material, I tested my knowledge with people like Frank Bowling and other black friends and acquaintances."

It was through Frank Bowling, a black painter who is actually a Guyanese by nationality, that Larry Rivers eventually made contact with several other black artists. "When I told them I was going to do a show on black subject matter," Rivers recalls, "they looked at me as if I was a nut. So, I said, why not contribute something . . . a painting, a sculpture, anything; and they said, what are you some kind of hip overseer? I said no, that I didn't think you had to be a chicken to talk about an egg, but that I was acknowledging their special expertise. Ya know, how they were chickens." In this casual manner, six black painters, Daniel Johnson, Peter Bradley, William Williams, Frank Bowling, Joe Overstreet and Ellsworth Ausby, made up the collective that would later produce *Some American History*. "An exhibition which could be seen as one piece composed of a lot of pieces," Rivers theorized. The consequences of this inclusion of black artists into *Some American History* is the obvious extension of group seeing over individual perception. Where Rivers falls short as the result of being "Ofay," and this is seldom, others in the exhibition bring the concerns of artistic expression to the wellsprings of innermost black feeling.

Actually, the idea for the exhibition, being the overriding vision of Larry Rivers himself by way of a commission, is unprecedented. No artist with a similar commission has ever opened it up to include the works of other artists. But Rivers, true to his lifestyle, often a gobbledygook of disjointed fragments, cannot resist expanding experience, much less extending invitations.

In contrast to today's minimal abstractionists with their rather severe structural fastidiousness, Rivers debunks the whole notion that more is less; instead, he favors the very human idea that more is more. Anybody, anything and anyone can get into the act. In fact, as writer Bob Reisner claims, even common everyday doodles such as graffiti, a form of underground communication between anonymous man and his world, can also make sort of off the wall contributions.

Borrowing this idea, Rivers incorporated wall writing into his 1964 set for the Imamu Baraka (LeRoi Jones) one-act play *The Toilet*. It is a leitmotif carried over into much of his work and there are few of his paintings that do not have some of this inclination to scribble and write over the surfaces of them. In *Some American History*, Rivers graphically illustrates this sense of anonymous communication through the words "Du Bois Died In Ghana," hand scrawled as if by a revolutionary.

The inspiration for this is a direct lift from the kind of revolutionary wall writing seen in New York subways. In its secrecy, this slogan "Du Bois Died In Ghana" provides just the right underground voice feeling for the ironic, almost subversive message that a great black American chose to live outside America, rather than in it.

Techniques such as these, the use of everyday folklore and public language of the street, the symbols and signs in store windows, on automobiles and photographs, all and everything typical of an urban environment, have put Rivers one step ahead of the pop generation.

This characteristic to incorporate still holds true for Rivers as he explains how *Some American History* took shape, "from a series of spontaneous interactions with endless troops of friends and associates."

Such incorporation of "friendly ideas" can be seen in one of the most important set pieces of the *Some American History* exhibit, *Lynching*.

"The idea was a blockbuster," Rivers remembers. "It grew out of a SNCC picture I had seen showing a lynching and a lot of white guys standing around smiling. At first I wanted to reproduce that situation. So, I chose to work in 3-dimension rather than canvas to make the event come alive. I made plywood figures and strung them up in my studio. James Haskins, the black writer who wrote *Diary of a Harlem Schoolteacher*, stopped by and looked behind each of the figures. He said, 'Oh, I thought there would be a white chick on the reverse side.' I took this to mean the idea was incomplete without the chick, so I put her on the floor underneath the figures, to emphasize the sexual inference under the issue of race in this country."

This capacity to go beyond completeness, to state precisely what art exhibitions normally don't state, is perhaps the most significant byproduct of *Some American History*.

Here are the hidden ideas that blacks feel and whites know, but that racism in America dictates should never be mentioned, out in the open; as they are in the work, *New Jemima*, by Joe Overstreet.

Overstreet, who normally paints in a non-figurative genre nevertheless departs from his usual style in a work which borrows the benevolent figure of Aunt Jemima from the familiar box of pancake flour. Flipflopping this image, Overstreet gives us a new and more volatile Aunt Jemima. "How many older black women must have resented this image," Overstreet explains. "How many had to play that role just to sneak home some food for their children? I wanted to say that now those children are grown, and that the old image of Aunt Jemima, unless things change drastically, can erupt into a whole new personality."

Shattering stereotypes in a similar manner, artist Danny Johnson departs from his normally abstract sculpture making to vent his response through the total realism of his large work, *Over Here, Over There*.

"This is a work," Johnson says, "that speaks for itself. It shows how black women in history have nursed white children, and how now you have only to look around to see white girls nursing black children. It says if you want some milk and you're a baby, you can go over there and get some and you can go over here and get some, which is just another way of saying that the lines dividing people are just a lot of bull."

While artists William Williams and Peter Bradley keep to less literal and more abstract responses to the theme of the exhibition, most of the artists contributing can be said to align with the tendency of the exhibit to pull away from abstraction.

By implication, this would seem to suggest that the communication of theme material may have something to do with method, especially when it comes to handling subject matter fraught with socio-political overtones.

Still, despite the usual fear that accompanies socially reflective art and the stigma (no less than racist) that has been particularly acute for black artists, one which accuses them of being sociologists if they paint black subject matter and not "savage" enough if they adopt white mannerisms, the attempt to resolve statement and estheticism in *Some American History* has been achieved.

Accomplishments along these lines can be seen in the work of Frank Bowling, the Guyanese artist whose large work, *The Middle Passage*, combines the map forms of Africa, America and Guyana into an autobiographical frame, where stenciled iconographs seem to haunt the work like ghosts.

Strongly disciplined by intellectualized beliefs, Bowling feels that painting must always be primarily art before it is statement. "I named the painting *Middle Passage*," he said, "because I am a product of the middle passage. But what is significant is the fact that I do not bring my images together because of the history and brutality of that terrible crossing, but rather in spite of it."

Equally grudging on this issue of keeping art out of the earthbound dungeons of cold, topical journalism is the characteristic, unprogrammatic way Larry Rivers approaches a subject. Inspired directly by what visually excites him, Rivers improvises out of a variety of materials that span a range from painting to makeshift carpentry.

Stoop, for instance, a 3-dimensional work originally conceived as a piece that might depict the squalor of a ghetto environment, turns out to

be more monumental than it is seamy. Constructed of wood and having the ambiance of an Egyptian sphinx, *Stoop* is the embodiment of Rivers' appetite for flourish on a grand scale; the kind of sweeping grandeur he gives to another wood constructed work, *Slave Ship.*

Magnificently appointed with its large expanse of sail and languorous jigsaw fashioned waves, *Slave Ship* has none of the chilling grimness, the iron shackles and wall-to-wall crowding one usually associates with the Atlantic crossing: here, Rivers, true to his artistic instincts, cannot help but transmute a truth, especially one which is not beautiful, into an art that is.

But where Rivers misrepresents history for the sake of art, he vindicates himself by spotlighting history on its own raw terms. This, Rivers accounts for with his numerous and authentic "documentary notes" spotted throughout the exhibition; some in the form of prints and writings that in their unadulterated presence bear witness to the past.

One such work, which can be said to have been raised to the status of art, just by dint of being rescued from oblivion, is an old print entitled *Returning Burns.*

Poignant in its literal translation of a real event out of history, *Returning Burns* tells of the ordeal of a runaway slave: "On Friday, when Burns was sentenced to return to slavery twenty-two military units including the entire Fifth Regiment of Artillery, were assembled in Boston to see that Burns did not escape and a cannon was set up in front of the courthouse. Beside the police of Boston, 1,500 dragoons, marines and lancers, with Burns in their midst, marched to the dockside through streets lined by a crowd of 50,000 persons hissing and crying, 'Shame!'"

These then are a few of the themes and people who make up *Some American History*, an exhibition conceived by Larry Rivers as a forum for visual communication where, finally, in these times of confusion and racial mistrust, art and political man are both commented upon and reconciled.

NOTE

1 [The critic in question was Walter Jones, in his article "Critique to Black Artists," published in *Arts Magazine* in April 1970. See p. 206–9 in the present volume. —Eds.]

1971

Eugene Eda, Mark Rogovin, William Walker, and John Weber, "The Artists' Statement," and William Walker, untitled statement, distributed at *Murals for the People*, exhibition held at the Museum of Contemporary Art Chicago, February 13–March 13, 1971

For this experimental exhibition, the Museum of Contemporary Art Chicago (MCA) turned its basement galleries into a workshop where the public could observe Eugene Eda, Mark Rogovin, William Walker, and John Weber making wall-sized murals, later to be displayed in various Chicago neighborhoods. Since the creation of the *Wall of Respect* in 1967 (see pp. 72–75), more than thirty murals had been painted across the city. Walker, the chief strategist for the MCA project, had previously collaborated with Eda on three mural projects in Detroit and had also recently cofounded the Chicago Mural Group (later renamed Chicago Public Art Group). Aware of the growing importance of this burgeoning movement, the MCA approached the artists in November 1970 with the idea of bringing their public-art practice into the museum. The artists negotiated with the MCA to ensure that members of the communities where the murals were to be installed would receive free passes to the museum. They also secured a guarantee that the murals would not be censored. Still ambivalent about their institutional ties, however, the artists held a press conference after the exhibition's opening at which they released a manifesto reasserting their commitment to producing socially relevant art for the streets of Chicago.

EUGENE EDA, MARK ROGOVIN, WILLIAM WALKER, AND JOHN WEBER, "THE ARTISTS' STATEMENT"

The movement to create Peoples' Art on public walls in Chicago began in 1967 with the inspiration for the *Wall of Respect* at 43rd and Langley Streets. This wall was initiated and supported through the cooperation of OBAC, a group of Black artists, and the 43rd Street Community Organization, working closely with the people in the community. This wall, like others that have followed, has been celebrated, loved, and protected by community residents because they had a part in it.

Although Black artists gave leadership to the Mural Movement, a small but growing number of Latin, Chicano, and white artists have followed their example. Since 1967, over thirty murals have been painted in Chicago neighborhoods, bringing Peoples' Art to the people of these communities.

This past summer, for the first time, grants from federal, state, and local foundations have made it possible for muralists to work on a larger scale. With the increasing press coverage, we came to the attention of Joseph R. Shapiro, President of the Museum of Contemporary Art. In November of 1970, he approached us with an idea for an exhibition at the Museum. We have been commissioned to paint portable-panel murals—the lower gallery of the Museum will be our studio—which will be donated to these places of our choice on completion: Eugene Eda, Olivet Presbyterian Church; Mark Rogovin, National Angela Davis Defense Committee; William Walker, South Side Community Art Center; John Weber, Pedro Albizu Campos Center for the People's Health.

Since this exhibition will be one of the first such Museum exhibits devoted to mural painting in a decade, it will hopefully give more exposure to the Mural Movement, aid in opening new sources of support for future projects, give us a welcome chance to create new murals for Chicago, and perhaps lead Museum patrons and visitors to seek out various murals in neighborhoods where they have been created.

Our former projects are located on streets in working-class communities—our patrons, critics, and new art-lovers are those living in the neighborhoods surrounding these mural sites. We work with the support of local community groups, and are aided by the community residents. They have never asked for our credentials or the prestige of a "name." They demand only that the artist bring respect, commitment, and vision to his work. Ultimately, it is the community residents and passers-by who most greatly appreciate the involvement of the artist. Unless one is actually witness to the enthusiasm, curiosity, and serious discussions of these newly involved art-lovers, one does not realize the vitality and the potential of the mural as a public art form.

We are dedicated to becoming artists for the people, entering into a living relationship with this vast audience, drawing on the peoples' boundless potential for creativity. In the words of Bill Walker, "Artist-to-people communication is the kind of relationship that would place the artist and his art in a position of respect, pride, and dignity, all of which the artist should have. These views are not based on the feelings of an idealist, hoping for something that cannot be or believing in something that he has never experienced; they are founded on the grounds of knowing from experience, of talking with people in a community during the time that the art project is in progress, of discussing the conditions of their problems and the world, and of realizing how art can become more relevant to the people of the world. During the course of these experiences, the artist is seen in a different light. The people no longer view the artist as being a 'buffoon freak of the ages. . . .' This new position that the artist can now feel gives him the dignity which will allow him to paint the truth with integrity, showing man what he has become—his inhumane ways, his inhumanity to his fellow brethren, his inability to be sensitive to others' feelings, and his tremendously developing skill in refining more devastating weapons with which to render himself into nothingness. Art is also seen as a force designed to dethrone ignorance from its pedestal of influence in the affairs of

man. . . . People are now realizing that public art is essential because it is relevant to each of them. . . . Art is a universal language. . . ."

We have joined together through necessity that demands that all creative forces work together for the benefit of men and women in struggle. We hope to end the boycott that keeps mention of the Mexican muralists and the Public Art Movement of the 1930's in the United States out of textbooks and lectures in art schools throughout the country. We want museums to go out into the communities, to truly be schools for the people. We want the walls of Chicago to be art galleries for the people. We are anxious to encourage more artists in all fields to "take to the streets," to become involved, and to work for the people. Our murals will continue to speak of the liberation struggles of Black and Third-World peoples; they will record history, speak of today, and project toward the future. They will speak of an end to war, racism, and repression, of love, of beauty and of life. We want to restore an image of full humanity to the people, to place art into its true context—into life. The new Mural Movement is not limited to Chicago, it is international. In the United States in recent years, murals have been created in virtually every large city, as well as in some smaller cities. Several different approaches are being tried, as well as many individual styles. We welcome this rich variety of experimentation. We would, nonetheless, like to cite *Sun-Times* art critic Harold Haydon's warning, ". . . Genuine people's wall painting, with its artist-to-people communication, could be neglected in the current move to decorate the city. It's easier and safer to sponsor exercises in abstract form and color. But this is a time when communication is important. . . ."

WILLIAM WALKER

After spending my youth in Birmingham, Alabama, and serving in the Air Force, I enrolled in the Columbus Gallery of Fine Arts. While there, I benefited greatly from the excellent teachings of Emerson Burkhart, Joseph Canzani, Samella Lewis, and Edmund Kuehn. During my studies

there, I was fortunate enough to be awarded the Earl C. Derby Award for Figure Portraits. The title of my work was *Neglect*. My first painting projects were in Memphis and Nashville, Tennessee. It was in Memphis that I first became aware of the fact that Black people had no appreciation for art or artists—they were too busy just struggling to survive. I then decided that a Black artist must dedicate his work to his people. At the same time, he must retain his relevance and integrity as an artist. In questioning myself as to how I could best give my art to Black people, I came to the realization that art must belong to ALL people. That is when I first began to think of public art. In 1967, I met with a group of Black artists, OBAC, and found their philosophies much in tune with mine. From this meeting came the inspiration for the *Wall of Respect* at 43rd and Langley Streets. The project included twenty-one participants, and was sponsored by OBAC and the 43rd Street Community Organization. In 1968, the *Wall of Dignity* in Detroit was completed by Eugene Eda, Elliott Hunter, Edward Christmas, and myself. We also worked with various Detroit artists on the *Wall of Pride* at Grace Episcopal Church. In 1969, I worked again with Eda on the *Harriet Tubman Memorial Wall* at St. Bernard's Church in Detroit, and later that year we completed the *Wall of Truth* in Chicago.

Through Margaret Burroughs of Chicago's DuSable Museum, I met John Weber. From this meeting came the *Peace and Salvation Wall of Understanding* at Locust and Orleans Streets near the Cabrini-Green Housing Projects. This wall was dedicated to the people on October 31, 1970. My current work, the *Wall of Love*, which is being painted at the Museum of Contemporary Art, will be permanently located at the South Side Art Center, 3831 South Michigan Avenue. The artist-to-people communication is the kind of relationship that would place the artist and his art in a position of respect, pride, and dignity, all of which the artist should have. These views are not based on the feelings of an idealist hoping for something that cannot be or believing in something that he has never experienced, they are founded on the grounds of knowing

from experience, of talking with people in a community during the time that the art project is in progress, of discussing the conditions of their problems and the world, and of realizing how art can become more relevant to the people of the world. During the course of these experiences, the artist is seen in a different light. The people no longer view the artist as being a "buffoon freak of the ages," as he has often been described in the past, nor do they see him as having no more talent than the scribblings of a pre-school child. Hence, the artist no longer fits into his old degrading stereotyped "world's worst!" image. This new position that the artist can now feel gives him the dignity that will allow him to paint the truth with integrity, showing man what he has become—his inhumane ways, his inhumanity to his fellow brethren, his inability to be sensitive to others' feelings, and his tremendously developing skill in refining more devastating weapons to render himself into nothingness.

Art is also seen as a force designed to dethrone ignorance from its pedestal of influence in the affairs of man. These barbaric, irrational forces, born in ignorance, create a state of terror that is a luxury which no man can afford, People are now realizing that public art is essential because it is relevant to each of them. Art is a universal language, destroying the barriers that stand so firm before man. The artist and his art are warning man of the dangers ahead. If man fails to understand this, total destruction may surely come. And so, remembering the timely words of *Sun-Times* art critic Harold Haydon, ". . . artist-to-people communication could be neglected in the current move to decorate the city. It is easier and safer to sponsor exercises in abstract form and color. But this is a time when communication is important. Accordingly, the agencies commissioning wall paintings would be wise to plan on more of these meaningful murals. . . ." I plan to devote my future to bringing forceful, relevant art to ALL people.

1971

Keith Morrison, *Black Experience*, pamphlet for exhibition held at the Bergman Gallery, University of Chicago, February 16–March 20, 1971

Keith Morrison studied at the School of the Art Institute of Chicago in the early 1960s, receiving an MFA in 1965. During his tenure as chairman of the art department at DePaul University, Morrison curated this exhibition for the University of Chicago. He intended to convey the breadth and diversity of works by Black artists, rejecting claims of "a common 'Black style.'" In his text, Morrison also notes the necessity of staging such a show on account of Black artists' lack of visibility in most exhibition programming. *Black Experience* included paintings, sculptures, prints, and posters by Ralph Arnold, Ausbra Ford, Barbara Jones-Hogu, Geraldine McCullough, Bert Phillips, and Nelson Stevens, all of whom taught art at colleges in and around Chicago.

KEITH MORRISON, *BLACK EXPERIENCE*

Black Experience brings together Afro-American artists of diverse approaches to art. These artists live and work in the Chicago area. They share a common ethnic heritage & as a result their visions span a range of experience common to Afro-Americans. Each artist creates a range of work that results from individual personality, temperament and philosophic disposition to a consciousness of being Black in America. It is the personality & temperament of each artist that is the source of that artist's uniqueness and originality. It is from a common vantage of Black awareness that a Black artist creates a personal philosophy. This common vantage of Black awareness is the "Black Experience." Yet Black experience is not necessarily distinct or recognizable in art by Black artists; for Black experience is an activity: an argument that each Black person, each Black artist must wrestle within his private being, to discover for himself a meaning to life & art. This exhibition includes painting, sculpture, prints, & posters. Paintings are by Bert Phillips & Nelson Stevens. The prints are by Ralph Arnold & Barbara Jones and Geraldine McCullough & Ausbra Ford have contributed sculpture. Jones and Stevens show a second dimension of their work by including posters. The poster is an attempt by some Chicago Black Artists (including members of Afro-Cobra, such as Jones & Stevens) to create ethnically meaningful imagery of Black experiences in America.

Black Experience has been designed not to show similarity, but divergency of Black artists. The philosophy behind this divergency is that there is no such thing as a common "Black style." Neither is this exhibition considered necessarily a "representative" show of Black artists. There are many Black artists in Chicago. If the gallery were larger this exhibition could easily include many other artists. This exhibition (which was by invitation to the artists, who kindly accepted) attempts only to be reasonably typical. This exhibition is of Black artists because it is recognized that the overwhelming number of exhibitions exclude Black artists. The irony of this fact is that exclusion of the Black artist is a greater loss to the public than to the Black artists themselves, who will be artists whether or not a non-black audience is fortunate enough—or educated enough—to see their art.

1971

Carroll Greene, "Romare Bearden: The Prevalence of Ritual," in *Romare Bearden: The Prevalence of Ritual*, catalogue for exhibition held at the Museum of Modern Art, New York, March 25–June 7, 1971

Romare Bearden: The Prevalence of Ritual opened at the Museum of Modern Art in March 1971. Fifty-six works by Bearden were displayed, including collages dating to the 1960s and an eighteen-foot collage-mural that was being shown for the first time. The staging of the exhibition was one institutional response to the agenda set out by the Art Workers' Coalition (AWC), a loosely organized group of artists, writers, and museum staff established in 1969 to advocate for artists' rights and demand that New York City's museums improve their relationship with artists and the public, partly through a more inclusive exhibition policy. Specifically, the AWC appealed for more shows to be devoted to women and minority artists. In the catalogue, the guest curator, Carroll Greene Jr., comments on Bearden's allusions to American cultural touchstones such as jazz, church outings, and card-playing nights as well as to the forms of African sculpture. The exhibition was the artist's first major retrospective and traveled to four other museums.

CARROLL GREENE, "ROMARE BEARDEN: THE PREVALENCE OF RITUAL"

The Prevalence of Ritual marks the mature fruition of a theme that has obsessed Romare Bearden for over thirty years—the aesthetic expression of the life and lifestyle of a people in visual and plastic language. In the collages of this show, dating from 1964 to 1971, he develops the theme that engaged him in his earliest works, beginning with the Southern series on brown paper. The ritual is the choreography of daily life, vibrant in movement and in the myriad shades of feeling and emotion common to humanity; it is nurtured by his knowledge of and experience in black America.

In talking of his art, Bearden comments, "I am trying to explore, in terms of the particulars of the life I know best, those things common to all cultures." His appreciation of an astonishing array of artists spans the continents and centuries and undergirds his mature oeuvre with a range of aesthetic allusions brilliantly absorbed into his own highly assured personal style. His goal consistently has been to create a universal art in a contemporary medium while remaining true to his particular cultural heritage and experience.

[*Here, Greene describes the beginnings of Bearden's career, his participation in the Spiral group, and his adoption of the medium of collage at that time and shows how the themes of the* Projections *series emerged from the artist's earlier images of Southern life.*]

When asked why he departed from abstract painting and chose the collage, Bearden said simply, "You can't always do things the same way." In fact he has been attempting to create an oeuvre in keeping with the restless modern sensibility, exhibiting spontaneity and the element of surprise. "Man's patience," he says, quoting the French poet Paul Valéry, "is destroyed by the machine." Bearden uses elements of the film documentary, allowing a projection of his images "right up front" to create a feeling of immediacy in his viewer. Bearden's *Projections*, with their haunting eyes and contorted physiognomies, are nothing short of visual confrontations.

In 1967, Bearden began to add generous amounts of color to his enlarged collages, as in the *Rites of Spring* (Carter Burden Collection). He often used colored paper and fabrics, or paper which he painted and then glued to the surface of the work. Since then his collages have become increasingly more sophisticated in color and design, less compressed, airier, and more elegant, beautifully exemplified in two works from 1970, *Patchwork Quilt* (The Museum of Modern Art) and *Mississippi Monday* (Shorewood Publishers). Here is an artist who truly enjoys the plasticity of his medium. In his mammoth effort to explore the formal elements of Negro life and to express its "innerness" visually, Bearden has not only chosen to deal with "black anguish," an undeniably pervasive element, to be sure, but also with a whole range of emotional shadings. "Art celebrates a victory," says Bearden; "I look for all those elements in which life expresses that victory." In America's technological society, increasing numbers of people feel that man is becoming dehumanized. Bearden holds that the lifestyle of the black in America is "perhaps the richest because it is the one lifestyle that is talking about life and about the continuation of life . . . and through all of the anguish—the joy of life."

If anguish is present in some of his collages, it is there because anguish is very much a part of the human condition. Anguish is as much a part of the "innerness" of the black experience as piety is part of a nun's. But in Bearden's collages there is also folklore—rural Southern style, with allusions to both American and African origins—that includes spirituals and jazz, card-playing nights and churchgoing Sundays, family meals and blue Mondays, set against lush Southern landscape and bleak Northern slums. Thematically, Bearden's work since 1964 is often analogous to that of Brueghel. Technically, it is influenced by Mondrian, as is evident in his interlocking rectangular relationships, and also by such older Dutch masters as de Hooch and Terborch. His forms and distortions owe much to African sculpture.

Bearden continues to explore the interrelatedness of apparently unrelated things—a fragment of patterned linoleum becomes a human arm,

moss becomes someone's hair, Southern cabins arc telescoped through the windows of decaying urban tenements, and the eyes of a cat become those of the conjur woman. Bearden has never maintained a photographic file nor does he use one. He uses pictures from newspapers and magazines which he skillfully frees from their sources and fashions to the needs of his collages. "Seldom have I used actual faces," states Bearden. "Most of my faces are fragments from different things," frequently African masks, usually varying in scale, and pasted together in a unified whole. Here is a master not only of structure but also of harmony and its achievement out of apparent disharmony. Sometimes a white hand will be attached to a black body: Bearden is not interested in the hand or the separate element as such, for essentially his concern is with the metaphoric use of the disparate elements, that is, the handness of hands and their aesthetic positioning within the construct of the collage. Bearden juxtaposes elements in order to lend emphasis to a single idea. His world is most often kaleidoscopically compressed in multiple spatial planes and his images are empirically related. "I try to show that when some things are taken out of the usual context and put in the new, they are given an entirely new character."

There are some persistent elements in Bearden's collage paintings—the train, the window, the moon, the haunting eyes of his people. Although Bearden abjures the idea of symbol in his work, he adds, "These [elements] should not be construed in a literary sense. Each painting envisions a world complete within itself."

The Prevalence of Ritual, then, is more than an exhibition; it is an affirmation, a celebration, a victory of the human spirit over all the forces that would oppress it.

Noah Purifoy, "Statement by the Artist," in *Niggers Ain't Gonna Never Ever Be Nothin'—All They Want to Do Is Drink and Fuck*, catalogue for exhibition held at the Brockman Gallery, Los Angeles, March 7–26, 1971

Although Noah Purifoy had participated in several group shows since spearheading the landmark exhibition *66 Signs of Neon* in 1966 (see pp. 60–63), this exhibition marked his first solo presentation. Founded in 1967 by the brothers Alonzo and Dale Davis in the Leimert Park neighborhood of Los Angeles to counteract the lack of exhibition opportunities for Black and other minority artists in prominent institutions, the Brockman Gallery later expanded to include studio and living spaces and public-art projects. For the exhibition, Purifoy created an installation that was intended to represent the living conditions of many African Americans. Although it was a profoundly abject environment, filled with live insects and rotting food, the purpose of such destitution was not necessarily to reveal the literal hardships of the Black community. Rather, Purifoy wanted to show the consequences of a racist society—how the psychological framework forced onto African Americans prevented them from leading progressive lives.

NOAH PURIFOY, "STATEMENT BY THE ARTIST"

"Niggers ain't gona never be nothing; All they want to do is drink and fuck."

The first part of this statement was traditionally held by Black people and the second part by whites. The psychology of this concept continues to exist today, manifested in our socio-economical struggle in the U.S.A.

Much has been said about the existing condition but very little has been done about it on the psychic or symbolic level. This is to say, laws have been passed to righten the wrong but nothing has happened to change our attitude.

In other words this exhibit is concerned with attitude, not alcohol and sex. It is concerned with the manifestation of a cliché that makes black people want to be white.

Poverty as displayed here (ten people living in one room) is the symbol of the manifestation. This condition is the results of the cliché. That is, "They won't let me be me, and I can't be what they want me to be, so fuck it." This attitude is unnatural and therefore symbolic: thus this exhibit.

The objects assembled here were collected from castaways of the black ghettos of this city. The artist who reclaims unwanted things is not unique. This is one of the basic necessities of the poor. But the poor seldom understand art as art as interpreted by the white culture. So this exhibition is directed at the have and not the have nots.

The poor would no doubt say, do not reclaim discards and in terms of recent happenings, burn it. We as artists do not claim to have the solution to the problem but the question remains who is responsible for the kind of poverty in the midst of plenty.

The problem with the problem is that we have been wrong. The problem of race in this country is not socio-economical it is psycho-morality.

1971

Frank Bowling, "It's Not Enough to Say 'Black Is Beautiful,'"
ARTnews 70, no. 2 (April 1971)

In this text, Frank Bowling examines the work of Melvin Edwards, Daniel LaRue Johnson, Al Loving, Jack Whitten, and William T. Williams, setting their work against that of Benny Andrews, Dana C. Chandler Jr., and the Chicago-based AfriCOBRA group. For Bowling, Black art was not message-based or directly topical but spoke in many ways at once. "The traditional esthetic of black art . . . hinges on secrecy and disguise," Bowling argues, using the term "signify" to describe artists' ability to communicate different meanings through their work depending on who is looking at it.

FRANK BOWLING, "IT'S NOT ENOUGH TO SAY 'BLACK IS BEAUTIFUL'"

Recent New York art has brought about curious and often bewildering confrontations which tend to stress the political over the esthetic. A considerable amount of writing, geared away from history, taste and questions of quality in traditional esthetic terms, drifts towards "relevance," arbitrating social balance and even quotas. For such writing to be serious, it must consider the artist's intent. Intentions, however, cannot be kept within formalist or literalist confines, even when the works display strong formalist or minimalist aspects. That the answers to questions of intent seem to match demonstrations of formalist or literal content, thus freezing the whole dialogue, leaves a highly complex, often fugitive and hence largely ignored area still to be investigated.

Much of the discussion surrounding painting and sculpture by blacks seems completely concerned with notions about Black Art, not with the works themselves or their delivery. Not with a positively articulated object or set of objects. It is as though what is being said is that whatever black people do in the various areas labeled art is Art—hence Black Art. And various spokesmen make rules to govern this supposed new form of expression. Unless we accept the absurdity of such stereotypes as "they've all got rhythm . . . ," and even if we do, can we stretch a little further to say they've all got painting? Whichever way this question is answered there are others of more immediate importance, such as: What precisely is the nature of black art? If we reply, however, tongue-in-cheek, that the precise nature of black art is that which forces itself upon our attention as a distinguishing mark of the black experience (a sort of thing perhaps, only recognizable by black people) we are still left in the bind of trying to explain its vagaries and to make generalizations. For indeed we have not been able to detect in any kind of universal sense The Black Experience wedged-up in the flat bed between red and green: between say a red stripe and a green stripe.

If formalism drove painting out of the arena of Action, and painting got to be more about itself as "process" and "thing" (we are not likely to forget the late Ad Reinhardt), painting didn't just isolate itself from questioning; it drove itself and the artists to declaring not just simply the works, but themselves, in a talismanic role. The art may be a simple box, but the artist remains a magician.

The painters I am about to discuss all work in New York. Although they all are black, they have been grouped together almost entirely in relation to their role as artists. They first came together with the curatorial assistance of Lawrence Alloway and Sam Hunter in an exhibition called 5+1 at Stony Brook University in 1969. Of the artists, Mel Edwards and Dan Johnson are sculptors, Al Loving, Jack Whitten, William Williams and myself are painters. It must be however understood that there are many other comparable artists, not necessarily connected with my main thesis but who must be included for reasons which will become clear both in this essay and in the future. These artists are the natural inheritors of modernism through the contributions of their ancestors in traditional African and modern art.

The arguments for an African legacy are often over-stressed and at times aggressively asserted. However there's no denying its emotional and political significance. It is clear that modernism came into being with the contribution provided by European artists' discovery of and involvement with African works, and their development of an esthetic and mythic subject from it. But the point I am trying to make concerns the total "inheritance" which constitutes the American experience and that aspect of it which black people can now (perhaps they always have) fully identify, due to the politicization of blackness. It would be foolish to assume, as some do, that the development of modern art through the contributions of African ancestors is solely the property of blacks, for it is evident that the filtering must include white consciousness.

I readily admit that this is partly a question of historical placement and time; it nevertheless remains a complex issue; to wit, a situation which does not shift objective facts, the works or the artists, into areas more readily meaningful. For there is a body of work there and there are figures on the

scene we simply have to deal with, no matter what the political climate is. At the same time parallel to the question of "intent" there is still the question of standards. How do we judge and salute works by black artists?

I believe that standards exist and complexity of "intent" can be judged by the ability of the individual artist: his ability to fulfil a meaningful talismanic role. But the meaningfulness of the artist's role in many areas of black life is similar to that of such popular figures as Imamu Amiri Baraka, Bobby Seale, Eldridge Cleaver and the late Malcolm X. It is interesting to note how the magic of the talismanic figure has been usurped by establishment art for its heroes at large, where we are led to believe that the most "relevant" artists are those who display the greatest "curatorial sensitivity." The trouble is that in an open-ended situation like ours, the establishment-hero functions more like an earnest modern Sunday school teacher—that is, hip.

Consequently, the artist-hero becomes a power behind the throne (a Western tradition which goes back to the Renaissance), or worse, a priest saying the last rites. He is not at all the same thing as a caster-out of spirits, who, it was held traditionally, combined his panache as a showman with the ability to receive, set up and articulate universal vibrations within the confines of a particular community and discipline. My point here is that black anything—energy, lifestyle, myth, traditions, even music—is now public property to be used by anyone who cares to, but often this use or rerouting is heavily laced with misinterpretation and bad vibes, producing a kind of hysteria only explainable in terms of politics and suppression.

The problems containing if not yet strangling an assertion that "experience" forges the content of art are such that a general statement in today's open-ended situation is available to any interpretation. The central principle that everything which exists can be analyzed into substance and essence, forces one to shift ground over whether works touted under the black label are consistent and positive examples of Black Art.

This is a complicated business, but if we examine some of the works themselves, certain distinctions emerge. There are the political-realist works of certain New York, Boston and Chicago artists, still committed to a mode with a long tradition in American genres, and also in 1930s paintings. Such Social Realism, used to create an irrational hyper-reality, permits the play of feelings without necessarily either including or considering the limitations of reality itself. None of it measures up to the impact or immediacy of a television newscast.

Unlike, say, the Surrealist painters, who choose an illusionist style to articulate a heightened sense of the reality of their erotic and dream world, they direct their attempts at captivating a local audience in finding a way out of a cultural dilemma. An example of this is the much reproduced and talked about *Champion* by Benny Andrews. Both the work, which is an ungainly papier-maché, collage and rope job, and the sermon the artist apparently preached (parts of which were duly published in *The New York Sunday Times*) at the Boston Museum of Fine Art (where the work was shown) for the benefit of a gathering of the brothers and sisters, stress the emptiness of a "magic event" at an exhibition of painting and sculpture which was not successfully turned into theatre. (The establishment press and the exhibition itself jeopardized any possible future effort in this area by the inclusion of works which could not be considered even theatrical props, much less art. Press emphasis on this aspect simply turned Andrews' lecture/happening into the empty gesture of tokenism the museum intended the show to be.)

The inherent problems are not resolved because, like so much bad realist painting, this kind of art is a denial of both forms, i.e. painting and sculpture, and that which truly exists in its own right, such as a tree, a table, a box, a man; as against a color or a relationship, in the disciplines of painting and sculpture which are a union of form with matter.

The true reality of particular entities is the embodiment in them of distinct form/matter as a species expressing itself in the spirit of the species, lending itself to being distinguished by such tried and proven (however arbitrary) substantives as, say, language-based systems (there is such a thing as black language in the U.S., as there is such a thing

as Neger Engels in Surinam, a well-known source for the continuation of certain African forms in the New World). And people may agree to observe certain rules only, perhaps, because of man's inherent drive towards order. Then knowledge of that reality consists in the apprehension of the *specific* (unmistakable!) in an expression of the group mind of that species. It is in this sense that one cannot deny the claims made for such artists as Dana Chandler, Gary Rickson and Benny Andrews, who probably rightly deserve their reputations as having produced Black Art. But the divorce between art (painting) and life (politics) fractures or blocks the suggestive or evocative intention to call up the spirit of the situation or event: what remains are particularities, in a journalistic sense, of an event. What is missing is the feeling, the complicated response, not as history, even instant history, not now as television or radio, but as direct "inherited" experience.

A work of art with the power of making actual or implicit the nature of the species immediately apprehensible to sense perception and *more,* must also stand up to a rigorous analysis consistent with that which is "inside" the given discipline. The essence of the articulated experience may belong solely to the species; it constitutes its essence, and not what was contrived by politics, fashion or mannerisms. Thus it might be discovered that the species Black may have a *face* as part of its essence, whereas its *color* is merely an accident. Color does not in any way define *black*. It is not enough to say "black is beautiful."

The traditional esthetic of black art, often considered pragmatic, uncluttered and direct, really hinges on secrecy and disguise. The understanding is there, but the overwhelming drive is to make it complicated, hidden, acute. Being *up front* is so often given a double edge, often turning such things as language inside out. What was overlooked in Mel Edwards' barbed wire and chains show at the Whitney was his wit, in the tradition of Duchamp, kept afloat by Robert Morris and Les Levine. The elegance and deliberately loose serial geometry were a sure cover for painful implications. The fact that so many critics missed the point is a lesson in the separation of white from black. Inherent in

this delivery is the bondage neurosis in top hat and kid gloves. This particular museum exhibition was not a game, but controlled criticisms gone beyond anything Minimal or anti-form had achieved. In terms consistent with the convention of dropping hints, Edwards "drew" a linear pyramid directly in a material whose identification is with agony; it is not the same activity as Morris or Olitski invoking the state of Fallen-on-the-floor. And Edwards' unforced delivery is the opposite of political-realist art. He reroutes fashion and current art convention to "signify" something different to someone who grew up in Watts rather than to "signify" only in the meaning of Jack Burnham and his colleagues. Never mind the implication of the "free drawing" of a pyramid as opposed to *building* one. This work was like taking the Classical tradition and Humanism by the ear and making them face reality from the inside. The trouble is if your gaze is elsewhere, only an act of violence will redirect you, and, as I've pointed out elsewhere, *don't burn the museum down:* this will only bar you from the art experience. Watching the museum burn is *a spectator sport.* Tangling with barbed wire hurts.

William Williams' work is like Frank Stella's in not being about memory. It's about discovery. There is almost no apparent residue, only amazed recognition as these bright abstractions register their charge to the eye and brain. The flow of energy is astonishing. But before I discuss Williams' work specifically, I want to establish a clear and to me obvious distinction between what Williams does and what Stella has done. Criticism, none the less influential for being word-of-mouth, seems to want to penalize the former. But I contend that this is what we are about: Self-evident change!

Stella and Williams don't share an educational background. One went to Abstract-Expressionist Princeton, the other to Bauhaus Yale. This simple fact is not only important, it's explicit. The influence on Williams' work, for very special reasons (social reasons, if you like, but it is self evident from the nature of the background of white American art, that he, like so many others before him who also happened to be black, couldn't identify with it) was *not* Abstract-Expressionism. Instead it appears to

have been European abstraction of the hard-won sort, represented by people like Albers, or even Johannes Itten. There is something (an attitude, a drive in so much of this energy) recalling the force of the Bauhaus, the inconsistencies of proletarian ambition; the implied, if not actual *kitsch*, of knowing too much and understanding too little, except in the larger societal sense. It is a kind of style and energy which glitters like a newly manufactured brass button.

Much of Williams' earlier work was close in spirit and execution to Lissitzky. The posture and the placing of forms recalled Russian Suprematism and re-enacted in an uptown situation things that one had read about that kind of revolutionary drive. More important however, compare Williams' jazzy, jagged 1968–69 works (when they settle into the format of the dominant rectangle, after the confused burst of first encounter) with Lissitzky or Malevich and one gets a near equivalent of that circle-and-square tyranny dominating the intentful works of the Russians. One begins to appreciate that the content of this work is not about abstract decorative high art, but aggressive hammer blows in the uptight geometry of color and line. Everything in those paintings—color as line, lines in between the colors—clashes wherever the elements meet in a confused surge of passion. The work is virtually irresistible, hallucinatingly original when it should be pathetic and disastrous.

In the end there is a reason for this attraction toward European abstract revolutionary art, not unlike the late Bob Thompson's absorption in European old masters. Over and above Williams' Yale schooling—in the sense of a talisman—this brother is standing on the corner winning a round of "the dozens," hands down, against odds.

The mood has begun to change in his recent work. In a four-part picture like *Overkill*, 28 feet long, what seems like leftovers of Cubist faceting have crept in, creating concave and convex drives, flattening and asserting equivalents or challenges to the surface geometry; but they seem on closer scrutiny more a filtration with what has come down to us from the flattening of certain spherical forms in the sculptures of Baluba art (with its distinctly

spaced out and incised hemispheric curves) than with any of Cézanne's discoveries. The picture switches from positive to negative, which intellectually implies cancellation. This is not such a new idea, in fact it is common currency. The astonishing thing is that just the opposite of the expected response is received. Looking at the painting top to bottom, left to right, the forced diagonal drifts both ways from the pink to the white panel through to the black and the off-blue into green at the end. You begin to want to hold on to *something*.

What is delivered through this hectic drive—a kind of circus go-cart sensation—is the idea that these pockets of space begin to exhaust one (they "giddy" the blood or whatever it is) because the exposed channels of the raw duck support, left like trails of tortured passage, have little to do with flatness, but build almost to relief. Kinesthetically the works begin to collapse in a confusion between painting and such sculptural objects as pyramids—pyramids which keep appearing in a tactile way, more sneaking up than appearing. It's as if a confusion of forms that once had to do with face masks and the psychological implications of the pyramid have come together to produce something completely original. Most of Williams' work is like this. I have difficulty convincing myself that they are paintings, even though painted. *Doctor Buzzard Meets Saddle Head* is an almost completely red and green painting. The saturated green field seems to accommodate the busy lines and swirls on the left panel allowing an illusory pyramid of green on the right to assert itself with a kind of no-nonsense dignity.

In a sense (not our sense, but painting and sculpture), the subtlety of black experience, as articulated by behavior, is amply demonstrated in several examples from the recent heated past. What however is never fully taken into account, hardly ever acknowledged, is the pressured and sustained denial of the natural curiosity of blacks born in the new world. Since time immemorial blacks have had to content themselves with the "sneaky" approach. It is a tradition of subtle, driven awkwardness, now stretched to the breaking point, now suddenly a moment not of release, but of explosion of voluptuous, cynical amusement. Irony and sudden

change, complete many-leveled contradiction are stock-in-trade and automatic. This is part genesis of the species and the finely wrought articulation of the sensitive. Most completely successful works by black artists can be viewed as direct, arrogant spoofs generated from a complete understanding of the issues involved in the disciplines. The game of white-face is not the same as black-face. Desperation takes on the image of survival and makes for grim touching irony in the face of extinction.

Robert Farris Thompson in an essay in *Black Studies in the University* points out that Anglo-Saxon America missed "an entire dimension of New World Creativity" and suggests that Afro-Carolinian potters made vessels "as a deliberate gallery of tormented faces in order to vent response to a slave environment." Further in the same essay he quotes a South Carolinian "Strut Gal" (accomplished dancer) of the 1840s: "Us slaves watched the white folks' parties where guests danced a minuet and then paraded in a Grand March. Then we'd do it too. But we used to mock 'em, every step. Sometimes the white folks noticed it but they seemed to like it. I guess they thought we couldn't dance any better."

Several black artists work in certain genres which I take to be pretty awful attempts at this spirit of "jive" (a word black people rarely use to mean dancing).

The work of Al Loving is a different story. Loving's educational background consists of undergraduate work at the University of Illinois and graduate work in Michigan. He also taught for five years in the Middle West. In fact Loving is very much a Mid-West middle-class or professional-class entity. Loving began as an Expressionist, and he still regards himself as one. However much of his early work (portraits of his first wife kinking her hair, putting on make-up, etc., in front of a mirror) also implied the geometry it *grew out of.* Rectangular windows, mirrors, etc., echo the fact of the framing edge in a way that convinces through its consistency and persistence. Objectifying impressed itself on Loving through this earlier work *into* geometry to the discovery that "even a box can be a self-portrait." The emphasis in Loving's earlier boxes, apart from

self-discovery, is on composition. Then he moved to change the shape of the supports of his canvases from the rectangular to other "viable structures." It was as though such perspectives could clear the confused or confusing Surreal imagery of the work of such an artist as M. C. Escher (whom Loving admires) and declare painting's distinct expressive content through structuring.

This observing through discovery of rules and insistent drive towards order, evident in Loving, is consistent with his background; it cannot carefully be explained without a long dissertation on this gifted artist's development. His "activated banding," "small fine lines," which seemed so imperative in the segments, the individual hexagonal pieces recently dominant in Loving's work (like being boxed-in, incarcerated) have now given way to color mixing. In this sense one can say that Loving's earlier Expressionist color is changing: "I'm thinking about color as viable structure." Instead of "not being conscious [of color] except whether I like it or not." The interesting thing here is, much as Loving is convinced by his "natural" colorist sensibility, as one follows the progress of his work, the lines keep creeping back. That I could be fooled by an apparent elimination of lines in these big pieces is heartening. But the lines are still there as function in the pure sense. Loving says: "If I could get color that's strong enough, the lines would go . . . but anyway I like what the lines do."

For lots of rarely mentioned reasons, Loving's work denies sedate enjoyment, if less so than Williams'. It is discomfiting like any new kind of art, however much it may operate within the context of the already accepted, and hence fully *understood.* And it demands maximum attention if the black shared experience and heritage are not to go wasted.

Loving's *Timetrip One,* 25 by 12¼ feet, consists of 11 hexagonal pieces, painted on primed or in some instances unprimed cotton duck, in totally artificial colors, held together by cunning as well as by experiments with chemical formulas. It is an important work. Even the dense brushing and priming do not let the colors operate as anything more than tints. The opacity pushes the artificial

light (under which most of this work is seen) back into one's eyes, to the extent that one can't see the color. It's ever too bright and dazzling, like bad, bad neon glitter.

A weakness in Loving's work, and it is reflected in his attitude, is rather like what went wrong with Neo-Impressionist painting. He seems to neglect the fact that color activants are not color expressions. His response, both intellectual and physical, is not essentially expressive (as was so much of what was done by the Pollock, Kline, de Kooning generation), but an ego trip into ways of excess or extravagance. Enormous paintings are more literal signifiers to a better way of life than those which illustrate freedom in realist or Expressionist styles.

Loving's painting intelligence is beyond question. After his early pictures, he decided that "just to go to other imagery made little sense. . . . I could repeat *any* imagery and still come up with the same . . . but I chose the cube or the box simply because it was a foundation to intellectualism . . . a sort of mundane form that could be very very dull unless a great deal was done with it." He was impressed by "Frank Stella's first pieces where he had dropped the Expressionist vocabulary about composition."

Even though painting is still dealing with the wall and the floor, its expressive content relates to how one responds to the object as a specific. Painting is so complicated that it really doesn't bear explaining except as to what it decidedly is not— i.e., not architecture or sculpture. In this sense, Jack Whitten's work gives off a sunny, glowing, natural response from somewhere in the spots of paint pushed up from orange to that kind of rich grey one only gets from an instinctive and natural response to color. The color is not greyed-out. On first confrontation one may be confused until one realizes that this grey has a richness which must have something to do with weathered Southern sensibility exactly in tune with itself. Whitten makes "fine" paintings which his new technique of pushing the randomly selected color through a fabric screen of various dots on already wet and receptive *other* fabric (in this case cotton duck) makes for a kind of tough choosing that only such a sensibility can

pull off. The pictures are so new and mysterious that only intuition tells me this *down home brother* has it in his hands, his mind, his psyche. His mind reading back to me is laughter. His very body action makes every mark without a mistake, even though painting is full of mistakes.

Dan Johnson's work is, he says in transition. He is under no illusion as to what it is he is doing. His sculpture may be a spectator sport, but his commitment is without question. His position in the community is easily consistent with his status as a kind of *Ebony* magazine STAR, emerging into a larger society. It's more than Bill Bojangles Robinson tapping out and shuffling the *Star Spangled Banner* at a party for President Nixon . . . or Larry Rivers' arrogant remark about "a better life for black people with the emergence of people like William Williams. . . ." If Rivers' remark has any truth or meaning, it is only true in my opinion for Dan Johnson, who is a magic man and should be Mayor of Soho, at least.

1971

Robert Doty, "Introduction," in *Contemporary Black Artists in America*, catalogue for exhibition held at the Whitney Museum of American Art, New York, April 6–May 16, 1971

Black Emergency Cultural Coalition (BECC), untitled statement in anticipation of *Contemporary Black Artists in America*, January 4, 1971

Nigel Jackson, untitled introduction, and unsigned foreword, in *Rebuttal to the Whitney Museum Exhibition: Black Artists in Rebuttal*, catalogue for exhibition held at Acts of Art, New York, April 6–May 10, 1971

John Dowell, Sam Gilliam, Daniel Johnson, Joe Overstreet, Melvin Edwards, Richard Hunt, and William T. Williams, "Political Communications" (letter to the editor), *Artforum* 9, no. 9 (May 1971)

Contemporary Black Artists in America opened at the Whitney Museum of American Art in April 1971. With this exhibition, which had come into being after an ongoing dialogue with the Black Emergency Cultural Coalition (BECC), the museum hoped to emphatically demonstrate its support of African American artists, having already presented solo shows by Al Loving and Melvin Edwards in its lobby gallery (see pp. 185–86, 193–94). The exhibition was organized by Robert M. Doty, a White curator at the museum. As Doty states in his introduction, his aim was to represent the full range of Black artists working in the country, asserting that race was the only attribute unifying the art on display. The BECC had urged the Whitney to employ an African American curator, who would have been able to bring an informed and authoritative perspective to the exhibition's subject matter. After the Whitney appointed Doty, the BECC staged a boycott. As outlined in the statement sent to the Whitney's director, John I. H. Baur, it was the BECC's "responsibility to respond to these gross failures on the part of the

Whitney with vigorous and relentless protest action." Of the seventy-eight artists who had been asked to participate, twenty-four dropped out. Those who remained included Frank Bowling, Fred Eversley, Tom Lloyd, Noah Purifoy, Raymond Saunders, and Alma W. Thomas.

Acts of Art, a gallery in Greenwich Village, responded to *Contemporary Black Artists in America* with a "rebuttal" exhibition featuring paintings, photographs, prints, and sculptures by fifty Black artists who were opposed to the Whitney's show, some of whom had even withdrawn from it. The artists Nigel Jackson and Pat Grey had founded Acts of Art as a space for Black artists to show their work, and it became an important venue in the early 1970s. In the catalogue, Jackson emphasizes the need for African American artists to have an outlet such as his gallery, which, importantly, was located "outside of the ghetto areas" and thereby offered a fine-art context for their work. Such a setting, argues Jackson, not only added value to the art on display but also changed wider perceptions about Black artists. The Whitney's show also provoked a group of seven artists to submit a statement for publication in *Artforum*. John E. Dowell Jr., Melvin Edwards, Sam Gilliam, Richard Hunt, Daniel LaRue Johnson, Joe Overstreet, and William T. Williams had all dropped out of the exhibition, believing it to be ill-conceived and lacking in complexity. In their letter, they describe the exhibition as "anti-curated" and tokenistic.

ROBERT DOTY, "INTRODUCTION"

This exhibition is devoted to commitment—to pictures and objects which affirm hard work, faith, patience, imagination, and aesthetic integrity; to creation, bringing forth life or causing life to be realized anew; to human values, both intellectual and emotional.

It is devoted to American artists who are Black—creative individuals, with widely disparate intentions, ideas and goals; artists whose works are categorized as "Black Art," or "Afro-American art," despite the fact that diversity is their universal trait.

It is devoted to concepts of self: self-awareness, self-understanding and self-pride, emerging attitudes which, defined by the idea "Black is beautiful," have profound implications in the struggle for the redress of social grievances. The Black artists of Chicago's South Side painted two civic murals entitled *The Wall of Respect* and *The Wall of Dignity*, and recently Romare Bearden wrote: "Whatever increases the self-awareness of black people will therefore enlarge the opinion they have of themselves—as well as the opinion other people have of them."[1]

In his history of the Negro in the United States, *12 Million Black Voices*, Richard Wright describes the culture of Africa: "We smelted iron, danced, made music, and recited folk poems; we sculptured, worked in glass, spun cotton and wool, wove baskets and cloth; we invented a medium of exchange, mined silver and gold, made pottery and cutlery; we fashioned tools and utensils of brass, bronze, ivory, quartz, and granite; we had our own literature, our own system of law, religion, medicine, science, and education; we painted in color upon rocks; we raised cattle, sheep, and goats; we planted and harvested grain—in short, centuries before the Romans ruled, we lived as men."[2]

Now, as a means of arousing greater knowledge and a desire for cultural heritage among their people, many Black artists are turning to the tribal arts of Africa as a source, taking as their subject matter folklore, religious and political stories and myths, animal and other symbols, illustrations of the people, and the vivid colors and rhythmic forms of tribal artifacts. This is, in fact, a rebirth of an earlier interest in the assimilation of the arts of Africa and America.

In 1925, Dr. Alain Locke advocated that Negro artists look to the "ancestral arts" as a means of incorporating a "racial idiom" in their work. For example, Aaron Douglas superimposed geometric motifs on his murals, *Aspects of Negro Life*, in the Countee Cullen Branch of the New York Public Library. The new interest in the tribal arts stems from a desire to comprehend the beauty of exotic and traditional art and a need, both personal and public, to foster manifestations of cultural wealth. A successful conjunction of tribal material and contemporary aesthetics is found in the paintings of Joe Overstreet, whose bold color patterns are laid on canvases suspended by ropes which suggest the ancient use of animal hides. Three young artists, Ellsworth Ausby, Algernon Miller and Ernest Frazier, use color and form to create painting and sculpture which are both abstract in the contemporary mode and evocative of tribal art. The union of past and present is once again proving to be a powerful stimulus.

Commingling with the intensified development of self-awareness is a conscious effort to increase and emphasize a socio-political content. Writing in 1940, Alain Locke noted that "Much of our contemporary art is rightly an art of social analysis and criticism, touching the vital problems of religion, labor, housing, lynching, unemployment, social reconstruction, and the like."[3] Recently, Edmund B. Gaither, curator of the Museum of the National Center of Afro-American Artists, stated that "Black art is a didactic art form arising from a strong nationalistic base and characterized by its commitment to a) use the past and its heroes to inspire heroic and revolutionary ideals, b) use recent political and social events to teach recognition, control and extermination of the 'enemy' and c) to project the future which the nation can anticipate after the struggle is won."[4] The Minister of Culture of the Black Panther Party is more explicit, commanding "all progressive artists to take up their paints and brushes in one hand and their gun in the other. . . . Bridges, buildings, electric plants, pipelines, all of

the Fascist American empire must be blown up in our pictures."[5]

Such extremist exhortations are categorically dismissed by many Black artists who refuse to believe that art should be subjected to the necessity of conveying a political message. They would agree with Barbara Chase-Riboud that "nobody should attempt to limit artists in their response to the world."[6] Indeed, many Black artists refuse to be subjugated to collective aims. One of them is Malcolm Bailey. His drawings and paintings appertain to the iconography of Black people, but in his opinion "there is no definition of black art. It is absurd to take a group of painters, whose various works and concepts differ, and categorize this group as exponents of black art just because of their skin color."[7] Writing under the title *Black is a Color*, Raymond Saunders asserts: "Racial hang-ups are extraneous to art. No artist can afford to let them obscure what runs through all art—the living root and the ever-growing aesthetic record of human spiritual and intellectual experience. . . ."[8] For artists such as these, freedom of expression signifies freedom for the individual.

During the twentieth century, a predominant subject of the Black artists has been the drama of daily life. It appears in the genre scenes of city life painted by Archibald Motley in the twenties and thirties, the portraits of heroes and leaders by Charles White, and the scenes of street life by Jacob Lawrence and Romare Bearden. Early in his career Bearden wrote: "At present it seems that by a slow study of rules and formulas the Negro artist is attempting to do something with his intellect, which he has not felt emotionally. . . . An intense, eager devotion to present day life, to study it, to help relieve it, this is the calling of the Negro artist."[9] In the painting, sculpture and graphics of Negro artists in the thirties and forties a concern for conflict, stress, and tragedy appears constantly. Because of his personal needs and the needs of his time, the Negro artist chose realism as the chief mode of conveying his emotions and experiences. Negro art students were taught theories of "truth to nature," thus encouraging acceptance of landscape, still-life and genre subjects as suitable topics. For the Black artist, realism was more than a style or technique, it was a means of communication. Charles White's portraits of leaders such as Frederick Douglass were a reminder of the role the hero played in the life of the Black people. Such images were a necessity, an assurance that Black people would endure.

So long as Black artists are inspired to create, they will continue to testify to the "Black experience," the special conditions, heritage and emotions which delineate the life of Black people. But creative drives cannot be channeled. Inevitably an artist reacts to the ideas and techniques which constitute the current mode, sensing and assimilating new directions of thought and vision, or the evolution of his own technique and ideas guides him toward a new result. Richard Hunt and Barbara Chase-Riboud first received attention for their figure oriented sculptures, but over the course of a decade both have worked toward abstraction, while retaining references to the organic in their pieces. As a young artist in California, Daniel Johnson shared a preoccupation with the value of discarded objects and produced rough assemblages which often symbolized racial conditions. Since moving to New York, Johnson has been preoccupied with problems of color, form and space. Melvin Edwards entitled an early group of welded steel pieces *Lynch Fragment Series*, but his recent work demonstrates a coalescence of static and flexible states rather than racial tragedy. William Henderson painted a series of demonic images from the black world, but he has now refined both his technique and imagery to pursue hard-edged, geometric abstraction. The nuances of color and images of Africa are the vehicle for paintings by Frank Bowling. These six are representative of a new generation of Black artists, who inherited their own culture and sought the universal canons of the visual arts. Their task will be the accommodation, or rejection, of venerable emotions and new stimuli.

Whether bitter or jubilant, the initial impetus for taking up brush or pencil, stone or metal, is often personal experience and its emotional condition. But the creative act is rarely sustained indefinitely by passion or desire. Generally the artist relies on conventions or systems, established methods and

procedures for organizing the format of object or image. A rational approach to complex problems is neither convenient nor expedient for the Black artist. He must answer to his own cultural loyalties and the community, both of which insist that he create art that expresses blackness. Nonetheless, young black artists are facing the dilemma. William T. Williams has made an outstanding contribution to modern painting by combining a distinctive regard for color with recent concepts of scale and the frontal plane of the canvas. Alvin Loving also employs color on a grand scale, constructing each painting by a system of modular units, and John Chandler manipulates color values and spatial relations. Their command of means is significant, but it is their ambition and integrity which demands respect.

Ultimately the Black artist and his audience must respond to "the authority of the created thing,"[10] that unique quality which originates only with the creative individual, and which flourishes only under a spirit of free inquiry. The need for that freedom was never greater.

BLACK EMERGENCY CULTURAL COALITION (BECC)

During the spring and summer of 1969, six months of negotiations between the Black Emergency Cultural Coalition and the Whitney Museum of American Art resulted in an agreement between the two organizations which was to have a profound effect upon the Art Community in general, and upon Black Artists in particular. The agreement, which reflected one of several demands put forth by The Black Emergency Cultural Coalition, was that the Whitney Museum would stage a major exhibit of the works of Black Artists, National in scope. It was further agreed that the museum would schedule the exhibit to take place during the art season's "prime time," beginning late 1970 and extending to 1971.

The exhibit, in the words of the museum's director, John I. H. Baur, would be "designed to assess the contributions that the best black artists are making the creative life of America today." Speaking for the Whitney Museum, Mr. Baur further stated, "We're taking these steps because we feel that Black Artists have suffered more handicaps than other artists, particularly in bringing their work to the attention of collectors and dealers. But our final judgment of what we buy and show will rest on quality."

Ignoring an earlier agreement that the work for the exhibit would be selected by a two-man committee consisting of one of the museum's curators and a qualified Black Art expert acceptable to both parties, the museum declared that its own curators would choose the show, utilizing the advice of Black Art experts "wherever feasible." We are dealing here with evidence that neither the museum's stated commitment to stage a Black Art show during the art season's prime time 1970–1971, nor its grudging promise to draw upon the advice of Black Art experts have been honored.

Because of the Whitney Museum's discourteous handling of the matter, The Black Emergency Cultural Coalition, with whom the agreement to stage a Black show was reached, had to learn through other reliable sources of the museum's rescheduling of the exhibit date to April 1971, a period that could hardly be considered "prime time." As to the selections for the show, our fellow artists across the nation have reported being subjected to such humiliating experiences as having Mr. Robert Doty, apparently the museum's lone selector, enter their studios and demand to see only this or that piece of which he had heard or with which he was previously familiar, at the exclusion of all others. Many Black Artists of outstanding ability have reported being passed by altogether, and no Black curatorial assistance has to our knowledge been drawn upon to date. An overall air of confusion and mistrust has resulted from the lack of information regarding the Whitney's preparation for the show.

With exceptionally competent Black curators such as Edmund B. Gaither, at the Elma Lewis School of Fine Arts, Dorchester, Mass. and such capable Black Art specialists as Randall J. Craig, of Philadelphia, Evangeline Montgomery, of the Oakland Museum, Dr. Samella Lewis, of the Los Angeles County Museum, Floyd Coleman, of the Atlanta University Center and Prof. Ridley of Fisk University,[11] and with forward-looking, sensitive art

institutions such as the Boston Museum of Fine Arts and the Civic Center Museum at Philadelphia, both with successful Black shows behind them, we must seriously question our need to tolerate the callousness of such as the Whitney.

Doty's and the Whitney's response to the community's urgent demand for complete and wholesome cultural nourishment has from the beginning been characterized by a reluctance in becoming an institution charged with the responsibility of providing and preserving its community's cultural health. It has thereby proven its irrelevance to the community.

We of The Black Emergency Cultural Coalition, being dedicated to the principle of upholding the community's cultural integrity, see it as our responsibility to respond to these gross failures on the part of the Whitney with vigorous and relentless protest action.

The Black Emergency Cultural Coalition is constituted as an action-oriented and watchdog group, to implement the legitimate rights and aspirations of individual artists and the total art community. It is founded on the belief that those persons most intimately related to and profoundly influenced by relevant problems affecting the art community, should have the ultimate responsibility for the establishment and executions of policies to deal with these problems.

The Black Emergency Cultural Coalition adheres to the principle of direct action, to be taken whenever and wherever necessary, to effect changes in any and all policies and practices which are alien to art and to Artists. One must only comprehend the power inherent in art to motivate the human spirit toward social change and freedom; to grasp the desperation with which the system works to obscure the beauty of Blackness in art in these revolutionary times.

Overcoming present and future obstacles to truly significant recognition of the Black artist's serious involvement in and valuable contributions to the world art community will require the active and often sacrificial participation of fellow artists, supported by the concern and cooperation of sympathetic friends.

We are calling for massive boycott of the Whitney Museum's Black show by all concerned Black Artists. All sympathetic members of the art community and all people concerned with cultural freedom. We call for this action in protest of policies and practices on the part of the Whitney Museum of American Art, in relating to Black Artists and the Black Community, which typify it as a racist institution, fully knowledgable of the fact that it could live down a bad Black show, while its sadly displayed participants might not.

NIGEL JACKSON, INTRODUCTION TO *REBUTTAL TO THE WHITNEY MUSEUM EXHIBITION*

ABOUT acts of art . . .

Through art that has been left us, we are able to understand the lifestyles of peoples that came before us. Now, today, if people of different ethnic backgrounds are to understand and relate to each other, what more appropriate way, than through their art.

If you're not a Black artist, you cannot fully realize the great need for an art gallery specializing in fine art by Black artists, LOCATED OUTSIDE OF THE GHETTO AREAS. acts of art fulfills this need, and in doing so, fulfills many other needs.

For the Black artist to emerge at all, a showcase outside of the ghetto, must accept his work. acts of art is such a showcase, DEALING IN FINE ART AND SPECIALIZING IN FINE ART OF BLACK AMERICA.

We offer works of art by living artists. We have at our disposal a large and continuously increasing number of highly acclaimed artists, both up and coming and well established, working in various mediums and styles.

acts of art, keeping foremost in mind cultural contributions, presents on canvas, in prints, with ceramics, collages, pen and inks, etchings, and sculpture, a continuously changing exhibit.

In addition to our in house exhibitions, the works of our artists may be viewed in art exhibits throughout the country. In museums; banks; schools; offices; libraries; restaurants; social gatherings and various community shows.

acts of art is a meeting and gathering place for artists and people interested in the arts. Visitors from all over the world have come to acts of art to view the outstanding art works we have available. We've had, in addition to opening events, debates: "Does Black Art Exist"; alumni meetings; poetry readings; lectures; group discussions and social events; artists painting portraits in the gallery. acts of art has been used as a background for photographers, been filmed for television and educational film strips, written up in magazines such as *Artforum* and *Essence*, newspapers such as *The New York Times*, *The Amsterdam News* and local newspapers from *The Villager* and *The Chelsea Clinton News* to *The Gleaner* in Kingston, Jamaica, West Indies.

In order to continue a project such as acts of art, it must be supported. People must take an interest in the art and the artists. They must spread the word.

On April 6th there were two openings of black art exhibits in New York City. The Whitney Museum opened its long-awaited, long-promised exhibit of what its curator, Robert M. Doty, considered to be black art. In response to such singular policies and attitudes on the part of the Whitney, acts of art, a black owned art gallery opened a rebuttal exhibition to the Whitney show.

The Black Emergency Cultural Coalition (BECC), cochairmaned by artists Benny Andrews and Cliff Joseph, was instrumental in persuading the Whitney to mount a black art exhibit. Asserting that black artists and critics had been consistently ignored by the establishments of art in this country, the Coalition began negotiating with the Whitney in the spring of '69. In addition to a major exhibit during the Museum's "prime time," the Coalition also sought to include more black artists in its annuals and increase its purchases of art by blacks. Needless to say, the Whitney fell quite short on its promises.

It is surprising that in 1971 a major establishment in America would be caught opposing what is essentially a civil rights demand of integration. The BECC proposals articulated minimal demands that too much blood and pain has legitimated— that some non-white representation be present in institutions that serve the public and supposedly reflect the state of American culture. These are not radical demands for control, but proper democratic proposals for due recognition and involvement.

Without deprecation to those who choose the Whitney, a few brave artists should be applauded for their determination to make a stand on a very important cultural and racial issue, in a country where race is never forgotten.

Nigel Jackson, owner-director of acts of art extended his personal invitation to the public to participate in the rebuttal exhibit by viewing the artwork on display in the gallery. The exhibition ran from April 6 thru May 10, 1971.

acts of art inc.

FOREWORD TO *REBUTTAL TO THE WHITNEY MUSEUM EXHIBITION*

The acts of art gallery under the directorship of Nigel L. Jackson opened a rebuttal exhibition to the Whitney show in April. Participating were fifty nationally and internationally active and competent artists. To my knowledge, this was the first art show truly representative of the national Black community since the Harmon shows of the nineteen thirties. An indication of the persistent inhibiting force of "white-power" is the assertion that this is not only the first truly representative Black art show in forty years but the Harmon shows of the thirties grew out of conditions that precisely equate the problems we are having today.

There is no way to separate this cultural effort from the social conditions which inspired and influenced it. While Black artists do sometimes concern themselves with principles of composition such as unity, contrast, repetition and so on, we are generally not believers in any so-called universal aesthetics, pure art, nor superior art. . . . Black artists tend to see these as the same old bigoted, vague rules and laws which are created and used by Whites and are still arbitrarily applied to their own work and to work about which they know little or nothing. These rules freely applied by Whites, have constantly resulted in the creations of Blacks throughout

western history being either obscured or labeled as unskilled, unsophisticated, prehistoric and primitive. These descriptions have been applied with the worst possible connotations. The acts of art show was more than just a rebuttal to one White institution or even to all White institutions. It assumed the right of each Black person to say "I am."

JOHN DOWELL, SAM GILLIAM, DANIEL JOHNSON, JOE OVERSTREET, MELVIN EDWARDS, RICHARD HUNT, AND WILLIAM T. WILLIAMS, "POLITICAL COMMUNICATIONS"

Recent social pressure has focused on the ethnic exclusion practiced by American cultural institutions. As a result some of these institutions have attempted hasty redress in the form of ill-conceived exhibitions. For a major museum, in 1971, to attempt a definitive survey of the works of the African American artist in the United States is important and precedent setting.

Such an exhibition should then be a model of its kind, and try to deal with all the complex issues (social and esthetic) justly. Such an exhibition should also discover that the roots of America's collective cultural experience are wider than they are deep, and that museum culture cannot simply continue to nurture a few varieties of European transplants. Furthermore, exhibitions that serve minority interests cannot be merely indignant reactions, but must be positive acts, which in good faith foster greater understanding and awareness in changing times.

As African Americans and artists involved personally and publicly as citizens and creative people, we feel that the quality of such a survey to a large extent depends on the intentions and integrity of the institution and its delegated curators.

We say that the Whitney Museum has anti-curated its survey which results in misrepresenting and discrediting the complex and varied culture and visual history of the African American. The museum thus acts as a falsifier of history and minimizes the value of our works and therefore ourselves. This exhibition has been organized and developed in the worst form of tokenism without any regard for our real qualities. The museum has initiated no in depth historical research of the collective quality of African American art. It has not done in depth personal biographies of African American artists. The level of administration and curatology of the museum is apparently of low caliber if we are to judge by the procedures used by the museum and its staff. It is a waste of time, energy and life to organize a large scale exhibition which negates a coherent viewing and analysis of the creative content, context, influence, and general value of the works of African American artists. We cannot endorse non-creative intentions and procedures; therefore, we refuse, withdraw and withhold our work from the Whitney Museum of American Art's Survey of Black Art.

NOTES

1 Romare Bearden, introduction to the exhibition *The Black Experience*, Lincoln University, 1970.

2 Richard Wright and Edwin Rosskam, *12 Million Black Voices*, New York, The Viking Press, 1941, p. 13.

3 Alain Locke, *The Negro in Art*. Washington, D.C., Associates in Negro Folk Education, 1940, p. 10.

4 Edmund B. Gaither, *African-American Artists: New York and Boston*, Boston, The Museum of Fine Arts, 1970. [See p. 229 in the present volume. —Eds.]

5 Quoted by Lawrence Alloway, "Art," *The Nation*, Vol. 211, No. 12, October 19, 1970, p. 382.

6 "People: Barbara Chase-Riboud," *Essence*, Vol. I, No. 2, June 1970, p. 62.

7 "Black Art: What Is It?" *The Art Gallery*, Vol. XIII, No. 7, April 1970, p. 32. [See p. 213 in the present volume. —Eds.]

8 Raymond Saunders, *Black Is a Color*, privately printed pamphlet, 1967. [See p. 71 in the present volume. —Eds.]

9 Romare Bearden, quoted in Cedric Dover, *American Negro Art*, Greenwich, Conn., New York Graphic Society, 1960, p. 32.

10 John Malcolm Brinnin and Bill Read, preface, *The Modern Poets*, New York, McGraw-Hill Book Company, 1970 (second edition), p. ix.

11 [Gregory D. Ridley Jr. (1925–2004) was an artist and a professor of art at Nashville's Fisk University. —Eds.]

1971

Melvin Edwards, "Notes on Black Art" (1971), first published in *Melvin Edwards: Sculptor*, catalogue for exhibition held at the Studio Museum in Harlem, New York, February 26–March 26, 1978

Melvin Edwards originally wrote this short essay in 1971 after being invited by Robert M. Doty to take part in the Whitney Museum of American Art's exhibition *Contemporary Black Artists in America* (see pp. 333–40). Doty had commissioned Edwards's text for inclusion in the catalogue but rejected it on the grounds that it was too critical of institutions that had not supported the work of African American artists. Edwards consequently declined to participate in the exhibition. The essay was eventually published in 1978, on the occasion of the artist's retrospective at the Studio Museum in Harlem.

MELVIN EDWARDS, "NOTES ON BLACK ART"

To talk of Black Art in America is to talk of the African American people. Black Art is works made by Black people that are in some way functional in dealing with our lives here in America. Since the most important thing is our dealing with our oppression by White America, our most logical works are those forms of social protest and those which build our self confidence and self reliance. Most African American artists either deal directly with their own familiar subject matter and symbols, or they indirectly title abstractions with the names of friends, heroes, relatives, harlems, musicians, foods, etc. There is no black artist who has not thought about his condition in America. As soon as Blacks know that a work was made by a black person then it becomes functional. The more explicitly concerned with the ways & symbols of black people, the more positive the response.

In the 20th century in american art there have been times when the confidence of the black artist has been stronger than at other times. When the mural painting social conscious nonwhite Mexicans were affecting the world most dynamically by using the symbols of their being Indian or African. They showed confidently that those were the positive things in themselves and that, to get the positive racial economic truth to their people, was the most important thing about their work. They came to the United States and Harlem and the importance of their ideas were taken into our own works. We are always affected by symbols and ideas that are good for us. Our knowing what is good for us all has not created one identifiable style, but it is getting us closer to that organization of our efforts to change our lives in this country. We must make works that use our lives and feelings as their basis for existence.

The work can either take the form of giving and using ideas, subjects & symbols for radical change, or the works can be of such large physical scale, and in the right places, as to make real change. It should always be known that these works are our methods of changing things. We must search for our own processes & symbols, if we can't find them in our individual selves then we must find them in our families and friends, in our cities (Harlem or Watts or South Sides or 5th Wards) in our rural Texas, Mississippi, Alabama, Georgia, Carolina, Ohio, Nebraska, Arizona, California, Utah. We must take ideas from Guyana, Brazil, Jamaica, Cuba, Puerta [sic] Rico, Trinidad. From the Philippines, New Guinea, India, Ghana, Nigeria, Algeria, Egypt, Congo, Zimbabwe, Zambia, Tanzania, etc. They are all ours.

The art establishment is offended by the fact that it can be pressured into an exhibition of the work of the american black artist. Historically american museums did not show the works of African Americans, because they would not consider african american art an integral part of american art. Now that the social & political pressures of the civil rights movement has begun to put pressure on museums the art world takes offense and is reactionary. The facades of liberalism are reacting on all the levels. The basic art establishments, galleries, art magazines, collectors, museums, university art departments, art schools, grant & financial aid giving institutions are upset that they can be identified as noncreative racist operations by their documented exclusion of african american artists from a tangible dynamic participation in the various roles and levels in the american art world. The art world and its dehumanizing institutions are not unique in this form of systematic exclusion of the creative abilities of African Americans. These same conditions are apparent in the music, cinema, theatre, television and literary worlds as throughout american life.

In 1971 all of this is known and the consequences of the past are sitting on the heads of the present. Museums are being criticized & picketed because of their basic lack of speed in changing to meet the real needs of the variety of cultures they pretend to represent. The real life of this european post colonial western hemisphere nation in North America is built on the land of the American Indian and the backs of African Americans, and contains a fantastically large amount of absorbed african culture and a much larger amount of unabsorbed unutilized African American creativity. African dance & music forms have been utilized and absorbed

both intrinsically and exploitatively. In the visual arts the absorption came through european colonization and bringing back examples of african art as the prizes & loot of conquest. Certain aspects (cubisms) of african styles have been utilized since the turn of the 20th century in european and american art. There was always a body of existing african art survivals in the Americas; in the Spanish, French and Portuguese speaking countries the evidence is highly visible. In the United States the visual creativity of the African American has been ignored and discouraged. Read through any one year of american art periodicals for traces of our heritage. It's not there. However there are survivals. Survivals are positive examples of the strength of our traditional art systems. Carved wooden grave sculpture in Georgia related to ancestor carvings in West Africa. Iron works with african patterns, shapes & forms as their decorative structure. Traditional plaited hair styles & clean headed yoruba hair cuts on our men. Painted faces going back to ritual faces. The complex sets of african american quilt patterns and systems have real relationships to african plane geometry. The designs are as complex as woven kente cloth from Bonwire & the choices of antisimilar harmony in accentuated color choices of organic patterns with geometric patterns against plain color are directly observable in how a Fanti woman in Ghana combines her blouse and bottom wrap. These things are all visually apparent as the connections are made with our heritage.

The important thing is not that the establishment has been offended by the pressures of the times but that African American creativity, on all levels, develops the ideas, tools & actions that provide the revolutionary change necessary for a positive world humanism.

1971

Tom Lloyd, "Introduction"; Melvin Dixon, "White Critic—Black Art???"; Tom Lloyd, "Black Art—White Cultural Institutions"; Imamu Amiri Baraka, "Counter Statement to Whitney Ritz Bros"; Jeff Donaldson, "The Role We Want for Black Art"; Bing Davis, "White Art Historians—Black Art"; Ray Elkins (The People's Artist), "Rebuttal to the Whitney Museum's Introduction"; Francis and Val Gray Ward, "The Black Artist—His Role in the Struggle"; and Babatunde Folayemi, "The Re-defining of Black Art," in Tom Lloyd, ed., *Black Art Notes*, self-published pamphlet, 1971

The backlash against the Whitney Museum of American Art's exhibition *Contemporary Black Artists in America* (see pp. 333–40) culminated in the booklet *Black Art Notes*, edited and self-published by the artist Tom Lloyd. Social activism was important to Lloyd, and in 1971, he founded the Store Front Museum in the predominantly Black neighborhood of Jamaica, Queens, to benefit the local community. In his introduction, Lloyd describes *Black Art Notes* as a "counterstatement" to the Whitney's exhibition. While the collection of writings had been instigated by *Contemporary Black Artists in America*, Lloyd points out that it had developed into a broader proclamation of the "Black Art philosophy." Although Lloyd used this opportunity to criticize the Whitney, he nevertheless allowed his work to remain in the exhibition.

The quotations in all capital letters that begin the text here were printed on the front and back fold-out covers of the pamphlet.

THE DEGREE TO WHICH BLACKS CAN EX-PUNG [sic] FROM THEMSELVES A NEED TO BE ANOINTED AS HUMAN BY WHITES AND REPLACE IT WITH A NEED TO BECOME THEIR OWN SELF-DEFINERS IS THE DEGREE TO WHICH THEY HAVE ACHIEVED LIBERATION.

PRESTON WILCOX

FOR THE 1970's AND BEYOND, THE SUCCESS OF POLITICAL, ECONOMIC AND EDUCATIONAL THRUSTS BY THE BLACK COMMUNITY WILL DEPEND ON BOTH THE AESTHETIC THAT BLACK ARTISTS FORMULATE AND THE EXTENT TO WHICH WE ARE ABLE TO CONTROL OUR CULTURE.

RON WELBURN

UNIVERSALITY RESIDES IN THE DECISION TO RECOGNIZE AND ACCEPT THE RECIPROCAL RELATIVISM OF DIFFERENT CULTURES, ONCE THE COLONIAL STATUS IS IRREVERSIBLY EXCLUDED.

FRANTZ FANON

WESTERN CULTURE IS SIMPLY DECADENT. IT HAS LIVED PAST THE POINT OF CREA-TIVITY OF ITS VALUES AND CONTINUES ONLY BECAUSE OF THE MOMENTUM OF ITS PAST.

JOHN O'NEIL

I WOULD LIKE TO SEE THE IDEA OF "UNI-VERSAL" LAID TO REST, ALONG WITH SUCH OUTMODED USAGES AS CIVILIZATION, AS APPLIED TO THE WEST; SOCIAL PROTEST, AS APPLIED TO AFRO LITERATURE; PAGAN AND FETISH, WHEN APPLIED TO NON-CHRISTIAN RELIGIONS; PRIMITIVE, BARBARIAN, AND FOLK, AS APPLIED TO LIFE-STYLES OR AS JUDGMENTS OF CULTURE; AND JUNGLE, AS APPLIED TO AFRICAN SPACE. THESE TERMS ARE TOO-HEAVILY WEIGHTED EUROPEAN CULTURE JUDGMENTS TO BE OF MUCH USE.

ADAM DAVID MILLER

BLACK PEOPLE THROUGHOUT THE WORLD HAVE BEEN SENTENCED BY WESTERN MAN TO CENTURIES OF SILENCE. AND NOW IN THE MIDDLE OF THE TWENTIETH CENTURY, IT IS TIME FOR THEM TO SPEAK. WESTERN MAN WROTE HIS OWN HISTORY AS IF IT WERE THE HISTORY OF THE ENTIRE HUMAN RACE.

JOHN OLIVER KILLENS

THE EARLIEST AFRO-AMERICAN ARTISTS— THE CREATION [sic] OF THE SPIRITUALS— CONSTRUCTED NEW FORMS WITH WHICH TO DEAL WITH THEIR RACIAL EXPERIENCES. NOT HAVING BEEN SEDUCED BY THE SCHOLASTIC MERLINS, THEY WERE FREE FROM THE MYTHS THAT BLACK MANHOOD WAS ATTAINABLE ONLY IF ONE TRANSCENDED HIS RACE AND GROUP EXPERIENCES.

ADDISON GAYLE, Jr.

THE WHITE MAN'S ESTABLISHMENT CON-TROLS THE BLACK ARTIST THROUGH THE MEDIA. THAT IS, THEY DETERMINE HOW MUCH EXPOSURE THE ARTIST WILL RECEIVE. WHAT THEY DO IS TO TAKE ONE ARTIST AND PRO-JECT HIM AS BEING THE BLACK VOICE. THIS HAS BEEN HARMFUL TO OUR COMMUNITY BECAUSE NO ONE MAN CAN CONVEY THE RICH-NESS OF THE BLACK EXPERIENCE. THIS HAS ALSO BEEN HARMFUL BECAUSE THEY HAVE MANAGED TO CONTROL THE IMAGE THAT HAS BEEN PROJECTED.

JOHN CHANDLER

ART WAS A LIFE EXPRESSION. THERE WERE NO ART MUSEUMS OR OPERA HOUSES IN PRE-WHITE AFRICA. ART AND AESTHETIC EXPRES-SION WERE COLLECTIVE EXPERIENCES IN WHICH ALL THE PEOPLE PARTICIPATED. ART,

IN SHORT, WAS NOT FOR ART'S SAKE, BUT FOR LIFE' S SAKE.

LERONE BENNETT, Jr.

WHAT IS BLACK ART? I WOULD VENTURE TO DEFINE IT TENTATIVELY AS THAT ART WHICH DERIVES ITS INSPIRATION AND SUSTENANCE FROM THE STRUGGLE OF BLACK PEOPLE FOR ECONOMIC, SOCIAL AND CULTURAL POWER; AND ART WHICH REFLECTS, CELEBRATES AND INTERPRETS THAT STRUGGLE IN A STYLISTIC MANNER WHICH IS MEANINGFUL TO THE AFRO-AMERICAN COMMUNITY AND MEMBERS OF OTHER OPPRESSED MINORITIES.

HUGHIE LEE-SMITH

BLACK ART CAN BE RECOGNIZED FOR ITS WARMTH, ITS FERTILITY, ITS VISCERAL QUALITIES.

JOHN BIGGERS

BLACK ART IS A VISUAL ATTEMPT TO FIND A VIABLE FORM WHICH RELATES DIRECTLY TO THE BLACK EXPERIENCE. WE ARE UNDERSTANDING IN A VERY PRECISE WAY THAT WE ARE A PEOPLE OF A PARTICULAR RACE AND CULTURE. IT IS THE GRAPHIC LANGUAGE OF SELF-ASSERTION AND IMMINENT MATURATION OF BLACK PEOPLE LIVING IN A DEGRADING AND OPPRESSIVE SOCIETY THAT OFFERS LITTLE LIBERATION OF THE BLACK POTENTIAL. IT IS AN ATTEMPT TO IMPRESS IN BLACK TERMS THE SENSE OF WHO AND WHAT WE WERE, WHAT WE ARE NOW, AND WHAT WE CAN BE.

PAUL KEENE

BLACK PAINTERS MUST REALIZE THAT WE, TOO, HAVE AN AESTHETIC. WE NEED NOT NECESSARILY WAIT FOR WHITEY TO APPROVE OUR AESTHETICS. WE HAVE A PSYCHOLOGICAL NEED: WE OURSELVES MUST FIND SOME SALVATION. WE MUST FIND THAT IT IS NO LONGER NECESSARY THAT WE WAIT PATIENTLY, WHILE THAT WHITE POWER-STRUCTURE-THAT-BE DECIDES WHICH ONE OF US WILL MERIT ANY CONSIDERATION, IF ANY, AND TO WHICH LITTLE BLACK ANTICIPATING ARTIST THEY WILL, IF THEY SO DEIGN, GIVE ONE OUNCE OF RECOGNITION.

BERNIE CASEY

UNLESS THE BLACK ARTIST ESTABLISHES A "BLACK AESTHETIC" HE WILL HAVE NO FUTURE AT ALL. TO ACCEPT THE WHITE AESTHETIC IS TO ACCEPT AND VALIDATE A SOCIETY THAT WILL NOT ALLOW HIM TO LIVE.

BROTHER KNIGHT[1]

LET OUR ART REMIND US OF OUR DISTASTE FOR THE ENEMY, OUR LOVE FOR EACH OTHER, AND OUR COMMITMENT TO THE REVOLUTIONARY STRUGGLE THAT WILL BE FOUGHT WITH THE RHYTHMIC REALITY OF A PERMANENT REVOLUTION.

RON KARENGA

BLACK ARTISTS SHOULD DEVOTE THEIR TIME TO EXPRESSING THE NEEDS, ASPIRATIONS, PHILOSOPHY, AND LIFE STYLE OF THEIR PEOPLE. THEY SHOULD DEAL WITH THE SOCIAL PROBLEMS THAT BLACK PEOPLE ARE HAVING IN THIS RACIST SOCIETY, SO THAT THERE WILL BE AN ACCURATE RECORD OF OUR PROGRESS FROM AN OPPRESSED TO A FREE PEOPLE.

DANA CHANDLER

BLACK ART WILL ELEVATE AND ENLIGHTEN OUR PEOPLE AND LEAD THEM TOWARDS AN AWARENESS OF SELF, I.E., THEIR BLACKNESS. IT WILL SHOW THEM MIRRORS, BEAUTIFUL SYMBOLS AND WILL AID IN THE DESTRUCTION OF ANYTHING NASTY AND DETRIMENTAL TO OUR ADVANCEMENT AS A PEOPLE.

BLACK ART, AS IS AFRICAN ART, IS PERISHABLE . . . LIKE A POEM IS WRITTEN NOT TO BE READ AND PUT ASIDE BUT TO ACTUALLY BECOME PART OF THE GIVER AND RECEIVER; TO PERFORM SOME FUNCTION TO MOVE THE

MOTIONS, TO BECOME A PART OF THE DANCE, OR TO SIMPLY MAKE ONE ACT. WHEREAS THE WORK ITSELF IS PERISHABLE, THE STYLE AND SPIRIT OF THE CREATION IS MAINTAINED AS IS USED TO PRODUCE NEW WORKS.

DON L. LEE

THE BLACK ARTS MOVEMENT IS RADICALLY OPPOSED TO ANY CONCEPT OF THE ARTIST THAT ALIENATES HIM FROM HIS COMMUNITY. BLACK ART IS THE AESTHETIC AND SPIRITUAL SISTER OF THE BLACK POWER CONCEPT; AS SUCH, IT ENVISIONS AN ART THAT SPEAKS DIRECTLY TO THE NEEDS AND ASPIRATIONS OF BLACK AMERICA.

LARRY NEAL

WE DON'T BELIEVE IN ART FOR ART'S SAKE; THAT IS AN ESSENTIALLY WESTERN CONCEPT. WE BELIEVE THAT ART IS A MEANS TO MAKE PEOPLE MORE AWARE OF THEIR HISTORICAL ORIGINS AND THE VITALITY OF THEIR OWN CULTURE.

TOPPER CAREW

TOM LLOYD, "INTRODUCTION"

The spirit of the Black Arts Movement is expressed here by Black artists of the many disciplines embodying Black Art. Their positive philosophies affirm a need for a collective effort to project, glorify and protect Black expression from the destructive forces that threaten its survival.

What began as a counterstatement to the introduction in the catalog (herein included as an appendix) of the *Contemporary Black Artists in America* exhibition at the Whitney Museum in April 1971 has transcended its original purpose and has become more than just a rebuttal to the misrepresentations in the introduction. It has developed into *Black Art Notes* which is a concrete affirmation of Black Art philosophy as interpreted by eight Black artists.

Many included are undergoing a baptism of thought; all are formulating principles and criteria as it relates to the Black aesthetic and the struggle for Black Liberation.

MELVIN DIXON, "WHITE CRITIC— BLACK ART???"

I am not about to defend the Black Arts Movement in any way, for it needs no defense. It is indeed beautiful and artistically productive in spite of itself. However, I would like to set the record straight about white involvement in the Black Arts Movement, mainly criticism.

Black Art, by definition, exists primarily for Black people. It is an art which combines the social and political pulse of the Black community into an artistic reflection of that emotion, that spirit, that energy. As an aesthetic foundation it seeks to step beyond the white Western framework of American art which has enclosed and smothered any previous expression of Blackness.

Both by choice and design, Black art is not a part of the American cultural scene. Its aesthetics is deeply rooted in the day to day existence and/or activity of Black people. Any investigation of this aesthetics has been denied or washed over so that an indigenous Black art has all but foundered in the mainstream of commercialism.

Black art reflects the activities of Black people. It unlocks the ideological barriers of the slave-nigger-negro-black mentality in us to foster a greater expression of the free creative consciousness. By definition it is beyond the sick white culture that runs the entire course of its Western aesthetics, and can now only make desperate attempts at grasping some essence of life through a decadent nudity which only exhibits pale, ragged, sterile bodies or forms in the name of new ART. Ha!

BLACK ARTISTS

Black artists don't need that, thank God. For we have a much greater realm to deal in. . . . The esoteric idiosyncrasies and nuances of Black life are open to our fruitful investigation. And we must take full advantage of its warmth and beauty, thereby realizing a greater artistic representation of life.

Because we choose not to follow traditional Western approaches to art and allow its tired definitions and categories to define us, we look to life itself, our life, which as a result of cultural oppression is infinitely more different than any other life on this planet. Therein we find our aesthetics and finally our critical expertise.

And yet, the popular media of today dares to send white critics to Black shows to review some idea, some expression of art which is totally alien to their existence and their accompanying Western frame of reference.

ANGRY?

As a result of the cultural incompetence of white critics, we find such ludicrous statements like, "Black playwrights are angry" or "So and So is Black America's version of P. T. Barnum." These statements show no insight into the accomplishments of Black artists, and only degrade the quality of the work through alien references. An insult? You bet it is! When are you people ever going to stop comparing us to dead "heroes" of the Western civilization which is all but dead itself?

Attempts at such misguided comparisons show quite clearly that white America is a long way from recognizing Black people as Black people. Must we always be whitewashed, and always misunderstood?

A white person as "critic" does not belong in Black art. He cannot establish himself as one who can effectively measure the worth of Black productions for they are beyond his jurisdiction. For example in Black theatre he can't even begin to question the acting, because he has little insight into the varying characteristics and movements of Black people. It has been more convenient for the white critic to label everybody as either a "militant" or a "Tom." That hardly fulfills the responsibility of the critic in his evaluation of the success or failure of the production.

OUTSIDER

A white critic in Black art is only an outsider looking in. He cannot validly assess the artistic merit of the Black experience because, more often than not, the whole ritual is simply beyond his comprehension or concern. He is unaware of the various rhythms and pulses within the Black community, or the ideological differences among Black people. He is not in direct communion with the artist, for Black artists speak primarily to Black people . . . the Black community, and from that spiritual union he is barred by necessity.

AFRAID

White critics cannot, or are simply afraid to, deal with the complexities of Black life styles and explore the ambivalent relations among Black people. This type of critical investigation must be the work of Black critics. It must be the commitment of the Black critic to effectively analyze the development of the varied Black arts and through a critical eye, focus towards the progress of Black art in all its dimensions.

Black art will never grow as a meaningful expression of Black people unless it is criticized by Blacks and geared in new directions with the Black community. As a member of the community, the Black critic must be a spokesman for the community and himself. He will then provide a truer assessment of the art and the artist in the move toward the liberation of Black people. White critics cannot function as such. They always stop at the "anger" and never fully and really get at the heart of the artist's message to his community/audience.

FOR BLACKS

All manifestations of Black art are first and foremost for Black people in an effort to liberate them to a higher level of self-consciousness. That goal has little to do with white people. So when the critics gasp at the Hollywood-ish revolution, "Uptight" and that sick, sick pseudo-militant clown show "The Lost Man," and say "Wow, look at all those angry militants, that's great" as they write in masochistic ecstasy, let the Black critics deal with the Black artists. We know what we are looking for. We know how effective Black art can be to Black people. And we deal with the situation through our own artistic and cultural frame of reference.

When white people stop trying to criticize Black accomplishments, then maybe Black artists will stop catering to the white audience for white approval. Then perhaps Black art will progress to a deeper spirituality beyond the decadent sterility of that Western omnivorous monster called "Art," . . . and indeed be BLACK!

TOM LLOYD, "BLACK ART—WHITE CULTURAL INSTITUTIONS"

A focus on the institutions of the art world establishment reveals that it is one of the most deeply racist faces of our society. Its oppressive factor in frustrating Black imagery cannot simply be bypassed. Its refusal to project our unique cultural contributions separate and apart from theirs is, in effect, a total rejection of or a belief that our culture does not exist per se; for them it exists only in the expediency of its immersion into the downstream of American art.

The introduction in the catalog of the Whitney Museum is interesting. It shows how a "white culture-maker for the Black people" can skillfully use Black artists' quotes out of context and turn them into a philosophy supporting the white man's vested interests. The intrusion into the Black experience was justified by the pretension that freedom can be achieved only in the unfolding of the art for art's sake concept. Indeed can an oppressed people afford the luxury of an "undynamic" art? The answer is "no." Besides the Black artist will never be free as long as the white man persists in playing his devil's game of picking who is to be considered free and who is to be admitted to his realm.

Indeed can the Black artists sit back and watch while white critics and white-oriented institutions dilute, polish and whitewash Black art? Again the answer is definitely "no." And if art is indeed a creative process which involves the conscious and unconscious mind and soul, then who can assess the intrinsic value, channel and determine the growth of Black art but the Black artists and critics themselves.

Black art stems from Black culture; and Black culture, in spite of all the imposition of Western culture, cannot but depart from an African source and cannot but proceed along its own line of development. A development which in the last centuries, has been warped and mutilated but which is now seeking to shake off the trammels of oppression and to achieve its own natural peak of progression. Inherent in such a development are conflicts and complexities which can be understood and analyzed only by the people involved in the struggle itself—here the struggle for a POSITIVE, SELF-AFFIRMING BLACKNESS.

It goes without saying that whites, be they racist (consciously or unconsciously) or well-intentioned liberals, cannot with any full meaning begin to fathom the depths of Black culture. They cannot but be falsely biased when they use their own yardstick of Western values (assumed to be universal) to judge Black artists in terms of their own experiences. Nor can they prevent themselves from slipping into stereotypes. Since they can only go so far—they may see anger or other outward manifestations in the work of the Black artists but they will never fully comprehend the lifestyles of the Black people enough to enable them to get to the core of the artists' dilemma or message to his own people.

On the other hand, white institutions which have the power to encourage and foster Black creative energies have failed to do so. Museums have more or less become an organ which promotes a non-art aesthetics of a Western aesthetic in its death throes. Check out the games being played—Non-art, Anti-art, Conceptual art, Impossible art, and Earthworks to bury all these bizarre fantasies in. Its constant compulsion for taking an anti-life posture shows that its artistic dynamics is ebbing out. While currently playing the games of the white artists the institutions are programming and pressuring Black artists to conform to the images and values of their white audiences by giving out token rewards, white recognition and acceptance into the art world. Consequently, some identify with their oppressors, others tone down their aspirations and deny the relevance of their color. One wonders to whom they wish to communicate and what do they wish to communicate?

The same might be asked of the white-oriented institutions.

Under pressure, these racist institutions make many deceptive moves—seemingly professing reforms. In the case of museums, they hurriedly assemble "instant token" exhibitions; always featured in these one-shot shows are the non-political "cooperative" Negro artists whose bowing movements are readily spotted as talent. Other institutions have gone so far as to install Negroes as trustees to give that "integrated look"; and very often they get angrier than their white counterparts when confronted with Black demands. These devices are used to create an illusion—an illusion that encourages conformity and non-creativity. They are methods to control us through self-denying Negroes and deceptive plots to frustrate Black imagery.

Although the artist's involvement in his community must have first priority there is still some justification to the Black artists' demand for the portrayal of their historical and contemporary accomplishments in established cultural institutions. Of particular concern is the Black youth in the Public and High Schools network. Compulsory educational requirements demand that they visit cultural institutions to view exhibitions. These collections, however, are invariably on the history and art of cultures other than their own. Curious minds and eyes are thus denied knowledge that relates to their own history and culture. Also, many institutions have educational departments which package and send out these types of exhibits to the respective schools. Since 35% of the youth attending the New York City Public Schools are Black this seems to be sheer ignorance or a deliberate conspiracy to deny a large segment of the cities' youth their rightful cultural identification.

It is evident that the cultural institutions of America have been created for the white middle and upper classes and designed to promote only Western ideas and culture. In this respect the Lincoln Centers and the other major institutions should be stoned out of existence.

Black people should be aware that their money supports these racist institutions. Cultural institutions are tax-exempt. Tax deductions are a form of public financial support which would find their way into the public coffers without this tax benefit. These institutions are a direct beneficiary of public money—including, of course monies from Black tax-paying citizens; they are therefore obligated to fulfill their responsibilities of full cultural identification for all citizens. As receivers of Local Assistance Funds from the State and other public agencies their responsibilities are made even more clear.

To ensure this representation the creation of minority-directed "Study Centers" within major cultural institutions is an immediate "must." Its focus would be the non-white oppressed minorities, particular consideration being given to Black representation. The "Study Centers" should be endowed adequate funds for a staff to conduct year-round exhibitions and programs—independently.

This program will correct some of the omissions and distortions of the past and more importantly, reflect what is happening to-day in the crucible of contemporary culture in Black and other neglected communities.

Suggestions for Study Centers in Museums and Performing Arts Institutions

1. Resources—In order to be an effective instrument of education a consistent effort must be made to acquire existing materials on the Black and other minority artists. The following should be acquired (by purchase, duplication, rental, etc.)

 a. biographies
 b. catalogs
 c. books
 d. records
 e. films
 f. critical studies
 g. slides
 h. clippings
 newspapers
 periodicals

2. Gallery space—Appropriate exhibition space for retrospective and current exhibitions. At least space for two exhibitions concurrently.

3. Publication of catalogs, monographs, biographical data on the artists. Varied levels, i.e., elementary and secondary levels.

4. Establishment of close ties with the academic community especially with ethnic studies programs always keeping an eye for sound publishable studies (theses) by scholars and experienced writers on art and culture.

5. The availability of GRANTS, COMMISSIONS, AWARDS to persons and/or groups of professional ability in specialized activity (art work, films, slides, etc.)

6. Liaison with appropriate departments of school systems.

7. The publication of a newsletter for the minority artists.

8. The establishment of an inter-museum program for the training of minorities in the museum profession (probably to be worked out with the Metropolitan Museum and the American Assn. of Museums. National in scope. Begin with a pilot project.)

9. Cooperation with other major institutions in arranging special travelling exhibitions and performing art programs.

10. Reproduction of inexpensive art works keeping in mind children and others who have little money (often times none) to acquire a good reproduction.

11. Photography and the exhibition of professional photography work from the above named group of artists.

12. The presentation of appropriate films, i.e., those related to the program of the Study Center. And, where appropriate, the sponsoring of lectures, symposia, etc., etc.

In addition to creating "Study Centers," major cultural institutions must decentralize, not through bureaucratic controls and administrative programming by putting a mini-Lincoln Center or mini-Metropolitan Museum in Harlem, but by decentralizing in a meaningful way. A way which would provide for relevant community control in areas of planning, administration, programming and funds.

It is also of prime consideration that Black artists should organize, not in splinter groups that can be divided and manipulated but, under one umbrella of common strength, conviction and purpose. Only then can effective strategies towards a common goal be devised. Thus we must create

systems embodying a Black aesthetics that will ensure our survival, signal our liberation and glorify our deliverance from overt oppression.

The creation of an independent BLACK ARTS COUNCIL which will support and protect the interests of the Black community and its creative artists is another "must." It could finance community cultural programs, create Black institutions, conduct national seminars, maintain communications, investigate and pressure cultural institutions, State Art Councils and Parks Department Councils for support.

Art, as far as possible, should be inter-connected with political and social action. Community art groups, dance workshops, storefront theatres, film workshops are springing all over the country. Artists are more and more gearing and investing all or part of their creative energies in social action agencies, mental health programs, drug addiction centers and youth organizations. This turning into the community indicates a certain awareness of others in the group—something which has been previously negated. Furthermore, since many of these depend essentially on neighborhood funding there is no requirement to support the establishment values of the dominant culture.

In a society where racist institutions are inhumane and unresponsive to the free expression of other cultures the Black aesthetic will assert itself in spite of all the obstacles of an alien culture.

IMAMU AMIRI BARAKA, "COUNTER STATEMENT TO WHITNEY RITZ BROS"

The idea that "politics," or more precisely, in the case of the Black Artist, nationalism, is only some unnecessary adjunct to the art of the black man, is white colonialism. Of course, the desire by black men over the world to be Self Determining seems a bit extreme to Colonel Blimp, who is now controller of western museums, tho his jr partner, Fagin, who used to run a mobile pickpocketry, is now riz in many cases, to aesthete in residence. This desire of the African Personality to reassert itself, as itself, and very consciously, very deliberately (& as other than step & fechit (for white desire) the 3rd

stereotype in the trio), is the eruption of a counter-form in the closed field of white definition. Ethics and Aesthetics, as Wittgenstein sd, are one.

And it is too late to trot figments of white imagination, posed as black artists, onto a scene of supposed seriousness for the concerns of humanity, and permit them to sing their allegiance to the Western world. The Richard Hunts and Barbara Chases & other less serious names touted as "non-political" black artists do not actually exist in the black world at all. They are within the tradition of white art, blackface or not. And to try to force them on black people, as examples of what we are at our best, is nonsensical and ugly.

Our feeling of *us-ness* is the beginning of our redefinition of ourselves as us-in-the-world. Just as we must understand "personality," that is, the special experience of a soul in the world (tho we do not accept "individualism" the great western ethic-aesthetic which has led to the chaos of the world) so as to speak of the black artist, the African Personality, as being "just like everybody else" is just simply not factual. John Coltrane is a special experience as projection of the African Personality, just as John Cage is a special experience as projection of the special experience that is the European Personality. True Integration in the world would be the world as a varied projection of special experiences each one refined to be hopefully beneficial in some way to the world. The personality as part of the total world community, yes, but we are not talking about the harmful "individualism" of say racism, capitalism, colonialism or imperialism.

The struggle for Self Determination is part of our actual lives, my man. The constant struggle to liberate ourselves, to raise our consciousness, to the point where we are Self Determining peoples is *an actual part of our culture*. The social forces and spiritual conclusions of men's lives are part of the fire that makes art. Men, including artists, reflect the context to which they owe their existence to paraphrase Maulana Karenga. But unfortunately we have always had yodelers of praise for boss even during slavery, some slaves wanted most of all to walk and talk like massa, and denied they were even slaves, certainly they later cd not understand what they had to do with africans, or the need to liberate them, since they were just lak massa, & had only massa's concerns. "Racial hangups" indeed, one lasting racial group was called lynching, and if one definition of "highart" is that it must never depict, draw reference to or exact meaning from, the real world of living men and women, African peoples have never made much art like that before, or during slavery, or now, while we move to make our gettaway.

To paint white colored and call it black is the white man's reaction to the movement of the Black Artist for Self Determination, which is the only "artistic freedom." A Black Arts show full of white artists in Black face, soulpimps, pathological niggers who love white flesh, is the white man's idea of what a black arts show is all about. He is so racist he cannot understand that there is beautiful expression in the world totally unrelated to his corny little version of where beauty's at.

But in criticism of even the righteous brothers involved with all this, World Africans will never be totally liberated until we have institutions of our own to maintain and develop our own expression, and to relate that expression to the world. We must suffer the distortion of other people's imposed definitions (which is racism &/or ignorance) when we willingly or unwillingly submit to their handling and "scholarship." Wd that we wd all move to establish our own institutions and be giving up great amounts of energy towards that end. It is also one form of self-defense. They are a pyramid of revolutionary purpose. Self Determination, Self Respect (by creating institutions that express & legitimize our culture) and Self Defense (physical mental & spiritual). Art should be about these things—It must be these things.

JEFF DONALDSON, "THE ROLE WE WANT FOR BLACK ART"

In their book *Black Rage*, brothers William H. Grier and Price M. Cobbs suggest that Black men defensively equipped with paranoic personalities survive the experience of America much better than those who are not so fortunately afflicted. And if this true,

if black paranoia is a requisite for black sanity, I have no anxiety regarding my own mental health. For I feel that there are forces all around me that constantly deny my humanity and even question the very fact of my existence.

These dehumanizing forces are present in every visible manifestation of the "American culture," from popular media to scholarly textbooks. If you examine a typical newspaper, you will find that Black people are only newsworthy when they are restricted, convicted, or evicted. One rarely sees a Black human-interest story, and I dare say that there are today more occurrences of genuine human interest in any black community on any given day than in most white communities in a whole week. For the black community is today enjoying a rejuvenation of the spirit and a sense of belonging and becoming which is overwhelming in its goal, its tempo, and its momentum.

BLACK IMAGERY IS EXCLUDED

In my own special field, art history, I am constantly confronted with assaults on the dignity of my past and creative worth of my present and my future. I find that the art of my forebears was not art after all, but rather the intuitive expression of a people whose system of government was "tribal," whose artistic output is in the "curio" class and categorized as "primitive art," and this despite the heavy debt that modern Euro-American art owes to the work of my ancestors. Indeed, we may even lay strong claim to a sort of step-parentage to classical Western art as well since archaic Greek art sprang from the loins of Egyptian art. All this despite the significant expression of black craftsman during the slave period, the extensive creative output of the Negro Renaissance artists of the 1920s and '30s, the Atlanta school of painting of the later '30s and '40s, the outstanding black murals of the depression years, and the artistically and socially important work done by black artists in the period since World War II.

ART FOR THE PEOPLE'S SAKE

Despite all these facts, the most extensive college-level reference work on American art, published as late as 1966, makes a one-paragraph reference to one contemporary black painter and one mulatto (that's the author's word) carpenter of the colonial period. No other black mark stains the pages of this scholarly ode to white supremacy, and the book is 706 pages long. Now while my remarks have reflected the situation in art history, similar cases could be made for black music, the black spoken and written word, black dance, the entire spectrum of what we call the arts.

But I don't tell this in a "woe-is-me" attitude. I tell you how a substantial number of us feel about what we see, and I tell you we don't like it, and here are some of the things we're doing about it. Black image makers are creating forms that define, glorify, and direct black people—an art for the people's sake. Those of us who call ourselves artists realize that we can no longer afford the luxury of "art for art's sake." Black scholars are reassessing the relevance of their studies in the light of black peoples present and future realities. We will no longer permit so-called higher learning to separate us from our people. We will no longer permit academic degrees to function as wedges between us and our peoples needs and desires. We will no longer permit scholarly language, useless theoretical doubletalk, and esoteric dilettantism to make our academic and artistic exercises unintelligible to our people. In other words, art or knowledge that does not serve the cause of the black struggle is a waste of valuable time and creative energy. Black artists and black scholars who do not respond positively to the cause of black mental and physical liberation will be considered irrelevant by their grandchildren, if I may paraphrase brother LeRoi Jones. And as we work to define and direct ourselves, as we respond to the challenge of black needs, you must realize, if you are women and men of good will, that you have an equally important challenge facing you. You must realize that race relations in this country will never be the same as they were "in the good old days." Actions must be taken by whites as well as blacks, if we are to remain in the same country (and there is some question as to that). And you must realize that our roles as blacks and whites are clearly defined.

GRADUALISM IS SUICIDAL

Universities and other institutions must not respond to our need with gradualism, for gradualism will be foolish and perhaps nationalistically suicidal at this moment in our history. You must not respond with tokenism because there you only delude yourselves. You must not respond with moderation because this will only make a bad situation worse, and at best will only forestall the inevitable cataclysmic confrontation that arises from hopeless frustration. And so for the sake of us all, if we are to remain one nation, divided even though we may be, we must propose programs that will immediately put right past wrongs and give directions for the future.

WE NEED A NEW AESTHETICS

In art, we are calling for the revamping of the present system of aesthetics and a purifying of the language employed in describing art forms of cultures which fall outside of the purview of the Greco-Roman-Renaissance tradition. Black and white are undesirable synonyms for evil and purity. The term primitive is inadequate for describing a nonliterate culture, and physical beauty and excellence that are truly universal and not limited to Europe and its cultural colonies. We insist on the inclusion of histories of African and Afro-american art in all the universities and educational institutions that serve black people. And these histories must be written by black scholars and not by well-intentioned white ones.

For there is a qualitative difference between being sympathetic and empathetic. And the emphasis I place on visual art is necessary, because visual art expression is the most profound reflection of a culture, and our people must become more aware of their rich cultural heritage.

BING DAVIS, "WHITE ART HISTORIANS— BLACK ART"

The Black artist to-day must not be lulled back to sleep by the white intellectual speech patterns of white art historians. It never ceases to amaze me how some people will attempt to know and understand a whole way of life that is unique to this country by "peering into." We all know to "peer" reveals only the surface characteristics and does not allow one to understand the total meaning of an expression. Most white art historians view the characteristics of Black artists and their work through their own limited and fragmented experiences. The white art historians' past interpretations of the Black man's involvement in art has been more like:

> White man's view of . . .
> BLACK: Totally negative
> BLACK MAN: UNacceptable as a man
> BLACK MAN'S ART: A way of personal expression foreign to the Black man unless practiced in a traditionally accepted style (white-oriented style)

This being the underlying negative attitudes of the majority of past white art historians, it is understandable why they are unable to identify with, dictate to, regulate valid subject matter—historically placed or accurately evaluated. Most of the art of the Black man includes the intellectual response that exceeds the capabilities of most white art historians due to social deficiencies.

He who stops to sort and place Black artists in pre-arranged cubes is already being passed by.

RAY ELKINS (THE PEOPLE'S ARTIST), "REBUTTAL TO THE WHITNEY MUSEUM'S INTRODUCTION"

The Curator has chosen to rap on a subject that no European can rap on. Black art is something that only a Black man can express. Racism in America has made it impossible for Blacks to do their own thing. Now we have people like him running around talking and writing on the subject of Black art and making use of the same old tricks, uncle tom's and black artists who paint things that have no real meaning to the life and death struggle of Black people.

I say *hell no* to that shit. A Black artist must build Black culture, and must be willing to give his life to make sure that all Black children have something of their own to be proud of.

Black people are being killed in the streets, and the Black artist is letting white man tell him not to paint about it. All culture and arts must flow from the People's revolution. Our artist must draw and paint pictures which will inspire our people to fight to free ourselves from the "white rope." African culture is very important. The old culture should be studied and saved so as to educate future generations of Black people.

When I see Black kids being jailed and shot I say, paint it, show it to the world. When there are no jobs for Blacks and children are starving I say, paint it. The Black artist's job is to show all the time the unjust and inhuman treatment of Black people, not to play pussycat with some European.

We have a job to do, and with the help of Allah we can achieve our freedom. As an artist I paint—a feeling that no white man can ever dream about. Nothing is more beautiful than being Black, and being alive and a part of the great mass of Black people all over the world.

FRANCIS AND VAL GRAY WARD, "THE BLACK ARTIST—HIS ROLE IN THE STRUGGLE"

The current phase of the black liberation struggle, this newest Black Power–Black Consciousness stage, successor to the old civil rights movement, is, without a doubt, the most profound and meaningful period of this century for black Americans. No period has produced such sustained political and social militancy among blacks; no period has been such a significant break with the old, stereotyped, white-oriented past; no period has so emphatically validated our glorious African past, as well as our cultural and racial beauty and life-styles. And no previous period has held such uncertainty for the black future. In fact, never in the Afro-American past has it ever been so convincingly uncertain whether we do in fact have a future in the white Western world.

If black Americans decide they do have a future in the white world, the wise prognostication would attempt a forecast no further than the next ten years. These will be pivotal, climactic years, for it will be decided in this decade of the 1970's whether blacks will cease to exist as a people in this country, whether they will discover real freedom and dignity, achieve a cordial accommodation with white people. Whether a state of permanent hostility shall exist between white and non-white peoples in the Western hemisphere. Whenever I talk about the future, it will be this decade I'm referring to. It isn't safe to venture a prediction beyond that.

One fact of that future has already been settled. This concerns the leadership, planning and execution of the liberation struggle, particularly in this century, has centered around one man or a group of men who were vested with charisma, strong abilities and minds, and dedication to the cause which propelled them out front as either the spokesmen for black people or the embodiment of their struggle.

This was true up to April 4, 1968. The shot in Memphis ended all that. In fact, the period of the "noble Negro leader" was headed for extinction anyway, for Martin Luther King, Jr., even if he had lived, would have been the last of the so-called "responsible Negro leaders and spokesmen," titles bestowed on us by white people. The period of sustained militancy and heightened struggle in which blacks have engaged the past five years has lessened the role of the old, familiar "leaders" such as King or Roy Wilkins, and increased the stature and importance of previously lesser known, but strategically placed, men and women whose major contributions to the history of the period and struggle was that they happened to be at the right place at the right time. If there is one lesson the post–civil rights period has taught us, it is that those most likely to shape the destiny of black Americans in the next decade are activists and artists, who may possess additional skills as organizers.

When discussing the black artist and his role, we must begin by dispelling the false notion that an artist is an artist, no matter what his color and that being black imposes no special responsibility on him. Though some black performers deny it, being black does have a particular meaning to the life and work of all black people, artists included, despite instances in which black people have overcome the barriers imposed by racism and achieved a measure of personal success.

Some black artists may have adopted purely Euro-American ways, may have the greatest appreciation for Western culture and values, or have been thoroughly inculcated (brainwashed, in other words) with the white, Western viewpoint. Even so, his Western inculcation cannot wipe away the subjective sense of rhythm, timing, speech and movement that his black culture environment instilled within him. The black artist may not even be aware of the extent to which blackness has influenced him, but in critical situations the influence will inevitably surface. To the extent that any black artist hides from or denies his African or African-American roots, his courage, honesty and dignity as an artist suffer.

How, then, does the artist react if he does admit to influences of being black? Does blackness impose special responsibilities or limitations?

If the black artist is special by virtue of color, does he have to "act black" or "think black" or somehow express his blackness in his every utterance, movement or work? The simple answer to these questions is no; his blackness will express itself, consciously or unconsciously. The crucial issue underlying these and related questions is the artist's own definition of himself and his work. The issue has been debated by black and white artists for decades, maybe longer; whether art exists for its own sake, or is there a related, higher purpose to one's art. If the artist accepts the first definition, art for art's sake, then he believes his work is its own justification and cannot be subject to any external considerations, or variations other than what he himself chooses to impose.

A second school of thought argues that art, like any other aspect of life, is influenced by the artist's own culture and background, and the current conditions of his existence. His art, therefore, must be an expression of life as he sees and feels it. Therefore, a Jewish painter reared in Czarist Russia, for example, cannot help but bring the influences of his life to his canvases. The same is true of a black American, living under the lash of white racism. What else should he be expected to reflect in his art but the feelings of a victim of racist oppression?

This realization seems logical, but did not become a distinct fact of life for black artists until the Harlem Renaissance, from 1919 to about 1931. There were good and great black artists before then but few, if any, distinguished themselves as "black" or "race" artists, preferring instead to be guided by the prevailing standards of art for art's sake.

With the coming of the Harlem Renaissance, the volume, quality and nature of black arts changed—from "mainstream American" to distinctly black art, with obvious, conscious emphasis on racial themes and pride, and with a new fusion of art with the political and social struggles of the day.

This NEW conceptualization of the role and responsibility of the black artist has tremendous import for the black present and future. It was no accident that Garvey-type black nationalism developed during the 1920's as the handmaiden of the Harlem Renaissance. Similarly, it is no accident that, in the late 1960's the cry for black liberation, black culture and identity are inseparable, products of the same source: an intense pride in being black. Black pride and black power are based on the same premise:

• All of America's institutions are racist to the core;

• The political powerlessness of black people—best symbolized by their colonization in big city ghettoes—is directly related to the racism of the white power structure;

• That powerlessness, a political phenomenon, has been rationalized by a set of theories of black inferiority, black laziness, black ugliness, black docility. In other words, a people with no sense of pride, heritage or value in being themselves;

• These theories have been validated by a white man's history and social science which justify and glorify white Western culture and standards, and the white Western economic and political hegemony world-wide;

• Black economic and political power—its theory, if not the fact—rest on a broad amalgam of ideas which reject the entire white Western interpretation of history, thereby providing the basis for a new politics, a new culture, a new economics and a new psychology of black consciousness and pride;

- A rejection of the old history and standards which would redefine the meaning of black existence, past and present.

With the advent of the black power movement, the black artist assumed a new role. The artist became the re-interpretor of the black past, the redefiner of the black present, and the analyst of the black future. He became a creator of a new blackness which has made the most significant break with the past of any generation of Afro-Americans. Since the black artist is central to the re-interpretation of the past, he must be central to the building of a new future.

In the future, I can see the black artist fulfilling six major roles:

1. creator;
2. critic (social and artistic);
3. propagandist;
4. activist;
5. hero figure to young blacks;
6. fund-raiser.

Let's discuss each one of these.

The Black Artist as Creator—The artist will "do his thang" to the best of his ability and commitment. He'll continue to write, paint, act, sing, dance, photograph, play and compose. The crucial difference will be that his reasons for engaging in his art—the standards governing his involvement and the kind of art he seeks to create—will be radically different from the old ones. As has been indicated before, black art of the future won't be art for art's sake, but will be based on a new fusion with the lives and times of black people.

If an artist or writer seriously probes the lives and varying moods of black people, the material he would find would be endless. He would not have to worry about variety and being "caught in a stereotyped bag," as some critics of black artists have charged. While on the point of black artists being "stereotyped," we can't go further without laying to rest that most ancient and preposterous criticism of black artists: that they aren't "universal." Briefly, the argument goes that black artists can't be black and universal at the same time; that, to conform to "universal" standards, black artists cannot treat black subjects exclusively but must move beyond race in their work to some mythical human (non-black) understanding.

Those who argue this point of view miss two obvious, but very essential points. First, their definition of "universal" is not that at all. It is a white, Western standard they are talking about—not one which derives its essence from a collection of thought from all over the world. Their universality is not so cosmopolitan that, say, students and critics in Japan, or Korea, India, or Ghana, Brazil or China would accept its verdicts the same as students in France, England or the United States. When the white critic talks of "universality," he means those forms, subjects and habits common to the white Western world, the United States, Great Britain, Western Europe and Australia.

What the critics ought to realize is that it is they—white Westerners—who are not universal, if we take the meaning of the word literally. The world is three-fourths non-white. How, then, do white critics and students of the arts assume the arrogance, the pure gall, to presuppose that themes drawn from the lives, culture and traditions of the world's majority are somehow not universal?

Secondly, if an artist draws his inspiration only from black people on the South Side of Chicago, is it not possible that South Side blacks are just as human and have just as much to add to the totality of the human condition as the Jews in the works of Philip Roth or Saul Bellow or the Irishmen in the works of James Joyce and Sean O'Casey? The experience portrayed is both limited and universal, if one understands it—as with any other nation's expression.

The new fusion of black art with the politics of black life does not demand that the black artist consistently, without fail, every time he creates, argue the moral superiority of anything, blackness included; nor flail away at the white man in every poem, novel, play, song or picture. There may not even have to always be conflict between "the honky" and black people. In short, blackness demands from the artist, a consistent honesty, a truth to his being, and the fulfillment to his obligation of being black. If these standards are obeyed, his range of

subjects and themes will be limitless, and his universality never in question.

The Black Artist as Critic—This role naturally follows from being an honest, truthful creator. Black artists dealing with the realities of the black condition and the white condition, are strong, forceful critics, indeed. One could argue that their criticism need go no further. However, it must go further. The artist must be a self-critic. The artist must be certain that his visions of life, as it is and as he would like to see it, are so accurately and clearly defined that those who view or listen to his work can share his vision. If the artist is to be crucial to the building of a new future, he has the responsibility to outline and advocate those laws, standards and values he feels are necessary to that future. The artist must be a visionary, a social analyst, the guardian of sacred morals and traditions, the teacher, the questioner and/or foe of those people, practices or habits which do not belong to the new, revitalized blackness.

The black artist has got to perform this role consciously, not necessarily at the risk of diluting his artistic integrity or freedom. The role of the critic, consciously and zealously pursued, will allow for maximum freedom. Indeed, the area of criticism itself may well be another dimension for artistic exploration.

The Artist as Propagandist—This function can engage us in discussion for a lifetime. It goes right to the heart of what academic purists call non-ideological art and scholarship. Their argument is that art and scholarship must be pursued without the imposition of ideological considerations which, if felt, will prejudice their results and jeopardize their integrity.

The non-ideological argument has essentials which, I agree, are useful to blacks. However, its application doesn't prevent black artists from fulfilling their roles of propagandists. That role comes naturally if the artist is true to his subjects as he honestly sees and feels them. Any good writer, for example, who lays bare the sickness of Western society, or the brutality of white Western man, is a good propagandist for the liberation struggle, perhaps unconsciously or unintentionally. There are legitimate limitations to this role and the artist must define his own line of demarcation between artistic fulfillment and the obligation as propagandist. Let me also point out that the liberation struggle does not demand that every single principle of Western society be jettisoned, but that it be revalued in terms of its usefulness to the struggle, and to the new black future. The crucial idea to remember is that the current status of the black condition demands the obligation be met in some way by the artist.

The black artist is morally bound to take up the cause of black liberation in his work, some perhaps more than others, but all to some degree. This assumption rests on two arguments: (1) That no black artist can be true to himself, having been born, reared and shaped by white Western (racist) institutions, without dealing with racism and, at least, by implication, the black liberation struggle. If he is to reflect those forces and values which gave him his being, his vision of the world, how can he avoid dealing with that world from his point of view and remain honest? (2) Although artistic freedom allows the artist a choice of subjects, moods and themes to treat, that freedom does not permit him to skirt the responsibility to black people and, in a larger sense, of all mankind. If there is any limitation on the artist's right to choose his medium, subjects and level of work, it is the overriding imperative of his own freedom as a person, his manhood, and the sacredness of his life as well as the lives of those he purports to explore or influence.

The Black Artist as Activist—The activist role has a practical as well as creative side. Practically, the black artist, like other black people, may one day have to engage himself in the struggle for sheer physical survival. He may have to pick up the gun and use it. If not that, he may be thrust into the position, at any moment in time, of being the chief planner or theorist for a particular phase of the revolutionary warfare. Even if these eventualities don't occur, the artist, from time to time, needs the exhilaration, the warmth, the education of personal contact with things happening in the street.

Creatively, if the artist is to capture the feeling and spirit of those critical movements among black people, he must be there. He must be a part

of them, among and of the people doing the shooting, the burning, the dying, whatever and wherever the action is. The black artist must sometimes become a reporter, not merely a statistical recorder of deeds, but an accurate reporter and interpreter of those deeds for the sake of an accurate historical record. He may record them as part of his art. Whatever his level of commitment and methods, the black artist must be involved. For activism is a critical part of that black life which he must live, know and explore and interpret. However, it should be added that being in touch with brothers and sisters everywhere, whether they are on the corner, in the bars, in the park or direct acting in the struggle, is a critical phase of the artist's preparation for creation, and of his "re-creation" (spiritually) for further creation (artistically).

The Black Artist as Hero-figure to Young Blacks—This role, relatively minor now, but which will grow in importance, has not been thrust upon some black artists. Perhaps it never will be. But it is important to discuss, however, because of the value of the artist's place in the building and shaping of the black future, and the uniqueness of the hero-figure in black life in America, especially the cities.

Outside of those image-figures young people find within their own families, the most popular hero-figures to young blacks have been athletes. Though their value to black children and as black hero-figures is grossly and dishonestly inflated by white people—particularly newsmen—the hero-figure, nevertheless, does have a place in the life of black people, if only to serve as a symbol of healthy adulthood. Black athletes, for the most part, were never the clean livers, and good Christians they were pictured to be. In real life, they were most frequently precisely the opposite.

The black artist, because of the increasing importance of his place in the emerging black communities across the land, may find himself thrust into the position of being one of the most popular, respected hero-figures by young blacks. If one examines the popularity of Ameer Baraka, or Don L. Lee, leader of a new school of militant young black poets; or of James Baldwin, Gwendolyn Brooks, Larry Neal in New York, or Gaston Neal in

Washington, D.C., one would find elements of the black artist already emerging as a hero-figure. The artist, through his work and personal example of discipline, will assuredly have its positive effect on young black people.

The Black Artist as Fund-raiser—Most black artists have already been doing this for some time and shall continue to do it with increasing regularity. It is also part of the artist's life and commitment to black people and their struggle. The amount of time devoted to causes will vary from artist to artist. Their activities will vary, depending on their talents and time. While some painters may find themselves selling some of their works and donating the proceeds to the community museum that sponsored the art show, black poets, or actors or singers may find themselves performing, without charge, at rallies in behalf of a worthwhile cause.

The artist as fund-raiser again raises the question of whether artistic freedom is somehow threatened and/or lessened by the demands of a rising social consciousness. To those harboring such fears or doubts, a short, but timely reminder: The burgeoning social consciousness which black artists express through their efforts to sustain worthy causes through fund-raising, should not be seen as a burden on their creativity, but as an opportunity to expand their understanding of people and things via increased contacts.

What kind of future can black people expect? The uncertainty of the black future is created by the uncertainty of the white response to black demands for liberation. In the interplay of demands and response, these facts are clear: black people will settle for nothing less than total liberation, white people will concede nothing without a demand. White people, given the options of black liberation or black extermination, may choose the latter, if they are led to believe that extermination of blacks will cause them no great sacrifice, and that this is the only way to handle "the problem."

The timing of the black future will be determined by the degree to which demands for liberation are met. However, which of the two options white people choose to exercise and how soon will be left up to the black people, for the choice and

exercise of either option will depend ultimately on the intensity of the black struggle, how much is demanded from whites and how soon. In this sense we blacks will ultimately determine our own future—or if we'll have one.

With the conflict clearly drawn, the future of black people in America seems to be limited to either repressions, genocide, continued hostility, racial separatism as a form of tenuous co-existence, migration to a motherland, or simply social and political stagnation—where we do little or nothing and just hope for a solution to the problems of race and class, in other words, Moynihan's "benign neglect."

Is there reason to hope for a just solution? Does a just solution seem imminent? Both answers are no, for an affirmative answer to either must be based on an honest assessment that the white power structure is changing fundamentally and accepting the inevitability of sharing power, wealth and freedom with non-whites. No such assumption can be made now, and yet it is this very change—in white people, white people with power—that must be the essence of a just, orderly and free society for blacks and whites.

If the black artist has a dilemma, it is that, despite his realization of the black burden and white responsibility, he must address himself primarily to black people at the present time. He cannot talk to the white power structure because it won't listen to him and because his primary responsibility is to black people and their plight.

The task of educating the white power structure of this country to morality and reason rests with white people, particularly white artists and teachers. For them and all well-meaning whites (whoever and wherever they are): their job is not to seek work, or understanding or chances for study among black people, but to exert their energies changing the minds and hearts of white people. Changes inside the hearts and heads of the power elite at Chase Manhattan Bank, General Motors, the Pentagon or the White House are worth far more to black people than all the changes that white missionaries could ever dream of making in Harlem, Chicago, Watts, Africa or anywhere else in the Third World.

BABATUNDE FOLAYEMI, "THE RE-DEFINING OF BLACK ART"

At this time in history when the Black man is beginning to control his own destiny, there is an urgent need for clarification and definition of all those elements that will create his new life style. It is common knowledge that, since being brought to this country, all aspects of the Black man's life have been forceably defined for him by white America. This is particularly true of Black Art forms. The lack of unity among Black artists, the lack of exposure and communication between the Black artist and the Black community, and the absence of a total cultural environment geared towards African concepts helped to kindle the distortion. Until the early '60s, white america was able to condition the Black artists and the Black people into believing that there were only a few Black creators worthy of mention. Black Art as an organized movement was thought to be totally absurd. Therefore, white america was able to dictate to some degree the type of visual images that would be exposed to the Black community and to the world. However, white america's control of the art world was emphatically opposed. Young Black artists began to join together in the true spirit of African communalism, in order to control the direction of their art forms. The Black artists, by purging themselves of all Western concepts and definitions of art and by submerging themselves in the traditional African and Eastern concepts of art, were able to re-establish the religious and spiritual motivations that made art such an integral part of Black culture.

Black art has been returned to Black people, destroying, once and for all, white america's concept of "art for art's sake." Such Black organizations as 20th Century Creators, The Weusi Artists, Afro-Cobra and others, in detaching themselves from the white art world, were able to re-define Black Art. Organizations of Black artists were able to awaken the visual conscience of Black people, and create a market for Black art among Black people. A decade ago, all this was unheard of and non-existent. Black artists in the '60s began to break the crippling hold the white art structure had on them. Within the last

ten years, the world has become acutely aware of the existence of a Black Arts Movement, and international publications attest to this fact.

There is now a growing nucleus of Black artists and many independent Black art institutions which will assure the following generations of Black artist that there is a well-laid Black creative foundation on which they can build. The Black Arts foundation is rooted in spiritualism and a conscience of the Supreme Being. Therefore, the white art world's feeble attempt to understand, control or define Black art is at best a "sad joke," because they are trying to hold back a force that has already passed them by. White america will never again define what is Black Art.

"Unless an artist consciously submits his talents to the will of his God he will never know the full scope of his creativity."

NOTE
1 [Etheridge Knight (1931–1991) was a Black Arts Movement poet. See n. 1 on p. 87 of the present volume. —Eds.]

Henri Ghent, "Notes to the Young Black Artist: Revolution or Evolution?" *Art International* 15, no. 6 (Summer 1971)

According to Henri Ghent, the Whitney Museum of American Art's exhibition *Contemporary Black Artists in America* (see pp. 333–40) was one of several shows in recent years that had proved to be not only disappointing but detrimental to the long-term career prospects of African American artists. Ghent condemned such attempts as token gestures that did not intend to reflect seriously on the production of African American artists. He attributed the inadequacy of the art presented in such exhibitions to a preoccupation with social commentary and argued that future shows should focus on artistic "excellence." With this, he introduced the concept for his show *8 artistes afro-américains*, which opened at the Musée Rath in Geneva on June 12, 1971. The eight participants in this first international group show of African American artists were Romare Bearden, Fred Eversley, Marvin Harden, Wilbur Haynie, Sue Irons (who later changed her name to Senga Nengudi), Alvin Smith, Bob Thompson, and Ruth Tunstall.

HENRI GHENT, "NOTES TO THE YOUNG BLACK ARTIST: REVOLUTION OR EVOLUTION?"

The primary efforts of the young black American artist should be directed toward the development of those *positive*, inherited and socially acquired skills and social attitudes that he has access to by virtue of his African heritage and black experience in America, for this unique combination of backgrounds and influences has positive features. In addition, it makes for an affective and intellectual organism that offers the black artist the basis for evolving a potent art of concrete orientation. If this organism is nurtured with sincerity and dedication, there is no doubt in my mind that black artists will achieve a high level of creativity that would further enhance America's leading role in the world of art.

Generally, the Afro-American artist fails to understand that in order to have a truly meaningful social revolution, he must first effect a *cultural* revolution that is built on solid foundations. It is only after a nation has been made aware of the indispensable cultural worth of its subcultures that it will willingly listen to suggestions for change and/or true assimilation.

The plethora of "black art" exhibits which have inundated the United States in the past three years have clearly pointed out the fact that the majority of black artists do not properly use their African cultural heritage to advance their social causes. An excellent case in point is the recent Whitney Museum exhibit, *Contemporary Black Artists in America*, which displayed far too many examples of "art" that could only be called emotional doggerel. Such unpalatable illustrations hardly provided a convincing report on the plight of blacks in America, and—at best—could only have served as catharsis for the individual.

These "gestures" of recognition of black artists by institutions such as the Whitney actually *prevent* black artists from using their natural endowments in the most effective way. The basic idea, of course is for such institutions to go on record as having given black artists a one-time "showcase"; and that's the end of that. The seemingly almost deliberate choice of sub-standard art that abounds in the majority of these "black art" shows is indicative of the insincerity that prevails among the white curators who, for the most part, have organized them.

What continues to sadden me—and others primarily concerned with *excellence* in art—is the incredible desperation that engulfs the majority of black artists, who literally clamor to exhibit even in these token shows. If they would apply, instead, more concentrated effort to creating the finest possible art—as opposed to exhibiting hastily-crafted works of dubious merit—there would indeed be a considerable difference in the overall quality of their creations. Moreover, black artists are being duped by their own "artist-spokesmen" into believing that once their work is even tokenly exhibited in prestigious institutions, they are "getting it across." In other words, the emphasis seems to be on projecting an inconclusive ideology rather than adhering to universal artistic standards. That they think someone is actually *listening* to what they have to say is, in itself, rather pathetic.

The assortment of weak works of so-called social commentary that comprised the Whitney Museum exhibit was about the most feeble argument for social change that I've witnessed in a number of years. It provided no insight into the wealth of cultural statements that black artists have to offer, nor did it succeed in convincing any sizable portion of the viewing public that the time for cultural incorporation or social reform is at hand. The ultimate tragedy of such exhibits can only be seen in the light of the fact that they impede artistic progress, as well as promoting dissension within the ranks of the black artistic community.

No one (least of all this art director of color) would deny the black artist the right to comment upon the grave social ills that have plagued his people over the centuries. However, if the black artist chooses to address himself to these grievances, he must first ask himself the question: "Will my statement stand as a universal artistic symbol long after the particular events depicted are forgotten?" Only an affirmative answer to this question grants the artist of social protest the right to continue with his

painterly call to revolution. It must be said that my awareness of these artists who attempt to present social grievances through art media has led me to include several of them in my previous exhibitions. They were not, I hasten to add, selected exclusively because of their expressions of social malcontent, but rather, in my opinion, because they made their statements in a highly *qualitative* manner. They too, I was convinced, wanted to be judged only by the artistic merit of their creations, rather than for the social content of their works.

There has been no primary concern either to include or to exclude protest art from the *Eight Afro-American Artists* exhibit which I have organized for the Rath Museum in Geneva, for example. In most cases however, so-called protest art falls so far short of the basic requirement of being art that it would serve no good purpose to present it to European audiences, or even American ones, for that matter. What distressed me most when viewing such work was the fact that the results invariably indicated an obsession with *what* was to be said rather than how *well* it should be said!

In my concern to select art that I deem creative and innovative, the styles that comprise the Geneva exhibition emerged. Since most creative endeavors of blacks today are *required* to be heavily sociological in content, it proved extremely challenging to select art which was noteworthy because it was, first of all, *art*; and if there were sociological implications in the work, this certainly did not alter the basic artistic considerations. In choosing points of reference and inspiration, the Afro-American artist should carefully decide what constitutes an authentic art source, as against drawing upon the misinterpreted and bastardized pseudo-African references that are all too common today. To copy from so-called contemporary African sculpture to gain a sense of form, or to repeat the mass produced "dashiki" designs, only negates the existence of the authentic African art that is to be found. By so doing, black artists not only deny themselves the experience of being truly confronted and inspired by great art, they also rob themselves of a knowledge of their *real* Negritude, which they constantly profess to be seeking. Instead, the Afro-American artist should call upon the best aspects of his African heritage (the intuitive sense of design, the extraordinary sense of color, and gift of improvisation), together with a temperament (naturalness of expression, vitality and humor) that has emerged out of his experience of forced acculturation in America.

Wilbur Haynie, one of four West Coast artists invited to participate in this first exhibition of contemporary works by African-American artists to be shown in a European museum, adroitly uses dynamic design and original color relationships in his Hard Edge paintings. This Los Angeles artist's *Untitled Study*, shown in these pages, for example, embraces the best principles of good *African* art without resorting in any way to mimicry. On the other hand, Ruth Tunstall, a 26-year-old painter-printmaker of Dallas, Texas, freely admits the influence of both Matisse and Vasarély. However, she tempers these influences in her own naturalness of expression, and what results is an art that is at once eclectic and innovative. *Naturalscape*, a mixed media painting with free-flowing and interlocking organic forms, clearly demonstrates how she utilizes both color and form to release her own very individual spirit.

Perhaps the one Afro-American artist whose work best epitomizes the marriage between the African spirit and the black's unique experience in America is Romare Bearden, the well-known painter-collagist. While he cannot be categorized as a social propagandist, Bearden has always taken up the relevant social concerns of the day—which most definitely includes the plight of his people. As a matter of fact, it was "the social condition in America" that "dictated a change" in his style. For years this North Carolina–born artist exhibited as an abstractionist; however, in the early 1960s—when his people's fight for freedom gained intensity—he felt he had to have his say, through his art. This, coupled with his childhood memories of the Deep South, inspired him to develop a new style, that of the photomontage and paste-up collage technique. We may also consider the fact that he may have entered the realm of social commentary because of

the influence of one of his teachers, the German-born George Grosz, who also felt the need to highlight the ills of a society in his art. However, it is obvious that, stylistically, Bearden always looks to ancient Mother Africa for basic inspiration—most particularly the sculptors and metalworkers of the kingdom of Benin. Essential as his formal training was to his development as an artist, Bearden's life-long association with other black artists and intellectuals should not be minimized.

Endowed with a strong sense of design—a special gift that may well be traced to his African heritage—the 57-year-old artist makes formidable use of the disparate elements of photography and documentary film to give immediacy to his work, and often to extend its meaning. The flame of life that permeates his silent rooms, his dignified people, emerges as much from his abilities as a master designer as from his consummate knowledge of the culture he depicts. "What I have tried to do in painting my people," he said recently, "is to see in their everyday life the great classic themes common to all human existence."

The remaining five artists whose work will receive international exposure in the Rath Museum exhibition are: Marvin Harden, draughtsman, of Chatsworth, California; Frederick John Eversley, sculptor, Venice, California; Sue Irons, sculptor, Pasadena, California; Alvin Smith, painter-constructionist, New York City; and the late Bob Thompson (1937–1966), painter. Talented artists all, they share only one other common denominator: they are all black and imbued with a kindred-ship that must by nature assert itself in whatever artistic direction. Beyond these factors, they are individuals, each subject to different influences, with different experiences and techniques, representing but a tiny percentage of gifted, innovative Afro-Americans.

It is hoped that the advent of the Geneva exhibition, *Eight Afro-American Artists*, will provide an occasion for Europeans to become acquainted with their art and, if possible, to share in the spirit in which it was created. This selected group of creative blacks foretells of a steadily-growing segment of serious and dedicated individuals who *acknowledge*

and *utilize* their Afro-American heritage and black experience in a most positive manner.

In my position as Director of The Brooklyn Museum's 3-year-old Community Gallery—America's first experiment in fostering communal creativity within that walls of a major museum—I am deluged with inquiries as to my views and opinions with regard to a black esthetic.

That these voluminous inquiries are directed to me may be attributed to the fact that I myself am black—as well as having been rather outspoken concerning the art establishment's remissness in exhibiting and acquiring the works of first-rate black artists. I am particularly pleased to be able to use this occasion to address myself, to the best of my ability, to some of the oft-posed questions.

1971

Steve Cannon, "Introduction," and "Conversation with Peter Bradley, Curator of *The De Luxe Show*," in *The De Luxe Show*, catalogue for exhibition held at the De Luxe Theater, Houston, Texas, August 15–September 12, 1971

In August 1971, *The De Luxe Show* was installed in an abandoned cinema in Houston's Fifth Ward neighborhood. Following the nationwide criticism of *Some American History*, an exhibition about race presented by the Menil Foundation just six months earlier (see pp. 309–14), *The De Luxe Show* sought to integrate African American and White artists on an unprecedented scale, highlighting a shared artistic endeavor. Dominique and John de Menil asked Peter Bradley, a Black artist from New York whose work had been featured in *Some American History*, to curate the exhibition, which they hoped would rectify the foundation's stature in the wake of the recent controversy. Many leading abstract artists were invited to participate, including Walter Darby Bannard, Anthony Caro, Dan Christensen, Ed Clark, Frank Davis, Sam Gilliam, Robert Gordon, Richard Hunt, Virginia Jaramillo, Daniel LaRue Johnson, Craig Kauffman, Al Loving, Kenneth Noland, Jules Olitski, Larry Poons, Michael Steiner, William T. Williams, and James Wolfe. The show was a huge success, and local visitors attended in droves.

Steve Cannon, born in New Orleans but living at the time in New York, had been a member of the Umbra writers' collective in the early 1960s. His novel *Groove, Bang and Jive Around* was published in 1969. Simone Swan, who conducted the interview with Bradley, worked for the Menil Foundation.

STEVE CANNON, "INTRODUCTION"

Everything was late. Everything had to be done in a hurry. The usual rush. The idea of putting on a show of contemporary artists in a beat up, done seen better days, forties neighborhood in Houston's Fifth Ward had grown out of conversations and a children's art show, at Rice University.

John and Dominique de Menil, who are known for putting on fabulous art exhibitions, had received such an onrush of enthusiasm for the children's show, record breaking attendance, the whole bit, they decided that a show of Now artists should be put up where the folks live and of which the folks would be proud.

Peter Bradley, the associate director at Perls Gallery, was called in to do the job and given a free hand. "I'll be glad to do it. if I can use artworks which I find most interesting at this time. And choose the place where I can have it. Let's find a place, some out of the way place, where people who don't usually attend art shows can see the work."

Two bars and a couple of after hour joints were discarded because the show would have to be in two different places. Finally, after a day of searching and going over the ideas, an old abandoned movie house was found. "This is it. This is the ideal place. I've always wanted space like this to paint in! Let's do it."

The folks lifted their eyebrows. But they agreed. Yeah. It's a little offbeat, but it will be unique.

Peter Bradley went into a huddle with the other artists in New York. They were completely turned around. Hey, that's a great idea. Sure. We'll be glad to participate. Wow. That's dynamite.

Peter chose two or more works from each of the artists, and lined up a photographer, a graphic designer and called the shippers and packers.

Meanwhile, back in Space City, the machinery was put into action. Rice's Institute for the Arts used its expertise to help prepare the old De Luxe. Two dudes from Texas Southern, Mickey Leeland and Jefferee James, were called in, one to coordinate the exhibition, the other to help with the publicity.

The old De Luxe was made ready in 3 weeks *flat* by Jones and Bynam.[1] The seats in the main area were removed, the walls hidden and the stage taken out. The balcony was left intact.

After two or three conferences, and words exchanged over telephone calls, Peter decided that the best thing is to leave the exterior and the lobby just like it is. This added to the historical significance of the movie house. The only thing we're going to change is the main floor space.

Within days. I dropped down to Space City, was met at the airport by Helen Winkler and taken directly to the De Luxe. A sign before we made the turn, caught my eye:

> If we ever stop building
> The future will look pretty
> Black.

I didn't get it. But sat on it for a minute. Helen was busily explaining to me about the De Luxe. We've got this big old movie house, rent free for three months. And two shifts of workers are getting the place ready.

We turned off the expressway onto a dirt road, passed two funeral homes, one with white cadillac limousines, the other with black bottom white top limousines—both ways you will be taken out in style, and entered the main drag, Lyons Avenue.

Signs advertising Hog Maws, Shrimp, Fried Chicken, Home cooking and Bar-B-Que caught my eye, as well as men wearing suspenders and overalls, ten gallon hats and brogans, making it down the street. Right away I knew I was back home. In the south.

The theatre is right up the street, Helen was saying. I saw young boys seated on front porches passing the wine, kids running up and down the street barefooted playing tag, and old men hobblin', talkin' 'bout how it used to be—and shooting wolf tickets.

We pulled off the main drag and parked before a tailor's. A sign screaming Tuxedo Rentals caught my eye. The old, dilapidated, beat up movie house—its marquee all battered with bits of frosted glass missing, signs outside in bright dayglow colors screaming for people to attend this dance, that concert and another's supper cluttered the exterior of the place.

It reeked of a bygone era when money was changing hands like heaven was the next stop.

Folks living it up. The war years. The movie house was known as the family show. And to beat back the rats, roaches, ants and spiders the folks were fighting at home, the De Luxe was the place to go. People would stand in lines, two three blocks long, in down-pouring rain, pants rolled up to their knees, waiting to get in. Once inside they would be turned on to a double-feature with a cartoon and comedy, and if it were summer, to a cool cool breeze. It lasted two decades, and faded in the sixties.

Workers climbing out the walls, falling from the ceiling, dancing across the cement floor bringing in scaffolds humming tunes by Count Basie, Duke Ellington, Lightnin Hopkins, blues with a heavy backbeat, shouted instructions to one another.

The area was more than large enough. Peter had anxieties about too much space between the paintings. But it was just about right. Fifty by eighty some odd feet. Enough room to house the forty artworks which were to be in the show.

The thrill, excitement and enthusiasm caught hold of everyone who was involved. I found myself willingly pulled in by the magic.

Along with Pat Faucheaux and Jim Blue at Rice's Media Center we ordered a whole catalog of movies from King Kong, Stepin Fetchit, Amos and Andy to a whole series of Cowboy and Horror films.

The idea was to have not only the exhibition of fine artworks, but to give the folks in the hood a brief review of American movies, so they could see where that was coming from.

Huge one-sheet posters, a reverse of the exterior of the De Luxe in black and grey, were pasted up all over town. Handbills, flyers, radio and tv time, and newspaper ads, let it be known the show was on.

But word of mouth is always your best bet. And that's what we were counting on. Everyone we talked with was amazed and enthused by the idea: You mean, you're gonna put an Art Show down in the Bloody Fifth Ward?

Yeah. That's right. A group of prominent artists, from New York, England, Chicago and California are going to show their work in Houston.

Bumper stickers on a blue background, print in black and white, flashed: *Hard Art at the De Luxe Show.*

"And why," had asked one of the reporters, "Mister Bradley, do you call it hard art?" Because it's hard to get to. Hard on the eyes, and you gotta look at it a long time before you know what's happening. That's why it's hard.

The tension mounted, along with the excitement as opening day drew near. First with the paintings and the sculptures, were they going to arrive on time? And the De Luxe? Was the building going to be ready? And the media. What would the reaction be to putting top priced art on exhibition in a redesigned movie house? And the people in the community itself, would there be any flak? There was no way to know.

We played the whole thing by ear, getting out the press releases, ordering film, having Peter and myself interviewed on the local educational channel, explaining: the purpose of the show is to let people who don't normally attend museums to see some of the best work that's being created in our time, and in familiar surroundings.

A couple of the artists, Kenneth Noland and Sam Gilliam, came to town to help hang the show. Clement Greenberg dropped in to say hello.

In cowboy hats, Texas styled tailored shirts, the three artists, along with the good folks from Rice's Institute for the Arts, Mickey and Jeff from Texas Southern University, a couple of community organizers and folks from the neighborhood, the whole show was made ready in less than four hours.

The interior of the building had been transformed into a curator's delight. Sheetrocked walls spray painted with two coats of white, a drop ceiling with track lighting installed, an eighteen foot high wall separating the balcony where the movies were to be shown from the rest of the gallery erected, and the cement floor sandblasted. Even the sidewalk outside had been hosed down, the entire area totally cleaned, and neat.

Mickey had posted the photos which just about everyone had taken, from those made at the children's show to those taken all over the Fifth Ward. The actual process of transforming the building and the collective photo on the cover of this catalog were on display inside the lobby.

Hence, social realism exterior, including the lobby, and a space-age, replete with everything, including air-conditioning, contemporary modern museum interior. Dynamite.

The De Luxe, with photos and artworks, told its own story.

On opening day, over a thousand people in their Sunday best had strolled casually through the old-made-new De Luxe to view the artworks. Smiles, happy faces and bursts of enthusiasm all over the place, took everyone by surprise.

The local media played it up. No putdowns. Rave reviews poured from as far away places as Fort Worth.

The local media were elated. They talked about the uniqueness of the show, prominent artists showing their works in Houston's Fifth Ward, the miracle of transforming the theatre, and the fact that some of the artists were there to answer questions about their work. Not a single bad word or putdown appeared in any of the media.

Kids and young adults were the ones who were the most impressed with the show. They scrutinized the artworks, made comments to one another and talked with the artists. The older people shook hands, congratulated all the participants and were delighted that new life, in the form of art and movies, now brightened up the Fifth Ward.

Thru love, respect and a deep commitment to the magic of life, the *Hard Art at the De Luxe Show* had been an idea floating around in a couple of people's heads, then made into an actuality by these very same people. Everybody, getting together, and doing it in less than six weeks.

As we go to press, over four thousand people have seen the show, spread the good word by word of mouth, and more and more will have been gratified before the show closes.

About the show, Kenneth Noland had commented, "It was an experience." And Peter Bradley had added: "We did it. It's out front now. There for everyone to see."

It was more than great fun. It was a blast. And a good time was had by all. Even the critics. Dynamite!

"CONVERSATION WITH PETER BRADLEY, CURATOR OF *THE DE LUXE SHOW*"

SS: You've spoken, lyrically, about art that's clear and free of obstruction. You even said free of pollution. What do you mean?

PB: It's just art that's clean and free and wide open, unlike the art of the fifties and forties which was cloudy. Pollock-type art—big globs that looked good but didn't strike you as being "clean." Clarity and order go all the way back to early Egyptian and African art, so-called primitive. Looks as if they're going to win again. Everyday simple arrangements of color and form seem to break the barrier of all of the erotic-expressionist art. Today's art might be telling a secret about the earth's environment. Art is becoming clean and neat. Clarity moves me. Maybe it's a message, a prophecy. I don't know.

SS: You seem to enjoy the sky, science-fiction, visions of galaxies and the universe.

PB: You see the sky all the time. You see great phenomena in the sky, or in puddles of oil and water on the street, that create fantastic, soft colors. Everyone who's participated in *The De Luxe Show* has those qualities. The art looks simple as hell—unobstructed. Somehow the artists seem to have put those ideas into practice ahead of time.

SS: You enjoyed hanging that show.

PB: The paintings have never been in that kind of space before. They held their own. They shouted in that space! Remember the huge yellow Olitski and how it just seemed to scream? I was afraid that my paintings and Noland's narrow ten-foot strips would be lost in that vast white space. Instead they seemed to get larger. They withstood, on their own. Like Danny Johnson's piece, they seemed to grow. This is a problem the Museum of Modern Art should experiment with. They've crammed dozens of huge paintings into a space and made them look smaller, instead of using the opposite formula. The Whitney, too. The only museum that seems to have found the formula would be the Walker.

SS: It's with warmth that you speak of the feeling that unites the works you chose.

PB: This selection breaks down the barriers that create this whole theory of black shows and white shows. *The De Luxe Show* marks the very first time that good black artists share the attention and the tribute with good white artists. The black artists look good with them simply because they are good. All the artists in the show certainly have paid their dues.

SS: Dues?

PB: Living in poverty. Wondering where the next penny will come from to buy paint, let alone food. Begging to be exhibited. Wondering whether you'll ever be heard, be seen. You can't make out unless you work full time at it. You have to figure a way to make the money to give yourself the time to make that art. Now they have the money and the time to work. That didn't come overnight. As for the blacks, this is the first generation of serious black painters in America.

Sam Gilliam started out eight or nine years ago in D.C. He wanted to make paintings, that's all. His paintings. Not an ethnic statement. Remember, he had no black American abstract artist to look up to! He's the first real black abstract artist that has proven to be great.

SS: When did you do away with image?

PB: When I found out that Kodak can do it far better than I can.

SS: Then what happened?

PB: I kept thinking of a way to apply the paint faster in order to see more color each time I painted. Also, I saw what Olitski had done with spraying. I couldn't do it by hand, it just wasn't fast enough. I had to turn to a mechanical device, a spray gun. The real reason I turned to the spray gun was because it's the only way to put the paint on fast. After working eight hours a day at Perls Galleries, that left me only four to five hours in the night to paint. With the gun I can see more color than mixing by hand. That killed my biggest enemy:

my right hand. This process did away with the tremendous indulgence to create something to which I already knew the answer. With a spray gun I can't foresee what will happen to the surface. With the hand it's all predictable. The spray gun, you know, has a kind of mind of its own.

SS: Surface also means feeling?

PB: Yeah. The shine of the paint, the scale, the texture, the depth, the quality.

SS: What do you see when you look at the surface?

PB: The unknown, the mystery. It deals with an unknown feeling and a feeling of the unknown; something I've never seen before. Using brushes I was always exactly certain of the way it would look. But I don't mean to say the spray gun is my final step.

SS: Your reverence for the unknown, is it at the root of your affinity with the artists you admire? Those you chose for the show?

PB: Yes. They're constantly taking a risk. Noland, Caro and Olitski took their risks, and today they're ahead, they're famous. But others in the show aren't. Let's say all of the artists in this show are children pushing every day toward a new expression. They could be out tomorrow. Yeah, they're constantly taking a risk.

SS: Peter, how did it all begin? How did it happen that you, a painter, were asked to function as curator for this spontaneous exhibition?

PB: I don't know. Didn't it come out of the Rice show *For Children*? Didn't that start the dialogue with the black community in Houston?

SS: I remember. First, there was a question of putting together, hastily and informally, an exhibition of black art in a poor part of Houston; then the idea was discussed with you. Your advice was sought.

PB: That's right. That's when I said that no black artist of any worth will allow his work to be shown in an all black situation, even in a black neighborhood. Some artists were upset by the 1971 Whitney

show of black art from which many withdrew (I refused to be in it) on the principle that we're artists first, artists who happen to be black. We've put too much of our life into our work, and we don't want to be lumped politically. We were proven to be right, at least as far as art criticism is concerned; for you'll remember that press coverage of the Whitney show concentrated on black political stances. Hardly a word was said of the art itself! It embittered many artists who, happy to accept recognition from a museum devoted entirely to American art, ended up being used as a socio-political football, tossed by the white press. Many artists felt trapped and cursed themselves for not having been wiser. They felt used. Anyway, while talking to John de Menil I explained that danger. So he asked, "Well, what would you do?" I told him. Two days later he called me up at Perls: "Peter, would you be willing to put a show together?" Just like that.

ss: You liked the idea?

pb: Yes, very much. Suddenly here's a chance for me to express my ideas for everyone to see! Very few artists ever get a chance to do this, very few. You know words aren't my medium. Art is. Here I'm given the freedom to express how I feel about today's art by selecting what I consider to be valid. As a curator attached to no museum, I have no dues to pay to anyone, no affiliation. It's a chance that artists are rarely given! I liked the risk: all criticism drawn upon the exhibition will have to be borne by me because the works are all my own choice. They're just things I like to see, somehow knowing they're right.

ss: Why Caro?

pb: Anthony Caro is really the first sculptor to make pure abstract sculpture since González and David Smith. His work still looks so strange and new, whereas Smith's is starting to look just a little bit old. I can see it coming. González is great art but it reeks of a period. Plus I think Caro is the best sculptor alive.

ss: Who's Wolfe?

pb: Other than the fact that he's been working with Ken Noland and Tony Caro, helping them make sculpture for the last three or four years (he'll be in a group show of Bennington sculptors at Emmerich downtown in the winter), he looks as though he might be one of the first to make sculpture turn upright without looking figurative. On the other hand Steiner has been able to make it look upright by laying it down at the same time.

ss: Upright?

pb: Yeah, to make sculpture that turns itself straight up and down. The scale of it alone gives a figurative quality. It's almost impossible to elude it. Yet, it's pure abstraction. I think these two guys, Caro and Wolfe, have it. Steiner too. This is the first time in history that sculpture has come to the same level as painting.

ss: Level of what?

pb: Level of appreciation. Viewers are starting to appreciate sculpture as much as painting as an abstract form. In the past they were given sculptures of nudes, Maillol, Rodin, and Henry Moore figurative forms. I'm not knocking the sculpture; instead, I'm sensitive to the viewer and his acceptance of new things being done.

ss: Then why is Caro's piece in the show called *Bull*?

pb: I've no idea why and how names are put on these things. It has no relevance to the art itself.

ss: What about the relevance of this show to the neighborhood people?

pb: To teenagers it's going to be something that comes to town. They don't understand it but it's fun like a circus. To the older folks it's going to be something that they don't understand but they know they should respect it because they hear it's important. But the young kids are *really* the ones that get something out of it. The kids between 7 and 10, maybe 12, because they haven't yet been indoctrinated by bad art, or ethnic art which I think is bad. There's a chance that they can read the art better than most people who frequent

museums and pretend they know. They have a much better chance to appreciate the art and the space. This is all light and airy and free.

ss: Are you talking about black people?

pb: Who else?

ss: Has New York reacted to the show?

pb: Anything that doesn't happen at the Modern Art Museum or some heavy Madison Avenue gallery goes unnoticed, as far as the media's concerned. Which is why, once you live in the city, you get the feeling no other place exists, other than Paris and London. There's a lot of space in Texas for a lot of things.

Simone Swan
August 1971
Houston

NOTE
1 [Jones and Bynam Construction Company was a local, Black-owned firm in Houston. —Eds.]

1971

Steve Smith, "Black Art: The Black Experience," in
Black Art: The Black Experience, **catalogue for exhibition held at Occidental College, Los Angeles, September 19– October 22, 1971**

Black Art: The Black Experience opened in September 1971 at the art gallery of Occidental College in Los Angeles. The curator was Steve Smith, a student at Occidental, whose idea for the show developed after he participated in a seminar on twentieth-century art. The exhibition included works by David Bradford, David Hammons, Marie Johnson, John Outterbridge, and Noah Purifoy, all of whom were represented by the Brockman Gallery, which lent works to the exhibition. The aim of the show was to relate "Black Art" to artists' personal experiences of being Black in the United States, framing the work as a reflection of the Black communities to which the artists belonged. Smith's essay, and particularly its footnotes, show that the arts discourse in Los Angeles was already being influenced by recent publications produced on the East Coast.

STEVE SMITH, "BLACK ART: THE BLACK EXPERIENCE"

Because of the multitude of differences in background, politics, formal training, personality, and even esthetic sensitivity among those American artists who are of African descent, it is impossible to use the term "Black Art" with any real definity and still include all of the widely divergent artistic endeavors of these men. The present exhibition defines "Black Art" as an expression which develops its emotional tenor and environmental content from the unique experience of the black man in America. Although there is tremendous variance in artistic style and content among the many American black artists, there seem to be three basically distinct attitudes which they have taken toward their work.

First, there are those black artists who have had extensive formal training, and who employ the recognized stylistics and techniques of modern art. Their work can he readily classified into the major schools of contemporary art: abstract expressionism, colorist, hard edge, or pop. Two excellent examples are Sam Gilliam, working with stained canvas in the tradition of Morris Louis and the Washington Color School, and Fred Eversley, working in the highly technical and precisely finished West Coast School of plastics. Both men are fascinated by the subtle variations in light, color and form which can be derived from the careful exploration of their mediums and consequently they have not expressed any particular racial feeling through their art. Because they are working within the accepted and conventional boundaries of current esthetics, these individuals can not be said to be creating "Black Art." They are instead, contemporary artists who happen to have black skin. Frank Bowling, a black painter and critic, refers somewhat disparagingly to this group saying:

> Frequently these young black artists insist that they are not "painting black." In a sense, this is an escape from reality. Any black artist who does not want to be identified by the color of his skin could be indulging in a subtle form of "passing."[1]

These men are frequently placed in a very awkward position; being caught between two seemingly opposite poles. The black community often resents their attempt to create art within the accepted European-American standards of aesthetic criteria and subject matter, viewing them as "Uncle Toms" desperately climbing the white Establishment's social ladder. On the other hand, though the two mentioned artists have developed such successful stylistic and esthetic criteria for their work that they compete with contemporary artists on an International level, the artistic "Establishment," including critics and museum directors, have commonly viewed any art done by a black man with a kind of condescending racism, frequently rejecting black art as second rate, and repeatedly excluding it from major surveys of American art. There are, of course, some black men such as Richard Hunt, Mel Edwards, Daniel Johnson, and Sam Gilliam, who have been recognized by both museums and critics as artists of great worth. These men feel that the recent "rash" of black shows, such as the Whitney's *Black Artists in America*, April, 1971, make the mistake of confusing race and esthetics; denying basic artistic standards in an effort to be "relevant." These may be very legitimate complaints from men who have been accepted by the art world; however, it is still very difficult for a young black artist to break the "cultural barrier," introducing any new "black esthetic" as a valid means of formal visual expression. Barbara Rose, for example, has stated that the quality of black art being done today "is largely on a level with what was produced in America during the thirties."[2] This condescending tendency helps to explain why so little of what the black artist has contributed to the development of contemporary American Art had been recognized and acknowledged.

The second major group consists of those black artists who have turned to Africa and its traditional art forms for inspiration. Many American black artists feel that by searching out their cultural roots in Africa, they are developing a logical and dignified heritage for their present work, but too often the richly symbolic forms of Africa which are

based upon centuries of tradition and philosophical development, are strangely misinterpreted or only hollowly copied by the "Neo-Africanists" here in America.

It is well known that African art, especially the mask forms of West Africa, were extremely directive in the development of modern art. Picasso and Modigliani, in particular, exploited the traditional forms of Africa without really knowing or understanding their full religious and philosophical meaning. The "Neo-African" style, as developed by the American black artist, seems to utilize many of the same "typical" African forms. Actually, among the tribes of Africa, there are many identifiably different formal visual esthetics. The traditional art of the Yoruba people, for instance, is unlike that of the Mendeo or Ashanti peoples. Trying to amalgamate these very distinguishable, often opposing, artistic forms into one "African style," is denying the authenticity and importance of the individual tribal modes of expression.

The direct influence of African art upon the contemporary black artist is a very complicated matter. Eugene Grigsby and John Biggers are two American artists who have frequently drawn upon the philosophical and visual manifestations of traditional African tribal art successfully integrating it into their recent work without sacrificing their own individual style of expression. However, centuries of forced acculturation through the institution of slavery has made it virtually impossible for the Afro-American to continue the traditional forms of African art.

On the other hand, because of the alienation experienced by the black man in the "white" society of America, the Afro-American has created a very distinct sub-culture within the boundaries of the dominant Anglo culture. For example, a certain temperament, containing all of the vitality and rhythm of jazz, has developed out of the estrangement and bitterness created by years of hatred and racism. What distinguishes and constitutes the unique quality of the black artist is the perception that he brings into his art, defining its content and alluding to forms and feelings which are very different from the environment and consciousness of white America. Therefore, the third major group of black artists (those represented in this exhibit) are engaged in a type of personal social comment based upon their insight as black men in America. This experience binds them in a very real way to the black community, and from it has risen a genuine, self-contained style that can be defined as "Black Art."

A developing racial pride and increased black awareness within the Negro community has made it possible for the black artist to take the positive step of freeing himself from an assimilationist role in the arts, accepting the expression of himself and his own cultural beauty as a valid form of contemporary art. David Hammons, for example, portrays the needs, aspirations, hopes, and feelings of the black community today. In *Close Your Eyes and See Black* (1970), he uses parts of his own body to create a surreal figural composition expressing the poignant reality of being black in America. Contemporary events often influence Hammons' art giving it obvious social overtones. In his *Prayer for America* (1970),[3] he integrates a silk screen image of the American flag into the composition creating a political reference to the recent Black Panther trials and shooting. Hammons is very conscious of the formal esthetic possibilities inherent in his unique medium, being able to capture the texture and structure of the body and its clothing showing such minute details as veins and stitching. But as a black artist he remains inseparably a part of the black community stating:

> I feel my art relates to my total environment— my being a black, political and social human being. Although I am involved with communicating with others, I believe that my art itself is really my statement. For me it has to be.[4]

In the same way, David Bradford's works such as *Yes LeRoi* (1969) are hard edged, hard cut expressions of a black man with a tremendous sense of racial pride and unity. His affinity for striking juxtaposition of extravagant, often blatant color strengthens his bold images and gives exalting vitality to his art. This work derives its strength and inspiration

from the black community, directing itself toward the people of that community and evoking a strong emotional response from the viewer.

Other artists comment with a more personal expression developing a black art that is based upon intimate experience. Marie Johnson's wall reliefs show a sympathy and tenderness for the black American reflecting his dreams and aspirations, suffering and pride. John Outterbridge in his *Homage to my Father* (1969) develops an image that is obviously linked to his own life and culture. He is deeply involved with humanity in an "effort to understand the ordinary things and people that stand close by not readily seen by many and seldom heard. Get to know them, for they are complete, and they are us."[5]

Noah Purifoy works in the medium of junk construction making art from the waste and destruction of our society. In works such as *Sir Watts* (1966) the implications to the Watts Riots and the tragedy of the holocaust are obvious, but man's ability to create order out of disorder and beauty out of ugliness is also essential to their meaning. Purifoy's current work relates the situations in which economically deprived people live. As an artist and social worker living in Watts, he is skillfully able to describe the Ghetto environment with found objects that were once a part of the situation being portrayed.

The black artist can express feelings and experiences that no one else can express with quite the same validity, because, as Romare Bearden once stated: "You can't speak as a Negro if you haven't had the experience."[6] Because the black artist has the capacity for this unique form of self-expression, he is creating a new art movement based upon defining black culture in America with a strong emphasis upon the social realities of being black in this country. Walter Jones, a black artist and critic, says: "There's still a mystique about you that hasn't been opened yet."[7] It is this fascinating, elusive, ultimately non-white quality like that inherent in jazz, that will prove to be the significant contribution of "Black Art."

NOTES

1 Bowling, Frank, "Discussion on Black Art." *Arts Magazine,* No. 43, April 1969, p. 16. [See p. 140 in the present volume. —Eds.]
2 Rose, Barbara, "Black Art in America," *Art in America,* No. 58, Sept. 1970, p. 56. [See p. 258 in the present volume. —Eds.]
3 [The work, now titled *Pray for America*, is in the collection of the Museum of Modern Art, New York. —Eds.]
4 Young, Joseph E., *"Three Graphic Artists,"* Los Angeles County Art Museum, January 26, 1971–March 7, 1971, p. 7. [See p. 274 in the present volume. —Eds.]
5 Press Release, Brockman Gallery, Oct. 12, 1969–Nov. 2, 1969.
6 Siegel, Jeanne, "Why Spiral?" *Art News,* No. 65, September 1966, p. 49. [See p. 57 in the present volume. —Eds.]
7 Jones, Walter, "Black Artists," *Arts Magazine,* No. 44, April 1970, p. 16. [See p. 209 in the present volume. —Eds.]

1971

Edward Spriggs, "An Intermediarily Pro/Position," and Cherilyn C. Wright, "*Ten in Search of a Nation*—Exhibition Review," in *AFRICOBRA II*, catalogue for exhibition held at the Studio Museum in Harlem, New York, November 19, 1971–January 22, 1972

After the group's first major exhibition, in summer 1970 (see pp. 219–20), AfriCOBRA returned to the Studio Museum in Harlem late the following year to stage *AFRICOBRA II*. The catalogue opened with an introduction by Edward Spriggs, who had replaced Charles E. Inniss as the museum's director less than a year after the museum had first opened its doors, in September 1968. Inniss had admitted that he, though himself African American, was not knowledgeable about the work of Black artists, and the hostile response to the museum's inaugural exhibition of Tom Lloyd's light sculptures—seen by many as too mainstream and out of touch with the local Black community—brought about Inniss's resignation. Spriggs, a dynamic poet and filmmaker from Cleveland, Ohio, had recently graduated from San Francisco State College, where he had helped to launch the journal *Black Dialogue*. He arrived at the Studio Museum with an understanding of the importance of community engagement and with his support for African American artists already well known. His early programming included retrospectives of Romare Bearden and Elizabeth Catlett (see pp. 400–401) as well as a show devoted to the renowned art faculty at Howard University in Washington, DC. As he points out in this text, deciding to highlight the Chicago-based cooperative so soon after its inaugural display reflected the force and dynamism of AfriCOBRA's aesthetic. *AFRICOBRA II* toured to five other venues in the United States. The catalogue concluded with a review of the group's previous exhibition at the museum by the writer Cherilyn C. Wright.

EDWARD SPRIGGS, "AN INTERMEDIARILY PRO/POSITION"

This is the second year of the AFRICOBRA at the Studio Museum in Harlem. They are here for the second time because we believe that they represent one of the most dynamic combinations of thought, talent and commitment that we know of in the visual arts during this, the era of the "Black Aesthetics" in America. Africobra is a Chicago-based cooperative group that—from their perspective as African-americans—is going about the righteous business of identifying and making use of the styles and rhythm qualities, both the apparent and actual, that finds expression in the lives of black people everywhere. We see in Africobra's concepts and philosophy the emergence of an honestly real-world and people-oriented body of creations. For them the Black aesthetic is not only a possibility, but is in continuous evolution in the lives of peoples of African ancestry. It functions daily in their every mode of expression. We also believe that they are in the fore of those who are forging a style of graphic creations that incorporates, in visual terms, those common characteristics shared by what is generally accepted as Black music and Black poetry.

So whatever you take the AFRICAN COMMUNE OF BAD RELEVANT ARTISTS' works to be, they are not to be considered simply as images of heroes, of sorrow or anybody's notion of protest. Consider Africobra's images to be arti/factors of rhythms. Bridges. Progressions across zones of feeling/thot. Yesterday. Today. Tomorrow. Bloods' memory. Looking into and out of what we know as us. Love. Much wider than the mere notional idea you mean when you say "art." Theirs is a moving away from what we previously understood as art toward a socially reverberating collection of verified truths, modulating visual signals that are closer to what shines/sounds like our own life/ritual/celebration.

Their deliberate imagistic poster-prints—and they want everybody to have some—are invested with definite grasps (truths) brought home in style(s) for the life-vision of the feeler-listener. Intermediary pro/positions they are. Cadences bracketing a specific kind of being/experience, i.e., metaphysical american; geographically in america and metapolitical here too. Black experiencing Black and giving it back—jet-like.

In and thru their various media, the Africobra creators attempt to scourge through the catacombs of our instance, pushing out the dead and the dying, resurrecting spineless souls; they want to expunge the components of our dollar-mache masters held together by the juices of our servitude; they want to provide the symbols to break our entrenched logomachy and push us generations ahead. Each of their image-rhythms, the pace of it, its heat/beat, verges on the future. Is kinetic like *that*. The idea is that action follows thot *by* design. Their intent is always beyond the present. Each piece futurebound.

They see "art" as a movement in-the-round—completing and complementing our bas-relief existence. Africobra's image/rhythms are about busting open the mausoleum-western-art-idea that exist in the plastic landscape of our minds. The "zombie" in us they want to be released. We who are colonized still by hypocritical dream-creeds they want released! The inner shaving of our lives, Africobra wants to spread upon earth surface and sky. They want to replenish our mind/soul/vision/generations. Africobra. Intermediarily. The African Commune Of Bad Relevant Artists. We dig their spirit as a family of image makers making diversity in their unity. And they say, still more is possible. And they want *you* to have some.

CHERILYN C. WRIGHT, *"TEN IN SEARCH OF A NATION—*EXHIBITION REVIEW"

NEW YORK, June 2—Have you seen/been there?
 Studio Museum. 2033 Fifth Avenue. Harlem . . . New York.

They sho nuff got something for you—
 AFRICOBRA

African-Commune-of-Bad-Relevant-Artists.

Come from

South Side, Chicago.

Moving toward

Our Nation.

AFRICOBRA . . .
gettin into sound/color tone/texture Family/
 nation/us.
. . . they even writin on they pictures . . . like

"WE BETTER THAN THOSE MF AND THEY
 KNOW IT" . . . like
"WE WILL BUILD HERE ARE NOBODY
 WILL" . . . like
"BY HONORING MALCOLM WE HONOR THE
 BEST IN OURSELVES." OO-oo-oo!

One of Gerald Williams pieces declares, *I am Somebody*, while Barbara Jones got a sister coolin it on the beach—in the background—miss anne, rubbing tracks in her body with sun-tan-low-tion . . . Sister say, "I am BETTER!" Yeah.

And Nelson Stevens (he a Taurus brother from Brooklyn) got a piece called *A Rite Soulful Brother* in bright/survive/stay alive acrylics. Mosaic. "Brother" come poppin out at you like he a galaxy in the nightsky . . . pah-pah/pah/POW! Brother Stevens did another one he call "JIHAD" . . .

. . . My father ask when he see, "What's a JIHAD? . . . I say "It's a HOLY WAR." . . . Daddy say "Right on!" . . .

. . . and he over fifty.

Wadsworth Jarrell: "If you can get to be bop you can get to me." Now y'all get to this—his piece called *Boss Couple*. Portrait of him and his beautiful manchild. Po-si-tive! Righteous thinkin! . . . He know a dynamic duo when he see one. And then there's his *Homage to a Giant*. It's Malcolm . . . Malcolm. In brilliant tableaus peepin' at/checkin' us out . . . and in humble service, honoring his gentle visage—two young/man/warriors/heroes of a new generation.

But we gotta get hip to elders. Next time you crack on an older brother (over fifty like my father)—check yourself—or better, check Carolyn Lawrence's *Pops*, or Jeff Donaldson's *Amos 'n' Andy 1972*. Them brothers been through a whole lot to get us here. They don' be jivin. You see mo life in they aging eyes then you find on the baddest night

at hugh hefner's. Yeah. They's the brothers what be saying stuff like: "If I can't cut the mustard I mo lick the jar!" Deal with that.

Nelson, Jeff. Carolyn, Wadsworth and Gerald paint. Jae Jarrell is a sister who designs clothes . . . and she got some sho nuff rags for you. Like a suit for sisters with bullets draped cross the jacket in mild attention—ready. She married to the Daddy of *Boss Couple*. They Know.

More handicraft/art. Remember ironwork patch work lye soap? Napoleon Henderson does tapestries. OO-oo-oo! Yeah. He got colors/energy/textures goin—every fiber a conducting vessel to be reckoned with. Touch 'em. let 'em blow your mind.

Brother Omar Lama did a piece of superb symmetry he call *Unite or Perish*. A beautiful 'fro-ed brother shown in two-self. Can you dig it? Unite. He got a *Black Jesus*, too. Mosaic. Shades of our great Eastern Empire.

The hippest thing about these works is that you and I can have them. They gon' be posters. Prices inespensive. Produced and directed by Love For Ourselves, Unlimited. For office, crib, wherever . . . (we gotta get into re-customizing our own environments). Coming soon.

Barbara Jones works specifically towards this end. She deals in silk screen, a hip process where originals can be mass produced cheaply . . . so all black folks can enjoy our art/self. Barbara got another piece so full 'o' rhythm. You can hear it when it say, "rise and take control." (You hip to "For My People," I know.) It moves over time and space . . . "rise and take control . . . rise and take control . . . rise (y'all) and take control."

You ever see the sounds made by Chris Gaddy, Thurman Barker, Joe Jarman and Charles Clark? Jeff Donaldson checked it/captured it for us. Approach with caution/a clear head/make yo mind reel, sho nuff. Then there's Wadsworth Jarrell's musician—writhin' 'n' bobbin'—a bad mf. You kin hear the whee-bo-bom-bah-blah-blee-bah-whoo! They don' be jivin.

Carolyn Lawrence, though, her picture dance. Like the one she call
Manhood. It
shoots straight.

flies right then
dips for the kill.

Sherman Beck BLOWS MINDS. He a Libra. He don' write on his pieces. He don' even name 'em. Don' need to. His Locus: the black/people/mind. Images come exploding out at you past a thousand infinities. It's deep. Yeah. He saying exceed your possibilities, people!

people!

Gerald Williams got something for you. A piece called *Wake Up*. You hip to King Alfred?/Off. U.S. Govt. campaign re: black folk? You should be. see Gen-o-cide. You better.

Oshun, Oba, and Yansan . . . *Wives of Shango* by Jeff Donaldson. Three sisters in proud affirmation of their womb-manness. Wives of Shango consorts to the god of thunder armed and ready to

move
toward
family/people/nation.

Black/woman
our
Queen/self

exquisitely honored by

Jeff Donaldson

. . . who loves us.

The ten bad relevant artists usher in a rich phenomenon—COOLADE COLORS. You hip to our flavor/hues? Orange, grape, lemon-lime cherry black-cherry. Can't nobody do in/with/to them what we were born knowing where/when/how to do. Click. (On my way out the gallery I saw a Sunday sister in a tunic—½ orange, ½ lemon-lime, and ½ size too small.) Aw right! They Know! COOLADE COLORS for days! And they jus don' be puttin reds and yellows and purples and greens together to be singingno rainbows. see Dells.

They make 'em jump out/beat our your heart-throb. make you understand the past and attend to the business of the imminent future—nation building.

And of essences—a rare panoply of contrasting
 values/Positive vs. negative space time/
see what it can do to your mind/
Diamonds and bullets/
exploding cosmic incompatibilities/
BLACKNESS?
THE SUPER REALITY.
ON FACES, shining temples, trembling
in proud anticipation rubied lips singing
Allah/Shango praises for today/
BLOOD AND MUSIC
OUR DESTINY
It's real/truth. And it's all to give re-rise to the
 greatest
FAMILY/PEOPLE/ NATION EVER . . .
we nod.

Have you seen/been there? *Ten in Search of a Nation*. Fifty-two experiences in African-American Art. Studio Museum. 2033 Fifth Avenue. Harlem . . . New York. June 21–August 30. [1970]
 You should.
 For nationsake.

1971

Samella S. Lewis, "Foreword"; Ruth G. Waddy, "Foreword"; Samella S. Lewis, "Introduction"; and Benny Andrews, Nelson Stevens, Noah Purifoy, Cleveland Bellow, and Elizabeth Catlett, untitled statements, in Samella S. Lewis and Ruth G. Waddy, *Black Artists on Art, Volume 2* (Los Angeles: Contemporary Crafts, 1971)

The popularity of *Black Artists on Art* (see pp. 176–80) resulted in the publication of a second volume in 1971. This iteration featured contemporary figures such as Benny Andrews, Nelson Stevens, Noah Purifoy, Cleveland Bellow, and Elizabeth Catlett and was expanded to include artists living and working in Africa itself. The 1970s were a productive time for Samella S. Lewis. As a professor of art history at Scripps College in Claremont, California, she became the first tenured African American faculty member in her institution's history. In the middle of the decade, she and two partners launched the journal *Black Art: An International Quarterly* (see pp. 536–37), and in 1978 she released the comprehensive textbook *African American Art and Artists*.

SAMELLA S. LEWIS, "FOREWORD"

No longer satisfied with having their art viewed as an extension of Western esthetics, Black artists throughout the world are striving to make artistic contributions on their own terms. In other words, they are insisting that their views in relationship to their art be expressive of their experiences.

In *Black Artists on Art*, Volume II, a large number of the artists featured are deeply concerned with the concept of cultural identity and cultural nationalism. Their art is related to daily experiences and they look to their own environments for sources of inspiration and motivation. They know that the act of creating is directly related to their expressive needs.

With the inclusion of the works of Black artists who reside in countries other than the United States, this volume touches on the concept of a global Black community with a common vision and concern for life.

For centuries Black people have been identified on a racial basis rather than on a nation basis. Because this kind of identification occurs frequently, efforts are being made to use it in an advantageous manner in the struggle towards the idea of Nation Building.

The concept of Nation Building on the part of Blacks is not new. Ideas related to this form of organization have been occurring and re-occurring throughout our history. Individuals such as W. E. B. Du Bois, Marcus Garvey and Alain Locke are regarded as a few of the giants who were advocates of a cultural homeland for Black people and who were early to note that "Black is Beautiful."

This volume and I hope future volumes of *Black Artists on Art* will speak to the concept of Nation Building. We can no longer afford the time nor space for unnecessary defensive measures. Our every effort should be used in aggressively responding to and establishing relationships and similarities between our brothers and sisters throughout the world. We must move on with the job of recording and documenting, from our own perspective, those meaningful social, political and esthetic realities of our society and indeed—of our world.

The basic life experiences of Black men, past and present, have not been those of other men. The difference when valued can form the basis for an art that can be a significant and enriching dimension of world art.

Black artists are becoming increasingly aware of the fact that they must be trained and prepared in spirit, mind and technique to develop as prime communicators and perpetuators of the cultural heritage of a large portion of the world's population. They must deal with global concerns of our people in a manner that contributes to their cultural, social, economic and political growth. This must happen before we can unite in a dynamic force for freedom and for liberation.

RUTH G. WADDY, "FOREWORD"

This is a time of political awareness and political activists. Black artists are becoming increasingly aware of and are recording the social position and role of Blacks in our society. Some of today's artists, however, have added the dimension of demanding a better social image to record.

In addition, Black artists in the late 1960s began to demand "equal time" in art reviews of the daily metropolitan newspapers, to picket museums instead of campuses, to demand that their own people buy and support their art, and to determine their own standards of esthetics. These artists realize that no matter how involved they may become in present day problems and issues, that technical competency is not to be sacrificed. It matters not where the work is shown; in a schoolroom, a tiny gallery or in a museum, it must be executed and exhibited in a professional manner.

Many people realize that the forty hour work week will go the way of the passenger train and that computers will be as commonplace in the home as vacuum cleaners are today. This is a far cry from some of the concepts that were held at the beginning of the twentieth century. But we who stay here must accept changes, in order to live in this galaxy in peace. Black artists are among those who are trying to give us a Headstart.

SAMELLA S. LEWIS, "INTRODUCTION"

Art has served man in a broad functional way throughout history. Works created by most individuals were generally for the perpetuation of a particular culture, society, group or clan; most expressed the deeds and aspirations of special interest groups. The theory of "art for art's sake," the belief that art results from and serves man as an esthetic non-essential, is a concept of the twentieth century.

The great periods of traditional art in Africa stand as monuments to utilitarian art in that the majority of the works created were made to fulfill the needs of the communities. Because artists worked and created for the benefit of the community, products which belonged to a political milieu and which were marked by general homogeneity, this did not rule out opportunities for individual expression. The African artists, like other artists, express their personal reactions to external stimuli in accordance with the esthetic norms of their community.

The traditional arts of Africa are important in the lives of the people. In Africa, objects that we choose to call art are used in the everyday affairs within the community. They are not held in high esteem out of proportion to their service. Should a work be lost or destroyed, a new one is simply made to replace it. This attitude keeps the art alive instead of prolonging the life of an object.

In contrast to African concepts, in the Western world the arts have traditionally functioned for those in control of power, and they have been used as instruments to maintain and perpetuate their power. Medieval and Renaissance arts of Europe served the church and state and were not without a relationship to sociology. Art was used as an instrument in the glorification of the institutions. During early periods of church domination, when most people could not read, they learned from "reading" pictorially the stained glass windows located in the cathedrals, the murals in churches and chapels, state portraits, impressive monumental sculptures, etc. The populace were not only informed but they were impressed with the power and might of those represented by the subject matter. Realizing the medium of control that art provided, both church and state saw to it that the direction of art remained in their hands throughout succeeding centuries. Re-examination of the history of the periods will attest to the fact that art was less of a non-essential esthetic expression and more for political and social control.

Social art was used in the early history of the United States to glorify the actions (any actions) of the government and of those sanctioned by the government. The recording of deeds from crossing the Delaware to killing Indians were sanctioned and promoted as nationalistic and American. This art told the people who their heroes were and who their enemies were. It was designed specifically to communicate and edify. Such art is now prized by museums and regarded as a part of the cultural heritage of this nation.

Any instrument or vehicle may be used for "good" or for "bad"—art is no exception. The direction one will take depends upon his particular perspective. In essence, the value of an art form or of anything depends to a large measure on the quality of service to a people. If the people only need an art form that provides non-essential esthetics then that is what should be provided. However, if a people are involved in a revolution and struggle for life then an added measure of social and political communication would be in order. It all depends on the *PLACE, TIME* and *THE PEOPLE*. Only those who are real participants (directly or indirectly) can truly decide. Others may intellectualize on the questions but in matters of life and death (culturally speaking) the participants must decide for themselves.

In following the misdirection implied in the social attitudes in the United States, that art is a luxury item to be used only after we are well fed and our bodies are sheltered, Black people are depriving themselves of a powerful ally in the quest for liberation.

We must pledge ourselves to the re-examination and re-affirmation of the human values stemming from the civilizations of our cultural past. We must do this in order that we might build upon the foundation that was laid for us centuries ago by those who used their creativity for the benefit of a total community.

BENNY ANDREWS

What ever it is I do or do not do in the paintings I paint really are attempts by me to communicate to the "Folks." While I could write yards on who the "Folks" are, just let it suffice to say for this time, they are "us."

The next question is automatically, who are "Us"? The answer to that automatic question at this moment is, "Us" are the "Folks," and I am one of them, and like I said earlier . . .

What ever it is I do or do not do in the paintings I paint really are attempts by me to communicate to the "Folks."

NELSON STEVENS
Afro-Cobra Member

We/I think/create from the rhythmic-color-rapping-life-style of Black folk.

We/I create with the dynamics of the Jihad Spiritual awakening. It's the Black powerful force of our people, which comes through us that I hope to give back to perpetuate our ever present force yon.

We believe that art can breathe life and life is what we are about. We create positive-life-images for positive Black folk.

We have started to work together as an African commune of "bad" relevant artists.

NOAH PURIFOY

To me art is not art as we generally see it, held in high esteem. It to me, is a mere act of doing something that fulfills or appeases the human urge to become universal. I am more concerned with the act of creating that I am with art itself. My primary concern is others getting into the act of doing something creative. Art is a tool to be used to discover the creative self.

CLEVELAND BELLOW

There are many factors that come into play when one attempts to write a statement about his creative efforts that are sometimes labeled art. My involvements with painting, drawing, printmaking and photography revolve around my concern for the human condition, as well as, the pure esthetic pleasure of creating. This human concern is determined by social, environmental, philosophical and political issues of the times.

Some have labeled my particular style as social protest, but I beg to differ. If I would label my work at all, it would be called social reality.

ELIZABETH CATLETT

Within the past few years I have gradually reached the conclusion that art is important only to the extent that it helps in the liberation of our people. It is necessary only at this moment as an aid to our survival. It has to be a means of communication between artists and people. I have now rejected "International Art" (European Art) except to use those of its techniques that may help me make the messages clearer to my folks. If my work at the moment seems contradictory in its form, I hope it is clear in content and that the form will clarify itself.

I have come to believe that only work is important. Our self-indulgence is a waste of time that we do not have. Our work can help us in the changes that we must make in this world in order to survive.

Art for me now must develop from a necessity within my people. It must answer a question, or wake somebody up, or give a shove in the right direction—our liberation.

1971

Elton C. Fax, "Preface," in *Seventeen Black Artists* (New York: Dodd Mead, 1971)

Elton C. Fax was born in Baltimore, Maryland, in 1909. After graduating from Syracuse University's College of Fine Arts in 1931, he moved to New York, where he taught at the Harlem Art Center and later at the City College of New York. Fax became internationally celebrated for his work as an author and educator, especially for the sketched lectures known as "chalk talks" that he carried out for the *New York Times* Children's Book Program between 1949 and 1956. Fax was also a prolific magazine and book illustrator. In 1971, he published his third book, *Seventeen Black Artists*, which profiled contemporary artists working in the United States such as Charlotte Amevor, Romare Bearden, Elizabeth Catlett, Eldzier Cortor, Roy DeCarava, Rex Goreleigh, Jacob Lawrence, and Faith Ringgold. In the preface, Fax comments on the "abrasive" environment in which all artists are expected to establish themselves but highlights the particular hardships experienced by Black artists "in a climate charged with white racism." In 1972, *Seventeen Black Artists* received the Coretta Scott King Book Award, which acknowledges literary and graphic treatments of African American culture, usually in the field of children's and young adult books.

ELTON C. FAX, "PREFACE"

If you are looking for a story loaded with fashionable cocktail party clichés about art and the people who produce it, this will not be to your liking. What you will find in the following pages is no esoteric critique. It is instead the story of seventeen sensitive human beings, what they have to say about the world they know, and why they say it in the way they do.

Like their many counterparts all over America, these seventeen people do not float pleasantly about in a benign vacuum. On the contrary (and with the exception of Elizabeth Catlett Mora, who lives and works in Mexico) they toil in an environment that is harsh, abrasive, and downright hostile to most of its artists. It is an environment that, while taking great pride in the efficiency and speed with which it wages war, does business, and conducts outer space explorations, has not (in its nearly two centuries of existence) established a meaningful, nationally supported program of the arts. The closest we ever got to that occurred in the 1930's when the Roosevelt administration created the Federal Theatre and the Federal Art Projects that provided work for artists during the Depression. When Pearl Harbor was bombed in 1941 the nation went to war against Japan, and the arts projects went out of existence. Individual artists who have "made it" in the popular sense of the term have had to do so without federal help.

[Here, Fax discusses the general economic challenges facing all artists in the United States.]

Such is the environment through which all artists in this country struggle. And in the patriotic traditions of "free enterprise" and "rugged individualism" each must fend for himself as best he can. The seventeen of whom I write here are no exception. Indeed, their situation is more acute since they are forced to tote an added barge and lift an extra bale for being black. What I mean is that they are black in that special and terrible and magnificent sense of what it is to be black in a climate charged with white racism. And because of white racism the experience of black people becomes a unique one for them.

Travel and contact have taught me that man's experience is universal and that no human experience dwells in a vacuum. I know, therefore, that what white racism imposes upon black people, it imposes also upon other nonwhites. But it doesn't stop there. White racism is destructive to whites also, especially poor whites. The poor white, however, has difficulty in recognizing that his experience relates to that of nonwhites, largely because he has been deluded into believing he belongs to the "superior" race. To him nonwhites do not count for much since they are merely the "niggers," "spies," "slopeheads," and "gooks" of society. What an effective job white racism has done in separating the poor white from the reality of his own miserable and unhappy experience!

When I speak of the "magnificence" of the black experience, I speak of the simple, uncluttered state and spirit of the man who soars above the meanness of the rejections and denials thrust upon him. He is that man who can face his oppressor and calmly say to him, "Because of you and, yes, in spite of you, too, I am a man!" When he is an artist that simple declaration becomes a thing of shining splendor.

But every man who suffers does not face his torment with that kind of dignity, and all black men (even those in the arts) are not made of giant stuff. Some would prefer not to be black, and their reluctance to carry that extra load is, in purely human terms, understandable. One hears the declaration, "I want to be an artist, not a black artist." Rejection of the "black" label suggests that those who reject it have been convinced there is something not really clean or valid in being simultaneously black and an artist. But even as they deny their unique black experience, their denial in no way negates or diminishes the potent truth of it.

Artists, like all other human beings, neither feel, nor see, nor think alike. They shouldn't. And if one is to survive as a truly creative force, he dares not seek to silence or obscure from view other artists who do not see as he sees. The role of the artist is creative rather than destructive. His knowledge of life teaches him that one man's exposure to adversity will drive him to look inward toward

those strengths that proclaim his manhood to *him*. Another man, under the same stimulus, will be driven to seek escape from that which is inescapable, even as he recognizes the futility of his flight. Knowing this, the true artist, surely one of the freest of individuals will not seek to violate the freedom and individuality of others.

The artists I have selected to write about here have more in common than race. Each is an excellent craftsman, having demonstrated a professionalism of performance acquired through study and hard work. Their collective devotion to the disciplines of their craft is no less arduous than their devotion to the themes they individually (and collectively) pursue as black artists. Each is, in his and her own way, a representationalist, doubtless because each feels that he can speak most forcefully in that style and manner.

While Eldzier Cortor, Jacob Lawrence, Charles White, and John Wilson, to mention but four, work almost entirely with black subject matter, John Torres, Norma Morgan, and Benny Andrews do not. Still, all of the artists in the following pages show in what they do a profound cognizance of the black experience. And these artists share another common trait. They are seventeen *undefeated* men and women. Bloody they may sometimes be, but they are quite unbowed. Indeed one finds in their strongest efforts a surging triumph over the environment; and one must bear in mind that this group is but a segment of a larger group of similarly motivated black artists working in America today.

One more thought about those in this book. They come from all areas of this nation of ours and from varying backgrounds and home influences. Four are women, one of whom has chosen to become a citizen of the Republic of Mexico. As they step forward to unfold their lives, much of what they are as individuals reveals itself. Far more than that, however, their lives reveal much about America—the beautiful and the not so beautiful. Those revelations, forged and tempered in the fires of the artists' creativity, emerge in related statements at once angry, caressing, and disturbingly handsome.

Edmund B. Gaither, "The *ABA* Idea"; Abdul Hakim Ibn Alkalimat, "Notes on Art and Liberation"; JoAnn Whatley, "Meeting the Black Emergency Cultural Coalition"; and Edmund B. Gaither, "Visual Art and Black Aesthetics," *ABA: A Journal of Affairs of Black Artists* 1, no. 1 (1971)

ABA: A Journal of Affairs of Black Artists was conceived in 1971 by Edmund Barry Gaither and funded by the Museum of the National Center of Afro-American Artists (NCAAA) in Boston. Gaither hoped to create a publication that could support Black critics and artists, offering features and interviews as well as educational and institutional resources. In addition to the articles reprinted here, the first issue included Evangeline J. Montgomery's essay "A 19th-Century California Black Artist" (about Grafton Taylor Brown [1841–1918], a lithographer and landscape painter) and a directory of Black-owned galleries and museums focusing on Black art. However, the journal was short-lived, and a second issue never appeared.

EDMUND B. GAITHER, "THE *ABA* IDEA"

The idea of a journal focusing on the visual arts life of black people is in no way new, nor does it belong to an institution or individual. Rather, this thought has crossed the mind of every serious black art advocate in this century. All have felt the need for some organ of opinion which could begin to facilitate the discussion and interpretation of the work of the black visual artist. However, like so many other ideas which black people have had, there has been abiding difficulty financing projects, and very often they have had to be compromised because they could not find an institutional base which could provide continuity and early growth.

By the mid-sixties, after a new energy had made itself manifest in black art, the need for an organ of national and international communication was even more urgently felt. Jeff Donaldson, an artist himself and a member of OBAC (Organization of Black American Culture), the group which created the original *Wall of Respect*, Chicago, organized a parley called CONFABA (Conference of the Nation-Forming Aspects of Black Art) at Northwestern University, Evanston, Illinois in the Spring of 1971. CONFABA, the largest group of black artists and black art advocates to come together, sought to plot a course for discussion of black creative work over the next decade. CONFABA pin-pointed a number of needs including that for a regular organ of communication between black artists, their advocates, and public. The immediate impetus for *ABA* grew out of CONFABA although that conference did not continue as a formal structure.

Feeling the most dire need for a journal of black art discussion, a number of us at CONFABA left only to get together again at the art workshop sponsored by the Congress of African People in Atlanta, Georgia in the Fall of 1971. At that time, the Pan-African Art Alliance (PAAA) was formed and as its first act committed itself to the publication of a catalogue which would assume many of the functions of an art journal but which would focus primarily on art work rather than formal discussion. The bulk of persons representing institutions

committed themselves to the realization of PAAA's objective and still share that commitment.

In the interval, the Museum of the National Center of Afro-American Artists found itself in the position of being able to offer a journal dedicated to the black artist an institutional home, and a budget for at least one year. Thus in the spirit of service to the black artist, and the black community at large, the Museum of the National Center of Afro-American Artists became a home for *ABA*.

The Museum of the National Center of Afro-American Artists, like others concerned with black cultural life, felt that such an undertaking was too large and too great a responsibility for one institution, and so it broached the idea to others interested in the journal of creating a national board to run *ABA*. *ABA* would then represent a broad spectrum of the national black community and would thus be able to serve the black artist nationally. The Museum of the National Center of Afro-American Artists would provide a base from which to coordinate the journal. This conception of *ABA* drew good support whereupon the organization of a national board was launched. That board is still in the process of formation.

In the meantime, it was felt that work on the journal should begin. The Museum of the National Center of Afro-American Artists tackled the production of the first issue. This is the product.

ABA, as realized in the first issue, is a harbinger of what it is to become. Subsequent issues reflecting a broadened input, will provide a fuller approximation of the announced intentions of the journal. They will include:

Several critical and/or art historical articles

Interviews

Notes on projects and proposals of particular interest to black artists

Book reviews

Directory of currently available educational or institutional resources

Calendar of current exhibitions of the work of black artists, and of exhibitions under preparation

Full listing of black owned galleries, black museum personnel, etc.

The current issue will introduce to the reader some new materials belonging to the above categories. Other data sections are only partially completed at this point. These will be more fully worked-out by the next issue.

The material which *ABA* proposes to print is intended to encourage precise and meaningful discussion within the ranks of black artists and black art advocates, to entice younger blacks into the criticism and promotion of black art and to help all of us gain a perspective on black visual arts activity which can insure black cultural hegemony.

We believe this initial issue will prove useful to you.

ABDUL HAKIM IBN ALKALIMAT, "NOTES ON ART AND LIBERATION"

Our struggle for peace and freedom must be waged on a higher level if we are to survive the repression of incipient fascism. There is a sinister scheme behind the selective assassination of Black leaders (Medgar Evers, Malcolm X, Martin L. King, Ralph Featherstone, and Fred Hampton); military suppression of "legal" protest (massacres of Orangeburg and Jackson State College); legislation to sterilize welfare mothers with more than one illegitimate child (proposed bill in the Tennessee Legislature); and Black Capitalism. This represents an attempt to subvert political movements, increase exploitation of poor unemployed Black people, and buy off the Black Bourgeoisie. So it is necessary for all progressive Black people, especially artists-intellectuals, to understand this growing fascism and carefully organize to struggle against it. Not to struggle against fascism is to commit suicide.

This brief article is intended to deal with two questions for the Black artist-intellectual.

(1) *Where are we now?* This question can be answered only if we understand our historical development. Frantz Fanon has described the ideological dialectic of African artist-intellectuals as consisting of three goal orientations:

A. to establish proof of our capacity to assimilate
B. to re-establish our traditional culture
C. to articulate the development of values in the people's colonial war of liberation.

All of these alternatives reflect a historical progression, although they currently coexist among African people today.

These three stages fit our history, especially the 1960's: (a) Civil Rights Movement for Democratic Reform, (b) Cultural Nationalism, and (c) Revolutionary Nationalism. Specific examples of these are the three most well known chairmen of SNCC: 1) John Lewis, now director of the Voter Education Project, an affiliate of the interracial Southern Regional Council; 2) Stokely Carmichael, now married to Miriam Makeba, living in Guinea and proposing a back-to-Africa version of Pan Africanism; and 3) H. Rap Brown, political refugee in the underground, sought by state and federal forces.

All of these positions have support as alternatives for the 1970's, and include many sub-types. The first alternative is no longer on the lower levels, but has manifestations in the U.S. Senate, on the Federal Reserve Board, on every major University faculty, and with thousands of elected officials. Major spokesmen for assimilationism are Prof. Martin Kilson of Harvard University, Bayard Rustin, of the A. Philip Randolph Foundation, Kenneth Clark of M.A.R.C., and Roy Wilkins of NAACP.

Cultural Nationalism, the second alternative, has moved beyond "race pride" to "Black is Beautiful," from "New Negroes" to the affirmation "We Are an African People." And there is an increasing thrust behind these trends with organization like the Congress of African Peoples, African Heritage Studies Association, Student Organization for Black Unity. The major spokesmen for this position today include Imamu Amiri Baraka (LeRoi Jones), Don Lee, and Jesse Jackson.

And last, Revolutionary Nationalism. This position brings together the notion of national liberation for an oppressed people, and revolution of world society for everyone's freedom. The spokesmen for this are Robert Allen, James Foreman, Huey Newton, Kwame Nkrumah, Sékou Touré, and

Amílcar Cabral; and the International Black Workers Congress. The Black artist-intellectual must be knowledgeable about these three alternatives and systematically work through them. You can dig on Malcolm's life and see how he did it. Malcolm Little and Detroit Red were on opposite sides of the law, each caught up in the alternative of assimilation, Malcolm X is alternative two, Cultural Nationalism, and Malik Shabazz alternative three, Revolutionary Nationalism. These are the stages of Black development that we must understand if we are to struggle on the highest possible level.

(2) *What must be done?* There are four critical questions that must be dealt with.

a) *What have we gained since 1954, and how can we hold it?* As Black artist-intellectuals we are in key organizational positions that give us access to resource, we have community facilities and growing publication outlets. The key is to protect this, but not at the expense of our people's needs. If there is to be a community gallery, then it should also serve for community meetings, free breakfast programs, etc. If we publish it should deal with the realities of Black exploitation and not simply the Beauty of Black.

b) *How can we more effectively build for the future?* The key word is study, collective study. We are in the process of building a new movement for change in the 1970's, and for this we need a network of study groups who are developing revolutionary theories of change while beginning to initiate small local programs. Build small study groups to generate community programs around the concrete needs of Black people.

c) *How to fight and destroy negative forces?* This task identifies the principal antagonistic contradiction as racism and capitalism. In other words we must get to a basic understanding by probing beyond symptoms to the real enemy. Just like the Vietnamese people must understand that General Ky is a puppet of the USA pentagon, the Black community must understand that the Black Bourgeoise [sic] and the police work for the same man, Mr. State Monopoly Corporate Capitalism.

d) *Who are the most progressive people and how to support them?* This must be an objective question you can answer with facts and not conjecture. In struggle each time you can accept a Brother, you are doing it to save your life. The same is true if you are analyzing an entire community, and accept a group of people like workers, welfare recipients, and students. And when you know who, the only reasonable support combines material goals and funds, with political support for the struggle's purpose.

So each Black artist-intellectual must understand the historical struggles of his people if he is to be in the struggle today. Political understanding of our oppression and liberation must be a necessary mental environment for artistic creativity if we are to have a flowering of Revolutionary Black Art.

The value of (an) art(ifact) is not its price or praise, it is the number of people exposed to it and its effect on those people.

Art must not be sold, it must be free.

Art must not be private, it must be public.

Art must not be stored, it must be used.

Art must not become our reality, it must help us find a better way to deal with our reality.

REFERENCES:

Mao Tse-Tung, *On Literature and Art*
Robert Allen, *Black Awakening in Capitalist America*
Harold Cruse, *Crisis of the Negro Intellectual*
Frantz Fanon, *Wretched of the Earth*

JOANN WHATLEY, "MEETING THE BLACK EMERGENCY CULTURAL COALITION"

At 1 P.M., January 12, 1969—a fair but piercingly cold day—a predominantly black group of about 35 persons began walking in formation before the Metropolitan Museum of Art in New York. They were carrying picket signs and chanting "Soul's been sold again."

This was the first manifestation of a group of black artists and art experts who had organized ad hoc the week before to protest the Museum's forthcoming exhibition entitled *Harlem on My Mind.* This exhibition encased the Museum's ambitions of making a sweeping statement on the cultural history of the people whose enigmatic world lies

on the periphery of the Museum. (The Museum is located at 5th Avenue and 82nd Street.)

The pickets were expressing their outrage before what they saw as the Museum's brazen omission of black expertise in setting up the show—which they felt had deteriorated into a white man's view of Harlem, emphasizing socio-economic aspects at the cost of all esthetic considerations. They were especially outraged that such a show had not included the work of a single black sculptor or painter.

The group called itself the Black Emergency Cultural Coalition (often written Black *Emergency* Cultural Coalition, and currently referred to as the B.E.C.C.). The abundant critics of that show helped chalk up a stoney victory for the B.E.C.C. But most of its members came away from that confrontation—which they had thought would be their last—with deep scars. The Museum had used the roughest tactics in dealing with the presence of this group of black artists who dared contest the legitimacy of Museum procedure. And those tactics seemed to have gotten silent consent from the decision-making chambers of other City museums. The B.E.C.C. had to face the reality that the tip of a great iceberg had been forced to surface: that iceberg, racism in the museum system.

The B.E.C.C. met on February 7, 1969, to form a more stable organization. They elected officers and set up some guidelines for membership. The ranks—which had quadrupled—were demanding an organized campaign to force the museum structure to consider their work and to place black art experts on lily-white museum staffs in decision-making capacities.

On April 24, 1969, the B.E.C.C. approached the Whitney Museum of American Art. Six months of subsequent negotiations resulted among other things in the Whitney's agreement to stage a major exhibit of the works of black artists, national in scope. That exhibition *Black Artists in America*, a show of more than 100 works by about 70 contemporary black artists is scheduled to open in New York this April. The B.E.C.C. is urging all black artists to boycott the show—alleging that the Whitney's handling of the show has been in bad faith with the negotiations.

I interviewed Mr. Benny Andrews, artist and one of the co-chairmen of the B.E.C.C., in his atelier on the eve of a demonstration which the B.E.C.C. staged before the Whitney Museum on Sunday, January 31, 1971. The other co-chairman, Mr. Cliff Joseph, is an artist and art-therapist; he and I talked at length at a café near the Whitney Museum the same afternoon of that demonstration.

I phrased the following questions in the same manner to both gentlemen:

Q. To your knowledge has any member of the Executive Committee met with reprisals because of affiliation with the B.E.C.C.?

A. (BA) The one museum with which we have the most experience in terms of in-and-out negotiations is the Whitney Museum. In that museum, though they did agree to buy works of black artists, to give gallery exhibitions of black artists and to include black artists in the Whitney Annual, no established member of the B.E.C.C. whose name is known has ever been selected for any of those privileges.

Q. But is it not true that you (members of Executive Committee) elected to close your studios to the Whitney Museum?

A. (BA) Yes, but the Committee members made that symbolic gesture only after we began to get telephone calls—which, incidentally, pin-pointed the Whitney's recruit route in setting up the show scheduled for April—informing us of the abrupt, discourteous way in which black artists were being approached by the show's only selector (white curator), Mr. Robert Doty.

(CJ) Before we formulated our policy of boycott because of Mr. Doty's behavior and the Whitney's refusal to use black curatorial assistance in putting the show together, our studios were open to the Whitney. Mr. Doty asked for slides of my work—which is stark social realism by nature. I got one noncommittal letter from him and that was it. He also visited the studios of some other Committee members. Nil! With the possible exception of one case, about which all the facts are not yet in.

Q. How many participating members are there in the B.E.C.C.?

A. (CJ) Participating membership ranges above 150 persons.

Q: What qualifications must participating members meet?

A. (BA) First of all they have to be black. That may sound racist . . . but the B.E.C.C. is dedicated—I repeat dedicated!—to the cultural needs of the black community. And while we may be able to work very well in some areas with other organizations for common goals in art, our specific goals relate to the special problems of the black artist.

Q. Are participating members subject to the same reprisals which the Executive Committee might encounter?

A. (BA) We found out from other all-black organizations which are doing things to change the status quo in this country that it is not good policy to give the names of your membership because they—and especially artists!—are usually so vulnerable to reprisals from institutions which they seek to change. So we (Executive Committee) *never* disclose the names of participating members on any occasion.

Q. Could you delineate your membership—e.g., as to predominant age group, status as artists, or styles of painting . . .

A. (BA) Most of the artists in the B.E.C.C. tend to be relatively unknown—though not totally unknown. Most of us exhibit and have been practicing artists all of our lives.

In this vein I would like to underscore that the B.E.C.C. is not in the market to say what is good art. We are not *for* a particular style of painting, neither are we against any particular style.

Q. Why, would you say, does the B.E.C.C. have limited appeal for older, more established black artists?

A. (CJ) Older, more established artists feel threatened by changes the B.E.C.C. seeks to bring about,

because these artists usually have found their niche within the establishment. They're *in*; they don't want to be *out*.

Q. How is the participating membership delineated as to geography?

A. (BA) The participating membership basically is located in New York. But when things come up like the national exhibition which is supposed to take place at the Whitney, our contact and communication is spread throughout the country—which indicates there are more black artists who accept us as their spokesman than the number who have cared to sign up with us and take on particular functions. (e.g., typing, designing and printing posters, running off stencils, picketing and demonstrating . . .).

(CJ) There is a plan, however, for establishing B.E.C.C.-oriented "cadres" throughout the country. We'll have more time for this after the confrontation with the Whitney is settled.

Q. Who are the associate members?

A. (CJ) Included in the associate membership are black art experts and curators, sympathizing white artists, and non-professionals engaged in creative visual art activities.

Q. How is the B.E.C.C. funded?

A. (BA) Our funds come out of the pockets of the membership. A few foundations have made overtures to us; but we have seen some of the most vital civil rights organizations "tone down" their stand on issues with the influx of money from foundations. We even approached some of these black organizations for support when we went against the Metropolitan. Invariably they (the organizations) said they couldn't commit themselves because of "a vote from the Board of Directors."

We are very afraid that outside money would force us to compromise our goals; and we're not in this thing to compromise . . .

(CJ) We do see the black community at large as a possible source of funds and support. But first we've got to awaken the black community to what

it's been missing in terms of "dues" from the cultural Establishment of this country.

Q. Could you pinpoint what you call "racism" at the Metropolitan and/or the Whitney Museum?

A. (BA) What we've run up against at both of these museums is a form of institutionalized or insidious racism—and therefore all the more difficult to pinpoint. It has to do with projecting negative images of black people by selecting only those figurative works which portray black people as empty-eyed and full of feelings of inferiority. Think of perpetuating such images within black children, who *do* visit these museums with their school classes and parents. They will believe like my generation did: that there are no black artists who have other things to say about the black experience. When there are! and have been for the better half of this century.

The museums we've been attacking insist on a white dictatorship in the selective processes—even where a black show is concerned. Though their white curators often don't even know who the black artists are and where they're located, these museums refuse to use black art experts who know the black art community through and through.

When it comes to the established cultural institutions, we are moving into the interior of the American society. We are going into an area where some of the people who engage in the most racist practices have very respectable facades. These people would never call anyone "nigger" in public; yet they move to the suburbs to keep from having contact with black people. They also make sure they won't have contact with blacks in their offices. . . . An example: At one point in our negotiations with the Whitney I put the question very directly to them. I asked, "Have you in this Whitney Museum of *American* Art ever—in thirty years of existence—employed black [*sic*] in any capacity other than guard or kitchen help?" Their answer to that question was "No!"

Q. What does the B.E.C.C. hope to achieve in this country?

A. (CJ) We're certainly not in this thing just to make sure black artists get paintings sold. Social truths, injustices that are being committed need to be exposed *on a very deep level*. The black artist can do this.

This organization needs to move in a political direction, to link up to all other human rights movements. And together these human rights movements should activate and organize the people to demand that those who are qualified (in the academic sense) and yet still truly represent *the people* run the institutions of this country.

Art and artists should constitute a powerful agent for communicating the need for reform and revolution in this country. . . . By "revolution" I don't mean the hordes rushing in and taking over; I mean the process I've just described (in preceding paragraph).

(BA) You notice that the "E" (in B.E.C.C.) stands for "emergency." We hope to be a kind of modus vivendi for bringing qualified black art experts (who are sensitive to the deeper needs and nature of the black community) into positions of authority—whereby they can assure exposure for black artists in the "sacred" halls of culture which have for so long omitted the black man. We also hope to "turn on" the black community to its artists and to means of dealing with institutions which indirectly and directly keep it (the black community) culturally deprived. If this is accomplished, our goal will be to go out of existence.

EDMUND B. GAITHER, "VISUAL ART AND BLACK AESTHETICS"

Aesthetics generally refers to the philosophy of beauty. It is an abstract notion used to define and state intellectually those pleasurable experiences occasioned by artistic encounters.

In every case, aesthetics has, at its core, represented the artistic judgment of creative arts within a fixed cultural context. Though some notions of universal beauty and the like have been postulated, all such views are in fact culture-bound, and therefore partisan. Aestheticians who have come from

the ranks of the educated elite have been charged with the job of defining, conserving, and promoting the central artistic values of the "in" culture.

There is, however, another sense in which aesthetics may be used, a more popular sense. Aesthetics, as a functional concept, describes the coherency demonstrated in the struggle of people in a culture to reveal their finest visions of the Good, the Beautiful. In this case, the term assumes a broader meaning and corresponds essentially with commonly held cultural aspirations.

The specific creation of the artist is, then, not only a particular exercise with an aesthetic value; it is also an element of the struggle for a fuller realization of cultural potential. This one may see in the total creation of the culture patterns of approved and cherished expression as well as of deviation.

Recently, young black visual artists and art historians have wrestled with discarding the semantic burden of the terminology used in historical art discussion. At the same time, they have striven to give meaning to terms such as black art, and black aesthetics, through equivalent terms. Always the necessity to make distinctions, to judge quality and locate the contemporary in the traditional, recurs and impresses itself anew. Consequently, the black discussant of the visual art has not escaped the direct need to clarify and come to grips with the notion of aesthetics, of black aesthetics.

Cultures, though never fully synchronized, strive toward coherency. This struggle is perhaps nowhere more apparent than in the arts. If a broad enough view of the total life of a culture can be gained, one can then suggest central tenets of its ideals of the Justice, the Good, the Beautiful. These ideals are internally generated and manifest themselves in all areas of the culture. Thus no question can be raised as to whether different cultures have different aesthetics, nor of whether each culture's aesthetics are self-validating.

It is evident that each culture has an essential and peculiar aesthetic system which is self-validating, although such an umbrella aesthetic is also likely to contain competing systems giving rise to artistic tensions. Occidental art is not Oriental art; each abides in its own system, each is valid, each is diverse and in some sense contradictory, no better or worse than the other.

How one may then ask, does all of this affect the black visual artist in the States? The answer is very complex, drawing its greatest difficulty from the complicated relationship between black people and their white matrix.

There were, and indeed there remain, intact aesthetic systems in Africa. Also there were, and remain, largely intact, African aesthetic systems in parts of the Americas. There systems, manifested in visual arts, dance, drama, music, speech, etc., vary in specific realization. However, they seem broadly to reflect an internally coherent life style emphasizing the rhythmic over the geometric, the spiritual over the scientific, the human over the machine, the symbolic over the factual. And though increasingly African tastes and African aesthetics are obscured by the input of colonial cultures, in many places the African has been able to digest these new elements on his own terms.

In the United States, Africans were made into "negroes" and on the return to being African, have become "black people." In being made into a "negro" in America, black people suffered major cultural surgery at the hands of unsympathetic doctors. Presently, black people find themselves painfully aware of a forced marriage in which they have been brutalized, while the colonialist and neo-colonialist, through ruthlessness, have prevailed.

Black culture, which has never disappeared and which is incapable of death, has nevertheless been forced to assume abhorrent forms, to lend itself to prostitution, and finally to be used to the advantage of the oppressor against the oppressed. Black culture is not fully intact, but it is vital. Black culture, twisted and distorted by white usurpers, finds itself at once defensive and boldly declarative, at once catholic and patriarchal. And the black visual artist, in honesty to himself, has to search for threads of his own overly-complicated and oppressed existence.

The black visual artist cannot create a black aesthetic. Aesthetics, functional aesthetics, exist by virtue of intact culture and its ideals. The degree to which black culture has remained intact in the

States is the degree to which there is black aesthetics. The degree to which black culture has suffered perversion and distortion in the context of white culture is the degree to which black culture has been compromised.

The degree to which the contemporary black artist is able to draw upon and make sense of the black experience on its own terms is the degree to which black aesthetics finds concrete manifestation.

Would that one could declare that all is well with black aesthetics, but one cannot. The stay here has been too tragic! In this nation time, the need is to reclaim the healthy facets of black culture, to add the best of the present, and to lay the groundwork for a real flourishing of genuine black aesthetics, a black aesthetic that is rich, honest, and capable of innovation within tradition.

1971

Robert Doty, untitled interview with Frank Bowling, in *Frank Bowling*, **pamphlet for exhibition held at the Whitney Museum of American Art, New York, November 4– December 6, 1971**

Frank Bowling's solo exhibition in the lobby gallery of the Whitney Museum of American Art took place just six months after his work was featured in Robert M. Doty's controversial exhibition *Contemporary Black Artists in America* (see pp. 333–40). Bowling showed *Texas Louise* (1971) and five of his other large map paintings, which he made by laying stencils of continents on canvas and spraying around them with spray paint, then washing layers of acrylic paint over and around the resulting shapes. Bowling's attitude toward the concept of "Black art" was beginning to shift by late 1971, but, having put forward the idea that Black art can signify different meanings to different viewers in his April 1971 essay "It's Not Enough to Say 'Black Is Beautiful'" (see pp. 326–32), here he emphasizes the importance of "ambiguity" in his own work. This would have been understood as something he valued in contrast to the unambiguous directness of work by artists such as Dana C. Chandler Jr. and members of the AfriCOBRA group. Bowling also insists here that "the black experience is universal"— words that anticipate later arguments that have been made about the map paintings (such as the view that the apparent melting of continents into liquid expanses of color poetically represents the experience of diasporic subjects in general, unfixed from nation-states yet able to find new ways of belonging in the world).[1]

ROBERT DOTY, UNTITLED INTERVIEW WITH FRANK BOWLING

What iconography is significant for you?

The iconography of my work, until recently, was almost entirely to do with my childhood. When I began to be bothered by the paintings I was doing as a student, I tried to make a film that would get rid of the whole business of iconography once and for all. Before the film, the things I made were based on the faces and dress, or undress, of various ethnic types in Guyana. I tried working with still life objects and attempting to fuse the shapes of the map of Guyana with Africa: all this before I went to the Royal College of Art in London in 1959. [. . .] After leaving London to live in New York, I broke loose and began to get much more involved in pure painting, trying to fuse the kinds of things I was interested in with what could actually be upheld viably in a painting situation. I eventually found the most comfortable way of actually dealing with paint and structures from the outside by leaning on ready-made shapes and photographs. The gradual turnover of rejecting what was too complicated led me to remove much of it entirely into another medium.

What control do you exercise over color?

Color for me is very personal, even though I set out intentionally, like everything else I do with my work, with a ready-made structure. The book says red is to green at a certain ratio and I'm very conscious of that. But, I think the very basic drive which keeps me constant, is the fact that I need to push the ideas as found over the edge where it happens for me: that is, on my painted surface. I feel it's reinvigorated and new. So, color is a sense of a very personal dilemma. I'm adjusting color almost entirely through emotional leads. Color plays an enormous part in my work, if not the most important part.

What antecedents are important for you?

I think what made me, what fed my enthusiasm and gave me courage to sustain myself painting in the face of a lot of family opposition, was the example of people like Goya. Goya was a very fashionable figure, and his whole commitment fascinated me. In technical problems, I leaned very heavily on Rembrandt when I was a student. I was inspired by realist painting, the Euston Road School of painters and Cézanne. I was very attached to the National Gallery where I became involved in the Renaissance and history painting, Poussin for instance. I'm still fascinated by so-called Traditional African art. But I think the most immediate antecedents are the artists here in New York and the drive and energy they have toward creating a new or personal view. [. . .] I met Jasper Johns and he was instrumental in making me feel the situation of being an artist was not just a cul-de-sac, and that one was free to do what one liked. I was living at the Hotel Chelsea at the time and he came to visit me. I was freely drawing in map shapes at the time and was very shy about showing my work: he put me at ease by saying he didn't own maps, that I shouldn't think twice about going out and buying maps, cutting them up and putting them together again. This attitude influenced me enormously. Shortly after, I went to Long Island and stayed with Larry Rivers. He showed me how to use an epidiascope, after which I made my first tracings of the map of South America, which was holding sway over my imagination after Guyana and Africa. From then on I used readymades or tracings.

The use of the map suggests a microcosm. Do you seek such concepts?

The question refers to some kind of 18th-century idea of a little (small) man in a little situation, very mechanical and small in scale; the world of black art. I don't believe, as a painter, in the idea of black art, but it's obvious the black experience is universal. The more I think about it the more I feel . . . yes, and no because obviously, in a way the whole idea of a microcosm as opposed to a macrocosm is something that I'm about in this sort of harassing situation. Yet, I feel reticent about committing myself totally to the idea: simply because over and above everything else, I feel very political about a lot of issues, and I'm certainly political about what it means to be an artist, an artist who happens to

be black, as such, and I think a lot of the things which have gone down makes what I'm doing a reflection of a much wider spectrum. In this sense I would agree.

Do you deliberately strive for ambiguity in your work?

Yes! I think that this is a very prime concern of mine. I think that in some sort of terrible way, the more you watch the less you see. It's kind of a guiding principle. . . . But it works the other way in painting. When you see a thing (a painting) you don't realise how much is there, because it's part of the trickery of what one is doing. I think paint as material opposes the rigidity of canvas and its supports in such a way that it tends to undermine the entire thing, so that one was to sustain the efficacy of canvas in his contradictory medium. The unknowable causation, the chance, which in itself sets up some kind of ambiguous, sort of tricky situation, in the best moments although no one actually reaches that stage. You can't have totally [sic] ambiguity. The ambiguous is *elusive!* I think that is the most marvellous state for the painting, where the thing really is giving out a certain kind of information, and withholding so much, that it fascinates you. And I feel that's an important aspect of the attempt to be a painter, or what being a painter is about . . . being totally involved in the ambiguous.

The word, "fascination," suggests that you are very concerned with human response to your work. What values are of real concern to you?

I'm very concerned about intellectual freedom, fair play, some kind of moral standards of justice, etc. But when I think of painting and try to harness it with all this stuff I think it sounds boring along side the vitality of painting. I think what can be excused or dismissed, as old-fashioned, mundane and boring, forces one to have certain standards by which as an artist and a person, to live. . . . One is forced to be a certain kind of political individual. I think that rejecting good-will is probably one of the most pernicious aspects of existence in the 70s. But it's very evident that people are still

awfully cynical or perhaps *more* cynical. Cynicism is very fashionable, and this forces one to take a stand, if one is really a concerned person, against indifference of this kind, because I often think that the advocacy of destruction without an alternative structure is really a kind of anti-life approach. For instance dropping out as protest became high fashion, a kind of kitsch high fashion, and one was forced then to seek an alternative. The alternative was, and still is, action. I think one cannot live without some kind of canon such as put-up or shut-up. I mean one is either going to do the thing and prove, not just simply to oneself and one's peers, but to the vast spectrum of concerned parties that this stoutness one is claiming has a solid underbelly on which to rest. I think if one can separate some of the things which sound old-fashioned and boring, one actually needs to be pro-life, and cope; literally to tackle the problems and try to solve them. Of course cut away debris. Of course destroy what's bad. If this is a rat-infested neighborhood, set it alight. I agree about all these things. But one must have an alternative plan because I really do think there are guidelines even if they do actually come under the old-fashioned and outmoded bag, for there aren't any others upon which one can particularly pounce and say: *that's it!*

NOTE

1 [See, for instance, Mark Godfrey, "Notes on Black Abstraction," in Mark Godfrey and Zoé Whitley, eds., *Soul of a Nation: Art in the Age of Black Power* (London: Tate, 2017), 178. —Eds.]

1971

Jeff Donaldson, "Commentary," in *Elizabeth Catlett: Prints and Sculpture*, catalogue for exhibition held at the Studio Museum in Harlem, New York, September 26, 1971– January 9, 1972

Elizabeth Catlett was born in Washington, DC, in 1915. She studied design and printmaking at Howard University before becoming the first student to earn an MFA in sculpture from the University of Iowa. Through her work on a mural project in the mid-1930s, she became aware of Diego Rivera, a major figure in the Mexican muralism movement. Rivera's commitment to documenting the everyday lives of ordinary people had a profound impact on Catlett, and she eventually moved to Mexico and spent the rest of her life there. Her 1971 exhibition at the Studio Museum in Harlem included recent prints such as *Malcolm X Speaks for Us* (1969) and sculptures such as the double-sided *Black Unity* (1968), which had recently been exhibited at the Brockman Gallery in Los Angeles. The Studio Museum catalogue is introduced by the art historian Elton C. Fax, who writes that "Betty Catlett is one of the hardest working and most highly trained and disciplined persons I know. . . . In her adopted country Mexico, Miss Catlett is indeed an honored and successful artist. She has not, however, been accorded the honor due to her in this country from those who presume to be the guardians of those aesthetic standards by which Betty has lived and worked. That failure here in the land of her birth can be ascribed directly to racism and petty bigotry." AfriCOBRA member Jeff Donaldson, who, by 1971, had left Chicago to lead the art department at Howard University, also contributed a text, reproduced here.

JEFF DONALDSON, "COMMENTARY"

When Wise Black Man of the Future recalls that the Elizabeth Catlett Exhibition opened up at the Studio Museum just 13 days after Nelson Rockefeller opened fire at Attica, he will probably frown, put us down and wonder about our priorities. When Brave Black Man of the Future sees Attica as another in a sinister series of worldwide genocidal acts committed against Black and Third World peoples in the Decade of our Destruction (1965–75), he will probably frown and buke us apathetically abetting the covert rip offs—job and Peace Corps, poverty, sterilization and dope programs, jive government pigs and irrelevant establishment education jobs. No, Wise and Brave Black Man of the Future will not comprehend our priority concepts when he recounts that *too many* of us persisted in doing *too much* "art" and *too often* in complementary tandem with the efficient elimination of our warrior class in overt wipe outs like Angola, Palestine, Mexico City and Vietnam; Panther raids, assassinations and jail. Black Artists ought to think about that. Some Black artists have, some have committed their art to the Struggle for Survival/Victory of Black and Third World peoples over their oppressors. Elizabeth Catlett has made that committment. She made it even before she said, "I believe that art should come from the people and be for the people."[1] Even before she said "I believe that art is important only to the extent it grows out of and affects the society of its time."[2] Elizabeth Catlett has no problem with priorities. Her work speaks to the needs and concerns of Black and Third World peoples. Her work is a visual bridge connecting our common ancestry. A connection manifest in comparisons of the Art and Social Systems of Ancient Egypt, Nigeria and Pre-Columbian Cultures in the West. In this connection she says, "I have done Mexicans and people have told me they look like Black people. Mexicans really *do* look like Blacks. (Beyond) the similarity in appearance (there is) a similarity of life styles and other important similarities. . . ."[3] Black and Third World Peoples need to be made actively conscious of their commonality of heritage and interests and also of their common threat from their common enemy. Black and Third World people need Elizabeth Catlett because her work speaks to these concerns, ever has and, hopefully, ever will. We need *visual reflectors* who celebrate the beauty, dignity and strength of Black and Third World Peoples. We need *visual interpreters* who define, clearly and heighten the consciousness of Black and Third World Peoples. We need *visual prophets* who propagandize for the political reunification of Black and Third World Peoples and who promote movement against our enemies. We need reflectors, interpreters and prophets who charge us with our divine mandate to regain our motherlands and our manhood and to punish those who persist in robbing us of them. Elizabeth Catlett offers visual praises to our potential. Wise and Brave Man of the Future will smile and praise her.

NOTES

1 Atlanta University Biographical Information form, 1952.
2 Atlanta University Biographical Information form, 1946.
3 Interview with Frederic Lewis of the Studio Museum, August 7, 1971.

Unsigned introduction; Noah Purifoy, "Art for the People"; and Gloria Bohanon, David Bradford, Dan Concholar, Alonzo Davis, Dale Davis, Marion Epting, David Hammons, Marie Johnson, John Outterbridge, Noah Purifoy, and Timothy Washington, untitled statements, in *Eleven from California*, pamphlet for exhibition held at the Studio Museum in Harlem, New York, January 30–March 5, 1972

This was the first major New York show devoted specifically to Black artists working on the West Coast. Many of the participants had exhibited at the Brockman Gallery in Los Angeles, whose directors, Alonzo and Dale Davis, were also artists and were included in the Studio Museum's exhibition. In his text, Noah Purifoy defines the objectives of Californian Black artists as being "in direct opposition to art for art's sake." Making reference to the Watts Rebellion of 1965, which devastated a Black neighborhood in South Los Angeles, Purifoy underlines the enduring impact of the event on his own art and that of his counterparts.

INTRODUCTION

One of the primary reasons for the existence of the Studio Museum is to provide opportunities for the work of Black creators to be presented and viewed in a sympathetic environment. In the past we have presented exhibitions from Nigeria, Haiti, Boston, New York, Chicago and Tennessee. Now we are surveying California as we continue to exhibit works from places wherever Black people are.

Eleven from California is our first glimpse at some of the emerging talent in that area. Included here are eleven artists with eleven different styles of presenting their particular and personal view of their collective socio-political environment. This survey includes artists who are basically centered in Los Angeles and have at one time or another been exhibited at the Brockman Gallery there.

Brockman Gallery is co-owned by brothers Alonzo and Dale Davis. To the two of them we extend our thanks for assisting us in the organization of this exhibition. We are also inclined to acknowledge here, that these two brothers have maintained the Brockman Gallery for five years, surviving the throes of operating a professional gallery devoted to promoting minority artists in a system/city such as USA/L.A.

NOAH PURIFOY, "ART FOR THE PEOPLE"

If I cannot speak for the Black artist on the west coast, at least, I can speak to what seems to be signs of a movement symbolizing a direction away from art for art's sake . . . toward art for the people.

Since the Watts riot of 1965 (when the smoldering flames fashioned forms for a handful of artists who, naturally overnight, took three tons of debris and made 66 pieces of sculpture), California Black artists, one by one, have continuously reached back to those days for inspiration, material and subject matter.

It seems natural that we should do this. For reaching back is only reaching back into our lives to describe and predict some of that which lies ahead:

That the socio-economic political and educational deprivities [*sic*] heaped upon the lives of Blacks from Watts to Richmond can no longer exist in the midst of plenty.

That: Like the Phoenix, our art says we shall rise out of this deprivation even though another city be sacrificed for the sake of change.

That: Underneath the scribbles and scolds and nail holes covered with paint to make a pretty picture, is flaming anger not satisfied to hang on the museum walls. Its essence walks out into the street and alley, into school rooms and tenant farms, prison camps and the Capitols speaking to the people in their own language of their right and mights.

The symbols of west coast Black art stands in direct opposition to art for art's sake. It insists that if art is not for the sake of something it is not art. It seeks to reverse the order of art in its mundane gutless orientation and create a language through which there is a collective understanding. And most of all it says to non-blacks this tongue in which we speak can best be comprehended by standing on your head or kneeling on your hands and knees.

GLORIA BOHANON

To create a visual sense of touch, to feel with your eyes, to become involved, to create a love affair between the visual and the tactile, a unity, oneness.

DAVID BRADFORD

Aesthetically I must deal with that which is constant within our black lifestyle. These are elements which are found in African art and the African lifestyle which are not necessarily part of the Western Aesthetic. It looks beyond the social and political aspect of Black Art and works toward an art which reflects my Africanness and my Black American experience. Just as the social and political aspects are very necessary parts of Black Art, so must this art reflect the 'Black Experience,' thus going beyond the black image toward a true African-American Art.

DAN CONCHOLAR

If I can, I like to throw the viewer off balance and at the same time pull him into the work itself. But this

requires active participation by the viewer. He must have a certain willingness to become involved. The viewer cannot just sit on the sidelines and observe; he can't see anything from there.

ALONZO DAVIS

I am involved in making visual statements not literary ones. It is for the viewer to interpret. Thus, I have chosen a few words to give an indication as to what my art deals with or is affected by at this time: direction, decision, pressure, black/white, morality, unity, change, feelings, politics, humor, symbols, heritage.

DALE DAVIS

It is sometimes out of the rejected that beauty and creativity springs. My art represents what can be done with the things some people consider worthless. I create my pieces from a box of "throw-aways" that represents those objects very much allied to a rejected people. It is from this box of "junk" that I have tried to create things of beauty to which we can all relate.

MARION EPTING

To find yourself attempting to defend one side or the other of a dualism is to find yourself in a position that is uncomfortable, confining, limiting, prejudicial, impossible to maintain, and dishonest.

DAVID HAMMONS

I feel that my art relates to my total environment—my being a black, political, and social human being. Although I am involved with communicating with others, I believe that my art itself is really my statement. For me it has to be.

MARIE JOHNSON

BLACK arts' function is the rediscovery of its own roots, and the examining of the depths of the beauty, poignancy, and the humor in the souls of black people. We are a people who protest, pray, curse and preach, sing, moan, grunt and scream, laugh, cry, live and love. I am to produce a portrait of a people: the reservoir of images is unlimited.

JOHN OUTTERBRIDGE

Presently my professor is love and life, my school is dedication to truth of expression. I am deeply involved with humanity and much less sacred subjects in an attempt to create an art that is a kind of deity. I work hard because I care hard, with the hope of someday becoming a total artist.

NOAH PURIFOY

These art things have to come from discards and wastes of a man-made world. They return to it as messages concerning man and his life. There must be more to art than the creative act, more than the sensation of beauty, ugliness, color, form, light, sound, darkness, intrigue, wonderment, uncanniness, bittersweet, black, white, life and death. Art itself is of little or no value if in its relatedness it does not effect change. The art works should be looked at, not as particular things in themselves, but for the sake of establishing conversation and communication, involvement in the act of living.

TIMOTHY WASHINGTON

I am dealing with message art: it is informative and relates to a poster in that it gives information. However, I want the information to be discovered; therefore, the message is subtle. I try to ask questions and make the viewer think and in turn look closer.

1972

Carroll Greene Jr., *Los Angeles 1972: A Panorama of Black Artists*, catalogue for exhibition held at the Los Angeles County Museum of Art, February 8–March 19, 1972

William Wilson, "County Museum Showing Work by Local Blacks," *Los Angeles Times*, February 13, 1972

One year after *Three Graphic Artists* (see pp. 272–78) opened at the Los Angeles County Museum of Art (LACMA), the Black Arts Council (BAC) initiated its second exhibition at the museum, *Los Angeles 1972: A Panorama of Black Artists*. Partly in response to ongoing pressure from artists in the community, LACMA agreed to host a six-week show featuring fifty-one local practitioners; rather than taking up one of the main exhibition spaces, the show was staged in a basement area usually rented out for non-LACMA exhibitions. Most of the works were by young, emerging artists who had so far struggled to receive major institutional recognition, although a few established figures, such as John Outterbridge, David Hammons, and Noah Purifoy, were also included. The show was curated by Carroll Greene Jr., whom the BAC had recommended to LACMA's curator of modern art, Maurice Tuchman. Reflecting in the catalogue on the "acceleration of the black struggle" in recent years, Greene could not advocate for art by African American artists that did not serve a social function and did not further the search for unity and collective identity. His exhibition centered on artists who were "willing to put aside mere aesthetics." William Wilson, art critic for the *Los Angeles Times*, was not persuaded. Wary of Greene's standards for selecting the works on display, which were tied to "the racial issue," he believed that the museum had exposed itself to charges of "tokenism and condescension."

CARROLL GREENE JR., *LOS ANGELES 1972:*
A PANORAMA OF BLACK ARTISTS

A Panorama of Black Artists is a survey of Afro-American artists in the greater Los Angeles area. Well-known artists have joined with younger talents in this co-operative venture of the Los Angeles County Museum of Art and the Black Arts Council. This invitational exhibition provides a significant opportunity for many artists to gain a wider public—with the options to view, rent, and/or purchase their works—than would be possible in any other way. *Panorama*, therefore, addresses itself to one of the most critically persistent problems facing black artists—that of obscurity and its subsequent psychological and economic effects. Until very recent times few persons, either black or white, were aware of the existence of the black artist. Fortunately for both the artist and the public this situation is changing, albeit too slowly.

Let it be said from the very outset that the artists' color of skin or ethnic background could not be inferred from the majority of works in this exhibition. The decade of the '60s found Afro-American artists, along with their compatriots, actively involved in the aesthetic experiments characteristic of American art since the 1950s when abstract expressionism flowered. Since that time the vogues in the art world have been kaleidoscopic. And, for the most part, the black American artist has vied for a place in the mainstream of American and international art. Some few now enjoy international reputations.

However, the decade of the '60s saw quickened socio-political developments and many social ills and needs were brought into the open with a new frankness. Importantly, that decade also saw the acceleration of the black struggle to achieve our legitimate aspirations as citizens and partners in the joint enterprise of nationhood.

Manifestations of this movement and the search for unity, identity, and values inevitably could not be evaded by the artists. The painters and sculptors who saw the need to reach out to the masses of black Americans began to experiment with "black consciousness" art. It was largely a figurative art which addressed itself to the condition of black people. It was art as social commentary and social criticism, art as eulogy to black heroes, art as perpetuator of history, and art as an inspiration to the accomplishment of social and political goals. All of these and other manifestations took place. Inevitably such art was community-based and frequently deliberately crude and far removed from modern standards of aesthetics.

But that was precisely the point. For, among black artists there was and continues to be a rejection of "art for art's sake." They hold that art during a revolutionary period must be socially purposive and not simply created for an elite. This has been a strongly anti-elitist movement that has been willing to put aside mere aesthetics for values which it felt to be more compelling at the moment. Consequently, the didactic and functional aspects of art as exemplified in many African cultures and at various periods in Western art history have been emphasized. The Afro-American artists might have joined in Picasso's statements of 1945:

> What do you think an artist is? An imbecile who has only eyes if he is a painter, or ears if he is a musician, or a lyre at every level of his heart if he's a poet, or even, if he's a boxer, just his muscles?

> On the contrary, he's at the same time a political being, constantly alive to heartrending, fiery or happy events, to which he responds in every way. How would it be possible to feel no interest in other people and by virtue of an ivory indifference to detach yourself from the life which they so copiously bring you? No, painting is not done to decorate apartments. It is an instrument of war for attack against the enemy.

Picasso has also made it quite clear that the enemy is the man who exploits his fellow human beings from motives of self-interest and profit, and these black artists have expressed similar sentiments.

The "black consciousness" art movement continues to develop. The often deliberate crudeness that was characteristic at an earlier period is taking on increasing sophistication and often transcends

the immediate cause of its inspiration. The very title of John Riddle's *1st Muslim Cow* haunts us and reminds us of that senseless and tragic event of recent history. And his *There's More At Stake Here Than Just Attica* is as provocative as it is original in conception and execution. Timothy Washington's *Kentucky Derby* is a handsome picture of a young black man standing beside a horse, but his symbols suggest that both the man and the horse are pawns in a game from which they derive little. Bernie Casey's handsomely rendered *Memories of the Last Park* also leaves us guessing.

Black Americans today are insisting on the "black image" in art (the way early Americans insisted on portraiture during the seventeenth and eighteenth centuries) because this image has so obviously been absent in any, other than disparaging, forms. Lyle Suter's more conventional painting *Sistah* is redolent with that indefinable quality of American blackness, or "soul," which, however elusive, is recognized when authentically rendered. The pathos of Fred Wilson's *Detroit Pietà* is as moving as John Outterbridge's *Traditional Hang-Up* is biting and cynical and M. Alex Bowie's pop art *Great American Still Life* is humorously cynical. Noah Purifoy, who seems to have emerged from the ashes of Watts, again compels our imagination with his junk art *Zulu* piece. His skillful organization of disparate elements from our "throw away" culture into formal structures recalls the phoenix of old— the renewing of life and the inherent possibilities that life affords.

Black American artists at this juncture increasingly seek to be closer to the Afro-American people. In the main, they are life-affirming and life-nurturing. And, as Romare Bearden has said, "The life-style of the black American is perhaps the richest because it is the one life-style that is talking about life and about the continuation of life . . . and through all of the anguish—the joy of life." The fertility and vitality of *Los Angeles 1972: A Panorama of Black Artists* attests to the truth of that statement. And, as any survey of art by black Americans at this time must do, it tells us something not only of aesthetics but of passion, freedom, sorrow, hate, and love.

WILLIAM WILSON, "COUNTY MUSEUM SHOWING WORK BY LOCAL BLACKS"

Now the County Museum of Art has dipped its august toe into the current of social evolution. The tide, as it turns out, is lukewarm. The occasion is the first spectrum survey of local Afro-American art in a major institution. Art by about 50 black Los Angeles area artists makes up *Panorama* in the museum's art rental gallery and members lounge.

The purpose of the exhibition is to test public response to a group of artists nearly unknown outside community art shows and small black galleries. They claim racially prejudiced exclusion from mainstream galleries. Galleries insist that the work is excluded only because of inferior aesthetic quality. Artists insist the only way to settle the argument is through exposure that will give them tangible evidence in sales and written criticism. The museum reasons that locating the exhibition in the rental area provides a testing ground for measurable public response.

Ideally, more mature artists will be encouraged to excellence. Others will hopefully suffer attacks of acute, therapeutic embarrassment upon seeing their patently amateurish efforts hung in a professional environment.

The museum has a complex series of bureaucratic categories for exhibitions. Many people interpret these categorizations as reflecting the museum's attitude toward material it presents. *Panorama* is not an "official" museum exhibition, according to LACMA senior modern art curator Maurice Tuchman, but is an "installation" co-sponsored by the Black Arts Council (not an "official" council). No matter what the facts, the museum has exposed itself to charges of tokenism and condescension in relation to *Panorama*. The rental area is (groan) in the museum basement. Terming the exhibition a test of public response sounds like the museum is involved in a timorous compromise, bowing to BAC pressure but attempting to withhold its status cachet from the exhibition.

Every factor in and around *Panorama* strongly suggests heads trying to be in two places at once. It is a study in how easily good intentions can look like hypocrisy.

Guest curator for *Panorama* is Carroll Greene Jr., who selected works with the unflagging assistance of LACMA's executive modern art aide, Betty Asher. Greene, who lives in Washington, D.C., organized such gap-bridging exhibitions as the Smithsonian's retrospective of Henry O. Tanner and a Romare Bearden exhibition seen at the Pasadena Art Museum.

Greene's standards for selection seem divided between normal, appropriate concern for aesthetic excellence and a concern for what he calls "black consciousness" art. His involvement with the racial issue has caused him to include some works substandard by any known measure. He defends this posture by evoking the spirit of new black artists who "reject art for art's sake."

"They hold that art during a revolutionary period must be socially purposive and not simply created for an elite."

The blood quickens to such a virile idea. Looking at the exhibition slows it back down. Not a single work is ragingly revolutionary or graphically propagandistic.

Panorama looks like any ordinary, attractive community art exhibition, except it is shown to advantage, professionally installed in the museum's galleries. It encompasses abstract art, such as Cecil Burton's plastics, with no discernible relation to revolution, formal or social. Such polemic as it offers is stated in the oblique language of art, as readily interpretable as personal psychology as social message. Lugubrious sentimental-realist works are too awash in self-pity to have the strength required for revolution.

If the idea is to be "socially purposive," why doesn't this art take the form of slogans, posters, comix or graffiti? Why is it not in the form, language and place accessible to ghetto people without the carfare to get uptown? What is it doing in the museum at all?

The plain fact is that *Panorama* is a coup by a group of moderate artists, would-be artists and their supporters who are interested in the social status values they think the museum provides.

Since the exhibition's aesthetic level rarely exceeds competence and the work itself mocks at militant social conscience, how are we to evaluate this phenomenon?

Viewed in one light, it is an amusing example of polite mau-mauing on one side and benign fudging on the other.

Viewed in another light it represents a serious case of personal and institutional identity crisis characterized by feelings of helplessness and confusion compounded by the unwillingness of all parties to take firm stands . . . especially in relation to art.

Ideally, *Panorama* ought to show the emergence of some artistic style or attitude we could characterize as "Black Art," something visually as resonant and original as the forms and spirit that characterize Afro-American music.

Panorama contains art with heavily colored decorative patterning like abstractions by David Ferguson and Francis Allen Sprout. The faces in Eileen Anderson's *The Family* are simplified to paranoid masks. Among the most accomplished works are fetishlike sculpture and weaving by John Outterbridge, Noah Purifoy and Stanley Wilson.

These African-heritage elements have long since been exploited by white artists. They look warmed over today. It appears almost as difficult for Afro-Americans to relate to their ancient ancestry as for any fourth-generation American.

The general characteristics of this exhibition boil down to a predominance of semi-symbolic works tending to crowded decorativeness. General conservatism hints at a stifled scream as if the artist somehow feared to fully express himself. Often there is irony—anger that turns on itself—more clearly expressed in titles than objects. Haunted by worrifulness, much of this art documents more what is hanging-up black art than what is creating it.

Extended conversations with black artists reveal they themselves do not know the nature of "Black Art." It is a hope, an aspiration. *Panorama* might be interpreted as an appeal to the museum to somehow find it. The museum can't so they pass the buck to the public. It won't find it either.

If a real and coherent desire for a "Black Art" existed, any 10 of the professionally competent artists here could create a style. It has been done before, either naturally through a group of mutually

involved artists, or more artificially through artists taking cues from a critic, dealer, or theoretician.

Since the obvious moves have not been made, maybe it is not "Black Art" as a style the artists really want. The struggle may be toward individuality. Several local black artists who have achieved identity as individual *artists* declined to show.

The most impressive artists in *Panorama* are the most individualistic and simultaneously the "blackest"—in that no one but a black man could have made their art. One is the remarkably personal, lyrical woodcarver Charles Edward Dickson. Others are La Monte Westmoreland and Alex Bowie who infuses Pop-style with vicious racial satire in his Cream of Wheat ad.

Young, insecure artists often cluster together for backslapping, politics and, most important, artistic dialog. When they achieve recognition they—more than members of other occupational groups—go their own way. Artists are notoriously private people.

Unless the aims of the clustering phase are primarily oriented to the making of exceptional art, the group can stagnate into a therapy group supporting mutual mediocrity and scapegoating as "misunderstood genius." It is a sensitive phase.

Panorama represents that phase. It represents a phase in society where the aims of art are murked over with politics. The exhibition can only be justified by the eventual emergence of people who make a freer art because they are unchained from racial monsters. As it stands *Panorama* is a graymush monument to artistic, social and institutional compromise.

Alma W. Thomas, untitled statement, in *Alma W. Thomas*, pamphlet for exhibition held at the Whitney Museum of American Art, New York, April 25–May 28, 1972

Alma W. Thomas was born in 1891 in Columbus, Georgia, but spent most of her life in Washington, DC. She was the first African American woman to be given a solo exhibition at the Whitney Museum of American Art. Although Thomas had received art degrees from Howard University and Columbia University and, for the better part of a decade, studied painting with Jacob Kainen, an influential local artist and curator of prints at the Smithsonian Institution, she dedicated herself primarily to teaching until 1960. After her retirement, she began painting full-time and soon became known for her vivid abstractions, in which short brushstrokes create circular compositions and striking geometric patterns. Thomas was heavily influenced by natural phenomena, whether patterns of light or scenes of space from the Apollo moon missions, which she discusses here. On the occasion of the Whitney show, on May 4, the *New York Times* published a short interview ("At 77, She's Made It to the Whitney"): "Who would have ever dreamed that somebody like me would make it to the Whitney in New York? I'm a 77-year-old Negro woman, after all. . . . When I was a little girl in Columbus, there were things we could do and things we couldn't. One of the things we couldn't do was go into museums, let alone think of hanging our pictures there. My, times have changed. Just look at me now." She was also quoted in the *Times* as saying, "Negroes have now made their political statement about their problems in the art world. It's time that they get down to work and produce an art they can really be proud of."

ALMA W. THOMAS

My earth paintings are solely inspired from nature. The display of the designs formed by the leaves of the holly tree that covers the bay window in my home greets me each morning. These compositions are framed by the window panes with the aid of the wind as an active designer. The rays of the sunrise flickering through the leaves add joy to their display.

Man's highest inspirations come from nature. A world without color would seem dead. Color is life. Light is the mother of color. Light reveals to us the spirit and living soul of the world through colors.

Spring delivers her dynamic sermon to the world each year, drenching one's thoughts with its magnificent outburst of light hues of colors to darker ones as the weather grows warmer. Autumn, with the aid of Jack Frost, gives overwhelming, luscious, strong colors to the earth to enrich man's soul, seemingly relieving him of the hardships he encounters in life.

I have always enjoyed the progressive creativeness of the artist as he releases himself from the past. He gives new, exciting expressions through experiences from this rapidly changing world of science, economics, religion, society, and new materials, etc. I think that is the reason that I evolved to this type of statement in my present paintings. The irregular strokes give an interesting free pattern to the canvas, creating white intervals that punctuate the color stripes. There is a rhythmic movement obtained, too. I do not use masking tape. Sometimes a few pencil marks are employed to prohibit my becoming too involved in the stripes. The large circular canvases, however, are freely designed.

My earth paintings are inspired by the display of azaleas at the Arboretum, the cherry blossoms, circular flower beds, the nurseries as seen from planes that are airborne, and by the foliage of trees in the fall.

My space paintings are expressed in the same color patterns as my earth paintings, with the white canvas forming intriguing motifs around and through the color composition.

I was born at the end of the 19th century, horse and buggy days, and experienced the phenomenal changes of the 20th century machine and space age. Today not only can our great scientists send astronauts to and from the moon to photograph its surface and bring back samples of rocks and other materials, but through the medium of color television all can actually see and experience the thrill of these adventures. These phenomena set my creativity in motion. Although I was unable to experience the thrill of witnessing a blast-off at Cape Kennedy, the enthusiasm of my friend Selma Stein, who did, inspired the development of two of my paintings, *The Launching Pad* and *The Blast Off*.

When Apollo was put into orbit, *Peanuts'* Charlie Brown left Snoopy spinning around to enjoy the unbelievable. This inspired the following 7 canvases of the sun rising upon the world and Snoopy becoming aware of the planet Mars: *Snoopy Gets a Glimpse of Mars*; *Snoopy's Vision of Mars*; *Early Sun Display on Earth*; *Sunrise on Earth*; *Day Breaks on Earth*; *Sunrise Creeps on Earth*; *Earth Wrapped in the Sunset*.

With the success of Apollo 11, man accomplished his greatest achievement. Emerging from the Eagle, our astronauts were the first men to walk upon the surface of the moon. This motivated the paintings: *The Eagle Has Landed*; *The Lunar Surface*; *Man Walks on the Moon*.

Before selecting the site upon which to set the *Yankee Clipper*, Apollo 12, the broadcast of the astronauts describing what they saw induced my painting called *The Fantastic Sunset*, and their return to earth inspired *Apollo 12 Splash Down*.

As I watched the return to earth of Apollo 13 on the television, I was fascinated by the rescue procedures of the astronauts. Three parachutes lowered the spaceship *Odyssey* into the Indian Ocean at dawn. Frog men swimming around the landed ship placed a collar around it to keep it afloat until the astronauts were hoisted up to the rescue helicopter. The painting *Splash Down of Apollo 13* was the result. To conclude my space series, I painted the *Eclipse* which occurred March 8, 1970.

1972

David Henderson, "Introduction," in *Joe Overstreet*,
catalogue for exhibition held at the Institute for the Arts,
Rice University, Houston, Texas, May 14–July 30, 1972

By the early 1970s, Joe Overstreet had moved on from shaped canvases based on West African motifs to canvases that were arranged like canopies, tied by ropes to the walls and ceiling and tethered to the ground. These works could evoke nomadic dwellings or, seen through a different lens, something more sinister: His knots sometimes recalled the ropes used in lynchings. David Henderson was a renowned poet who had been a pivotal member of the Umbra writers' collective in New York in the early 1960s. By this time, he was teaching literature at the University of California, Berkeley, while Overstreet was teaching studio art at California State University, Hayward. The pair had already collaborated in 1970, when Overstreet designed the cover of Henderson's award-winning book of poems *De Mayor of Harlem*. In his text, Henderson describes the growing attention Overstreet was receiving "from art connoisseurs to the people of the street" and alludes to the mounting of numerous solo exhibitions of his work across the country. According to Henderson, the success of the artist's recent hybrid forms was due to their ability to embody the "spirit" of Black art while remaining completely contemporary.

DAVID HENDERSON, "INTRODUCTION"

Joe Overstreet's opening at the Dorsky Gallery in the Fall of 1971 drew all the beautiful bohemians of downtown Manhattan. All sizes, shapes, and colors merged into the lush flight-bound designs of his stretched paintings, named after voo doo transatlantic hoo doo gods. As the faith suggests, spirit was as exuberant as a Mambo in possession—for once there was an opening of the spirit of art, paintings taking flight from the walls secured by ropes as the means of transference into the other world, the tremendously stately blues uplifting the resolute reds, swayed by motion kinetic and delivered. The beautiful women present, coming out of the limousines, off the streets, seemingly out of the sky, in droves, proved that beauty begets beauty. The beautiful people. Not the hackneyed uptown propagandists but those who have marked their individuality by dedication to the dance and the stage, the arts and literature and music, but, most of all, to their own souls. Later that night at Ornette Coleman's the music wafted far into the night, the exuberance increasing, flowing, merging through the mind with the spirit of music, dance, and gaiety.

At the show I watched a very beautiful dancer from the Harlem Repertory Theatre staring at *Flight Gods*, unconsciously take steps of improvisation, swirling as the colors and design swirl, making the painting come alive as only a painting can be alive if it is viewed. The entire purpose being human in its utter sense, so entirely human, that liberal political words sound foolish next to the admiration expressed by his dancer—non-verbal, as non-verbal as paint yet expressing a sum total of love, from seeing love. Within Joe Overstreet's new work is a deliverance of the two major colors of the spectrum. His reds start with the terracotta copperwash of his earliest period of emphasis on portraiture, with tentative abstraction. His early portraits bring me back to the portraits the very first "Negro" painters painted. Holding steady the same keen eye of the African, the Yoruban sculptor, noting the light of the eye, the divisions of light upon the face, "the mimesis at midpoint," that realm between absolute abstraction and absolute likeness, that makes

you see abstraction in the figures and forms in the abstractions, the blending and the working of these elements.

So beautiful is it to be knowledgable of a body of works, to see the development. Overstreet's development takes fantastic leaps; a weird keen, merging into Ken, knowledgable of Ka (the African concept for subtle body). A continued brilliance of eye and style, executed in genius design, becomes a constant in Joe's work. Joe's reds become very Martian, with a human reflection of blood, to lush yet royal red, as in *Mirage*, first shown at the Oakland Museum. His blues have gone from an early neutral position to a prominence within his rendings of the spectrum. His detachment from the stretcher and also from the center of the painting gives the viewer a new mobility toward greater freedom.

The blending and mutings of American Indian colors with the mystical colors of hoo doo are together in *Hoo Doo for Mandala*.

In Overstreet's latest paintings, *Blues*, *Polytopal God*, *California Landscapes*, and *Fire Dance*, among others, I get positive emotional feelings. Within the personal geometric projections I see two sides of a thunderbolt. The visible and the invisible made perceptible. The give and take between the heavens, so as "as above so below," the harmony of the heavenly spheres and the earthly sphere. Something a spaceship camera cannot deliver. The view of the Earth from above, in Overstreet's case, as within; and also the sense of the tilt of the Earth. Not as if the world were flat, nor straight up perpendicular, but slanted within the perceptual macrocosmic vantage. Rain cloud formulations floating across Earth's vagina. That sensuality. Ruby red, like the flushed nipple of Eros. Earth copulating with the heavens. Grays, the subliminal hues, divide and support illusion. As Overstreet recently said: "I want to see abstractions of life in sex, in landscape, in violence."

Overstreet's personal geometric illusions become the pyramid; then become the pussy, the Yoni female energy encompassed by Shango thunderbolts, from the clouds, then beyond the earth, beyond perceptual range of the canvas.

Blue is wonderfully realized going into a spiritual plutonium, ultraviolet aided and then released

meta-borders into a merging of fourth dimensional neo-prototypes. The red realized as deep alluring topaz led to realization. The lighter Aquarian blue sapphire becomes the natural space of prudence and wisdom.

Joe Overstreet in his development has encompassed every major facet of mainstream Negro-Black artistry/ancestry to this stage and is now charting new directions in the total mainstream.

Overstreet's collectors range from David Rockefeller to LeRoi Jones (Imamu Amiri Baraka); from his *Mafia* purchased by the Port Authority of New York for the World Trade Center, to the modest collection his Aunt Mary has in her East Harlem walk-up. Joe Overstreet's triumphs have manifested themselves on several planes: critical acclaim from the top art critics of the East and the West coasts, popular acceptance from conservatives and radicals, from extreme white and from extreme black, from art connoisseurs to the people of the street. His development and mastery has included the major multi-Afro conceptuals to transatlantic Black American art forms; from Ashcan to Action Painting and Abstract Expressionism, from spiritual Third World invocations to pure Black Art. In the last three years Joe Overstreet's shows in Harlem, Berkeley, New York City, and Los Angeles have elicited critical acclaim, mounting and building in intensity. Of Overstreet's comprehensive show at the Studio Museum in Harlem Frank Bowling, brilliant critic and painter in his own right, felt this way:

> It is the most challenging pictorial confrontation in my recent experience. This show is a triumph! . . . Overstreet, along with other major painters, is exploring painting as a first-order activity. He is unique in that with all the rhetoric, his efforts in breadth and detail provides us with an unusual, distinctive and bold understanding. Color resonance for emotion, shape for edgy understanding of protection. Space for essential change. The wall is not dealt with formally, but with utter distrust.

While John Canaday of *The New York Times* sophisticatedly felt that Overstreet's paintings had " . . . ten times the verve and at least as much decorative effectiveness as Frank Stella's," Thomas Albright of the exotic *San Francisco Chronicle* goes into it more:

> Overstreet clearly has searched deeply for an answer to one of today's most crucial esthetic and cultural questions: The creation of an expression which at once retains the spirit of what we know as Black Art, and is also thoroughly mainstream. His resolution is a series of unique and uniquely successful, canvases which partake of both painting and sculpture. They suggest the potent presences invoked by talismans associated with religious and magic rituals, and at the same time they are grandly masterful abstractions which one appreciates simply because they bring into being a thing of beauty which had not existed before.

So be it: Joe Overstreet.

1972

Kay Brown, "'Where We At' Black Women Artists," *The Feminist Art Journal* 1, no. 1 (May 1972)

The early 1970s saw the advancement of the feminist art movement in the United States. An important and groundbreaking publication was the *Feminist Art Journal*, which was founded by three New York scholars, Patricia Mainardi, Cindy Nemser, and Irene Moss, in 1972 and ran quarterly until 1977. The first issue featured this text by the artist Kay Brown, in which she reflects on the success of *"Where We At": Black Women Artists—1971*, an exhibition staged at the Greenwich Village gallery Acts of Art in summer 1971. Nearly a year after the event, Brown describes the continuing accomplishments of the all-female Where We At artists' collective, whose membership had been growing. Perhaps most significant was the group's recent show, *Cookin' and Smokin'*, held at the Weusi Nyumba Ya Sanaa gallery in Harlem. The gallery was operated by the influential Weusi collective, many of whose members, in making their own work, took their cues from African art. *Cookin' and Smokin'* was the first time Weusi had promoted artists outside its own collective. Brown already had a rapport with Weusi, having joined the group in 1968. However, as its only female member, she eventually left to collaborate with other women in the context of the Where We At collective.

KAY BROWN, "'WHERE WE AT' BLACK WOMEN ARTISTS"

In the summer of 1971, six Black women artists: Kay Brown, Jerrolyn Crooks, Pat Davis, Mai Mai Leabua, Dindga McCannon and Faith Ringgold met together to plan the first Black women's art exhibition in known history.

The show was held during the months of June and July at the Acts of Art Gallery, 15 Charles Street in Greenwich Village. Interest in the exhibition was so great that within the few weeks before the show, the artists had doubled in number to twelve women artists including painters, sculptors, and photographers.

The theme of the show was: *"WHERE WE AT"—BLACK WOMEN ARTISTS 1971*. The title depicted the significant role of the Black woman artist and showed the community that we did exist—in numbers. Heretofore, the viewing public appeared to believe that the Black artist was synonymous with the Black male artist. Many of the artists who had worked for years had not been given opportunities for exhibiting their works.

The exhibition was a resounding success. The theme of the show was retained as the name of the group itself: THE "WHERE WE AT" BLACK WOMEN ARTISTS. The group was determined to stay together in unity to continue exhibitions and to develop projects to benefit the community.

At the time of this writing, the group numbers seventeen while inquiries for membership continue to pour in. The group wants to remain open to as many professional women artists as possible.

The members are:

Carol Blank, Kay Brown, Vivian Browne, Carole Byard, Gylbert Coker, Jerrolyn Crooks, Iris Crump, Pat Davis, Doris Kane, Mai Mai Leabua, Dindga McCannon, Onnie Millar, Charlotte Richardson, Faith Ringgold, Akweke Shingho, Ann Tanksley, Jean Taylor.

Since the first show at the Acts of Art Gallery, the WHERE WE AT group has had an exclusive show at the WEUSI-NYUMBA YA SANAA GALLERY, 158 West 132nd Street in Harlem. It was the first time in the gallery's eight year history that it had an organized group of artists exhibiting outside of WEUSI'S own group. The women artists also participated in the 1270 Women's art show dedicated to unwed Black mothers and the care of Black children, as well as the innovative PAX Bed-Stuy organization dedicated to the exposure, support and promotion of Black artists in Brooklyn. There are several other exhibitions in the near future, such as re-opening the EXPERIENCE GALLERY in Brooklyn, May of this year as well as the New York Public Theatre, the Community Gallery at the Community Church, the Langston Hughes Cultural Center, Corona Queens in April, and the Selma Burke Gallery in Pittsburgh as well as several others. The traveling exhibition is available for any persons interested.

1972

Tony Eaton, Lou Draper, Beuford Smith, Ray Gibson, and Fred Beauford, "A Rap on Photography," *Black Creation: A Quarterly Review of Black Arts and Letters* **3, no. 4 (Summer 1972)**

Founded in 1969 by Fred Beauford and published by the Institute of African American Affairs at New York University, where Beauford had studied, the literary journal *Black Creation* was an outlet for the growing number of Black creative practitioners who were exploring their culture and its achievements. This conversation, initiated by the magazine, was the first time the notion of "Black photography" was examined in detail in print. The photographers Louis Draper and Beuford Smith were joined by Beauford and writers on the magazine's staff. The discussion was intended to provide insight into the work of individual photographers and to consider images being made by Black photographers across the board.

TONY EATON, LOU DRAPER, BEUFORD SMITH, RAY GIBSON, AND FRED BEAUFORD, "A RAP ON PHOTOGRAPHY"

Because of a lack of understanding of the field of photography, we at *Black Creation* invited several working photographers up to our office to talk about their art. Included in the discussion were B.C.'s Photography Editor, Tony Eaton; freelance photographer and instructor in photography, Lou Draper; photographer/instructor, Beuford Smith; and freelancer, Ray Gibson. We had invited the excellent photographer Pat Davis to join us but she was unable to make it at the last minute. B.C.'s Editor-In-Chief, Fred Beauford, who has also worked as a photographer, joined in the conversation.

BEAUFORD: A black photographer recently said on a T.V. program that he could tell a picture taken by a black photographer. Is there such a thing as uniquely black photography?

DRAPER: My feeling is that black photography, or what you refer to as uniquely black photography, is something that, except in rare instances, doesn't exist. It's the criteria that we're trying to build upon. If we consider that photography is roughly 170 years old, and that we have been involved in it only a very short time, it's something that has to evolve. It's not something that you start with. You are dealing with a mechanical instrument and you are also dealing with certain things that have been prescribed. The whole idea of making synonymous your feelings for the camera with your life experience is something that takes a while to develop. It would be, I imagine, akin to jazz and akin to certain very distinctly black outlets. I think it would have to be based on, first of all, the penetration and concentration on the area that is specifically ours in terms of physical images—I don't know what that would be. Certainly, it would be involvement with history, it would be involvement with social movements. It would be involvement with those things that have shaped us and directed us in the 20th Century. And I think it requires an investigation into the nature of what it means to be black, and a translation of that into optical terms. I don't think that when I look at a photograph by a photographer that I necessarily know it's a black photographer. I don't think that's a very accurate statement for me, anyway. You are talking about something that is unique. You're talking about something that is beyond the physical image. You are talking about something that has to do with inner knowledge, and I don't think we have evolved into a school or a tradition of black photography. I think that this is something that we are striving for.

EATON: Do you feel that a black photographer is now capable of going throughout the world and expressing himself (or herself) in other parts of the world other than black?

DRAPER: It depends on his criteria. I think that he is capable of doing anything he wants to now. Black people can be totally white if they want to be; I mean they are capable of doing that. Expressing yourself is a by-product of expressing your subject. And in expressing your subject there is the whole coming together of what it is that shapes you, what it is that has caused you to be the kind of person that you are, and select the kind of material to work with that you do. And I think in the long run it's an evolutionary process. It's like style; it's something that evolves out of a concentration on the material, and I don't think we can talk about it beforehand. I think it will be shaped by the things that we involve ourselves with. I think the criteria is endless. I think there are a number of things that have to be discovered that we are not even aware of at this point, i.e., what can we translate into graphic form that is relevant to us?

EATON: I feel that we are very limited unless we happen to strike that pose where we can get out and really become somewhat free to search and explore our own people, and other peoples of the world. But there are very few outlets where a black photographer can go in and just pull a steady six months just studying and then coming back with the material.

GIBSON: You know, Tony, when you say that sense of being limited, I sometimes wonder about that.

I think one is as limited as the person. I think the source material is there. I think the things to evolve and involve ourselves in are there also. Like the writers are there, by and large. The music is there, but so much of it is a personal challenge to the individual. Or it is a sense of his personal need, his personal sense of doing that. I don't think that cameras react to us any differently than they do to anybody else. Emulsions are emulsions and ASA's are ASA's. But it is ourselves in conjunction with the society that we are born into, which is a very material society, that counts. I don't think any of us can get beyond that. It's like, why does a person become a Malcolm or a Martin? Certainly most of us don't even endeavor to do that. But there was something within those individuals that drove them to the point that they did. What makes a photographer? What makes him go out and do certain kinds of images? Why didn't he just stick with weddings; why didn't he just attempt to be another fashion photographer or another whatever? I believe that there are things, there are questions that come from the inside and have to do with our own personalized feelings. I believe that one involved in the sense of being black and seeing America, somewhere along the line you have to say, hey, a lot of this shit really doesn't involve me. When I hear about the Declaration of Independence or George Washington or Abraham Lincoln they're all hollow, empty cells to me because I don't see that much change. I walk through the streets and I see cats wasted. At one time I became very angry. I still do. But now I am beginning to interpret them as victims. What I am trying to say is that somewhere along the line there has to be that supreme personal conviction. Especially when there's very little remuneration— whether it be financial or even the acknowledgment. You know, like how many cats really do know about Roy DeCarava? His statements point out questions; they show him as a probing individual; they show him not from the outside. He has statements where he ponders questions that Bruce Davidson couldn't even see now. And they come out of his own existence. It's almost like a fat cat who's a wino or whatever or a cat who's strung

out. If you really examine his life it's a hell of a complex thing, and I'm talking about from the inside. I'm saying this is flesh of my flesh, blood of my blood and not just something analytical or not just some sense of saying, hey, I'm going to turn out a nice job, or I want to do a beautiful Guggenheim on these people. I think there's a hell of a lot of difference when it's *these* people and it's my mother or my father and there is that sense of directness and/or the sense of saying, hey, wait a minute, how much of this shit really does apply?

SMITH: You know, I can only deal with all of this in terms of my own efforts and my own feelings, and the direction where I want to go. And that takes me somewhat beyond black photography because, essentially, I don't think we have to title it as such. I think of the people who dealt with mathematics, who dealt with the building of pyramids, architecture and all that. There's no need for us at this point to deal with the four hundred year syndrome of slavery. There was a point in history when black people were involved with everything under the sun and my frame of reference in terms of dealing with the black experience goes to that period, not this abbreviated period of deprivation and slavery. We know that we were shapers of the world and in a parallel situation. I think that if black photography is going to be meaningful it's going to have to continue that role. It's going to have to shape and point the way, rather than deal with the kind of reaction to. It's going to have to initiate. It's going to have to begin to decipher what this whole thing about black experience is. What are we talking about in terms of history, in terms of politics, in terms of economics, in terms of spiritual consequences? What are we talking about in terms of human interaction? And how is that to be plotted graphically into meaningful images? My own feeling is that black photography has to be responsible in an educational way at this point. And I think education is quite broad in the sense that it causes people to build. It's a barometer of where they have been, and an indication of where they will go. I think it is infinite. I don't think it is in any way limited. I don't think dealing with the black

experience as I am expressing it is limited. I think it's quite broad. I think it's much more than I'll be able to tap in my lifetime if I were involved totally. There is so much that has to be said and so much that is there, so much raw material that has to be tapped, that there is no end to whatever we can involve ourselves with. I see it as the only thing that I can do. This is what I know and I try to deal with what I know. I try to deal with those things that have shaped me, those things in which the experience has gone through me; in which there has been a response, a reaction, an emotion, a catharsis or whatever. I don't think you can deal with things that are theoretical. You have to deal with things that are more accurate. Certainly you use books and you get an indication from other sources. But I mean, at some point the experience has to be actual. I think I have to respond, to be open enough to allow myself to respond, and from there possibly draw from that experience and be able to make some meaningful images.

BEAUFORD: Do any of you believe that the photographer is primarily a creative artist rather than a mere recorder?

EATON: I don't think that is the person's fault; it is the label that has been put on the person who is working. When this person feels the need to express himself, when he reaches the level where he is constantly working and constantly doing what he needs to do, then the people around him say that he is an artist. From an individual who is doing—I doubt whether I know anybody who is struggling to be an artist. But I know people who are struggling in the media, in painting, dance and with the camera. You can't deal with something this emotional and be involved with a title.

BEAUFORD: In other words you are saying that the title has no relationship to what you are doing?

EATON: Right! I agree fully with Lou.

SMITH: I've kind of kept out of this conversation because there is a word that has been going around that I haven't really understood, and that's the word "artist." Now what differentiates a person who paints; say you have two men painting. How can you say this guy is an artist and this guy isn't? Who can set the standards? Just what is an artist?

EATON: But I think that is the outside world too. It defines a person.

SMITH: But they say Andy Warhol is an artist.

EATON: They say, but you ask Andy Warhol and he may say he is a businessman who has found something that works.

SMITH: See that's what I am saying about the word "artist." There are so many contradictions that I can't associate with that word.

BEAUFORD: There is another point that keeps coming up about evolvement. One of the things we notice at *Black Creation* is that most of the photography that we receive, by and large, is concerned with sort of street scenes and the ghetto and you now, garbage cans, the "woe is me" philosophy, as Lou said. So if we are going to evolve, then in what direction will the evolvement go as far as black photographers are concerned? What else should they be doing?

SMITH: I can only speak in the personal way I feel about it. I've always been concerned with what I feel is a black image, and what I feel is pertinent to me and to other black people. But I've never photographed a bum on a sidewalk, even when I first started in photography. But I'm not even knocking that kind of photography because that's also a part of how black people live. But I think where the black artist should go is to show the other side for change. We never see a guy's old lady or his mother or his grandmother just walking down the street on a Sunday afternoon. We never see these kinds of photographs. We always see the "woe is me" sort of thing and I think we should go into a direction that shows the other side of black people.

BEAUFORD: Do you think that some photographs are actively perpetuating negative stereotypes of the black community?

SMITH: I think it gets back to what Lou Draper said. Something about the photographer should know himself. I think that kind of photography comes out as the photographer sees himself. I don't think he has himself too together if he's constantly photographing this kind of thing without adding some kind of light to it. I'm not against photographs of bums in the street per se, maybe that's a contradiction, if they can add something to it, or transcend—if he can say why this bum is here. Or say, next week the bum will no longer be there, this is where he was and this is where he is going sort of thing.

DRAPER: It's funny, because when I look at most black pictorial books, I see very little of my environment. I just feel that there is much more. My life, my black experience, if you will, is much richer than most of the black photographs that I have seen, most of the photographic work that I've seen that depicts it. I would like basically to deal with a number of things. Those things that manifest themselves in front of the camera and those things that I have to forcibly bring together in another process. Because there are many things that I feel that have to be dealt with that are illuminating, and are quite profound and that somehow have to be tackled. I have to deal with them, and I have to deal with them on my own terms. And you now, there are images from history, images from contemporary life that deal with courage, some that deal with longevity. One of the most fantastic images that I have experienced was the Olympic Marathon. Who won the marathon? Symbolically that means a lot to me. I think this is what we have done. I think we have won the marathon, I think that we are on the upswing. I think awareness is a beginning—actively involving yourself in the process of your own liberation and who you are about. And I'm concerned with building. I'm concerned with how I can use my energy to point the way to how to build that nation. And I don't think that a responsible artist should be involved in stagnation. I think he should be involved in growth, in having to water the flowers.

GIBSON: You know I would support what Lou has said 100 percent with the sense, that again, I think that one of the things that was so personal and so inspiring to me about Roy was that he took people that you didn't find at that time in *Ebony* and you don't find in *Ebony* today and you don't find in *Look* or *Life* or any other magazines. And he saw something in them, he saw a sense of dignity, a sense of worth in them. There is a photograph in there of a woman and she's standing by an ironing board, and that's all, but I think that in itself is just as monumental as anything. And I think it was that kind of sense that . . . I don't think that Bessie Smith can be ashamed of Aretha Franklin. You look at me strangely when I say that. What I am trying to say is that there has been a strong resurgence from down under, or whatever. There are a hell of a lot of people like Wilson Pickett, like jazz itself. At one time it wasn't supposed to be what it is. And these cats have carried the force of something. Or if you look at poetry. Today it has gotten away from the sonnet, it has gotten into a whole black thing and it comes from the damn street itself. But yet, still it finds a dignity in that, it comes from the mass, wherein at one time there was Du Bois talking about the gifted ten. But it's the mass itself who is going to give—give out of itself. And I think that's the kind of thing I can identify with. That's what I was trying to say about Aretha Franklin and Bessie Smith. On the one hand people can say, hey, she was nothing but a drunk and just sang some songs, but on the other hand if you listen to what she was talking about, and if you listen to Aretha Franklin, there is a definite extension of us. And Aretha is not about "woe is me"; she's talking about moving on up. It's the same with Nina Simone, but it's in another sense, a sense that can take this whole dispersed diffuse kind of thing and give it some nurturing and blanketed feeling. Hence, a lot of people can come to a single audience, and all of them within their own selves can be aroused by this. I've seen people just stand on their toes and clap because they feel that there is a sense of somebody out there eloquently that many of them just don't have the voice to say.

BEAUFORD: And you think the same thing can happen with photography? It's interesting that we are having this conversation, because the writer I interviewed for this issue, a guy named Al Murray, was saying essentially the same thing about writing, that the writers perpetuate the "woe is me" syndrome, the pathological Negro syndrome and they never really reflect the life that they have led, the rich lives they have led, and the only persons that have really done that so far are the musicians. They have actually broken out and into new fields, opened up things to the point where black music is internationally recognized. Can photography do that?

SMITH: Lou brought up something that really didn't dawn on me that should have. Our whole thing was music. When we got off the boat we communicated with each other through music by singing. Photography just came into existence a hundred years ago or whatever and the black photographer just got into it in the past fifty or sixty years—so really we have a lot of work to do in order to get where the musician is and by the time we get where he is now, he's going to be gone someplace else.

EATON: Why do you think that the musicians will be far ahead in time than we with cameras?

SMITH: For one reason I think the musician has a larger audience than the photographer and the photographer works under more limited conditions than the musician. The musician can stay in his room, think up all kinds of things. With photography you can do it to a certain extent, but at least the photography I deal with is kind of based on me catching it right then. I can't set it up, well maybe I could set up some things, okay, I do it—now who sees it—nobody but friends. But the musician, okay, I show someplace, but that's not too often, but the musician usually plays and travels all over the country and goes to Europe. Did you ever hear of a black photographer having a show in Europe—or a show all over the country?

BEAUFORD: Not only that, but I think there is something else important—immediate feedback from a mass variety of people. You know, when a musician plays he can feel the vibrations coming in from the audience.

SMITH: What you are saying is that we are kind of working out of a vacuum?

DRAPER: That, within a certain extent, is true, but the satisfaction of being involved, the satisfaction of being able to achieve something and to stretch the possibility of just communicating that whole thing I think sometimes can be enough. Because a photographer doesn't just make pictures, a photographer is just a person. I've experienced much more and much deeper feelings that I am able to record with the camera. It has made me a much more responsive and much better person, a much more committed person. All that won't be in my photographs, but I think it is essential that I be that kind of person. And in relationship to music, what you said earlier is that there is a certain degree of abstraction that music has; there is a certain degree of synthesis, emotional/musical synthesis that music has that I think that if we are able to match its success, we are going to have to bring toward photography a whole new thing. Photography is basically rather analytical. It's very Western; it's also very un-African in a certain sense and I think that what we are going to have to do is establish a criteria which would enable us to better use our own traditional roots. And to be able to shape that, we are going to have to call upon that in us so that the mechanical instrument is going to evolve imagery that is unique for us.

BEAUFORD: Can it be done?

DRAPER: I don't think we have a choice. I think it will be done if we apply our energies to it. I don't think there is anything that can't be done.

1972

Ray Gibson, "Roy DeCarava: Master Photographer,"
Black Creation: A Quarterly Review of Black Arts and
Letters **4, no. 1 (Fall 1972)**

This profile of Roy DeCarava, the second major article on his work, after
A. D. Coleman's essay in *Popular Photography* (see pp. 195–201), includes
important statements by the artist-photographer.

RAY GIBSON, "ROY DECARAVA: MASTER PHOTOGRAPHER"

Roy DeCarava does not look like his age. In fact, the only things that give any indication of his 52 years is a love for Billy Holiday's "If the Moon Turns Green" and the presence of a pair of old man's comforts on his slightly pigeontoed feet. His voice moves with the full emotion of what it's projecting as he points out that he "was educated, or went to school, let's put it that way, in New York City."

An early involvement with art as a major during high school and two years of Cooper Union gave him the mechanics of painting.

DeCarava later joined the Harlem Art Center on 125th Street (funded by the government as part of the WPA program) and has fond memories of the experience. ". . . It was a beautiful experience," he said, "because it was alive. It was vital and I really felt at home. It was run by a Black woman, Gwendolyn Bennett, and she ran it. Most of the instructors were Black: Elton Fax, Norman Lewis, Ronald Joseph and Sargent Johnson. So, I stayed there as long as it lasted until it collapsed because of politics, and what not."

Working as a technical illustrator to support his family left Roy little time for doing silk screen printing. So as a means of conserving what time he had, Roy in 1946 started to use the camera as a way of capturing scenes that he would later sketch. ". . . I was interested in having art be important to people, to address itself to as many people as possible. I went into the print media and it, theoretically, made it possible for people to own works of art at a reasonable price, so that when I went into photography, I just carried that over."

The work of Henri Cartier-Bresson was his greatest influence, for DeCarava liked his direct approach to people coupled with this lyrical use of the usual elements. "I also was familiar with the Farm Security Administration's photography," he said. "In fact, I owned a book called *We Have Seen Their Faces*, and there was another book of prints by Richard Wright called *Twelve Million Black Voices*.

"I had the one man show at the 44th Street Gallery. I think it was in '49, and at that time, a photographer who was a friend of the owner suggested that I go up to see Steichen. I went to see him and showed him my work. He overwhelmed me with his reaction. In fact, I think he bought some prints at the time. He suggested that I try for a Guggenheim . . . to give me a chance to work. He sponsored me along with several other people (Romare Bearden, Jacob Lawrence, Mrs. Homer of the Countee Cullen branch) and in 1952 I received the grant.

"I wanted to photograph Black people, simply because I felt it was ridiculous that nobody was doing it. The only people who were attempting it were white photographers and they were doing it from an exotic or a social sense. I just had this overwhelming urge to say something honest and positive about poor, Black people in the city. Because I was poor and as far as I was concerned I was them too; the only difference was that perhaps I had survived enough to be able to do something that they weren't able to do. So this is what my Guggenheim was about. I worked on it for about a year. It was something I wanted to do and I really felt good doing it."

Four prints from the fellowship were chosen to be part of Edward Steichen's *The Family of Man*—a show that spent some time at the Museum of Modern Art and then went on a tour of the world. But fast on the heels of these personal triumphs came the hard truth that publishers were not interested in the beauty of the Black image; this was proven every time he went from company to another in a vain attempt to get a book published from the remains of the fellowship work. So the photographs were placed on several shelves in his closet and there they remained for some time until one day while looking at some of Langston Hughes' "Simple" stuff a thought crossed DeCarava's mind that Langston might like to see his photos.

"I called him up and told him I had these pictures I wanted him to see. He not only liked them he said, 'Hell man, we got to get you a book.' I said I been all over and nobody wants 'em. . . . So he took my pictures around to all the publishers that

424

RAY GIBSON

he knew and one of them said if he would do that text they would publish my photographs. *The Sweet Flypaper of Life* was the result."

Were this portrait to continue along this historical vein one would not get the full sense of what makes Roy DeCarava one of the greatest living photographers, Black or white, of today.

There were other photographers who trained their cameras on Black subject matter, but none with the truth and compassion of this man. Through the work in his *Sweet Flypaper of Life* one sees, for the first time, photographs on the same personal level of involvement as Richard Wright's *Black Boy* or Bessie Smith singing the blues. There is a Black man ascending into the light of a new day; two dancers clinging passionately to one another; a child of the street looks, but smiles not; these are more than photographs; they are images born of one man's passage through life. These images come from his own personal ". . . belief that there should be no dichotomy between what one believes and what one does." He has gotten beyond the state of merely reporting, he has gotten to where: "I just want my work to be as completely honest and as deeply emotional as I can make it. I don't have any particular goals in mind other than I want to take the kind of pictures that have never been taken before. When I say never taken before I mean in terms of the intensity and importance. I'm addressing myself to Black people first. There is a certain responsibility that each of us in his own discipline should survive and help other Black people to survive, and that includes photographers."

These thoughts brought to mind the Kamoinge Workshop and how he and other photographers came together out of a common need to form a Black esthetic and to further the development of photography. The workshop exists today taking on new meaning since its original conception. Over the years it has housed such photographers as Herbie Randall, Lou Draper, Ray Francis, Beuford Smith and Jimmie Mannas.

In these times when superficial Black images are so prevalent on the screen, stage, television, books and museum exhibitions, it is important for us to recognize and acknowledge a man who has dedicated his life's work to the reproduction of our true selves. His old men are our fathers, his old ladies are our mothers, his children are our children and his people are us.

"I think," DeCarava said, "that there's a lot to be said that's not being said. There's a lot of responsibility that's being shirked. Like I said before, I don't think that Black people can afford the luxury of being stupid, of being unaware, of being irresponsible. I don't think that we can afford that luxury. I think as artists, as photographers, we have a responsibility to give as much as we can, as much as we know. So that perhaps someone else might go a little more because of us, feel a little bit more because of us. I don't see art as an individual function as much as a social function."

Louis Draper, "The Kamoinge Workshop," *The Photo Newsletter* 1, no. 4 (December 1972)

In 1963, a group of African American photographers came together to establish the Kamoinge Workshop in New York. In the language of the Kikuyu people of Kenya, *kamoinge* means "a group of people acting together." The collective was founded by Louis Draper, Albert Fennar, Ray Francis, Herman Howard, Earl James, James Mannas, Calvin Mercer, Herbert Randall, Larry Stewart, Shawn Walker, and Calvin Wilson, and Roy DeCarava was elected the first director. The workshop provided a nurturing environment for the production of work as well as a forum for critique. Kamoinge exhibited at a space in Harlem and, later, in other venues, including the Countee Cullen Branch Library and the International Center of Photography (ICP). As DeCarava pointed out (see p. 198), Kamoinge was a way "to say things about ourselves as black people that only we could say." Although many remained in the group long-term, the membership did evolve: In 1972, Ming Smith became the first and only female photographer to join. At the time this article by Draper was published in the *Photo Newsletter*, the workshop had fourteen members.

LOUIS DRAPER, "THE KAMOINGE WORKSHOP"

It is our endeavor to produce significant visual images of our time. In the area of human relationships, political and social interactions and the spiritual world of pure imagery, the needs are basically the same; that being the establishment of contact with self is the key, the source point from which all messages flow. We speak of our lives as only we can.[1]

Four photographs were all that made up the original Kamoinge Workshop. It was 1963. We had come together in a rather relaxed atmosphere; our Sunday evenings usually consisting of well-blended John Coltrane, Brillante wine, stewed chicken, bless the ladies, and a dash of photographs. Once in a while a most pertinent thought might be offered just as Jim Brown streaked downfield on a long touchdown jaunt.

The word "Kamoinge" is derived from the Kikuyu and represented, in essence, and ideal. Literally translated, it reads "a group of people acting together."

Much was expected of us as photographers, our only criteria being the best effort within our capabilities. It was assumed that we would be regularly in attendance and that the production of photographs was of primary consideration. We met as friends, which enabled us, I think, to survive some rather severe print criticism at times. Seriousness was that ingredient reserved for the work itself, but a full range of feelings made their way into a night's conversation. Being firmly convinced that photography is its own limitation, my feelings were that the production of good photographs is as much involved with good music and conversation as it is with a thorough investigation of all other forces surrounding us. This attitude was shared without question and we found little opportunity for insecurity amidst emotional flights by a fellow member. The creative spirit offers no precedent, consequently no data sheet to a plan of behavior.

Later in 1963 at a photo studio in Harlem, a number of photographers were to assemble: photographers of many diverse backgrounds and abilities. There was an expectancy for exchange and a curiosity borne of isolation and exclusion. Somehow we all knew that this kind of association was essential as a means of being strengthened against the indifference of established photographic institutions.

The Kamoinge Workshop was present at this gathering and contributed to the organization of this body of photographers. We all needed an outlet for our work, a means of supporting ourselves and a forum of peers who would view our work with honesty and understanding.

There was much excitement at that session. Enthusiasm was high. Sensing that conditions faced by this group of photographers were, in many ways similar to our own, the Kamoinge Workshop optioned to affiliate itself and offered its name for possible consideration. The name "Kamoinge" was adopted and the nucleus of what became the current Kamoinge Workshop was established.

We saw as our purpose, the nurturing and protection of each other; challenging each other to higher attainments. We championed each attempt as proof of our faith and evidence of our unity.

Not without a good deal of debate and much discussion, the first Kamoinge Workshop portfolio was produced. Fourteen of the fifteen photographers then comprising the workshop were included in that first portfolio. The statement issued with the portfolio read: "The Kamoinge Workshop represents fifteen black photographers whose creative objectives reflect a concern for truth about the world, about the society and about themselves," and accompanying that, "Hot breath streaming from black tenements, frustrated window panes reflecting the eyes of the sun, breathing musical songs of the living." —Louis Draper.

In character these photographs were models for our concerns during those hectic and exciting years. The march on Washington had just taken place and many photographers had been a part of that. In many cases a direction had to be created for what had photographically been accumulated. Logical suggestions followed; a show, a book, or maybe a portfolio; something to put these energies into focus and to give that focus depth. Others had engaged themselves in self-assigned projects or

those initiated by the collective body. This portfolio was a direct result of these thoughts, and while limited in production and not original photographs (offset photo copies) did, I think, set the tone for succeeding events.

Soon after, *Portfolio II* followed. In contrast to the first portfolio, they were original photographs, prepared in a limited edition of fifteen total portfolios. Ten of these were sent out as gifts to institutions around the world. The list included Atlanta University, the University of Mexico and Howard University. Other places were the Schomburg Collection, the Museum of Modern Art and the Museum of Negro History.

One of the most controversial, but unanimously accepted projects that the Kamoinge Workshop involved itself with was the "Final Man" theme. This was a poem written by the Jamaican poet Basil McFarlane and was the first consciously African oriented theme undertaken by the workshop. In interpretation, the poem proved to be highly challenging and as a consequence, much heated conversation and pictorial diversity ensued.

In the Spring of 1964, Edward Steichen had a large exhibition at the Danbury Academy of Art in Connecticut. Sponsored by the N.A.A.C.P., it was an effort to raise money for its local chapter. Steichen invited Roy DeCarava, at that time chairman of the group, to exhibit with him at the Academy. DeCarava, in turn, extended this invitation to the other workshop members.

One basic fact that was pointed up in this exhibition was that we needed a space to show our work. In Danbury, we had only a small corner of the room, and generally felt that our presentation, while adequate, was deserving of better exposure.

Soon, plans to move were afoot. As a meeting area, the studio was adequate, but inflexible. We would wait several months before that move became evident. In the interim, we used each others' apartments. Here, we could have more time and occasionally prevail upon a willing wife or girlfriend to whip up a stew of our staple of rice and beans.

While membership at that time was open and guests were welcomed, word got around that a photographer ran the risk of very tight jaws if he came in, made his presentation and found out that his s--- wasn't together. Member photographers faced the same hammer, as I remember. Several guests were invited to the workshop to share experiences, show photographs, or simply view our work. Some of those in attendance were S.N.C.C. photographer Tom Wakayama, playwright and poet George Bass, South African photojournalist Peter Magubane, Langston Hughes, Henri Cartier-Bresson and R. E. Martinez of *Camera Magazine*. It was Martinez who invited the workshop to contribute to a future issue of that publication. In the July 1966 issue of *Camera Magazine*, the workshop is represented by some twenty-odd pages of photographs and text.

By now, the workshop had set up quarters in the Market Place Gallery. This we leased for a period between 1965 and 1966 and produced two group shows there. One show was entitled *Theme Black* and the other *The Negro Woman*. By now the gallery, unofficially known as the Kamoinge Gallery, had begun to attract regular visitors and was fast becoming a focal point of photographic activity in the Harlem area. Exhibitions were scheduled, as work or projects by individual members were produced.

After a while this space became confining as well as some of the workshop ideas. Ray Francis, always one to make his own way, was one of the first photographers to venture out. He took a leave of absence to seek our more personal endeavors. Herbert Randall, who had just been awarded a Whitney Fellowship, took off for Mississippi. He spent the "Summer of '65" photographing and playing hide and seek with guess who?

While there were exceptions to this, the workshop had become rather dogmatic in its outlook and showed a tendency to limited perspectives. As restlessness set in and our interests broadened, we could no longer stomach the steady diet of run-down tenement and sad-dyed tots. While often beautiful, these photographs often became an imposition rather than a commitment. In the midst of this upheaval, Roy DeCarava resigned, Albert Fennar affirmed his independence and fifteen-year-old

David Carter, whose spirit I will remember, kept us mindful of who else we were.

The Countee Cullen Library exhibit was the last group project by the Kamoinge Workshop for some time to come. It would be our best effort up to that time. The air bristled with anticipation. Photographers were known to have smiled coyly when queried about their expected entry into the exhibition. You can bet we were all up for this one. Having been roundly criticized for marching backward and for not being too grateful for favors bestowed, we would "reply our way."

The exhibition was entitled *Perspectives* and included every member of the workshop, even those on leave and out of town. We reserved three guest spots for Kenny Dunkley, Mel Dixon and Earl James, a former member.

The family survived, though altered by new priorities. Many of the photographers had simply outgrown the workshop as it was originally constituted, so that for the next six years it was to function on a much more multi-faceted level.

Some of us began teaching or conducting seminars, others became involved with motion pictures or commercial photography. Others journeyed out on a more personal search. In spite of this, the unity remained, for as a photographic family, we wear well. In thinking about that period now, the immediate association conjured up are responsiveness, wit, and a gut tenacity of large proportions.

In 1966, Jimmie Mannas and Herbert Randall went to Brooklyn to work in the human resources project "Youth-In-Action." Later Lou Draper and Ray Francis were to join them. Shawn Walker went to Cuba, Adger Cowans to Europe, and Herman Howard to the U.S. Army's "Vacation Spot" in Asia.

When Jimmie Mannas set up his production company, it offered another outlet for photographers to present their talents. Some worked with him on films, and others under his and Beuford Smith's coordination, contributed to exhibits and seminars at Notre Dame and Amherst University.

Without a doubt, the Kamoinge Workshop has been a most important factor in the development of young minds in photography and will continue to do this. Whether through exhibiting, lecturing, teaching or just plain rapping, the workshop has dealt a mortal blow to the efforts of slander mongers. Indeed, we are an "embarrassment of riches" to the poor of spirit and the not too swift of mental exposure. What we now know, in looking back, is that the experience has been worthwhile. That such a diverse and multi-talented group of photographers came together at that point in 1963; growing both artistically and philosophically, is eventful. Even more important; that we are still together and stronger in spirit as well as participation, echoes the theme of our recent exhibit, entitled *Alive and Well in 1972*.

NOTE

1 [Here, Draper is quoting from an unpublished document setting the agenda for the Kamoinge Workshop that is held in the Louis Draper Archive, Virginia Museum of Fine Arts, Richmond. —Eds.]

Sue Irons (later Senga Nengudi), "CAPS GRANT— SCULPTURE: Statement on Work" (grant application), 1972

Sue Irons, who later changed her name to Senga Nengudi, was born in Chicago in 1943. She moved to Los Angeles as a child and later studied art there, first at Pasadena City College and then at California State College (now California State University, Los Angeles). In 1966, she spent time in Japan as part of her postgraduate studies, and on her return, she began a series of sculptures incorporating plastic and colored water, some of which Henri Ghent included in his 1971 show *8 artistes afro-américains* in Geneva (see p. 362). Nengudi was based in New York between 1971 and 1974. In 1972, she wrote the following grant application to help fund a series of sculptures in which she planned to cut colorful nylon into ghostlike figurative shapes. Ultimately, she installed the works in outdoor spaces in Harlem, stringing them up so that they could be moved by the wind. Nengudi's interest in spirits was related to the work of David Hammons, Houston Conwill, and other artists with whom she would later collaborate in the Los Angeles–based collective Studio Z (see pp. 544–45), all of whom also showed at Linda Goode Bryant's New York gallery Just Above Midtown (JAM).

SUE IRONS (LATER SENGA NENGUDI), "CAPS GRANT—SCULPTURE: STATEMENT ON WORK"

Spirits is the subject I am working with. The inner souls or spirits of people I have seen on the city streets; particularly, in Harlem. There is a series of 25 of these souls made out of nylon flag material.

The pieces are basically two dimensional. The material is seen at its best with natural sunlight shining through it; which intensifies the colors of the pieces. If shown inside the same effect may be captured by spotlight. These are basically outdoor pieces. And, when the wind hits them they begin to talk and move about. Again, in an indoor space fans may be substituted to gain the same effect.

There are a series of grommets at strategic points on the pieces. Nylon cord is attached through these holes. And, the cord is extended to the wall fixture and/or whatever fence or building protrusion that is available and secured there.

1973

Faith Ringgold, "A Message to the Could Be Political Artists of the World from Faith Ringgold," statement delivered at 61st Annual Meeting of the College Art Association, New York, January 25, 1973

By the early 1970s, Faith Ringgold had established herself in international art circles; in 1972, for example, she participated in the *American Woman Artist Show* in Hamburg, Germany, sponsored by GEDOK, the venerable European organization for women artists. Activism remained an essential part of her practice, and in May 1973, Ringgold, her daughter Michele Wallace, and Florynce Kennedy, Doris Wright, and Margaret Sloan-Hunter founded the National Black Feminist Organization to address the unique issues affecting Black women in the United States and their relationship to the broader feminist movement. Earlier that year, Ringgold had spoken at the annual meeting of the College Art Association, which took place in New York City. As part of a panel discussion titled "What Is Black Art?" which included Nigel Jackson, Art Coppedge, Kay Brown, and Valerie Maynard, Ringgold continued her ongoing quest to ensure that women artists be treated equally to their male counterparts. Political art, she pointed out, could be defined as such only if it included "the unconditional and immediate equal participation and involvement of all *women* as people."

FAITH RINGGOLD, "A MESSAGE TO THE COULD BE POLITICAL ARTISTS OF THE WORLD FROM FAITH RINGGOLD"

Let us no longer speak of being humanist, leftist, radical, subversive, political, liberal, socialist, communist, yippiest, militant, black nationalist, pan Africanist, Chicano, Indian, Puerto Rican, brothers, blacks, rebels, revolutionary artists unless you are also talking about being feminist.

Likewise, let us not try to do art that is political or think politically unless that politics includes the unconditional and immediate equal participation and involvement of all *women* as people.

Unless your first priority is equality for all—all women people equally with all men people—then what you are suggesting as political art is only more oink-oink biggy-boo bullshit art, done with a right on instead of a right up. And maybe right now the male chauvinist artworld, black and white, male and female, on the left and right, will not see what you are doing. But art lives, and today's narrow prejudiced views become more obvious and ridiculous with time tomorrow.

All art and artists that seek to eliminate, conceal or in other ways ignore the equal existence of women as a potent part of every struggle, whether it be the art of black people or of other so-called ethnic groups, or prison art or peace art, or poverty art or struggle art or high class subtle message art is for the timid left or right or center.

The struggle for equality of women is the only truly radical force operating today in any and all societies and among all people because it involves people of the same and different races, ages, sexes and classes, both in our bedrooms, our factories, places of business and in the streets. No one escapes this revolution, and its resolution has the potential to change the world. She who once only rocked the cradle will one day rock the earth. Maybe peace will make the difference. We have already had more than 2000 years of male wars.

But certainly all those who ignore the feminist point of view in political art have missed the boat on a dry dock.

1973

Edward Spriggs, "Search for a Black Aesthetic," in Richard L. Pope, ed., *The 1973 Compton Yearbook: A Summary and Interpretation of the Events of 1972 to Supplement Compton's Encyclopedia* (Chicago: William Benton, 1973)

This essay by Edward Spriggs examines the attitudes of Black artists relatively early in the decade. Referring to the arrival of a new epoch for African Americans, Spriggs predicts that the "protest art" of the 1960s will be replaced by a celebratory art led by collective values that appeal to "black people everywhere." Citing the Chicago group AfriCOBRA as representative of these ideals, Spriggs suggests that Black people will achieve nationhood through a revival of heritage rather than the "mere rage" of the previous decade.

EDWARD SPRIGGS, "SEARCH FOR A BLACK AESTHETIC"

Some black artists in the 1970s are stepping out from the shadow of the slave ships, out from the shadow of the plantations, out from the shadow of the cultural imperialism of the international art marketplaces. As the sun sets on these social and political chapters of the history of the African in the Americas, some Afro-American artists are marching out of those shadows to control the moon of their life. Since 1619 this movement, this progression toward self-determination, has been both an internal and an external one. It has been both political and cultural. The black experience on these shores encompasses both positive and negative experiences. It has been a historically tragic saga that includes the physical and psychical abuses suffered here. It is also a saga that includes the strengths, renewals, celebrations that have evolved from the struggle and pain of past and present.

The fact of this reality, this black experience, is central to all honest discussions about any aspect of black life and culture in the Americas. As much as it disturbs many Americans, white and black, no sincere observations or projections about our affairs can be broached without acknowledging the fact of the slave and post-slave life of the black man under European domination.

The subject of this article is neither the question of the European's guilt nor the protest that characterizes much of what we call black art. My theme is the emerging concept of black creations and values that motivate the black artists of the 1970s. However, in order to fully appreciate how the seemingly new attitudes have evolved, one must (and I emphasize it again) keep in mind both the social and the political relationships that blacks have had here in the West. For it is these relationships that have in part shaped the ideas and motivations of the contemporary black artist.

THE ARTIST AS ACTIVIST

Because so much is going on by way of the creative outpouring from black communities all over the United States, there is considerable confusion concerning what it is all about, how to talk about it, and what it means. The visual arts in black communities are taking on meanings and functions other than those that normally obtain in other communities. Furthermore, many young black artists are projecting their art in a fundamentally different way even from that of black artists of earlier periods.

The black artists who have come to maturity during the 1950's and 1960's are social activists, community-oriented people. They are political. They are committed to putting their talents and energies to the service of the black community. Witness the large outdoor murals that are being created in metropolitan areas such as Boston, Mass.; Chicago; St. Louis, Mo.; San Francisco; New York City; and elsewhere. Many of these projects were initiated by the artists themselves. The paintings just appeared suddenly, without sanction from landlords or any kind of outside-the-community approval. (Some of them, of course, have been commissioned and approved.) Witness too the storefront galleries, community or neighborhood museums, artists' cooperatives and workshops that are springing up in most large ghetto areas. Even the artist himself has taken to the streets to disseminate his creations at prices that attract community residents. For some of these artists the streets have become both studio and gallery.

Black artists hold frequent local and national meetings in order to share ideas and information. While this activity has not produced a local, regional, or national style of art, there has developed a unifying sense of dedication and common purpose among many artists of African descent. A definite supportive atmosphere has developed as well. It is an atmosphere that holds great promise for contemporary black artists.

BEING BLACK IS FIRST

How then does the contemporary activist-artist define himself, and what does he see as his role? The general attitude of the black activist-artist is that he is black—of African descent—first and an artist second. By that he means that he accepts his "Africanness" as a gift of birth, and this fact is more important to him than his talent in art. He is

not concerned about whether his consciousness of being of African descent came before or after his conscious choice to be an artist. He sees his talent as a gift of personality to be used in the celebration of black life.

Two important things are implicit in this attitude. The first is of cultural importance. It is the conscious act of defining oneself, in no uncertain terms, as a person with specific spiritual and cultural links that connect him with black people wherever they are in the world. It further recognizes that what motivates and informs his creations is a history that embraces specific impulses and a specific heritage. The second thing of importance in this attitude is political. It involves the coming to terms with the sociopolitical reality that surrounds black people daily, rather than adopting the Western posture of alienation from self and environment. The contemporary activist-artist assumes the role of a liberator. He sees it as his duty to establish a synergetic relationship between himself and his environment, believing that each gives shape and form to the other. Of course, an art for art's sake is not possible with such an orientation.

Let me here offer the reader some background to the ideas and attitudes that motivate a great number of black artists and thinkers today. Above all, one should keep in mind that the cultural explosion occurring in black America is the result of ideas that have been fermenting for several decades in the black world.

NEGRITUDE AND SOUL

The social and political background for the term "black art" can be found, just as can that for the term "black power," in the synthesis of ideas and efforts of such men as Edward W. Blyden, Marcus Garvey, W. E. B. Du Bois, George Padmore, Kwame Nkrumah, Nnamdi Azikiwe, Julius Nyerere, and a host of other figures in recent African and Afro-American history. These men were the architects of such ideological views as "African personality," "African socialism," "Pan-Africanism," and "negritude." Alexander Okanlawon, in an article titled "Africanism—A Synthesis of the African World-View" (*Black World*, July 1972) combines these

views in what he projects as a more comprehensive ideology—"Africanism." He says:

> In other words, each represents a certain aspect of the doctrine of Africanism: Negritude, the cultural-literary; Pan-Africanism, the political; African Socialism, the socio-economic; African Personality, the humanistic.

The more specifically literary antecedent to black art is the concept of *negritude*. This concept was initiated primarily by French-speaking African colonials who were concerned about the situation of the Negro in a culturally alien world. They saw the position of any one group of blacks as being common to that of the vast majority of blacks wherever they were in the world. This philosophy gave rise to an interest in the characteristic impulses, traits, and habits that may be considered more markedly Negro or African than white or European.

A similar cultural concept paralleling the French-speaking African one of negritude is the English-speaking Afro-American concept of *soul*. The term "soul" did not gain widespread use until the 1950s, when black jazz musicians began to use it. In the early '60s black intellectuals adopted the term to refer to the black way of doing certain things as opposed to the white or nonblack way. More importantly, they used the concept of soul in discussing negritude and its expression in the United States. To date, Lerone Bennett has provided the most celebrated definition of soul, in "The Negro Mood" (1965). For him:

> *Soul* is a metaphorical evocation of Negro being as expressed in the Negro tradition. It is the feeling with which an artist invests his creation, the style with which a man lives his life. It is, above all, of the spirit rather than the letter: a certain way of feeling, a certain way of expressing oneself, a certain way of being.

Bennett's definition of soul is also a definition of negritude. Although the two concepts are not at all dissimilar, of the two soul has been less debated. Afro-Americans from all walks of life understand and use the term "soul." It is at once a household word and a philosophical concept.

THE FUNCTION OF ART: CELEBRATION AND LIBERATION

This, then, is the background of the political and cultural ideas that have informed present-day black artists in their search for a black aesthetic. It is this background that determines their approach to art and life. They take the position that black art is first of all a subjective art; it is subjective because it affirms that there is a collective, though not entirely identical, experience that blacks the world over share. It affirms and objectifies the way of life and dignity of black people.

The black artist takes the position that his is a functional art, in that it serves to revive self-pride and confidence and recognizes no dichotomy between art and life. It celebrates life and provides at the same time a unifying sense of significance in the world. Through his art he liberates the African personality from cultural servitude.

The influence of these political and cultural doctrines on black artists who matured during the 1950s and 1960s can best be appreciated by examining the recent manifesto of a group called "AFRICOBRA: Ten in Search of a Nation," by Jeff Donaldson, published in 1970. AFRICOBRA (The African Commune of Bad Relevant Artists) is a Chicago-based cooperative that was founded in 1968. Its members are Donaldson, Napoleon Henderson, Jae Jarrell, Wadsworth Jarrell, Barbara J. Jones,[1] Carolyn Lawrence, Howard Mallory, Jr., Frank Smith, Nelson Stevens, and Gerald Williams. This group of talented and committed artists is in the fore of black artists who are developing a body of creations that incorporate the common characteristics of what is generally conceded to be "black art." AFRICOBRA's collective ideas are projected quite clearly, yet poetically, in a statement by Donaldson, one of the founding members:

> We strive for images inspired by African people/experience and images which African people can relate to directly without formal art training and/or experience. Art for people and not for critics whose peopleness is questionable. We try to create images that appeal to the senses—not to the intellect . . . images which deal with

concepts that offer positive and feasible solutions to our individual, local, national, international, and cosmic problems. The images are designed with the idea of mass production. An image that is valuable because it is an original or unique is not art—it is economics, and we are not economists. We want everybody to have some.

TOWARD A TRUE "BLACK ART"

With AFRICOBRA we are witnessing a group of artists, in this the era of "the black aesthetic," who from their perspective as Afro-Americans are attempting to identify style and rhythm qualities that are expressive of black people everywhere. Theirs is a Pan-African perspective. AFRICOBRA should be looked at more closely as an indication of the direction of black artists in the 1970s.

The new black artists are not motivated in the direction of establishing cultural parity between white (European) art and their own. Convinced of the depth and richness of their own creative heritage, they strive to validate that heritage in the eyes of other blacks while simultaneously carving out a supportive and humanistic environment for its survival.

The black artist of the '70s will move beyond the protest art of the '60s and renew the celebration and pageantry of our collective ethos. He will no longer need to avenge personal and collective suffering through art but will direct his energies to articulating the needs, spirituality, direction, and values that will liberate or reorient his own and the colonial mind.

This is indeed a new epoch for black Americans. For many black artists it signals a time for reviving those "ancestral gifts" and "ancient skills" that Alain Locke referred to more than three decades ago. It is an age for moving beyond mere rage—it's Nation Time and black artists are searching. Black artists are immigrating into self, family, and nationhood—and celebrating the process.

BIBLIOGRAPHY

Baraka, Imamu Amiri. *A Black Value System.* Newark: Jihad Productions, 1970.

Césaire, Aimé. *Return to My Native Land.* Baltimore: Penguin Books, 1969.

Okanlawon, Alexander. "Africanism—A Synthesis of the African Worldview," *Black World*, July 1972, pages 40–44 and 92–97.

Shapiro, Norman R., ed. *Negritude: Black Poetry from Africa and the Caribbean.* New York: October House, 1970.

NOTE

1 [Barbara J. Jones and Barbara Jones-Hogu, the author of the essay on pp. 440–45 of the present volume, are one and the same. —Eds.]

1973

Barbara Jones-Hogu, "The History, Philosophy and Aesthetics of AFRI-COBRA," and Carolyn Lawrence, Jae Jarrell, Barbara Jones-Hogu, Frank Smith, Gerald Williams, Wadsworth Jarrell, Howard Mallory, Napoleon Henderson, and Nelson Stevens, untitled statements, in *AFRI-COBRA III*, catalogue for exhibition held at the University Art Gallery, University of Massachusetts at Amherst, September 7–30, 1973

By 1972, many of AfriCOBRA's members had left Chicago. Nonetheless, the group staged an exhibition in September 1973 at the art gallery of the University of Massachusetts at Amherst, where Nelson Stevens was teaching. The accompanying catalogue featured an essay by Barbara Jones-Hogu outlining the group's initial objectives and discussing the development of its philosophy over the years as well as its future plans. Individual statements by the group's members offered personal insights into their artistic goals and their experiences of sharing a collective ambition. (Jeff Donaldson's contribution was his earlier essay "AFRICOBRA 1: *10 in Search of a Nation*"; see pp. 263–65.)

BARBARA JONES-HOGU, "THE HISTORY, PHILOSOPHY AND AESTHETICS OF AFRI-COBRA"

In 1968 a group of Chicago artists came together at the request of Jeff Donaldson in the studio of Wadsworth Jarrell to discuss the premise that Black visual art has innate and intrinsic creative components characteristic of our ethnic group. The artists at the meeting consisted of painters, printmakers, textile designers, dress designers, photographers, and sculptors who felt that their visual expression was definitely affected by the fact that they were Black and that their Blackness contributed a specific quality to their visual expression. Many of the artists at the first meeting were members of a visual art group which was then defunct, the Visual Workshop of OBAC (Organization of Black American Culture)—who created the *Wall of Respect* in Chicago in 1967. This mural became a visual symbol of Black nationalism and liberation.

Once the artists had concluded that there were specific visual qualities intrinsic to our ethnic group, another meeting was set for each person to bring in his or her work for analysis by the group. At that meeting the following visual elements were selected: bright colors, the human figure, lost and found line, lettering, and images that identified the social, economic, and political conditions of our ethnic group. When we had found our common denominator, our next step was to ponder whether a group of Black artists could transcend the "I" or "me" for the "us" and "we" to create a basic philosophy that would be the foundation of a visual Black art movement. We wanted to create a greater role as Black Artists who were not for self but for our kind. Could we sacrifice the wants for self and ego to create the visual needs of our kind? Yes, we can!

A nucleus of artists felt that a collective effort was possible under a common philosophy and a common system of aesthetic principles. The basic nucleus was composed of Jeff Donaldson, painter-teacher; Wadsworth Jarrell, painter-photographer, painter-teacher; and Gerald Williams, painter-student. We had all noted that our work had a message: it was not fantasy or art for art's sake; it was specific and functional by expressing statements about our existence as Black People. Therefore, we began our philosophy with functionalism. Functional from the standpoint that it must communicate to its viewer a statement of truth, of action, of education, of conditions and a state of being to our people. We wanted to speak to them, and for them, by having our common thoughts, feelings, trials, and tribulations express our total existence as a people. We were aware of the negative experiences in our present and past, but we wanted to accentuate the positive mode of thought and action. Therefore our visual statements were to be Black, positive and direct with identification, purpose, and direction. The directness of our statement was to be conveyed in several ways:

A. The visual statement must be humanistic, with the figure frontal and direct to stress strength, straight forwardness, profoundness, and proudness.

B. The subject matter must be completely understood by the viewer; therefore lettering would be used to extend and clarify the visual statement. The lettering was to be incorporated into the composition as a part of the visual statement and not as a headline.

C. The visual statement must identify our problems and offer a solution, a pattern of behavior or attitude.

D. The visual statement must educate; it must speak of our past, present, or future. Black, positive, direct statements created in bright, vivid, singing cool-ade colors of orange, strawberry, cherry, lemon, lime, and grape. Pure vivid colors of the sun and nature. Colors that shine on Black people, colors which stand out against the greenery of rural areas. Cool-ade colors, Black positive statements stressing a direction in the image with lettering, lost and found line and shape were the beginning elements which created COBRA, the Coalition of Black Revolutionary Artists.

As COBRA began activating their philosophy, we felt that everyone should work on a particular theme, the Black Family. The group met every two weeks to analyze and criticize the progress of each member as they completed their composition.

These critiques became extremely important, since they gave the artists a chance to work independently and jointly while having a group of his peers point out his strengths and weaknesses. As each artist developed his expression in a COBRA philosophy and aesthetics we moved on to the second theme, "I Am Better Than Those Mother Fuckers," and we are. When the second theme was finished, we dropped the idea of a definite theme and decided to start identifying problems, and solutions to problems, which we as Black people experience. Therefore in the third work and thereafter each artist worked on a theme which he or she felt was pertinent to our existence as a people.

At this point Napoleon Henderson, the weaver, joined the group, and we became six, which later changed to seven as Nelson Stevens, painter-printmaker, came into the group. Yet we continued to grow with Carolyn Lawrence, painter; Omar Lama, a draftsman in pen and ink; and Sherman Beck, a painter and illustrator. During the same period we evolved from COBRA to African COBRA to AFRI-COBRA, an African Commune of Bad Relevant Artists. We moved from a national perspective to an international perspective. All Black people, regardless of their land base, have the same problems, the control of land and economics by Europeans or Euro-Americans.

The change from COBRA to AFRI-COBRA also crystallized our philosophy and aesthetics, such as:

THE PHILOSOPHICAL CONCEPTS

1. IMAGES, a commitment to humanism, inspired by African people and their experience; IMAGES which perform some function which African people can relate to directly and experience. Art for the people, the people reflect the art, and the art is for the people, not for the critics.

2. IDENTIFICATION, to define and clarify our commitment as a people to the struggles of African peoples who are waging war for survival and liberation.

3. PROGRAMMATIC ART, which deals with concepts that offer positive and feasible solutions to our individual, local, national, and international problems.

4. MODES OF EXPRESSION, that lend themselves to economical mass production techniques such as "Poster Art" so that everyone who wants one can have one.

5. EXPRESSIVE AWESOMENESS, that which does not appeal to serenity but is concerned with the eternally sublime, rather than with ephemeral beauty. Art which moves the emotions and appeals to the senses.

THE AESTHETIC PRINCIPLES

(These principles were drawn not only from the work of the artists in the group but also from our inheritable art forms as an African people.)

1. FREE SYMMETRY, the use of syncopated, rhythmic repetition which constantly changes in color, texture, shapes, form, pattern, movement, feature, etc.

2. MIMESIS AT MIDPOINT, design which marks the spot where the real and the unreal, the objective and the non-objective, the plus and the minus meet. A point exactly between absolute abstractions and absolute naturalism.

3. VISIBILITY, clarity of form and line based on the interesting irregularity one senses in a freely drawn circle or organic object, the feeling for movement, growth, changes, and human touch.

4. LUMINOSITY, "shine," literal and figurative, as seen in the dress and personal grooming of shoes, hair (process or Afro), laminated furniture, face, knees, or skin.

5. COLOR, Cool-ade color, bright colors with sensibility and harmony.

As we expanded our philosophy, we developed as a group who created messages that dealt with the past to give definition to our existence in the present, to identify the images and activities of our present situation, and the future which would show a direction toward purpose and solution. Our endeavors and thoughts culminated in 1970 in *Ten in Search of a Nation*, an exhibition held at the Studio Museum in Harlem. The work we exhibited was on view to educate and was not for sale. We did not want to promote individual gain from the images, but we did want to stress a unified effort of giving our messages to the people. We had plans to create

poster prints of the work so that everyone could have some AfriCOBRA messages. Our endeavor was well received. It was the first time that most of the viewers had seen a group of artists working toward a concerted philosophy with images that told Black people *Unite, Unite or Perish, We Will Build Here or Nobody Will*, because *I Am Somebody, I Am Better*.

Each artist dealt with their images in different perspectives. Nelson Stevens dealt with the spiritual aspect of nation building in *Jihad, Uhuru*, and *Ujamma*; he wants "to get as close as possible to the jihad . . . to images of those brothers and sisters who have never existed before," while Jeff Donaldson dealt with the modern *Amos and Andy* who are not for Toming but are seriously dealing with our problems with an advanced weapon. His Oshun, Oba and Yansa, the *Wives of Shango* (God of thunder and lightning, who balances all debts), are three sisters who are ready for combat with bullet, belts, and guns, while the *Shango Shortys* are dealing with their past in the tensions of today in a high-strung society of crystal-clear glass.

Lawrence wants to "Take the past and the present and make the new image." She records her concepts in *Pops*, a tribute to an old man, while in *Manhood* she points in a direction of responsibility for all men. Jae Jarrell, the dress designer, laid out strong messages on her garments with strong patterns, textures, and colors of *Black Family, Unity*, and *Manhood*.

Wadsworth Jarrell stated, "If you can get to Be-Bop, you can get to me. That is where the truth is." The rhythms of his Be-Bop can be seen in the repetitious letters and colors of *Cool-ade Lester*. Jarrell's *Homage to a Giant* pays tribute to many pertinent leaders, such as Malcolm X, Martin Luther King Jr., Jesse Jackson, Fred Hampton, Huey P. Newton. His images (visual) state that we must be about *Tightening Up the Game*, and *This Time Baby*, we are not going to be turned around from our objective of total liberation.

Each artist brought his peculiar talent to the commune and exhibit. Sherman Beck, a magic maker, extended himself through the magic of his medium. Although he had no titles on his work, he dealt with another realm of the spiritual essence of man which could be seen and felt in his paintings. Napoleon Henderson, the weaver, looks toward himself and Africa as his future. The title of his work does not speak of the significant symbolism, bright harmonizing colors, and textures in his words [sic] *Doodles, Cool-ade Icicles*, and *Bakota*.

Yesterday, today, and possibly tomorrow Gerald Williams will respond to the potential for Black Nationhood and the need to develop that potential when he created *I Am Somebody, Nationhood*, and *Wake Up* to the King Alfred plan of concentration camps; while Omar Lama works toward positive images—images that will inspire Black people to a higher level of consciousness in *Black Jesus* and *United or Perish*.

Last but not least is Barbara J. Jones,[1] who states that *Black People*, a total people, a total force, *Unite*, as we learn of our *Heritage* as Africans in a racist country in the *Land Where My Father Died* that needs to *Stop Genocide*, while Black men must *Rise and Take Control*.

We moved from *Ten in Search of a Nation* homeward with important feedback from our viewers, which gave encouragement, inspiration, and direction for the future. . . . The future works of AfriCOBRA became more stronger, more powerful and more accessible as we started creating silk-screen poster prints which was another phase of our basic philosophy. The poster prints made our images available to a larger audience at a reasonable price. For the prints, which were a total group effort, we selected one work from each artist, especially works that had been exhibited in the *Ten in Search of a Nation* exhibition. Lawrence's *Manhood*, the first print, enthralled everyone in the group as we finished the last color and saw the crystallization of many trials, errors, and color separations. The completion of the first print produced a quick production of the next three, *Unite, Wake Up*, and *Uhuru*. The prints that followed were *African Solar* and *Victory in the Valley of Esu*. In the process of working on the prints, we lost Sherman Beck and Omar Lama, but we gained Howard Mallory, ceramicist-jeweler-textile designer, who did a great deal of work on producing all the prints.

In between the production of the prints we did find time to create broader visual statements about the changing conditions of our time and our people. Our new statements related the strength and determination of Angela Davis and Martin Luther King Jr., the truth and wisdom of Malcolm X, the continual fall of Black education, and the need of education to be based on the history and accomplishments of Black People. Our children have put up a tough struggle to *Keep Their Spirits Free*. Our images still stressed *Nation Time* but emphasized: *Don't Forget the Struggle*, we all need spiritual unity as featured in *Spirit Sister*, *Wholly People*, and *From These Roots* we gain strength. If we *Get Some Land Black People*, we need land to survive, for land provides the essentials that cultivate and nourish life, and *We Must Go Home with Something*. These images were the foundation for our *AfriCOBRA II* show at the Studio Museum in Harlem in the fall of 1971.

Nothing is continuously stable, and things must change, perhaps from young to old, east to west or vice versa, or marching seconds of infinite time never to return. In our development we began to change; we first changed in position, time, and space. The first to extend our commune was Donaldson, who moved to Washington, DC, to become the head of the Howard University Art Department early in the spring semester of 1971. Next to leave, Wadsworth Jarrells with one child at hand and one on the way moved eastward to Connecticut, Massachusetts, and later to Washington, DC. The extension of our space relationship broke down our immediate communications and communal development, but it also built personal progress without the intervention of momentary feedback of criticism in our trials and tribulations, which created a more responsive or irresponsive action. As we attempted communications across country, we continued to work and develop, but at a slower pace. Before long another AfriCOBRA member, Stevens, had made his way eastward to Amherst, Massachusetts, and what was six became five again. We began with five members in Chicago. The work of AfriCOBRA will continue to grow, because we have a foundation by which we have built a value

system of our work and a philosophy which guides us toward a common aim of artistic endeavor. The works exhibited in AfriCOBRA expressed the expansion of our creative effort in new media, new techniques, new styles, and a new member, Frank Smith, painter.

Where will we go from here? As time moves, so shall we, to a broader and more expanded commitment to our people visually, mentally, and physically. Our new visual statement shall explore the gamut of our existence.

THE INDIVIDUAL AND THE FAMILY

A. The growth of the individual from the cradle to the grave. We will express the physical, mental and emotional changes of the male and/or female as they develop from a baby to a child to a teenager—adult and old age; and in so doing, we can state their trials, their errors, accomplishments and success, their character, wisdom, foolishness, etc.

B. We will have visual statements of how we see the positive or negative relationship between husband and wife, mother and child, and father and children. What type of roles are we playing and are our roles relevant to our whole existence as people. We will extend our visual imagery to speak of our relationship and activities of our extended family—the cousins, uncles, aunts, grandparents, godparents. How they created strong influences on our life, past and present? The family relations with other families of other groups of the same or different ethnic groups. We will identify ourselves visually at this time-space and record our daily activities, our values and the styles of our day. We will record our dances, our athletics, our hobbies, our night life, our parties, our meetings, our leaders, our labors, our children and their education.

OUR VISUAL IMAGE WILL BE GREATLY CONCERNED WITH EDUCATION

A. There are different contents of education, including the spiritual education of the family. This is not to place spiritual education in the christian church, but to state a need for a spiritual religion based on the needs of our people and a supreme being which reflects ourselves and our needs.

B. The humanizing aspects of education are respect, truth, and brotherhood. The role of man; the role of woman; the role of child and family to the total group. We must be concerned about establishing positive values and relationships in these aspects of education.

C. Our visual image will express the academic education of learning one's history, circumstances and accomplishments.

D. The industrial education of producing and being productive for self and kind in the building of every component needed to run a nation.

OUR VISUAL IMAGE CAN STATE OUR SOCIAL NEEDS AND SOCIAL SERVICES

A. Health facilities and services. Visually, what is the state of health facilities and services. We will express the need to develop our own health facilities in order to safeguard the health of our people.

B. We will express the protection of safeguarding the welfare of our old, young and those in need. We must be responsible for their welfare.

C. We will visually analyze our protective forces in the police or the use of security guards. Do they actually protect and serve our communities? If not, how can this be altered? The protection of the community and all its components should be our responsibility and should not be allocated to an opposing group.

D. We will visually express a need to establish and develop our community institutions such as cultural, social, educational and religious or spiritual centers and provoke positive actions by visually stating how these organizations should develop the philosophy and ideology of blackness and its welfare and continuous existence.

THE ECONOMIC NEEDS

A. We will visually state types of jobs available to our people and the types of skills and professions needed to run a nation and not just those that are teachers, lawyers, and doctors, but those who are also needed are people skilled in the technology of food, clothing, and housing industries. Those who make operations run such as janitors, secretaries, programmers, repairmen, etc.

B. We will be concerned about the types of businesses and industries which must be created to be self-sufficient people.

C. We will develop new solutions to different types of needs and services which employ community personnel, yet develop and perpetuate our people as a cohesive community.

VISUAL STATEMENTS CONCERNING THE PRESENT, PAST AND FUTURE POLITICAL NEEDS AND DEVELOPMENTS

A. What type of governmental or guidance unit should be developed and put into practice and the types of rules and regulations which should govern us as a group, which would provoke the need for government and self-governmental plans over not today but the next twenty or thirty or one hundred years. We are kept from developing future programs because we are kept in an unbalanced state of either acting or reacting to our present circumstances. These methods and solutions to constant flux can be visually stated.

B. Political and group cohesiveness is needed to build a strong Black nation and to develop our total culture. Visually we can state the need for group action toward the positive needs in a cooperative direction.

RELIGIOUS NEEDS

A. We will develop an image which stresses a strong religion which has us as the base of its origin with the Supreme Being and the mediator reflecting our physical being. We must illustrate stronger ties between our people and for our people. We must develop a more concrete moral code.

In fact, AfriCOBRA can move toward stating and restating repeatedly the needs for organization, purpose, and goals of our people for a stronger cohesive body and the need for racial nationalism. AfriCOBRA will not only state our problems and solutions but also state our emotions, our joys, our love, our attitude, our character, our total emotional and intellectual responses and feelings. Art can be a liberating force—a positive approach concerning the plight and the direction of our people. Visual imagery should bring us together and uplift

us as a people into a common unit, moving toward a common destination and a common destiny. WE IN AFRICOBRA SHALL HELP BRING THIS ABOUT.

CAROLYN LAWRENCE

Presently I am interested in the relationship of our Black children to the Movement as they participate in it. I feel it is very important that children be allowed to develop as children, but that Black youngsters in particular must be made aware of their responsibility to retain their ethnic identity as well as their personhood as they strive for excellence in every way. It is our responsibility as adults to be sure that our young are not consumed in the struggle but that they are made stronger because they understand how they must function in a racist society.

In regard to the creative process, I have found that I mentally go through a kind of germinal period. During this period I am trying to think through an idea as well as consider how I want to deal with that idea. It is during that period that I am most selfish with my thinking time and most irritated when having to meet with the group. It is a most unsettling feeling not to have a concept firmly planted in my mind.

After the germination period when I have actually begun to work I want to come out of myself and talk about art—open my work for comment by others in whose judgment I have confidence. There is real fulfilment in having something really important to do, for one's time is precious. After a piece is complete, there is a kind of emptiness as well as a real need to start thinking again of something that must be done—a new challenge.

JAE JARRELL

I produce garments with patterns, textures and colors that duplicate the richness of the patterns, textures and colors of Blackness. Preservation of our heritage motivates me to design for my Sisters and Brothers adornment that reflects our beautiful culture.

Strongly influencing my work are African sculpture, weavings and jewelry. The lines, seams, and decorative work of my garments reflect the rhythms I experience from African art.

BARBARA JONES-HOGU

Fundamentally I have been a printmaker since 1966. At that time I was concerned with my people and their condition and position in the United States, and expressed my feelings through lithographs, woodcuts, etchings and silkscreens. The bulk of my work at the beginning dealt mostly with Black and White, therefore, the media which are used were graphics in which a series called *America* was produced. In the series I used the symbols of America: the flag with the stars of the Ku Klux Klan; the skeleton (Symbol of Death-Genocide to people of color) which is the foundation of the country; Red, White and Blue; and the Swastika, Symbol of Racism. The subject matter of the series was concerned with the desolation of my people *In the Land of the Free and the Home of the Brave.* . . . The suppression of Black progress was expressed in *My Country 'Tis of Thee, Sweet Land of Liberty* and a new THIRD Reich in the POLITICAL ARENA, *Resist 1968 Law and Order in a Sick Society.*

In the latter months of 1968 I became a member of COBRA and my expression changed from the negativism of America to the positivism of defining and building a BLACK NATION. My subject matter changed from desolation and depression to themes of *THE BLACK FAMILY; I AM BETTER; HERITAGE*; and *UNITE.*

My color schemes changed from Red, White and Blue to *RED, BLACK and GREEN*; and my People's color changed from red-violet to gold and copper the riches of the earth. Serigraph became my total medium of expression which dealt with bright vivid colors of red, orange, yellow, lime, and grape.

The new work dealt with messages to my people, a form of visual education which stated a direction in which all Black People must be concerned, *We Must Survive*; *Stop Genocide*; *Nation Time.* The messages are created were concerned about Uniting Our Forces, Survival, Liberation,

Acquiring Knowledge, Our Responsibility to Our People and Building a Nation, a *BLACK NATION*. But as I saw the commercial world make the symbols of the *NEW BLACK CONSCIOUSNESS* a fad by producing Afro wigs in all colors from black to blonde, even shocking pink, mass production of dashikis and African dress; movies such as *Guess Who's Coming to Dinner* which O.K.d Black and white relationships, and the onslaught of black movies which cast false Gods and Ideals of money, clothing, cars, sex and dope as the ingredients of power (to run a Black syndicate–Neo-Colonial control of vice); my images began to state that *Black Man Must Rise*; *Rise and Take Control*; *Black Man We Need You, Leave those White Bitches Alone* and *When Styling (Super-Fly) Think of Liberation and Self Determination*.

In all my work I am concerned with messages to my people because they must and will survive and create a new world by confronting and defeating the ordeals of the present physical and mental conditions in which the system tends to manipulate them.

FRANK SMITH

I think of my work the same way as my teaching. Believing that images/culture/education are functional instruments for reinforcing the values of society that produces them. And believing further that Africans in the die aspera should retain their social and cultural identity to Africa, I look home, to Africa, for the sources of my work. The traditional symbols of African societies and the symbolic use of color are fundamental to each piece. In that sense works are masculine or feminine instructional or hymns of praise to those who have dedicated their lives to Pan-Americanism. Further, I believe that bad politics is necessarily bad aesthetics. The merit of a work is synthetically involved with its function within the society that produces it. This tells me clearly what we as Black image-makers should be about.

GERALD WILLIAMS

Before becoming a part of AFRI-COBRA, I was interested in creating landscapes, still lifes, and abstractions. But in the light of growth in our people's position in the world, and challenges that we were involved in, doing landscapes and abstractions seemed too ridiculous. Painting became a meaningless activity.

I see some artists today doing landscapes and flowers, and I question the validity of their endeavor in the light of the urban environment in which we find ourselves. When I stopped and looked around I found the real landscape was the city where we lived and that part had become decimated and we were becoming likewise. It was and is not very pretty. The solution to the problem of course doesn't rest in the arts, but there is room for their use.

In AFRI-COBRA I, I found out that to express those things which are positive about us can be a liberating factor. In the painting *Message from a Giant—Garvey*, the message is a positive one. It is an attitude we need to have all the time. We must be the best of ourselves and not try to be the best or worst of others. When we build our institutions and stop trying to take over their dead or dying ones, then it rings all the more clearly.

For the future I see more growth on my part and AFRI-COBRA's. Such growth is possible because of our link with our people from whom we derive so much nourishment, and whom we know are definitely growing.

WADSWORTH JARRELL

Through my years of experience and observation of people, I have found that African people are the forerunners, innovators, creators, the hip. African people are my motivation.

So in my art I must reflect the attitude of my people, the colors, the style, the hip, the rhythm.

My role is to make social imagery to intrude upon the thoughts to jar the senses of African people. To produce an Art which is as warm and awesome as the songs and prayers of Sunday Morning Baptist meeting. Art that's getting into the color and sound of those songs and prayers. An art that African people can relate to.

The awesomeness of African sculpture and the rhythmic patterns used in African weaving has been

a profound influence on me. The vibrant lines and colors of African art are duplicated in African music and African music is duplicated in Afro-American brothers and sisters like Bird, Dolphy, Trane, Muhal, Tyner, Pharoah, Shepp, Sister Aretha, Al Green, Max Roach and "hey man!" (These cats are Bad, Black and Beautiful.)

I'm painting the colors, the sounds, and the message of this music.

My paintings is for and about African people. The Mother Country . . . Africa for survival.

HOWARD MALLORY

I seek to do the best with my abilities. I seek to be a positive force with Black people. I'm a spoke in the wheel, which grinds away at the oppressive forces which are against Black people.

We are the richest Black people in the world, but so long as one nigger, Black or colored person is enslaved in mind or body, we with all the affluence and fat pockets will also be enslaved. We are tied to each other and will be responsible for the suffering. Our responsibility is in giving personal direction toward total liberation.

Malcolm said, "by any means necessary," to me this means—art, pen, gun or labor of any kind.

Too often the Black artist thinks only in terms of his art to truly express his intent. These influences are the desire, as Black people, to be free of force. I think that for me the creative process goes beyond clay, it takes many other forms, and I generally follow the dictates of the spirit that moves me.

My political philosophy is: BLACK COMMUNALISM ONE MIND ONE BODY

NAPOLEON HENDERSON

MY WORK, IN ITS ESSENCE IS "SPIRITUAL" "MEANING-FULL"

this is how I feel while embracing my fibers as they fold into their images.

—image—creation + meaning + ritual

I do not make "art" rather I am participating in ritual, a ritual as important to the Afrikan man as it was to his CREATOR. The ritual of harmonious interlocking, creating a whole . . .

—I am not the "CREATOR," but the instrument of the "CREATOR." I am his instrument, endowed with his knowledge of harmonious interlocking.

—we are his highest—most (was) obedient creation.

as the creator did, so has the AFRIKAN MAN, this knowledge + ritual + meaning-full purpose . . .

—when ritual is gone—fashion invades

—decoration and adornment no longer has spiritual timeless meaning—full of shit now and changes like "NIGGERS" change, to the tune of the new "color-less (god).

—YEA! I'm doing my thang."

—I, know what it is to be "BLACK" (when it was in fashion)

—I'm an international Playboy boy boy Shaft in Afrika—America—Europe—or anywhere "cept" where I ought to be!!

—like my DADDY (home with his family building a fence next to his garage) COULD SWEAR, I DECLARE!!

—yes "DON'T IT MAKE YOU FEEL GUILTY"

—"DON'T LET IT END BEFORE YOU LET IT BEGIN" . . .

We must be about the business of expressing what is "BEAUTIFUL" ourselves . . .

What is MEANING-FULL—so as to have full meaning-full lives . . . being ever conscientious of our Euro-American mind allowing our AFRIKAN mind to devour it, and spit it into the bowels of hell!!

—we are the patterns of what is "CLASSIC"

—YES WE ARE MEANING-FUL—noses, FULL eyes FULL lips FULL hair and skin Full of COLOR, all the colors in the universe!!!!!!

—now is the time of TRANSFORMATION

—our images must be transformation (meaning-full) images

—transformation forward (in an AFRIKAN sense of time—looking back at what has gone) to the point where we define those images projected onto our minds.

—reviving the ritual participation in the herbal science (not being high just to be high) for that is genocide ! ! !

—WE MUST BECOME "PUSHER-MEN" OF OUR SPIRITUALITY

OF OUR UJAMMA

OF OUR ROOTS—HOME—AFRIKA.

—stabilize our economy, then there is no need for fashion—WE ARE FASHION. We just don't believe in buying or selling

ourselves to

"OURSELVES"

WE MUST BECOME PUSHER-MEN

FO' REAL!!!

—WE MUST NOT PRESERVE to do that, is to keep what is DEAD.

—INSTEAD, WE MUST BE ABOUT REVIVING, GIVING NEW LIFE TO THAT WHICH IS DEEP IN OUR SOUL, OUR AFRIKANNESS, LIFE.

NELSON STEVENS

AS A BLACK IMAGE MAKER, it seems to me that my work cannot be about the sterility of the red, white and blue life-style but rather about exploring alternatives. I'm dealing with the cool and casual rhythms in us. Like the rhythms we walk when we believe the ground we walk on belongs to us . . . and cool like the posture we strike when we are letting a sister know our point of view on a matter of primary importance. Sometimes I deal with the hot screams of the sweet thunder and the fire sirens which cause us to explode . . . but always with rhythm. Like we be doin'.

Whatever rhythms prevail, it's my attempt at a picture that says "I'm talking to you!"

The people I choose to depict are born of Black spiritual nobility. Born a long way from home and knowing the meaning of we, they live among us spreading their beauty.

It's my hope that they can speak to the humanity in you and that you might see something of them in the next brother or sister you re-meet.

I delight in re-assembling the secret rhythms of you in space.

It is through a sense of history that my present philosophy and images were born.

ALAIN LOCKE was correct when he told us to look to our past, our African well spring of ideas.

Through his vision it becomes clear where the Europeans found the vitality and wealth to sustain 70 years of picture making. What we must do is go directly to that original great source and check out our own vision in our contemporary space. We can now look, in our time and with our eyes, to see the aesthetic complexities and functional meanings in order to revitalize our images. Perhaps, with this new vision, it's not about Expressionism, Surrealism or even Cubism.

We go all the way back to the beginning. The now famous findings of the anthropologist Leakey have added more proof to the Honorable ELIJAH's claim that the beginning of man's existence was in Mother Africa. Leakey, Jr. is even more specific. He, speaking with the weight of the anthropological world, points directly to his diggings in Kenya, concluding that the home of the Original Man was indeed Africa.

Hurdling the auction block we can also learn. Studying the 20th century elder giant image makers, Bearden, Lawrence, Biggers, C. White, Woodruff, Sargent, Douglas and Hayden, teaches. In becoming as acquainted with these names as I was with Armstrong, Bird, Coltrane, Pharoah and Aretha, I have helped my vision and my hearing—and started to feel the ability to freeze these rhythms in my head, later to project that fluid image on canvas, to sing of the rise of the Sun People. Time is but a line which makes its meandering path through history. We, you and I, are the Dot of now. . . . Having to give meaning and direction to our time. The time and the course of the line can be charted with no less than our maximum efforts. I have tried at different points in time to know whether my motivation for filling up a canvas with color is more aesthetic or political. I find that the answer changes, but the two are no longer easy for me to separate. For me the creation is the result of a marriage of aesthetic and political forces which results in a union of harmonious aspects of energy. Hopefully, these energy heads are filled with the cosmic fallout of Malcolm and will serve as bridges to bring us closer together. Image is both political and aesthetic at once.

Recently I have become curious about how the image comes into being, and that investigation

has led me to low levels of technology and taking slides of a work in developing stages. This seemed interesting at first, but did not allow me enough insight, for I missed too many steps and it lacked an animated quality. Currently, I am working with a paint brush in one hand and a 16mm camera in the other. Now things are coming clearer, I find myself more deeply concerned with the craft, conceptualizing newer and more exciting forms. Already it has meant restructuring my studio classes both in concept and technique.

AFRI-COBRA is a family of image makers of which I am a member, teacher and student. This is a family in which my concerns are not strangers. This, in and of itself, is a benefit. It has kept me from considering myself an exception which can be the case if one feels isolated.

AFRI-COBRA has analyzed color theory, design elements, rhythms and tempos as related to composition. We have researched our craft and helped each other, patiently and honestly, to understand our own assets and liabilities while raising profound aesthetic questions, some of which have yet to be realized graphically. Sharing aesthetic and political findings with members who have similar goals can be very exciting. Also it sharpens one's outlook to continually rub against perceptive and gifted craftsmen. My concern now is that there be more organizations with similar goals to those of AFRI-COBRA.

Today we have competent image makers, craftsmen, dealing ideograms and weaving messages, spells, and we will not go away. For we insist on a more functional art. An art that warns and praises, an art that involves and concerns, an art that speaks the truth to the people as it sings of their perfections and of higher levels of the spiritual condition. There is no 180° dichotomy separating art and propaganda, for all art is also propaganda. But there exists non-aesthetic and meaningless art as well as empty messages.

The real danger is trying to communicate and understand. Immediately the image maker risks being superficial, creating images too easy for the maker and receiver. The image maker must lodge layers of content with such impact that only a brain surgeon could take corrective measures. We are doctors of aesthetics who tie up nerve endings to make mental and spiritual connections and maybe even dislodge the lost Coca-Cola sign which was observed.

We are exploring an art which allows the image to inform new meaning even after the viewer has lived with the image for years. This is the price the leafleteer gives up gladly for the immediacy of his passion (as he should) but it should not be thought that the leafleteer is any more devoted to a political persuasion than the image maker. They only differ in crafts as a first-aid man is different from a surgeon, while neither is less dedicated to saving lives.

We/I think/create from the rhythmic-color-rapping-life style of Black folk.

We believe that art can breathe life and life is what we are about. We create positive-life-images for positive Black folk.

We have started to work together as an African commune of "bad" relevant artists.

NOTE

1 [Here, the writer is referring to herself by her maiden name. —Eds.]

Diane Weathers, "Kay Brown: An Artist and Activist," *Black Creation: A Quarterly Review of Black Arts and Letters* **4, no. 1 (Fall 1973)**

This profile of Kay Brown was written by Diane Weathers, who soon after became an editor at *Black Enterprise*. Speaking with Weathers, Brown considers the impact of gender on the formation of her artistic self. She describes her first encounter with artists of the Weusi collective in 1967, shortly before graduating from the City College of New York, as an illuminating moment that consolidated her ambition to be an artist. However, the negativity she encountered, both individually and as part of the collective she went on to cofound, Where We At, underlines the sexism women artists were still forced to endure. Nevertheless, Brown sees her all-female group as providing "strength in numbers" and contributing to an "important revolution" that was taking place in the United States. Brown continued in her roles as a "community artist," feminist, college art teacher, and activist as the Black Arts Movement evolved through the 1970s.

DIANE WEATHERS, "KAY BROWN: AN ARTIST AND ACTIVIST"

Growing up in Harlem and now living in Brooklyn, [Kay Brown] is an artist, a writer and lecturer, a poetess and a mother. As a teacher, she worked for a while at the Children's Art Carnival in Harlem, and the public schools in Brooklyn. She is now the only full-time art instructor at Brooklyn's Medgar Evers College, setting up an art program from scratch and trying to convince the powers that be that the best artists/teachers are not necessarily those with "degrees." She is a community artist in the truest sense, preferring to exhibit her work in office buildings, libraries, churches, homes, schools—wherever there is space and people. One of her dreams is to organize a workshop, in the middle of Bedford Stuyvesant, where folks could learn the techniques from Black artists and create their own works of art.

She is very much her own individual—expressing this individuality in terms of "we"—first as a member of the Weusi Artists and later the "Where We At" Black women artists.

"What I am sorry for most," she states, "is that I didn't discover who I was earlier and not so damn late. . . . I feel that I've wasted a lot of time getting very deeply involved in trying to solve problems that were really not my fault but have to do with the social climate and the social system we live under . . . even in relationships with males, I think that I spent a lot of time trying to deal with them when it would have been better if I had spent my energies developing my art."

But it wasn't until 1967, when, at the Countee Cullen Library, she first saw an exhibition of works by Harlem's Weusi artists—that Kay began to believe in her talents as an artist and work seriously to develop them. This experience was for her, nothing short of overwhelming—a revelation of sorts.

"All of their work had an ethnic reasoning or relationship behind it," she recalls, "but a new art form, that I hadn't seen prior to that, which was really a transition from the abstract art of the White schools, took forms that had to do with African forms, African shapes . . . or they took motivation from African sculpture or masks."

What most of the "Where We At" women did have in common was that at one time or another, most had encountered sexist/racist attitudes which hindered them from exhibiting their art. But there is strength in numbers and they were able to arrange a number of group shows and consequently received a considerable amount of publicity from the news media. However, despite the fact that the women, both as individuals and as a group had achieved a certain amount of recognition as being artists of the highest caliber, they were denied a show at the Studio Museum in Harlem on the basis that the museum would not put on a show which "divided the sexes."

Initially, all of the "Where We At" women's work was an expression of the Black experience and at one time, Kay felt that any serious artist must produce work that was ethnically related. She has come to accept however, different philosophical approaches to art as either a means for an artist to experiment in his or her media or an indication of where their head is at. "Even Black artists who are into what may appear to be totally non-ethnic related subjects are making a statement about themselves and about the manner in which they view what is taking place around them."

"A good work of art may not only reveal what an artist perceives but what he doesn't perceive as well . . . whether people want to believe it or not, we are involved in a revolution which is going to be excelled to the point where there will be a lot of bloodshed. With any important revolution, the artists are recording it and if an artist says that I refuse to record it—that I am going to close my eyes and say it is not going on—they are not fulfilling themselves as human beings."

Kay's work is Black oriented, specifically Black woman oriented.

Her early expression was primarily through collage (mixed-media) with which she attacked racial oppression. She still feels that collage is the best means of making strong statements about our social situation but she now concentrates on printmaking: etchings and woodcuts, at which she is a master.

While it has been her art experience which has enabled her to develop her tools for expression, it

has been her vast life experiences and extreme sensitivity to things happening to her from without as well as from within, which has been the basis for this expression. It is this life experience which Kay is always tapping, and is the source of the themes: Black love, Black beauty, Black loneliness, motherhood, African images (the perceptions of one many times removed), which she interprets through her graphics.

Sister Alone in A Rented Room, an etching which Kay did in 1972, is one of her strongest works. *Sister* is on one hand, a bitter reminder of a condition that all oppressed women who have ever known loneliness and are tired of being lonely, would like to forget. Yet, she is beautiful because her mere existence states, "You're not the only one—I've felt it too."

Perhaps her children are down in the South or in the West Indies; or her old man has left her and she's tired of cleaning white folks houses. She is all of these and none of these. The truth she reveals is universal/Black; speaking to us in all of our dialects and tongues and it is timeless—ancient and enduring forever. Much of Kay's work is somber because she has experienced so many personal disappointments. But there have been moments of happiness, such as that which is expressed in *Spirits Laughing*, an etching done in pinks and purples—amorphous forms—evoking a mood that is sheer Joy.

Kay Brown is a strong sister and a determined fighter, but even the strongest warrior knows when a battle has been lost. Her oldest son Clifford has, since childhood, grown up in various State Hospitals. Although tests have shown that he has no brain damage, he has never been given therapy—just drugs to keep him "calm." At 18, he is an addict with little chance of ever being able to function normally even on a minimal level.

"I had some good experiences at City but for the most part, the teachers there, because they were white, could not relate to what I was trying to do. I wanted to create my own art forms—my own kind of painting—and I was discouraged from doing so."

It was through her involvement with Weusi, something which a few sisters have charged was a token membership, that she received this much needed encouragement. Kay feels that she was accepted into the group, not because she was a woman, but because she was an artist, whose work they respected and with whom they had developed a natural attachment.

Kay admits however that initially they may have regarded her as somewhat of a novelty and that being the only woman among them may have unjustifiably inflated her ego. "I felt that I was the only woman artist out there but after working with Weusi for some time, I began to realize that there were many women artists and that perhaps I too was affected with the myth."

Her experience with Weusi was a positive one, perhaps too positive. "It gave me a sense of my own talents that I don't think were real at the time. When I temporarily left the group, I was forced to take a good and realistic look at my talents and re-evaluate myself as an artist. I saw that there was still so much more room for growth."

Kay left Weusi for a while because she had been left out of a particular group exhibition. It had been Weusi's policy to never show as a group unless all of the members were represented and at the time, she felt that they were in fact disregarding her because she was a woman. But between trying to take care of the business end of the gallery and getting hung-up in her own personal problems, Kay had allowed her work to dwindle. She now views that particular incident as a lesson in the importance of an artist continuing to produce and grow.

"A woman artist has to be careful that she doesn't become incapacitated by a personal situation which she allows to detract her from her work. Even though I now see myself as an artist first, and then a woman, this wasn't always the case. We have to be careful, simply because we've been conditioned to be women first and told what our roles are supposed to be and then we feel guilty when we're not fulfilling those roles. I am an artist, a teacher and an administrator, in that order. I don't feel that I am any less than a woman because I am naturally a woman, but my primary concern is to fulfill myself as an artist."

Just as Kay's initial contact with Weusi was a turning point in her life, her break with them was just as significant. Shortly afterwards, she and 13 other female artists came together to organize the

first known major Black woman's exhibition, at the Acts of Art Gallery in Greenwich Village. The show, held in the summer of 1971, was entitled *"Where We At"—Black Women Artists 1971* and was the genesis of the "Where We At" Black women's group.

"The spirit that we had and the experiences we exchanged made us feel that it would be a good idea to stay together and continue to put on shows. It made me realize that there were many good Black women artists who were quality artists but had been discouraged from showing."

It was at this time that Kay developed a close relationship with Faith Ringgold, one of the few Black artists/feminists, who has since become Kay's "spiritual mentor" and whom she refers to as a "pioneer" among Black women artists. Kay turned to the "Where We At" women seeking the same unity of spirit and purpose that she had found in Weusi. She quickly became the group's "prime mover" working days and nights arranging shows, seeking funds for workshops that the group wanted to establish in the community and trying to find that common ground on which all of the women could come together. "Trying to get so many women from diverse situations together in a sisterhood is a challenge. A few were merely interested in their own selves and tended not to see themselves as artists first, letting their womanhood or sex-self get in the way of achieving this sense of sisterhood and not realizing their power as a group."

With a sense of frustration and hopelessness, Kay continues to fight for Clifford on another level: through her art. She is currently working on a piece entitled *Willowbrook—1972* in which she is attempting to show the "hell and misery" that her son and others like him have to go through under a system which destroys children.

"I will continue to fight forces that try to destroy me or those that I bring forth from my body. I will fight those who destroy my man so that he will either be crippled with dope or cannot function in a society that has castrated him so that I cannot relate to him as a strong woman because a strong woman is a threat." This lady has come a long way, but for her it is only the beginning.

1973

Betye Saar, "Black Mirror," *Womanspace Journal* 1, no. 2 (April–May 1973)

Claudia Chapline, "Reflections on *Black Mirror*, March 31–April 22," *Womanspace Journal* 1, no. 3 (Summer 1973)

Samella Lewis, "Introduction," and Josine Ianco-Starrels, untitled text, in *Betye Saar: Selected Works, 1964–1973*, catalogue for exhibition held at California State University, Long Beach, October 1–25, 1973

Betye Saar was born in 1926 in Los Angeles, spending her early childhood in the Watts neighborhood but growing up mostly in Pasadena. After studying interior design and sociology at UCLA in the late 1940s, Saar developed her printmaking practice while employed as a social worker. Both her prints and her later assemblages signaled her interest in mysticism and astrology. It was after the assassination of Dr. Martin Luther King Jr. in 1968 that her work became overtly political. Saar began a series that included *The Liberation of Aunt Jemima* (1972), which became representative of her commitment to Black liberation as well as to radical feminism. The assemblage was on view in *Black Mirror*, an exhibition of work by five Black women artists that Saar curated at the Los Angeles gallery Womanspace in March 1973, and a reproduction of it appeared in the gallery's journal alongside the text by Saar included here.

Just months after *Black Mirror*, Saar's first survey show was staged at the Long Beach campus of California State University. Other works from the same series as *The Liberation of Aunt Jemima* were on view as well as new assemblages made with bones, feathers, and human hair. Saar's first shrine sculpture, *Mti* (1973), was also shown. Samella S. Lewis introduced the catalogue; the gallery's director, Josine Ianco-Starrels, contributed one of the first poetic responses to Saar's new works.

BETYE SAAR, "BLACK MIRROR"

Black Mirror is the theme at WOMANSPACE from March 31 through April 22nd.

The works of five artists, Gloria Bohanon, Marie Johnson, Suzanne Jackson, Samella Lewis, and Betye Saar, will be exhibited. The exhibit and events will interpret the black woman's reflections on herself, the way she lives, the thoughts she thinks, the way she looks, loves, and creates.

The black woman has been labeled mammy, Aunt Jemima, Sapphire, and baby. Hey, we're all that and more. We are in the throes of discovery. We are searching for a past that has been long denied us, emerging from a period of a white program society, and now attempting to form our own mirror image. Deep in our inner consciousness (though generations removed) there still exists the essence of Africa (soul?). This essence is the core of our survival and the basis of our creativity. This creativity takes many forms—words, music, dance, art, and most important, life-style. The African concept of "life is one and the arts the unifier" is our premise. For us the arts are expressed black soul, an extension of black life-style.

We don't want to teach, we don't want to preach—we want to share. We want YOU to look into OUR mirror; hey, can you dig it!

CLAUDIA CHAPLINE, "REFLECTIONS ON *BLACK MIRROR*, MARCH 31–APRIL 22"

Black Mirror exhibition at Womanspace included five black women artists who present in their work insights into black life style. On the afternoon of Sunday, April 1, the artists were at Womanspace to informally discuss their work, and on Saturday, April 7, Dr. Samella Lewis, Professor of Art at Scripps College, spoke about Art and Black lifestyle and showed slides of contemporary black women artists' work. Dr. Lewis' conviction is that there is no separation between art and life, nor between art and craft.

I enjoyed this relaxed and friendly week at Womanspace. During the discussion with the artists, Betye Saar talked about the constant collecting of materials for use in her assemblages, inspired by the work of Joseph Cornell. She is interested in the recycling of materials and images. Some of her work invokes memory; dried flowers and old postcards are treasured in a box called *Grandmother's Garden*. It recalls feelings about childhood adventures when visiting Grandma. Of Ms. Saar's mystical works, I found *Aunt Sally's Mojo* the most haunting. The Mojos use organic materials to work positive magic through those symbols of humanism and cosmic consciousness—the hand, the crescent, the star, set in a box, painted and feathered in tones of alizarin. This is strong stuff. Ms. Saar only practices good magic. *The Liberation of Aunt Jemima* series expresses something else. Here Ms. Saar is "changing negative images into positive ones." In *Measure for Measure*, explosives in the left hand balance pancake mix in the right. Betye Saar works intuitively to evolve a personal expression. She is interested in psychic experience and the relationships of material and images. Her work is also expressive of the interest of many black people today in African heritage, the history of slavery in this country, and the continuing struggle for equality.

Samella Lewis shows three strong lino-cuts. She works by direct cutting into linoleum with rhythmic and expressive gestures. The boldness of her stylization and simplicity of black ink on white paper are her language. *Field* is especially striking. A female figure seated in a field stretches upward into a circling of energy, one hand clenched, one hand outstretched.

This is a song, a cry, a dance of laboring women. Gloria Bohanon shows neatly executed spray paintings, in oil enamel, of her children's faces and reaching hands. I am reminded of cut-outs of profiles in silhouette which were popular in the 30's. I also get the feeling of the cold light from the television when one is alone in a darkened room at night. Ms. Bohanon expresses a sense of peace, beauty, quiet and softness in her work. She is very interested in hummingbirds, flying and the sky.

Suzanne Jackson, who is also a poet, shows acrylic paintings. She is interested in African and Egyptian history. Her figures are a mottled acrylic wash, partially emerging from fields of white, mustard flowers, birds and heart shapes, symbols of freedom and love. They evoke the feeling of ancient

frescoes. I liked *Not Everything We See Is Real* and *Escaped*. A boy reaches with a blue hand for a yellow bird while behind him a white bird flies in a pale blue shadow. Suzanne Jackson's paintings are pale in color and rich in meaning.

Marie Johnson makes painted assemblages from salvage materials. She shows waist-up portraits of real people made like enlarged paper dolls from the family album. The old fence has been given new life with the friendly faces of loved ones, real hair, scraps of cloth pasted on for the clothes, even real spectacles on *The Grandmother*. Don't I know her? I'm sure I've seen that Grandmother before, sitting on her porch in her silver circle. Ms. Johnson uses the circle again in *Family Circle* where the family is close together, a unit set in a field with a rainbow behind them. She painted her father as *The Reverend dressed in black*. I am sure that is the preacher whose house I passed each day on my way to school in Virginia. Marie Johnson asks herself "How real are they?" She is trying to speak of the universal through the specific. I think she succeeds, particularly in the works where the figures are cut-out and casting their shadows on the wall.

SAMELLA LEWIS, "INTRODUCTION"

A native of Southern California, Betye Saar often visited her grandmother in Watts near the famous Simon Rodia Towers. As a child she watched the construction from a distance but was only able to experience their majestic quality close up after she reached adulthood. The impact of the towers upon Betye and her work is evident in many ways. Perhaps the memory of their construction contributed measurably to the nature and character of her artistic expression.

Her early interest in the mystical is evident in her prints and drawings. The occult, palmistry, astrology, phrenology merge into voodoo, hoodoo, and shamanistic fetishes flow into concerns of social and political significance—they are all involved in Betye Saar's mature style. Her work rediscovers the essence of African beliefs.

Her constructions and boxes serve as containers for artifacts that reflect heritage of historical or personal mementoes. Betye Saar's multi-dimensional works dissolve distinctions between painting and sculpture. Her use of color, combined with three-dimensional objects compel us to experience works from an highly personal perspective. Combining prints, metal, wood, fur, bones, paint, mirrors, and other materials, she sometimes involves the viewers through the use of reflective surfaces or charms them with hidden seeds in her mojo bags.

In the late 1960's Betye began collecting commercially produced derogatory images of Blacks. She sought to transform their impact from negative to positive forces. Her works exposing this brand of racism are hard-hitting and bear titles based upon products such as Darkie Toothpaste, Black Crow Licorice and Old Black Joe Butter Beans.

In her *Liberation of Aunt Jemima* series a grinning image is transformed from "mammy" doll into an aggressive warrior for Black Liberation: the collage of labels depicting traditional roles becomes a background for the determined figure. This symbol—a cliché of the Black female—is used to express a new strength emerging out of the old strength forged by servitude and endurance. The real Aunt Jemima will be free. Betye Saar uses her mojo consciousness to conjure the liberation of all Aunt Jemimas . . . and Uncle Toms, too.

JOSINE IANCO-STARRELS

Symbols . . . life and death . . . bones, birds, sirens . . . questions searching mystical ancient beliefs . . . for answers in stars, moon, sun.

Astrology, Phrenology, Palmistry . . . Logic discarded—earth taking its place among constellations—Zodiac signs shaping lives. . . . Moons rising in mysterious windows with textures and colors of rainbows and stars . . .

Fetishes, charms—beware of the evil eye—spirits concretized—shrines invoking deities long forgotten . . . ceremonies remembered; black and white magic never totally erased.

Humor assists old pride become new strength, arising like the phoenix out of pain and ashes.

Memories gentle, evocative, exquisitely fragile . . . sophisticate [sic], always mysterious, delicate but strong.

1973

Benny Andrews, John Coplans, Dana Chandler, Ademola Olugebefola, Howardena Pindell, and Wee Kim, "Black Artists/White Critics," panel discussion presented in conjunction with the exhibition *Blacks: USA: 1973*, held at the New York Cultural Center, September 26– November 15, 1973

Blacks: USA: 1973 opened at the New York Cultural Center on Manhattan's Columbus Circle on September 26, 1973. Cosponsored by Fairleigh Dickinson University, the exhibition was curated by Benny Andrews with input from a selection committee that included, among others, Samella S. Lewis. As Andrews wrote in the exhibition's catalogue, the "prejudicial situations" faced by Black artists in the past had underlined the necessity to "make selections of their works among themselves." Reviewing the show in the *New York Times* on September 29, Hilton Kramer complained that it "jumbles together so many different levels of achievement—and lack of achievement—that the serious spectator soon abandons any attempt to discover a consistent artistic standard." While Kramer praised the work of Norman Lewis, Al Loving, and Ellen Banks, he concluded that "there is a quantity of work included that simply does not meet even a minimal museum standard." The public programs for the show included this panel discussion, which focused on the problem of White critics' tackling Black art and the lack of opportunities for Black critics. The conversation was moderated by Andrews and included the artists Dana C. Chandler Jr., Ademola Olugebefola (of the Weusi collective), and Howardena Pindell as well as the *Artforum* editor John Coplans and Wee Kim of *Arts Magazine*. The recording of the discussion, published here for the first time, is at times inaudible, and edits have been made accordingly.

BENNY ANDREWS, JOHN COPLANS, DANA CHANDLER, ADEMOLA OLUGEBEFOLA, HOWARDENA PINDELL, AND WEE KIM, "BLACK ARTISTS/WHITE CRITICS"

BENNY ANDREWS: Before I start out with the panel, I would just like to say that working with the people here at the Cultural Center really was very rewarding, and I think it had a lot to do with the fact that most of the people are women, and we got along great. I would just like to say that. This is really a very serious thing that's taking place tonight here. While, as individuals, artists and critics are really rather charming and interesting people, we are sitting in for a much larger group of people, and that is both the people who control the media and the people who feel that they are controlled by the media—the artist, and, in this case, the black artist. We would like to try to keep the panel very crisp and straight, and we do not expect that we really will resolve many questions tonight.

For a long time, the black artist, especially over the last five or six years, really has been fighting to get a place in the sun, and to be able to exhibit. But we are really being stifled by the critics. There is almost no exhibition of our work that is put on that is not put into a corner. A lot of it has to do with ignorance, but a lot of it really does have to do with prejudice. Rather than me do so much talking, I'm going to ask each panelist to talk maybe a couple of minutes to give a feeling or some ideas that they might have about this kind of exhibition, about black artists, either from the standpoint of being a critic or editor of publications that deal with artists or from the standpoint of the artists on the panel.

Now, the artists on the panel are rather diversified, and that's very important to understand. We've gone to the place where we can no longer be called just "black artists." I mean, that was necessary when we were outside of all of the exhibiting institutions, and we had to literally get together as a group of five hundred or seven hundred and storm the institutions to get our work inside. Now, we must show that we are as diversified, as talented, and as universal as anyone. And that's why the group on this panel are fairly representative of different aspects and different points of view. The exhibition itself, upstairs, is an attempt to deal with areas that normally are not allowed into museums, and, of course, *that* can be talked about, and a lot of the criticism against the exhibition has been just for that reason. But I can tell you, the people that are coming to the exhibition, who are not as jaded in art-magazine slang, seem to be enjoying the show, and that in itself is really a coup. Now, I'm going to start with just a kind of a statement about each person, to at least break it in to a lot of the people that do not know them. The first, the artist on my right, Dana Chandler, is from Boston. He was one of the artists that literally bulldozed the Museum of [Fine Arts] in Boston in 1970, to put on one of the most historical exhibitions that took place in America. I think there is a little suggestion that he had the Panthers behind him. And he was working out in the streets and he did a lot of wall paintings: we are dealing with a street artist.

As a critic, Wee Kim, who was a former editor of *Arts Magazine*, on my right, will speak from her experience as a critic and also as an editor of one of the major art magazines in the country.

On my left is the artist Ademola, and he is with the Weusi Art Gallery, and he works from African motifs. All of the artists that are on this panel are represented in the exhibition upstairs. And, of course, that is the point of view, and artists who work in that manner have had so much trouble exhibiting in what is called the mainstream museums.

The next artist is Howardena Pindell, who has the two large abstractions upstairs, and she is also a curator at the Museum of Modern Art. And the last person is John Coplans, the editor of *Artforum*, and probably, as far as I'm concerned, probably one of the most, if not the most, important art magazine in America. It carries a lot of ads and a lot of very important articles on different artists, and it's very influential. Now, I would like to ask John Coplans to make a statement, for about a couple of minutes.

JOHN COPLANS: Benny, I think it would be interesting to hear from some of the artists first—what they feel—and then for us to do it, if you don't mind.

ANDREWS: Would any artists on the panel like to? Ademola, would you like to open up?

ADEMOLA: Well, I think the best thing I could say is that representing a group or nucleus of artists who, as Benny related, have their roots in the African core, shall we say . . . however, I think it's very important for everyone to understand that when we say African motif, we look at our art. There is something very contemporary. We are using our heritage as a reference point, but this, we feel, is a heritage that has no beginning and has no end. So, it's very important, I think, for everyone to understand that we are coming from a very contemporary view with a very close bond to our beginnings. I represent the Weusi artists, who also is a street group, if you want to call it, or guerrilla group. We were in the streets of Harlem since 1964, bringing the art to the people. This has always been our particular philosophy—that you have to bring out the people. Because black people are not, shall we say, museum and gallery people. I won't elaborate on the reasons for this, particularly. So, I'm happy to be here tonight to be able to express a certain point of view from a very important statement of black artistic expression.

ANDREWS: Howardena, would you like to make some statements about exhibiting and some of the feelings you've had in exhibiting your work?

HOWARDENA PINDELL: Well, I went through the usual art-school system. I went to Boston University and Yale University's art school, and I think my experience with critics now, the past few years, echoes the experience I had when I was growing up and going through the art-school system, in that there were very few blacks at that time at art school. We were treated by the teachers, who were white, as invisible. We were condescended to, and I think, basically, that's what the attitude of my *audience* [has been] over the years that I've been more or less in the New York art scene. Although

some critics do come to the studio and respond to the work the right way, generally the black artist is invisible, and if he isn't invisible, he's being condescended to.

ANDREWS: Well, Howardena, you work in really a very abstract manner. Do you find that you are able to compete with other artists—with other non-black artists—that work abstractly?

PINDELL: What happens is occasionally I will get wiped out of the competition because I'm a woman. Years ago, I was attempting to get out of the museum business, and I got a job because they thought I was a black male artist. And I showed up, and I wasn't a black male artist, and the job disappeared. Evaporated.

DANA CHANDLER: I would like to direct a question to the gentleman from, what is it, *Artforum?* Do you have a black art critic on your staff, and if not, why not?

COPLANS: No, we don't have a black art critic on our staff. We don't have a black art critic on our staff because basically we haven't found anyone that fits our style of viewing the world, or our style of viewing.

CHANDLER: What is your style of viewing art? Because I hear that all over the country: "We don't have someone that can view our art." What are you talking about, man?

COPLANS: Look, cut it out. I'm prepared to have some kind of a dialectic with you or dialogue with you, but if you're going to start on that level of aggressiveness, I'm not prepared to go on with the meeting. I'm prepared to discuss things, but not on those terms. Now, if you want to be an intelligent human being and discuss it at that level, then—

CHANDLER: Whoa, whoa, whoa. Whoa, let's not challenge my intelligence.

COPLANS: I can make a statement. But don't start that kind of aggression on me.

CHANDLER: Why not?

ANDREWS: Dana—

COPLANS: Because you can go and fuck yourself, that's why. Plain and bluntly.

ANDREWS: Just a moment. We will continue, we will continue. I said at the beginning that since this is the first time that we've actually had an occasion where the black artists met with the white critics and white editors, [this] is a natural thing to happen. It sounds as though I'm standing in front of a play explaining to the audience as the play takes place behind me [*laughter*]. But I can assure you that this is the most natural thing to happen in this first meeting. This will not be the [last] meeting between the black artists and the white critics, and it will get better, and we will get beneath the surface. But right now, I would like to ask John to please explain the policy, as he sees it, of *Artforum*.

COPLANS: I can do that, Benny. Let me explain. It seems to me that, over the past four or five years, there has been a considerable amount of black activism by artists in order to obtain, should we say, a place in the sun, a piece of the pie. And over this period of years, they have had a considerable number of exhibitions in museums. They have placed—and I think quite rightly—simple pressure on, to open up their avenues toward showing black art. And clearly, as a result of that activity, a certain amount of sorting and selection has gone on. However, I don't think that this process in itself has in any way changed the position of the black artist. Those black artists that were, should we say, admired by their white colleagues—my use of the term "white colleagues" to mean that they're white colleagues in both art and criticism—basically remain in the same position. I think that someone like Richard Hunt . . . his position hasn't changed in the least bit. He was very much admired four years ago, and he's still admired today. The problem, it seems to me, that's occurred is this: has activism in itself changed opinions? One of the things the artists—black artists—very correctly, I think, fear or note is that they have no critics of any significance on their side, except, I'd say, Frank Bowling, who consistently writes on black art. I don't know how well, in relationship to the art

itself, and how well they think he writes, but he does speak very well for them. He speaks a lot for them. Outside of him, I think, there is hardly anyone else.

Sitting as editor, I have a number of reviewers, and they are given absolute freedom to go out and review. We do nominate exhibitions in New York City that we would like to see covered. Critics have the freedom to turn in copy, and we, generally speaking, I would say, print that copy as it comes in, except for minor editing in English and things like that. We do not alter their points of view. And every time a black artist shows, we do attempt to cover the show. I think we have covered quite a number of the shows. The problem is, generally speaking, that galleries do not show very much in the way of black art. Therefore, we reflect, of course, the lack of black art in galleries. I've tried to make some remedial steps in that direction, but they haven't been very significant, I must admit. I did do a bibliography on the black arts to try and give as much information as possible. But beyond that, the position is, I admit, pretty rough, and until the gallery system itself, the support system itself, changes, I don't think you'll find particular changes in the art magazines, because the magazines are dependent on the gallery scene. Now, the only change that could take place is if black artists themselves begin to produce their own sophisticated critics that know black art very well and can deal with it in the kind of terms that we're interested in being dealt with—very sophisticated terms as far as writing and ideas. So, I don't think much change will take place as far as criticism is concerned.

CHANDLER: Thank you. I would suggest that people like Edmund Barry Gaither at the National Center [of Afro-American Artists in Boston], Samella Lewis in California—and I could go on with a list, and perhaps people from the audience could give you a nice, long list. All have the sophistication necessary to write very piercing critiques of black art. What I suggest is that perhaps your standards are somewhat racist and would not allow them to do the writing for you. Because we have the

people; we had the people; we will continue to have the people. We do not control the media. That is the problem.

COPLANS: I'd like to reply. I think there is a great problem here, because the same kind of accusations that black artists may say against white critics, that there is a kind of adversary situation between critics and artists, applies equally for white artists. Many of the complaints that I hear from black artists, I hear also from white artists. Women artists, for example—very much so—and from other minority groups. The point is—

CHANDLER: How is it that we always get lumped in with those?

COPLANS: Because the situation is very similar. You both consider yourselves underprivileged people.

CHANDLER: No, we consider ourselves people who are being oppressed by you. There is a big difference. You've got your big old foot on our head. We are not underprivileged. We are oppressed. Just take the foot off and everything would be cool. See, there is no real problem.

COPLANS: There is a problem.

CHANDLER: I don't have any problem. You see, you can't criticize my work anyway. I really don't care what you say. I care what my people say. But I would like to see them get the opportunity to say it. There are several things that could happen that would allow that—first of all, a black magazine that's got to come on the scene that gets distributed all around the country. Secondly, it has got to get sold in the right places—that means in the black community and the white community—equally with any other magazine.

COPLANS: But there are hundreds of black magazines. You get no support from your own community. None whatsoever.

CHANDLER: It's not true.

COPLANS: *Ebony* . . . You've got dozens of black magazines. You've got black newspapers all over the country. And not one of them will support you.

CHANDLER: Not one of them will support whom?

COPLANS: Not one of them will employ, regularly, a black art critic. You can't fault the whites when your own people, who are, in some areas, immensely rich, do control the media and television stations—and all kinds of things like this—have all kinds of access, don't care about you. You can't come and shit on me.

CHANDLER: I'm going to shit on the both of you. Really [*laughter*], I don't think they're any right. If they do wrong on me, they ain't right, either.

COPLANS: Well, tell them that, they're your people. Tell them—

CHANDLER: Oh, I do. I do. I do. Like the lady said, the whole damn country is ours. Not just one segment. See, this business of lumping black people in the corner has got to stop, just like you do.

COPLANS: Let me explain something to you. First of all, art is not looked at other than for what it is by the people that write for *Artforum*. It is not looked at other than for what it is. In other words, a critic who approaches a work of art approaches it as a statement made by someone. Now, this kind of notion you have got, that black art is being held up by white critics, in a sense, is absurd. It would be equally absurd to say that jazz was held up because white critics didn't write about it. Jazz wasn't held up, it was written about by white critics, it was devoured by white people very intensely, and admired by them very much.

ANDREWS: Dana, Dana, Dana—we will get back to this. But at first I wanted different people to at least get an opportunity to introduce themselves. Now, on my right here is Wee Kim, the former editor of *Arts Magazine* and a critic. *Arts* probably has a different philosophy than *Artforum*.

WEE KIM: First of all, let me say that the appropriateness of my being here, neither as a white critic nor as a black artist, is not meant to be a social protest. It would seem to me that there are a lot of problems. I can understand John's point of view.

I can understand Dana's point of view. And there are two issues that personally seem to me very clear. One problem is that if you're going to be an independent black culture—and I'm speaking directly to the black artists, at this point—you obviously, or perhaps, would like to leave the white man out. If that is true, then why not a black magazine? Why not black critics? Why not a black editor? That is something that you have to solve if you believe that there is a black culture. Is your art speaking to the black man and not to the white man? Otherwise, there is a more profound issue, and that is, to whom are you speaking in terms of your art that you are making? Is that the whole of society, and if it is the whole of society, what does that mean? What is the meaning of making art? Whom do you admire? With whom do you want a dialogue? What is art about? Substantiation of presence? Inspiration? Conviction? Those are all very important issues to what art is. And to me, as a personal stance, that goes beyond problems of being black.

ANDREWS: I think that the discussion needs to be opened up a little more. I would like to refer to Hilton Kramer's review of this exhibition, and I think that this is where maybe John and Dana probably disagree. I will read a paragraph from Hilton Kramer's review of the exhibition upstairs: "Other works in this wide-ranging anthology will no doubt appeal to other tastes. It must be said, however, that there is a quantity of work included that simply does not meet even a minimal museum standard." And I think that this is where the gap is between the black artist and the white critic. When John speaks, he speaks from a standard, it seems. In other words—and even Kim, you seem to suggest that there is this sacred standard that is being maintained—this museum, or this critical, standard. This is what Kramer is doing. But if you go one step further and you ask, what museum standard? Then you start questioning a lot of the works that have been exhibited or criticized, and what have you, in the art magazines and in the museums, and you realize the standards are what people decide they are.

I'll just give you an example of the Whitney Museum of American Art standards. To dig a hole, and then dig around it, is the art. To withdraw money from the bank, and the interest, is the art. To put ice cubes on leaves, and the melting is the art. I can go on and on, and that is just one museum's standards. So, then, when we talk about these people upstairs—the inhabitants from the prisons, or the African experience, or what have you—and these are the kinds of things that Kramer ignores, we start getting this discrepancy. I've had experiences of meeting with museum people, and their criticisms of our being in the museum, either to be collected or to be included in the exhibitions, has always had to do with this obligation on the part of the museum to maintain these standards. And yet, the Whitney Museum of American Art put on a major exhibition where the artist was to do the work in the museum on the walls. So, they didn't even *know* what they were going to get. . . . They had an exhibition that was called *The Art of the Thirties*,[1] and they could find no black Americans that could qualify for that exhibition . . .

We need to get into the area that really is where the conflict is, and that's the area of standards. In other words, there have been standards that have been set up, and they really are used to keep us out [*applause*]. I think that a person like Ademola, the kind of work that he does, and the people from his gallery, would probably experience even more [of that] than the people like me who do work from what is called, for the lack of a better term, something like "Colored American" art. I do black figures that are acceptable in America. But when he works from something that is much more definitive[ly] African, he receives minimal attention. So, this is the kind of thing that I think the people on the panel here probably could deal with a little more.

CHANDLER: I am not at all concerned about what *Artforum* says about my work, or the kind of criticism that it might mount on my work, if it ever deems to write about my work, as long as they spell my name right, which they don't do too often, either. I don't even worry about it from that vantage

point. I am much more concerned about black artists and black critics, and black people in the arts, having the opportunity in America, whether they have to take that opportunity by force or not, which is the way it looks to me, to write about themselves, for themselves. I don't think we even get that chance in this country, and if we do, we have to comply with somebody's jive-ass standards so that some jive-ass people will print it in their jive-ass magazines.

I am much more concerned about the whole concept of having black artists develop their own thing. The problem in that is that every time we try to develop our own thing, that is specifically for us and geared to us, along come them white folks to jam us. You know, then you've got to change these words here, and then go through all these little jive-ass trips. I am not at all concerned with what these white folks say about my work. I am concerned with what my black people say about my work. If they say my work is good, that is the only validity that I need. I'm in this show because *they* asked me to. Period. I would not be in this show under any other circumstances, because I really don't care, even about this place. This place just does not have the kind of meaning to me that forced me to want to run down here with my painting. You know [*makes an impression*], will you hang it on the wall, sir? I'm not into that.

As far as I'm concerned, this is just space. Black art is being shown for people who want to come and see it. Now, some of them are going to be white. It's cool if they can dig it. If they can't dig it, that's their problem. Deal with it the best way they can. Come in, walk in, pay your money, and leave. I don't care. I get really furious at folks trying to run some jive-ass European standards on me about sophistication and all of that. If you want to go into that whole thing about sophistication and all that jazz—you come from us, we don't come from you. You come from us. So, when it comes to standards, we're the ones that taught you your standards, and then you misused them. So, don't give me that. I don't want to hear it. Just run that by some other fool. Just run it by some other fool.

COPLANS: And why show in a black museum in a white city? Why don't you show in Harlem?

CHANDLER: I think I have. That's on one level. I think I have. But that's the thing, you see—this community ain't yours.

COPLANS: I don't claim—

CHANDLER: Wait a minute, you just talked about some white community. This community ain't yours—you just stand it, that's all. We're not yours. . . . Anybody here read *Artforum*? How long have you seen anything about us that says anything that is of any value to us? [*Pause.*] But I guess the shallow person is sitting down at the end of the table. I don't want to get into no personal dialogue with you—

COPLANS: That's all you've done ever since I walked in!

CHANDLER: I'm dealing with you in terms of your magazine. I don't care about you personally. You don't mean nothing to me personally. I *am* interested in your magazine and the force in America, and what it does.

COPLANS: If you've got minds, use them, and you'll make your art a force of America. You won't do it with cheap rhetoric. Your future to make great art is by making art, not by talking about it.

CHANDLER: I ain't actually got no problems with that.

COPLANS: If you've got no problems, go on making good art, and I look forward to discover it. But you won't make art with your tongue! You make art on canvases.

ANDREWS: Now, we've reached that point again—Dana, John. Down, down. Excuse me, excuse me.

KIM: I'd just like to ask a few questions. Let me go back a bit to Howardena. If you feel somewhat discriminated against as a female artist, why are you making art? Are you making art as a political statement? Or are you making art to make art?

PINDELL: It's part of my life. I make art because it's a total part of my life. I tell you, one experience that

every black artist in town will have is an attitude that is brought to your work, if someone does take the time to look at it—in that, people have a certain expectation of you as an artist if you are black. I've had many critics who have come down, who have attempted to come down, who have said, oh, I didn't think you'd be that good, as almost a second breath. You know, as if they spontaneously reacted like, oh, I didn't expect that. Every panelist here— every black artist on the panel—has had that one experience. And that is prejudice.

Am I doing art for art's sake, or was I making a political statement? As an artist, I may be idealistic in seeing my work as a total expression of me. But realistically, daily, I have to deal with what people put on me. And it's the reality of my existence that I deal with when I do my work, but it also is part of an expression of me as a total. Most black artists cannot become as idealistic in many cases as white artists because, daily, we have to deal with certain realities that make us a little more sensitive [*applause*].

ADEMOLA: I've been listening very curiously to everything that's going on, and I think it's very important for all of you to understand the basis from where these opinions are coming from. I'm referring directly to Mr. Kramer's particular article, and the particular paragraph you read, actually, in an instant, sums up, a great deal, the attitude that is prevalent among the white critical world. From personal experiences, I find that people who come to see a show of mine—both black and white—outside of the critical world usually respond very well. They relate to my work, even though the images basically may have black significance. They all relate to it on a universal basis. However, as soon as a critic—who, again, is in the position of wielding this power, or having the broad base of communication through a publication—as soon as he begins to deal with my work, automatically it's put into a shell. Of course, I can understand this, because if you look at the history of what we call art in this country, or in the world, for that matter, you'll find that the so-called primitive art that actually changed the

face—was used, in many instances, in the modern art movement, is still to this day looked upon with curiosity as something primitive, even though the designs and the architecture that went into creating this work is so universal that many of the so-called modern, most avant-garde movements within the Western art world have not even caught up with it yet. But still, it will be viewed as curious or primitive.

Now, this points directly to the fact that we're dealing again with hypocrisy and prejudice. I've found that whenever a white critic has to deal with black work, and if it has any type of significance or any type of image that is clear, automatically it becomes something apart from the mainstream of art. Now, this to me is very curious, because I'm the one who has respect for all culture, all people's cultures. Certainly, looking at one of Van Gogh's works or Renoir's work, it is fine and supreme in its own cultural context. And it is regarded as a work of art. However, when a black man, or a black artist, expresses himself in a manner that is particular to his particular ethnic background or heritage, it is regarded as something inferior. And this is a direct tracing to the prejudice that has dominated throughout the world, because art is only a reflection of society. A lot of what is happening here now, to me, is rhetoric. Nothing is going to change until we as black people, number one, as Mr. Coplans pointed out, begin to support ourselves. Because my art [*applause*] is concerned with bringing a gist or bringing reflections of ourselves. Our art is not, by any means, confined to just black people. All our artistic expression is something that is available to the world. And as I said before, when I find people off the streets— who, to me, are the most important people—they react to my art and the art of my contemporaries in a very realistic manner. It's just when it comes to the critics, who, in many instances, represent the hierarchy or the governmental order, that they feel it necessary to keep the black images or the black artists in their place. So, nothing is going to change, as I said, again, until we as a people begin to support one another. Now, as far as my statement to white critics, I should hope that they

mature enough in their understanding to begin to deal with art on a realistic basis [*applause*].

Now, specifically, there have been articles written about my work. I remember one very, very clearly. I think it was in that show, Benny, that traveled throughout the Midwest. It was organized by Bell Telephone Company in Chicago.[2] They did a big spiel on Sunday, a whole full page, and lo and behold, when they described my work, the particular critic described it as "voodoo, beyond the big West." "Spooky." You see what I'm saying? He did not deal with this art in terms of the form, the composition, the color. He dubbed it as something that is "spooky." You see? To me, this, again, is going right back to that same feeling, that same prejudice, that is dominant throughout the whole context of the so-called critical world—where you go in looking at the thing, looking to find something odd there. There is no basis for Kramer, who is recognized throughout the world as a major critic, to even have the audacity to make a statement that the work does not meet minimum museum standards. As Benny adds, what the hell is "minimum museum standards"? I've been to the Guggenheim Museum and saw rags tied together and draped from the ceiling. You know what I'm saying? [*Applause.*] And this is considered great art. So, there again—

COPLANS: He happened to be a black artist. Rags tied to the ceiling. You're talking about the work of a black artist.

ADEMOLA: I'm not talking about the work of a black artist.

COPLANS: You know who I'm talking about. Al Loving. Well, Al Loving is a black artist. The materials you use have nothing to do with what the sophistication of the art is.

ADEMOLA: Mr. Coplans, we are not dealing with emotionalism now. I'm dealing with a specific area of thought that is dominant within your particular outlook. And I'm not dealing specifically with you, I'm dealing with white critics, period. And I'm telling you exactly—I'm not theorizing at any point here.

COPLANS: But your examples are wrong.

ADEMOLA: I'm taking an example that is very clear here: where a man has made a statement that they do not meet minimum museum standards. Now, this is one statement. I've seen it tenfold throughout critiques of black artistic expression. And there is no one in the world that is going to stand there honestly and tell me that this is not a strong case of prejudice.

COPLANS: No, because I happen to agree with him. I think that's one of the shittiest shows upstairs I've ever seen. And it doesn't meet minimal professional standards.

CHANDLER: What is your name?

COPLANS: Coplans.

CHANDLER: Coplans, Coplans. Mr. Coplans, would you please clarify for us what minimum museum standards are?

COPLANS: I have not written the review. You ask Hilton Kramer to—

CHANDLER: I am asking you your point of view. I asked you *your* opinion.

ANDREWS: You said that you agreed with him, with the statement.

COPLANS: I meant that you can show whatever you like in the museum. However, criticism as such can say whatever it writes about also, and you can either reject it or accept it. You can say it's indelicate, or it's right, or it's wrong. Now, you have a notion in this country of a free race—of people who are independent. They can write in whatever manner they like. And you can reject their writing or you can accept their writing. Some people will agree, some people will—

CHANDLER: You're not dealing with my question at all. Would you please be kind enough to explain to us, since we would really like to understand your *sophisticated* way of thinking, what minimum museum standards are in *your* statement?

COPLANS: I didn't make a statement.

CHANDLER: From *your* point of view.

COPLANS: I think it was a bad show.

CHANDLER: Can you tell us why the show is a bad show?

COPLANS: It's a bad show for a whole variety of reasons. I don't find the work in itself at all inventive. I don't think that it has any personal vision. It doesn't seem to me to make a statement, with one or two exceptions. But taken as a whole, as a selection of work, it doesn't seem to me to represent the best that is going on in black art. It doesn't seem to me to meet . . . it's so far below the standards, what the best is, and what the best artistic accomplishment is in black art, that I look at the show, and I think the show is very poor. It's as simple as that. That's judging it by black standards.

CHANDLER: Wait a minute, wait a minute, wait a minute, wait a minute. Mr. Coplans, what are black standards?

COPLANS: The best artists that I can see.

CHANDLER: Black standards are the best artists that who can see? I think you are very much out of place, because I would at no point attempt to interpret what is "white standards." So, I think you are very much out of place.

COPLANS: I interpret white standards every day.

CHANDLER: You're a white man. You have the right to do that.

COPLANS: I'm interpreting Chinese standards. I'm interpreting all kinds of standards in the United States.

ANDREWS: The thing I would like to say is that again, like I said earlier, [this] is probably a very educational thing, because I've always said that museum standards are not handed down from heaven. I'm a boy from Georgia that picked cotton, and I'm a guest curator at the New York Cultural Center. That gives you an example that these people are not anointed to be doing certain things. And they are human beings that write these

magazines. So like these exhibitions, and make all that money that was in that auction. And it's very important for the public to see and hear people talking. I think that the education that we are giving up here tonight will probably make quite a few of you—when you read criticism, look at the works of a lot of the artists here and anyplace else—probably will make you look a little longer. I'm not saying who is right or who is wrong, but human beings make these decisions, and this is one of the things that the very, very insulated, small group of people have managed to keep apart from the large masses. We were made to believe that there was something magical or godly going on behind those big doors. We managed through pressure—and this is not just the black artists, but the women artists, the poor, people like that—to pry open some of the doors. The important thing is for the majority of people to get the education. The ones of us who get a chance to sneak in every once in a while can know it. But it's not enough if the larger group don't see it. Now, what I'm trying to say here is that John is an editor of probably the most important art publication in the country, and those are his statements. I'm trying to be the moderator in this situation.

ADEMOLA: What I am particularly concerned with is the attitude of looking upon the creative efforts of black people as being something that is odd, that is out of context with an overall effort by all creative people. And this, to me, is the utmost important thing. I must stress again that I think it's more a maturing that I'm hoping will overtake the white artistic community, and that, to me, is the most important thing. As far as what is going to be happening, black people like myself, black artists like myself, are going to continue working and continue showing. Within that particular context of the group I'm in, yes, we are definitely concerned with being in the midst and are serving the needs of our community. However, we are concerned with an international community, and that is very important. So, if the white art-critical world does not mature into looking upon our art as something that has an international flavor, that has

the same quality and the same inherent means and definitions that is peculiar to any particular ethnic group—if they do not, basically, we will step over them. I, personally—and many of my contemporaries—are organizing, and, basically, our shows will be going all over the world. And, at that point, I think that the critics here in this country are going to look very, very foolish, because once you step out of this country, there's another attitude. We're very deluded and disillusioned [*applause*] about this mess that just keeps us entwined in thinking that this is the supreme judgment here, this is the supreme objective, in America. And it's not that at all. So, that's all I really have to say [*applause*].

COPLANS: As I said earlier, the situation of black people in America, particularly their political situation, and their aspirations and hopes for a bigger slice of the pie, is one thing. But what I'm saying is another thing. I'm saying that the very nature of art is an extraordinary thing. What I'm looking for when I look at a work of art—and I think what lots of other people are looking for when they look at a work of art—is something that's rare, that you don't come across very often. Something that's very extraordinary and something that opens people's eyes in a remarkable way. In other words, lifts them up to the insights and perceptions of a particular artist. Now, I don't think that art has anything to do with democracy. I don't think art has anything to do with politics. It has to do with a particular level of poetic insight. As a critic, I see this as my only function, to try and find this particular kind of work and to write about it.

CHANDLER: You're incredible, you really are— aside from what went on here, this business of my seeming to pick on this man, which is true. It was very deliberate. I wanted him to be insulted. I wanted to really talk about what I would hope would happen to us as people. That we would, as Ademola suggested, view ourselves on an international level, on a world level, and realize that we make up a large part of the world, and that America is just one plate that ain't about us. It's just one plate that ain't about us. We have to be about the whole world, and the real world, and deal on that level in terms of getting what *we* need—our own museums, our own books, which we can share with other people, since we're all about giving and sharing anyway. And we have to be about getting what we need to do the things that we need to do, so that we can survive in this country. That basically is the only message or statement that I want to make. All this other thing was just so that we would have a clear example that all of this other stuff ain't about us [*laughter*]. And he showed us it ain't about us [*applause*].

NOTES

1 [Andrews is referring to the exhibition *The 1930s: Painting and Sculpture in America*, which was on view at the Whitney from October 15 to December 1, 1968. —Eds.]

2 [*Black American Artists/1971* was on view at the Illinois Bell Telephone Company Lobby Gallery in Chicago from January 13 to February 5, 1971, then traveled to a number of sites in the Midwest. See pp. 266–71 in the present volume. —Eds.]

1973

Toni Morrison, "Foreword," and Clayton Riley, "Introduction," in Joe Crawford, ed., *The Black Photographers Annual 1973* (New York: The Black Photographers, Inc., 1973)

Launched in 1973, the *Black Photographers Annual* was the first publication to identify and acknowledge Black photographers working in the United States, from historical figures to practitioners of the present day. Four volumes of the annual were released over the course of seven years, all of which showcased emerging Black photographers while reflecting on their predecessors. Each volume sought to explore the nature of photography as an art form while simultaneously addressing the issue of racial representation and the role of photography as a means of political engagement. The annual's editorial team consisted of current or former members of the Kamoinge Workshop, and well-known writers were invited to contribute essays. Toni Morrison wrote the foreword to the first volume. The author had published her debut novel, *The Bluest Eye*, three years before and would release her second, *Sula*, toward the end of 1973. The format for the *Black Photographers Annual* stayed the same throughout its duration; publishing high-quality reproductions of photographers' work remained of prime importance.

Clayton Riley, a writer, actor, and radio broadcaster who advocated for African American playwrights—and performed in the original production of Amiri Baraka's play *The Dutchman*—contributed an introduction to the inaugural volume.

TONI MORRISON, "FOREWORD"

This is a rare book: not only because it is a first, but also because it is an original idea complemented by enormous talent, energy and some of the most powerful and poignant photography I have ever seen. It was conceived as a commitment to the community of Black artists, executed as a glorious display of their craft and their perception. Consequently it is an ideal publishing venture, combining as it does necessity and beauty, pragmatism and art.

It is also a true book. It hovers over the matrix of black life, takes accurate aim and explodes our sensibilities. Telling us what we had forgotten we knew, showing us new things about ancient lives, and old truths in new phenomena.

Not only is it a true book, it is a free one. It is beholden to no elaborate Madison Avenue force. It is solely the product of its creators and its contributors. There is no higher praise for any project than that it is rare, true and free. And isn't that what art is all about? And isn't that what we are all about?

CLAYTON RILEY, "INTRODUCTION"

In the new time, in the new space we begin to occupy, we are seeing and hearing ourselves, seeing ourselves as possessors of beauty—a redefined sense of beauty—beginning with color, extending to shape, a new Blackness, real and strong as our history, pushing consciousness toward a new place—an understanding, a belief, the awareness of self . . . all new, perhaps, but ancient in concept.

We are confronting now the correlation between image and destiny. (Flip Wilson's comically stated premise that "what you see is what you get" is, finally, not so comic after all.)

America has prepared many lies for the general and specific population. Ours has been the myth of our ugliness. All wrong were our skin tones, ranging as they do from mahogany to cream, misshapen have our features been in spreading the broad nose and large lip across the map of faces descended from Africa's coastal tribes and inland royalty by way of this nation's southern ports of entry, slave markets dotting America's recent historical landscape.

Challenging these things, doing urgent battle with them, is a task, is a difficult act of special defiance, but so worthy, so deeply significant we must note and acknowledge and revere all those responsible, all those involved.

The artist, for example. The creator, the visionary, moving, doing, seeing things to be shared finally with a public too long taught to respect limitation and narrow perspectives.

The nation is surrounded by images of what it is supposed to be. And becomes institutionally and individually what those images imply, what they indicate, what they impose. The Black visual artist, his work for many years denied a true and complete public, develops muscle and emotional determination through a years-long struggle simply to be, exist and work. Thus here, in the pages beyond, an energy displayed, measures of awesome vitality and the recognition of what has always been available but hidden, an existence, a people, a whole situation and vitalized legend walking, talking, breathing in the land.

A life. Captured in tears or whatever smiles are possible whenever. A human darkness breathing an extended strength into the nation's fractured folklore. Faces, the contours of which indicate constantly the parade of events, moment to moment systems of tragic consequence, hope, loss, courage, rage, fear, the love of life and person, whatever passion may remain of the spent spirit. Lives. A freer, less distorted chronicle of our times. Other truths than the ones we have or have not been told.

In this volume then, the blood of the nation's Blood, the heart and flesh of a still-wandering tribe, traveling long and resting briefly, rarely, living the proverb: no rest for the weary.

Here, Moneta Sleet has given access to the ravished majesty of our late Lady Day, Billie Holiday who taught us to use the language, sing the song to a fuller and more expansively communicative advantage. Her arms and legs needle-pointed like a profane fabric, her eyes revealing the nearness of death, a death, ultimately, for us.

For us.

And Leisant Giraux lending to us the face of a woman as a warm Black moon in a tweed jacket,

ancient, patient, a globe of lost and living loves telling us in silence to keep on keepin' on.

Magnificent presences, jewels in our mythic constellation. Mahalia Jackson captured in an overpowering moment by Bert Andrews, captured as the gospel truth. Naked hand on a naked gate, a blended sexuality related by the lens and eye of Adger Cowans; two young and dreaming dancers doing an older ritual grind, and staring into a new world. —Lloyd E. Saunders

And spiritual things, too. A blur at the top of a step, as Theron Taylor bears witness to someone vanishing up some ancient (roominghouse[?]) staircase.

Our pain. Elation. Fury. The flow of human rhythms, staccato heartbeats, hands frozen into gestures of exalted and vulgar expression. Reality. Purposeful. Accidental. Amartey Dente . . . dancers. The pursuit of a language only the body translates well.

They exist here. The artists who have caught them in the process of being alive, electric, profound in their humanity. And the masters are represented also. Roy DeCarava, priest of our culture, showing what his wise eyes have seen. James Van Der Zee, as well, detailing his long encounter with these United States.

And all those who have informed the spirit here, and whom I mention, if not on these pages, then in my heart for the magnificence of their art and its impact. (In my heart where, indeed, there is more space.)

A collection, then, of the works of Black photographers, a monumental testament both to their enormous gifts, and to the people from whom they have come, the people, wondrous and strong, who have been their subjects for this study of life.

1974

Milton W. Brown, "Jacob Lawrence," in Milton W. Brown with Louise A. Parks, *Jacob Lawrence*, catalogue for exhibition held at the Whitney Museum of American Art, New York, May 16–July 7, 1974

Jacob Lawrence's was the first solo exhibition by a Black artist to be held in the main galleries of the Whitney Museum of American Art, as opposed to the lobby gallery, where shows had been devoted to younger figures such as Al Loving and Melvin Edwards. By the 1970s, Lawrence had established himself as a masterly painter of African American life. He had started out at the Harlem Art Workshop in the 1930s, where he was taught by Charles Alston, and later attended the Harlem Community Art Center, led by the sculptor Augusta Savage. In 1940, Lawrence received a fellowship from the Julius Rosenwald Fund to complete what would become one of his most iconic works, *The Migration of the Negro* (later called *The Migration Series*). This group of sixty panels, which depicts the flight of African Americans from the South, became the first work by a Black artist to be acquired by the Museum of Modern Art (in this case, jointly acquired with the Phillips Collection in Washington, DC). Lawrence's flat, geometric style of painting was always grounded in his personal experience, and he identified his style as "expressionist." The artist later taught at Brooklyn's Pratt Institute, from 1958 to 1970, then accepted a full professorship at the University of Washington in Seattle, where he taught until 1983. Milton W. Brown was an art historian affiliated with the City University of New York, and Louise A. Parks was a doctoral student at CUNY. The final paragraph of Brown's catalogue essay, reproduced here, reflects on Lawrence's status and how it relates to the artist's universal outlook, so different from that of younger Black nationalists.

MILTON W. BROWN, "JACOB LAWRENCE"

Jacob Lawrence was the first Black artist to be accepted so completely by what was essentially a white art world. He was also the first wholly authentic voice of the Black experience in the plastic arts. He has carried the honor and the burden well. It has not been easy to live as a token Black in a white cultural world, nor to suffer the inference of "Tomism" from his fellows. From the beginning, his art was not only about Blacks, but represented them honestly without idealization, sentimentality or caricature. At the same time, as a social realist, he considered the struggle of his people as part of a larger "struggle of man always to better his conditions and to move forward . . . in a social sense." Times have changed and the "integrationalist" stance has come under attack from younger militant Black artists. He admits readily that his acceptance was unique, that there are color bars in art as in life, that Blacks in America are unfairly treated, even oppressed and exploited, but he also insists that he was helped by whites and has been successful in a white world. No one can question his credentials as a "Black" artist and he is proud of his achievement, but like many of his fellow Black artists, he would rather be accepted just as an artist. It is not only Lawrence's racial posture that has come under attack. For a large part of his creative life, since World War II, social art has been out of favor, and though he may continue to sell, exhibit and receive honors, he gets little critical attention in an art world dominated by other values. Still, he continues to survive and create. In an interview, Lawrence was asked by Carroll Greene how he managed to maintain his identity in an art world so hostile to his beliefs. Lawrence answered, "I have an assuredness of myself."

1974

Jack Whitten, "From an Interview with David Shapiro, April 1974," in *Jack Whitten*, pamphlet for exhibition held at the Whitney Museum of American Art, New York, August 20–September 22, 1974

Jack Whitten was born in Bessemer, Alabama, in 1939. He left a deeply segregated South for New York, arriving in 1960 to study at the Cooper Union for the Advancement of Science and Art. Whitten met several artists during this time, including Romare Bearden, Willem de Kooning, Franz Kline, Jacob Lawrence, and Barnett Newman. His own gestural abstract paintings were shown at the Allan Stone Gallery. Around 1970, Whitten began to experiment with what he called "developers"—tools such as Afro combs and rakes, which he pulled through layers of acrylic paint on canvases spread out on the floor and attached to boards. He likened his goal of producing a painting with a single gesture to the photographic process of developing an image. The works shown in his 1974 solo exhibition at the Whitney were from his *Slab* series. Whitten did not publish many statements or sit for interviews in the 1970s, but he maintained an important journal of studio notes in which he reflected on the situation of Black artists.

JACK WHITTEN, "FROM AN INTERVIEW WITH DAVID SHAPIRO, APRIL 1974"

The ball is flying, you don't think of catching it, you catch it.... My painting is a form of drawing. In the process of raking—raking is line—things happen. The whole painting is line. The whole painting is one line, let's face it. Some people take joy in the fact that nothing is happening—But Pollock, Rothko, Kline, these are my guys, these are my gods.

Do you know that Crete is the edge of the Western World? That's where we in the West draw the line. Right across those waters is Africa. Soho—the whole thing turns into a flea market.... As for scale, I used to play tenor sax—not the soprano and not the bass clarinet or bass saxophone. Nice mellow tones. Not too big, not too small but like John Hancock's signature . . . able to be read. That's my idea of scale.

These works were painted 1973–74. The main thing is immediate raking, horizontal rakings. They're organized by chance. When I rake them in a split second, there's no way of knowing. It's a gambling situation, but you set up the situation to gamble with a lot of paint, maybe gallons of paint.... This is my idea of history: History traveling in a straight line like my horizontals. I catch a piece of it, but it's going forever. It's part of a story that's been going on, still is going on, and always will be going on. The space I gave you is a frame that freezes a piece of action.

You take paintings built on grid systems. I don't structure like that. It gives you a play pen to play in, then you can do anything you want to. I don't have that play pen. I rake across and develop it and what happens, happens.... You might see a face, a landscape. But it's not a crude legibility.

Whatever happens, I want to trap it in the surface. I'm really *into* surface. And I'm working with things that go very fast. It has something to do but is simpler than the "speed" of abstract expressionism. De Kooning said he wanted one skin, but he goes through several manipulations to get that skin. I want one skin too, but I want it in one physical manipulation.

It's like light, like a camera trapping something in a single fix. A camera is dark, a certain amount of light enters and the amount of light is what traps the image. Whatever happens on the plane of my painting has to take place instantly and has to catch and freeze something.

When I say speed I'm not talking of the emotions. I keep coming back to the word PHYSICAL. My platform is a heavy constructed platform—it's a huge architectural drawing board. It's a draughtsman's situation. The paint is applied very much like a tile setter, filling a layer of mortar. It is called "floating," and one must have the experience of knowing just how much concrete is needed to set the tiles in place. So my paint is put down, like a workman putting up a sidewalk. . . . The word "develop" is important. A huge 12-ft. piece of metal attached to a wood frame, that is my DEVELOPER, which rakes across the plane. It happens very fast. De Kooning needed big house painters' brushes. I took one of those brushes and blew it up to twelve feet. I have a twelve foot brush. I have a vast brush: 40–50 lbs, easy.

Harsh criticism might call this landscape painting.... But there is no most powerful region. There is no horizon line in my painting. I don't know if it's a Jungian "big dream."

On Lispenard Street I'd sit by the window and see a certain color on the street, a color someone was wearing on a shirt, I'd go back and grab that color and mix it and put it in. Take Smithson's *Spiral Jetty*. He uses tons of dirt; I use paint. Art comes from everywhere. I can be a saint and make art. I can be a stone devil and make art.

1974

Vivian Browne, "Norman Lewis: Interview, August 29, 1974," *Artist and Influence: The Journal of Black American Cultural History*, no. 18 (1999)

The conversation excerpted here, between the artists Vivian Browne and Norman Lewis, was first published twenty-five years after it took place in 1974. Browne, who was initially known for her politically oriented paintings, had recently cofounded SOHO20, one of the first women's art cooperatives in Manhattan. Lewis had been working for over forty years, first as a social realist and, since the late 1940s, as an Abstract Expressionist. Lewis had been part of the Spiral group and, in 1969, participated in the protests against the Metropolitan Museum of Art's *Harlem on My Mind* exhibition (see pp. 134–35, 223). In the same year, the artist, along with Romare Bearden and Ernest Crichlow, founded Cinque Gallery on Lafayette Street in Lower Manhattan. Named after Joseph Cinqué, the leader of the *Amistad* slave-ship mutiny of the 1830s, the gallery was dedicated to supporting emerging African American artists.

VIVIAN BROWNE, "NORMAN LEWIS: INTERVIEW, AUGUST 29, 1974"

Can you tell us about Spiral? How did it start?

I would like to know what your impressions about Spiral are first.

Reggie Gammon told me that he was a younger artist coming in and that Richard Mayhew brought him in. It was an organization that was supposed to be a vehicle that was going to help black artists show. There was the older group of artists who felt that some of the younger ones didn't quite deserve to be in there.

That was true. The unfortunate thing that happened was that it ceased to be as discriminating as it should have been. We certainly didn't approve Reggie coming in. He got in possibly because of Mayhew.

There was a need for just being together. We got this store on Christopher Street. It took us about a month to come up with a name. The whole idea was of something going upward. Spiral suited that.

Then we thought of having a show. This was the height of King's involvement in the South and we wanted to do something.

When was this?

In 1964.

How big was Spiral?

To begin were with there were fifteen of us. Then a lot of people got in, because I don't think we were discriminating enough. After a while it got to be like a social club, which was unfortunate. But despite that the feeling continued that there was a need for this place.

Actually, it wasn't so much about getting together to show as it was to talk aesthetically about things. It wasn't about trying to exclude certain people. If they had the experience, fine. The whole tenor of the thing was set on people like Hale Woodruff and Charles Alston.

Spiral wasn't an employment agency. It had nothing to do with people making money, and Reggie came looking for that. I feel that many of the conversations deteriorated due to the fact that some of the guys needed money.

People like Ad Reinhardt asked me if he could join. I told him that he didn't have the same problems as the black artists did. We excluded certain people, regardless of what good artists they were, because they didn't experience any problems, because they were white. It even got to a point when we questioned Romy.

Because of his gallery standing?

No, because of his color.

Wasn't there some emphasis in Spiral on color? The show that you did put on was called *Black and White*.

That came out of the March on Washington and Selma. There was a movement at that time of black and white togetherness. There was a hell of a movement all over the country then, of Blacks and Whites trying to understand each other. We were involved with white and black people and wanted to do something as artists. We limited it to the two colors of black and white. It was up to you to run the gamut of white to black. Romy started this whole thing of collage, and I just used black and white paint. I did about ten paintings to get one good one. This was in the summer of 1965.

Aesthetically, some of the guys mixed the colors and got gray. Romy used pieces of newspaper. The only shithead was Al Hollingsworth. He used brown in the paintings and said to us, Who are you to tell me what I can't use? Once he was in Spiral he felt he could do what he wanted.

When did Emma Amos join Spiral?

I think about the time Reggie came in.

Did an artist have to sponsor another artist to join?

Yes. There were some beautiful things that came out of that *Black and White* show. This is all you've got to work with so what are you going to do? The things that came out of this show were very good. People like Merton Simpson did some very angry faces. Very strong.

At least we felt we had gotten them to bring the best. You couldn't apologize for your work. We first elected a hanging committee so there wouldn't be any favoritism, we hoped.

How and why did Spiral close?

Kind of foolishly, because for the longest time all we did was talk. The conversation was beneficial. Then we'd drink, and it frequently got very personal, which was good. You had to live up to what you said. I remember that one night Bill Majors said something to Hale Woodruff and they almost got into a damn fight. Majors said, "I don't think you're shit" or something like that. It seems that he had been carrying this grudge for a long time, even before Spiral existed. Woodruff said that he wasn't going to come back to meetings any more and he wouldn't stand for being insulted like that. Because of this Majors set a standard that he himself had to live up to, which he didn't. Certain things started happening to him, which were exactly like what happened to Woodruff. Woodruff got into a university and became a professor, which has a lot of dignity and a hell of a responsibility. The same thing is true of any son of a bitch who is crying today about not having any time to paint. Make up your mind. You can make as much of a contribution being that much of a thinker. I think Reggie Gammon has fulfilled more in teaching than he had done in his painting.

Once we got together in Spiral we became aware of our poverty and how much we needed each other. In unity there's strength. So we stuck together. We had this place on Christopher Street, we were paying something like $95 a month, and then the landlord wanted $150 a month. That was it. Romy and I started looking around for another place.

I did the majority of work in this place. I was the first president. I thought there was a hell of a need for it, and I didn't mind how much I did because I thought it was important for us, and I still do. It's a shame that something should fail in order to prove that you're right.

We looked all around. This was before SoHo, and we couldn't find a place. We couldn't get these guys to give ten dollars a month. They'd go out and spend fifty dollars on booze, and you couldn't get ten dollars for rent. We were trying to find a place for less than a hundred dollars, but most places were $110 or $125.

Then we got wind of a possibility of a grant, and that's how Cinque got started. I think it was in 1968. Romy got a grant for thirty thousand dollars to start it. The reason I believe that we got the money was because it was such an insignificant sum in relation to what we should have asked for.

How did Ernie Crichlow get into Cinque? He wasn't in Spiral.

I don't know how Crichlow got on the scene. I think it was just the fact that he had a car, and Romy and I were looking for space and asked him to take us around. Later I said, "Goddammit, how the fuck did this guy have so much to say?" Then we were always fighting. We finally got a space over at the Papp Theatre. They gave us the space free. Romy and I wanted it to look like a gallery on Fifty-seventh Street. We had a guy rip everything down and put up good walls. I still never liked the place, because it was so out of the swing of things. I don't think the gallery should just exist because of the theatre. The place was never open during the day. Who goes to look at pictures at night? And even when it was open nobody came. We were paying people to run the damn place, but half the time they weren't there. That used to peeve me, because people would want to see my work or Romy's work, and there was nobody there. It gave Chris Shelton an opportunity to learn what it is to run a gallery. Shit, he was letting the fucking artists tell him what to do. I told him that we hired him because we respected him and he should dictate what these artists' work should be, not them dictating to him. If the work merits being shown, show it, but no favoritism.

Cinque has done some wonderful things for artists who ordinarily wouldn't have any avenues open to them. We do these shows at no expense to the artist, and we get nothing. If they sell, all the money is theirs.

So this really started when you were looking for a new home for Spiral?

Yes.

So, in the future you will continue with the gallery. What about your own work?

I think you can exhaust what you are doing, and exhaust even New York City. The whole thing of going abroad to Greece and Crete has replenished me. It has given me the urge to create new things.

Where are you teaching now?

I teach at the Art Students League. The students are like zombies.

With teaching you spill yourself out.

I like to feel that I earn what I get. The class has a model, and it would so easy just to let them work on it uninterrupted. This is 1973, and we are not at the National Academy. There is something more than light and shade.

Do you have any personal statement to make in closing?

The only thing I could say is that I wish white America could not just visually and physically feel the involvement and investment that black people bring to this country, but also see them as human beings. Also, black people involved in creative fields should have doors opened for them, because they are Americans too.

When Vincent Smith had a show, John Canaday in the *New York Times* went on to elaborate about the frustrations of black artists in America, and then in the next paragraph he compared Vincent Smith to three other black artists. This isn't necessary. In last Sunday's *New York Times*, an Italian writer mentioned Canaday's article. She talked about Canaday isolating this thing and how it becomes black again. I was glad she wrote this, because we should have avenues that are open to us so that we can express ourselves without this kind of frustration. And the goddamn *Amsterdam News* doesn't help.

Are you saying that we really belong in the mainstream?

We are so much a part of the mainstream that if black people would suddenly go on strike for one day in America, it would shake the economy.

Look what they did at the Willard Gallery. You were the only black member. And look what they do now. Sam Gilliam is heightened to such a tremendous degree because he is a black artist who can somehow operate in a white world, but he is kept separate.

Well, at this moment they are making a hell of a lot of money on his blackness. It's like, "Look what a black man did," rather than "Look what an artist did."

What was the philosophical intent of the establishment of Cinque Gallery?

I think it was very mercenary in the sense that on the part of the people who benefited, I don't think there was that concern. Maybe I'm playing black artists down, but when you find something you can give tribute to, or if you don't find something, there's no reason to give tribute. I see no reason to pay homage. If there's something behind it let's not make it any bigger than it is. The artists who came wanted something we provided, which was avenues for them to exploit. And many of the guys who we helped didn't have any goddamn philosophy behind them. There were a lot of things that I objectively discovered, one of which was that there was not that much talent around.

The reason we started this was to encourage younger painters. For example, if we showed you, then maybe we would give you a show two years later, because in the interim we'd have exhausted all the people and talent that there is. So why say there is new talent when there's no new talent? We were constantly showing new people, but just going a level below the standards that we set.

What do you see are the possibilities, and in what direction are we going for the future? What would you like to see happen for the black artist?

I would like to see a sense of togetherness. Out of that comes something very beautiful. I used to enjoy this with white artists, just talking. You'd get hung up and go home and try to do certain things with color. You'd come back the next time and show what you had done. I would like to see more curiosity and more awareness of the fact that the rules are made to be broken.

Do you think of that in terms of art and aesthetics, or in terms of art and black artists?

I don't see any difference. They're artists. You keep saying "black artists." There are artists who ought not to be black. I don't think they're saying anything more than white artists.

You don't even have to mention the word "black." I know who you are talking about. You don't say "black Romy Bearden." You don't say "black or white de Kooning." So I know who the hell you're talking about. I saw your show,[1] and in my excitement about the things I saw, did you want the word "black" used? The only thing black about it was Vivian. It was the white lines and the textures that make this work function for me, that made me want to have it.

The reason I'm bringing this up is because everybody now is talking about "black" this or "black" that. You are going to be in two black shows in one month. The shows have "black" in their titles.

You have raised a lot of questions. Much of what happens to those men and women of color who paint in America depends largely on the part of white America. Whether it's politics or anything else, you find that people have to involve themselves in order to bring any kind of dignity to themselves in America. I think it has always been true in the history of America of Blacks. The very nature of the fact is that unless you become white, as long as there is still racism here, you are not getting your just dessert.

Maybe it's better if white America is surprised. Like people come to the Art Students League to take class. I tell somebody to do something, and

some of the white people are surprised and say, "Who is he?" Then they discover that I'm the instructor. The rest of the students who have studied with me for a few years snicker a little, because of the ignorance of these people. I frequently acquaint people with the fact that there are ten other classes in the school at this moment, and they would do me a great favor to go to the office and ask for a change of class if they don't like what I say.

I don't see any reason to bandy what I feel or think. It's not a question of being over-sensitive. Thank God I have a certain discrimination. Some people might say that I'm being oversensitive, which I don't think I am. I know what I want, and what I desire, and I don't have to be less than what I am to achieve. If somebody created a jewel that I want, I don't care who made it. If it is good, I want it for myself.

With Camille's horse, it just so happens that I saw it and I wanted it. I wasn't in her place a half an hour.[2]

What you really are talking about is the negation of a black aesthetic.

Do you think differently?

Yes, I do. I don't negate an aesthetic that comes out of a black experience.

When that period comes around in America where black women and black men cease to be hustled, harassed, raped, it won't be because of an aesthetic, but just the fact that they belong to the human race.

I don't see you as "black Vivian Browne." I just see art. I don't see any black experience. I just see work that, through certain frustrations, produces this. I don't give a damn. I don't need your biography to understand your work. Your bio doesn't tell me it's any more human.

I would agree with that. You take somebody like Valerie Maynard, for instance, whose work you know. Many people would say that her work is an exponent of the black aesthetic or a transcendence of African feeling of being in

America. She is very direct in her work as far as being black and African is concerned.

Is she from Africa? You're using a lot of phrases. Don't make me a party to this. I get uptight and rather than be objective, I become subjective because you are asking certain questions. You are asking me them as if you believe them. I don't think you would ask me these if you didn't believe them yourself.

That's not true. The reason I'm asking you them is that I think that you think about art and you are a social human being. You have been involved with numerous organizations that have helped people. I have been caught up in all of this stuff. Two or three years ago I wasn't black enough. Not only for my students, but also for other artists.

What other artists? If you want to talk you've got to expose yourself and open your legs. I'm being quite serious. When you mentioned Valerie Maynard I saw that show at the time, and I can't remember the things I said at the time. Also when I asked you whether she was African, and you said she wasn't, that did it for me. One of the things I find so beautiful in this book on Africa that I have, is that you go to the north and it's different, and you go to the northeast and it's different. They are all black and you don't even have to know that they are black, but it's not the same art. There are little differences. Here, most Blacks who are copying African art don't know a goddamned thing about Africa. You can spend the rest of your life just learning the whole psychology about this nation. This is a lifetime of work. It's like a son of a bitch goes to Harlem, lives there for two weeks, and then sits down and writes a fucking book. It's a lot of shit. I find this true of black Americans who go to Africa. Suddenly they become Africans. Goddamit, I know a lot of black women who've had involvement with African men. That's something else again, as men to black women.

I don't find the work of Valerie Maynard that African. I don't even find somebody like Pearl Primus doing dance that is African. Crichlow and I used to bitch about her and I would say, "Shit, this girl ain't nothing." There isn't any creation from her. It's a copy—a bad copy—of African dancing. Recently a writer in the *New York Times* reviewed her performance based on an African wedding. It was a disaster. It almost looks like burlesque.

You look at a piece of African art and you don't have to say anything. You just look at it for its beauty.

Perhaps I was sort of needling you.

I told you what I felt about you, if you were listening. You wouldn't ask me those questions if you were thinking. You're teaching at a university and you're letting a bunch of fucking shitheads maneuver you by telling you that you're not black enough. What the fuck are they talking about? Do they know what it is to be black? Do they know what it is to be exploited, if they're white?

Let's talk about people like Ed Spriggs, not because he has manipulated me, because he didn't do anything to or with me, but people like him and the kind of influence he has over hundreds of people and artists. That's what I'm talking about. Like the Studio Museum.

Why do you support these things?

I don't think I do. Because if I did, I wouldn't mention his name.

I don't think you should wait until things get to such extremes, whether you use his name or not. I've used people's names today, and I just only hope that you guys have that kind of discrimination and understanding to understand the context in which I use those names. I spoke about Benny, and when I talk about him as an artist, I said he's not a good gambler because he doesn't perform well. They are not only taking themselves down, but they are taking me down with them. When I see them I say, "Don't laugh in my fucking face." Like Andrews was up at the show at the Whitney Museum and comes over to me. I said, "What's the matter? Can't you find somebody interesting over there to exploit?" Jayne Cortez and Mel Edwards were standing right there. Shit, I don't bite my fucking tongue. Andrews said, "Oh, Norman. . . ."

You can't let all these people upset you into being maneuvered into a position. One thing the university should give you is a great deal of courage and well-being, because you're in a good position. See, the difference between you and me is that I expect somebody to kick me in the ass, and you don't.

The definition of black art maintained itself as long as the grant money did. When the grant money stopped, we didn't have to worry about it any more. I found that to be very destructive in the sense that people had to posture and be blacker than this and blacker than that. Mainly to posture for a National Endowment grant. However, Mel Edwards got it all.

So what. Don't think about it. Just come out of it bigger for not being considered for a grant. This is what I have tried to do all my goddamned life. You lose nothing.

Elsa Honig Fine has written a book. She is saying certain things about black artists and that there are certain theories. There are all these black artists in a separate grouping and that their aesthetic is particular.

Is she white?

Sure she's white.

It's like the book published by Cedric Dover. I wish that had been a black guy who had done it. Unfortunately, those who are historians don't do it because there is not enough immediate money. Why is it some fucking English writer, across the ocean, can conceive of putting something like this together and the book company grabs it, which some black cat could have done here? And he did it so indiscriminately that he included everybody who ever lifted up a fucking pencil as an artist.

There will come a time when ethnic groups will find some scholarliness and certain ventures where you bring as much to yourself as being an artist by the work that you do. Like Alain Locke had that kind of scholarliness. But there's no money here. Locke laid the groundwork for some Blacks to go into this field. Now, all of a sudden everybody is writing on black artists. But I don't think that everybody is capable of writing.

First of all, in the visual arts there are people now who are involved with art history and they had to fight in the universities to get their doctorates in art history on a black subject. One person I know is doing a biography on William H. Johnson and another person, Regina Perry, is doing a book on Afro-American art and artists. Samella Lewis is doing a book. The thing about it is if you get an artist to do something like that in two minutes, it's flaky. You get an art historian to do it and he or she does a scholarly job. It takes time, and in between you get Elsa Honig Fine, who in a year and a half puts a book together, and it's out on the market right away.

If a black person put out a book like this he'd probably be trying to paint too.

Exactly.

For instance, I don't think Jeff Donaldson, despite all of his charm, has enough experience to be in a position to evaluate art.

There was a guy who showed at the Willard Gallery. This guy studied at Princeton and then became a professor. The son of a bitch had to go through all of the channels of being an artist. He tried to get an exhibition for the experience, so he would know what the hell he was doing. This took about ten years. Fifteen years later this guy is working on this book and it gets approved. It's taken him many years. Now, Jeff Donaldson doesn't have this kind of experience. There's another son of a bitch, a guy in Pittsburgh, Brooks Dendy. We were at someone's home and we were talking and this guy irritated me. I tried to be polite and asked him why did he submit to certain indignities. He tried to make some valid reason for it. Yet I find he acknowledges this by including his whole family in what-the-hell he's doing. His cousin did this, his wife did that. This was with the exhibition. It was like a picnic. The exhibition was like a three-ring circus.[3] He comes along at a time when you want to support him because he is doing

a show in Pittsburgh on black art. Then he starts up at the top gallery and by the time he's finished he's in the basement. That's where he belongs.

Why the basement?

Because he's bringing in so many issues and so many compromises.

He had poetry; he had dance, music. He's sort of a multimedia theatre person. What happened at the Pittsburgh show was that Charlie White said, "How is it our finest painters are in the basement?" That was as far as Dendy could get them. Maybe Pittsburgh is totally ignorant of our finest artists.

He should have asked for the ground floor, not the basement, goddammit. They couldn't have done that if he had fought them tooth and nail.

This is all about how we are treated, and looked at, and what we settle for. Now, Brooks Dendy, in that particular situation, created a circus.

These fucking nobodies like a Dendy pop up like a fucking weed, and there are so many of them. I think they should be cut down before they grow, but you want to help everybody. But this thing of just helping somebody because he's a brother is stupid. This is the same guy who is taking a knife and ripping me up from top to bottom. I've got to be careful, and I've got to find out if this guy brings enough experience to what he's doing, so you are not taken in by things. Your first impulse is to believe in it. But hell, there's Benny who has done many things. He got that prison thing going. I wonder how many prisoners have gotten shows from the money he's gotten to give them shows? This would be interesting if somebody wanted to investigate to see how many prisoner/artists benefited.

Do you think that your political actions should be removed from the visual activity?

I don't see how any politically involved pictures help any black situation.

What are your goals now?

To continue working without interruption. To continue to have insight.

To continue to grow,

I could grow and not have insight.

In the last year you have reentered a field that you had been very prominent in, which is graphics.

Possibly the reason for this was for a moment I made tremendously large canvases. I truthfully don't know anyone other than a museum who would buy and house these paintings. Physically I always felt very good when I felt superior to the canvas in height.

That's my ego. I now plan to paint pictures that I can house and that people can own. They are like your children whom you want to go out in the world.

I went back to graphics because some things are small enough for people to own. There are more people who could comfortably afford to buy and house a print.

The main reason was that I could make many things of one thing and they are accessible. However, since I've been doing the damn things all I've wound up doing is giving them away.

NOTES

1 [The show Lewis attended may have been *Paintings, Drawings, Etchings*, Browne's 1974 exhibition at Artist House, New York. Browne also had work in *Blacks: USA: 1973* at the New York Cultural Center (see p. 457), and shortly after she interviewed Lewis, she would participate in *Synthesis*, Just Above Midtown's inaugural exhibition (November 19–December 23, 1974). See p. 483 in the present volume. —Eds.]

2 ["Camille" is presumably the artist Camille Billops (1933–2019), with whom Lewis was close. —Eds.]

3 [The exhibition was *U.S.A.... ?... 1971–72*, Carnegie Institute (now Carnegie Museum of Art), Pittsburgh, PA, November 4, 1971–May 4, 1972. J. Brooks Dendy, the exhibition's curator, worked in the Carnegie's Division of Education. —Eds.]

1974

Linda G. Bryant, "Introduction," in *David Hammons: Selected Works, 1968–1974,* catalogue for exhibition held at the Fine Arts Gallery, California State University, Long Beach, September 29–October 17, 1974

David Hammons's first institutional exhibition was organized by Josine Ianco-Starrels, curator of the art gallery at California State University, Long Beach—the site of Ianco-Starrels's important show of Betye Saar's work the previous year (see pp. 452, 454). Having begun her career at the Lytton Center of the Visual Arts in Los Angeles, where she had presented *25 California Women of Art* (which also included Saar) in 1968, Ianco-Starrels was tireless in her support of African American and feminist art practices. The exhibition at CSU documented a crucial period of Hammons's output, corresponding with the decade he spent in Los Angeles (he would move to New York in 1974). Linda Goode Bryant, who at the time was the director of education at the Studio Museum in Harlem, noted Hammons's "extreme concern for the development of a personal aesthetic." A month after the exhibition closed, Bryant opened Just Above Midtown (JAM) in New York and included Hammons in the gallery's first exhibition, *Synthesis: A Combination of Parts or Elements into a Complex Whole.*

LINDA G. BRYANT, "INTRODUCTION"

As we walk through constructions of rope, bricks and feather, masturbations or bullet shot arms, imprisoned by closed gallery doors, it becomes apparent that we have reached a period in our aesthetic peregrinations where a major endorsement has been given to the elevation of ideas as the primary concern. Presented in its purest form, the idea or concept becomes the medium, separated from other traditional artistic forms of expression.

Whereas this elevation of idea is in natural rhythm with its aesthetic predecessors, in its new position it may find itself enmeshed in theoretical priorities, muddled in a scramble for recognizable landmarks.

Perhaps due to its new position and the lack, as yet, of established criteria, the artists, the critics and their audiences are engaged in endless dialogue to substantiate or legitimize this new incarnation of art.

This situation is further complicated by conditions that are open to gimmickry for the sake of innovation and the market place's constant demand for "novelty."

These attitudes have often resulted in a type of aesthetic castration seen in works that are neither philosophically, spiritually or visually communicative.

David Hammons is an exception on this scene. He is an artist whose works demonstrate a freedom in the exposure of idea that is not compromised for the sake of novelty or any other consideration. The work shows a dedication to creation based on an extreme concern for the development of a personal aesthetic. Using his body as a plate, he produces graphic statements of great strength that leave the viewer both intellectually and emotionally energized. Working from the negative (the placement of oiled body to surface) to the positive (exposure of surface to powdered pigment), Hammons uses the results of this process to relate structure to idea. The latter, common to artists through the ages, is now done in a strikingly contemporary version, literally and figuratively personalized.

His ability to control enables the artist to use images of individual body parts, their textures and shapes and to incorporate them into a totally new entity, flawless in connection and coherent in perception. The works emerge full of power, evoking a dramatic response in the viewer. It is a clear, convincing, persuasive statement which subtly but without equivocation communicates the idea to the onlooker.

Hammons has not allowed himself to become restricted or stagnant in his search for creative expansion; in his subsequent work he has taken the pure "body print" and geometrically incorporated it into symbolic shapes varied by use of paint and collage. A series resulted, based on the SPADE; using an actual shovel, he added other materials like chains, producing a sculptural word-play that is also a philosophical and political statement about man—the Black man—in relationship to this society.

Though Hammons creates what in today's aesthetic language is termed "tangible products" or "objects," he has remained totally involved with the exploration of ideas and concepts. With materials like sand, he created sand carvings based on the Spade symbol, that lived briefly and dissolved, etched only in the viewer's memory, witnesses to an ephemeral moment.

The art of David Hammons embodies a visual energy emerging from the artist, flowing toward the audience. He is bold, yet shows a concern for aesthetics, an art based on personal innovation which everyone can experience.

1974

Martin Kilson, "A Debate: The Black Aesthetic— Opponent," and Addison Gayle, "A Debate: The Black Aesthetic—Defender," *Black World* 24, no. 2 (December 1974)

The December 1974 issue of *Black World* featured this heated confrontation between two prominent African American scholars with completely opposite views about what the Black Arts Movement signified. Through their individual essays, Martin Kilson, a political science professor at Harvard University, and Addison Gayle Jr., a literary critic and professor of English at Baruch College, effectively summarized the two sides of the Black art debate. A vehement critic of Black separatism, Kilson believed that pairing art with political ideology impeded the creation of a "true aesthetic form"—one that could serve all communities through its "universal quality of humanity." In opposition, Gayle believed that Black art should be judged by how successfully it could serve African Americans in particular. For him, the existence of a discrete Black culture was essential, especially in the wake of what he considered the overly moderate actions taken by the civil rights movement. Along with a close group of peers that included Amiri Baraka, Hoyt Fuller, and Larry Neal, Gayle advocated for art that would create positive change in all areas of Black life. Gayle was a regular contributor to *Black World* and received editorial support from Fuller, the journal's editor, for the essay published here. Two years after the article appeared, *Black World* permanently folded, signaling the increasingly niche appeal of a publication that had been a beacon of the Black Arts Movement.

MARTIN KILSON, "A DEBATE: THE BLACK AESTHETIC—OPPONENT"

Over the past decade of the Black separatist movement, it is fashionable for the spokesmen of the creative arts to pronounce the existence of a "Black aesthetic" which, they think, maximizes man's peaceful character. On the other hand, the "white aesthetic" is, they tell us, obsessed with man's destructive and power-creating proclivities. Thus the spokesmen for a "Black aesthetic" believe that it is more conducive to the humanization of power and authority, while the "white aesthetic" dehumanizes.

Moreover, the spokesmen for a "Black aesthetic" argue that the dehumanizing character of the "white aesthetic" dictates its critical canons; these canons are formalistic and therefore are humanistically arid, emphasizing artistic creation as a thing-in-itself. As a major spokesmen of the new "Black aesthetic," Addison Gayle has put it that the "white aesthetic" endeavors to "evaluate the work of art in terms of *its* beauty and not in terms of the transformation from ugliness to beauty that the work of art demands from its audience." The "Black aesthetic" on the other hand, differs fundamentally in its critical canons: "The question for the Black [artist]," says Addison Gayle, "is not how beautiful is a melody, a play, a poem, or a novel, but how much more beautiful has the poem, melody, play, or novel made the life of a single Black man?"

This outlook is based on the assumption that no meaningful aesthetic exists outside of human or political needs, and thus the claim for a "Black aesthetic" is valueless without linkage to the daily needs of Negroes. Thus Addison Gayle remarks that "The Black Aesthetic . . . is a corrective—a means of helping "Black people out of the polluted mainstream of Americanism. . . ." Indeed, the ultimate purpose of artistic creation within the framework of a "Black aesthetic" is to "de-Americanize" the Negro. Or, as Addison Gayle puts it, "the problem of de-Americanization of Black people lies at the heart of the Black Aesthetic."

Now Addison Gayle's view of the "Black aesthetic" as a creative act is excessively political. Nowhere does he and other theorists of this viewpoint actually specify the elements of form, style, and sensibility that are customarily associated with an aesthetic mode. Their conception of the "Black aesthetic" is, then, devoid of those awesome concerns with human-cultural introspection which have been at the center of man's aesthetic quest for thousands of years. Instead, the new "Black aesthetic" is curiously outward-looking: that is to say, it derives ultimate meaning and purpose from action rather than from contemplation. This is, I think, a pity, because neither great art nor an enduring aesthetic is available for any people merely through action or politics.

In my view, therefore, the new "Black aesthetic" movement is not really that new at all: its antecedents are found in the militant ideological movements of the 20th century that seek a moral or ethical rationale through the politicization of the creative arts and processes. History, Karl Marx has said, repeats itself only twice—first as tragedy, second as farce. I need hardly mention therefore the fate of aesthetics and the creative arts under the Communist and Fascist movements of this century and in other kinds of political and nationalist movements as well.

In my view, it is unfortunate that Addison Gayle, Larry Neal, Imamu Baraka, Hoyt Fuller, and other spokesmen for the "Black aesthetic" have learned nothing from history. They would have us believe that the "Black aesthetic" can solve the problems of power that Blacks confront. Or, as Gayle puts it, the "Black aesthetic" can be "a means of helping Black people out of the polluted mainstream of Americanism. . . ." In Addison Gayle's view, what is particularly bad about "Americanism" is the special status given to power in our society. Thus, for the theorist of the "Black aesthetic," power in America is "opposed to humankind, against the dignity of the individual . . . : to be an American is to lose one's humanity. What else is one to make of My Lai, Vietnam? A Black soldier has been charged with joining his white compatriots in the murder of innocent Vietnamese women and children. How far has the Americanization of Black men progressed when a southern Black man stands beside white men and shoots down, not the enemies of his people, but the niggers of American construction?"

At bottom, what the theorists of the "Black aesthetic" are claiming is that the elements of degradation or dehumanization imposed upon Negroes are inseparable from American society, and indeed all white societies. Now I would grant that the vicious oppression of Negroes during the past several centuries of white supremacy accounts for much of the dehumanizing features in Negro life. But what these theorists fail to grasp is that dehumanization was neither invented by whites nor will it end with them. The deeply perverse capacity of men to dehumanize their relationships with each other is vast, extending beyond the boundaries of race, tribe, religion, and ethnicity. The tendency for groups like Negroes and Jews, victims of excessively cruel amounts of dehumanization, to project themselves as somehow intrinsically incapable of dehumanizing behavior, is understandable. But, alas, this approach lacks validity; the claim by groups like Negroes and Jews that the victim has higher morality on his side is problematic. Often the victim is merely weaker, not morally superior.

Thus, the circumstances that stimulate inhumanity in men can work their will on Blacks and Jews as on any other group. Indeed, the painful ironic fact about the position of Negroes in this matter is that the major dehumanizing act that placed Blacks in their historic plight in Western society—namely, the Atlantic Slave trade—was not without assistance from Black societies themselves. The bitter truth is, and it must be faced gravely by all Blacks, that ruling *strata* in African societies willfully participated in the Atlantic Slave trade during the 16th–19th centuries. In exchange for their services these African chiefs received the opportunity for greater power within African societies and a variety of material rewards from Western civilization, including some which were as frivolous as beads for adornment. Without such willful participation of Africans in the slave trade, the brutal centuries that Negroes have experiences in the Black Diaspora would have been impossible.

Thus it is evident that the new "Black aesthetic" rests on dubious historical grounds. It rests, also, on questionable moral and ethical deductions about the racial dimensions of the human situation.

Race as such endows no group of men with humanistically superior capability. What is more, the theorists of "Black aesthetic" are mistaken in their belief that aesthetics derive from power processes. Such a belief produces not aesthetics *but ideology*. And the distinction between aesthetics and ideology is profound. *An aesthetic civilizes; but an ideology rationalizes*. Or as Professor Dickie has put it, aesthetic awareness is "disinterested attention."[1]

In other words, a true aesthetic—adequately revealing of the complexity of human behavior and circumstances—is not and cannot be the same thing as an ideology. The purpose of an ideology is to function as an excuse, or a fabricated explanation of those actions by men who have ulterior motives. All efforts to impose modern ideology upon the creative arts and the creative process have produced nothing but a Frankensteinian travesty of the creative arts. This is as true for the efforts of the modern Communist and Fascist Movements to make the creative arts subservient to an Ideology, as it is of the current Black Nationalist movement to make the creative process subservient to the new Black ideologies. As a result, there is little doubt in my mind that what Addison Gayle and others call the new Black Arts is in reality a travesty of the true creative artistic capacity of Afro-Americans.

Those who today shout from the rooftops that there can be no aesthetically viable and meaningful Black art except through an explicitly Black ideology are, I think, sadly mistaken. They refuse to face the fact that 150 years before they were born, the American Negro slave fashioned one of the most enduring forms of Black arts and of the Black aesthetic—namely, The Negro Spirituals. They refuse to face the fact that in the 19th century, the American Negro innovated another enduring example of a true Black aesthetic—namely, Jazz. American Negro Jazz, as a form of the Black aesthetic, is a powerful expression of the human spirit's capacity for making a universal statement about the nature of the human condition. Men throughout the world—whether in India, Egypt, Communist China, the Soviet Union, or in white racist America—all recognize and admit the truly aesthetic quality of Negro Jazz. In other words, through Negro Jazz men of

profoundly diverse cultural, historical, religious, and racial backgrounds can discover something of themselves, something of their own fate on earth, something of their own persistent strivings to make life a more humanistically meaningful experience.

Now it is precisely on this issue that I myself oppose the Black Nationalist spokesmen of the new Black Arts and the new so-called "Black aesthetic." This new Black Arts is nothing more than an ideology; it is an effort to subordinate the deeply profound and penetrating creative processes of Black people to an ideological movement. Addison Gayle and Amiri Baraka want to politicize the creative energies of Black peoples in a manner that would exclude the possibility of white people ever being able to discover some profoundly meaningful facet of their own white selves through an appreciation of the Black aesthetic.

I repeat, in conclusion, that this approach to the Black aesthetic is simply an ideological and political exercise. It has nothing whatever to do with the creation of a true aesthetic form. Of course, it is understandable that after a century of white racism in American life, some Blacks would become so frustrated and embittered that they would attempt to separate Black creative processes from those of white folks. But, yet, it is necessary for those of us who truly believe in man's universal aesthetic capacities to respond to our Black separatist brothers by reaffirming the universal quality of humanity. When I was at Lincoln University 25 years ago, we were taught this by seminal intellectuals and scholars like my dear friend and mentor, Dr. Horace Mann Bond, Dean Joseph Newton Hill, H. Alfred Farrell, the actor Roscoe Lee Browne who have demonstrated that Black folk can produce creative arts whose aesthetic powers have profound meaning not merely to Black people, but also to whites and all other peoples. It is, therefore, in this sense that I am a critic of the new so-called "Black aesthetic." It is in this sense that I hope the young budding intellectuals and artists now in Lincoln's Melvin Tolson Society will keep their humanistic perspective intact as they interact with the new so-called "Black aesthetic" movement. They must help to restore to this movement a more humanistically valid concept of aesthetic creativity.

ADDISON GAYLE, "A DEBATE: THE BLACK AESTHETIC—DEFENDER"

Hoyt Fuller, who has withstood a fair number of attacks in his day, might have warned me that my policy of not responding to my critics would embolden some and spur others on to more, intensified attacks. Steve Cannon, who never fails to respond to his critics, once wondered aloud how I would allow tripe written by William Styron to go unanswered. Throughout the years, others have advised me that a vigorous defense is oftimes the best offense. The advice notwithstanding, however, I have refused to answer criticism directed against me, first, because I have been reluctant to deal with trivia—and the criticism of most of my adversaries has been just that trivia—and, second, because there is so much work to be done and so little time in which to do it, that to respond to each nonsensical critique would leave little time for much else. Again, I have always believed that people who read my books have a damn good right to criticize them, and that I, the author, have let myself in for it by subjecting my ideas to the marketplace.

This essay does not change any of that! I am, by nature, a peaceful man, a non-combatant, and I hope this is the last time that I will be forced to devote time and energy to answering nonsense, to coping with a very serious disease now infecting some segments of the Black community—a disease, I call Fridayism—which must be defined, analyzed, and rendered impotent, in order that others may continue the very important work, to quote Amiri Baraka, of creating a Black poem and a Black world. Martin Kilson is not half so important as the disease, but he is symptomatic of it, and his recent address, "What Is A Black Aesthetic?," illustrates the debilitating effect that the disease can have on the Black psyche, leading to the infected to inveigh, hysterically, against the concept of the Black Aesthetic in general and its advocates in particular.

Were Kilson the only antagonist of the New Black Arts, there would be no need for rebuttal. After all, his constant attacks on any black endeavor not meeting the approval of white Americans, and his continual fantasy in which he envisions himself

as a Black intellectual (?) ambassador to the white world or, more precisely, Black missionary to liberal whites, the sterling example of sanity and reason among Black insanity and unreason, in addition to his unimaginative, uncreative, unanalytical thinking, does not exactly qualify him as an opponent worthy of breaking a date with a pretty girl in order to do battle with. Moreover, in reading his statement in the *Harvard Advocate* (Spring 1974) ("It is then the absence of a *discrete culture* among American Negroes that ultimately bedevils the new 'black art.' This art, as it were, lacks authenticity. That is, 'black art' is not valid *in itself.* Validity depends upon an *explicitly antithesis* white America"), it is clear that the Black man in 1974, who believes that neither he nor his product has validity or sanction without the approval of white people, is already so far gone that nothing I can say will help him.

The real issue, therefore, is much larger than Kilson. He and others have become dangerous, not because of what they say, but because they address Black audiences, who, often unable to hear the side of sanity and reason, are left no options but to accept flimsy premises leading to erroneous conclusions. Because no Black person should be left with nothing but the ideas of Kilson to enlighten him, this essay, though seemingly a response to charges made by Kilson is, in effect, a response to the arguments of others, who, incapable of dealing intellectually with the concept of the Black Aesthetic, attempt to do so through appeals to emotion and superficial arguments couched in the abstruse abstract jargon of the academics.

First: a definition of terms. The term, Fridayism, my own, is derived from Daniel Defoe's novel, *Robinson Crusoe.* Near the end of the novel, the Black Friday, having been civilized by Crusoe, joins the Englishman in repulsing an attack by other Blacks, lays his life on the line, so to speak, in order to protect, not only Crusoe, but his own newly won "civilized" status. Now one may rationalize Friday's actions by arguing that he had become, in effect, a slave of Crusoe, that he was a first generation Black man, thrust suddenly into contact with Western culture and technology, that his response, whether out of fear or gratitude, was to be expected. To explain similar actions by the sons of Friday, however, after centuries of immersion in the West, is a different matter. They, after all, have lived among the descendants of Crusoe, have witnessed their acts of inhumanity against man, whatever the color or religion, have witnessed their pragmatic attempt to destroy the human spirit. What then accounts for continual defense of Crusoe and his, for obeisance to his wishes, even though he no longer constitutes a physical threat?

There are, one supposes, many explanations, but one that explains a great deal is what I have called Fridayism—a rationale based upon the Pavlovian theory of behavior. In the Pavlovian experiment animals were conditioned to salivate at the ringing of a bell; food was the stimulus. In time, the food was removed, but the animals continued to salivate in its absence. Like Pavlov's model, the sons of Friday no longer need the stimulus—fear or gratitude—to propel them into action to protect the interests of Crusoe and his. Once Crusoe and his brood are attacked, from whatever source, the Fridays salivate in college journals, *The New York Times Book Review*, badly written books on Black authors, and public forums. They have concluded recently that the greatest threat to Crusoe comes from the Black Nationalists, and *sans* food, they have rushed to his defense. Their line of defense is varied and concerted, including not only the Black cultural movement, but the political and social movements as well, and their objective, though seldom stated, is to return Black people to the romantic, myopic era of the "We shall overcome" years and "integration now": in short, they seek to protect the Crusoes of the world by depicting Black Nationalists as insane, irrational extremists, representative of only a minority within the race, who have, despite centuries of rebuff, not forsaken the goal of assimilation. Their defense in the cultural area centers specifically upon the Black Aesthetic movement, and in each of their critiques, Imamu Baraka, Hoyt Fuller, Don L. Lee, and Addison Gayle are singled out for special opprobrium. Their charges range anywhere from the statement that Black Aestheticians are anti-Semitic—a non-literary evaluative term—to the argument that they are hopeless romantics. Neither

of these statements, whether true or no, explains anything, therefore, in response—and using Kilson's address as a model—to insure that clarity and cogency prevail, I have had to place the charges into a framework which would allow for intellectual, rational discussion.

Foremost among the charges is that Black Aestheticians "shoot from the hip," do not do their homework, make *a priori* assumptions—in one word, they are un-scholarly. Now scholarly, depending on who defines the terms, can mean one of two things: a search for truth, or validation of a truth already discovered. Carolyn Fowler Gerald's essay "The Black Writer and His Role," which begins with a set of well thought out assumptions and moves intellectually to a valid conclusion, is illustrative of the first. Stanley Macebuh's book *James Baldwin* is illustrative of the second: "If one may go by Theodore Gross's observation on the matter," writes Macebuh (another antagonist of the Black Aesthetic), "there is hardly an American critic or teacher of literature who has not had to contend with the web of issues posed for criticism by Black Literature in this country. . . ." What is important is not that the observation is erroneous, but that Macebuh has accepted the conclusion of a critic whose scholarly credentials are as dubious as his own. Thus, to be scholarly in the first instance means to sift through information, to accept nothing is given, to arrive at truth through one's own understanding and reason. In the second instance, to be scholarly means to accumulate the proper number of footnotes, quotes, addendums, and a bibliography which no 10 men, let alone the author, could possibly read in a lifetime. Moreover, it means to accept as gospel, without question, the authority of white critics, whose own *a priori* reasoning has led to questionable truths. Such material is to be found in college journals, complete with style sheets which demonstrate the art of footnoting, spacing accurately, and paragraphing precisely. Missing, of course, is insistence upon creativity, upon using one's imagination, upon understanding, upon striving for clarity: academic jargon is the rule, abstract thinking a must, and total confusion a necessity. Needless to say, few Black Aestheticians would care to be "scholarly" in this fashion.

The essence of scholarship should be hard work, the kind of work which involves not only the search for truth, but the testing of these truths in the public arena, through experimental trial and error. No writers in America meet this criterium better than Askia Touré, Hoyt Fuller, Imamu Baraka or Don L. Lee. Their written works are testament to the depth of their reading and comprehension, and exhibit a knowledge of the history and politics of the world, that few writers in America possess. They are not, however, content to quote white authorities, to accept the dubious theorems of dubious critics, or to allow their new found truths to gather dust on bookstore shelves. Askia Touré has long been engaged in the Black Community; Hoyt Fuller is not only the guiding light behind the new Black Renaissance, but a force in OBAC, Chicago's outstanding cultural organization, as well as an active participant in planning for the forthcoming African Festival. The works of Baraka in Newark and throughout the Black communities of the world are well known, and Don Lee has established a publishing company and an institution for the education of Black children.

The argument that Black Aestheticians are unscholarly, however, is secondary to that which states that what these critics call an aesthetic is nothing more than a political, social movement, anti-white and anti-universal, completely parochial in design and practice. Their "outlook is based on the assumption," writes Kilson, "that no meaningful aesthetic exists outside of human or political needs, and thus the claim for a 'Black aesthetic' is valueless without linkage to the daily needs of Negroes. . . . Now Addison Gayle's view of the 'Black aesthetic' as a creative act is excessively political."

The relationship between art and politics was enunciated long before Addison Gayle and the Black Aestheticians were born. In *The Republic*, Plato spoke at length concerning the threat posed by the artist to the utopian republic, believing that he could persuade men away from the ideology of the state. The art of the Bible is the art of persuasion, and the most lyrical passages are designed to move men in one direction as opposed to another. The conflict in Cervantes' *Don Quixote*, the first

novel written in the Western world, is between illusion and reality, and Cervantes, opting in the final analysis for illusion, uses art to suggest to this audience that pragmatism, in a world ruled by men, is a necessity. The job of the novelist, to paraphrase the English writer Henry Fielding, is to instruct and to entertain, and the instructions offered by Fielding and his contemporaries were designed to make the English middle class aware of its strength and power. Nathaniel Appleton, Noah Webster, and John Trumbull, among the earliest of American writers, saw no dichotomy between art and politics, each agreeing with the dramatist John Nelson Baker that America needed an art "to celebrate American events." The Black novelist, from William Wells Brown to Richard Wright, was engaged in the hopeless task of convincing the American public that Black men were not, as earlier writers had defined them, three-fifths of men, but human beings. Those, however, who have been most antagonistic towards art as politics—outside of Black opponents of the Black Aesthetic, who know little of literary history—were the writers who spearheaded "The New Critical" movement of the 1920's.

Like Kilson and others, they argued that art should be autotelic, self-enclosed, harboring no political or social message. The aesthetical qualities of a poem, novel, or play inhered in its form and style, principally, in the technique by which the artist, through dexterity of language and manipulation of lines, made us conceive the beautiful. Yet, these were the same men, who, earlier, thought of themselves as "The Southern Agrarians," and the political framework within which they operated is outlined in the book I'll Take My Stand—a racist, fascist document bearing great similarities to Mein Kampf. Their political program for America involved reincarnation, a return to antiquity, wherein, America might be reborn in the image of Greece and Rome. Here, they argued, was art at its best, simple, beautiful, exhibiting an aesthetic unspoiled by industrialization, technology, northerners and Black people. They sought a world of no conflict, struggle, or challenge, and they offered this prescription for an aesthetic—"art," as one of them declared, "should not mean, but be."

Such an aesthetic, which conforms to Kilson's description of "disinterested attention," is one Black Aestheticians will have no part of. Despite the African influence upon Greece and Rome, the world of peace and tranquility, which supposedly existed in the Greek city-states, close to the Aegean, is not our world. Unlike Kilson, we cannot echo the sentiments of Angelina Grimké, "Let us forget the past unrest— We ask for peace," for we know that peace is antithetical to the human condition, that so long as men be oppressed by other men, so long as men be exploited by other men, so long as hunger, poverty, and fear exists in the world, so long will peace remain an illusion, in which only white Don Quixotes and Black Sancho Panzas have the luxury to indulge.

For it is in one's perception of the world that leads to an aesthetic concerned only with form, structure, and technique, with being, not meaning, as opposed to one concerned with man's spiritual, political, and social needs. Kilson sees a world different from the one I see. In true scholarly fashion, he quotes me out of context: "To be an American is to be opposed to humankind, against the dignity of the individual . . . to be an American is to lose one's humanity." The America that I see, as the quote implies, is markedly different from that of my opponents; it is not the world of the integrationists, one in which a small band of élite Blacks achieve status by serving as mediators between the Black and white communities, not the America envisioned in the rhetoric of moving quickly to correct ancient injustices—no the America of freedom and democracy, of egalitarianism, where man is regarded with love and tenderness. The America I see is one in which Black people—whether they acknowledge it or no—are daily confronted with indescribable acts of inhumanity by other men, whose claims to superiority rest upon the ephemeral grounds of color, an America where men who dare to be different are stunted in their growth, never allowed to achieve full manhood, without undergoing the most terrible of struggles, an America whose sense of morality, justice, and decency is secondary even to that of the jungle cat, an America, whose most appropriate metaphor is not the statue of Liberty but Attica prison in New York.

Given such a world, how does one confront it? Integrationists, who admit part of this truth—even Kilson, speaks of "white racist America"—caution patience and advocate appeals to conscience. The millennium, they tell us, though 300 years overdue, is just around the corner, and we must, therefore continue to prove to the Americans, that we are worthy of freedom, never let them believe that we are so ungrateful for their coming generosity that we could conceive of a culture, life-style, or world view different from theirs: "Addison Gayle and LeRoi Jones [Kilson is unable to believe that Imamu would discard his American name for an African one][2] want to politicize the creative energies of the Black people in a manner that excludes the possibility of white people from ever being able to discover some profoundly meaningful facet of their own white selves through an appreciation of the Black aesthetic."

To wage a campaign along Kilson's lines, one designed to convince white people of our commonality, would, of course, constitute the very political and social aesthetic that, otherwise, he opposes. Thus, the Black writer believes that, through art, Black people might discover profound meaningful facts about *their* history and culture, is concerned not with art, but with politics, not with mankind, but with race. To be viable and noteworthy, in this infantile attempt at constructive reasoning, an aesthetic must be conceived by whites, legitimized by whites, or directed at whites. Here, Kilson and his supporters are at one with the New Critics.

In his charge, however, that Blacks are no more humane than whites, Kilson has left not only most of his supporters behind, but also the most racist historian. "The bitter truth is," he writes, "and it must be faced gravely by all blacks, that ruling *strata* in African societies willfully participated in the Atlantic slave trade during the 16th–19th centuries. . . . Without such willful participation of Africans in the slave trade, the brutal centuries that Negroes have experienced in the Black Diaspora would have been impossible." Racist historians have, at least, assigned mutual culpability, argued responsibility between the African chieftains who sold Blacks into slavery and the white invaders and

colonialists who bought some, stole others, and captured still more. Kilson, however, in an attempt to negate Black Nationalist charges of American immorality and inhumanity, is willing to rewrite history, to argue that slavery resulted from Black greed and treachery, that were there no status-seeking Africans, Americans would have turned elsewhere for the brawn and muscle to build their cities and to harvest their cotton crops. Kilson and his supporters know more about the practice of selling out Black people than I do, yet, even if one indulges in this fictional account of history, how does this negate the contention that the last place in which one would search for decency and morality is among white Americans. Using Kilson's argument, it may be possible to contend that the slavery that existed among the Greeks and early Christians was due to the collusion of African chieftains, yet the philosophers of Greece and the Christian religion, while acknowledging the existence of slavery in their orders, point out ennobling aspects of Grecian and Christian antiquity, never allow the world to forget that alongside slavery and brutality were concepts, practices, and theorems which, they claim, ennobled and dignified man. Kilson is unable to see such qualities in the ancient Africans, indeed, is blinded by their culpability in the slave trade, will not recognize that alongside those Africans who sold Blacks were those who did not, were those who constructed and developed humane societies, where each individual was regarded with decency and respect.

The need to prove white American innocence is *all* pervasive in Kilson's truncated theology; yet, if one accepts his contention of white American innocence in the slave trade, how does one continue to champion such innocence in light of the acts of inhumanity practiced on the plantations and in the cities in an America far from the African chieftains, the indiscriminate murder and maiming of Black people, the purposive attempt to transform men, women and children into chattel? How does one make the case for American innocence, today, when white racism destroys hope and faith, forces people onto drugs, keeps them inured in the welfare of poverty? How, again, does one explain away

the atomic bombing of the Japanese, the centuries of lynching and castration of Blacks, the massacre at Attica prison, the napalm bombing of the Vietnamese, American support of regimes of terror and oppression like those in Rhodesia and South Africa? Kilson's rationale is the classic one: Blacks have not done these things because we have lacked the power: "Often, the victim is merely weaker, not morally superior."

Now the *intelligent* writer can never accept the argument that human nature, but for the pragmatic considerations of strength and weakness, is everywhere the same. To do so means to champion universal evil, to contend that people are incapable of change, and thus to espouse the ephemeral theory of art for art's sake. Kilson's conjectures concerning what the racial situation in America might be were the tables reversed for Blacks and whites demonstrates his ignorance regarding Black history and literature. Nowhere does the literature and history of Black people support the claim that murder and oppression are endemic to the Black character. Quite the contrary, our history and literature speak of man's belief and faith in man, of each person's commitment to the elevation of the human spirit, of love and fidelity to family and principle, of the belief that the New Jihad is possible even in the face of armageddon.

To argue the contrary implies that centuries of brutality suffered at the hands of Americans, not African chieftains, was due to our weakness, our impotence, and yes, to our cowardice. I do not believe this! Those many thousand gone are testament to the courage and dignity of people who believed that through their struggles—oft-times their martyrdom—they could change the institutions and people of America. I am convinced they were misguided, that nothing short of a holocaust can change white America; yet the morality evidenced in the lives and actions of Blacks from Harriet Tubman to Martin Luther King should be ample refutation to the arguments of those so desperate to enclothe themselves in the American flag that they are willing to accept American hypocrisy, oppression, and evil as their own. I have no quarrel with them. I believe still that Frederick Douglass'

admonition in 1852 needs little emendation in 1974: "There is not a nation on the earth guilty of practices more shocking and bloody than are the people of the United States, at this very hour." (African Chieftains were not included in this statement.)

Of the charges leveled against the proponents of the Black Aesthetic, none receive such universal support as that which states that "these Black writers want to tell other writers how to write," want to dictate the form and content of the works of creative artists, and thereby relegate art to ideology: writes Kilson, "Now it is precisely on this issue that I myself oppose the Black Nationalist spokesmen of the new Black Arts and the new so-called 'Black aesthetic.' This new Black Arts is nothing more than an ideology; it is an effort to subordinate the deeply profound and penetrating creative processes of Black people to an ideological movement."

Now those who contend that ideology and politics are antithetical to art know little of art, have read few novels and poems, and comprehend nothing of the little they have read. No matter the age in which they live, writers live in societies, non autotelic, where ideology and politics enhance their perceptions, help to formulate their world view. That man is a political animal is a belief shared with Aristotle by writers throughout the world, and the most intelligent of them know that it was not due to the non-ideological components of their works that Cervantes was jailed, Pushkin hounded by the Czar, Byron feared by the British upper class, Wright forced to leave America, Baraka threatened with jail, or Solzhenitsyn exiled from the Soviet Union. Those who wield power, as opposed to those who theorize about it, have always understood that form and structure, style and manipulation of language, are only vehicles for forwarding political and ideological positions. This is a reality with which every critical movement—even the New Critical one—was forced to come to grips, to admit that, after all, the essence of a work of art lay, not in its being, but in its meaning.

But the opponents of the Black Aesthetic know all of this: they do not really discern an antagonism between art, politics, and ideology, are not opposed to critical systems that enunciate standards and

guidelines; no, what they are opposed to is a particular kind of ideology and politics—Black Nationalism—and a Black critical system, as opposed to a white, which suggests guidelines and standards. Members of the "writer should be allowed to write anything he wants to school," they argue that the Black writer belongs to an *élite* group—he is not "a Negro writer, but a writer," and is responsible only to his art. The absurdity of this point of view was demonstrated some time ago, when I questioned a member of this school: "At a time when drugs are decimating many Black youngsters, should the writer be free to write poems and novels glorifying drugs, though this may lead in some small way to an increase in Black addicts?" The answer was an unqualified "yes."

Now freedom for the writer is one thing; nihilism is another. Freedom, after all, entails responsibility; nihilism, irresponsibility. To suggest that the Black writer owes no obligations to the Black community is not to champion freedom, but nihilism, to contend that though he gains his creative import, his nuances of thought and perception from the Black community, that even though the community conditions his way of looking and feeling, offers him a storehouse of material and experiences, that despite this, he owes nothing to the community, is free to indulge his fantasies at its expense. The best example of this kind of nihilism/irresponsibility are the Black films; here is freedom pushed to its most ridiculous limits; here are writers and actors who claim that freedom for the artist entails exploitation of the very people to whom they owe their artistic (?) existence.

Simply put, the advocates of freedom for the Black writer are convinced that he belongs to an *élite* club, that somehow, by becoming a writer, he has escaped the daily acts of terror and oppression faced by other Blacks, that he has, in a sense, become integrated into the American society. The Black writer, however, is no more than a Black man or woman who writes, and the same acts of inhumanity directed against other Black people by Americans are directed equally against him. His books are no antidote against American racism, do not immunize him against exploitation and brutality.

Given these realities, his claims for freedom in light of the limited freedom of other Blacks is absurd, for his, whether he knows it or not, is irrevocably tied to that of others, and until other Blacks are free, he cannot be, neither as man, woman, nor artist.

Those who clamor for freedom for the writer, however, would add legitimacy to their cause, had they, historically, opposed the attempts of white critics to issue guidelines restricting them, had they, for instance, had the courage and the intellect to take on Robert Bone, Theodore Gross, Herbert Hill, Norman Mailer, Louis Simpson, and the reviewers of the *New York Times Sunday Review of Books*. Instead of taking them on, however, "the freedom for the writer advocates" quote them continuously, echo their sentiments that Black writing must be "universal," that the Black writer must use his creative imagination to carry him beyond "the narrow parochialism of race": writes Kilson: ". . . It is necessary for those of us who truly believe in man's universal aesthetic capacities to respond to our Black separatist brothers by reaffirming the universal quality of humanity."

The "universal quality of humanity" is clearly visible in Sophocles' drama *Oedipus Rex*, wherein the protagonist, white, wrestles with guilt and shame after seducing his mother and killing his father; not visible in Ron Milner's drama *What the Wine Sellers Buy*, wherein the protagonist, Black, confronts old myths and stereotypes, masters them and moves forward to assert his manhood in a racist society; the universal quality of humanity is quite apparent in the Russian novel, which according to one critic, "speaks of the great Russian soul," in the Jewish novel, which treats the Jewish experience, in the English novel, which deals with the experiences of Englishmen; it is not apparent, however, in Black novels that deal with the Black experience, not in *Native Son*, nor *Youngblood*, nor *Captain Blackman,* nor *The Autobiography of Miss Jane Pittman*, despite the fact that the experiences depicted in these works are similar to those undergone daily by three-quarters of the earth's people.

Follow this reasoning to its most absurd conclusion, and the Black writer is free, can achieve universality, only when he is capable of distorting

his experiences, of transforming them into non-recognizable abstractions, in order to appease and placate a white audience. Needless to say, Black Aestheticians have a different view of the humanitarian, universal aesthetic. We believe that it was demonstrated in the lives and experiences of Harriet Tubman and Denmark Vesey, Frederick Douglass and Martin Delany, Sojourner Truth and Marcus Garvey, Malcolm X and Martin Luther King, H. Rap Brown and Ron Karenga, and that their struggles for dignity and courage under fire, make them paradigms for man's historical bout with the forces of racism, models for that three-quarters of the earth's people, non-whites, who do not measure up to Kilson's definition of "universal."

Finally, this, in microcosm, is what concerns the antagonists of the New Black Arts movement. Charges that Black Aestheticians are unscholarly, advocate politics and ideology, want to deny freedom to the writer, all pale into insignificance alongside the fidelity of these self-appointed defenders of white American culture to white standards, white images, symbols, and metaphors. Like Friday, they are those to whom the white god has come in all his fury and majesty, and upon whom he has bestowed his blessings. Centuries of Americanization have convinced them that the myths ring true, that Blacks are incapable of undertaking and succeeding in any endeavor, whether running Black studies programs or creating a New Black Arts—without the aid, support, and approval of whites. Having gained *entree*, of sorts, into the world of the Americans, yet realizing, subconsciously, how precarious their own position is in that world, they devote much of their energy and what little creative potential they possess to assuring whites that they are different from other Blacks.

Their tirades against Black Nationalism, therefore, are to be found in the writings and rhetoric of their white ventriloquists, who oppose self-determination for Black people, because, like Thomas Nelson Page and Thomas Dixon, they need the images of Blacks as impotent, docile children, helpless without the master's guiding hand. Their opposition to the New Black Arts, never stated, is due to the fact that it calls for re-evaluation of white values, a questioning and challenging of the ethics and morals of this country, a belief that man's humanity to man is possible once the symbols, images, and metaphors bequeathed by white men to Black men are redefined and restructured. For the Fridays, to move outside the voice of the ventriloquist would place them in a very precarious position indeed, for their sense of self, strength, and status, is proportionate to their acceptance and approval by the white world, and without such approval and acceptance, like Freud's child, lost in the wilderness, they would have to confront the terrifying void of their own incompetence.

One final word: Nothing that I have said here will move the adversaries of the Black Aesthetic to attempt serious intellectual evaluation, and the reason is that Fridayism leads to terminal illness, not subject to cure by intellectual or rational reasoning. This does not disturb me. I know that Friday is nothing more than the surrogate for Crusoe, the complete personification of the Pavlovian model, who, robot-like, responds upon impulse, and I have always preferred to deal with the Crusoes, with the ventriloquists, who at least, sometimes, demonstrate originality in thinking. The continuing attacks against me, however, coming not primarily from Crusoes, but from Fridays, have caused me to seriously evaluate this position, and though I still long for peace, for seclusion away from the noise of hysterical and paranoiac adversaries, perhaps, such longing is wishful, is at the least quite unlikely; it may be, therefore, that as far as Martin Kilson and others are concerned, this is not the last word.

NOTES

1 [George Dickie (1926–2020) was a professor of philosophy at the University of Illinois at Urbana-Champaign. See George Dickie, "The Myth of the Aesthetic Attitude," *American Philosophical Quarterly* 1, no. 1 (January 1964): 56–65. —Eds.]

2 [As ultimately published, Kilson's piece refers to Amiri Baraka by his preferred name. See pp. 486–88 in the present volume. —Eds.]

1974

Randy Williams, "The Black Art Institution," *Black Creation: A Quarterly Review of Black Arts and Letters* 6, no. 4 (1974–75)

Randy Williams was born in New York City in 1947. He became known for his sculptural assemblages and installations and also established a strong career as an educator, ultimately holding positions at Manhattanville College, New York State Summer School of the Arts, and the Metropolitan Museum of Art. Shortly before this article was published in what would be the final issue of *Black Creation*, Williams completed his graduate degree in art education at Sir George Williams University in Montreal. Part of the essay reflects on the vital role played by the Studio Museum in Harlem, New York, which at that point had existed for just over five years. This excerpt focuses on the gallery Just Above Midtown (JAM), which opened at the end of 1974.

RANDY WILLIAMS, "THE BLACK ART INSTITUTION"

The momentum of Black art has paralleled the political development of Black America. The Black art community has turned away from and rejected the destructive flattery offered by the existing white art institutions, and Black artists have not allowed themselves to become paralyzed by Western aesthetics, styles and schools. Of course, we have never been the "sweethearts" of Western art history, and we have never been established as a major theme in American art. Still, we are determined, and our momentum is symbolic of our will to touch our viewers; our determination is possible because of the existence of our aesthetic places of worship. Our museums, our galleries, our art institutions are no longer shadows of ideas in our minds; they are now realities; they are comprehensive areas of vital visual information; they are vitamins for a growing culture, a culture that is both complex and simple, a culture that found her youth in America and her antiquity in Africa.

Unlike the impenetrable museums and galleries of the white art world, Black art institutions are, and should continue to be, intimately involved in meeting the needs of the Black community. Agitated into being by the lack of exhibition space in the white institutions, our Black art institutions basically create *space* for Black artists to exhibit in. But more than merely providing exhibition space, they must confront the problems of educating the Black public, of giving explanations of answering questions, and sometimes even formulating the right questions to ask. These museums and galleries must affirm and fix a history and aesthetic of Black art for the public.

What the recent Black art institutions have done, more specifically than anything else, is to make us aware of the quality and quantity of works being done by Black artists today. They have also made us aware of the corresponding aesthetics and of our historical and artistic development.

These are encouraging signs for the Black art world. But, in spite of these encouragements, many of the institutions that promote and exhibit Black art are collapsing because of lack of money.

Yet, there are some important, monumental Black institutions that have not collapsed, that have not compromised the Black aesthetic, that are building a legacy for the future. This article commemorates these institutions.

[*Here, Williams briefly describes venues in Boston, Washington, DC, San Francisco, and New York, concluding the survey with Just Above Midtown.*]

Another important gallery is Linda Bryant's Just Above Midtown Gallery at 50 West 57th Street. With the opening of JAM, I venture to state that the struggle for at least recognition by Black galleries is over. But this is not to say that we will not have other struggles, and it is not to say that just with the establishment of a place like JAM that the battle is over—far from it, for we must continually build and reinforce and support our existing art institutions. But JAM marks a first—first major Black gallery in the all-important mid-town Manhattan area. JAM opened in late 1974 with a group show of 12 artists: five from New York, six from LA and one from Mexico. An extraordinary turn of events is taking place in the Black art world and JAM is in the forefront of that overwhelming force.

From the brief survey above you can see that the difficulty Black artists had in finding exhibition areas is no longer as problematic as in the past. But, while the situation that existed in the past is being repaired—slowly, carefully, painstakingly—we must not be fooled, for we are still facing an establishment whose essential purpose is to keep the Black artist aesthetically and economically powerless. Our current art institutions exist because the establishment institutions would not allow us in in the first place. It was their fraudulent practices that stimulated the development of our institutions. Our philosophy is sufficient for our survival, but our money is not. We must always develop financial sophistication and strength, if our current galleries and museums are to survive. In the near future we must build anew with the need of the community in mind; build new and better buildings—strong, sturdy places for our art.

There are many images possible in the future for the Black artist and his cultural institutions. The

artist should be distinguished by what he is capable of becoming, and our aesthetic definitions will help establish what he is to become.

A positive art museum of the present and of the future should stimulate the viewer and it should have a continuing effect on him, even after he leaves. The viewer should have a better understanding of his life as it exists in our packaged atmosphere. An art institution is not the measurement of an artist's individual success, but rather is the measure of the achievements of a dialogue between the artist, the art institution and the community.

Our museums and galleries are the biographers of the Black artist, for without them we would never have a visual history worth mentioning. Without Black art institutions we, our artists, and our future generations do not have a future, and without a future investment the present is unbearable.

1975

Mimi Poser, Linda Goode Bryant, and David Hammons, "Just Above Midtown Gallery," *Round and about the Guggenheim*, **WNYC–New York Public Radio, January 2, 1975**

The gallery Just Above Midtown (JAM) opened in New York on November 18, 1974. Linda Goode Bryant, frustrated by the conditions Black artists faced in the art world, decided to provide a platform for the exhibition and sale of their work in the heart of Manhattan's commercial art district, on Fifty-Seventh Street. Bryant's intention was to establish a venue that was equal to those available to White artists. It was the first time New York City had seen an enterprise of this nature. In a radio series organized by the Solomon R. Guggenheim Museum, Mimi Poser interviewed Bryant along with the artist David Hammons, who had recently moved to New York from Los Angeles and whose work would be shown at JAM a few months later (see pp. 514–15).

MIMI POSER, LINDA GOODE BRYANT, AND DAVID HAMMONS, "JUST ABOVE MIDTOWN GALLERY"

MIMI POSER: Good evening. This is Mimi Poser at the Guggenheim. Our subject this evening is JAM, or, J.A.M.—the acronym for Just Above Midtown, a brand-new gallery owned by blacks, run by blacks, and representing black artists. It's located just above midtown, in the heart of the art-gallery establishment, on 57th Street. Our guests this evening are Linda Bryant, director of JAM, and artist David Hammons. Good evening and welcome to you both. Am I right in calling it JAM, or do you call it J.A.M., or Just Above Midtown?

LINDA GOODE BRYANT: We call it JAM.

POSER: You call it JAM, too. Okay. [*All laugh.*] Linda, you must have had very strong reasons for opening this gallery in the heart of a white art gallery establishment. What were they?

BRYANT: Actually, it all came about after going to the West Coast, visiting the whole California coastline and talking with artists, and also being in New York for about a year and a half and realizing that black artists didn't have a commercial outlet. We have museums, we have nonprofit galleries, but we didn't have a business, that was not funded, that could actually promote and sell art on a professional or mainstream-gallery-district kind of level. That was one of the reasons.

POSER: Does this hold throughout the United States, or just in New York?

BRYANT: Primarily . . . I'd say, pretty much throughout the United States. There are one or two galleries that sprinkle through. I think there is one in Detroit. I don't believe there is one existing right now on the coast that is primarily dealing with continuing exhibitions, that's purely commercial.

POSER: Why did you choose to come downtown? Why not up in Harlem?

BRYANT: That's a good question. What happened was that I decided that when I thought of the idea—hey, I'm going to start a gallery—which was

kind of a gut response one day. I work at the Studio Museum, and I had walked in, and I—

POSER: Will you tell our audience what the Studio Museum is?

BRYANT: All right. The Studio Museum in Harlem is a museum that is dedicated to the promotion and exhibition of Afro-American art, consistently, and it is located in Harlem, on Fifth Avenue, right off 125th Street.

POSER: But it's a museum, not a commercial gallery.

BRYANT: It's a museum, right. It's not a commercial gallery. So, I walked in one day and I saw an artist, Valerie Maynard, who is also being handled by the gallery, and for some reason I just said, Valerie, I'm going to start a gallery, and she said, do it! Which was kind of a challenge. So, then I started thinking about it seriously, and I realized that you have areas where you already have preconceived notions, and Harlem is one, or "Uptown" is one, and the same thing with "Downtown," or Soho. So, you have black artists who have been intimidated by the gallery mechanisms. And I said, well, hey, I want to put it in a neutral area. So, at that time, I said, well, I'll put it on 86th and Broadway. I found a fantastic place, and that's where the name came, Just Above Midtown, on 86th and Broadway. As I started getting really into it and started working out the whole dynamics of running a gallery, I realized that if the purpose was to be commercial, and for promotion and sale, then the place to be was in a major gallery district. And so I investigated the Soho area and 57th Street, and ended up with the address on 57th.

POSER: But you still haven't answered why it couldn't be done uptown.

BRYANT: Actually, I think . . . several reasons. I think that uptown, you're dealing with, number one, a community that lives in the area, that has also been, I'd say, alienated to the Western concept of art and has not dealt with the visual arts in any kind of dedicated . . . not even dedicated, but a consistent kind of way. You find that the

community deals more so in the music and the performing arts, but the visual arts are like the lowest on the black-culture totem pole.

POSER: Do you understand why?

BRYANT: Well, I mean, we can go into a whole historical thing, where we sang as slaves, and we could also do such things as dance or even get into some kind of role playing, which relates to acting. But in terms of communicating by writing or even visually, it was somewhat limited, except for the artisans that worked and did wood carvings or woodwork or furniture making for the slave master. It's that kind of thing. It was a slow process. Most of the early artists that came out of the 1800s, late 1800s, the 1900 era, went to Europe to study, so it was basically very European. The audience they had was European, or Western, and it's just continued through. Even though you had the big period of the Harlem Renaissance, when there was great activity in the visual arts—actually, when the black artists really started to come out.

POSER: When was that?

BRYANT: The 1920s through to the '40s. You had the political movement, like with [Marcus] Garvey. You had the writers Langston Hughes, Countee Cullen. And at the same time you had visual artists that were producing in the period. But the whole concept of buying, in terms of art as an important object—it's easy to go and buy an LP, but when you start to talk about buying a painting or buying a print, even, it becomes very difficult for the economic structure of that community. So, I said, well, that's a problem. I realized that in terms of the gallery's survival—and it had to not be a one-shot, a six-month thing—it needed finances. You're going to have to deal with the traditional buying public. And the location—blacks and whites frequent 57th Street, so it's not limiting the market. But I find that a lot of black artists have not gotten out of a dedication to a community— they still have that, they maintain it in the art. But they feel that their art shouldn't necessarily be segregated. It shouldn't be just "black art" and be put in a box.

POSER: Well, that's a subject I want to get on to in a little while. In all the press releases that I've read about the gallery, you use the term "Afro-American" rather than "Black" or "Black American" art. Why is that? How do you feel about that, David?

DAVID HAMMONS: Terminology . . . basically, it's terminology, and the period that we're into—Black American art, Afro-American art—it's basically the same. It's very hard for me to dissect. In doing art, all I can deal with is the consciousness of the art, which has a black theme to it. Basically, the two terms mean the same, don't you think?

BRYANT: Yeah, and I think the choice in terms of Afro-American comes from—

HAMMONS: Labels.

BRYANT: Right, labels. Dealing with realtors, when I was searching out spaces, and calling realtors and saying, what's the rent, et cetera. The minute I said "black art," I think they had some preconceived notions of black velvet things with big tears, or graffiti.

HAMMONS: Black magic.

POSER: In other words, they weren't thinking of serious art. They were thinking, more or less, of folk art in the black idiom.

BRYANT: And I think, also, black art has a connotation of having—

HAMMONS: Black power. All of those things.

BRYANT: Right. And also subject matter. Like, you only think that black art can deal with a black subject matter. Well, not all Afro-American artists deal with black subject matter. A lot of them produce in the mainstream. To say "Afro-American art"—it can deal with a whole spectrum of how African American artists are producing.

POSER: Of course, we have all heard that black artists are not represented in the museums and the galleries, and the cry is: we haven't had any good black art in the commercial galleries or the museums. Is this true?

BRYANT: No, I would disagree. That whole premise—

HAMMONS: [*Laughs.*]

POSER: I mean, you've heard that, I'm sure.

BRYANT: Yeah, I've heard it. [*Laughter.*] I've heard it a lot. It's primarily museums. As a Rockefeller Fellow, I ran into that a lot, when I would challenge either gallery dealers or museum directors as to why there wasn't black art. You get into a whole thing where people use a double kind of meaning for a definition. They'll say that art is universal, but at the same time, from my perspective, if it were universal, then you wouldn't have ethnic groups being eliminated from museum collections or exhibitions or art gallery dealers.

POSER: But have they been eliminated?

BRYANT: They have, on a large scale.

POSER: There are some artists we all know of, who are in galleries.

BRYANT: Right. They sprinkle through galleries. A lot of them complain that they're not getting the promotion that the white artists are getting.

POSER: How do you feel about that, David? You are an artist. Have you had trouble getting representation? Have you had trouble getting into museums?

HAMMONS: I'm from the West Coast, and the problem out there isn't as severe as here. There aren't as many artists on the West Coast. Most of the shows that I'm in, they're usually group shows. What's happening in the country now, if there is a black art exhibit, they throw all the artists together.

POSER: The good and the bad.

HAMMONS: Right, the good and the bad. And it comes out to me like listening to an LP that has ten selections on it from different artists: you hear the individuals. Whereas I would rather see one artist have a one-man show, and he show forty paintings, instead of having forty paintings by forty different artists. So, throwing everyone into the barrel—that bothers me, and that's still happening.

POSER: In other words, you want to be chosen on quality, not the cohesive factor being that you're all just black.

HAMMONS: Right. Not necessarily me being chosen, but a black artist being chosen that can represent—

POSER: Well, one of you. [*Laughter.*]

HAMMONS: I think I'm in line, behind a lot of other people who are better than me. I would like to be chosen someday, but I'm not ready now.

POSER: Who do you think are the best black artists around now?

HAMMONS: I would say Joe Overstreet, Danny Johnson. These are contemporary artists. They're not necessarily dealing with the black subject matter. Their art is very universal and deals with color statements, but I really feel that they've paid a lot of dues in this city. They've been around here for ten years, and they're still getting kicked around, I feel.

POSER: One of the things that we've heard about the kicking-around business is that there is inequity in the prices paid for black art, or Afro-American artists, as you wish. Is that true?

BRYANT: Definitely. I think if you take someone on the scale of a Romare Bearden, or on the scale of a Jacob Lawrence, who have gained even mainstream recognition—if you prorate that with a Pollock, or you prorate that with a Rothko, you see a vast difference in sale price, which shouldn't exist. They're contemporary to the people in their quality of work, and their innovativeness in terms of the creativity is comparable. But, at the same time, you see this large gap in sale price. That was very apparent to me at a Parke-Bernet auction at one time. It was a Halpert collection, I think— Edith Halpert—and you had purple poppies going for $150,000, and you had a Jake Lawrence going at $12,000. It was kind of stifling to me why there was such a price differentiation.

HAMMONS: What Linda has just said—it's the same thing happening with music. Elton John's getting maybe a half a million dollars to perform, and then

someone like Little Richard, he's getting maybe $10,000 to perform. Black performers who have paid their dues and still aren't making the money that young white performers are making.

POSER: So, what I gather is that you're attributing this to that still ever-present prejudice?

HAMMONS: Definitely. Definitely.

BRYANT: Consider sale prices and how they're really derived—museum credentialization, critics' support, and also gallery support. The fact that there wasn't a commercial outlet for Afro-American art means that it couldn't even try to attempt to break into that kind of syndrome, in terms of creating a market where you had buyers that would support artists at that level and continually promote them. You wouldn't have buyers that would actually continue to bid against one another, to raise sale prices. You don't have that kind of following. And that's one of the purposes for JAM—to break into that kind of market syndrome.

POSER: Do you think that this is really the best way of getting black artists recognition and fair prices? Or, would it be better for you to have them recognized by already recognized galleries—with a ready clientele, with the museum connections, with the international connections?

BRYANT: The black artists have been so alienated against that whole mechanism. A lot of black artists—I mean, really good black artists—wouldn't even want to deal with a gallery from that viewpoint. And so, I think that it was important to establish an outlet that was sensitive to their needs and that was genuinely concerned about the promotion of their artwork from beyond being just a product. You have a lot of dealers who are like, it's my product. This is a very sensitive and creative thing that has a lot of meaning. So, when they affront a person like that, artists back off.

POSER: Well, you use the word "promotion," and it seems to me that the word might be "education."

BRYANT: Right.

POSER: And how do you propose to go about doing this? Aside from having the gallery, how do you propose to get the public, white and black, educated to the idea of black art?

BRYANT: That's one of the major things about the gallery. To me, one of the unique things is that it is about education. Because it has to be, to even get a buying following. A lot of it is just publicity—programs like this. A lot of it is when people come into the gallery. It's not about the gallery attendant sitting back and going, do you want a price list? It's about actually talking to them about the artists. It's a very intimate, warm thing, when you walk in JAM. People actually do talk to you about the artists, where they've been, what they're trying to say. At times, people come in and say, this is more like a museum! You're feeding as much information out of the gallery as possible. I hope that the gallery in the future can even establish a complete catalogue in terms of slides, and also a registry index of Afro-American artists and the works they produce, so it does become an educational outlet as well.

POSER: David, how about the question of exclusivity? Many artists are with one gallery, and that's the only gallery they deal with. What would happen if a very, very well-known gallery approached you and said, okay, we want to handle your work? How would you handle that? And how would you, Linda, handle it? Would you insist on exclusivity, because, after all, if one of the very well-established galleries were to approach you, it would mean money, recognition, and everything that goes with it? How would you feel about that?

HAMMONS: I don't know how I would handle it. If white galleries are finding out that they can make a lot of money off of black art, I'm sure they're going to start looking at black art. In '68 it was happening. All of a sudden there was black art, and every magazine in the country was doing an article on black art—*Time, Newsweek*. I'm basically an artist, and I want all of my interest to go into doing the art. All of these other things are political, and I have to deal with them, but I don't like to, so I really don't know how I would react.

I might go with the black, I don't know! It all depends. [*Laughter.*]

POSER: It's a tough question.

HAMMONS: It is. It really is.

POSER: Linda, how would you feel about it? Would you encourage one of your artists to do it? Would you discourage them and say, hang in with us, maybe we'll make it?

BRYANT: I would say that most of the artists in the gallery now—the twelve artists that are with the gallery—have a dedication to seeing it work. They will actually have buyers that they've had in the past come in and buy from the gallery and give up that percentage, which isn't actually necessary. And I think it's from the fact that they're involved in building a foundation, that I'd hope that they would stick with it until it did flourish into being a very prominent gallery.

POSER: One of your aims is to encourage participation by Afro-Americans in art investment. Do you think that there is such a market in the black community?

BRYANT: There's definitely a market.

POSER: What evidence have you had of this?

BRYANT: Well, in terms of professional people coming in, being able to buy.

POSER: I was going to ask you, who are the people who are buying?

BRYANT: I think that your highest money market would be your entertainer. An incredible experience, I think one of the best I've ever had, was having Stevie Wonder in the other week, and him spending two hours at the gallery. And it was his first time experiencing art. It was an educational experience. He just kept going, wow, this is great, I'm glad that you were sensitive to know that I could do this—to touch sculpture. Roberta Flack is hosting an exhibition. So, you have that kind of money and power, but at the same time you have doctors, and at the same time you have businessmen. It's about saying, this piece of art will enhance not only your home, it will support your culture. And it also will give you some kind of feeling, back and forth, as a visual reaction.

POSER: Are there any big black collectors now?

BRYANT: Your largest collections of Afro-American art are of course in institutions like colleges, like Fisk, Howard University. Also the Schomburg Collection. You do have black collectors, a lot of them that lived through the Harlem Renaissance—it was like a barter thing, I'm sure. They gave a poem and they got a painting in exchange. A lot of people say, if I can buy a Mercedes-Benz, why should I pay that much for a painting! So, it is about trying to break down that barrier to the visual arts.

POSER: Well, we come again to the point of education. David, you wanted to say something.

HAMMONS: Right. I think that the experience I'm having on the West Coast is that. . . . What I'm experiencing here in New York is that a lot of black people see art, but they don't necessarily buy it, because they see so much. Whereas as on the West Coast, black people don't even see that much black art, so when they do see it, they try and buy something, because of them not even knowing that it exists.

POSER: Is there a big community of black artists on the coast?

HAMMONS: There is a large community, and most of them are doing rather well. There's much more happening. I have a lot of shows on the West Coast. There's much more exposure. The galleries are usually full. Here, I just see that there are so many galleries, so many artists—there's so much art.

POSER: Yes, we've had that proliferation in the past few years.

HAMMONS: It does make it a little difficult to expect everyone in town to be at your opening.

POSER: I want to talk now about the white audience. For a long time, blacks were expected, and expected themselves, to react to the white

experience. In recent years, blacks are taking pride in their own culture and in their own heritage, and they have learned, or perhaps re-learned, to respond to and express themselves in terms of the black experience. Now, we come to the flip. Do you think that a white audience will or can respond to art which is clearly derived from this unique experience?

BRYANT: Almost definitely. The whole visual presentation comes from an experience that makes it unique from what they're seeing. There has been support from critics, in terms of the gallery's concept. They're saying, hey, this will finally give a boost to 57th Street, it will be some-thing different and new. Also, the fact that the art is incredible. If you take a color book of Randy Williams's—which I had never seen before—and the concept of that, which has nothing to do, thematically, with black. Just the presentation—that hasn't been done before. That's equally as stimulating as something else.

POSER: I was thinking of David's work, which is clearly based on the black experience. And, as I say, we have this flip.

BRYANT: But still, at the same time, because David does body prints, it could be nothing but a black presentation on that paper. The same thing—the technique is so unique, and the composition is so exciting, that people get past the thematic thing and get into a purely aesthetic kind of evaluation of the piece of art.

POSER: Linda, very briefly, I heard that Thomas Hoving sort of gave you the impetus to do this. Would you tell our audience that story?

BRYANT: Well, I was a Rockefeller Fellow at the Metropolitan Museum. We were in conversation, and I said, well, why don't you have more ethnic art, specifically black art, at the Met? He gave me a challenge to produce sixteen black artists—quality artists—that he could present to the board. I said, okay. So, the gallery is kind of a kickoff from that. Okay, you told me to do it, here it is. Like, let's get into it now.

POSER: And he did come to the opening.

BRYANT: He came to the opening, and we've been talking ever since, which is really good.

Allan M. Gordon, "Allan M. Gordon Interviews Himself: The Phenomenology of a Black Aesthetic; Introductory Remarks," in David C. Driskell, ed., *Amistad II: Afro-American Art*, catalogue for exhibition held at Fisk University, Nashville, Tennessee, 1975

David C. Driskell was born in Georgia in 1931. In 1949, he enrolled at Howard University in Washington, DC, where he caught the attention of the faculty as an exceptional student. James A. Porter, chair of the art department and author of *Modern Negro Art* (1943), became his mentor. After teaching at Howard from 1962 to 1966, Driskell became chair of the art department at Fisk University, where he succeeded another prominent African American, Aaron Douglas. In 1975, Driskell presented *Amistad II: Afro-American Art* in Fisk's art gallery. The show included a range of works of the nineteenth and twentieth centuries, and the catalogue featured Driskell's extensive essay "Afro-American Art: An Inside View," in which he provided a model for assessing Black aesthetics based on either a physical or a symbolic presence. The catalogue also included this text by Allan M. Gordon, a well-known critic who went on to have a significant career as a professor of art history at California State University, Sacramento. Presented as an interview with himself, the dialogue reflects on the Black Arts Movement's politicization of the African American artist and the overriding expectation that "Black art" illustrate real-life concerns.

ALLAN M. GORDON, "ALLAN M. GORDON INTERVIEWS HIMSELF: THE PHENOMENOLOGY OF A BLACK AESTHETIC; INTRODUCTORY REMARKS"

Q. Questions regarding the role of the artist and the nature of the art object appear to be at the center of most controversial discussions about a Black aesthetic. Does this controversy still exist?

A. Yes, the controversy still exists, and, to a certain extent, it could have a positive effect if it suggests that discussion is taking place. Terms such as "Black Aesthetic" and "Black Art" have only recently come into use; consequently, there has not yet occurred a vigorous intellectual inquiry into the possible meanings and permutations of these concepts.

Q. Are you suggesting that the controversy will be resolved or will disappear after a certain amount of discussion?

A. The controversial issues may or may not be completely resolved but they should become more clearly focused.

Q. What do you mean by that?

A. The idea of being or becoming an artist in this country, for an African American, is indeterminately linked to certain social and political responses. This, understandably, had caused questions raised about art and aesthetics to be dealt with as political issues. Answers have been formulated referentially to political expediency. Thus, Black aesthetics have come to seem analogous to a socio- or politico-aesthetics.

Q. What do you mean by politico-aesthetics?

A. I am not absolutely sure, but I have in mind some concept that gives an exclusively sociological or political interpretation to the role of the artist and the art object. It delimits the meaning of art.

Q. In what way?

A. Such an attitude suggests that art should create only objects of practical use, but not create images for spiritual needs.

Q. Is this also true for Black music?

A. Is what true for Black music?

Q. Is Black music used in a politically expedient manner?

A. This seems less true for Black music for several reasons. One has to do with the medium and nature of music itself, and the other with the way Black music developed in this country and its subsequent influence on world music.

Q. Would you explain that a bit more?

A. It is simply more difficult to make music illustrate in an explicit manner certain political and social ideas or programs. And, conversely, it is, of course, easier to persuade the visual artist to turn his work into illustration.

Q. I take it that you feel that it is somehow wrong for an artist to illustrate certain political or social ideas?

A. Not in itself. The history of the art of western and nonwestern societies is replete with instances of the artist making manifest ideas that had profound and significant social meaning.

The art of the Quattrocento and the Cinquecento, the art of the Mexican muralists of the 1920's and 1930's, and African art are just a few examples.

However, the very best art from all of these transcends any limitations or suggestion of illustration. There has to be a difference in meaning, importance and intent between a T.V. commercial and cinema verité, a book illustration and a painting by Bearden. There still lingers in the minds of many the notion that art is a picture about something, a statue of someone or something.

Q. Do you think the Black artists have been or are being asked to be illustrators?

A. To a certain extent, yes. I think it has been done unknowingly and with the very best of intentions. There are many Black leaders in local and national government, education, labor, law and the professions, the local communities and other

places that are astute and expert and who are sincere in their efforts to advance the cause of Black people; however, most of them have very little understanding of the problems of the visual arts.

Q. What are some of the problems and do you blame politicians and others for these problems?

A. Maybe it would be unfair to single out politicians. Actually there were probably more writers-poets, playwrights, novelists, and so-called militant leaders who were most influential in their exhortations to artists. Let's just call them all non-artists.

Q. OK. How much are non-artists to blame for whatever the problems are?

A. The artists themselves are probably as much or more to blame than non-artists for certain problems as they now exist. But in order to understand that, it will be necessary to fill you in on some of the historical circumstances surrounding the development of the concept of a Black aesthetic. OK?

Q. OK.

A. The idea of a racial art, a Black art, was given serious intellectual attention for the first time in this country during the postwar decade of the 1920s. The art produced by the Black artists from this era differed from their predecessors in its special emphasis on what Langston Hughes called their "dark-skinned selves." However, it was essentially a literary movement dominated by the poet, the novelists, and the playwright.

Hughes was aware of this. He said during that time (1926) that he hoped to see *within the next decade* a growing school of Black artists who would create with *new techniques* the expression of their own "soul-world." At the same time, he felt that a Black literature already existed and Black music had already achieved worldwide fame. This assessment was essentially true since the visual arts were dominated by a single person, Henry O. Tanner, who was the epitome of the academic, salon artist in style, technique and subject matter and he was in exile in France.

African art was inaccessible, both physically and spiritually, innovative European art was unknown, American art provided only the most self-conscious, uninspiring examples and, thus, the Black visual artists really had no usable tradition nor prototypes from which to work. There was no artistic nor aesthetic leadership that addressed itself to the particular problems of the plastic arts. Only in the work of Aaron Douglas was there any stylistic acknowledgment of the possibility of treating subject matter and other formal relationships in a manner other than academic. His work was abstracted from natural forms and was reduced to flat, simplified shapes that emphasized an elongated angularity. He was able to maintain a subtle balance between representation and abstraction that was both expressive and decorative. Above all, it had promise as a new style for the "New Negro." Unfortunately, Douglas' was an unheard voice in the wilderness. He soon reverted to a sterile, more predictable realism.

Q. Does this suggest that the legacy of the Harlem Renaissance was essentially a literary legacy?

A. That is exactly my point. Alain Locke tried to talk about African art as a source for the Black artist. He was apparently, not understood. He did not mean to paint a picture of an African piece. Du Bois felt art should not only be directly related to social reform but should be unadorned propaganda.

Q. This surprises me about Du Bois.

A. The point is that the other arts seemed to have been able to create themes and modes that more readily sprang from the cultural experiences of being a person of African descent in America, and subsequently, developed characteristics that were different in significant ways from the art of white America. The visual artists felt that subject matter alone would give the work importance.

Q. Isn't that what makes Black art *Black*?

A. I think that you've touched on part of the controversy—what makes Black art Black. But let's continue with our history lesson before we get to that.

Before the questions of the role of the artist and the function of art as it relates to an African American culture could be properly discussed

(there was an intervening Depression and a world war), the Black Power Movement of the 1960s was ushered in by Martin Luther King Jr., Stokely Carmichael, Malcolm X, the Black Panther Party, and militant college students. It was the nationalistic components who exhorted the artist to, once again, use his art to serve a political end. In this case, his art was to be a weapon of liberation. Once again writers gave advice: One Black poet[1] said that the artist and the political activist was one. The Minister of Culture for the Black Panther Party said that to draw about revolutionary things, the artist must have shot and/or be ready to shoot when the time comes.

These statements and others like them reflected the intensity of that decade but perhaps did little to clarify, in any aesthetic sense, the artist's role or the nature and perception of the art object. It was probably more confusing to the artist who was being, in effect, told that he and his art had value only if he were a revolutionary and his art could be considered revolutionary as it "exposed the enemy" and "supported the revolution."

Q. Isn't it correct to assume that art should be judged by some social criteria?

A. Yes, I think it should, but what social criteria? Art by its very nature is social. How it is socially employed depends more upon the customs, traditions and needs of the particular society of which the artist is a part. I suggest that the visual artists were not prepared to be revolutionary.

Q. Do you mean psychologically?

A. I mean psychologically, conceptually, philosophically, technically, stylistically—all of these. Collectively, they were not ready in the 1920s and neither were they ready in the 1960s. It's somewhat like asking someone to do advanced research in Chemistry when he hasn't yet finished elementary research. If this chemist is unaware of what has already been solved or what some of the advanced problems are, he could very easily make public some of his projects that he thought were "advanced" solutions only to be embarrassed later

when he discovers that those solutions had been discovered decades ago.

Q. Was this the dilemma of the Black artist?

A. Yes, the visual artists have found themselves in somewhat the same position. The times demanded that there should be "Black art"—an art that was different from other American art (even revolutionary) just as Black music was different.

In their haste to conform to and comply with the revolutionary fervor, it was perhaps all too easy to conclude that it was subject matter which was to differentiate and characterize a Black art. Thus, many artists assumed that pictures of Black guerillas, sharecroppers, raised fists, rats, garbage cans, head rags, watermelons and such was the essence of Black art. These subjects were usually depicted in the most conservative, pedestrian, academic manner. The subjects were usually not treated as sensuously as they had been by white artists such as Homer, Eakins, Marsh or Mount.

Q. What of those artists who were not "into" Black subject matter?

A. The Subject-Matter Group dismissed the other artists. I think this happened because there was neither an understanding of the theories and aesthetics underlying much of contemporary world art, nor was there a sufficient interest in the art of traditional, nonwestern societies, which may have provided alternative models. Instead, the Black artists made their own models which in many ways were reminiscent of American social realism of the 1930s. Those artists who deviated in some fashion from the above schema were confronted with outright hostility or dismissed as producing art that had no "relevance" to the "Black community." This was the attitude a few years back toward the work of Tom Lloyd and Bob Thompson.

Q. Is that part of the controversy?

A. Yes, partially. After the 1960s subsided, you could hear what may have been whispered before now being spoken aloud—and that was certain artists saying there was no such thing as "Black Art." There was just Art—good or bad. They went

further. Some said that they were not Black artists, but artists who happened to be Black. One artist[2] was quoted in a national magazine as saying there was no such definition of black art. He thought that it was absurd to take a group of painters whose work and concepts differ and to categorize them as exponents of black art just because of their skin color. Yet, he felt there was a "definite black political experience."

Q. Did the artist realize the incongruity of his statement?

A. Apparently not. However, most discerning individuals must realize that the socio-cultural conditions that fostered a black church, music, and politics existed and exist for the artist. His perception and conception of these conditions may not in the past have been too keen. Nevertheless, they are there. He needs only probe his own psyche deep enough to find them.

Ralph Ellison had said that this kind of probing which explored and revealed the unending plastic possibilities of the Black Experience (and the world) was much more important than the telling-it-like-it-is of so-called protest art.

Q. To suggest there are no differences and that all art is Art—isn't that to deny the differences among Chinese, African, Inca, Eskimo, German Expressionism, Russian Suprematism and other modes?

A. I would say yes. However, I think in the case of this denial by certain Black artists that it is or was an attempt to disassociate themselves from work by other Black artists that was conceptually simple, technically weak and as one of my colleagues describes it just plain boring.

Another factor that has contributed to this is a lack of a discerning audience.

Q. There is no audience for Black art? What about the Black community?

A. Contrary to what the Black community's self-appointed spokesmen (such as writers, politicians, college students) say, most community persons don't seem to know the difference between a Lawrence and a Lichtenstein, and probably couldn't care less.

Even in metropolitan areas where there are large Black populations—Los Angeles, Detroit, Chicago, San Francisco, the Big Apple itself—there are few first-class galleries and museums that are treated in some serious fashion. And since art appears to have a very low priority and there is a lack of a critical or appreciative audience, many artists have sought acceptance by non-Black galleries, museums, collectors and critics.

I find fault with this only if the artist feels that he has to deny himself in order to participate. Many create pale, derivative imitations of their non-Black colleagues. However, I have found that much of this work intended to reflect certain current fashions in the so-called mainstream reveals, underneath, an African sensibility.

Perhaps it is that subconscious archetype, that Jung describes, forever etched on his African brain, trying to manifest itself.

Q. What is this African sensibility?

A. This is the essence of what makes the art by Black artists different. It doesn't matter whether he is in America, Brazil, the West Indies or the Ivory Coast. If you allow for certain cultural variations, you can still distill features that are significantly different.

Q. What are some of them?

A. First of all, there is general agreement (explained by the art historian Werner Haftmann) that the two frontiers of art, in terms of a polarity, are exemplified by the reality of nature as is seen in the real object chosen at random and placed in a strange environment that takes on the image of a "magic thing," the absolute thing.

The other end is the opposite of the world of natural appearances, of things, objects and is the world of absolute form, the reality of man that belongs to the human mind and in which the mind represents itself.

It is the difference between the "fetish" as an object and Malevich's black square on a white ground; the opposite of the world of natural appearances and things.

1. The Black artist tends toward the reality of nature and the magical quality of the object. This reflects a recognition that art in its origin was magic. It also recognizes that art can merge the individual with the whole. This "wholeness" is a definite African ontology.

Thus, the objectness of the work of art predominates. Rather than merely reproducing things, things are defined and revealed anew. In order to bring back the magic into art (religion, science and art were once combined in a latent form in magic) real objects with their own character, color, power and which occupy real space are called forth and used. These objects, and things, sometimes unaltered and filled with a special vitality, dissolve the boundaries that separate the real and illusory—art and life.

Black art no longer needs to refer to illusionistic conventions—perspective, depth, chiaroscuro, relief and so forth, because it is not a representation of a segment of nature in a mimetic sense. It is an autonomous object, a thing that derives its power and being from its constituent parts, and its meaning is completed as it is perceived.

2. Black art rejects the anecdote, but rather affirms and reaffirms truths that are profound and go beyond the temporal values. It attempts to become indispensable in recognition and change in the world.

3. It is also against Beauty that is analogous to sweetness and prettiness. There is an absence of sentimental attitudes. Just as the Blues are neither wholly sad, nor wholly happy, but rather possess an ambiguous, bittersweet quality, a hint of pain; controlled violence.

4. The clash and tension between the illusory and the real created by "found" objects and objects taken out of context create and recognize power and the resultant dissonance relates to the dissonance created by the clash between flatted notes in a melody and regular unflatted harmonic structure of jazz; or the kind of dissonance that occurs when the musician attempts to play quarter tones.

Q. Are there artists who demonstrate these qualities in their works?

A. Yes. I think you can find much of these qualities in the work of Betye Saar, Oliver Jackson, Romare Bearden, Noah Purifoy, Richard Hunt, Alvin Loving, Ray Saunders, Marie Johnson, David Hammons, Claude Clark, to name a few.

Q. How do those artists that do not employ the assemblage technique manifest their "African heritage?"

A. I think that an African sensibility is manifest more by an attitude, by style, by a way of perceiving the world than by a particular technique. I think there are definite African elements in the work of Gilliam, Loving, Overstreet, and Chase-Riboud in the improvisatory quality, the sense of transformation that occurs; the element of chance, the sense of extemporizing, the deviation and arbitrariness with the hanging construction of those artists, for example. There is a certain quality in the work of Lawrence and Pippin in their magical isolation of objects and things that either become mysterious cult metaphors as they are taken out of their context, or transformed into "fetish" objects. Or, in the case of Lawrence, an unmasking occurs that reveals the essence beneath, that which remains when the superficial, the superfluous has been stripped away.

As the Black artist is able to acquire the necessary support to sustain his work: critical attention, Patrons, Museum, Gallery, and Audience recognition, and a chance to investigate himself, he will be in a position to reveal more cogently that which has been concealed by "time, custom or by our trained incapacity to perceive the truth."[3]

NOTES

1 [The poet in question was Larry Neal, writing in the *Black Fire* anthology: "The artist and the political activist are one. They are both shapers of the future reality. Both understand and manipulate the collective myths of the race. Both are warriors, priests, lovers and destroyers" (p. 656). See p. 111 in the present volume. —Eds.]

2 [The artist in question was Malcolm Bailey. See p. 213 in the present volume. —Eds.]

3 [Here, Gordon is quoting Ralph Ellison, roughly. See p. 99 in the present volume. —Eds.]

1975

Benny Andrews, "Jemimas, Mysticism, and Mojos: The Art of Betye Saar," *Encore: American and Worldwide News* 4, no. 5 (March 17, 1975)

In March 1975, after coming to the attention of the curator Marcia Tucker, Betye Saar was given a solo exhibition at the Whitney Museum of American Art in New York. A few days prior to the exhibition's opening, Benny Andrews's feature outlining the evolution of the artist's work appeared in *Encore: American and Worldwide News*. As Saar explains in the piece, the activist stance of her works of the early 1970s had recently given way to a more introspective and secretive approach. The first issue of *Encore* had come out in spring 1972. Ida E. Lewis, a writer at *Life* and the *Washington Post*, was the magazine's founding editor. She had previously been the editor in chief of *Essence*, a lifestyle magazine aimed at African American women, but left after a year to launch a publication that was more political in tone. The first issue included a review of the presidential candidates from a Black perspective and a feature on the poet Nikki Giovanni.

BENNY ANDREWS, "JEMIMAS, MYSTICISM, AND MOJOS: THE ART OF BETYE SAAR"

The Uncle Toms, Aunt Jemimas, and Little Black Sambos that artist Betye Saar shows in her works with guns in hand instead of hoes and pancake turners are the foundations for the artist's recent works, which will be exhibited soon at the lobby gallery of New York City's Whitney Museum of American Art.

Born in Los Angeles in 1926, Betye Saar presently lives in Hollywood and is a professor of art at California State University in Northridge, California.

In Saar's exhibition, which will open March 20 and run through April 20, there are codes, secrets, and many other thought-provoking elements. "My work," states Saar, "is not for lazy minds, or those who want everything spelled out." It's ironic that Saar's work is being shown at the Whitney—the museum run by the "cotton gin family." But perhaps there is no better place to show the liberation of Tom, Jemima, and Sambo.

When asked how she arrived at the statements made in this exhibition, Saar replied, "I've been a collector all my life. About ten years ago, I became familiar with the work of Joseph Cornell, an artist whose work, for the most part, consists of various objects he collected and displayed within boxes. At that time I was working mostly with prints and drawings, but after seeing Cornell's work, I began to work in three dimensions by framing some of the memorabilia in windows and boxes."

As for the development of the subject matter, Saar explains, "My early work contained images connected with the occult, palmistry, phrenology, and astrology. Then I went into a kind of ethnic occult. By ethnic occult I mean African fetishes, mojos, and boxes containing organic or natural materials such as bones, seed pods, and feathers. Afterward, my work developed into a Black imagery, divided into two series. The first I called *Exploding the Myth* in which I used derogatory images, such as Aunt Jemima, Uncle Tom, and so on, and related them to the Black liberation movement in this country. In the second series, which was untitled, I put together old photographs of Black people from the early 1900s through the 1930s and 1940s to give an idea of what Black people were like during those times. My current work involves all three—the occult, fetishes, and Black images."

Since her initial use of the fetishes, Saar feels changes have taken place in her work. "For example," she says, "in my previous work my message was very clear, especially when I used the Black derogatory images. *The Liberation of Aunt Jemima Series* was represented by a Black woman—an Aunt Jemima type—holding a gun instead of a rolling pin. Now my messages are more subtle. There is more secretiveness about them because I think this represents the way Black people feel about the movement today. They've got over the violent pain and have become more introspective and are doing more thinking and plotting. Blacks are dealing with their enemy on a secret level. The political messages are still in my work, but one has to think harder to find them."

For those curious about why Saar frames all her work in boxes or windows, the artist explains, "The window is a way of traveling from one conscious level to another, like the physical looking to the mental or the spiritual. The boxes represent a 'contained' kind of secret that one can open and look into, then close if he wishes to leave that particular idea."

Betye Saar's philosophy about art isn't one she turns on only when she works. Her everyday existence is art. "My lifestyle," explains Saar, "is completely involved with art rather than art being something that I do. I consider how my house looks and the kinds of food I prepare (and how I serve them) as art forms. I look upon my body and my choice of clothing, giving attention to colors and accessories, as art forms. Also how I move my body, whether dancing or sculpting, is an art form. When I teach, I try to relate these feelings to my students so that they, too, can relate more to art as a way of life rather than as a part or fragment of their existence."

Linda Goode Bryant, "Greasy Bags and Barbecue Bones," press release for exhibition held at Just Above Midtown, New York, May 5–30, 1975

Greasy Bags and Barbecue Bones was David Hammons's first solo show in New York and one of the earliest exhibitions at Linda Goode Bryant's gallery Just Above Midtown (JAM). At the time she offered Hammons the show, Bryant expected that he would be making new "body prints" (see pp. 261–62, 274–76). However, the artist chose to create a new series with unexpected materials. While Betye Saar had already begun incorporating human hair into her works (following a visit with Hammons to Chicago's Field Museum in 1971), Hammons here combined hair gathered from barbershops with other materials associated with everyday Black urban life. One of the works included in the show was *Bag Lady in Flight* (1975), which made reference to Marcel Duchamp's canonical *Nude Descending a Staircase*.

LINDA GOODE BRYANT, "GREASY BAGS AND BARBECUE BONES"

On May 5, 1975, JUST ABOVE MIDTOWN GALLERY proudly presents an extraordinarily unique exhibition by west coast artist DAVID HAMMONS. Noted for his *Body Print* productions which evolve from the delicate technique of using the body as plate, oils and powdered pigments, Mr. Hammons expanded his symbolism beyond social and political commentaries to include a synthesis of African pattern combinations with cloth, cardboard and inks. Progressing further, Mr. Hammons began to develop from a thematic concentration on the Spade. From ephemeral moments of Spade sand carvings to spade-shaped body prints, Hammons simultaneously worked directly with shoveled spades; cutting, welding, incorporating African mask motifs, saxophones, ties, chains, and other appendages—accenting themes, manipulating responses.

Recently, using oils and mixed-media as reference, Mr. Hammons has embarked upon a most exciting presentation. Combining oils (bacon, vegetable, pork) in varying degrees of thickness to flattened, large brown bags, he creates the most unexpected shapes, textures, and hues. In attaching the remains of barbequed pork and beef ribs along with triangle sparkle areas and human hair, Hammons is producing one of the most visually astounding art presentations of the seventies.

Frequently shown in museums and galleries on the west coast, David Hammons is included in such collections as the Los Angeles County and Oakland Museums.

This exhibition will be shown through May 30, 1975.

1975

Elizabeth Catlett, "The Role of the Black Artist," in "Arts and Literature," special issue, *The Black Scholar* 6, no. 9 (June 1975)

Elizabeth Catlett's conviction that art should enhance the lives of all people is highlighted in this essay, in which she calls for a more robust relationship between artists and their community. Catlett believed that it was artists' responsibility to document ordinary everyday lives. Indeed, her main concerns were always the "liberation of exploited peoples" and the preservation of their cultural traditions, and her works drew heavily on Black life and the experiences of women. *The Black Scholar* was founded in November 1969 by the poet Robert Chrisman and the sociologist Nathan Hare to provide a robust platform for Black cultural and political thought in the United States. The year before, in February 1968, Hare had been hired by San Francisco State University to create a Black studies program—the first program of its kind in the country. The birth of the department was inspired by student-led opposition to Western intellectual hegemony and racist scholarship that characterized traditional college syllabi.

ELIZABETH CATLETT, "THE ROLE OF THE BLACK ARTIST"

> After emancipation . . . all those people who had been slaves, they needed the music more than ever now, it was like they were trying to find out in this music what they were supposed to do with freedom: playing the music and listening to it—waiting for it to express what they needed to learn once they had learned it wasn't just white people the music had to reach to . . . but straight out to life, and to what a man does with his life when it finally is *his*.
>
> —Sidney Bechet in *Treat It Gentle*

The two hundred and more black visual artists gathered together in a California university during Easter vacation, 1975, were trying to find out what to do with their art, for the life of the black man in much of the world still is not *his*.

The National Conference of Artists has grown during its 19 years of existence—in size and in scope. When I first joined in 1961, a small group of black artists, mostly teachers and students from isolated areas in the south, met at Howard University together with a few from Chicago, Washington, Baltimore and New York. Their aim seemed mutual assistance in solving their professional problems, since they were more or less working alone. The big name black artists were not there—those represented in museums and by gallery dealers—except for two or three. Discussions included earning a living, organizing exhibitions and creative problems. Greetings were read from David Alfaro Siqueiros in his prison cell and a petition for his freedom was signed.

Things in the organization have changed since then. This year the artists were concerned with the role of black art, the black aesthetic, the relation between the visual arts and dance, music, drama, literature, religion, etc. There was a coming together of black artists from all over the country. A charter plane brought over a hundred from the east coast for a togetherness with those from the south, mid-west and west coast. A few big names were there; more were absent, even those living in California.

The theme was black art—for we are all black artists. Discussions included the Arts and Prison, Art Education (most of us are teachers), the History of Black Art (oral), Black women in the Arts, Developing Neighborhood Art Programs, etc. What these artists are in search of is the means, the how-to and whereby of reaching the mass of black people through their art.

This is the principal preoccupation of all artists who consider themselves first black and then artists. I cannot speak for the others who are artists first and black when it is convenient to be so. The big question, especially for young artists and students, is how do we develop to serve the black community, what is our role, what form do we use, what content? What are our priorities?

To come anywhere near answers we must first face some realities. Black artists are more recognized and have more opportunities today than ever in the past. There are national exhibitions, national slide collections, books published on black art, films on black art and individual artists. Some have one man exhibitions in major U.S. museums—The Modern, the Metropolitan. Dealers are interested in having us in their galleries—we sell, money can be made from us. There are grants to study, at home or abroad; there are funds to exhibit, and jobs in important universities with big salaries, as teachers or artists in residence.

The why of this situation so advantageous to black artists needs to be well understood in order to be well utilized. It is the establishment's answer to the struggle of black people for equality and liberation. We have put the lie to cultural non-existence with black music. It is proof that the oppressor must admit, for it is the only U.S. contribution to world culture. It is reality that we must endure Barbra Streisand's diluted interpretation of black music in order to hear Ray Charles subordinated in her television program, that without him would have no entertainment value.

Why the growing acceptance of black art in the American art scene? Because black people demand

it—for black studies programs, for museums and cultural centers supported by their taxes, because of the oppressor's fear of black folks "getting out of hand" as in the 1960s.

In the beginning these national black art exhibits were selected by white art authorities and criticized by white art critics. Invariably the black artist fitting into the current "American art scene" is praised and back-patted while any artist deviating towards meaning for a black audience is condemned as "primitive, social or political." They have now learned that these exhibits must be selected by black art specialists and that quite a few exist.

Let us look briefly at the formation of the American art scene and examine the role of the black artist in it. The collector buys according to the market and the gallery/owner dealer's suggestion. He is making an investment in art instead of on the stock market. It was said of the museums during the Open Hearing held by the Art Workers' Coalition in New York in 1969: "The trustees of the museums direct NBC and CBS, *The New York Times*, and the Associated Press, and that greatest cultural travesty of modern times—the Lincoln Center. They own A.T.& T., Ford, General Motors, the great multi-billion dollar foundations, Columbia University, Alcoa, Minnesota Mining, United Fruit, and AMK, besides sitting on the boards of each other's museums. The implications of these facts are enormous. Do you realize that it is those artloving, culturally committed trustees of the Metropolitan and Modern museums who are waging the war in Vietnam?"[1]

Where do we as blacks move in this arena? As artists we participate in all the big exhibitions possible for thusly we build our curriculum vitae. We exhibit in collectives and work up to individual exhibitions in our universities, in foreign countries where we have gone to study with grants, then in galleries or museums. We become part of public and private collections, with our works demanding continually rising prices. We can never affect in any way the controlled art situation in the U.S. with its class character, racist characteristics, and commercial base, under the present system.

What is there for us *outside this* scene? There is the culture starved black community with its complexities and its tremendous need for visual art, more so because of the mesmerizing effect of commercial television. The black artist is seeking more and more to move within this community. He is investigating our past and interpreting history to awaken us to our great cultural heritage, giving us an additional weapon with which to combat racist historical myths. There is no question as to who we are and where we are going—black people on our way to liberation.

We must learn from inside the struggle because of its changes as the people change. Only as a part of the mass can we recognize its needs as to our artistic contribution. Because art needs to be public to reach the majority of blacks, regardless of class, the artists are taking art to the streets in mural painting, to the churches and other meeting places. They are working in cultural centers with both children and adults; some are bringing a chance for artistic expression into the prisons. We must go where black people are. Our struggle is not for black culture but for black liberation. We should analyze the role of our artistic production in these terms.

A work of art may be spiritually, emotionally, or intellectually rewarding especially in the realm of the real/ordinary/popular. It does not need revolution as its subject in order to be revolutionary. Up to now it has had little effect on political or social revolution. It will not create authentic social change, but it can provoke thought and prepare us for change, even helping in its achievement. For art can tell us what we do not see consciously, what we may not realize, and that there are other ways of seeing things—maybe opposite ways. What seems ugly may be seen as beautiful and vice versa; what seems important may be trivial as presented by the artist.

Only the liberation of black people will make the real development of black art possible. Therefore it is to our advantage as artists as well as blacks to lend all our strength to the struggle. As culture represents only one aspect of a people the artist must make his production an integral part of the totality of black people.

Are we a part of the movement for black liberation? Or are we comfortably settled as educators, miseducating future black creators or perpetuating the art myths of racist America? Are we concerned first with ourselves (as part of the American way of life), with mutual admiration organizations, concerned with self-esteem and self-enrichment, vainglorious in our self-praise as artists that we are interpreting black life? Or are we so sure that *all* black is beautiful that we no longer strive for learning, for more understanding of ourselves, for technical excellence, for new means of expression? Painting the color is not sufficient. We must produce the *best* for our brothers and sisters.

As students and artists we have special problems. Although the question of how to professionalize ourselves has been partially answered by grants from public and private foundations we constantly face a lack of understanding on the part of white confronted with black creativity, especially in art schools. These teachers have no ability and no desire to deal with the emotion/empathy/soul that is such a necessary component of black art. They expect no more and insistently demand *only* the intellect so exalted for centuries in western culture.

The grants themselves come with the intention of preparing trained servants for the establishment, go-betweens who will try to establish in the black student, by example or directly, conformism to the white supremacist ideology with which American and western art are so saturated. We must be on the constant guard that we are not manipulated by means of these purposely confusing possibilities.

The public character of art has been mentioned because of its increasing interest for many artists. Beginning with the murals in Chicago and extending to major cities throughout the U.S., black street art has influenced other national groups such as Chicanos and Puerto Ricans, as well as the artists in the movement to liberate women. The interest shown by these muralists in the Mexican revolutionary art movement as a source of information and inspiration has not been reflected among black graphic artists. "Public Art" (Siqueiros' phraseology) in Mexico was divided into mural painting and graphic art. The work of José Guadalupe Posada early in this century and the 30 some years of what was the Taller de Gráfica Popular (Popular Graphics Workshop) are not well enough known by black artists. An understanding of the significance of both in the social and political injection of art into the lives of Mexicans would greatly benefit black printmakers. The emphasis in printmaking in the U.S. is on technical excellence and limited editions of prints for an exclusive buying public. In the TGP emphasis was on the use of art for the benefit of the Mexican people and as a weapon against fascism and imperialism, as well as technical excellence. Without limiting editions in linoleum engravings and printing editions up in the thousands, graphic art could be sold cheaply and its class character completely eliminated.

Culture can be a beginning for our involvement with other peoples who share with us racial or national discrimination and exploitation by a common enemy. Today it is difficult to wrap ourselves in "Blackness," ignoring the rest of exploited humanity for we are an integral part of it. Blackness is important as a *part* of the struggle—it is our part—not only of blacks in the U.S., Africa and the Caribbean, but of Chicanos and Puerto Ricans in the U.S., and the peoples of Asia and Latin America exemplified at the moment by the Chileans and Vietnamese. Through art we can bring understanding to Black America, Chicano America, Puerto Rican America, etc. of the character of racism, the need for its elimination, our mutual problems and our differences. The graphic and plastic image is invaluable, more so because of the extended illiteracy and semi-illiteracy among us.

In this brief analysis the cultural and social necessity to combat U.S. racist domination of black art has been touched on. There exists a multiplying contingent of conscientious black art historians and critics, museum and gallery directors, cultural centers, investigators and writers whose ambition is a presentation of the reality of black art. Support in the community is also developing in the form of individual and organizational collections. Contact between the artist and the community must

be concentrated and cultivated more especially by those blacks in administrative and coordinating positions. Black Studies programs can aid in the development of interest in and cooperation with black artists and their organizations in their attempt to integrate art into the lives of black people. For this our art and all the books, slides, exhibitions, etc. should be controlled more by our people and organizations.

An attempt has been made to distinguish between two possibilities for black artists—on one hand the attempt to enter and establish oneself in the existing U.S. art world and on the other to participate as artists directly in the movement for black liberation. Additional involvement in the liberation of exploited peoples throughout the world has been suggested. There is no intent to attack any black artists for we are brothers and sisters and not enemies. We have not arrived at any absolutes; we are searching. Each work of art by each artist has its own form, its own meaning. Today's form is not yesterday's, tomorrow's is not today's.

NOTE

1 *Studio International*, Nov., 1970.

1975

Burton Wasserman, "Where the Flesh Ends and the Spirit Begins," in *Barkley L. Hendricks: Recent Paintings*, catalogue for exhibition held at the Greenville County Museum of Art, Greenville, South Carolina, August 23– September 28, 1975

Barkley L. Hendricks was born in Philadelphia in 1945 and studied painting and photography at the Yale School of Art between 1970 and 1972. Despite the inclusion of his work in exhibitions such as the Whitney Museum of American Art's *Contemporary Black Artists in America* (see pp. 333–40), little was published about his work until his solo show at the Greenville County Museum in South Carolina in 1975, and he did not, in these early years, give interviews or issue statements. Burton Wasserman was an artist and art historian teaching at Glassboro State College (now Rowan College) in New Jersey, and while not explicitly addressing the Black subjects of Hendricks's paintings, he finished the article contemplating the concept of "soul." Hendricks later recalled, in the chronology for his 2008 retrospective *Birth of the Cool*, that in preparing the Greenville show, "I was told I would not be able to show any nudes. I later discovered they had white nudes in their collection. My black nudes were just too 'black,' so I've been told."[1]

BURTON WASSERMAN, "WHERE THE FLESH ENDS AND THE SPIRIT BEGINS"

Barkley Hendricks brushes color on canvas like nobody else in the world. Mixing his paint with a rare blend of light and mystery, he creates awe inspiring visions that are uncanny in their capacity to transcend time and space even though they seem to show pictures of people and things anchored in the here and now.

Beyond the sharp focus of external details Hendricks' art projects an intensely vivid inner vision. The image of overt reality on the canvas is only a wrapper for the deeper experience he shares after you get down to the threads beneath the paints. And yet, unlike so many other painters who traffic in the revelation of "inner visions" Hendricks avoids all the trite and twisted clichés cooked up by those who claim to illuminate the meanderings of their subconscious. Instead, Hendricks' subject matter consists of people and things he knows from the grind of his daily life. Faces, bodies, clothes, basketballs, and even tin cans have served as grist for his creative mill. What emerges, virtually like justice itself, has been ground exceedingly fine; fashioned into forms as solid as Stonehenge.

While his style does make use of highly literal representation, Hendricks has nothing in common with the hack illustrator who merely turns out slick pictures and nothing else. The colors and textures he registers so crisply on canvas are nowhere near the end-all and be-all of his efforts. His figures are not people; they are *pictures* of people. As such, they identify abstract essences. For example, they reach into the metaphysical possibility of enduring past measurable time, all the way to the point of touching infinity. They also probe the potentialities of being able to come and go anywhere and everywhere within the same moment.

With a knack that defies easy description, his language of vision penetrates such eternal mysteries as the sense of loneliness people feel in complete isolation; what it's like to be near the world and yet also, entirely out of touch with anything or anybody; and how entirely vacant a space can actually be when it otherwise seems to be quite full.

The more you study his pictures, the more you perceive the simultaneous existence of polarities. Logically, that may not sound sensible or even be possible; at least not in a practical or material sense. But, in a Hendricks picture it is possible and it does happen. For example, you see images that are both public as well as private. Forms are alive and yet not alive (but they are definitely not dead either). The figures seem to be in a distant dream while they are also in the immediate present. They are familiar and yet strangely unfamiliar. While a particular scene may seem to be as calm as anything can be, it is also stretched to the breaking point in the tightness of its tensions. Sitting back, supposedly relaxed, his figures could just as well spring right out of their skins should the right stimulus suddenly cause them to unzip the cocoon of stillness that seems to enclose them.

Hendricks' work may not be pure in the same sense that art by a Piet Mondrian or an Ad Reinhardt is pure. However they are pure in their own intensity, integrity, and freedom from dilution. Furthermore, they are powerfully pure in their rich painterliness. In no way do they lend themselves to possible adaptation as textile designs or any other sort of trivial decorative function. Any such attempt would not only cheapen Hendricks' art, it would also destroy it beyond recognition. That's why his pictures are such a blessing and a relief from work worn ragged by exposure to a world in which paintings seem so frequently destined to bear the burdens of extra-art expectations. Hendricks' art is thoroughly useless for such external applications. It is only good for human consumption, internally, where the flesh ends and the spirit begins. And if you will, you may choose to remember that another word for spirit is soul.

NOTE

1 [Barkley L. Hendricks, "Selected Artist Chronology," in *Birth of the Cool*, ed. Trevor Schoonmaker (Durham, NC: Nasher Museum of Art, Duke University, 2008), 117. —Eds.]

1975

Cindy Nemser, "Conversation with Betye Saar," *The Feminist Art Journal* 4, no. 4 (Winter 1975–76)

As noted earlier, the *Feminist Art Journal* is often recognized as the first long-standing, mainstream title dedicated to art made by women. The conversation here between Betye Saar and Cindy Nemser, the journal's editor, is an example of the type of interviews with contemporary artists that were published alongside profiles of historical figures and exhibition reviews.

CINDY NEMSER, "CONVERSATION WITH BETYE SAAR"

Betye Saar is a California artist who has drawn deeply and skillfully on her experience as a black woman to create an impressive and hauntingly beautiful body of work. Born in 1926 in Pasadena, Saar grew up in a middle class ambience but frequently visited with her grandmother, who lived in Watts within sight of the famous Simon Rodia Towers. At the age of 34, after studying graphics design, Saar turned to collage into which she incorporated objects and signs associated with the occult. In the late 60's however, with the quickening of black consciousness and militancy, her art began to reflect her new political awareness. By using "derogatory" images, stereotypes such as Aunt Jemima and Little Black Sambo, as well as such titles as *De 'Ol' Folks at Home, I've Got Rhythm (We Shall Overcome)* and *Two Darky Songs*, she constructed some of the most poignant and pointed visual statements of black feminist protest to come out of the early '70's.

While Saar was converting symbols of oppression into symbols of revolution (Aunt Jemima is equipped with a rifle and a revolver), she also began to rebuild black pride by delving into African culture and using its traditions as source material for her shrines and hanging pieces. Collages created out of bones, feathers, leather stripes, and beads are given titles such as *Gelede* and *Mojo Bag* which come out of secret African tribal rituals. Drawn back to the mystic through her African roots, Saar once more included the occult into her works, utilizing archetypal signs and symbols from the transcendental teachings of both eastern and western philosophies and religions. After casting her net wide enough to pull in artifacts from the distant past and the geographic remote, the artist has recently settled down to explore, in an intensely personal manner, the black American culture of the 20th century. In works such as *Bittersweet*, 1974, and *Miz Ann's Charm*, 1974, old photographs as well as faded pieces of clothing and jewelry all serve to evoke memories of a private and at the same time collective past in which problems of both a personal and political nature manifest themselves.

Betye Saar is one of those rare artists who has been able to build a contemporary but universal vision out of the changing social attitudes of the past decade. Her one-woman exhibition at the Whitney Museum in 1975 proved that strong political and social commitments are no deterrent to a delightful aesthetic accomplishment.

CINDY NEMSER: When I saw your exhibition at the Whitney Museum last March, I was particularly struck by the evocative imagery you use in your boxed collages. Could you talk about how your work evolved?

BETYE SAAR: My work is divided into three groups. In the first group I go in and out of the mystical or the occult: Tarot cards and zodiac signs. That started when I was a graphics artist dealing with drawings and paintings. Then after the black movement began I found my work changing because of my strong feelings. I started collecting my derogatory black images. By that I mean Aunt Jemima, pickaninnies and Black Sambos—and by using that black imagery my work changed and became a revolutionary art. For example in *The Liberation of Aunt Jemima*, I take the figure that classifies all black women and make her into one of the leaders of the revolution—although she is a pretty strong character anyway. But there was a time, even during the revolution, when blacks put other blacks down as "Uncle Toms" and "Aunt Jemimas." It is only recently that we realize that we are here because of the particular role that they played—the subservient role that protected the youth so that they could grow up and get an education.

NEMSER: Well, your Aunt Jemima looks anything but passive.

SAAR: Yes. She's got a small revolver in one hand and a rifle in the other, and although she still has a broom with a pencil attached to its handle and a pad fastened to the center of the collage those items are not necessarily to be used for making grocery lists.

NEMSER: You did a series of Aunt Jemimas in 1973. What was *The Liberation of Aunt Jemima: Cocktails* about?

SAAR: Dextra Frankel, a curator, invited me to be in a show with the theme of bottles at that time. I have her Aunt Jemima as a bottle that was transformed into a Molotov cocktail.

NEMSER: Was there a real Aunt Jemima?

SAAR: Oh yes. In the beginning General Mills selected a black woman to play Aunt Jemima and she went around saying, "I's in town, honey." But she is also representative of all the black women who worked as mammies or house servants. They covered their hair that way and wore that kind of apron. In New Orleans they sell pralines and things like that but they are still Aunt Jemimas.

NEMSER: She meant good things to eat.

SAAR: Yes. She was a woman who could cook, who was full of love, a family person. The characterization was negative in that the black woman could *only* be seen as an Aunt Jemima or else she was seen as a hooker, a piece of property. After all, most of the black women's children were mulatto, fathered by the white slave owner. She was a piece of property to be used whenever he felt like it.

NEMSER: What about this box entitled *Whitey's Way* with the slyly leering white alligators?

SAAR: I showed that at the Los Angeles Institute of Contemporary Art recently. It's from 1970 and part of my political phase. Alligators are part of the derogatory black imagery since pickaninnies are known as alligator bait.

NEMSER: I have never heard that expression.

SAAR: It's a southern term from Florida and parts of Georgia where there are swamps with alligators and crocodiles.

NEMSER: And evil white alligators lined up and ready to pounce on any black baby that comes their way. These political works have a lot of irony in them. It's almost like Jewish humor.

SAAR: It does have that similarity. You have to laugh to keep from crying.

NEMSER: What about the occult aspects of your work? In the boxes you showed at the Whitney there were lots of fascinating symbols and fetishlike objects such as feathers and bones. I notice that your pieces have titles such as *Aunt Sally's Mojo* and *Mojo Bag*. What does the term Mojo mean?

SAAR: Well, from my involvement with the black movement I moved into a concern with black history going back to Africa and other darker civilizations such as Egypt or Oceania. I was interested in the kinds of mystical things that are part of non-European religion and culture. The Mojo is a charm that brings you positive feeling, like a rabbit's foot or a four leaf clover. It is a fetish that you keep next to you to bring you good luck.

NEMSER: You use other references to African religious beliefs and cults in your collages. What do the titles *Gelede* and *Giza* signify?

SAAR: Gelede is a secret society of the Yorubic cult which uses the mask of the queen of the witches in their secret rites. However, my mask doesn't look anything like the African ones. *Giza* is Swahili for darkness, blackness, and that assemblage is all black, constructed out of black leather, black beads, black bones etc. It is also a fetish object.

NEMSER: So you are exploring imagery that is both black and occult and putting it together in such a way as to express black concerns of both the past and the present.

SAAR: Yes. Then there is the third group which contains black nostalgia which is made from turn-of-the-century old photographs. These nostalgia pieces are softer and gentler. Some of them also have occult images in them. Here is an early box called *Gone Are the Days* which wasn't in the Whitney show. It started out with a photograph of two really beautiful black children, a little infant girl and a little boy standing by her. I found it in a second hand store and I started thinking "What happened to those people?" I started telling that

story by using certain symbols—for instance the hands holding the heart would be a love theme and the black skeleton would be death or maybe a hand holding cards—the ace or the queen—which meant life is a game. From then on I kept finding other photographs of memorabilia and I put them together and just got a feeling and told a story.

NEMSER: When I looked at the boxes I saw a resemblance to Cornell's in that his are collages and have occult symbols too, but I also see your boxes as much more accessible. They do have a narrative element and at the same time they are very personal. One of the aspects of your art that I admire most is its immediacy. I don't believe in the notion that if something is incomprehensible it must be good. To me important art has a universal appeal so that many people can interact with it on different levels, and that doesn't mean that it must be simplistic or a cliché.

SAAR: I was very impressed with Cornell's work and he has influenced my work just because his was the very first kind of thing I had ever seen in a box. I have always liked collecting little things and liked collage, but when I saw it in a box it just seemed perfect.

NEMSER: When was that?

SAAR: There was an exhibit in Pasadena '69 or '70 when I was a student doing graphics and etching. I found an old leaded window up at Big Sur and I brought it home and framed the graphics in it. Then I began gluing things on top of the window so my formation grew out of the flat or two dimensional. When I saw Cornell's boxes it seemed natural to go into boxes.

NEMSER: It is also natural to put things one collects into boxes.

SAAR: But to put a glass on a box is something else because that makes it into a framed thing. But I don't think my boxes are like Cornell's because his imagery is very different and so are the colors he uses. I do have symbols such as the sun in common with him.

NEMSER: What led you to the occult originally?

SAAR: I think it always has been there for me. As a child my mother told me that I was clairvoyant but once you get into school you lose talents like that. The occult doesn't play that much importance in my life except that I have a great faith in whatever happens happens—Kismet, you know. People ask me, "can you read palms or Tarot Cards?" I checked into it but it bores me. But I like the imagery in these things.

NEMSER: Well the Tarot Card figures are archetypes. T. S. Eliot used them in "The Wasteland" and they appear in so many cultures. They seem to be proof of a collective unconscious. Did you know that you were an artist from the time you were child?

SAAR: I recently found some drawings that I made when I was in kindergarten and I should frame these and have them in my retrospective.

NEMSER: Are you going to have another retrospective?

SAAR: No. I had one two years ago at the California State University at Los Angeles.

NEMSER: Have you always lived in California?

SAAR: Yes. I was raised in Pasadena and went to U.C.L.A. Then I was married and decided to go back to school to get teaching credentials. I went to Long Beach and got involved with printmaking and etching there. After that I decided to work on a masters in graphic designing and etching. I did some drawing, entered competitions, won prizes and started making a little money. Then I felt that perhaps I was some other kind of artist rather than a designer.

NEMSER: How old were you when you made that decision?

SAAR: That was in 1960. I had started going back to school in '56. I'm 49 now so I was 34 then.

NEMSER: That interests me because there is always talk about the problems of young artists. I think the concept of a young artist is not one that should

necessarily be governed by age. What I mean is that if you begin working at 40, then you are a young artist at 50. It seems to me that it is unfair to have opportunities for people under 35, prizes and special shows, and to give little encouragement to late starters, especially women who were often held back because of family concerns. I find it fascinating that you found where your real interest and commitment was when you were in the middle of your life.

SAAR: It took a long time for me to say, "I am an artist." I would say, "I am a designer or an artisan or a craft person." To say I was an artist took a lot.

NEMSER: Why was that?

SAAR: I was so insecure about that. You know at that time blacks were not particularly encouraged in the arts.

NEMSER: You found it doubly difficult in being a woman and being black. I suppose you had to overcome tremendous obstacles in terms of self image. Did the Civil Rights Movement, at that time, give you confidence?

SAAR: As you ask that I am just flashing back on that time. I lived in South Bay when I was going to Long Beach State and was taking a print course. I was keeping a sketch book and was showing it to my teacher. He stayed in his office most of the time and at first I was discouraged because he didn't give us any technique. Fortunately, however, I had a firm background in printmaking so mostly we would rap. I told him I was having problems with my husband in taking this class because he was also an artist and his ego was involved. My teacher said, "He can't use you for an excuse for his own inade- quacies. Once you know you are an artist that's your particular jelly bean (those were his words). Then you just hold onto that and nothing can really change it; it's the only thing you can trust." Up until then nobody had ever talked to me that way. I didn't even know I had it in me. It took an outsider to say *that* what's in you and you should hold onto it.

NEMSER: With your husband you were coming up against the problem of *the* male-female competition.

SAAR: Yes—but it could have been a conflict between two women or two men. If you have a close relationship there is competition; if one wins a prize and the other is locked out, there's bound to be bad feelings, especially if you happen to be married to the person. But, at the same time, he was very supportive to me because I didn't have to work. I could stay home and make art. He is still supportive to me even though we are divorced. He is a restorer and repairs things for me and cuts mirrors.

NEMSER: So you were really caught in a bind because he made it possible for you to do your art but he resented it when your art began to emerge.

SAAR: That competition could have a lot to do with his own personal problems and I just happened to be there and brought it out.

NEMSER: Do you use a lot of personal material in your work—things that belong to you?

SAAR: Very seldom up to now. I like to buy things and my excuse is that I can always use it for my art. I *just* hoard it. But *just* three weeks ago my aunt, who was 98, died and when I was disman- tling her house I found what could be another ten years of work. There were boxes of old photo- graphs from 1901 and earlier and there were her old dance cards—all sorts of stuff for which I had been paying a lot of money. I've decided I can't junk all this so now I'll start on a series that is about her. Then the work becomes even more personal.

NEMSER: I did get that sense of the personal in all your pieces.

SAAR: But the things in those other works were from strangers, people I didn't know.

NEMSER: But they were people's effects, their possessions, and they link up with everyone's sense of what is personal for white as well as black people even though the people in your photo- graphs are all black.

SAAR: Yes, that's true. I was in Womanspace and a mother of one of the artists, a Jewish lady, came up to me and she pointed to one of the photographs

and said, "This is just like the people in my house when I was a little girl. They wore lace and cameo pins and fixed their hair that certain way." I suppose if it were a different country it might be alien but in the United States there are more similarities than differences. It's the same with my boxes. I have one called *The Shield of Quality* that opens up flat and it's light colored. The girls in it are from the 30's. It is one I call a "Bogie" Box—that is a particular kind of black society from the late 20's and 30's—a bourgeois type of thing. It has that sort of elegance and that's why I call it *The Shield of Quality*—it's like a front or a protection. The box developed the way it did because of its color, which is high yellow like the color of my skin. In Negro society one's social class depends on one's color or the texture of one's hair or education.

NEMSER: Then *The Shield of Quality* is a kind of commentary, almost a self-critique.

SAAR: Yes. It comments on the class structure within black society. Then in contrast to *The Shield of Quality* I have that very dark box called *The Time in Between* which has a black fan. It is all very black and has a deep mystery to it.

NEMSER: There's a lot of death imagery in your work. There are skeletal forms and owls and other images associated with death.

SAAR: That's part of the mystical thing too—birth and death and life is *The Time in Between*.

NEMSER: The symbolism of black and white is fascinating. Throughout literature those colors have had different connotations. In *Moby Dick*, Melville reverses them and white is evil while black is good. Ahab puts the little black cabin boy Pip down at the bottom of the boat and it is analogous to forcing his sense of guilt deep down into his unconscious so that he can ignore it . . .

SAAR: Switching the color thing is a good thing to do.

NEMSER: I am interested in this early piece of 1969 called *Black Girl's Window*. Does that have a special meaning for you, almost like a trademark?

SAAR: It seems to because I have used it on a couple of announcements and also it was the turning point when I brought the graphics through to the other side and glued things on the top of the glass. The little wooden panes are used to form small boxes.

NEMSER: And it contains many of your favorite images: sun, moon, stars, totemic animals like the wolf. There are all the elements that make up life, such as love and death. Then there is the little black girl with her nose pressed against the window looking out.

SAAR: Or looking through.

NEMSER: I loved this *Grandma's Garden* with its accumulation of pressed butterflies, ferns, weeds and wilted petals pasted on as if they were still fluttering around this old family photograph. What does *Grandma's Garden* mean to you?

SAAR: My grandma lived in Watts and there are lots of gardens that grew like hers. It's as if you could drive down the street there and say that is *Grandma's Garden* because of the way the flowers grow—as if I just threw out all the seeds and they grew wherever they landed. There are no formal beds or little rows and maybe that isn't important. There they just let them come up because they like flowers and color.

NEMSER: You talked about "Mother Wit" on a panel at the College Art Association last year. What did you mean by that expression?

SAAR: That refers to an intuitive kind of thing—using your common sense, your mother wisdom.

NEMSER: Do you think having "Mother Wit" is a particularly black characteristic?

SAAR: No. But the expression is. Another ethnic group would call it something else.

NEMSER: I also notice in your work that you use the symbols from other ethnic and religious groups. In *Wizard*, 1972, you use the Star of David.

SAAR: After I went through the nostalgia thing I found the work going back to the mystical again. I have quite a few, like this work, which is called

Essence of Egypt. It evokes the secrets of the philosophies of the religions that deal with the people in that part of the world. *Wizard* is more about the European countries—countries associated with the Jewish Star and the Cabala, the Jewish book of wisdom and sacred rites. Then I have one work called *Lama* which has to do with eastern feelings.

NEMSER: So you are tracing spirituality throughout all different cultures. It seems yours is an art meant to bring people together.

SAAR: Yes, and into each one I interject elements of other cultures. For instance, in *Wizard*, the tapestry is from a Chinese wall hanging. There is also a regular star and a crescent which is Moslem.

NEMSER: And then you deal with the heroic image of the American Indian in *My Last Buffalo* depicting the dignity and fighting spirit of Indian chiefs and warriors.

SAAR: That was another political statement that I did in 1973 when the Wounded Knee incident occurred.

NEMSER: In most of your work you have tapped into your heritage as both a black and woman and have been able to develop a new imagery that projects black and feminist values in a positive and universal way. How do you feel about the conflict between those who say only imagery that refers to black experience is authentic, as opposed to those who say there is no such thing as black art?

SAAR: I think it just depends on the individual. Many black people have to go through many learning experiences to find out about both themselves and their art. Not that I have all the answers. I am still growing and going in different directions from where I started out but much of my work did go into making social statements. For me it was like therapy. I had to do it.

NEMSER: In the same way women have to go through all those derogatory images of women, all those stereotypes in order to work their way through that and move on to something else.

SAAR: I don't know if the artists who don't do that are more white oriented in art. I don't know if they are indifferent or if they are playing a game for the market.

NEMSER: Well, women have come up against the same problems. Should we be making specific female imagery and if so what would that imagery consist of? And if we are not making that kind of imagery are we male oriented?

SAAR: It really comes down to the strength of the individual.

NEMSER: There was a great furor about black art a few years ago with lots of black shows. It was a fashionable issue and now the interest seems to have died down. Do you think real gains have been made or was it just tokenism?

SAAR: Well I think a lot of institutions are turning their back on blacks. They feel they are not going to blow up the museums so they can relax. The old bigotry is still there and nothing is really solved. I don't know what the outcome will be except that the good artists will try to keep it together and keep putting up a fight, but you can only do a little bit at a time. It's a process of re-education. The women have to do the same thing.

NEMSER: I think if there is to be a change in the entire social and cultural structure blacks and women must work together. Change must come about through the leadership of the minority groups and those who have been disenfranchised. We have nothing to lose and much that is new and vital to add. After all, if you haven't had much in the first place you don't have to worry about holding up the *status quo*. That's our strength as artists. We are not afraid to make an art that makes a strong social statement. So in the end things are opening up for both blacks and women.

SAAR: Yes I think so. As we get more exposure and recognition our work gets stronger and better.

1975

Earl G. Graves, "The Importance of Art Patronage," in "The Business of Fine Art," special issue, *Black Enterprise* 6, no. 5 (December 1975)

Black Enterprise was founded in August 1970 by Earl G. Graves, who, after serving in the Green Berets, had sold real estate and worked as an administrative assistant to Senator Robert F. Kennedy. Graves's mission with *Black Enterprise* was to encourage economic empowerment in the African American community through educational "how to" articles on finance and entrepreneurship. The journal was pivotal in raising the profile of Black consumers, and in 1973, it published the first list of the top one hundred Black businesses. The December 1975 issue tackled the topic of the Black art market. Graves pointed out in his publisher's note that Black artists could sustain their careers only if the Black community supported their work. Acknowledging the lack of value that African American culture placed on the visual arts, which was, in part, a response to the mainstream art market's disregard for Black art, he underlined the vital role that Black patrons could play.

This issue of *Black Enterprise* also included a feature on Black gallerists such as Linda Goode Bryant, a profile of the collectors Leon and Rosemarie Banks, an essay by Romare Bearden, and a feature by the magazine's associate editor, Diane Weathers, that quoted various artists, including Al Loving, Suzanne Jackson, Fred Eversley, and Howardena Pindell, on their experiences with the art market.

EARL G. GRAVES, "THE IMPORTANCE OF ART PATRONAGE"

Black artists are among the most unique contributors to our cultural heritage. As a group they have given us some splendid moments of unsurpassed beauty marked by insight both rare and perceptive. They have captured for all time some elusive yet universal truths about ourselves and our society and frozen them on canvas and in wood or metal, radiating a kind of joy and mystery that can be unraveled only by the beholder.

Yet many of them toil in relative anonymity, caught in an endless cycle of work and merchandising, obscure figures who engage our attention only at dinner parties or some other such occasions when we want to speak knowingly about all things cultural. It is a vicious cycle, one that maddens as it consumes first the artist's passion, then his energies and finally his self-confidence. Little wonder that in this field, perhaps more than more, only the strongest—and sometimes the luckiest—survive. (Of course, here we are talking about "fine" artists as opposed to commercial artists, whom we will appropriately discuss in a forthcoming issue.)

The sad truth is that too many of us do not take our black fine artists seriously, claiming them only after they have been certified elsewhere as genuine talents. Even then too few of us patronize them. But if black artists and their rich contributions are to be sustained and permitted to flourish we must do more. It is not enough simply to admire only what we have been told to admire by the established art world.

That is not to say that those artists who have labored long and valiantly to achieve recognition are not deserving. They doubtlessly are. What I am saying is that art is not the province of any anointed group or geographical location. There is no single way to express art. Indeed, at its best, art is a masterful interchange of expression that transcends rigid boundaries and narrow definitions. One need only look at the works of a Picasso or a Modigliani to understand the debt these masters owe to more "primitive" art forms—which in this instance happened to be African—to appreciate this essential truth.

But today's black artists, as those in our recent past, are the captives of an art world establishment which is frequently indifferent to their efforts or too often commercially preoccupied with the bottom line those efforts will bring, to nurture or encourage those whose works do not fit a prescribed mold. As a consequence, too many black artists have languished in the backwaters of the art world surfacing only after years of determined efforts. Others give up the battle completely, and are lost to us forever.

True there are those whose talents are early recognized and rewarded but these exceptions merely prove the rule. There are others like Romare Bearden, who appears with me below,[1] and Jacob Lawrence who is featured elsewhere in this issue, whose indomitable artistry won for them an indelible place in the world of art, but both "paid their dues" along the way. Today both men command handsome fees for their work, but as black men they sit astride a world that is deeply troubling to them. They know intimately the precarious world of the black artist.

For years black colleges nourished and encouraged black artists, exhibiting their works, promoting their efforts and providing balm for their fragile egos. But as these colleges have begun to feel the financial strain of our troubled economic times even more keenly than in times past, their ability to provide continued assistance along this line has been seriously reduced.

That is why I think it is imperative that black businessmen begin to assume this role of encouraging and supporting our black artists. As you know, I always support the causes that I believe in. This is one.

The fact is that last April, *Black Enterprise* held an art exhibit at our headquarters in New York. 46 artists were invited to display their works. A modest collector, I have always been interested in art. Indeed, Romare Bearden was commissioned to do one of our covers (December 1972) and I am fortunate to own some of his work. But when the exhibit was finally hung I was frankly not prepared for the sustained quality of excellence that was on display. And from the enthusiastic response of the hundreds of people who came to see the exhibit, neither were

they. Personally, it was an eye opener for me. For on display were the works of fledgling young artists as well as more established figures. And their work depicted life and captured emotions with such artistry and perception that one could only marvel at the way those images kept leaping out at you, communicating with you.

I suppose it could be said that it is the civic duty of black businessmen to support black artists and there is some merit in that. But that hardly seems necessary. There is an obvious need for us to develop artists in the same way that we help to develop scientists, but there is more. Our children need artists as role models. Our youngsters need to be familiar with black artists such as Romare Bearden (with whom I am pictured above in his studio) and our own outstanding art director, Ed Towles, just as they know Henry Aaron and Muhammad Ali, so that they can grow up with a well-rounded understanding and appreciation of our culture. There are both tangible and aesthetic reasons for black business support of black artists and the most attractive reason is that, if you are serious, you can have it both ways: An art collection that is aesthetically rewarding and at the same time an investment that is financially viable, one that appreciates with longevity.

The basic reason for such a fortunate situation is that, despite their talent, the work of black artists generally is underpriced. But as their work becomes better known and better accepted, those collectors who early appreciated their work will find their investment mushrooming in value.

But more important than that, the purchase of black artists' work will bring you a discovery about a part of yourself that is both challenging and rewarding. Too frequently, business can be all bottom line and balance sheet, but you will find that in supporting our art you will have uncovered another dimension: An investment in art is also an investment in our culture.

With that thought in mind, I would like to dedicate and present this issue to all black artists, and to you, our readers, in the spirit of Christmas.

NOTE

1 [Running with the original text was a photograph captioned "Romare Bearden, master painter, shows some of his work to BLACK ENTERPRISE publisher Earl G. Graves (right) and Art Director Ed Towles (left)." —Eds.]

1976

David C. Driskell, "Evolution of the Black Aesthetic: 1920–1950," in David C. Driskell with Leonard Simon, *Two Centuries of Black American Art*, catalogue for exhibition held at the Los Angeles County Museum of Art, September 30–November 21, 1976

Two Centuries of Black American Art was presented by the Los Angeles County Museum of Art (LACMA) as its major exhibition for the American bicentennial celebration. The landmark show was the first historically comprehensive exhibition of works by Black artists to be staged at an American museum. Curated by David C. Driskell, who had been recommended to the museum's board by the artist Charles White, the exhibition featured more than two hundred works by sixty-three artists. Driskell's goal was to show that Black artists had been fundamental to American visual culture for over two centuries. Works in the show dated from 1750 to 1950 and highlighted creators whose contributions to American art had mostly been omitted from historical accounts. Although Driskell did not focus on contemporary art in the show, toward the end of his long catalogue essay he did weigh in on the current debates about the Black aesthetic, expressing skepticism and concern about the Black nationalist position taken by some and the impact of their rhetoric on other African American artists. The exhibition saw record-breaking attendance and went on to be shown at museums in Atlanta, Dallas, and New York.

DAVID C. DRISKELL, "EVOLUTION OF THE BLACK AESTHETIC: 1920-1950"

No viable aesthetic was developed among black artists between 1930 and 1950 because black leaders and intellectuals did not take their artists nor their art seriously. Unfortunately, neither did many black artists. It was assumed that art was trivial, peripheral, while politics, economics, and religion were of central importance.

Black art, unlike black music, was never valued purely for its power to captivate the spectator. Instead the art object always served as a sign of some other cognitive interest, and could be neither pleasurable nor exciting unless it was "socially significant." It had to be treated not as art but as a lesson in social history or an instrument of social change.

By assigning a function to art that it might not be able to perform, this attitude caused artists to try to synthesize their work within familiar framework of known, familiar experiences. Any approach that was removed from ordinary experience (abstraction is a prime example) was rejected. Art could not be autonomous, independent, self-sufficient. Value was seen not in formal organization, but rather in the literal depiction of objects, persons, and events of "real life." This attitude was reinforced in the late 1960s when urban artists formed cohesive groups such as Afri-Cobra (African Commune of Bad Relevant Artists) to create work in a style reflecting the mural arts. The subject matter of black art became all important: the closer art resembled "real life," the more one could "learn" from it. As a result the imaginative, sensuous totality of a work was neglected, if perceived at all. Subsequently, the value of the art depended on how moral, praiseworthy, or politically valid the subject was.

This explains the ire of Du Bois and others who thought there was real danger in the twenties penchant for portraying the "Negro character in the underworld." It also explains why Porter criticized those artists who attempted to capture in their work the "exotica," as defined by white critics.[1] Since art is evaluated in terms of its subject matter, something outside the work—the model—becomes central to its meaning. This attitude has fostered among too many black artists the notion that a "good" work of art is differentiated from a "bad" work of art essentially by its subject matter and its imitation of a "real life" model. Thus the black artist and his audience have inadvertently accepted and acted upon premises that are more pertinent to ethics than aesthetics.

However even within the academic, realist tradition the genius of an artist can elevate him above the literal. To this end, the art of Charles White has captured the beauty of blackness as seen in the expressions and daily activities of his people. More than any other academic artist he has searched the souls of black folks, registering in his supremely successful realism the unique qualities he has found. He overcomes the problem of using his art literally to mirror social injustices by portraying peoples whose joys are experienced even in periods of suffering. No one needs the revelation of a secret code to understand Charles White's art even though he used black content in his work. He reveals those fundamentals of truth known by all who believe man to be "the measure of all things."

Not only White but many other black artists have mastered academic techniques while expressing their ideas in contemporary forms. John Rhoden, Walter Williams, Edward Wilson, Elizabeth Catlett, and Earl Hooks, to mention a few, are among the many seasoned artists whose works explore the dimensions of form that reveal the dynamics of a black aesthetic.

Romare Bearden has articulated on several occasions those theories of art that be believes to be basic to the establishment of a black aesthetic. While he has accepted African art as an element in his own work, he has not allowed his art to become overladen with saccharine "right-on" Africanized forms created by many of the young artists of the 1960s. The young black artists who resorted to imitative forms that relied heavily on the surface qualities and iconography of African art were chastised by the critics. In 1946, long before it was fashionable to discuss the concept of black identity in relation to African heritage, Bearden wrote:

It would be highly artificial for the Negro artist to attempt a resurrection of African culture in America. The period between the generations is much too great, and whatever creations the Negro has fashioned in this country have been in relation to his American environment. Culture is not a biologically inherited phenomenon. Modigliani, Picasso, Epstein and other modern artists studied African sculpture to reinforce their own design concepts. This would be perfectly appropriate for any Negro artist who cared to do the same. The critic asks that the Negro stay away from the white man's art, but the true artist feels that there is only one art—and it belongs to all mankind.[2]

Since the 1950s it has become increasingly evident that some of the issues central to art of the 1920s, 1930s, and 1940s have not received the kind of critical analysis needed to separate aesthetic from non-aesthetic concerns. Such a distinction has not yet been established; if anything, there has been a return to placing the artist at the service of a movement. And if artist and political activist are considered one, the black artist must link his work to the struggle for liberation. Regrettably, the artist has been intimidated by the implication that his art is trivial unless it is politically oriented.

The black community must come to realize that art can have intrinsic value, and act accordingly. Otherwise, it will limit its artists to reproducing when they could define and reveal; to dealing in the anecdotal when they could discover and express truths that go beyond temporal values. Only when we recognize the historical patterns of isolation and accept the responsibility of supporting those artists who express themselves in a universal language of form will black American artists be seen as major contributors to the art of this country.

NOTES

1 [James A. Porter (1905–1970) was a pioneering art historian at Howard University and an artist in his own right. —Eds.]

2 "The Negro Artist's Dilemma," *Critique*, November 1946.

DAVID C. DRISKELL

1976

Samella Lewis and Val Spaulding, "Editorial Statement," *Black Art: An International Quarterly* 1, no. 1 (Fall 1976)

Black Art: An International Quarterly made its debut in 1976. The journal, founded by Samella S. Lewis, Val Spaulding, and Jan Jemison, was intended to keep up the momentum of Lewis and Ruth G. Waddy's popular book series *Black Artists on Art*, two volumes of which had been published, in 1969 and 1971. The inaugural issue included a section on Elizabeth Catlett, who had been a lifelong mentor to Lewis, and featured an image of Catlett's sculpture *Mother and Child* (1971) on the cover. The editors issued an opening statement that set out their motivations. The rhetoric of the Black Arts Movement is evident in their discussion of a "living art" that could provide a resource for "human development." In 1984, *Black Art* became the *International Review of African American Art* (IRAAA) as it widened its remit to include the visual art of people of African descent throughout the Americas.

SAMELLA LEWIS AND VAL SPAULDING, "EDITORIAL STATEMENT"

Art is a basic component of and partner in the full understanding of historical and cultural experiences and their potential as resources for human development. To aid individual functioning—psychological, social and esthetic—we must realize the uniqueness of each culture and the value of its art. In addition, there must be the understanding that there are no cultural or national barriers to an individual's expression of a private world through the various modes of art.

A living approach to art entails a composition of experiences rich in vibrant, personal relationships and communal interactions. True art is not a brief or passing moment of external elements or techniques. Instead, it is a matrix of joy and sorrow and pain and fulfilment expressed through myriad paths of feeling and visualization.

Black peoples are especially fortunate in that theirs has always been a living art. The profusion of cultural experiences permeates the whole of life.

In bringing you *Black Art: An international quarterly*, we will chronicle the heritage of our ancestors, encourage the participation of our contemporaries and enrich this heritage for our descendants.

Betye Saar, "Juju," in *Recent Works by Houston E. Conwill: Juju*, catalogue for exhibition held at The Gallery, Los Angeles, 1976

Houston Conwill belonged to the group of Los Angeles artists known as Studio Z (see pp. 544–45), all of whom were interested in performance art. Conwill, who had studied with Jeff Donaldson and Lois Mailou Jones at Howard University in Washington, DC, and recently completed his MFA at the University of Southern California, was drawn to African ritual, myth, and history. For this exhibition, held in 1976 at Samella S. Lewis's gallery (previously known as Contemporary Crafts Gallery), Conwill showed sculptural works made of latex that functioned as props in ceremonies he also carried out in the space. In the catalogue, Betye Saar, whose own work engaged with the ritualistic nature of magic and witchcraft, describes these multimedia installations as "large ritual hangings" that "emerge as folklore." Conwill was also associated with the Los Angeles Street Graphics Committee, a group of artists who painted socially minded murals around the city.

BETYE SAAR, "JUJU"

This series of current work by Houston Conwill serve as a bridge from his ancestral memory to the technology of today. The rock engravings and paintings of Tassili and legends of lost cities of Africa are documented by his large ritual hangings of latex and roplex. Houston is concerned with the blending of concepts (of magic, of form), of information transmitted thru hieroglyphics and symbols (guardians, comings and goings, defeat or victory, life and death), and of a history of a people embedded, recorded, and suspended.

The process. Points of power or concentration of creative energy. 1. The gathering of materials (old/new). 2. The mixing of the elements (earth/water). 3. The marking of the clay; symbols/images (does the spirit guide the mind or the hand?), sounds (chants, spirituals, blues, jazz also leave their mark). Eyelets line up to perform for function and design. Technology (pour the latex and roplex). 4. Spirit power again guides assembling and stitching of the shapes. 5. The applying of the colors to transform media into simulated nature. The final product, the media, the messages emerge as folklore, as Ju Ju.[1]

NOTE

1 A generic name of African magic practices—secret societies, cults, and brotherhoods knowledgeable in ancient traditional secrets that may affect life and death. JuJu is coldly objective, there is no good or evil, positive or negative, right or wrong, it only is!!

Senga Nengudi, "Statement on Nylon Mesh Works, 1977," distributed at *Répondez s'il vous plaît*, exhibition held at Just Above Midtown, New York, March 8–26, 1977

In 1977, Senga Nengudi had two solo exhibitions of new work consisting of pantyhose stretched between fixtures on gallery walls, ceilings, and floors; sometimes, she filled parts of the nylon sheaths with sand. *Répondez s'il vous plaît* was mounted in March at Just Above Midtown in New York, and *Nylon Mesh Series* took place at the Pearl C. Wood Gallery in Los Angeles in May. The latter included a performance piece enacted with fellow artist Maren Hassinger, in which the pair moved through a web of pantyhose that alluded to the societal restrictions placed on women. This statement was produced as a handout for the New York exhibition and explains Nengudi's choice of materials. The artist connects her lived experience of motherhood with the historical exploitation of Black women's bodies, specifically when they were made to serve as wet nurses to White children on Southern plantations. Nengudi had begun to use the materials discussed here in the previous year, when she showed several related works at the Los Angeles Municipal Art Gallery in Barnsdall Park.

SENGA NENGUDI, "STATEMENT ON NYLON MESH WORKS, 1977"

I am working with nylon mesh because it relates to the elasticity of the human body. From tender, tight beginnings to sagging end . . .

The body can only stand so much push and pull until it gives way, never to resume its original shape. After giving birth to my own son, I thought of black wet-nurses suckling child after child—their own as well as others, until their breasts rested on their knees, their energies drained.

My works are abstracted reflections of used bodies—visual images that serve my aesthetic decisions as well as my ideas.

Benny Andrews, "A JAM Session on Madison Avenue,"
Encore: American and Worldwide News **6, no. 6**
(March 21, 1977)

This article by Benny Andrews reflects on Just Above Midtown (JAM) three years after it opened its doors. Even then, the gallery, an incubator for Black conceptual artists, remained an anomaly in New York's commercial art sector.

BENNY ANDREWS, "A JAM SESSION ON MADISON AVENUE"

After three years of doing the unexpected—above all, staying afloat—the Just Above Midtown Gallery (JAM), located in the heart of New York's art center, is still going strong.

JAM has been through some difficult times since Nov. 18, 1974, when its dedicated owner, Linda Bryant, first opened the gallery doors. On opening day almost anything nice that could be said about a gallery owned, operated, and patronized by Blacks was said; for the first time, it seemed, there was a full-fledged Madison Avenue gallery solely committed to the promotion of Black artists and their work.

Every few weeks a new exhibition went up, featuring artists such as Suzanne Jackson, David Hammons, Alonzo Davis, Palmer Hayden, Valerie Maynard, to name just a few. They reinforced JAM's image as a gallery devoted to presenting Black artists. People came, drank wine, talked—and more often than not did not buy.

One of JAM's problems was that no recognition came from the art media. Television features and mentions in other public information outlets appeared, but in the art media, where regular art buyers look for information and guidance, JAM was ignored.

By the end of JAM's first year, Bryant was finding it increasingly difficult to pay the rent, utilities, and other operating expenses. In June 1975 she sent personal letters to artists and patrons who had visited the gallery, asking if they would donate a work or buy raffle tickets for works in the gallery to keep JAM going.

The well-attended fund-raising benefit that resulted brought in about $1200, but although the fund-raising drive "really was helpful, the money amounted to only about a month's rent," says Bryant. The next few months were rough. "We weren't able to develop a consistent clientele from the institutions or the private sector, although we did make major sales of the works of Palmer Hayden to the Metropolitan Museum of Art and to Philip Morris Inc. We got some offers from people who wanted to buy the gallery and let me remain as a figurehead—things like that. Then the gallery underwent a change of incorporation. This enabled JAM to receive funding for certain public services, such as starting a lecture series and undertaking a critical analysis of Afro-American art from the 17th century to the present."

Since its beginnings, JAM's stable has undergone substantial changes. Bryant explains: "The gallery has developed a certain style, or feeling towards art. We started pulling away from representational works about a year ago. For example, JAM now presents artists such as Senga Nengudi, who works with nylon mesh filled with sand, automobile tires, and objects that might suggest women, such as dishes. Two others are Noah Jemison, who uses beeswax pigment on raw canvas, and Jorge Rodriguez, a sculptor who works in steel."

Beginning last year, JAM began to introduce the work of White artists, too. "The gallery started to concentrate on qualitative statements that exhibited new concepts and new materials—and those kinds of statements aren't necessarily limited to race," Bryant says. "Moreover, I saw the need to create a forum that presented Afro-American artists on the same platform with other established artists."

Reaction to this policy came from Blacks and Whites alike, she says, but for different reasons. "The controversy centered about the exhibition *Statements Known and Statements Now*, which presented works by White artists such as Jasper Johns and Jim Dine along with works by Black artists such as David Hammons and Raymond Saunders. Blacks felt that the gallery had compromised its principles by exhibiting the works of White artists, and Whites complained that 'non-established' artists were shown with 'established' artists."

Artists now represented by JAM include Hammons, Noah Jemison, Randy Williams, Senga Nengudi, Jorge Rodriguez, and Valerie Maynard, as well as Palmer Hayden and Howardena Pindell. (Both Hayden and Pindell will be featured in major exhibitions in the coming months.) Bryant admits JAM is not completely in the clear, but after three years she is hopeful about the gallery's future.

1977

Studio Z, untitled statement, in *Studio Z: Individual Collective*, catalogue for exhibition held at Long Beach Museum of Art, California, December 11, 1977– January 15, 1978

Studio Z, untitled statement, distributed at performances and events held at "The Studio," 2409 Slauson Avenue, Los Angeles, undated

Studio Z was a loose collective of Los Angeles artists based in the former dance hall on Slauson Avenue where David Hammons had his studio; other members included Senga Nengudi, Frank Parker, Houston Conwill, Ulysses Jenkins, Maren Hassinger, RoHo (born Donald E. Davis), Joe Ray, Franklin Parker, Kathy Cyrus, Ron Davis, Greg Edwards, Duval Lewis, Barbara McCullough, and Roderick Kwaku Young. Starting in 1976, the group collaborated on performances and actions such as Nengudi's *Ceremony for Freeway Fets* in March 1978. They regularly exhibited at LA's Pearl C. Wood Gallery and Gallery 32 and also used the Slauson Avenue building to host concerts by musicians such as the jazz pianist Horace Tapscott. In 1977, the curator Kathy Huffman organized *Studio Z: Individual Collective* for the Long Beach Museum of Art. While the artists displayed individual works, here they explain, in a jointly written statement, how each artist's contribution emerged from collective thinking, particularly from the "spiritual presence" produced by collective work. The constituency of the group overlapped with the artists showing at Just Above Midtown in New York, but unlike JAM, Studio Z was not a commercial enterprise. After the Long Beach exhibition, Nengudi, Conwill, Parker, and Hassinger continued to make occasional performances together.

STUDIO Z (STATEMENT IN CATALOGUE)

elements of now are posted onto the scenes of our thoughts, our thoughts include the absolute, we are dealing with pieces of a dream manifested into the reality of a physical presence. an individual collective is the unit from which we function. a spiritual presence hovers over the collective energy gathered like the grasshopper becomes the locust: we are about a collective energy working toward change ... change to open up our awareness to our own thought processes and environmental influences and the interaction of ours with others until ours are others and others are ours. becoming the bright light that makes us realize we have been touched by the presence of the gods.

STUDIO Z (STATEMENT DISTRIBUTED AT PERFORMANCES AND EVENTS)

STUDIO Z is a group of artists and associates who joined together through mutual feelings that all forms of the arts are interrelated and should be presented so that painters, writers, musicians, actors, dancers, and crafts-persons will have the opportunity to work together.

Our goals are to expose the creative talents of artists, both known and unknown, and to communicate the fusion of their intellectual and spiritual involvement to the world community.

By displaying the interrelatedness within all creative fields we hope to open the doors to a comprehensive educational exchange in which the artists and the community will be closely involved, one with the other, for the purpose of stimulating an ongoing process of creativity.

We are a vehicle producing programs which facilitate mutual education involving the artist with the community and the community with the artist.

STUDIO Z is a forum for the arts offering the community poetry readings, musical concerts, art exhibits, dramatic presentations, dance concerts and film exhibitions.

In the process of exposing the community to these art forms, we stimulate their interest and involvement in the Studio. We recognize the necessity to continue this growth on a larger and more stable (financial) basis. We need donations, grants and whatever is required to keep STUDIO Z growing.

Yvonne Parks Catchings, "Is Black Art for Real?" *Black Art: An International Quarterly* 2, no. 3 (Spring 1978)

Yvonne Parks Catchings was born in Atlanta in 1935. After studying studio art at Spelman College, she earned a master's degree in art education from Columbia University in 1958, then moved to Detroit, Michigan. In addition to teaching art in the city's public schools, Catchings became known for her paintings featuring abstracted, dreamlike landscapes and strongly simplified figures. She was featured in the second volume of *Black Artists on Art*, published in 1971 (see p. 381), and in 1976, her own book, *You Ain't Free Yet! Notes from a Black Woman*, was published by the DuSable Museum of African American History. This essay of 1978 is forthright in its conviction that art created by African American artists is a category in itself, because "the Black man and the white man represent two different time zones in America and . . . have different stories to tell."

YVONNE PARKS CATCHINGS, "IS BLACK ART FOR REAL?"

There are those in America who say there is no Black art. They say that art is neither black nor white, that it is colorless. They are wrong.

Who can deny the work of Langston Hughes, James Weldon Johnson, Sterling Brown, Countee Cullen, or Henry Ossawa Tanner? These were Black artists who did their thing in America—and some outside it.

Their styles were unique as much as the people to whom they spoke and the messages they expressed. Who can deny them?

Art represents the character and history of a people. The English have art for the English character and history; the Spanish for their people; the French or Italian for theirs.

African-American (Black) art, like the rest, reflects the people from whom it comes. Black art is separate from white art in America for concrete historical reasons which involved the Black artist himself. That is, the uniqueness of African-American history produced uniquely African-American artists.

The story of the Black artist in America is a story of constant adapting and adjusting—sometimes abandoning altogether his creative talent or expression. History says this was because of the prohibitions of slavery, segregation, and the evils of exploitation and racism.

Thus, the artist's hands were limited both by the slavemaster and by the very personality of slavery itself. He was removed from the sculptured figures of Benin and Ife art in West Africa. He gradually forgot the technique which produced the creative wonders along the Nile, the Congo, and the Zambezi rivers in Africa.

Now he worked in the fields from sun up to sun down. Spare time was survival time. Who was free to carve stone or etch in wood, to mold clay, or paint on canvas? He was a slave with only the ancient, ancient rhythm to speak of.

And the Black artist did speak with rhythm. From the first hummings of the spirituals, the first blowings of "jazz" through the saxophone, and much later, the strokes of the painter's brush, he told the story of his life and that of his people inside America. To be sure, Black artists are late returning to the two and three-dimensional art forms such as painting and sculpture. Painters and sculptors have yet to go as far in their mediums—and to express as much in wood or clay or on canvas—as the black musician has with his instrument.

Black art should not be judged by white standards any more than judging the Egyptian sculpture of the golden age with the sculpture of the Italian Renaissance or the paintings of the sixteenth century Florentine painter Leonardo da Vinci with the sixteenth century Japanese painter Sesshu Toyo. All were works of genius and produced marvelous stimulants for the eyes. But they were different races of people with different histories.

Paintings done during the Italian Renaissance and the Baroque period were very different. The paintings of Raphael cannot be compared to Caravaggio's of the Baroque period. Raphael belonged to the Renaissance with its great awakening of the classical arts. The Catholic church was in great power at the time. Everything was ideal and heavenly. The Virgin Mary was always pictured as a young, lovely maiden. Her hair was always in place. Her garments were never wrinkled, and her bare feet were never shown. Saints were always pictured with a head full of hair. They were never shown with bald heads. The Virgin Mary looks like an eighteen-year-old maiden in Michelangelo's late Renaissance sculpture, Pietà, even though Mary had to be forty-five or fifty years old at the time of Christ's death. Art was ideal during this time of history.

Caravaggio, one of the most revolutionary painters in history, came during the time when the Catholic church was under question. Baroque paintings are not ideal. Caravaggio painted *The Death of the Virgin* which is a painting of the virgin on her death bed. Her bare feet are shown, with a wrinkled dress. Her hair is not in place. Surrounding her are saints with bald heads. Caravaggio had the audacity to use a dead prostitute for the model of the virgin. Everything about this painting shocked the church, and the friars who had commissioned Caravaggio to paint this picture rejected it. Painting a scene like this during the Renaissance period was unheard of.

Caravaggio ushered in the Baroque school of painting. He not only brought a new way of interpreting saints but he introduced a new way of interpreting light. We do not want to get involved with the technical details in this discussion, but it is important the way he interpreted what was occurring in his environment.

Caravaggio and Raphael represented two different periods in history. They lived in two different worlds in Italy at different times.

The Black man and the white man represent two different time zones in America and are living in two different worlds. The Black artist and the white artist have different stories to tell in America.

Today's "Black Awareness" calls old habits into question and offers fresh ones. One painter said, "We must hear with new ears and see with new eyes."

As the Black artist moved into his own—from the early 1900s to now—museum curators and art critics have tried to deny his existence especially by comparing his art to white art. Too often the artist was famous or unknown depending upon his willingness to imitate white American styles and put aside the styles characteristic of the history and heritage of Black Americans.

That is a tough demand. It strikes at the very fundamentals of art. The elements of form, color and perspective must be carefully taken apart and rejoined in new positions.

Authentic African culture re-emerges as the reference point of new perspectives. The Egyptian statue of the Black Queen Hatshepsut looks nothing like the Italian Michelangelo's Moses. Black artists will have to meet the new demand before white artists beat them to it. From Africa Georges Braque and Pablo Picasso plagiarized African art forms that they called "cubism." However, Picasso and Braque received the credit.

Unfortunately, many Black artists have been totally brainwashed by white standards. They have dismissed from their minds the power and brilliance of Black art. This is likely rooted in the schooling they received as children. They were likely taught in grade school that Goldilocks and Snow White are beautiful and should be imitated. The lesson said that white is clean and black is dirty. Doctors, nurses, and brides were white. Thieves and murderers were black.

But a "Great Black Awareness" is here. How can the Black artist become his own man? By claiming the Jacob Lawrences and Horace Pippins, the Archibald Motleys and Henry Ossawa Tanners—freely and openly.

People such as Hale Woodruff, Charles White, Haki R. Madhubuti, Margaret Burroughs, B. B. King, Duke Ellington, Charlie Parker, and Richmond Barthé belong to the millions of Black people who have come up from slavery. Such people are the giant-sized example of the limitless creativity which for too long has been lying fallow.

Finally, any who would ask if Black art exists must give an account to those persons named, any who would separate Black art from the white artists' Campbell soup cans and hamburgers on canvas must be willing to recognize a separate people of unique character and history.

There is one liability that Black artists must be aware of and that is the danger of copying white artists. Black artists should not abandon their culture and rebirth as some Black artists of the early nineteen hundreds did. Most artists during the nineteen-twenties were made to feel ashamed of their culture; so they denied their blackness and imitated whiteness. Black people must accept their beautiful culture of singing spirituals and gospel, playing jazz, eating chitterlings and pig feet, and boiling clothes in black wash pots. Don't copy; the price is too great for one to sell a great culture for a few dollars.

The Black man has said much about America, and he will continue to make a greater statement in the arts. He will always paint, play an instrument, sculpt, or mold a blacker shade of Truth—and always tell it like it really is.

1978

Linda Goode Bryant and Marcy S. Philips, *Contextures* (New York: Just Above Midtown, 1978)

Contextures was published by Just Above Midtown (JAM) to document the project *Afro-American Artists in the Abstract Continuum of American Art: 1945–1977*, a series of exhibitions that had been held at the gallery throughout 1977. In the book, Linda Goode Bryant and Marcy S. Philips discuss a growing trend they describe as "contexturalism," referring to the work of Senga Nengudi, David Hammons, Howardena Pindell, Randy Williams, and others. In contrast to practitioners associated with Process art such as Richard Serra, whose work the authors viewed as "self-definitive," these artists were able to work abstractly while still incorporating outside references. They exceeded the typical margins of art, particularly through their use of "remains." Contextural artists also developed new ideas of "energy, mysticism, automatism and ritualistic process." Although Bryant and Philips did not restrict their essay to Black artists, they put them at the center of this new tendency in art.

LINDA GOODE BRYANT AND MARCY S. PHILIPS, *CONTEXTURES*

Developments in abstraction over the past seven years have invariably reflected further investigation of Dada, particularly Duchamp, and Surrealist references and/or premises and philosophies of style developed since the mid 1940s. Thus the process, materials, artist and art object interchangeably become the prominent elements of content and intent.

Abstraction, since Abstract Expressionism, has consistently been involved in the isolation, reduction and illumination of the physical, perceptual and metaphysical properties which constitute reality. The nature of these pursuits has been primarily focused on finding and exposing these properties as they exist naturally and inherently within the confines of the art object. In doing so, the art becomes self-definitive, ceasing to rely on or refer to external phenomena for definition. By isolating and separating its physical, perceptual and metaphysical properties, reducing its effect on and relation to external phenomena and maintaining its definition within the art object's confines, art is placed in a restricted context; its definition and, thus, reality are marginal.

In a radical departure from this method, process and approach to art, a notable development has been occurring since the early 1970s based not on direct derivative associations nor on a synthesis of the past. It is through this process of clarifying and incorporating the contents of the margin that they define the context meaning and relationship between art and reality. Characteristically, the marginal elements will maintain their nature and integrity throughout this incorporation and, thus, define their specific selves. Simultaneously their contextural meaning will be exposed.

While common factors exist between the works of the artists involved, the nature of its development appears happenstance and can be noted on the East and West coasts, particularly in New York and Los Angeles. The artists work independently, resulting in individually designed objectives. Relationships and similarities among them only become apparent through the cross-examination of these objectives, materials, process and ultimate visualization of their works.

Prominent factors which both distinguish and connect their works are primarily the role and position of art to reality, the role and position of the artist, and the process and the use of "remains" as the material in which the art objects are made.

Through an approach akin to modal logic, the Contexturalists work from a method in which reality is perceived in two possible conditions: one, that it is reality; or two, that it is not reality. Through modality these statements of fact are considered merely as possibilities which may or may not be probable or actual. Rather than fixed, actual or certain, these statements become transient and only find clarity and definition through the contextural and transitive process used by these artists. In this sense, the artist acts as a medium in which the properties and conditions of reality are synthesized. Through this synthesis, the context whole of a given reality is presented.

The Contexturalists work primarily from their personal perceptions and accumulative experiences with internal and external phenomena. The artists' interest in the viewer and broader public becomes subordinate to their objective to define themselves, and to determine their own relative and context positions to reality.

The transitive process used by the Contexturalists consists of four elements: content, context, concept and definition. By maintaining the integrity of the individual properties, an equation is established between them in which the properties of the first element are equal to the properties in each of the second, third and fourth elements. The characteristics of these properties will not be transformed or altered. The manner in which they are perceived during each elemental state tends to imply transformation. This implication, however, results from taking the actual marginal properties and placing them into context, thereby altering their perceptual meaning but not their physical characteristics.

As opposed to reduction and isolation, the Contexturalists work from an additive method, placing the content properties into context meaning. They

go outside of the margin to complete the definition that exists within the art. Each individual property maintains its own distinction which, when incorporated in context, not only defines itself but also the environment in which it inhabits.

The use of "remains" as material is common throughout the works of these artists. The extent to which remains are used, however, varies. At times they are the dominant material and constitute the art object (Hammons) or they are incorporated with other objects and materials, often ready-mades and discards, in order to formulate the nature and characteristics of the art object (Williams). The types of remains which are used ranges from clothes dryer lint, smoke (fumage), sand and hair, to wax, grease, paper dots from hole punched paper and wood.

By definition, remains constitute the matter or substance left over from a primary action. Unlike a discard, which had a function or purpose that ceased to perform, or a ready-made which has an intended purpose and function which it still performs, the remain has no particular purpose or function, or a definition clarifying its intent. The nature and conditions of its existence are ephemeral. The properties of ready-mades and discards are stable. They are not flexible or meant to be transient.

Duchamp's *The Fountain* (a ready-made), when taken from its natural environment and placed into an art environment, physically retains its perceptual meaning, Conversely, it can be taken from the art environment and placed back into its natural environment without changing any of the properties which constitute its initial definition and reality. Its self-contained physical, perceptual and metaphysical properties will not alter in its presentation in either environment. However, the process of isolation and reduction, as well as its placement out of context in order to alter the manner in which it will be perceived, will completely transform its original intent, definition and function. The urinal, outside of its natural environ, ceases to be the urinal that exists within its own and natural reality. In an art context it is unable to perform its initial and primary function, intent, purpose or definition.

The transient properties of remains, however, allows them to be utilized within the transitive process of the Contexturalist without transformation, distortion or alteration in meaning. David Hammons' hair, when taken from its initial environment and incorporated within context, maintains its properties (physical, perceptual and metaphysical), and continues to perform its function. The hair, regardless of the environment and context in which it is placed, will maintain all its initial elements and properties. The external perception of the hair will not change. The context in which it is perceived may alter its meaning as opposed to the Dadaist process of isolation and alteration of the ready-made or discard which changes its physical, perceptual and metaphysical definition and reality. The meaning and reality of the remain will stay constant throughout its context incorporation.

An acknowledged element and consciousness shared by many of these artists has been music and dance. A spiritual quality, as well, is apparent in their works as they seek to involve, through context, the essence of reality. The works do not become symbols of the real or spiritual continuums, however, but rather become the transit in which these two elements co-exist. The nature of their work provokes sensory, psychological and visual perceptions.

Contextural elements have been apparent in the works of David Hammons since the 1960s when he began exploring contemporary printing processes and abstracted figural forms. During this time he extensively experimented with various printing techniques involving and incorporating body imprints. Extracting all but the fundamental components of traditional printmaking and expanding on contemporary methods, he developed a body printing technique which directly utilizes the body as the printing plate. His process involves three stages as he works from the negative to the positive image. Oiling the areas of the body to be printed, he then presses them onto a surface. Through sifting powdered pigment, obtained from decomposed sticks of chalk (remains), these imprints are exposed.

Unlike methods commonly associated with body printing where the body marks a plate which is then used to transfer this marking onto a surface (Johns, Marisol, George Segal) or where the body is inked or painted, pulled, draped and rolled

across a surface (Yves Klein), causing additional visual effects which distort the integrity of the actual impression of the body's surface, Hammons' method produces exact, accurate and undistorted impressions. His body prints maintain the integrity of the plate's surface, producing imprinted replicas of body structure and texture.

Hammons' earliest body prints integrate social and political symbolism with distorted figural forms and textural compositions. Paradox, which he achieves through integrating commentary and satire into visual vignettes of seemingly contradictory imagery, becomes a significant element in the works created between 1967 and 1972. Initially these vignettes incorporated ready-mades and discards. Hammons, as well, translated the body print onto a silkscreen which was then used to transfer the imprint onto the final surface.

In *Black Boy's Window*, 1968, Hammons incorporated the body print within an actual window frame and panes. Transferring the initial imprint to silkscreen, he disassembled the window, printing each pane separately. After the printing process had been completed, he reassembled the window, panes and shade which could then be left up or pulled down by the viewer.

Hammons creates visual as well as structural tension within his compositions. Through the sequential placement of the six panes, the vertical perspective is accentuated by the central placement of the figure. By eliminating the arms, suggesting their presence only by the placement of hand prints on each side of the figure's head, the vertical pull becomes more prominent only to be contradicted by a decorative horizontal dissection. The embryonic stages of his technique are apparent as undefined textural areas inhibit the individual and distinct structural areas of the figure's imprint. Balance is achieved, however, by the emotive qualities of his images. A barred foreground and the elimination of the arms and lower torso of the body further accentuate the imprisonment of the figure.

Hammons has consistently worked with symbols. During this period the American flag is a recurrent theme; as the border and frame for *Injustice Case*, 1970, to the body wrap for the female

in *America the Beautiful*, 1968. Textural effects become more prominent as the hair and torso areas take on definable qualities.

Between 1969 and 1971, textural effects dominate the works. The symbol is removed and his considerations for space move from the geometric division of the picture plane to visual delineations which occur through textural transitions and juxtapositions. Hammons also relinquishes almost all allegiance to a literal presentation of the body's structure.

In *Close Your Eyes and See Black*, 1970, Hammons distorts the structure of the body, making the parts compact and seemingly self-contained within the torso area of the figure. By controlling the amount and application of the powdered pigment, texture becomes a decisive element in defining the movement which occurs within the figure's confines.

During 1971 Hammons moved from paradox toward contextural definition. Focusing on social, political and symbolic connotations of actual objects, he began a series of works incorporating the spade shape which led him to a series of three-dimensional works using actual spades or shovels. Derogatory social connotations of the symbol are dispelled as the spade (cut, tied and chained) becomes a fetishlike apparition endowed with dramatic and spiritual overtones as in *Laughing Magic*, 1973.

Intrigued by the various possibilities of presenting the spade, Hammons developed a series of spade mysteries. Process works evolved involving the spade or its shape in a series of social and psychological dramas. From being killed by an automobile to being destroyed by its own image, these works return to paradox as they refer to racial, social and economical conditions.

Concurrently, Hammons continued his abstraction of the body prints. Employing aspects of his earlier assemblages, he superimposes the textural quality of the imprint onto the textural surfaces of collage material. In this series of works, areas of imprint are restricted to defining the interiors of the collage fragments. The spade shape is adjusted to a pyramidal form which is used as a decorative motif sequentially distributed throughout the background plane.

The body form was completely abstracted by the latter part of 1974. Eliminating collage, he restricted his surface to imprints defined by repetitive shapes and textures which he acquired from various types of cloth and found objects. To achieve this abstraction he alters his technique: first he oils and prints the shape which will define the external boundaries of the form; then he presses into and abstracts from this layer of pigment with body parts and found objects in order to define and abstract the internal areas (*Ragged Spirits*, 1974).

Both stimulated by a growing interest in the work of Duchamp, as well as his concern that the creative process not be dictated by "need of money," and as a result of his use of found spades, Hammons moved away from a reliance on art materials. His objectives were constantly proclaimed as he sought to make art that ". . . no one will buy . . . outrageous art . . . it will make people think, think about themselves and what that means. You can't sell this . . . they won't buy this . . . old dirty bags, grease, bones, hair . . . it's about us, it's about me . . . it isn't negative . . . we should look at these images and see how positive they are, how strong, how powerful . . . our hair is positive . . . it's powerful, look what it can do. There's nothing negative about our images, it all depends on who is seeing it and we've been depending on someone else's sight. . . . We need to look again and decide."

Hammons' *Bag Series* consisting of found brown shopping bags, organic and manufactured grease, hair, rib bones and glitter emerged in 1975. Working from the natural folds and crevices of the bags, he developed the line and form compositions of these works. Attaching bag to bag, Hammons is able to construct horizontal and vertical movement by gradually changing the placement of one bag onto another. In *Untitled*, 1976–77, a wing-like form is projected on both sides of the vertical hair band which acts as the central axis. Resembling an open fan, the movement and direction of these undulating forms are emphasized by the paper's folds creased in a manner which allows them to jut from the surface, creating a shadowy depth. Hammons stains the surface of the paper using thick and thin grease. Once the initial layer of grease is applied he rubs it into and out of the paper's surface, creating stain variations. This accomplished, Hammons changes the type of grease. Again, rubbing into and out of the paper, he is able to vary the staining effect and alter the surface complexion. Additional layers of grease are applied in order to provide textural build-up and variation. These areas are generally utilized to emphasize or de-emphasize the contrast between the light, dark and shadowed areas. Color is introduced by attaching glitter to the outer edges of the fans. Maintaining his pyramidal and triangular forms, these color areas assist in accentuating the movement of the outer edges and provide contrasts to the subtle stain patterns and coloration of the bags.

In many of these bags Hammons attaches the remains of barbecue rib bones. Glitter was sprinkled upon these uncleaned and naturally decaying attachments, and they were then tied to the outer edges of the bags in order to accentuate horizontal or vertical movement.

Intrigued by the effects of hair when incorporated within the *Bag Series*, Hammons began his *Hair Series* in 1976. His first work incorporated hair threaded wires with a Yoruba mask which was suspended from the ceiling and adorned with a gown of plastic. The hair-wire acted as a floor environment which enclosed the fetish. In subsequent works the hair was attached to found objects (*Murray's Can*, 1976) or placed behind glass in frames. These framed works primarily focused on the textural properties and compositional potentials of hair. Sifting coarse hair through a strainer, Hammons created a background of fine bits which were superimposed with curly locks and delineated with straight strands. These confined hair works were then freed, strung on rubber bands and stretched to scales of ten feet in length. Attaching and stretching rubber band to rubber band, Hammons developed wall drawings of lyrical and staccato movement. Jutting up, jutting down, dissecting horizontal and vertical planes, these seemingly suspended balls of hair perceptually intrigue and deceive as they allude to ephemeral motion while statically contained.

Through further investigation of the properties of hair, Hammons found that the sifted hair, when

placed in a mold, could provide its own support. A series of hair pyramids was developed. Each individual and unified pyramid is imbued with its own distinctive textural and tonal qualities as in *Untitled*, 1976. Placing these pyramids on the floor, Hammons arranges them in a combination of open and closed patterns. An interest in pattern continues in the hair works as he uses the sifted hair as stuffings for holes in found metal and screens. These works generally consist of six to ten quilt-like components, and are often reminiscent of the geometric compositions found in African textile designs. Later, Hammons combines the hair threaded wires and screens with large forms or unsifted bodies of hair and barbershop debris, achieving a contrast between the patterned, linear and the undistinguishable.

In 1977, Hammons returns to the hair threaded wires, but now frees them from any attachments and allows their form and interaction to determine their line, movement and compositional structure. No longer confined, they create environments of lyrical, staccato and, at times, seemingly sporadic energy. In *Untitled*, 1977, each individual wire maintains its own perceptible characteristics and distinctions. In groups, they physically narrate their environment in a manner which often taunts the viewer into acknowledgment and interaction. This physicality is enhanced further by their organic, tactile and sensuous nature.

Untitled, 1977, breaks from all restraint, distributing energy across the wall as the wires appear to grow, crawl and multiply while continuing the elusive and perceptual deception noted in the *Rubber Band Series*.

In *Untitled*, 1977, Hammons physically confines the hair-wires between the intersection of two walls. Almost in defiance of this restraint, the wires disseminate an energetic activity through their bending, pulling and interweaving, creating a nervous tension and agitation. In this work, Hammons returns to his concern for the triangular-pyramidal form which he emphasizes by enclosing the right angles with hair-wires.

Working with space, Hammons has maintained his concern for creating environmental and atmospheric conditions which provoke, engulf and contain the viewer. The nature of these works repel and intrigue, include and exclude participation from the viewer. The nature of this participation is based purely on the viewer's perspective and willingness to be included within the contextural composition and presence of the work.

Hammons continues his use of images, symbols and materials, responding to a variety of attitudes and conceptions, often contradictory, which he then incorporates into his interweavings of the physical, perceptual and metaphysical properties of the internal reality of the art object and the external reality of experience. This contextural process allows him to assert and define his relative position to art and reality.

Hammons' interest in the viewer has been one wherein the conditions of their reaction and response is predicated on an environment in which contradiction and his contextural "truth" coexist. With no assistance, the viewer is left to decipher the distinctions.

Hammons' placement of the art on the ceiling in order to make "people look up," thus jolting their natural and usual position and relationship to the art object, occurred to him in the early 1970s which he conceptualized in *Gray Skies Over Harlem*, 1977. This environmental piece incorporates objects and materials from egg shells to tea bags and roaches with colored wire and hair. He alters the position and perspective of the viewer by placing the work on the ceiling, subordinating the viewer to the object. This archeological-like icon continues to exude nervous and sporadic energy, dissecting the meaning and content of each object, collectively providing contrasts, conflicts and similarities through which his definitions and reality are proclaimed.

Tension, environment, architecture, atmosphere and emotion are prominent elements in the anthropomorphic structures of Senga Nengudi. Working with nylon mesh and sand, she twists, pulls, intertwines and sags her material into sensuous and sensual emotive formations.

Nengudi's work during the latter part of the 1960s and early 1970s consisted of water-filled vinyl forms. Folded and twisted, these self-contained

transparent and physically limp structures were pushed into long, thin rectangular shapes. By adding color to the water (which was heat-scaled into the vinyl), Nengudi was able to juxtapose color and form into layers of visually penetrable mass. Tension and flexibility were obtained through the varying distribution of water throughout the plastic, holding it in place by the folds and twist of the material and the weight of the water. These skin-like folded forms were often draped over ropes and twisted into figural distortions.

From the early to mid 1970s Nengudi experimented extensively with a variety of materials in order to decipher the qualities and properties which would be necessary to achieve maximum flexibility and elasticity. During this time Nengudi developed a series of works with rope and flag material. By tying these outdoors, the wind became an additional element in the works. Therefore, varied and unexpected undulating waves and movements occur as the air current interacts with the pliable forms, imposing a natural dimension into the work.

Nengudi had begun working with nylon in 1975 and in 1976 her nylon mesh and sand works emerged. One of her primary concerns has been the immediate impact of emotional, rather than intellectual, experience. With a background in dance, she seemingly choreographs the object's movement by the tense and abstracted interweavings of emotional, intellectual and social or human experience. Lyrical movement is embodied within the stretched and pulled linear extensions and appendages of the object's central axis.

Her initial works were self-contained, and the nylon stretch and extension were minimal. Distortion of the nylon's naturally limp condition was achieved through tying and knotting. In general, these works rely on the incorporation of ready-mades and discards as the foundation from which they will protrude, surround or extend.

In Inside/Outside–Winter, 1977, rubber, foam and sand act as determinants for the object's form. By placing the nylon mesh over horseshoe-shaped foam both covered with rubber tubing, and creating surface and textural interplays of contrasts from the cool, smooth and slick surface of the rubber to the grainy, warm and sensuous surface of the nylon, she is able to achieve subtle to sharp color and textural variations. Patterned stockings are exposed and emphasized as their stretch by the sand illuminates the threading.

The works increase their organic and sensual feel by stretching and knotting which allows the sand to fill individual pockets. Suggesting human organs, these sand-filled pockets awaken and provoke the viewer's tactile sense since he/she is encouraged to poke and to squeeze, assisting the slow oozing of the sand from the nylon's pores.

While maintaining her incorporation of found objects and debris, Nengudi releases the nylon from its dependence on a foundation of support in Chant–Winter, 1977. The nylon becomes self-supporting. Stretching the waistband by one foot, Nengudi allows the nylon to define its form from its own natural folds and stretch. The waistband and pelvis extension act as the central axis. Tension is reduced and limited to the knotting of two nylons in what might constitute the focal point of the work in the upper center. Contrast is achieved through a fetish-like neckpiece which extends from the suspended waistband, and forms a horizontal dissection immediately below the knotted focal point. The rips, runs and tears are naturally exposed, enhancing the subtle textural qualities of this piece. In contradiction, the piece exists in a relaxed suspension with the tension created through the stretched waistband support and central knot.

Nengudi works in a figural motif which is abstracted beyond specific visual references, but achieved through gesture, movement and an imagery indicative of body parts and structures. "I am working with nylon mesh because it relates to the elasticity of the human body. From tender, tight beginnings to sagging and. . . . The body can only stand so much push and pull until it gives way, never to resume its original shape. After giving birth to my own son, I thought of black wet nurses suckling child after child—their own as well as those of others—until their breasts rested upon their knees, their energies drained. . . . My works are abstracted reflections of used bodies, visual images that serve my aesthetic decisions as well as my ideas."

The tension and the strain, the sagging and the pull become prominent elements in *R.S.V.P XIII*, March, 1977. Reintroducing sand, Nengudi extends the nylon seemingly beyond its physical endurance by attaching it to the ceiling and wall from three points. This triangular formation acts as the boundary in which the central axis is developed. Incorporating sand into the dangling mesh, the vertical pull is further accentuated. Tension exists within the stretched and attached elements as well as in those which hang loosely from the axis. Color, hue and textural variations persist as Nengudi continues to vary the type of nylon which is incorporated within the piece. The sagging pockets begin to taunt the viewer's sensibility since they resemble breasts or testicles which have been stretched to a state of anguish. The environmental and atmospheric nature of this piece engulfs the viewer, challenging response and participation while seducing the viewer through its tactile and sensual qualities.

Nengudi relaxes the tension in *Swing Low, Spring*, 1977. Maintaining the triangular-pyramidal form, she lessens the stretch of the nylon, allowing areas to droop. In an almost suspended animated pull, the nylon is supported from the ceiling. A foreground horizontal band is created through two perpendicular nylon strips which are perceptually stabilized by a lower horizontal fold and two sagging pockets of sand. The slight curvature from the two strips and the triangular pointed "head" alludes to a lyrical and almost demonic display of mischief.

In *Insides Out*, 1977, a tight-knotted tense disturbance is created through the utilization of the limited spatial area between the boundaries in a series of repetitive knots. Again, applying a discard as the hanging support for the piece, she concentrates the areas with varying pockets of sand and knots which tangle and squeeze. The dominating vertical emphasis stresses the tight and discomforted confinements since each contained element appears to struggle for unentanglement.

In *I*, 1977, Nengudi returns to her overall use of environmental space. The nylon and sand pockets act as testicles and breasts, stretched, pulled, suspended and rested, expanding their tension from a repetitive series of attachments to the surrounding walls. The sensual, sensuous and tactile elements prevail as the atmosphere surrounds the viewer in a provocative seduction of his/her senses. Nengudi's concern for architecture becomes illuminated as the work defines arcs, corners and crevices accentuated by its confines.

Environmental divisions of space and form are apparent in *Internal I and II*. Extending the stretch and increasing the number of attachments to the wall, a lyrical and suspended form is achieved. Eliminating the sand, this work is purely defined by the stretch and pull of the nylon against the wall.

Symbolic imagery is implied more through the character and formation of form than through the nature of the materials and the incorporation of objects which have socio-sexual-political connotations in her context. Unlike Hammons, however, her iconography is more subdued, avoiding or subjugating the intellectual in order to evoke emotion and experience into concrete and prominent elements of definition and reality.

[*Here, Bryant and Philips discuss the work of Susan Fitzsimmons, Gini Hamilton, Wendy Ward Ehlers, and Betye Saar.*]

Rites and rituals embody the essence of Houston Conwill's works. In a more literal translation of African concepts into contemporary experiences than occurs in the works of Hammons or Saar, Conwill creates two-dimensional works which act as foils for ritual performances that involve the artist as griot (storyteller) and the viewer as initiated members of his rites.

Casting and pulling roplex and latex from molds, he sews these forms together as "leaves in a book with all its pages exposed simultaneously." He terms these forms petrigraphs because they resemble "petrified animal skins." These leathery-skinned plaques are then embossed with patterns, insect forms, symbols and lines which act as hieroglyphic narratives of stories, tales and myths referring to past and present human experiences. Unlike Fitzsimmons, who exposes and integrates the states of natural and technological phenomena, Conwill alludes to organic material through an illusionistic surface produced by a variety of paint application

and technique in order to produce earth-like hues and texture which suggest organic exposure to natural elements.

Initially Conwill worked in a Gilliam-like paint-wash and canvas folding technique. Since 1974, however, his works have evolved into spiritual and ritualistic commentaries on modern conditions. His theory and method are based on energy and power sources which result from age and continued use. He terms his works *Juju*, a "generic name for African magic and power practices," since his beliefs are based on energy rather than matter as the true nature of things. The nature of things can be controlled by man, as the energy can be controlled through ritual. The reuse and age of the object determine the level of power that it will contain.

These petrigraphs act as memory aids during the ritual. Each contains informational systems of primal icons resulting in a story or tale; a map of human activity and environmental textures.

Recurrent images on the petrigraphs are the roach, fish and alligator. A gut bucket (symbolizing the food remains given slaves and the base level of emotion or experience), a goblet and a ceremonial stool are three-dimensional objects in which the petrigraphs' narratives and ritual performance are incorporated.

Conwill gives meaning to his imagery as the roach signifies plague or bad times; the fish, the sign of life; and the alligator, the messenger. The ritual acts as a cleansing process in which the artist is joined by ancestors to celebrate survival and life. The texture of the work reminds one of body scarifications. In *Edison Tale* the surface of the petrigraph takes on landscape qualities as identifiable objects and personal notations provide the content narrative of the work.

Music is a prominent element in these ritual-works. Initially using spirituals and the blues, Conwill incorporates music in order to "bombard the ears with sounds . . ." thus activating additional sensory participation. He often uses saw dust to induce the sense of smell.

Since 1976 Conwill has incorporated a metallic quality with a more vivid palette. In addition he has included traditional African music in his rituals

which increases the emotional purging of the participants and provides an even more direct and literal connection with African traditions.

While Conwill's art theoretically concerns the conjuring of energy, powers and spirits through contemporary iconography and ritual, it perceptually considers the distinct and similar properties inherent to both modern and ancient technology and primal existence. Contexturally, Conwill provides definition and redefinition, leading the viewer into the surrealistic notations of human thought through maps, formulas and images of the real and spiritual realms of human existence.

[Here, Bryant and Philips discuss the work of Donna Byars.]

Numbers and arrows provide the referential linkage between order and disorder, and content and thematic elements in the personal iconography of Howardena Pindell.

Sharing the other Contexturalists' concern for energy, mysticism, automatism and ritualistic process, Pindell, after the mid 1960s, moved from figurative renderings influenced by de Kooning. Interested in points (dots or spots) as substance, Pindell began to work with ellipses in dot patterning exploring field and illusionary space by 1968. Reminiscent of Poons, Pindell's canvases were influenced by the imagery of microscopic chemical systems and bonds. Like an amoeba in water, her biomorphic forms float in space on the canvases' surface. Uniformly placed dots and brush strokes on the canvas provided the atmospheric conditions of her optical fields, comprised of color and form.

Pindell began her collection and use of remains in works dating from 1969. Initially she selected the one-quarter inch point in the making of her templates. These templates consisted of the one-quarter inch dot uniformly achieved by punching holes into paper. After, color was sprayed through the holes, forming the dot imagery. The one-quarter inch punchings were saved and used in works dating from 1973. The dot imagery of her early 1970s canvases covered the entire surface, providing a variety of visual effects resulting from movement, light and form. Her use of a grid or underlying system

is apparent yet contradicted by de-emphasizing the geometric, rendering the grid in an almost imperceivable state and accentuating the lack of order and the appearance of automatism through irregular shaped, unstretched canvases.

By 1973 a nonchromatic palette was used in the drawings made from the template remains, thereby making color incidental to the perceptual effects which occurred through form, structure and composition. Numbering the dots sequentially, she initially used a grid-like ground as the structural format for the works. The numbered dots are placed in rows, adhering to the grid formation. This sequence, however, is ignored as they are placed numerically at random. *Untitled #4*, 1973, adheres to this format as the dots provide distinct yet similar contrasting characteristics.

Pindell's use of numbers evolved from her interest in ancient and modern writing. She felt number notation provided drawing-like qualities as well as a symbolism of modern language and culture. The numbers were employed to distinguish the dots as well as provide a reference for distance, size, mass, quantity and identification.

The second phase of her dot-numbered works also occurred in 1973. Scattering the dots across a surface of graph paper or three-dimensional grids she constructed from thread placed on top of a foundation board, she increased the random appearance of the dots, accentuating the contrast between order and disorder. Using a spray adhesive, the dots connect in space, forming three-dimensional structures. They hang, fall and intersect, creating depth and a spatial vastness which occupies the total surface of the picture plane. The order and disorder of these works at times become synonymous. Essentially, while the individual numerical displacement and random positioning of the dots can be perceived as disorder, the overall effects provide a unified structure reinforced by identical dot size, and by the grid and surface density which creates a solid, undivided ordered effect. In these works Pindell incorporates powdered-like substances which enhance their tactile quality.

Pindell considers this process of order and disorder one of arrangement, taking facts and information and rearranging the sequence in which they will be perceived. In her *Letter Series* this rearrangement and removal process are clearly apparent. Taking old letters, she cut, rearranged and combined their parts, altering their original intent and individual context, as well as making the personal impersonal by their random and visible display.

By 1974, Pindell returned to the color palette. Removing the numbers from the dots, color now acts as the distinguishing characteristic. She maintained her overall use of space with no fixed focal point. Density and movement were increased through the opaque surface. Contradictions were continued as the overall effect of the work immediately implied static as well as active interweavings. The forms seem to float, yet are sustained. They appear heavy and weightless, continuous yet disjointed.

In 1975 Pindell began her use of arrows in her non-chromatic drawings to aid in distinguishing and determining speed, distance, action and position. She began to make her own paper in order to achieve a translucency in quality which was not possible in the 100% rag paper she previously had used. Translucent in nature, her paper provided spatial expansion as the numbered dots and arrows float in space through the front, middle and back layers of the paper.

During this period she altered her color drawing process. Essentially, the drawings have been produced through her removal and rearranging method. She began first with a series of two-dimensional drawings made with acrylics, gouache, watercolor and oil pastels. These drawings were then folded and punched. The resulting dots were gathered together and added to other dots which collectively make the final drawing.

Recently, Pindell has increased the number of structural elements which inhabit the picture plane. She incorporates not only the dots but also hair, board slats, color pigment, the material from which the dots are punched and other remains which she places randomly on and throughout two-dimensional drawings and three-dimensional grids. The three-dimensional grid is more dominant since it acts as a structural linkage between

the architectonic formations created by the protruding boards and dots as in *Untitled #88*, 1977. In this work the surface areas become more dense since the sculptural qualities seem to challenge the restrictions of the plexi-glass boundaries. Arrested movement and sustained rhythms abound as the drawing appears to be frozen in time, possibly capable of expansion and release without notification.

In *Untitled #83* [*sic*] a tension and depth are qualified by the intermingled interrelating forms. Sparkles have been included as they seemingly "wink," tease and provoke underlying optical surprises, catching and throwing light from within the art object's confines. This depth, these sparkles, the order and implied disorder provide the mysteries and secrets in Pindell's world. The optical activity which occurs forces the viewer to look, re-examine and reassess as he/she tries to ascertain the total imagery and physical properties of the work. Questioning and uncertainty become common visual effects. The work appears almost ephemeral in its visual presentation as the forms play within and without an assortment of remains.

Pindell's recent canvases employ this same quality of surprise and secret. An equal visual suspense is created as the color dots bleed into textural non- and monochromatic fields. She continues her assortment of remain materials to build on the textural quality and visual characteristics of the works. Her concern for the quality of materials becomes more pronounced as she arranges and rearranges their potential effects when placed beside, between and in juxtaposition to one another.

During 1977 the grid of the canvas has become the canvas itself. Making patchwork quilts from square-cut canvases, she continues to obliterate the perceptual dominance of the grid by the build-up of paint and textural devices on its surfaces.

Since 1975 Pindell has developed a series of works, *Video Drawings*. Continuing her concern for order and disorder, she randomly draws her arrow and number system on a piece of acetate which is then adhered to a video screen. Turning on the video and choosing the stations and programs at random, she shoots thirty-five millimeter photographs through the transparent acetate surface. By crumpling the acetate or moving the camera when shooting, she is able to vary the resulting effects of motion, vibration and distortion.

In *Video Drawing: Swimming Series*, 1976, the juxtaposition of arrows and numbers increases the blurred moving appearance of the background, providing visual maps and interpretation to the form and future movement of the calves, ankles and feet. Order and disorder are rampant as focal points are suggested and dispelled.

Pindell's concern for diagramming thought, relative positions, order and disorder and the mystical and ritual suggests an infectious obsession. One is able to examine the individual elements constituting a contextural whole in order to discern his/her potential ability to notably understand and affect the conditions in which he/she exists.

[*Here, Bryant and Philips discuss the work of Bimal Banerjee and Noah Jemison.*]

Large acrylic canvases, ranging in size from four to ten feet, dominate the early works of Randy Williams from the late 1960s to the early 1970s. Incorporating formal elements of Hard-edge and Op, Williams focused on color spectrums defined by pastel horizontal bands. His primary concern during this period was the use of color in relational formats which evoke emotive and optical effects. These formats were prescribed by a catalog of predetermined formulas devised from a series of investigations exploring the effects of various combinations of color range, intensity and hue. These combinations then translated into formulas which became the basis for the compositional structure of each work.

Generally restricting his palette to variations of pink, yellow, green and blue, Williams extracts all but the elemental properties of color, achieving minimal or reductive results which focus exclusively on line and color interactions. The reductive quality is further enhanced by his flat application of paint, eliminating any textural or expressionistic suggestion. By varying the line or direction and width of each band, an illusionary fore- and background are achieved. Contrasting and seemingly spontaneous band assortments emerge from his combination of

repetitive and non-repetitive color bands. Thus, the band arrangement is not numerically sequenced nor are the size, length or width consistent throughout the total work.

Color and color arrangement become an essential component of his optical effects. The properties of each individual color when combined and placed side by side with the properties of another create an illusion of change and difference. Essentially, the same color intensity and hue, when placed in the context of another intensity and hue, will vary in optical effect depending on the color placement.

Color and color placement are further utilized to evoke emotive effects. While maintaining the same color, hue and intensity, repeating it throughout the canvas, Williams is able to provoke a variety of sensory perceptions by his relational formats. These effects indicate and imply a variance of color which only exists perceptually.

In addition to the concern for line and color relationships, movement becomes a prominent element in these works. Through implied and actual variations in line and color, the integration of thin lines between color bands accentuates illusionistic movement. These thin lined bands are often of a color different from the bands they connect. However, the incidental nature of their application, as well as the overall effect of their placement between wider bands, deemphasizes their distinctions, making them almost imperceivable. As a result of the combinations of line, color and accents, a symmetrical force is achieved, exposed through the relational patterns established by similar and contrasting elements.

During this period, Williams worked on a series of drawings which combined the skeletal structure of the human figure with geometric line drawings placed in the fore- and background areas. Employing a similar system of symmetry and use of subtle devices noted in the paintings, Williams focused on form similarities between the triangles, squares, circles and rectangles occurring in the skeletal and line drawings. Color is used merely as an accent in the first drawings. As these works developed, he began to incorporate subway maps and watercolor bands. The lined shape becomes solid form and the

subway maps become the connector between repetitive shapes.

The drawn lines become the connecting factor between the shapes in each form rather than color. The skeleton is distorted through elongated poses and its space is restricted by lines placed on the immediate outer edges of the figure. Williams, then adding Color Aid paper and cutting into the surface paper, juxtaposed white with color backings. The Color Aid is used also as geometric collage accents on the surface.

The technical and exacting aspects of these drawings are assisted by his usage of a compass. This allowed the hard-edge quality of the paintings to be translated to the drawings. Dissections of the skeletal form led to further abstraction where the drawn line and collage became more prominent. His use of maps was extended to include the use of discarded pages from books and paper debris.

Williams' use of discards and debris in these drawings which date through 1975 predict his transition into Contextural Art. Fascinated with the book concept, he began his first book series, but continued his investigations of form and color interactions. Utilizing standard drawing books, he cut geometric forms into the pages. A number of white on white, form on form works resulted. Retaining this format, he began adding color paper. Initially attaching the color to the pages within the confines of the book, he allowed them to extend beyond the original pages, causing a shaped and irregular frame or defining boundary. These works became expansive in size, ranging from four-by-four inches to four-by-five feet. Cutting and assembling color and construction paper on the pages, exacting geometric lines continuously occur. Through the usage of color paper, this series of books concentrated more subtly on the relations between line and form since he utilized the print size and design as a guide to cut and formulate geometric shapes.

Moving from the horizontal bands and pastel palettes of earlier canvases, Williams, between 1975 and 1976, worked on a series which he termed *Music*. Using music as the catalyst for these works, he began to visually construct the melodic and textural elements of jazz and classical music. Unlike

the works of Dowell which primarily focus on the compositional structure of sound, Williams concentrates on its impressions. No longer utilizing an illusionistic fore- and background, he defined a separation between the two, juxtaposing lyrical and hard-edge forms on a solid background. Initially, the fore- and background planes of these works were developed with the same color but were contrasted by changing the register. As these works developed, three layers came into existence—a front, middle and back—defined, again, by changing the register of the color. The top layer forms engulf all but the corners and sides of the surface areas. By flatly applying the paint and building it up, Williams suggests a continuation of his cut-out methods of extraction. The negative and positive become superimposed as the fore- and background become intermingled, almost contradicting what appears to be an apparent division of planes. The integrity of each interconnected form is maintained through his thin line device of the implied and actual connecting parts. In *Study for Music IV*, 1976, Williams begins to expand his palette. Utilizing four colors, and for the first time employing a dark ground, the forms become more distinct. Accents are not only line but color markings which divert visual attention away from any implied focal point. *Blues People*, 1976, marked Williams' return to subtle variances in hue changes while adding an interplay between contrasting colors. These contrasts are restricted to interconnecting lines which dissect the background and middle layers. The background is no longer solid, but rather is built from almost undistinguishable color changes. Since late 1976, Williams has completely eliminated pastels, limiting his palette to investigations of color differentiations through subtle tonal interplays. Reductive to the point of implying minimalism, Williams again relies on accents in order to challenge these subtleties with old and contrasting line areas. While synthesizing the elements of his earlier works, he accentuates the overt, balancing it with the subtle. He developed layer upon layer of shape and form, extracting and adding color as a means of delineating the areas. His transitions are quiet. A green rectangle will suddenly be transformed into a curve without the

slightest indication, leading the viewer further and further into layers of visual activity.

His drawings have developed into works on paper consisting of shapes and forms made from debris and remains. He continues his concern for the geometric, utilizing found paper bags, burlap, string and watercolor. Williams works from the natural folds of the bag to define and dissect shapes and forms. Maintaining the repetitive element, he provides alternate modes of perception of simple shapes. The circle is perceived from its positive and negative properties. The rectangle is intersected by triangles, repeated, distorted, altered and perceptually transformed.

Presently, Williams' works on paper fuse lyrical and architectural line into textural compositions. By increasing the amount of the remains material, a tactile quality is achieved which subtly plays on the separation and distinction of protruding and receding planes. In *Untitled, October #1*, 1977, Williams focuses on a central vertical axis (string) which is perceptually strengthened by the off-center line markings which lie under and above the dissecting horizontal band. The graphic texture echoes the natural texture of the bag, providing contrast to the flat paper ground, and accentuating the textured canvas strip. The balance of horizontal and vertical is achieved through repetition of the horizontal by the top fold of the bag. Perceptually, the work would appear perfectly in balance but through seemingly accidental strands of thread protruding from the edge of the canvas strip as well as the isolated graphite diagonal marking to the lower right side of the picture plane, Williams deliberately upsets this balance, allowing accident and happenstance to exist.

Williams' books series since 1976 is his most obvious involvement in Contexturalism. No longer a progressional subordinate to his two-dimensional illusionistic explorations into form and space, these three-dimensional structures embody pages and covers of contextural relationships and definitions.

In *Merchants and Masterpieces*, 1977, strong compositional elements are balanced by contextural content and meaning. The history of art is assessed as the book's contents are bound shut,

and the relationships between the significant and the frivolous are displayed. The process of creation is illuminated by the used paint brush, rope and the measuring stick. All acting as compositional reinforcements to the interplay of horizontal and vertical pulls, they exude a significance that overpowers the suppressed contents of the book. The act and the process are escalated as documentation is subjugated to a subordinate position.

In *L'Art Abstrait*, 1977, Williams pits irony and wit against an artistic commentary which alludes to abstraction in a mocking yet supportive way. Incorporating lottery tickets, hooks, cloth and wood, this open-faced construction intricately contains a Dadaist reaction to art as it assesses abstraction and the seeming impasse which is occurring. "The particular art object—at once ferocious, elegant, mocking and beautiful—has something very precious about it." Its visual definition, while seemingly reactionary, provides inroads allowing further expansion, exploration and investigation of abstract development.

Williams breaks from contained constructions in *Homage to the Edge of a Corner*, 1977, incorporating space and environment as components within the total composition. A jarring tactile sensation is created by the vertical corner row of razor blades. The corner is accentuated further by the open frames which intersect at right angles, forming a structural interplay between the triangle and square. These are repeated by the video cover and its wooden stand in which a ruler is placed, covered by exposed razor blades. This sits on a carpet of cloth which is used again as a square and triangular hybrid achieved by extending a thin fishing wire from its corner to the ceiling at the section where ceiling and wall intersect. Corners and illusions of corners are constantly repeated.

In *Twenty-Three Years of Black Art*, 1977, Williams produces a direct and poignant statement in which a more obvious and blatant display of contextural meaning and definition takes precedence over his subtle devices. The catalog, *Two Hundred Years of Black American Art*,[1] is pressed and concealed behind a metal black shoe-shine stand. A washboard occupies the upper portion of the covering for the John Coltrane album it conceals. Textural effects of the washboard's surface are balanced by a wood-textured overcasing at the bottom. The bolts used to compress and conceal add an additional feel of weight to this structure as the contradictions are exposed through contextural definition; reality declared, illusions dispelled.

NOTE

1 [The correct title of the catalogue is *Two Centuries of Black American Art*. See p. 533 in the present volume. —Eds.]

1978

April Kingsley, "Black Artists: Up against the Wall," *The Village Voice*, September 11, 1978

April Kingsley worked as a curatorial assistant on the Romare Bearden exhibition at the Museum of Modern Art, New York, in 1971 (see p. 321) and was a frequent contributor to several art publications throughout the 1970s, including *ARTnews*, *Artforum* and *Art International*. From 1977 to 1979, she was a critic at the *Village Voice*. In this article, Kingsley presents a bleak picture for African American artists at the end of the decade. Despite the sea change in exhibition opportunities and offers of commercial representation from galleries, the prospect that "some black artists might begin to be rated with their white peers" had proved to be short-lived. Kingsley felt hopeful about the ongoing productivity of African American artists, referencing Linda Goode Bryant's concept of contexturalism. However, she lamented that their work was not receiving its rightful recognition, which could have resulted in a "new movement-complex, spearheaded, this time, by blacks."

APRIL KINGSLEY, "BLACK ARTISTS: UP AGAINST THE WALL"

Ralph Ellison's *Invisible Man* emerged dramatically into view during the '60s, in art as everywhere. He now appears to be sliding into obscurity. The 1969–72 spate of black art shows has dried up; public monies to institutions sponsoring black art, such as the Cinque Gallery and the Studio Museum in Harlem, are being cut; and resistance to studio faculty quotas and public art projects and commissions (other than those designated for specifically black neighborhoods) is growing steadily. One finds oneself asking, "Whatever happened to . . . ?" about even big name black artists. Now that we're slipping off the peak of black consciousness, the separate inequality of past days is starting to look good.

Holger Cahill once wrote about the WPA: "It is not the solitary genius but a sound general movement which maintains art as a vital functioning part of any culture." If Cahill's dictum has been realized in the black art movement, it might have released the same sort of pent-up energies as Abstract Expressionism did in the wake of the WPA. Romare Bearden, who has been accepted by the white art establishment since the early '40s and has been on practically every grant-giving board there is, feels that the WPA was the best thing that ever happened to artists, black or white, and that the present burgeoning funding bureaucracies, with their misguided attempts to judge art qualitatively, are doing more harm than good. "People will rate themselves," he says. "I'd rather see them run a lottery in SoHo than subsidize all those committees."

Bearden has always been one of those favored token blacks. Richard Hunt, Jacob Lawrence, and Benny Andrews also do well; their work is shown in good galleries and is often included in museum exhibitions and collections, and they frequently get speaking engagements and job offers. Some of this attention (but usually grant money instead) flows, or used to flow, to a second select group: Fred Eversley, Sam Gilliam, Richard Mayhew, Alvin Loving, Melvin Edwards, Daniel LaRue Johnson, Jack Whitten, Frank Bowling, and William T. Williams. But even these "familiar" names aren't doing very well, especially in galleries and museums.

The crucial first step for any artist is to get his or her work seen; only later can it be judged in the company to which it belongs. Natural percentages make it difficult for minorities to obtain even that first hearing. The large group shows of black art in the '60s (climaxed by MOMA's dual exhibitions of Richard Hunt and Romare Bearden in 1970), helped many artists take that first step, but even more importantly a few good galleries began adding blacks to their stables so that their work could be seen in depth. This raised hopes, which have since largely been dashed, that some black artists might begin to be rated with their white peers.

Currently there are fewer than half a dozen blacks spread among the dozen current "best" galleries (Leo Castelli, John Weber, Sidney Janis, Andre Emmerich, Paula Cooper, Sonnabend, Nancy Hoffman, O.K. Harris, Fischbach, Marlborough, Pace, and Max Hutchinson). Other galleries with less space, fewer collectors, and less clout with museums—Lerner-Heller, Cordier & Ekstrom, ACA, Robert Miller, Dintenfass, and Dorsky—have managed to hold on to some good black artists, but many of the best have not yet been caught, or refuse to rise to less gratifying bait than that to which they had been so briefly accustomed. (Women, incidentally, have been infiltrating those "best" galleries for years, having successfully made the jump from "hearings" in separatist galleries and shows more easily than blacks.)

The main trouble with all of this is that the '70s could have offered optimum conditions for growth of black art. There is no dominant style, patterning is acceptable, increased emphasis is being put on humanism and content, and mythic primitivizing tendencies are blooming. Black artists' African roots and the social, cultural, and political significances of their American heritage could have given them an advantage, especially now that the diversity of black art styles (mainstream, ethnic, separatist, etc.) mirrors a more generalized diversity. The formal strengths of African art, its majestic power, could have conceivably repeated the impact it had on modern art 75 years ago, but this time directly

through living artists. The energy is there, but it smolders in isolated fires.

The majority of the recent work I've seen by black artists is powerful. Melvin Edwards's seven years of welded sculpture exhibited at the Studio Museum in Harlem last spring established his consistent superiority in this mode. But "So, who knew?"—and until his work appears at Marlborough, Emmerich, or Tibor de Nagy, where his competition shows, who will? Nothing comparable to Edwards's dense, masklike reliefs out of welded tool and automobile parts has been done since the early work of David Smith, and there is no counterpart to the rhythmic coordination of counterbalanced masses in his large sculptures, with their intimations of vernacular architecture despite the high-level sophistication of their means. Most work in this vein (by Michael Steiner, Joel Perlman, Tony Rosenthal, for example) is technically good, formally pleasing, but emotionally empty. Edwards's work, however, is rich in metaphor, implication, and connotation; with no loss of plastic vigor.

A few new galleries have sprung up outside the traffic lanes of the art-going public that frequently feature work by blacks—the Tim Blackburn Gallery and the community Gallery in Chelsea, Peg Allston's residential show places, and the Consortium on West 62nd Street. Ellsworth Ausby exhibited a few of his brilliant new emblematic, multipartite abstractions at the Consortium last March, but you really have to make the trek to his studio in the wilds of Brooklyn to see his work in depth. A gentle man despite his dreadlocks, Ausby has engineered an exciting synthesis of Constructivism and primitive geometric patterns. His brightly colored canvas strips and sections have a leathery quality that augments the shield or weaponlike connotations of his angled configurations. When stapled directly to a wall, the work conjures up visions of tent art.

William T. Williams's latest paintings in rearrangeable vertical sections also relate to temporary patterned wall-coverings. Obsessed with the diagonal within rectangular bounds, he has been struggling for years to reconcile his expressionist urges with the rigorous formal training he received at Yale. His introspective, sensitive spirit, painfully seesawing through various solutions to this dilemma since his dazzling start in the early '70s, has at last broken through in his new loosely painted, rhythmically structured canvases that offer a profusion of conflicting patterns. The context in which these paintings are publicly seen, however, will be all important in establishing Williams in his rightful place—at the forefront of current tendencies in patterned abstraction and additively structured modernism. No small or out-of-the way gallery will do.

Edward Clark, who pioneered the shaped canvas in the mid-'50s as a literal extension of his Abstract Expressionist brushstroke, is another painter whose huge canvases demand large clean spaces on well-travelled art lanes. The speeding horizontal lines that set the ellipses they traverse into spinning orbits make Kenneth Noland's stripes look as static as the feet on Balla's dog. The intense golden-orange heat (inspired by African sunlight and topography) in his recent paintings generates enormous energy. They represent a remarkable extrapolation of Abstract Expressionism into intellectualized post-painterliness.

If black men of such high caliber have had difficulty getting their work viewed in proper settings (none of them are currently with a gallery), imagine the problems black women artists face. Finding no solace within the heavily macho black-art movement, most of them identify and associate with the women's art movement instead; but to a large extent they are disenfranchised from both. If they go to Africa to examine their heritage, for example, they tend to be badly treated by their male "betters"; while if they try to socialize like white women artists, they are ostracized in subtle, and not so subtle, ways.

Such is the situation even for Howardena Pindell, a curator in MOMA's print department who shows in the best feminist gallery—A.I.R. in Soho—and the best ethnic gallery—Just Above Midtown on 57th Street. Because she is black, and because she steadfastly refuses to use her museum position to help her career as an artist, she can't get into the "best" non-separatist galleries, despite her substantial reputation as a fine, innovative abstractionist. Currently, she seems to be moving

APRIL KINGSLEY

out of the obsessive repeat minimalism of former years into daringly decorative, all-over surfaces that are structured within flexible 3-D neo-Cubist grids. In these new stately paintings, she creates a high-level synthesis of modernism and deep-seated archetypal drives.

Betye Saar, Faith Ringgold, and Senga Nengudi have opted to eschew referencing their powerful, mythic images to modernist developments. The quality of their work, the authenticity of their sources, and their commitment to using imagery drawn from their black heritage should ensure their place at the forefront of the neo-primitivist movement. Instead, they are generally left out of such shows as the *Primitive Myths* exhibition Allen Ellenzweig organized at the Queens Museum last spring.

Linda Goode Bryant and Marcy S. Philips, who run the Just Above Midtown Gallery, have made a valiant effort to correct common errors of omission in their recent publication, *Contextures*. They have rewritten the history of post-war American art to place black artists like Raymond Saunders, John Dowell, James Little, and Manuel Hughes within a mainstream context. They invented the term "contextures" to name the often funky, deeply personal, neo-primitivizing styles that are typified by Saar, Ringgold, and Nengudi, as well as Donna Byars, David Hammons, Houston Conwill, Randy Williams, and Wendy Ward Ehlers. All of these artists use detritus in their work—body prints, hair, lint, nylon stockings, cockroaches, and memorabilia. All of the work they discuss is both formally and emotionally compelling.

Its significance is obvious, and despite the overly detached and generalized text, one would like to see this book be required reading for all dealers and museum curators. If the work of black artists were more generally known, the conservative, directionless '70s might be revolutionized by a new movement-complex, spearheaded, this time, by blacks.

1978

Benny Andrews, "The Big Bash" (originally published in *Black Creation: A Quarterly Review of Black Arts and Letters* 6, no. 4 [1974–75]); Benny Andrews, "New York's 21 Club" (originally published in *Encore: American and Worldwide News* 6, no. 9 [May 9, 1977]); Benny Andrews, "Black Artists vs. the Black Media" (originally published in *Encore: American and Worldwide News* 6, no. 13 [July 5, 1977]), in Benny Andrews, *Between the Lines: 70 Drawings and 7 Essays* (New York: Pella, 1978)

These essays appear in Benny Andrews's book *Between the Lines: 70 Drawings and 7 Essays*, a collection of the artist's writings published in October 1978. The book included a preface and an accompanying drawing by the painter Alice Neel. The pair had become close friends after the Schomburg Center at the New York Public Library mounted a joint show of their works in 1966. The seven essays in the book, which provide a summary of Andrews's writing throughout the 1970s, originally appeared in magazines such as *Black Creation* and *Encore*, where Andrews had been a columnist since 1974.

In "The Big Bash," Andrews describes the situation of African American artists as "a surrealistic nightmare." After being invited to the party (namely, the mainstream art world), Black artists were offered a "partially filled glass . . . with a dirty liquid," which they were expected to drink gratefully. Andrews was defiant in his commentary and remained dedicated to social causes through his role at the Black Emergency Cultural Coalition (BECC). The art classes he had been teaching at the Manhattan Detention Complex ("the Tombs") contributed to a major expansion of the prison art program across the country in 1971. Andrews later became the art coordinator for the Inner City Roundtable of Youths (ICRY), which sought to combat youth violence in New York. In 1976, he was part of a group that picketed the Whitney Museum of American Art's exhibition *American Art from the Collection of Mr. and Mrs. John D. Rockefeller 3d*, which claimed to cover three hundred years of American art but contained not a single work by a Black artist and only one by a (White) woman.

In "New York's 21 Club," Andrews discusses the problem of White-owned galleries' dictating the careers of African American artists. He cites just a handful of artists who had received commercial representation despite the existence of more than four hundred galleries in New York at the time. "Racism is put on display in more galleries than Black art is," he comments. The artist's outlook was no doubt informed by his own negative experiences in the early 1960s at Forum Gallery, which discouraged his interest in painting the rural poor of the South.

BENNY ANDREWS, "THE BIG BASH"

The position of Black painters, writers, musicians, actors, etc., in the arts today is something like a surrealistic nightmare.

Imagine yourself finally being invited to this big bash.

You're all dressed up like everybody else and you enter to find yourself in the midst of all the beautiful people, beautiful things, and all that's been really happening since man figured out how to make certain things worth something, and everything else worth nothing.

In other words—you're where it's at.

The craziness starts when you look at the drink you've been served by a smiling benefactor. The glass is dirty and there's only a little bit of dirty liquid in it—about one-fourth of an inch. And even though your glass is the same shape and size as everyone else's, you know that theirs are clean and filled to the brim with sparkling champagne.

So you stand there holding your dirty glass with the dirty little bit of liquid, and very coolly look around the room. Oh, what a beautiful scene, and there are so many of the people you've heard about, wanted to meet, wanted to be around.

But, first you think that maybe you should go back over to the kind person that served you this drink and ask for a clean one.

As you walk towards the bar, several of the people stop you.

"How are you?" they ask so friendly-like.

"I'm fine," you reply, kinda' happy that they recognized you.

"I saw your latest piece," several of the important people tell you.

"In fact," states one of the most important people there, "I've always admired you and the fine work you've done. It's commendable."

"Gee, thanks a lot," you say and add, "but I'm surprised that you feel that way about the work I've done in certain areas because it was always directed against people like you. In fact, I remember specifically naming you in some of my protests."

"Oh, that's all water under the bridge. Now I'm with you. In fact, I'd like you to meet So-and-So

here; he's also considering you for some of his upcoming projects."

"Wow, that's great, I've always tried to get to you, Mr. So-and-So. Just imagine, if I could have reached you a year ago, how much better off people like me would have been."

"Oh, is that so? I never knew that," Mr. So-and-So says with his perfectly beautiful mouth.

You notice that even though they're still smiling graciously, they're talking to other people like themselves and you're all alone. "Excuse me," you say to the air, and continue on to the bar. "It's amazing," you think to yourself. Here you are in this place with all these people. "Things sure have changed," you say to yourself, as you ease close up to the bartender.

"Er, excuse me but this glass is dirty and besides, it only has a little dirty liquid in it." You speak very quietly so that none of the others can overhear you.

"Just keep it for now and be grateful. The next one will be a little cleaner and have a little more liquid. You must be patient, after all this is the first time we've served you people." He turns away from you and pours the glistening, bubbling champagne into new glasses for everyone else and winks at you.

Stepping off to the side and still holding your dirty glass with the little dirty liquid, you decide that you'll mention this to some of the people you know there. Looking around the room you spot a person you've known and admired for as long as you can remember. Besides, he's not exactly one of the bluebloods. When you make your way over to him, and he spots you, he lets out a warm smile and embraces you as you meet.

He's holding a clean glass with sparkling champagne in it.

"It's so great to see you," he says and before you can mention your dirty glass, he's escorting you around the room introducing you to everybody. What strikes you as funny is that nobody notices your dirty glass, and of course, none of them have dirty glasses.

There were times when some of them did but no more.

When you get the opportunity, though, you pull this friend aside and say to him, "Look, I think this

is all well and good, but I have a dirty glass with only a little bit of dirty liquid in it."

"Yes, I know," he says looking around to see if anyone is listening.

"I'm going to point this out publicly, not just for my own integrity but for the ones like me who aren't here," you say a little defiantly.

"Look, don't you ever get tired of making trouble? Are you telling me something I don't know? How many years did I drink out of dirty glasses that didn't even have just a little bit of dirty liquid in them? I'd tell you what was in the glasses but it would turn your stomach. You people must learn that it takes time to get clean glasses—you can't just get them overnight." He had gotten himself riled up as he spoke, and when he finished he started mumbling under his breath.

"Okay, okay, forget I mentioned it. I just always had so much respect for you and what you stood for. Sure, I know that you've drunk from dirty glasses. I just thought . . . ," and your voice trails off because you realize that he's not listening to you. The first chance you get you walk over to another friend and, in pretty much the same way, you're made to look like a troublemaker.

"Why can't you just enjoy yourself tonight like everyone else?" one person asks you bitterly.

Finally you decide not to try and talk to anyone about your dirty glass anymore. It's hopeless. Walking over near a potted palm you decide to empty it into the pot and just hang around a little longer and split. To your surprise, as you get to the potted palm, there is the newspaper woman who really has always told it like it was whenever something shady came along.

"Hey, it's great to see you here," you say, and the two of you are truly glad to see each other.

"And how have you been since I last saw you?" she says looking you up and down.

"Oh, in trouble as usual I suppose. I've missed seeing you though and well, I just have to confess, I've always had a soft spot in my heart for you. It's just that you were always there when the going looked the worst and people like me will never forget you for that."

"Oh, pooh pooh," she says.

"Look at my glass. It's dirty and I'd like to tell you why," you say showing her the glass with the dirty liquid.

"Why?" she asks as she takes out her notepad.

"Well it's like this. . . ." You tell her all about tokenism, hypocrisy, phoniness and compromising yourself. Then, as if struck by a lightning bolt, it occurs to you that she never took down a word. She just stared at you blankly as you talked. You don't say anything but you understand: she's no longer listening to you or your kind, and with a few clever "tata's" you part.

There's no question in your mind now. You're leaving.

"Hey man, what's happening?" A familiar voice calls out to you from over near the bar. You look up. "Wow!" you exclaim, "it's old what's-his-name," and you rush over to him. He's stoned out of his head.

Your heart drops when you see his glass. It's dirty and in his case, being refilled over and over with the same one-fourth inch of dirty liquid that you've been carrying around in yours all night. You hustle him off into a corner where nobody can overhear you and ask pitifully, "Man, why are you drinking that dirty liquid out of that dirty glass?"

He looks at you with steel in his eyes and says, "I'm trying to make it man. Sure this stuff is vile, and these S.O.B.'s love to see me drinking it but they're going to give me something for it. They've already promised me that if I drink enough of this shit, I'll be one of the few of us that they will deal with."

"But how can you do it, man, after all the stuff that has gone down? How could you face all those people outside? You know, the young, the ones who were killed, beaten, the poor ones and . . ." you say and he interrupts you by jabbing his finger in your chest.

"Don't give me any of that crap. I've paid my dues and ain't nothing, nothing going to come from trying to fight these V.I.P.'s. Now excuse me, I got to get back over to the bar. I promised myself I would drink a lot of this stuff tonight."

As he rushes back over to the bar and thrusts his dirty glass out for another refill, you gently drop your dirty glass with its little dirty liquid down on the floor and watch as the glass breaks into millions of

little pieces. Quite a few of the people see you, and for an instant, they flinch and look at you strangely.

Then they all go back to drinking their bubbling champagne, laughing and being the clever beautiful people they've always been.

It's many moons later now, and your friend—the one that was drinking the stuff out of the dirty glass—has been doing very well recently. In fact, there was quite a big write-up about his latest work and he's always being invited to every big happening in the arts world. Rumor has it that his glasses are dirtier now, and he's drinking more and more of the little dirty liquid. And his work has changed—it's much weaker now.

Since the time you were at that big affair, you've talked with a lot of artists/friends who are in the same boat you're in, and some of them agree that they're not going to drink that dirty little liquid out of those dirty glasses. But there have been a few, though, who've asked to be put on the invitation list so that they could be invited to the next "big bash."

BENNY ANDREWS, "NEW YORK'S 21 CLUB"

New York's 21 Club is more than a fancy restaurant.

More than 400 art galleries are listed in guides for the greater New York area. About six are Black-owned, give or take one or two because some of them come and go with the new sunlight and change hues with first-of-the-month rent blues.

More than 250 Black artists peddle their insights in the New York area, a majority of them actually getting up every morning and trying to become accepted artists in the eyes and minds of the general American public. About 21 of these are listed in the stables of the 400 or so White-owned galleries. The number varies, but a tacit quota keeps the figure hovering dangerously around 21. At the moment there may be 19: Jacob Lawrence, Raymond Saunders, and Walter Williams in the Terry Dintenfass Gallery; Benny Andrews, Art Coppedge, and Barkley Hendricks in the ACA Galleries; Romare Bearden in the Cordier & Ekstrom Gallery; Vincent Smith and Avel de Knight in the Lacada Gallery; Charles White in the Forum Gallery; Richard Hunt in the Dorsky Galleries, Ltd.;

Richard Mayhew in the Mid-Town Gallery; Ellen Banks in the Susan Caldwell Gallery; Betye Saar in the Knowlton Gallery; Alma Thomas in the Martha Jackson Gallery; Ed Clark in the James Yu Gallery; Barbara Chase-Riboud in the Betty Parsons Gallery; Al Loving in Fischbach's Gallery; and Frank Bowling in the Tibor DeNagy Gallery.

On a national level, the most prominent Blacks regularly displayed in White galleries are Sam Gilliam in Washington, D.C., and Bernie Casey and Suzanne Jackson in Los Angeles. The signs saying "No niggers allowed" are not outside the building but inside people's heads. Racism is put on display in more galleries than Black art is. When asked why his gallery didn't show any Black artists in it, one dealer said, "I really don't know any good ones that aren't already taken." "What about Norman Lewis, Lois Jones, Dana Chandler, Hale Woodruff, Carole Byard, Joe Overstreet, Camille Billops, Richard Yarde?"

"Never heard of any of them except Lewis," the disinterested dealer said, fingering some papers uncomfortably.

Even the galleries that do have Black artists aren't angels by any stretch of the wings of imagination. The Dintenfass and the ACA both have three Black artists, and sometimes you'd think they were the NAACP the way they take credit for helping Black artists. In fact, "off the record," as many gallery dealers or owners like to hedge, "it's dangerous to have too many," and in most cases one is more than enough.

Why is there so small a number of Black artists in these galleries? Racism rages, to be sure, but there are other reasons too. Black people really aren't buying much. The Black artists that are in these White-owned galleries—the token number of us—are very often to blame also.

Not only have we, your "21 nigger artists," sewn up the token list in those galleries, but we've pretty much gobbled up the crumbs that go along with being represented there. Look at the facts.

I am a consultant for the National Endowment for the Arts, often judging exhibitions and fellowships, judging for the New York State Council on the Arts. I'm the only Black on the boards of the

College Art Association and the Foundation for the Community for Artists and the only Black with a regular column in a major publication. Richard Hunt is a director of the National Endowment and the Illinois State Council for the Arts; he gets most of the major sculpture commissions for Blacks and is the only Black sculptor to have had a one-person exhibition at the Museum of Modern Art. Romare Bearden is a senior fellow of the Rockefeller Foundation at the Metropolitan Museum; the only Black to have a solo exhibition of paintings at the Museum of Modern Art, Bearden is also one of the two Black artist members of the prestigious Institute of Arts and Letters. (Jacob Lawrence is the other, and the only Black artist to have had a one-person exhibition at the Whitney Museum of American Art.) This triumvirate—Hunt, Bearden, Lawrence—are the only Blacks to have ever had solo exhibitions in the major New York museums.

Richard Mayhew is the only Black on the board of directors of the MacDowell Colony. Most of the New York 21 have received either a Guggenheim, a National Endowment, or a Prix de Rome grant, and in some cases have gotten them all. When it comes to being mentioned in anthologies, doing talk shows, or being the token Black artist for lecture tours, these 21 artists get more than their share of the invitations.

The best way for an artist to get the attention of a gallery dealer is to have someone already in the gallery recommend him to the dealer. When an artist is doing well, which always means selling, he has influence to exert with said gallery.

All the hundreds of Black artists out there without commercial gallery representation should corner the tokens and make them respond to questions. "What are you doing for Black artists who are being denied the opportunity to show their works in galleries?" "Do you honestly stand up for the best interests of Black artists when you're behind the closed doors of jury rooms?" "Do you feel comfortable with your success and acclaim when there are so few other Black artists being given any opportunities to exhibit, lecture, and sell their works?" "Would you, as a token Black artist, confront your dealer with the works of deserving Black artists if it meant you'd jeopardize your own unique standing in the gallery?"

Asking these and other questions give the unacknowledged artist not a damn thing to lose—except maybe membership in the club of Black artists not being shown in the galleries.

BENNY ANDREWS, "BLACK ARTISTS VS. THE BLACK MEDIA"

"Where do Black artists get off criticizing us about covering the activities in your art circle when your own people [the Black press] don't seem to give one good damn about you." When John Coplans, then editor of *Artforum* magazine, screamed this out while sitting on a panel titled "The Black Artists and the White Critics," the truth of it hurt.[1]

I moderated this affair, which was held at the New York Cultural Center in 1973, and recall that it was Dana Chandler, a militant street artist from Boston who evoked the remark. Chandler had been criticizing the lack of coverage of Black artists in the White-controlled press, both art and non-art.

In the audience were a large number of Black artists who could only share looks of dismay and shrug their shoulders in unison, for like me, they knew that as horrible as the statement sounded, Coplans, a dedicated, proud White South African, had spoken an irrefutable truth. The Black press neglects Black art and Black artists. To the obvious question, Why?, some obvious answers come to mind, the principal one being no advertising money is available for promoting exhibitions and happenings involving the Black artists.

Usually the Black press gets one or the other to cover Black art: a young college graduate who is writing to see how it feels to be published or an old former college professor whose concepts of contemporary art stop around the 1950s. If this is not easy to believe, look at all the so-called bicentennial exhibitions involving the works of Black artists and see how they only represent 175 years of artwork by Black artists. The persons putting the exhibitions together couldn't deal with the artists of the 1960s.

Leading Black publications see art as something akin to interior decorating and that to do a

good job of presenting it, one should show an array of color reproductions of the works with the picturesque artist standing in front of it dressed like a fashion model. The text to these coffee-table presentations usually deals with the artists' "fabulous incomes, posh living, and exotic lifestyles." Of course, maybe one or two Black artists who made a few dollars from an exhibition can put on this kind of front for a couple of weeks; but in reality, Black artists are much more serious about their work and are involved with more important things than trying to look and act the part of Hollywood stereotypes. The Black press's preoccupation with "the latest or more recent art style" also hampers its doing any successful treatment of works by Black artists. Too often those who write simply lack any knowledge of what an artist and his work is all about. Yet since such articles are done, those writers serious and knowledgeable about Black artists and their work feel discouraged, reasoning that if light, inept treatment is the preference then there's no need for them to bother doing anything better.

Over the years, I've observed some of the well-known publications' treatment of the Black art world. A couple of years ago the *Amsterdam News* attempted to deal with Black artists seriously, creating a separate magazine section solely for this purpose. This venture lasted a year; then, as abruptly as it began, it stopped. The paper still has the magazine, but the art coverage is mostly topical.

Ebony is a prime example of the "how-not-to-be-serious-about-art" publication, but still present it. This publication's coverage usually consists of one extreme or the other; that is, there will be eight pages given to one of the five Black artists it considers to be "living Black masters": Jacob Lawrence, Richard Hunt, Romare Bearden, Charles White, and Geraldine McCullough. Or it will give ten pages to the doings of young amateurs who paint or sculpt images of the most recent "Six O'Clock News" topics. The articles' writers—again usually totally uninformed about the life and aims of artists—cull information concerning those about whom they write from articles appearing in White publications. The platitudes in such articles are plenty, but always lacking is sound criticism or even evidence

of the writers trying to dig beneath the surface in attempts to seriously talk about the many gaily colored reproductions accompanying their stories.

In December 1975 *Black Enterprise* dedicated a complete issue to Black artists, and the issue remains the best treatment so far about Black artists. But the publication has not done much else in this area.

I have been writing a regular art column for *Encore* since 1974. I have tried to make people aware of persons and issues of interest in the Black art world. Often I have turned the column over to guest writers, some of whom were critical of what I had written in an earlier column.

Additional hope for serious coverage of the Black artists' works in a newspaper, as the *Amsterdam News* once attempted, may soon be evident in *Easy*, which serves as a guide to the arts in New York. This publication has been encouraging Black writers and photographers to produce a fine arts publication. While it's too soon to hail this publication, it is not too soon to point it out as perhaps being one newspaper willing to notice the Black art world.

A new art quarterly, aptly called *Black Arts*, is also impressive. Should this publication succeed, Black artists will know for certain that they have someone in the media who knows and shows what they are doing.

More publications could be mentioned here, but these few give a clear picture of the present state of the Black press's attitudes and doings regarding the coverage of Black art and artists. No, there are no simple answers to the complex problem of proper media coverage of Black art and artists. Everyone shares the blame for how things now are, even the general Black public, the readers of the Black press. In fact, often when editors of the Black press are confronted with their banal coverage they point their fingers at their readership, saying that their readers aren't interested in Black art, but rather in clothes, gossip, new cars, and celebrities, and that since it takes money to publish, they must do what will get them money.

I'm convinced, though, that the same way Black folks, like everyone else, want to know about

clothes, gossip, cars, and celebrities, they also want to know about art. Now if the Black press can get around to seeing this and take the Black artists' output seriously, all of us can scream out together against any White South African art editor who laughingly asks, "Where do Black artists get off criticizing us about covering the activities in your art circles when your own people [the Black press] don't seem to give one good damn about you?"

NOTE

1 [Coplans's words in the transcript of the panel discussion reproduced on pp. 457–67 of the present volume are slightly different: "You get no support from your own community. None whatsoever.... You've got dozens of black magazines. You've got black newspapers all over the country. And not one of them will support you.... You can't fault the whites when your own people, who are, in some areas, immensely rich, do control the media and television stations—and all kinds of things like this—have all kinds of access, don't care about you" (p. 461). —Eds.]

1978

Lowery Stokes Sims, "Third World Women Speak" (account of panel discussion held at SOHO20, New York, October 13, 1978), *Women Artists News* 4, no. 6 (December 1978)

The complexities faced by Black women artists in the United States as they navigated issues of both race and gender were the subject of this panel discussion held at the Manhattan gallery SOHO20. The gallery had been founded a few years earlier by some twenty female artists as a stand against discrimination in their field. The discussion was moderated by Lula Mae Blocton and featured Camille Billops, Howardena Pindell, Faith Ringgold, Selena Whitefeather, Vivian Browne, Tomie Arai, and Zarina (Hashmi), most of whom had work in an accompanying exhibition at the gallery. As outlined by the Metropolitan Museum of Art curator Lowery Stokes Sims in her summary of the discussion, each of the speakers related how the feminist movement had failed Black women artists, because White feminists were "incapable of comprehending the peculiar plight of non-white women."

The subject of inequality among female artists would be explored further in the forthcoming "Third World Women" special issue of *Heresies,* to which a number of the panelists contributed. Launched in January 1977, the feminist journal was an offshoot of the Heresies Collective, which sought to establish new narratives around the history of female artists. Yet, the group of (largely White) artists and writers was called out early on for its lack of inclusivity. One issue of the journal prompted a letter from the Black feminist organization Combahee River Collective questioning the absence of minority artists in the magazine. The discussion at SOHO20 also highlighted several other barriers African American women were forced to confront. Howardena Pindell raised the notion of "Queen for a Day"—a reference to the ever-changing interest in work by Black artists, depending on "the climate of the time" and "political—rarely if ever esthetic—considerations."

LOWERY STOKES SIMS, "THIRD WORLD WOMEN SPEAK"

As artists, non-white women have had not only to defy expectations in role patterns, but to overcome the stunted creativity of colonized peoples whose indigenous culture has been disparaged and denied by the power class for 500 years. While white (Anglo-European) women have had some access to art training and advancement (through family relationships: fathers, brothers), and some expansion of opportunity in a highly technological society, non-white women have had to confront residual "traditional" roles.

These and similar issues were discussed in the talk "Third World Women Artists," held at Soho 2020 Gallery in conjunction with an invitational exhibit by eight Third World women: Camille Billops, Lula Mae Blocton, Evelyn Lopez de Guzman, Yoko Nii, Howardena Pindell, Faith Ringgold, Selena Whitefeather, and Zarina. There was added interest in the fact that several of the artists and panelists are involved with the Third World Women issue of *Heresies*, due in spring.

Moderator Lula Mae Blocton, after welcoming the audience, said that women from different cultural backgrounds are struggling to find the commonality of their experience and broached the question, "What is 'Third World'?"

Tomie Arai began the session by describing her work with City Arts. She had come to City Arts as a disillusioned artist looking for a way to make art relevant to her anti-war sympathies, her feminism, and her concern with lower-class communities throughout the city. Arai showed slides of mural projects of the last four years. Her approach included a demystification of the art process and solicitation of community members' perceptions about themselves and their world, which were then incorporated into the murals. She noted, incidentally, that nearly 50% of mural artists in the nation are women.

The second speaker, Howardena Pindell, began by showing slides of her art as it has evolved over the last eight years. The audience was fascinated by the presentation, particularly with technical aspects of the work. Then Pindell chronicled her 11 years

in, out of, and around the art world: finding a studio, a job, a gallery. She characterized the art world as an extended family, which excludes artists who are not members. Her witty account of the politics and polemics of a black woman facing chauvinism and the double standard included a description of the "Queen for a Day" syndrome: Interest in black artists' work waxes and wanes according to the climate of the time and out of political—rarely if ever esthetic—considerations.

Faith Ringgold declared at the outset that she would not dwell on her problems because "people don't sympathize with black women." For her the key issue was survival as an artist; if that could not be accomplished through conventional avenues, then alternatives would have to be found. She hired an agent to book the lecture/performances she organized with her soft sculptures, finding her own audience, albeit largely outside New York City. The tactic allowed her to continue doing art and at the same time to support herself. The itinerant activity required a more "portable and personable" art form than painting. Ringgold described her transition from painting to making soft sculpture, recalling family resistance when she retreated alone to her studio to paint. To preserve her home life, she turned to a medium that was not only portable, but could be worked on sporadically in a social situation. This illuminated just one of the dilemmas faced by non-white women, whose group values may, as in this instance, militate against individualistic (i.e. artistic) expression, particularly by women.

Vivian Browne faced a similar reproach from family and friends who could not understand why her art demanded so much time. She reminisced about the days when she and Ringgold were in the New York City school system, frustrated at being relegated to administration, denied an opportunity for creativity. Browne said she is now "coming out" after three years of administrative responsibilities, although the assignments that interfered with her art did initiate her into the working of the power structure.

For Selena Whitefeather, initiation into the frustrations of hassling with the power structure came through involvement with the Feminist Art

Institute as she and co-workers struggled to negotiate a site. Whitefeather mentioned her work with video and drawing and, for the last eight years, a preoccupation with plants, an interest first sparked by her grandfather. As a young woman she was, typically, not interested, but she rediscovered the enthusiasm as an adult.

The nuances of interaction with men and male-dominated institutions—from schools to galleries and museums—were also discussed. The consensus was that black women had not benefited as much from the black movement as white women had from the women's movement. Indeed, the speakers seemed more conscious of their identities as non-whites than of their political situation as women. For them, individual encounters with the feminist movement had been keenly disappointing. Most of them had found white feminists incapable of comprehending the peculiar plight of non-white women—either because they were partners to the oppression or because they were too preoccupied with their own immediate priorities to deal meaningfully with those of others.

Third World women in this country exist on the lowest economic level: that condition has been reinforced by a deliberate stereotyping of each group—for example, black "mammy" or "Sapphire," Hispanic "spitfire." These images determine the attitudes of society as a whole, even that of their own ethnic groups. Even when individual women manage to enter a higher economic class, stereotypes persist and affect social interaction.

Selena Whitefeather described a case in point. She has been embroiled in a conflict over basic policy with white members of the Feminist Art Institute. The planned fee structure and time schedule of the Art Institute's workshop would place these courses beyond the reach of poor "minority" women financially and practically—a lack of empathy at the most basic level.

It is always up to the last speaker to suggest alternatives, and Camille Billops rose to the occasion. She enumerated her activities as sculptor, ceramicist, teacher, author, and archivist and reiterated Ringgold's theme of self-help and determination for minority women. To illustrate, she noted the Hatch-Billops Collection, born out of her realization that only blacks could take responsibility for documentation of their presence in the country's cultural life. She warned against the wasteful preoccupation with the white male power structure and proposed that women infiltrate the establishment and exploit it to their advantage. (She also warned that power, once attained, entails loss of the idealistic innocence that fires revolutions.) Billops envisioned a new society, with information flowing freely, without distinctions or restrictions, to all members, a healthy society based on human references.

The evening was a compelling compilation of opinion, perception, and biography. Because the focus was on the individual women at the outset, an overall picture of the political realities of Third World women could be seen only in recurrent themes. There was surprisingly little discussion of the political role of the art. Only Tomie Arai dealt with this, although Faith Ringgold asserted the political purpose of her art without elaborating.

In view of the rhetorical marathons about art and politics in which black Americans have participated over the last decade, one may assume that such issues have been talked out and assimilated and now are taken for granted or bypassed. Unfortunately Blocton's initial mandate for a definition of "Third World women" was not fulfilled.

Third World semantics had been grappled with during planning meetings of the committee assembled last spring for the *Heresies* issue. *Heresies* had made an open invitation to all interested women, leaving definitions to the black Americans, West Indians, Chicanas, Puerto Ricans, and Asians who then congregated. In this evening's discussion, Zarina pointed out that black American women, inhabitants of the affluent technological society of the "First World," could not be considered part of the "Third World" confederation of underdeveloped countries. The dilemma is that although black American women may have relatively greater access to material resources, they share the political reality of other non-white women.

But this divergence in perception vividly illustrated how multiple levels of enfranchisement within the socio-economic and political context of

the American capitalist system obscure the actuality of power. As a white woman in the audience pointed out, the greatest problem facing disenfranchised groups in this country is that the oppressor is not clearly defined. Until we gain a clear perception of the situation, the condition of non-whites and women will not change.

1979

Dawoud Bey, "Reflections on *Harlem U.S.A.*" (statement about exhibition held at the Studio Museum in Harlem, January 14–March 11, 1979), in Matthew S. Witkovsky, ed., *Dawoud Bey: Harlem U.S.A.* (Chicago: Art Institute of Chicago, 2012)

Dawoud Bey was born in 1953 in Queens, New York. At the age of sixteen, he visited the *Harlem on My Mind* exhibition at the Metropolitan Museum of Art, compelled by the controversy around it (see pp. 134–35). The images he saw made a huge impact on him, motivating him to take up photography. Bey began visiting Harlem in 1975, a couple of years prior to enrolling in photography at Manhattan's School of Visual Arts. He documented life in Harlem as he saw it on the streets. His intimate pictures both revealed what the neighborhood represented to him personally and acted as a collective portrait of a moment in the community's life. A series of twenty-five black-and-white photographs depicting military veterans in a marching band and women on their way to church formed the basis of his first solo exhibition, which ran at the Studio Museum in Harlem in early 1979.

DAWOUD BEY, "REFLECTIONS ON
HARLEM U.S.A."

These photographs and the experience of making them was for me a homecoming of sorts. For while I never lived there, a large part of my family's history was lived in Harlem. In addition to the aunts, uncles, and friends who eventually came to live there, it was in Harlem that my mother and father met. I was born shortly after they moved to the suburbs of Queens to escape the things they felt Harlem was becoming. Or perhaps, like other people, they wanted a chance for more than they felt Harlem offered. But others, thinking differently, had stayed. So we frequently found ourselves piling into the car for the ride to Harlem. I remember those trips in an interesting kind of way. Driving through the crowded streets, I was amazed by what appeared to be the many people on vacation. It seemed to me that no matter what the day, everyday was Saturday in Harlem. But as the relatives one by one moved from Harlem, the trips became more and more infrequent, until finally they stopped altogether.

I began photographing in the streets of Harlem in 1975. At first these visits were just weekly excursions. On those occasions much of what I did was not photographing, but spending time walking the streets, reacquainting myself with the neighborhood that I wanted to again become a part of, seeing up close the people and the neighborhood I had glimpsed from the car window years before as a child. As I got to know the shopkeepers and others in the neighborhood, I became a permanent fixture at the public events taking place in the community, such as block parties, tent revival meetings, and anyplace else where people gathered. The relationships and exchanges that I had with some of these people are experiences I will never forget. It is in those relationships and the lives of the people that these pictures recall that the deeper meaning of these photographs can be found.

1979

Larry Neal, "Perspectives/Commentaries on Africobra," in
Africobra/Farafindugu 1979, **catalogue for exhibition held
at Miami University, Oxford, Ohio, 1979**

A survey of AfriCOBRA's work was presented in 1979 at Miami University
in Ohio. The exhibition, which coincided with a third wave of new mem-
bership in the collective, was organized in association with the conference
"African and African American Traditions in American Culture." Larry
Neal's writing had always been important to Jeff Donaldson and the other
members of AfriCOBRA, but this seems to have been the first time Neal
wrote about their work.

LARRY NEAL, "PERSPECTIVES/ COMMENTARIES ON AFRICOBRA"

One of the most enduring and significant manifestations of the Black Arts Movement of the sixties was the creation of Africobra/Farafindugu with its compelling ideology. This artistic ideology springs from the ethos of African American and Pan-African spiritual and political culture. This aesthetic ideology seeks to impose a new visual reality on the world; and in the process move the audience to a more profound realization of its inner possibilities.

Art/image making is, fundamentally the working out of the mysteries that undergird human experience. The icon, or image, represents the symbolic identity of both the artist and the audience to which the work is addressed. In the case of the wondrous and awesome images of Africobra/Farafindugu, we are speaking of images that when juxtaposed together represent the visual narrative of a Nation asserting its artistic consciousness.

Here we enter a world where the connection between music and color become vividly manifested. Further, we must note these artists are attempting to stretch and extend their use of colors across the full range of the spectrum—much like Coltrane attempting to squeeze a multiplicity of tonal patterns and textures out of every note played on the saxophone.

In both contexts (image making and sound making), colors and notes are essentially units of energy. The aesthetic ground for this approach to making art seems to be rooted in the rhythmic values of African aesthetics, what Léopold Senghor called the "vibratory shock."

These artists, many of them trained in the techniques and procedures of Western art, have turned these very same technical procedures towards the elucidation and expression of a unique and varied African American attitude towards the business of making images. They present to us an iconography bestowed on them by the pressing and always exciting culture of the African American. In this sense, we could call them the "visual griots" of the African American community.

The Africobra/Farafindugu was formed in Chicago in 1968, "the year of consciousness." The movement announced itself as the African Commune of Bad Relevant Artists (Africobra). In this aesthetic vocabulary, the term "bad" means bold; "bad" means aesthetic integrity, artistic and social commitment. It further means an intention to project strong and engaging imagery; imagery that illumines the beauty and glory of the African experience in the West.

1980

April Kingsley, "Afro-American Abstraction," in *Afro-American Abstraction: An Exhibition of Contemporary Painting and Sculpture by Nineteen Black American Artists*, catalogue for exhibition held at P.S.1, Queens, New York, February 17–April 6, 1980

This exhibition, curated by April Kingsley for P.S.1, included recent works by Barbara Chase-Riboud, Melvin Edwards, David Hammons, Maren Hassinger, Senga Nengudi, Howardena Pindell, Martin Puryear, and William T. Williams, among others. Kingsley felt that the experience of traveling to Africa had impacted many of their practices since the various "Black shows" of about ten years earlier and that other Black artists, even if they had not traveled to the continent, were more closely aligning their work with various spiritual, philosophical, material, and formal aspects of African art. Kingsley's catalogue was not published until a year after the P.S.1 show, after she had spoken with many of the artists at length about this turn in their work.

APRIL KINGSLEY, "AFRO-AMERICAN ABSTRACTION"

Afro-American Abstraction is the first important survey of its kind since the spate of shows devoted to Black artists around 1970. Thus it serves to update the work of some established Black artists, as well as to introduce many talented younger artists who have emerged since that time. It seems to me that, despite the enormous diversity of their abstract styles, these 19 artists convey a common spirit. Since each is an American at work in the 1970s, the art naturally reflects the modernist tradition—their direct heritage—and demonstrates the wide range of esthetic options currently available, from shaped canvas, patterning, and assemblage to welded-steel construction and installation art. However powerful their commitments to mainstream modes, the work of these artists also evokes a subtle involvement with their African cultural heritage. A majority, in fact, have visited Africa, and certain characteristics of the great African artistic tradition are visible, whether intended or not. These include a bold physicality, rhythmical liveliness, and textural richness, as well as tendency to use linear, geometrical imagery, and high-energy color. The work is active, not withdrawn; robust, not tentative. It would seem these artists are at last realizing the potential that Alain Locke, champion of the "New Negro Movement," prophesied more than 50 years ago when he said, "If African art was capable of producing the ferment in modern art that it has, surely this is not too much to expect of its influence upon the culturally awakened (Black) artist."

A few years ago when I was preparing a *Village Voice* article on the current situation of Black artists, I found that a number of them had been affected, directly or indirectly, by recent contacts with African culture. William T. Williams made the breakthrough into the brilliant kind of painting seen in this exhibition after a trip to Nigeria, and the light and colors of the African landscape poured into Edward Clark's paintings after his visit in 1973. Martin Puryear, who spent two years teaching secondary school in Sierra Leone, West Africa, picked up a great deal of hard technical information from the woodcarvers there which remained apparent in his fine craftsmanship. Melvin Edwards was using much of what he learned about African vernacular architecture on various trips to make powerful post-formalist sculptures out of welded steel planes, and Richard Hunt, though he never actually visited the continent, collected African sculpture in such depth (owning dozens of examples of most styles) that his work was unconsciously reflecting its values.

I also found that a number of younger artists—many of whom showed at Linda Goode Bryant's Just Above Midtown Gallery—were making explicit connections with African experience in their art without having been there. Houston Conwill likens the value of this heritage to a number squared in mathematics (which is quite accurate considering the fact that African Art was a major source for modernism in the first place). It raises the work to a higher power, he says. Within the art community as a whole the ritualistic and mythic aspects of art and art making were beginning to replace "mere formalism," and thus this development among Black artists had far-reaching significance. For Maren Hassinger and Senga Nengudi, involvement with dance and performance led to sculptures incorporating a sense of movement akin to that of African sculpture and ritual.

In a recent WBAI interview William T. Williams spoke about some of his main concerns being "the notion of myth and magic and the notion of a work of art having a spiritual function in society, and not being either a decorative object or an object that's engaged in purely formalist endeavors." Earlier in the '70s he'd been struggling to reconcile these ideas with the rigorous formal training he'd received at Yale that had brought him so much success at the outset of his career. In Africa, which Williams visited for Festac in 1977, the artist was (and still is) a necessary member of the community. According to Black scholars W. E. B. Du Bois and James A. Porter, "He often combined the functions of medicine man, chief and maker of magic figures," and "artistic expression was a vital part of the lives of everyone." This fact was probably as important to Williams in developing a new approach to painting after his return as any of the visual material he saw

there, such as textile designs or architectural and sculptural decorative devices.

In the same WBAI program, Jack Whitten said that in addition to the fact that his main concern is with plastic content, "being Black at this time in America puts me into a rather unique position. It gives me a chance to offer something that has been lying dormant for a little over five or six hundred years. When we speak of that which is spiritual in my case it definitely goes back to Africa. If there is a certain thing that we are to believe in, Jung's theory of collective unconsciousness and so forth, I tend to agree with him. All my experimentations point to the fact that there is a certain sort of unconscious element, historically speaking, that's still alive . . . the spirit is still alive even though we were removed from Africa."

These words, and those of Edwards and Loving who were also on the program, reinforced my intuitions and confirmed my conviction that the Afro part of Afro-American was coming to have almost as much importance for the artists as the American part. Once the show was up and I was able to see the works collectively, formal links with the linear, geometric, colorful and textured aspects of African art were obvious. The symmetry of Tyrone Mitchell's and Charles Searles' sculptures and the rhythmical vitality of Jamillah Jennings'; the geometric, linear forms and energetic color of Ellsworth Ausby's heraldic wallworks; Alvin Loving's dyed canvas constructions; and David Hammons' use of Negro hair, African symbols, and irregular patterning, all make direct connections with Africa. The ceremonial mask aspect of Barbara Chase-Riboud's bronze and silk-cord sculpture; the textile derivations of James Little's surfaces; and Howardena Pindell's encrusted grids (this one dedicated to the Macumba goddess Iemanja); make oblique references. If one seeks out other more subtle correspondences, Senga Nengudi's hanging fabric piece has a coincidental physiognomic similarity to Bambaran antelope heads, Sam Gilliam's *Phantasy* and *Dupont Circle* suggest warrior's shields, and the clear geometric shapes of Bakota figures seem bound up somewhere inside Melvin Edwards' *Homage to the Poet Leon Gontran Damas*.

In general one can say with certainty that there is in all the work a particular vitality, an attitude of aliveness, of vivid equilibrium, which an African would term "looking smart" (as African dancers are judged to look at their best), that sets the work apart in visual presence. This energy is a shared resource.

1980

Benny Andrews, "Charles White Was a Drawer," and M. J. Hewitt, "We Got the Message and Are Grateful," in "Charles White: Art and Soul," special issue, *Freedomways: A Quarterly Review of the Freedom Movement* 20, no. 3 (Fall 1980)

Freedomways published a special issue on Charles White in fall 1980, following the artist's death in October 1979. The editors commissioned twenty-one essays by writers and artists such as Margaret G. Burroughs (also known as Margaret Taylor-Burroughs), Alice Walker, Nikki Giovanni, and Tom Feelings. White's lithograph *Sound of Silence* (1978) was reproduced on the cover of the issue, which was themed "Charles White: Art and Soul." Benny Andrews focused his essay on White's masterful skills as a draftsman, which had resulted in drawings Andrews identified as "the ultimate symbols of Black people." For Mary Jane Hewitt, director of the Museum of African American Art in Los Angeles, White's art enabled people to "see beauty in blackness for the first time." *Freedomways* was one of the most influential African American cultural and political journals, known for its intellectual editorials on the civil rights and Black freedom movements. Launched in 1961, the publication ran its last issue in 1985. The journal had supported White throughout his career, and the artist's work appeared on the cover several times.

BENNY ANDREWS, "CHARLES WHITE WAS A DRAWER"

All of us at some point need to be able to recall and reflect on works by individuals that have given a sense of solidity to our lives. No matter how secure or successful we might be, there are moments in our lives when we need those references.

I regard Charles White's black and white works of art as just such references. Long before I knew his name or was even inclined to look it up, I remember his drawings as being for me the ultimate symbols of Black people. It's been so long now since I first saw White's work that I don't recall what the subjects of those first drawings were; yet I can see them vaguely in my mind. They were in one or more of those poorly done books which give token recognition to what Blacks have accomplished in U.S. society. The drawings were of a first black doctor, a first black explorer, etc. Later, when I became one of those token Blacks getting this or that for the first time, I grew to resent those pitiful gestures of acknowledgment, my resentment being directed toward the society that perpetrates the offenses not at White's drawings. Today, as I visit universities, museums, prisons and other places where people gather to talk about the arts and artists, very often the one black artist people know of is Charles White. And, as had been the case with me, lots of people know White's work without knowing or caring what his name is because the work speaks for itself. This means that somehow, in his work, the essence of that much used and abused term Black Art comes through.

Over the years, White's drawings incorporated headdresses, hairstyles and other features which could be construed as representing the growing awareness among Blacks of their African heritage and are closely associated with our identification with Africa today. Yet even when he depicted Black Americans in overalls, suspenders and brogans, carrying tools one could get at any local hardware store, there was never any doubt in my mind that the people shown were African descendants.

Recently, as I went from room to room of the massive Pablo Picasso exhibition at New York's Museum of Modern Art listening to admirers of that artist's works, I couldn't help but think about Charles White—an artist who, to my way of thinking, embodies what should be the essence of art and of the artist's life contrary to how we in the U.S. are taught to conceptualize that essence. We are taught that the artist is one who strives through all kinds of deprivations and rejections to express his/her personal, subjective ideals. But White's work speaks of a different, less individualistic mission. One senses from his drawings that he felt charged with the responsibility of portraying people, specifically Black people, both realistically in terms of their everyday lives and idealistically from the standpoint of their dreams and aspirations. Throughout his artistic endeavors, he never deviated from that task.

White's career illuminates a subtle, historic facet of the experience of being Black in the U.S. that is seldom cited—namely, the deleterious effects poverty has on black artists' ability to explore and develop their art. One can experiment with many different styles and techniques, using the endless array of materials available to the U.S. artist only if one has the money. Most artists, including those who are white, are faced with the problem of securing adequate art supplies when they are growing up, but for none is the problem so great as for young Blacks. In the great majority of elementary schools that Blacks attend in this country, art programs offering the opportunity to experiment with different materials and learn about various artists' philosophies are practically nil. (In addition to their schools being poorly supplied, black youngsters are often confronted with the feeling, on the part of their financially-strapped parents, that valuable paper should be used for the "basics" like reading, writing and arithmetic and not for frivolous things like making pictures.) When they reach the secondary level and are thrown into classes with students from more affluent families and schools, impoverished Blacks are at a disadvantage in terms of awareness of the use of various materials and media. Thus, in order to establish themselves as being on a par with their peers, black art students often rely on their drawings. In my 18 years of teaching art and having numerous young Blacks bring their artwork to me

for evaluation, the most frequent reply to the question, "What area of art do you want to concentrate on?" has been, "I want to be a drawer like Charles White"—the quality of whose work they feel justifies their choice.

Indeed, Charles White was a "drawer." That term means exactly what it says: He drew rather than painted or sculpted. In this specialty, he was a master. And through his unique ability to draw he developed the ability to work in printmaking equally well, using mostly blacks, whites and grays, very seldom color. All of us who are familiar with White's work know that he also painted in oils and other media, but his greatest technical achievements derived from his ability to draw.

Thus, White stands as a beacon of hope for aspiring black art students and provides a foundation for their appreciation of other artists who excelled in the art of drawing like Ingres, Dalí and Rockwell, to name a few. Unfortunately for all of these masters, most of the people who control exhibitions, set prices for artwork and determine what is reproduced and what is considered major art do not regard the art of drawing as an end in itself, but rather as a means of reaching the ideal of becoming a painter, sculptor or designer. The Picasso exhibit at the Museum of Modern Art, among other examples one could cite, underscores the lamentable fact that although White is represented by galleries all over the country, money has not been forthcoming for a well-deserved, prime time presentation of his work and ideas in the nation's major museums. A goal for the future should be just such a presentation.

M. J. HEWITT, "WE GOT THE MESSAGE AND ARE GRATEFUL"

Charles White made the plea—"Please see my blackness!"—to a group of college and university professors and librarians at a workshop on African American History and Culture which I directed at the University of California, Los Angeles, in 1969. They had gathered from as far away as Virginia and Missouri, but were mostly from the Western states, to learn how to expand their libraries to include and to teach their students about the black experience in the United States. The workshop participants were both black and white, young and less young, and all were respectful of this great artist who had taken time away from his creativity to spend a summer's afternoon with them. His awe matched their respect. "Black Studies! What a revolutionary idea," he thought.

He described his own discovery of black achievement while attending a Chicago high school that was seventy-five percent white:

> At the impressionable age of fourteen, I discovered a book called *The New Negro* by Dr. Alain Locke, who was professor and chairman of the Philosophy Department at Howard University. And Dr. Locke, our first Negro Rhodes Scholar, had achieved a very esteemed position as one of the outstanding authorities on black culture. He was the authority at the time. And I discovered this book at fourteen. I had been a very voracious reader. And, man, it blew my mind. It blew my mind. I discovered that Folks wrote books! That Folks wrote fiction; they wrote poetry; that they were sociologists, anthropologists. This was the period of the so-called "Negro Renaissance." The whole New Negro was about this. . . . It's a classic. . . . I didn't know black people did these things!

Our revered guest speaker went on to describe the atmosphere of his Northern, predominantly white, urban high school where black participation in United States history was usually given a one sentence treatment.

I saw heads nod with understanding as he recalled, "We had Mr. Bid for U.S. history. Mr. Bid was a very magnanimous soul. He deigned to sum up 300 years of history with . . . 'Crispus Attucks was the first man to die in the American Revolution, and, incidentally, he happened to be black.' And that was the extent of Mr. Bid's recognition of Black history." That just whetted young Charles White's appetite; so he embarked on his own research effort: "I discovered Denmark Vesey, Harriet Tubman, Sojourner Truth and Fred Douglass. Well, I certainly couldn't accept Mr. Bid's one sentence, could I?"

Having made these momentous discoveries about his heritage, he wanted to share them with his fellow students and his teachers. His second-year history teacher told him to shut up and sit down when he asked why Mr. Bid had not included the feats of all these black heroes and heroines in his teaching. So he sat down and dropped out of further class participation for a year. He attended because it was a required course and he could not drop it. But he no longer participated. His own research project continued, however.

Charles discovered the great, nineteenth-century, black tragedian Ira Aldridge and decided he, too, wanted to be an actor. He had been designing the scenery and the costumes for their school plays and so decided he might have some Aldridge potential. "At fourteen and fifteen, this new discovery of mine started me off into Black studies. And so when I hear this term Black Studies and find you are all teaching it, it sounds very strange. It sounds very strange and very exciting."

These youthful discoveries of a rich and heroic cultural heritage motivated Charles White's work; and his work, in turn, has enabled many of us to see beauty in blackness for the first time.

Dr. W. E. B. Du Bois described the stigma black people felt when confronted with a black image in the early 1920's. Colored folk, he explained, like all folk, love to see themselves in pictures, but they are afraid to see the types which the white world has caricatured—the "grinning Negroes," "Gold Dust twins" and "Aunt Jemimas." When *The Crisis* put a black face on its cover in 1920, Du Bois claimed its 500,000 colored readers did not see the actual picture—they saw the caricature that whites intended when they made a black face. When *The Crisis* readers were asked why they objected, they stammered, "O—er—it was not because they were black, but they were too black. No people were ever so black."

"Is it because we are ashamed of our color and blood?" Du Bois wondered and then answered his own inquiry. "No! It is because Black is caricature in our half-conscious thought and we shun in print and paint that which we love in life. . . . Off with these thoughtchains and inchoate soul-shrinkings, and let us train ourselves to see beauty in Black."

One of our greatest mentors in this process of learning to see beauty in black was Charles White. Cedric Dover described him as "a painter by the right of having raised drawing, with conte crayon or Chinese ink, to the level of painting. He is also a preacher, but a preacher so inspiring and so searchingly eloquent that people of all faiths and nations have been uplifted by him." On our response to Charles White's people, Harry Belafonte observed, ". . . his people take on a reality all their own. You feel that somewhere, sometime, some place you have known these people before or will meet them somewhere along life's journey. You are enriched by the experience of having known Charles White's people. . . ."

One hears a lot of talk about universality in art from art critics, educators and intellectuals; and since most of them are European or Euro-American, universal translates as European. Well, Charles White eliminated that confusion for black folks. At the same summer workshop for professors and librarians, he concluded his remarks with a plea; and that plea was addressed to what he called "do-gooders" who would "reward" black achievement by not seeing your blackness: ". . . he will see you as a man," White explained, "and he will accept you. Lord, deliver me from the platitudes of these 'do-gooders'! Please see my blackness. I say that please in the first confrontation. Backing that up is a demand to see my blackness. If you don't see my blackness, you ain't seeing me, baby. That blackness is the essence of what I am!"

This man called White saw the universal human image in black: "For almost 40-some-odd years I've been dealing with the Black image, and mainly it's because I find white folks too difficult to draw. I often say that facetiously, but it doesn't really matter because when I draw white folks they turn out to look like Black folks. I've had a Black Lincoln, and I've had a Black-white Fred Douglass, and I've got a Black Christ. . . . I see images in terms of Black, but in a universal concept of blackness. What do I mean? I think I mean that I have a concern for all peoples of the world. I have a concern for humanity. I think the lifedeath of humanity is very important to me—how to survive. I'm romantic

enough to believe there's a better way of life to be achieved by mankind than what exists today. I use the Black image to make a very personal statement about how I view the world—my hopes, aspirations, and dreams about all people. And I say to the world, 'if you cannot relate to this Black image, that's your problem, baby—that's your problem.' . . . Black humanity has been thrust into history, has been catapulted into history as a universal thing about survival, a survival with dignity, survival of humanity. . . . Survival even to the classic religious concept—the Christian concept about man, his soul, his spirit. The tactics used here have to be very revolutionary tactics to protect this survival, to insure this survival."

We got the message . . . and are grateful . . . for the enrichment he brought to our lives.

Lorraine O'Grady (as told to Lucy Lippard), "Performance Statement #1: Thoughts about Myself, When Seen as a Political Performance Artist," 1981

Lorraine O'Grady was born in 1934 to Jamaican immigrants and raised in a middle-class environment in Boston. Having worked in various fields before becoming an artist, she carried out her first public performance on June 5, 1980, at the opening of *Outlaw Aesthetics*, the inaugural exhibition at Just Above Midtown's new location in downtown Manhattan. She had recently started volunteering at the gallery. While at JAM, she came into contact with a new guard of experimental artists, including David Hammons, Maren Hassinger, Senga Nengudi, and Howardena Pindell. O'Grady used the gallery's opening night to debut her fictional persona Mlle Bourgeoise Noire, a 1950s beauty queen who appeared in a white gown and tiara and carried a whip studded with white chrysanthemums. O'Grady had recently seen the exhibition *Afro-American Abstraction* at P.S.1 (see pp. 583–85) and felt that much of the work there was too cautious.

LORRAINE O'GRADY (AS TOLD TO LUCY LIPPARD), "PERFORMANCE STATEMENT #1: THOUGHTS ABOUT MYSELF, WHEN SEEN AS A POLITICAL PERFORMANCE ARTIST"

You've asked about my political concerns. . . . I guess I experience art as a way of discovering what I really think and feel. In an odd way, I also look to art to help me define my political beliefs. I find it so much easier to know what I'm against (monopoly capitalism, personal and social cruelties of every kind) than to know what I'm for. But the achieving of aesthetic form frequently gives me something in which I can believe, about which I can feel, "This is true." And because, more often than not, the aesthetic process is set in motion by an angry response to a political perception, the result has frankly political implications.

As an advantaged member of a disadvantaged group, I've lived my life on the rim—a dialectically privileged location that's helped keep my political awareness acute. But the main reason my art is "political" is probably that anger is my most productive emotion. I think that, for me, politics will always be more a matter of emotion than ideology— and I say that in spite of the fact that I was trained in the social sciences (for several years I was a career officer with the U.S. Departments of Labor and State) . . .

But certainly no one is going to go out and man the barricades after seeing a piece by me (at least, none that I've produced so far). My work is too complex for that kind of response. And where the critique gets most specific, the audience is often most limited (as in Mlle Bourgeoise Noire's criticism of black art that doesn't take risks). Performance is the art form with the most limited audience, and my part of it is even more so. To believe that a performance piece, or even Performance, can have a political effect is like having a Great Man theory of history. The most I really expect my work can accomplish politically is a small contribution to the task of creating a climate of questioning and refusal.

The reasons I go on with Performance are two: first, because I'm stuck with it. It's the only art form I feel capable of both mastering and expanding aesthetically. And second, because I believe it is an acceptable political option. I'm convinced the struggle for a just society is a kaleidoscopic one that has to be fought in all shapes and colors simultaneously. An upper-middle-class black woman making art that insists on cultural equality performs just one necessary political function.

I confess [that] in my work I keep trying to yoke together my underlying concerns as a member of the human species with my concerns as a woman and black in America. It's hard, and sometimes the work splits in two—within a single piece, or between pieces. But I keep trying, because I don't see how history can be divorced from ontogeny and still produce meaningful political solutions. (I'm referring to the long-range result of the work, of course, not to what I actually do).

. . . As I said, I'm sure my art will always be political because of who and what I am. And I seem to get my best political ideas when looking for aesthetic solutions.

1982

Dawoud Bey, "David Hammons: Purely an Artist,"
Uptown 2, no. 3 (1982)

David Hammons relocated permanently to New York from Los Angeles in the late 1970s. In addition to his exhibitions at Just Above Midtown (JAM) and his contributions to museum shows such as P.S.1's *Afro-American Abstraction* (see pp. 583–85), he began creating unannounced performances and ephemeral sculptural works on the streets of Harlem, interested in reaching viewers who were not expecting to see art and conscious that other artists might learn of his activities only through rumor. Dawoud Bey got to know Hammons and sometimes photographed his activities.

DAWOUD BEY, "DAVID HAMMONS: PURELY AN ARTIST"

"I'm not concerned with creating pieces that need be put under glass. When you put something under glass, you kill it. You've put a barrier between the viewer and the work."

On meeting David Hammons one is struck by his clarity and sense of quiet compassion. He doesn't speak much, but listen closely when he speaks. For here is an artist whose work is in conflict with the dictates of the commercial art world and its fluctuating tastes. Hammons is committed to creating works of art that exist in their own right; in their own time and space. Some of us may never see them. In fact, most of us probably won't. Yet the sense of myth created by the unseen is one of Hammons' concerns. Not that he preoccupies himself with it, though. But he understands the implications.

Word of mouth is a powerful thing, indeed.

How many of us actually went to see John Coltrane? Even those of us who never got to see him have heard the legendary stories of how, on a given night, 'Trane blew a particularly heavy set; blowing maybe for three hours straight. Or we hear about that certain way that 'Trane carried himself among men. So he lives on.

All art carries with it an aura of magic if it is truly doing its job. Or if the artist is truly a magician. Or a shaman. David Hammons is.

Walk through Harlem on any given day and you will see David Hammons work. The work he does for the people who cannot go to SoHo and gallery-hop. The people that he knows. The people he comes from. Bottles stuck on top of bare branches protruding from the ground. From vacant lots and cracks and crevices in the sidewalk. Hammons transforms them. Creates visual music and something to smile about in an environment that doesn't offer a lot in the way of jokes. But those cheap wine bottles have touched Black lips. Lips looking for a cheap way out of a predicament whose ultimate cost is very high. So Hammons knows this and gives our travails a new context—art. In very public spaces. The ultimate alternative space if you will.

But he has been there. In the Art world, that is. He has seen it from up close. Until 1975 he created what one would call traditional work. Works on paper. Prints. Body prints. Works framed and put under glass. But in 1975 he decided to re-think his direction. So he began creating environmental pieces. Sculpture, some people would call it. He transforms physical space—bringing to it those things he knows best. His success is in his ability to make the work metaphorical and socio-cultural. And he holds it all together with his underlying sense of order. Structure. Make no mistake about it. He understands that structure is the key. You have to know the rules before you can break them. And Hammons continues to break them. All the while creating work that could not be mistaken for anyone else's. All the while knowing that the act of creating is the thing itself. All the while knowing that whether through the written or spoken word, history will show that, yes, David Hammons was here.

Emma Amos, "Some Do's and Don'ts for Black Women Artists," in "Racism Is the Issue," special issue, *Heresies*, no. 15 (Fall 1982)

Emma Amos was born in 1937 in Atlanta. At the age of sixteen, she enrolled in a degree program at Antioch University in Ohio and, following her graduation, earned a diploma in etching from London's Central School of Arts and Crafts. By 1960, she had moved to New York, where she assisted the textile designer Dorothy Liebes and developed her etching and lithography practice through classes at Atelier 17 and Robert Blackburn's printmaking workshop. Following the dispersal of the Spiral group, of which Amos was the youngest and only female member, she taught at the Newark School of Fine and Industrial Art and, in 1977, developed and cohosted the craft-oriented series *Show of Hands* for the Boston public television station WGBH. Amos was also briefly an editor at *Heresies*. This essay appeared in the fall 1982 issue, themed "Racism Is the Issue." The feminist journal continued to revise its editorial strategies as it reached its fifth year of circulation. Although it had attempted to include more Black, Asian, and Latina artists in its pages, many still viewed its approach as problematic. The journal directly confronted the matter in this issue, publishing the perspectives of nearly sixty women. Amos contributed a satirical, as well as practical, essay that advised her contemporaries on how best to survive in a White, male-dominated art world.

EMMA AMOS, "SOME DO'S AND DON'TS FOR BLACK WOMEN ARTISTS"

DON'T admit to being over 28 unless you are over 58. It's handy to be either young and hot, or a doyenne, like Neel or Nevelson. In the middle, it's finding time and space, jobs, kids, lovers, husbands, and hard slogging, no glamour, no news.

DON'T take your art to Soho or 57th Street without Alex Katz's written introduction. Soho/57th Street doesn't dig blackass art. (They do still love "primitive" art, but don't be confused.) I think unsolicited slides are reviewed so the director can continually reinforce decisions about what he or she will NOT show.

DON'T complain about being a black woman artist in the '80s. Many people, both black and white, think you were fashioned to fit the slot in a turnstile—a mere token, baby. They may also think, deep down, that your minority face is meal ticket entitling you to some special treatment they're not getting. All minorities have this problem; you've just got to tough it out.

DON'T fantasize about winning recognition without breaking your behind for it. There are no "instant winners" in today's art world, the MacDonald [sic] Awards not inclusive. (Hope springs eternal.)

DON'T fret about things over which you have little control:

> The landlord raises your rent when you put new wiring in the studio.

> Your work overflows every available space, and even your new $400 flat file is delivered already full.

> The show you're in next month is not insured.

> The show you're in gets reviewed, but the writers went to the John Simon school of criticism and your work gets singled out as too _____.

DO take good slides every 3 months or so. Business in the art world is transacted through transparencies. Art that doesn't look good reduced to 1 × 1⅓ probably shouldn't be reproduced. More people may look at your ektachromes than will ever see your work for real.

DO show as often as you can—new work if possible. Discourage curators from selecting work whose ideas you're no longer involved with. It's hard to do, but each show should reveal something more about you, a progression.

DO exhibit with people whose work you like and in which you find similarities to your own. There's nothing intrinsically good about being a loner; finding parallels won't make you a "groupie."

DO be supportive of all your artist friends. Your peers are the people who see your work as it's happening. They give you feedback and keep you going.

DO extend yourself:

> Let the Studio Museum know you're alive.

> Let the Met know you're contemporary.

> Let the Museum of Mod Art know you're permanent.

> It'll probably net you only a "thank you," but we need to let them know how many of us are out there.

DO be thankful and shout "Hallelujah!" for:

> Dealers, agents, and pals who work at JAM.

> Lovers, husbands, children, patrons, and friends.

> Norman Lewis—whose art, elegance and concern impressed so many of us.

> Alma Thomas—she hung on, and it was worth it.

> Nellie Mae Rowe—she keeps working, an incredible Atlanta "folk" artist.

> Norma Morgan—the engravings, the work! Where is she?

> Romare Bearden—bright, open and deserving of all the praise.

Samella Lewis and Val Spaulding—whose *Black Art Quarterly* is so beautiful.

Hatch-Billops—the collection you must see, to know what "black art" is.

Bob Blackburn—the artist's printmaker and shoulder for 25 years plus.

James Van Der Zee—who has always been an artist.

Hale Woodruff—who would help any artist black or white.

Lena Horne—for her transformation and hard work.

Tina Turner—who found herself and is free.

Toni Morrison—who invents and forms worlds.

Duke Ellington—whose music is our soul.

Stevie Wonder—he deserves to be taken more seriously.

Bill Cosby—kills us on Carson, and buys art, too.

Ntozake Shange—who shows us how to use the system and how to survive success.

Maya Angelou.

Katherine Dunham.

The "do praise" list goes on.

1984

Hugh M. Davies and Helaine Posner, "Conversations with Martin Puryear," in Karen Koehler, ed., *Martin Puryear*, catalogue for exhibition held at the University Gallery, University of Massachusetts at Amherst, February 4– March 16, 1984

Martin Puryear was born in Washington, DC, in 1941. Between 1964 and 1966, he lived in Sierra Leone as a member of the United States Peace Corps; he also learned traditional woodworking techniques there. He later studied at the Royal Swedish Academy of Fine Arts in Stockholm and at the Yale School of Art. Puryear's first major exhibitions were group shows at the Corcoran Gallery in Washington, DC, in 1977 and at the Solomon R. Guggenheim Museum in New York in 1978, where several of the works discussed here were first shown, including *Self* (1978). This interview was published in the catalogue of Puryear's first solo museum exhibition, in 1984. One notable feature is the artist's account of the impact of learning craft skills in West Africa and of his exposure to cultures where the "ego" plays less of a role in the creation of art than it does in Western societies.

HUGH M. DAVIES AND HELAINE POSNER, "CONVERSATIONS WITH MARTIN PURYEAR"

SELF AND BASK

HD: Dualities and tensions appear to be among the strongest characteristics of your work. For example, *Self* looks like it's solid, but it's really a very thin shell. And it appears to be carved, but in fact it's constructed.

MP: The strongest work for me embodies contradiction, which allows for emotional tension and the ability to contain opposed ideas. So on the face of it *Self* is organic, almost as if carved out of a block, but in reality it was made over a form, built in layers. It was very important to me that the piece not be made by removal or by abrading away material, but rather that it be produced by a more rational process. It was put together piece by piece, though I finally arrived at a shape that existed *a priori* in my mind, and it was a carved kind of shape. It looks as though it might have been created by erosion, like a rock worn by sand and weather until the angles are all gone. *Self* is all curve except where it meets the floor at an abrupt angle. It's meant to be a visual notion of the self, rather than any particular self—the self as a secret entity, as a secret, hidden place.

HD: And how does *Bask* compare to *Self*?

MP: *Bask* is more calculated and more pure. The shape is a single arc floating above a straight line. It's meant to float above the floor and to stretch taut along the floor. While it reads as a dark silhouette, with an organic, slowly curving contour rising above the floor, the lower edge is sharp like a blade, dead straight, and fixed along the same ground plane as the observer. I wanted these different qualities to co-exist in a single work.

HD: What is meant by the title of *Bask*?

MP: It's the archetypal notion of basking, of lying extended in the sun like a seal or a whale.

RECENT WORK

HD: The circles you've been making in the last few years seem to involve concerns of both painting and sculpture.

MP: The circles are about line. From a few feet away they become lines drawn on a wall, yet they do have volume. I have to build things. Even when I returned to the impulse to work with line on the wall, it was not with paint, pencil or crayon but by building it. Each of the circles reads as a line, but it really is an object. In a sense I guess you could say it's drawing with wood. David Smith drew with iron and steel; this is drawing with wood. I felt this to be particularly true of *Some Tales* of 1977, which I assembled element by element, line by line, using spokeshaved wooden saplings instead of drawn lines.

HD: Does *Equation for Jim Beckwourth* of 1980 work in a way similar to *Some Tales*?

MP: Very much. *Beckwourth* also uses line, but in this installation the raw skin thongs were stretched horizontally to form straight lines in contrast to the twisted lines made of saplings. The two halves of the equation were different in their materials but alike in that both halves included helical lines placed on the wall at eye level, like writing. Essentially the piece had two zones, one of skin and one of wood. The skin side was made up of tightly twisted rawhide thongs and a large rawhide cone serving as one polarity high up on the wall. The other half, the wood zone, was composed of twisted vines and saplings, making loose, looping irregular coils; and a timber and sod object resting on the floor. The object was a box or cabin shape with a fuzzy turf top, like a domed sod roof. An extremely long, slender sapling connected the rawhide cone and timber and sod box diagonally.

HD: Is the rawhide cone comparable to the rawhide in *Cedar Lodge*, which you built at the Corcoran Gallery in 1977?

MP: The *Beckwourth* rawhide cone was probably more symbolic, whereas the rawhide in the Corcoran was used more like a light filter, kind of an amber skylight.

HD: *Beckwourth* and *Some Tales* then, are about drawing with wood, making lines with wood, both two- and three- dimensionally. What about the circles?

MP: Well, the circles are both line and object, but they're also a format for paint.

HD: Do the circles involve any symbolism? Do they consciously suggest the image, for example, of a snake biting its tail?

MP: I don't think so. Some of them do begin to suggest things—that's how the title *Tango* came about. But normally I just start out with forms and shapes and colors. Making sculpture that you know you're going to paint is very different. I make the basic circle, which is usually not a true circle, and then confront certain choices; what should the scale and thickness be; should the circle be tapered or left parallel all the way around, undiminishing; should it be faceted, perfectly round, or flattened to become oval in certain sections; should things be added to it? Once you've begun with the form you start to think about the color—the pieces usually get a color almost simultaneously. Usually when a piece starts to settle into a shape it begins to have its own color.

HD: So the shape will suggest a color?

MP: Almost always. That's the only way that I can consistently make peace with the notion of putting color on an object or a shaped thing. It changes the nature of the object so much once you put on just one thin film of color—it becomes a totally different thing. The form has to be made to carry the color from the outset.

[. . .]

BACKGROUND

HD: It might be useful to talk a bit about your background. How did you come to be an artist?

I know you were an undergraduate at Catholic University. Were you an art major?

MP: Toward the end of my college years I majored in art. I began college by studying biology and during my sophomore and junior years I got involved in art and finished with a degree in art. I was painting a lot and was just beginning to make sculpture when I graduated.

HD: Had you been interested in art before college?

MP: I had always drawn and painted, even before I went to school, and I was always interested in building things, not sculpture so much but functional things—guitars, furniture, canoes and so on. I always had a real appreciation of and took real pleasure in making and constructing things. At a certain point I just put the building and the art impulse together. I decided that building was a legitimate way for me to make sculpture, that it wasn't necessary to work in the traditional sculptural methods of carving or casting. After graduating I went to Africa for two years, from 1964 to 1966. After that I went to Sweden for two years to study at the Royal Academy in Stockholm.

HD: Had you planned what you would be studying at the Royal Academy?

MP: Yes. I had been accepted to study printmaking. I did two years of etching, and a lot of sculpture without instruction, in the evenings. This gave me two years to teach myself what I could about making sculpture. It's a very informal school. You're given a studio and if you want critiques or instruction it's available, but never forced on you.

HD: Why did you pick Stockholm and the Royal Academy? Did you want to go to that part of the world?

MP: I was curious about Scandinavia and interested in the furniture and woodworking done in Denmark and Scandinavia in general. I was also intrigued by the North, and by the possibility of living in a new proximity to the Arctic. I've always been fascinated by the Arctic and the Sub-Arctic;

I had been impressed with polar cultures for a long time.

HD: What interested you about Danish furniture?

MP: It seemed to me that Danish furniture had evolved out of a craft tradition into modern production without losing the vitality of the original precedents—or so it seemed to me from a distance. What appeared to be a lot of care and craftsmanship at close range turned out to be the result of very sophisticated technology. But it was all interesting to discover, and I did manage to meet James Krenov, a superb woodworker who was living in Stockholm at the time. He opened my eyes to an entirely new degree of commitment and sensitivity to materials. The process of making has always been central to everything I've done. How an object will be fashioned has always been, for me, part of the conceptual process. In Africa, I saw carpenters and woodworkers and furniture makers and builders of all kinds who had no machinery or advanced technology. That was the first exposure I'd had to real indigenous craftsmen. Their work was part of a continuous tradition, not a revival.

ART VERSUS CRAFT

HD: How does the African craft tradition compare to the crafts in America?

MP: In more traditional, more slowly evolving societies, there is always a down playing of the craftsmen's ego. You spend time learning, in an almost menial way, initially, from an acknowledged authority, and you only earn the right to be an artist, with anything personal to invest in the work, through mastery. In our culture the ego is paramount from the beginning. As young children, we're told to pick up clay or paint and "express ourselves." In Western society we're conscious of our place in a much more expanded cultural cosmos. The making process itself can be crucial or it can be quite incidental, like an afterthought, really. For my part the physical act of making a work of art is essential.

HD: So you see the distinction between art and craft not as an issue of hierarchy, but of difference. The *Pavilion-in-the Trees*, your project for Cliveden Park in Philadelphia, has an architectural character which intrigues me. It creates a peaceful space for the visitor/viewer.

MP: I think art can exist within any craft tradition. Craft is just another way of saying means. I think it's a question of conscious intention, finally, and personal gifts, or giftedness. It seems that in art there is a primacy of idea over both means or craft, and function. Idea has to transcend both. I think this is probably why it's so difficult for us to make art out of something functional, or in a realm where craft has been nurtured for its own sake. I would never insist that the *Pavilion-in-the-Trees* in Cliveden Park be called sculpture. It's a small enclosure set on tall poles that will be built in a wooded park in the Germantown area of Philadelphia. It has a domed grid roof of redwood and is reached by a sloping ramp from the ground. Given that categories are blurred these days I would still say that it's a public amenity, designed by a sculptor, which tries to invest a public facility with a bit more poetry than it otherwise might have.

HD: Do you see function as a limitation or as an inspiration?

MP: I think it can be either. For an absolute purist it's obviously going to be a limitation, or a kind of pollutant. For me it's a fascination and a challenge to occasionally include notions of use into things I make.

ABSTRACTION

HD: What sort of painting did you do at Catholic University?

MP: It was a time of real transition. I had taught myself at an early age to reproduce the look of things, but I was quite unenlightened about abstraction. As an art student I had to come to grips with non-representational art, which I did late and with a lot of difficulty. I didn't become a non-objective artist overnight. I went through a

series of stages, of learning how to see abstraction, and of giving up old habits. I finally gave up two-dimensional work altogether.

HD: Why did you feel compelled to come to terms with abstraction?

MP: It seemed legitimate, finally. Although I had the skill to render images effectively, I had no sense of how to make a really powerful composition, which in the end is based on abstract organization. In studying Franz Kline and Robert Motherwell I saw that their work derived its force from the same dynamics as the work of artists like Pieter Bruegel or Paolo Uccello. I still had to work my way through all of this step by step—literally to abstract from reality; this happened in Africa. I was no longer painting in Africa, but drawing. I did sheaves and sheaves of drawing. I also did woodcuts which of course are an easy way to make a graphic composition without getting involved in details. Then I stopped making flat images. In Sweden I realized that I was much more interested in making objects than in creating two-dimensional images of objects. The pleasure I took in making things found expression in sculpture. Rather than carving or casting, I took to building objects. At that point Minimalism became a strong clue for me about how powerful primary forms could be.

HD: Your work has an evocative, archetypal quality which is quite unlike Minimalism. It seems very personal, very far from the industrially generated forms made by Minimalist sculptors.

MP: Yes, well, Minimalism legitimized in my mind something I have always focused on—the power of the simple, single thing as opposed to a full-blown complex array of things.

HD: How did graduate school affect your approach to art?

MP: Studying at Yale put me close to New York. I had been out of the country for four years, and I hadn't had much contact with New York as an undergraduate, apart from rare weekend visits to the Modern, the Whitney, and the Metropolitan Museum. When I came back from Europe in 1968 I began visiting Soho for the first time, and became acquainted with current values in American art.

BEING AN ARTIST

HP: You lived in New York for a while. Was that important to you in your development as an artist?

MP: When I was in New York, I felt like I had my nose pressed up against the glass; everything was very immediate. At one time it seemed like a real necessity, and I suppose it was. I spent four years there, but after the first year it seemed less important for me as an artist, although it remained exciting just as a place to live.

HP: What were your expectations of a life as an artist?

MP: I didn't approach the prospect of being an artist with the notion that anything was guaranteed, or that I had a right to anything, least of all success. It's the kind of life you go into with a lot of hope, but you really take your chances. The reward has been the chance I've had to live a life that involves doing what I love more than anything else, and having that be at the center of my life rather than on the periphery.

1984

Benny Andrews, Sam Gilliam, Al Loving, Faith Ringgold, Jack Whitten, and William T. Williams, untitled dated statements, in Joseph Jacobs, ed., *Since the Harlem Renaissance: 50 Years of Afro-American Art*, catalogue for exhibition held at the Center Gallery of Bucknell University, Lewisburg, Pennsylvania, 1984

In 1984, one of the first exhibitions to reflect on the art produced by Black artists working on the East Coast in the 1960s and 1970s was mounted at Bucknell University in Pennsylvania. The accompanying catalogue featured interviews with artists such as Benny Andrews, Romare Bearden, David C. Driskell, Al Loving, Faith Ringgold, William T. Williams, and Jack Whitten. Although the interviewer's words are omitted, most of the artists seem to have been asked the same questions: They were invited to discuss the beginnings of their careers, the circles in which they moved, their thoughts about the category "Black art," the relationship of their work to jazz and to African art, and the exhibitions that were being curated in the period in question. (Sometimes, the artists refer to the interviewer as "you" or preface a comment with "yes," in reply to an omitted question.) The interviews have been edited for length for inclusion here. It is clear from reading them that the disagreements that existed between different camps of artists in the early 1970s remained strong into the early 1980s.

BENNY ANDREWS, SEPTEMBER 11, 1984

I was at the Chicago Art Institute from 1954 to 1958, which was in the middle of Abstract Expressionism. I was working representationally because I wanted to reflect what I knew and where I came from. I was one of the few black artists who was really that much from the South. I'd come up experienced in people who'd left our home and went away to what we called "The North." And when they came back, they always made fun of us. There was a denial of their past when they came back speaking "proper." I decided when I left that I would never deny or reject where I came from and that I would always understand who I was.

I started working in collage because I found oil paint so sophisticated and I didn't want to lose my sense of rawness. Where I am from, the people are very austere. We have big hands. We have ruddy faces. We wear rough fabrics. We actually used the burlap bagging sacks that seed came in to make our shirts. These are my textures. And in my collages I never wanted to deceive anyone—I never tried to make the collage fool the eye. I wanted to go into the format of collage, but I didn't want to do it in a slick way. As I mentioned, I was always self-conscious of denial, and I never wanted to do that. I have always wanted to be challenged to be a good artist, and part of that is transcending any one thing or any one element, be it being from the South, being poor, being black or being a representational artist. But on the other hand, I don't want to give up anything, and yet I don't want any of those things to dominate, because I'm more than that—I'm a total being.

I've never seen myself as doing political paintings. My work reflected what to me was happening at that time, and it had some political significance. But I would say that as a fine artist it's probably very hard to do political work, because then you become a little too angry. I try to let my work come from my emotions and feelings, and in order to do something as specific as political things, I think I would have to stylize and limit myself.

Now, *Did the Bear Sit Under the Tree?* is not political in the way that people may think. The idea originated from the continuous protesting and fighting that the people were having with the flag at the time. The flag was the symbol of the country, and there were all of these groups—black groups, women's groups, anti-war groups—who, everytime they did anything, had to hold the flag up. The police had the flags on their lapels as they were gearing up to keep you from marching. It was always the flag, and it was always from behind the flag that all this was operating. So the work was talking about the problem with the flag, which really represented the constitution and all the rights that the people were actually fighting for. And yet it was brought out as a barrier, behind which was everything it stood for. It was also a barrier between people. So I had this symbolic figure, and because I am a black person I used a black person as the vehicle in this case. I could have used a white person, and the meaning would have been the same. But in this case it was a black person who is shaking his fist at the very thing that is supposed to be protecting him and that he's operating under.

SAM GILLIAM, JULY 9, 1984

I came to Washington in 1962, when it was a breeding ground for color field painters working after Kenneth Noland and Morris Louis. I met an artist, Tom Downing, who was himself a color field painter. Tom and I would go out together and discuss painting and various things. He was the one who told me that I was behind in my work. He also told me that my ideas about art were too much like those that came from textbooks. In many ways it was contact with him that made me look at modernist painting for the first time. And within a year I changed from a figurative painter to an abstract painter.

I first showed in New York in 1968, at the Byron Gallery on Madison Avenue. I had a great show! This is the time I stopped doing the striped paintings and started doing more overall paintings. I wanted to deal with a certain aspect of scale. I ended up making a 30-footer. Working on that scale is spectacular for artists, but it's hard on the dealer, who in a sense has nothing at all he can sell.

The show established the real format for going into the draped paintings in the respect that they dealt with the whole space.

I have always felt very conscious of trying to find the point of non-control, that point at which the absolute aspect of control of the work is absent. This relates, of course, to the pouring of color onto fabric and then allowing the piece to be formed by gravity, which is almost like floating a feather through the air and watching it take an unpredictable course as, at some points, it just happens to be supported by a buoyancy.

Even the draped canvases were not romantic. They were gestural. I think of them in the context of wholeness. They are more a record of an activity, a record of incident. I am looking for the phenomenon of existence. Is that romantic? Perhaps in the objective sense, but not in the subjective sense.

Works such as the Martin Luther King paintings and the construction *Dark As I Am* mean very personal things. They are very heraldic aspects of a particular time. They do not change the meaning of painting for me. Rather, they help me to interpret and to clarify times or concepts. Figurative art doesn't represent blackness any more than a non-narrative media-oriented kind of painting, like what I do. The issue is the works deal with metaphors that are heraldic. I must have made some six or seven Martin Luther King paintings. The paintings are about the sense of a total presence of the course of man on earth, or man in the world. The humanistic aspect is perhaps the total aspect, the total subject of all painting or art, whether we like it or not. The principal Martin Luther King painting, *April 4, 1969*, was made specifically to commemorate Martin Luther King's death, just in my style. As an artist you are as much the medium as the medium you are working in; you are not only present, but you share the feeling and expressions that people go through.

Dark As I Am came out of a period of very deep insideness. It came from trying to think out the possibilities beyond the facade of the draped canvases. I began to rely on a certain amount of Dadaism to do things, especially the Dadaism of Schwitters. In fact, there was a series that went along with the

Dark As I Am installation which was called *Jail Jungles*. The works were actually made off the street, that is, they have found objects in them. In a sense. what was happening in the *Jail Jungles* series is not unlike the relationship of metal to canvas in the *Pantheon* series. At the time of *Dark As I Am* and the *Jail Jungles* series, I did two works with found objects: one was for women, and the other, which had a camera in it, was for James Van Der Zee.

When you think about the social history of this country, you wonder how could anyone think about painting at the damn moment when the other side is so denying. Mary Schmidt Campbell told me at the opening of the Hale Woodruff show at The Studio Museum in Harlem that Hale said, "What a great thing; this is the first time I have seen all of my works all in one room." You have to ask yourself why anyone really chooses to paint. And yet the significance of the mark or the bending of form in space and things like this suggest a form of survival.

AL LOVING, JULY 24, 1984

I came to New York on Halloween, 1968, and moved into the Chelsea Hotel with the family—Wyn, Alicia and Ann. We were waiting for our first loft, which was on the Bowery just south of Houston Street. I came to New York to meet Ken Noland and Frank Stella because I was doing hard-edged geometric art and I didn't know the difference between the two artists. I felt eclectic to both of them, except that I was dealing with illusion, a powerful and overt illusion.

When I got to New York a lot of things were happening. For instance, I had never met any of the black artists who were basically formalists. I was from Detroit where Reverend Cleage was having his black art conferences. I would go to the meetings, and there would be pictures upstairs, mostly by the street artists of Detroit, the guys who sat and did portraits. There were paintings of people in the struggle, people in chains, slaves, romantic pictures of Africa, and so on. I had just gotten a B.F.A. from the University of Illinois, and I knew a little bit about aesthetics. So I had to ask the question, "What is black art?" Was art supposed to be propaganda for

the Civil Rights Movement? That seemed to be the attitude at the time. I remember I began to separate my activity in the street from painting. I just could not bring them together somehow. I kept trying though. There was one convenient point when I did it with Pop Art. When I came to graduate school I tried for a while to synthesize Pop Art with Expressionism. I did gigantic American flags, with thick paint, and black and white dogs chewing each other's back legs and chasing each other around these flags. A guy was sitting on a couch watching TV holding cattle prods. But that was the only time I tried to work that way. There was no way for me to relate my experiences on the street on canvas. I would go to meetings, to marches and to sit-ins, but they were totally separate issues. I thought I would be exploiting the question to try to paint those issues. I have never seen a political painting.

Guernica to me is not a political painting—it's a nice synthetic cubist painting. It doesn't affect me to the point that it says this is the first time that men dropped bombs from the sky on people.

When I came to New York the only black artists I had heard of were Jacob Lawrence and Romare Bearden, and at the time I considered them local artists. I had not seen an artist who was black who was dealing with questions I had some curiosity about until Sam Gilliam. And that was exciting. And I only knew him through his art.

When I arrived in New York the Black Emergency Cultural Coalition had just begun and the *Harlem on My Mind* show opened the week after I arrived. I remember getting out of a taxi and finding a picket line in front of the museum. We got in line, and that's where I met William T. Williams. We went around the circle finding out why people were picketing the show. I signed some forms.

And then William T. Williams and I went down to Max's Kansas City and had dinner. He was the first person like that I had ever met. He'd finished Yale shortly before. Howardena Pindell, Jack Whitten, Joe Overstreet, it was the first time we ever met each other. We were all coming from all over. These were the artists who were living in lofts downtown, who had come from Texas, California and Oregon,

and we found each other fairly quickly. There was also a large group of black artists who dealt with representational traditions. For example, Gerald Jackson, who lived across the street on the Bowery, was not a formalist. I remember Joe Overstreet was considered the "Father of Black Art" at the time because he said he was! It might be true in reference to contemporary art.

I don't really know why I was the one selected to show at the Whitney in 1969, but it put a lot of pressure on me. It put pressure on me to become noneclectic. It was embarrassing on a certain level. At the time I was absolutely thrilled. Dick van Buren was at my house when Marcia Tucker called and said, "Al, we have a gallery downstairs that is for people who don't have galleries but who have work that we like. Would you do a one-person show in December?" That's the way it was presented. This was in October. I said, "Sure."

Sure, I had to ask myself why the Whitney Museum was giving me a one person show when I had been in New York only ten months. As if I didn't know, right? You don't ask questions; you just do it! So that's what I did, and I tried to give it my best shot. But it was a worrisome situation. And I knew why. I was thirty-three years old. I wasn't a kid, and I knew who I was, what I was doing and why I was there. I had expected it to take three years to integrate myself into New York City and to find my little nook. Adjusting to New York was quite a trip. Whatever you are doing, there are one hundred other people doing it. Everyone is after just what you want. And that blew my mind. It was exciting. Everything up to that point felt okay, except that show.

The show traumatized me in other ways, especially the idea that I would be successful and would have to deal with that success. I sold all the art in the show, and I sold all the art I did for the next year. And that was without going through a dealer, without doing anything.

And then there was all the pressure being put on the Whitney to show black artists. Personally, I thought it was crazy to attack the museum about those issues. I'm not saying the museum was ever going to move itself. It is fifteen years later and the Whitney is exactly the way it was then. Obviously

everything was just nonsense. What it did for me at the time was okay, however. I had taught college for four years. That was nonsense, because no one ever looked at my art when I was hired! So now help was coming along; someone was going to get me a show at the Whitney under similar circumstances, and I didn't like that very much personally. But this show was happening, and I couldn't get around it. I knew my work was still eclectic at the time, and I didn't like the idea of presenting myself as having an aesthetic.

So my Whitney show was quite successful, but it didn't reinforce my commitment to doing that kind of work. That hard-edge geometric art just felt awful to me. I couldn't figure out how to get back to the process of making art. As a painter I felt that. Working with acrylic and masking tape was totally cerebral stuff, and the soul was starving. I began to really hate the stuff. I felt I had to make a major break in my art. The question I asked myself was how to reinvolve myself with the process of painting.

The break came in 1971. I did a wall in Detroit in my hard-edged style. It was the seventeen-story building I just mentioned. There was something exciting about the fact that it was so big and it was in my home town. But there was an accident; somebody fell off the scaffolding. At that time there was a quilt show at the Whitney. This was the period of acid and sunshine and that whole thing. I remember I had gone to Newfoundland that summer to get off the stretcher bars somehow, although I didn't know what that meant. I just had to break this box I was in. I was in absolute pain. And then this worker fell in Detroit, and that blew my mind. So I went back to Newfoundland, got up the next morning and cut up sixty geometric paintings. We had a sewing machine there, and I learned how to use it to sew the canvases back together in ways that I could enjoy them better. I found I could control the color relationships better. And I felt like a free man. All I did that summer was cut up these canvases and sew them back together. It opened my options a lot.

I began painting acrylic on canvas, when my wife said that dyes might be a good idea. It was a question of how could I get as much color down as fast as I was going to need it. It was a perfect idea.

I went around the corner to a variety store on Elizabeth Street, and I bought all the Tintex dye that they had—fifteen buckets! I ran back to the house, began tearing up all the canvas I had and started dyeing the cloth. It just blew my mind. I dyed fabrics for four weeks, fabrics of all different sizes. I just kept making colors, and as long as I had enough dark, middle and light values, the colors didn't matter. I was just dunking this stuff in buckets and feeling glorious. But I had no idea how I was going to put the pieces together! And Zierler [Loving's gallerist] kept saying he was going to come by and see the art. But after I had a whole corner full of color, that is, full of dyed fabric, I just started laying the fabric out on the floor and pinning it together. That day I tacked the first work on the wall, and it absolutely blew my mind. I had completely come out of the whole thing. Yes, this was the first work in the style of the work that is in your show, Self-Portrait, April 1984. It was completely non-geometric. I was working in a purely intuitive fashion and had gotten away from setting up formal problems that I would then work out. The works were completely automatic. It was back to expressionism in a way. The drawing now was fabric. And instead of an illusion, which the boxes had been, this stuff literally hung in space. For a while I was fairly dramatic, bringing pieces down from the ceiling and letting them come across the floor.

But the work had its problems. It certainly wasn't free, in the sense of presentation. How do you sell the work? That was the problem Zierler was going to have. I took that show to the gallery on the subway. When Zierler wasn't there I put the show up by gluing together loose pieces and pinning them up, either stuck on the wall or hanging from the ceiling. Zierler said he liked the show. But he couldn't really sell the art. I felt as though I was ripping the man off. There were serious problems in terms of the integrity of the piece once it was taken down: what do you do with it, and who can put it back up? In a sense you stayed married to these pieces forever. Also the works were made for a specific space and would only work in that space. It was fortunate that museums always gave me a specific space and I could make a piece for it.

My going off the stretcher really had nothing to do with Sam [Gilliam]'s work. I knew he had done it, which gave me the right to do it. But my work wasn't like Sam's at all. For me it was a question of occupying space and still thinking of myself as a painter. The *New York Times* review that year described my work as soft sculpture rather than as painting.

I was a dancer the first three years in New York, dancing with the Batya Zamir Dance Company. I was a stout dancer. It was an innovative form of dancing which utilized personal gravity. I feel this experience was important, because dancing in real space supported my move into hanging fabric and environmental art.

I really didn't feel as though I became a non-eclectic artist until 1974 when I started working in corrugated cardboard. The Whitney show in 1968 made me realize that I had to develop a unique statement. I didn't think I'd achieved that with the dyed cloth pieces. I first showed the corrugated cardboard pieces at Fischbach in 1974, and they were my reaction to the graffiti on the sides of trains. These pieces were about nine feet long and four or five feet high. What happened was I went back to the wall. I would get corrugated boxes, tear them up, doodle on them, paint them, put them together and throw ink on them. They were abstract, and they were fun. But they didn't sell.

Coming out of the geometric abstraction I had been doing for years and going to cloth and then to corrugated cardboard, I wasn't a very safe bet for someone looking for an artist with stability. But it was a chance I had to take, that is, to leave the geometric work behind. It didn't matter. I feel that it was a part of my education. I was looking at everything going on around me and discarding what I didn't need, and I finally felt comfortable with the corrugated cardboard. And I finally withdrew after my seventh year in New York. I had been showing all the time, and I had been taking commissions for the geometric work to pay for experimentation and growth.

I didn't notice myself moving away from Noland and the mainstream. But I just felt I understood what those questions were about, and I was going somewhere else, although I didn't understand where the work was going. But I found that I had put down the paintbrush and found another way to do art, and that was to make things. Romare Bearden was important to me for this reason. He had been an abstract expressionist painter, but ultimately he cut up those works to make his first collage pieces. Looking at Bearden's collages made me realize that the cloth works I had been doing were actually collage, and all of the work I have done since has been some form of collage. What you see in the fabric pieces and the corrugated cardboard pieces is that aspect of me that doesn't paint but makes things. But I'm not a sculptor.

I feel that there is some connection between my work and an African tradition. I think I'm African in the sense of making things, and I think that that is something that characterizes the better and more intelligent black artists of this time. But you don't have to be black to work this way. Most of the women I know make things. And, of course, a lot of white artists make things as well.

I also feel that there is some significant connection in that all of the people I knew who came to New York in the early '70s worked in acrylics and then by the mid '70s they all began to make things. And we did it without discussing what we were doing with one another.

For example, my work relates to Howardena Pindell's. She doesn't paint; she makes things. And the work has an intellectual base. Or James Little may work in oil, but you can't tell how those works are made. The same is true of Jack Whitten's work; it may be acrylic on canvas, but you cannot tell how those works were brought about. If there is any stylistic difference between us and the white artists, it is the same stylistic difference that can be found in jazz: jazz is about taking conventional instruments and making something else happen with them. And we're no different from those people. And that's why our work is pure abstraction.

But it has only been in the last ten years that a group of people has arrived intellectually who deal with this question of making things without being "colonial" to Africa. And this group deals with the animism of the black heritage. I think black people

have essentially the same religion that they had the day they came here, which is an animist religion. And soul and intuition play a large role in the work of the better black artists. But the work also has an intellectual base. So we don't relate to the mainstream. Hype without integrity is wasted. Our art proceeds in a steady process, and it simply moves on its own. The alienation we have for the mainstream is a failure to connect with what is happening there, and I did not have that experience until just recently. I just cannot relate to what's going on there. I feel the extremes of European influence in American painting and what we do are widening. Oh, yeah, I started in the tradition of the mainstream.

FAITH RINGGOLD, SEPTEMBER 10, 1984

My first mature work dates to 1963. That's the summer I took the kids and went up to Oak Bluff, Massachusetts, armed with books by James Baldwin and then LeRoi Jones, now Amiri Baraka. The idea was to find out what direction my art was going to go in, that is, what I was going to be saying and from what point of view I was going to create an art relevant to black people. I was forced into that situation. First, there wasn't a great deal going on at the time that might suggest that a black artist should be doing work like this. There had been, of course, the earlier artists, such as William H. Johnson, Jacob Lawrence and Palmer Hayden, and I find that period very fascinating. But other than that, there was an atmosphere in 1963 that black art should just try to fit in.

Now, I wasn't doing that in my regular life. I've always been very political and always lived in Harlem and always remained very heavily true to my roots as a black person in America. But somehow it seemed that the black artist forgot his or her roots. I hadn't been inspired by what I learned at City College, which was basically the Western masters. I had been to Europe, where I saw the works I had been studying, and was taken up with Impressionism, which I imitated in the late '50s and early '60s. As a student I tried to paint pictures of black people, but met with a great deal of frustration because my professors couldn't show me how to mix the colors to make black skin tones. They felt I was just being exotic when I ended up with green and purple. So I gave that up and tried to create a picture that would be acceptable and started doing French Impressionist flowers and trees.

About 1960–61 I went around to galleries trying to get in with this work. I went into the Ruth White Gallery on East 57th Street, with my French Impressionist pictures, and the dealer said to me, "You can't do this." I didn't ask her why, because I knew what she meant. I looked around the gallery and saw that many people were doing exactly what I was doing. My husband was with me at the time, and he said, "This is not your heritage and your culture, and you're coming at it from the outside; what you should be doing is something that you know, something that's coming from your own experience." Now, I don't think the dealer meant me well by telling me what she did. I think she was saying, "You've got to be kidding." And I thought about what she said and went to Oak Bluffs.

Baldwin and Baraka inspired me more than any artists or any other individuals at that time. They and African art were my inspirations. So I went to Massachusetts and began to do the *American People* series. I didn't call it that at the time. As a matter of fact, the director of the first gallery I belonged to named it that. Yes, I finally got a gallery on 57th Street, the Spectrum Gallery, which was a cooperative gallery. In those days cooperative galleries were very strong and very good. I did rather well there. I was the only black, although not the only woman. In my show of 1967 I showed the large mural-size works, like *Die*. After that my palette got darker as I took the white out and used colors that looked like the colors of black people. So I was deeply entwined in my own look. Also I employed African art as my "classical" art form. Instead of looking to Greece I looked to Africa. So those were my beginnings. I didn't have to worry about whether collectors were going to collect me or whether my work was acceptable, because I was not pursued by those people anyway. I figured that one out fast. All I had to worry about was that my work was acceptable to me, since I had neither an audience nor a market.

There are several reasons why I moved into doing the unstretched canvases or tankas about 1973 and the soft sculptural masks. About that time I thought about the association of painting with the Western tradition. As long as you're painting, you're going to be influenced by European traditions. So I moved into fabric and the soft sculpture to get away from that altogether. A second reason was that I wanted to draw on the strength of my own heritage in sculpture and in cloth, and that meant returning to African traditions that women used, such as sewing. My mother had been a fashion designer, and I had done sewing on my own. At that time I never thought that that was anything that you could do as a so-called "fine artist." But there I was in the early '70s with new attitudes that had come about by understanding what it meant to be a black person and identifying African art as the classical art form. I also had come to understand what it was to be a woman, a black woman, and that it was all right to sew.

This was also a period when my daughters were growing up, and there was a need for a lot of activity in the house. I really couldn't isolate myself to paint. Painting is a very lonely experience. You have to be by yourself and concentrate before you do it, while you're doing it and after you've done it. I couldn't afford that kind of time away from my family. What I could do was sew and create soft sculpture, because I could have people around. In formulating the plan of the sculpture, I had to be alone. But how long did that take? A lot of that kind of thinking goes on in my head while I'm taking a shower or while I'm going to the store. So that's not time away from the family anyway. And the time that I used to make the work I could be sitting right there, with everybody all around me. So it was a perfect solution in the '70s to sew because it allowed me to continue working. Women often fail when it comes time to have a family. We get phased out. We fall in love, get married, have kids, and our lives become hectic and crazy. We can't do our work or we decide not to do our work because it's more acceptable to the men in our lives that we not work. I've always been committed to doing work and so was my mother. My mother was a housewife, but,

at the same time, she had her work and became a fashion designer. I have always been very passionate about working, which is not the same as having a job, so if I can't do my work one way, then I will do it another way. But I will work! So my sculpture came out of the understanding that I had to get away from painting. The sculpture was a perfect solution because I was able to keep on going and also embrace the traditional woman's life. Since I was a feminist, that was important.

Now, if you're going to be a sculptor, you've got to look at African art. African sculpture is fantastic, and most sculptors would agree with that. And you've got to look at the sculpture made from coast to coast in Africa. There's hardly any group of people who have embraced an art form with so much ingenuity and presented so many ways of seeing things. This is to say nothing of the fact that modern art originated partly through artists looking at African sculpture. So why shouldn't I look at it? I was trying to start something, so why shouldn't I look hard at African sculpture and not at Picasso. Of course, I could be influenced by Picasso. But I didn't want to let it be just that, and I wanted to try to go straight to the source, the same source that Picasso went to.

We don't even have to look at African art if we could close our eyes to Western influences and not be intimidated by thinking that whites are going to be upset if we do our natural thing. Little black kids who know nothing about Africa do African things. If black people were left to their own resources as black kids are, then they too would do what is natural, and what is natural would be for them to see the way that African artists see. Your art comes out of you, what you look like and your natural feelings about yourself. That's why African art looks the way it does—it looks like the people. And you cannot live someone else's experiences. You can be inspired by them, but you cannot be an innovator without going to your own roots based on your own experience. Look at my work. You saw a European influence, but I cannot develop in it a new Western form because I am not European. I am naturally influenced and inspired by some European forms because I am here in America. But I cannot

create a new Western form of art because I am not coming out of that experience. What I am creating will always be AfroAmerican. And I don't see anything wrong with that, because I don't see anything wrong with me as an AfroAmerican. Just as surely as I don't have any problem with not being a man or white.

Yes, I think it is true that I made the soft sculpture and moved into performance art because I wanted to make work that the community could relate to easily. And people really like sculpture better than painting. Also I think people are more willing to accept sculpture from a woman too, and a black woman, than painting. I think too many people just closed their eyes to my painting. They think painting comes from a man, and a white man at that. The sculpture was okay because it was called "dolls." They could say they were crafts and write them off that way.

My support came from colleges and universities across the country, and not the art community in New York. And the universities were more, receptive to my work because of the women's movement. They understood that this was work by a woman that was based on her experience as a black woman. And they wanted to see more of the work.

Thank God that colleges and universities are still interested in something that's new and different. If it weren't for them I wouldn't be talking to you now—I would have been eliminated a long time ago, like so many black women artists have been eliminated.

What was also nice about the colleges and universities was the fact that the audience was willing to let the soft sculpture be whatever I said they were. They didn't think of it in terms of dolls. They wanted to know what the work was, and their attitude was, "You tell us." It's a time in their lives, that is, the students' lives, when they're learning and open, and they're accustomed to people coming at them from unexpected directions. But in the commercial art world, people feel threatened when you do something different. It was very difficult, especially showing with black artists, who were men. I remember one black artist, who should have known better, introducing me as a weaver. This was in 1972

when I began the tankas, which were paintings on unstretched canvas. He went up to my paintings and asked what they were, and I said, "Those are paintings." He insisted they were "wall hangings," and I replied by saying that, "A painting hangs on a wall; this is cloth, but painted cloth." People just couldn't deal with the work in the '70s.

By people I mean men, and black men. The white men weren't even looking at what I was doing, so I guess I can't put them in it. At least the black men were looking, but they were confused about what the work was. They were all doing the abstract thing, in the mode of Stella. Maybe I shouldn't say that, but that's what it looked like to me. They were doing paintings stretched on canvas, as big as possible and as mainstream-looking as possible. And then somebody comes along who is pooh-poohing all that. I did it in the '60s with my political work, which was taboo, and then in the '70s with the tankas and the soft sculpture. Yes, all the work was very, very unpopular with the black artists and with the people who put shows together. And we're talking about the men.

Of course, in the '60s there were not that many people making political art. Benny Andrews was making political art, but he was a man. And if I had been a man, my art would have been okay too. The only other people I can think of right now who were making political art at the time were David Hammons, Dana Chandler and the people who were painting murals on buildings. I never did the kind of political art that showed black people beaten down and broken. I came at it from a totally different point of view, and that's why I mentioned that I was inspired by Baldwin and Baraka.

I have always been political in my life as well. I am the one responsible for the first demonstration of black artists against a museum in New York. That was in 1970, against the Whitney Museum of American Art. The Whitney did a show about artists from the '30s, and they left out all the black artists. They didn't include one. So Henri Ghent put together a show of black artists of the '30s for The Studio Museum in Harlem and wrote a press release saying that the Whitney had snubbed the black artists. The Studio Museum called a meeting

to discuss the situation, and I was invited through Vivian Browne. Also at the meeting were Eleanor Holmes Norton, John Coplans, Betty Slayton and Henri Ghent, to mention but a few. Many of them were shocked when I said, "Look, we don't need to worry about whether the Whitney Museum is going to get angry about Henri saying that they snubbed black artists. Forget about how they feel. Why don't we have a demonstration." Henri said, "Yeah," and the planning got started.

The demonstration took place and was covered by Grace Glueck in the *New York Times*. Of course, my name was not mentioned. The women were pushed to the back as the men took over. They were the ones who talked to the press, and they were the ones who did the talking when the time came to go in and sit down and talk to the Whitney. The men were having their private meetings and were just using me for my mouth because I had the nerve to say things that they wouldn't. They were guarding their careers; they didn't want to get in too bad with the Whitney because in the final analysis they intended to be on the walls there. That was the last thing on my mind.

So I left that group and joined Tom Lloyd at the Art Workers Coalition at the Museum of Modern Art, where we did demonstrations and negotiated for a Martin Luther King wing for the museum. The wing would have been devoted to Hispanic and black artists. And part of the package was a show for a black artist. We suggested such names as Jake Lawrence, Romare Bearden and Charles White, and as a result Romare Bearden and Richard Hunt got a show together.

Yes, you're right, all the names mentioned were those of men. Elizabeth Catlett and Alma Thomas never came up. I was not a feminist in those days. I was working with men, which I wouldn't have been if I had known better. The things that happened during the period I just described brought about my feminism. I had put all of my energy and time into trying to make changes for whom? Other people, for men. For black men, sure, but so what? I wasn't even invited to the opening of Romare Bearden's show! It was at this point I decided that I couldn't continue to devote my life to helping other people.

That was a loser's game. I had to find out who I was again—I was back at the drawing board. And that's when I figured it out, in 1970–71, that I was a black woman.

So I started working with women. In 1970 we liberated the New York version of the Venice Biennale. They brought the American section to New York, artists like Andy Warhol, Robert Rauschenberg and Bob Morris. Morris was called the "Prince of Peace" then. I said we had to make this show 50% women. These guys were all superstars, but were they big enough to understand that if you're going to struggle against racism and sexism, then you shouldn't have a racist sexist show? If they put that show on, we were going to close it down. My group included Camille Billops, Michele Wallace, Vivian Browne and Kay Brown, among others.

In 1971 Kay Brown, Dindga McCannon and I cofounded the only black women artists group, which was called Where We At: Black Women Artists. I got a black women artists show at the Acts of Art Gallery that year, which was how we got together. I was also involved with the women's demonstration at the Whitney in 1970 for 50% representation of women in their shows. I was instrumental in getting Betye Saar and Barbara Chase-Riboud into the Biennial, which marked the first time a black woman artist ever exhibited at the Whitney Museum. That was accomplished through my participation with the Ad Hoc Women's Organization.

JACK WHITTEN, JUNE 4, 1984

The question of whether or not an uninformed viewer can perceive anything black in my art, such as in *Kappa* (1976) which was shown at the Museum of Modern Art this summer as part of their recent acquisitions exhibition, arises only in a social context. The answer to the question really doesn't make that much difference. But at the same time, there is a grid working in that painting, and I see that grid as coming from Africa. In effect, that grid is a visual DNA, and I think it explains how a lot of artists see. It just so happened that my working with the grid at that time coincided with the minimalist thought here in the States. So two things are going on in the

painting: first, I am a New York artist working at a particular time in history, and, second, I am of African descent. While it's evident for me to sit here and say that that painting has a source in Africa, it is not evident to the average viewer. Keep in mind that my connection is also with the African wood carvers, and there's a grid under that work, a molecular structure, that explains how the artist perceives things. I started carving wood about 1962–63 in order to understand the grid better and, of course, to understand African art.

Reading books about the work just wasn't enough. There is something still, alive from Africa in African-Americans despite the fact that it has been a long time. What the sculpture did was make me aware of the molecular physicality of painting, or paint as matter. My approach to paint is to cut it up, chop it up, saw it, and so on. This attitude not only came out of my understanding of African sculpture, but it also came out of my experience in the construction trades. I used to work with a cabinet-maker, and then I worked with plasterers and concrete people. One of the first jobs I had in New York was working as a laborer for the company that built the subway construction extension on the Flatbush Avenue line in Brooklyn.

But my work wasn't initially physical in the '60s, except for the physicality of gesture. Nor was I dealing with the notion of the grid. I was busy searching for what I called my identity, just finding out who I was. You have to remember that the '60s were really high-powered. They were emotional and they were excitable. I keep going back to a review of a show I had at Allan Stone in the '60s that described one work as graffiti art. The painting was vicious, and the reviewer said it was a savage work and a graffiti-inspired race-war painting. People were tearing into one another in the image, and the blood was flying from these forms that were half-animal and half-human. Of course, I was motivated to make this kind of imagery based on what I saw happening around me. It came out of being black and out of experiences in the South. It came out of seeing the polarization that existed in society and saying to myself that whatever those people do out there it was not going to distort me the same way. I didn't

accept the violence coming from the white side or the black side. And that's why the work has the caption of, "Look, Mom, look—see the funny people."

I guess I was working in a figurative tradition at the time because close buddies of mine were Bill White, that is, William White, who is now dead, and Joe Overstreet. The three of us were rather close. I was especially close to Joe, and we were both making expressionistic figurative painting. I met Allan Stone in 1965, and he started supporting me a bit. He put me in a show in '65, and he bought some works from that period. He was my first New York collector.

Bill Rivers was also important for me in the '60s. He wasn't a figurative painter at all, but he was an inspiration for all of us. We used to meet at his house a lot for dinner. He was the one who introduced me to the meaning of art, and later I had that same sort of relationship with Norman Lewis. Although my work was figurative, it was coming out of an abstract expressionist approach to painting. I was using the techniques of the abstract expressionists, such as the automatic physical application of paint. I considered the works from that period as analytic. They were like turning my head inside out, trying to get a picture of what it looks like inside of me.

I knew Bob Thompson in the '60s. Despite the fact he was a figurative painter, he wasn't supportive for me in the way that Bill Rivers was. Bob Thompson was the only one of us who was making it with any degree of success. Martha Jackson was supporting him then, and I remember seeing a couple of his shows at her gallery. I wasn't that close to Bob because our lifestyles were different. I went around with him from time to time, but we never got close. Still, I admired him. His figurative work was much more quiet than mine, which was wild from 1964–69. But I think Bob and I were going through the same sort of thing, as was Overstreet. But Bob's work was much more quiet. He was drawing on the European masters, such as Gauguin and Matisse, while Overstreet and I were much more attuned to the hyperemotionalism of Abstract Expressionism.

You have to keep in mind that I was dealing with the themes I was in the '60s out of necessity.

I was dealing with the pressure of being a black in America. And keep in mind I'm not talking about some kind of intellectual choice here. This was a psychological necessity. It's just there, and you have to work with it. You work with it, or it works you.

My work in the '60s came out of process, which in turn relied upon my earlier surrealistic involvements, especially with automatism. Imagery appeared in my work whether I wanted it to or not. And I know exactly when this started, 1965. I started having an experience in which I thought I was going crazy. I began seeing images on walls and floors, for example. And I became increasingly hyper up to '69, when it reached a peak. I felt as if I was flipping out, and the anxiety attacks kept coming until someone suggested I start karate or yoga, both of which I did for three years.

But beginning in 1965 I did a series of paintings that were great. I've never shown any before. 1965 also represents when my awareness of the impact of photography on visual perception began. The gray paintings grew out of a statement that I wrote on my studio wall: "The image is photographic; therefore, I must photograph my thoughts." These works were done by using black and white paint on heavy cotton duck canvas, trapping the paint between layers of dacron or sometimes a thin silk material, and then wiping off the excess. Some of the scenes you would see in these abstract paintings were so gruesome that people actually threw up upon viewing them. The paintings were abstract, but people had the same experience they had when looking at cloud formations—they found imagery in them. And the paintings became stronger and stronger each year. It just got to the point that faces stared out at me from the paint and my hand just put them there.

My work became genuinely abstract in the late '60s. I was taking carpentry jobs, and I started working with some Italian plasterers, one of whom was a real master at reproducing the old fashioned decorative molding you see in rooms. I was fascinated by his techniques and worked as closely with him as possible. My work just automatically changed because of this particular job. I built a platform on the floor of my studio and poured a ⅜-inch layer of acrylic paint which I worked with a rake. So my work in the '70s came out of a preoccupation with process, except for the geometry in the work, which was purely conceptual. Actually, I was relying on my earlier involvement with Surrealism or automatism. This is why the black-and-white paintings of the mid '60s had imagery in them whether I liked it or not.

My abstraction comes out of emotion. I think abstraction always comes from something, and in my case it is coming out of experience, in particular, my personality. In a sense, I find that the process of painting is like a computer at work: there is a lot of information available for me to deal with and sort out. I now read astronomy a lot. We think we know a lot about astronomy, but we only know so much. You reach a point in astronomy when you think you know something, and then all of a sudden, due to something else, something else opens up and the entire picture changes. My experience in painting has been very much like that. I'm forced into a position where I accept the fact that the painting is more about the journey than the destination. I found that I was trying to handle too much information at a given time, and as a result I stopped working in acrylic just to slow my hand down.

I feel that I am a master of spontaneity. I've studied spontaneity, and I admire Hans Hofmann's concept of the spontaneous. I used to play the tenor saxophone in college, and I played with a dance band in the South. What I learned most was how to use improvisation, which I would do with five other musicians at one time. You have to know the key you're working in, and you should have some sense of melody. And there should be a spiritual consensus among the players. These are the only known values.

This interest in improvisation and spontaneity goes back to my early childhood and the church. We used to do call and response for prayer, which was improvised prayer. One person would start it off with a lot of choral answering back and forth, and then another person would pick up the theme. The idea was to make one spiritual thing happen. I have seen the same spiritual thing happen in folk dancing in Greece, where twenty-five or thirty people just take off and soar. The beat is there, and then

the spirit, and then all the people become one. I've seen it in the South with prayer, and I've had the experience when playing music. And those kinds of things filter over into my work. My work becomes a vehicle for these same spiritual elements. You see the same thing in Mark Rothko, whom I admire. I see those paintings as a device for meditation.

I can't define what is black in my work. I think it's not necessary that I have to define it as much as I should know that it's there and that's really the position I would like to be seen in. I'm black, and my sensibility derives from my being black. But I'm also dealing with art and art on the highest universal level. And that's what I want to be known for. I want to maintain that search for what it means to be black, whatever it is, and we're still piecing that together. But at the same time, I must deal with this within the issues that have grown out of the history of art. I want to correct some of the misunderstandings that history has written about me as a people, and I want to correct them by projecting my values on the mainstream. If one were to ask, those are my precise goals in painting.

People try to use the word physicality to describe black artists' work. That's not good enough. After all, there are plenty of white artists' works that have physicality. It's going to be something along the lines of sensibility that defines black artists' work. There will be something that's felt in the work. The closest word I can get to that is presence, and it's a word I use often. It's the same word I use when speaking of African sculpture. Something lives in that stuff that makes it different from a piece of Greek marble. There's something that connects us, and I think we are all dealing with that same thing.

I think the big mistake that black artists in general make is that their work is too limited. They're not dealing with art on a global scale. They tend to look at art as limited to a closed community. My advice would be for all blacks, not just artists, to travel. If I had a lot of money I would set up a foundation for young blacks to travel just to get them outside of what they know of America. When they return, they would find that what they've confronted in the States is a very small thing in relation to the whole world view.

Well, I'd like to answer yes to your question of whether or not I feel a certain camaraderie with black artists, more so than I do with white artists. There are very few artists whom I admire, black or white. I am only attracted to other artists if their work interests me. Otherwise, it's purely social. When I find black artists whose work interests me, it's a fantastic feeling, and I do feel a sense of camaraderie.

Most of the time I have avoided showing in black art shows. Only when I was interested in a particular group would I show. One of the best I did was when I first met Mel Edwards. It was a show at the American Greetings Gallery which included Mel Edwards, Benny Andrews, Reginald Gammon and myself, among others. The show was either 1967 or 1968. That's when I first met Mel, and meeting Mel was the best thing that happened out of that show. Another show I enjoyed participating in was 5+1 at Stonybrook, which was curated by Lawrence Alloway and included Mel Edwards, Bill Williams, Frank Bowling, Danny Johnson and me.

When I think back on the other shows that I participated in in the '60s when there was so much activity going on with the whole black thing, I feel that most of it was just too amateurish for my taste. Often there was a failure to go after quality, and there was a grouping of people just because they were black. I can't accept that. For me to go out and be in a show because everybody's black is ridiculous. I think there's a validity to doing a show of black artists, but I wouldn't call it black art. We're dealing with people here, and we have to adjust our perceptions to the art as a specific entity to each person. That was one of the points I was trying to make in a letter to you. When you're doing an historical show, you can get away with it. But the minute you set up a show as being about black art, that's a little more difficult for me to deal with. Not a little bit more, a whole lot more! You shouldn't take Jack Whitten out of the context of being black. But at the same time, you have got to be able to accept Jack Whitten on the level that he works on, which includes issues that concern artists throughout the world. The fact that Jackson Pollock came out of the American West is important. That's in part what makes the work. For me, being black has

something to do with the making of the image. But it is also important that I am from the South, that I worked in the construction trade, that I am living in New York in the 1980s, and so on.

One thing that art history has taught me is that revolution in art always deals with plasticity. It is not just a question of the type of subject matter one works with. A lot of people accept the fact that as long as there are black faces screaming on a canvas and it deals with social issues, then that's black art. I don't accept that. Art has to be global, and for me it is plasticity that revolutionizes art. And my endeavors in art have always dealt with the plastic concept. That's when I'm at my best, and I'm beginning to see that everything I've been working with is leading up to the element of space in painting. I feel that we are setting the stage in painting for a totally new concept in space, and that's what I'm working towards. There's a big wave setting up out there that revolves around the notion of space in painting, and I want to be on it.

WILLIAM T. WILLIAMS, JUNE 26, 1984

When I came to New York in 1968 I shared a studio on Broadway with Peter Bradley, who had been at Yale with me, and I met a lot of people really quickly. By the end of the summer I had settled in and was relatively established. I had met a lot of people who became helpful, some for their own reasons, others because they were interested in the art. Dore Ashton turned out to be the one who was most interested in me as a human being and as an artist, and she put her career on the line. At the end of the next summer she called me and said that she was putting together a show, *L'Art vivant aux États-Unis*, in the South of France at the Fondation Maeght and that she wanted me to be in it. She came by the studio and selected two paintings, *Sophie Jackson L.A.M.F* (1969) and *Truckin'* (1969). Then she talked the Fondation Maeght into buying me a ticket to bring me to France and into putting me up. Also in the show were Robert Wilson and Jake Berthot.

My paintings at this point were anti-flat and anti-formal, that is, going against formalism. They were irrational. Formalism to me had to do with a

certain kind of rationale. I wanted to be irrational and to present an almost expressionist way of perceiving the world. But, no, I wouldn't call this irrational approach madness. I think it demonstrates the difference between classical music and jazz. The former is based upon playing what's written down the same way each time, and its perfection is how well the orchestra can play it the same way.

Whereas in jazz the interest is that it has to be played differently each time because the emotion is the lifeline of the music. There's also a certain kind of tension in those early works and an anxiety that's created because of the way form and color exist. It seems to me that these issues were never talked about. They were high-anxiety paintings.

The early paintings were thought of in two ways. I used to make preliminary drawings, and they were worked out on the canvas pretty much. But I did not stay with the preliminary drawing on the canvas. Once the drawing was put on the canvas, I stayed with that. At that point the only changes I could make were with the color. I was caught between two issues: an interest in Color Field Painting and an interest in expressionism, and in trying to reconcile the two. There was too much imagery in these works for them to be really involved in Color Field, but my use of color made a lot of the color field people interested in me. But I wanted to make painting that was somewhat of an icon. The structure almost took on the sense of objectness. Whereas I think the Color Field painters were trying to get rid of the object quality altogether and just allow the experience of the color to become the theme of the painting, without color being descriptive of the edge or the core, etc. That aspect of Color Field never interested me because I found that that was not my temperament. I was interested in something much more concrete, something almost sculptural in its approach.

One aspect of jazz that interested me in the late '60s was its complexity, especially its complex polyrhythmic structure, and I consciously began to seek out jazz at the time. It was the first time I met a number of jazz musicians and heard first hand what they were thinking and talking about. I was also interested in jazz because it was a reassertion of cultural identity.

This was also the first time I had ingested a large amount of African art. Prior to going to Yale I had never really looked at much of it. I had only seen it passively. During the period of graduate school I spent a lot of time reading and looking. Coming back to New York was when it really started coming together for me. A lot of it had to do obviously with finding myself as an artist and trying to get rid of influences. But the pressure of the social and ethnic situation led to a certain need to define and pinpoint issues. I always knew that what I wanted to do was to make an aggressive statement. I wanted a picture that had muscle on the wall. I wanted a picture that was confrontational, one that you could not look at and walk away from without forming an opinion.

My thinking in terms of jazz and improvisation in the late '60s was a result of my having grown up with it. I grew up in a family where there were musicians, and I listened to music every night. When I came to New York there was no way that I could deny that I was black; the white art world wouldn't allow me to forget it, and the black art world wouldn't allow me to forget it. Now, the question is not whether I'm a black artist; it's whether I'm a great artist, and whether the quality of my art says something about humankind that everyone can respond to. I was not willing to make a work of art that was fixed in time, art that would only relate to the late '60s and relate to a kind of relatively provincial attitude about blackness. It seemed to me that the issue of black and white is a relatively provincial issue if you think about the population of the world and realize that whites are really the minority rather than the majority. Once you have that kind of consciousness, you can forget about black and white and go on to other issues. The issue was the quality of the art, and when one wanted to address the quality of the art, I would get involved in the conversation.

My relationship to Frank Stella and to certain other aspects of the period were in some respects actually coincidental. My attitude toward making art was and still is that I don't want to make art in relation to anyone else. My art was something that I was doing as an activity that I was involved in. If others began to group it, fine, but I couldn't allow myself to think in those terms because I would be denying something very important about my own consciousness. A good look at the art of the period, such as that of Stella, would show that I was drastically different. My coincidental relationship to Stella was something that was created by the press. I think what happened was that a certain racism was taking over, and there was a certain glossing over of the significance of my art. People just didn't want to deal with the content of the work and the seriousness of the endeavor. There was a denial of the intellect that was involved in creating the work. Any clear reading of the dates when pictures were done would reveal that there were parallels and in some instances I was ahead of my contemporaries on certain issues, especially in dealing with a certain kind of convoluted space, that is, space that contained volume and pushed up toward the surface, and space that at the same time contracted into a flat plane. But at the time critics and art historians were not willing to see and acknowledge the importance of that contribution. The so-called critical writing was really about the social phenomena that society was trying to understand. I think a disservice was done to all of the artists of that period, not only by white writers, but by black writers as well, because the writing did not focus on the content of the work. The writing was not about art but about people. All I insist upon is that I can have my own vision and that my vision not be dependent upon or corroborated by someone else's vision, that is, by someone who comes along later and gets credit for ideas I had presented earlier and that were glossed over.

I can remember a show put together by Irving Sandler called *Critic's Choice 1969–70*, which included Friedel Dzubas, Leon Golub, Stanley Landsman, Roy Lichtenstein, Robert Morris, Philip Pearlstein, Sylvia Stone and Jack Tworkov. Sandler talked about me as being a young urban artist who was making paintings that picked up the tempo of the city. He claimed if you looked at them closely you could see the fire escapes and teeming tenements. I couldn't believe it! I realized the extent to which I was being taken for granted and that the man didn't have the slightest idea of what I was

involved with. He hadn't even spoken to me—not at all! He just knew I was black. He didn't realize that the New York I grew up in was Far Rockaway, near the beach. He was just taking a stereotype of what he thought a black artist was and using it. I just decided that I wasn't going to fit into anyone's stereotypes. I saw a patronizing attitude going on around me that was absolutely shocking. There was no critical thought whatsoever going on, absolutely none. It was "business as usual." Artistic temperament cannot live in that kind of nonsense. It depends upon critical thought.

I think it was in 1969 that I started showing with Mel Edwards and Sam Gilliam. I was working at The Studio Museum. I had written a proposal when I was in graduate school called Artists-in-Residence in the Community. What I had wanted to do was go back to a community and make works of art. This statement obviously has all kinds of social, almost socialist, overtones, but I had an interest in public art. But I am not talking about making a community-based art or an art that reflects the needs of the community. The issue was providing a support mechanism, both psychologically and financially, for artists. I wanted to create a context, namely an artist-in-residence program, through which money could be funneled to artists which would allow them to ponder the kinds of issues and questions that come up in a graduate program.

Al Held referred me to Mel Edwards soon after I arrived in New York. When I met Mel he had not shown in New York. He had not had a gallery, and he had been in the city basically eight years. All the same, there was an enormous humanness when I first met him. There was anger, but there was a humanness, an enormous sensitivity. He was only making models at that point, hundreds of models for sculpture. We hit it off as human beings, first of all, and we discovered that we had quite a few common things that we had gone through. And he was a really intelligent man.

When I was asked by The Studio Museum to put a show together, I started thinking about whom to show with. I had seen one of Sam Gilliam's paintings at the Byron Gallery, and I thought Sam would be very good. And then there was an artist named Steve Kelsey, who was a Yale graduate, and I thought it would be interesting to juxtapose him, Mel, Sam and myself. There were sensibilities that were common in terms of aspiration. We were all ambitious, and we were all making statements that could hardly be described as timid; they were all large powerful statements in the tradition of heroic painting. And I decided I wanted to show that. For the first time Mel got to do large-scale work. He did sculpture with long chains and barbed wire. The protest overtones were very clear, but it was done within a formalist context.

At this point in my career I wasn't interested in showing on 57th Street, and I say that with all honesty. It was my first year out of graduate school, and I was just moving around trying to understand what New York was all about. It wasn't until 1969 that I thought I was focused enough to go and pick out galleries, and even then I thought it was too soon. The Museum of Modern Art bought one of my paintings, and I was thrown into the fast lane. They not only bought it, but they exhibited it for six months, right in the lobby where you walked in. It was talked about a lot. I wasn't exactly in seventh heaven, however, because I was trying to figure out what this was all about. A number of the trustees of the Museum of Modern Art bought my paintings, and in fact just about all the early works I sold were to trustees of the Museum of Modern Art or other museums. Otherwise, there were almost none in private hands.

I think the thing that happened was that the pressure was more than I had ever experienced before. The company that I was placed in was pretty highpressure. I was getting calls from curators from major museums all across the country. Some of the people whom I had become friendly with were wealthy and powerful. I didn't want to get caught up in all of this, not just because it was more than I would ever have, but because it was a question of whether those were my values. I didn't want to deny where I came from and the values I grew up with. So all of a sudden I was getting some hostility from other minority artists. And I was getting attacked by white artists who were saying that I was selling just because I was black.

I think I made some important contributions to Western art in the '60s and '70s, contributions that had to do with new ways of looking at color and new ways of structuring color to create spatial volume. What's going to have to be addressed is that I am of a generation that can be described as the "lost generation." Both black and white artists of my generation have not been given their due. The series of movements that happened so quickly in succession between 1970 and 1983 precluded any clear historical analysis of artists and their input. It was like one fashion after another. This had never happened before because there had always been a longer period of time to analyze. Historically, we have seen a block of ten to fourteen years just disappear. That's my point.

The important issue for me is breaking through this historical wall that I see, and each generation is trying to do it. You want to be placed in the context of the history of this activity, and you want it said that you were one of the best in the history of the context. There have been different styles, different attitudes, and your contribution to Western civilization fits in here. That's what we're all after. It's a bigger ballgame than whether we have a show on 57th Street. That's really relatively unimportant, although when you think about the art of the last ten years, the commercial context supports the historical context. When there's a gallery that's been pushing you and placing you in a public stance, then the critical support is there too. I think I suffer as an artist from having a lack of financial sources, that is, a major gallery, which has been supporting my paintings and putting them into the think tank. But this isn't something that's irrevocable. I think the only thing that's important to me is that I continued to make art during that period. Also, there's been a growth on my part during that period that I'm not sure most others have had. A lot of it has been a willingness for me to get away from something that was successful and open up a new area.

There is something that is very essential about a work of art, and that something is a humanness. A work of art can have a cultural context to help us understand it, but it also has to have another aspect, a humanness, that allows it to transcend the cultural boundaries. I think that the works of art that I have always been interested in have been of that kind. When I first went to museums I had little or no inclination to take into account the cultural significance of works of art or the iconography. My appreciation of them had to do with the care that I found inside them and the human response I had to them. And I have tried to evoke that same kind of human response in my work.

It seems to me that the most pressing topic or issue from an historical point of view is someone writing about the quality of the work and describing what quality is in relationship to a society at a given place and time. The most important thing for us as a generation of artists is that the definition of quality be reestablished and a statement of facts and a statement of conviction be made that these works represent quality.

AFTERWORD

ZOÉ WHITLEY

There are texts of their time and those that, in retrospect, appear to transcend it. While nearly all the words assembled here were published at the time they were written, their dispersal in the years and decades since means that it has been more difficult than it should have been to spread collective knowledge of the period in question and therefore to recognize the texts' continued timeliness and genuine cultural resonance.

Where does culture reside? Who speaks for whom in reflecting that culture? It is both a profound pleasure and a responsibility honored that such a variety of responses to these questions are finally collected in one volume. The perspectives on culture presented on the preceding pages articulate the viewpoints of our artist-scholar forebears, who dedicated their lives to manifesting and celebrating the fullness of culture. The texts here are one part of the story of how rich and varied culture is.

Culture is not always anthologized or recorded; it survives though oral histories, passion projects, and personal archives, too. We've been taught for so long that culture is housed in our museums and libraries, yet all too often there are absences and silences on the shelves, walls, and plinths where a truly representative cross section of culture should be found. I'm reminded, almost tearfully, in this context of the tremendous importance of the Hatch-Billops Collection, amassed in New York by the late creative duo of James V. Hatch, charismatic theater historian, and Camille Billops, indomitable artist and filmmaker, starting in 1968. I recall Jim's telling me that his introduction to Black culture came from fictional personages such as Mark Twain's Jim, an escapee of enslavement. The framing of culture in the singular, perhaps, stymies many of us before we can even get under way in understanding its vastness and richness. Important volumes of collected texts such as The "Soul of a Nation" Reader prove the plurality of culture and allow it to exist on the page as a collective noun rather than a reductive caricature.

A favorite passage of mine about culture can be found in the social activist Selma James's Sex, Race and Class—The Perspective of Winning: A Selection of Writings, 1952–2011. The passage conjures so vividly the complex ubiquity of culture—its ability to be felt and to flourish in any and every environment, irrespective of social status or institutional imprimatur.

The word "culture" is often used to show that class concepts are narrow, philistine, inhuman. Exactly the opposite is the case.... To delimit culture is to reduce it to a decoration of daily life. Culture is plays and poetry about the exploited; ceasing to wear miniskirts and taking to trousers instead; the clash between the soul of Black Baptism and the guilt and sin of white Protestantism. Culture is also the shrill of the alarm clock that rings at 6 a.m. when a Black woman in London wakes her children to get them ready for the baby-minder. Culture is how cold she feels at the bus stop and then how hot in the crowded bus.

James understands that culture encompasses the pride of inhabiting a body devalued by dominant social norms, the grind of the workday, the sense memory of illness, and the ordinariness of meal planning alongside the pure glory of color and the spark of aesthetic innovation. Culture meets us where we are; we can seek it out, but it is already part of who we are and how we live.

CREDITS AND COPYRIGHTS

The publisher has made every effort to acknowledge correctly and to contact the sources and/or copyright holders of all materials and images included in the book. Any unintentional errors or omissions that the publishers become aware of will be corrected in future editions.

Marion Perkins, "Problems of the Negro Artist," keynote address delivered at first National Conference of Negro Artists, Atlanta, Georgia, March 28–29, 1959; first published as *Marion Perkins, Problems of the Black Artist* (Chicago: Free Black Press, 1971). Published most recently in *The Art and Activism of Marion Perkins: "To See Reality in a New Light"* (Chicago: Third World Press, 2013). The copyright holder notes that the poem "Of Marion Perkins," by Dr. Margaret G. Burroughs, was written as a tribute to Perkins in 1972. Reprinted by permission of Useni Eugene Perkins, Estate of Marion Perkins

Clebert Ford, "Black Nationalism and the Arts," *Liberator* 4, no. 2 (February 1964). Reprinted by permission of Susan Batson, Estate of Clebert Ford

Unsigned statement in *Spiral: First Group Showing (Works in Black and White)*, pamphlet for exhibition held at 147 Christopher Street, New York, May 14–June 4, 1965. Every effort has been made to obtain the appropriate permissions for this text. It appears here in the service of scholarly interest.

Lawrence [Larry] Neal, "The Black Revolution in Art: A Conversation with Joe Overstreet," *Liberator* 5, no. 10 (October 1965): 9–10. Reprinted by permission of Evelyn Neal, Estate of Lawrence Neal

Jeanne Siegel, "Why Spiral?" *ARTnews* 65, no. 5 (September 1966): 48–51. Originally published in *ARTnews*, September 1966, pp. 48–51. Copyright © Artnews Media, LLC. Reprinted by permission of Artnews Media, LLC

Noah Purifoy, "The Art of Communication as a Creative Act," in Noah Purifoy (as told to Ted Michel), *Junk Art:*

66 Signs of Neon, catalogue for *66 Signs of Neon*, exhibition held at Markham Junior High School, Watts, Los Angeles, June 20–29, 1966. Courtesy Noah Purifoy Foundation © 2017

"Signposts That Point the Way" (unsigned review), *Los Angeles Times Home*, October 9, 1966. Reprinted by permission of Noah Purifoy Foundation

Ishmael Reed, "The Black Artist: Calling a Spade a Spade," *Arts Magazine* 41, no. 7 (May 1967): 48–49. Reprinted by permission of Ishmael Reed

Raymond Saunders, *Black Is a Color*, self-published pamphlet, June 1967. Courtesy of Raymond Saunders and Stephen Wirtz Gallery

Organization of Black American Culture (OBAC), "Black Heroes" (statement on the *Wall of Respect*), August 1967. Reprinted by permission of Jameela K. Donaldson, Estate of Jeff Donaldson

Gwendolyn Brooks, "The Wall," read at opening of the *Wall of Respect* on August 27, 1967; first published as part of "Two Dedications" in Gwendolyn Brooks, *In the Mecca* (New York: Harper and Row, 1968). Reprinted by consent of Brooks Permissions

Don L. Lee, "The Wall," read at opening of the *Wall of Respect* on August 27, 1967; first published on August 29, 1967, in *Chicago Daily Defender*; published in slightly revised form in Don L. Lee, *Black Pride* (Detroit: Broadside Press, 1968). Reprinted by permission of Dr. Haki Madhubuti, Third World Press

"Wall of Respect" (unsigned article), *Ebony* 23, no. 2 (December 1967): 47–50. Courtesy EBONY Media Operations, LLC. All rights reserved

Robert Newman, "*American People*: Faith Ringgold at Spectrum," press release for exhibition held at Spectrum Gallery, New York, December 19, 1967–January 6, 1968. Every effort has been made to obtain the appropriate permissions for this text. It appears here in the service of scholarly interest.

Jay Jacobs, "Two Afro-American Artists in an Interview with Jay Jacobs," in "The Afro-American Issue," special issue, *Art Gallery* 11, no. 7 (April 1968): 26–31. Reprinted by permission of William Bendig, Hollycroft Press

Larry Neal, "The Black Arts Movement," in "Black Theatre," special issue, *TDR: The Drama Review* 12, no. 4 (Summer 1968): 29–38. © 1968 by The Drama Review. Reprinted by permission of Evelyn Neal, Estate of Lawrence Neal

Evangeline J. Montgomery, "Why New Perspectives in Black Art?" and Paul Mills, untitled text, in *New Perspectives: Black Art*, catalogue for exhibition held at the Kaiser Center Gallery, Oakland Museum (Art Division), Oakland, California, October 5–26, 1968. Reprinted by permission of Oakland Museum of California

Earl Roger Mandle, "Introduction," in Earl Roger Mandle, ed., *30 Contemporary Black Artists*, catalogue for exhibition held at the Minneapolis Institute of Arts, Minneapolis, Minnesota, October 17–November 24, 1968. Reprinted by permission of Roger Mandle, Estate of Earl Roger Mandle

Emory Douglas, "Position Paper 1 on Revolutionary Art," *The Black Panther*, October 20, 1968: 5. Reprinted by permission of Emory Douglas

Edward Clark, "Un musée pour Harlem" [A Museum for Harlem], *Chroniques de l'art vivant*, no. 1 (November 1968). Reprinted by permission of the Estate of Edward Clark. Translation by TransLingua Associates, Inc., courtesy Hauser & Wirth, New York

Ralph Ellison, "Introduction," in *Romare Bearden: Paintings and Projections*, catalogue for exhibition held at the Art Gallery of the State University of New York at Albany, November 25–December 22, 1968. "The Art of Romare Bearden," copyright © 1977, 1986 by Ralph Ellison; from *Going to the Territory* by Ralph Ellison. Used by permission of Random House, an imprint and division of Penguin Random House LLC. All rights reserved

Frederick Fiske, "Reflections from Within-Without: The Black Artist," and Victoria Rosenwald, "The Black Murals of Boston," in "Art in the Ghetto," special issue, *Harvard Art Review* 3, no. 1 (Winter 1968–69). Every effort has been made to obtain the appropriate permissions for this text. It appears here in the service of scholarly interest.

James T. Stewart, "The Development of the Black Revolutionary Artist," in Amiri Baraka and Larry Neal, eds., *Black Fire: An Anthology of Afro-American Writing* (New York: William Morrow, 1968), 3–10. Every effort has been made to obtain the appropriate permissions for this text. It appears here in the service of scholarly interest.

Romare Bearden, Sam Gilliam, Richard Hunt, Jacob Lawrence, Tom Lloyd, William T. Williams, and Hale Woodruff, "The Black Artist in America: A Symposium," *The Metropolitan Museum of Art Bulletin* 27, no. 5 (January 1969): 245–60. Excerpted from "The Black Artist in America: A Symposium" by Romare Bearden, Sam Gilliam, Jr., Richard Hunt, Jacob Lawrence, Tom Lloyd, William Williams, and Hale Woodruff in *The Metropolitan Museum of Art Bulletin*, v. 27, no. 5 (1969): 245–260. Copyright © 1969 by The Metropolitan Museum of Art, New York. Reprinted by permission

Benny Andrews and Cliff Joseph for the Black Emergency Cultural Coalition (BECC), untitled statement, early 1969. © Estate of Benny Andrews / VAGA at Artists Rights Society (ARS), NY

Roy Wilkins, "Preface," and Carroll Greene, "*1969: Twelve Afro-American Artists* in Perspective," in *1969: Twelve Afro-American Artists*, catalogue for exhibition held at Lee Nordness Galleries, New York, January 22–February 8, 1969. The publisher wishes to thank The National Association for the Advancement of Colored People for authorizing the use of this material by Roy Wilkins.

Frank Bowling, "Discussion on Black Art," *Arts Magazine* 43, no. 6 (April 1969): 16–20; Frank Bowling, "Discussion on Black Art—II," *Arts Magazine* 43, no. 7 (May 1969): 20–23; Frank Bowling, "Black Art III," *Arts Magazine* 44, no. 3 (December 1969–January 1970): 20–22. Reprinted by permission of Frank Bowling

James R. Mellow, "The Black Artist, the Black Community, the White Art World,"

New York Times, June 26, 1969. © The New York Times Company. Reprinted with permission

Dana Chandler Jr., untitled text, in *12 Black Artists from Boston*, catalogue for exhibition held at the Rose Art Museum, Brandeis University, Waltham, Massachusetts, July 20–August 31, 1969. Reprinted by permission of the Rose Art Museum, Brandeis University

Larry Neal, "Any Day Now: Black Art and Black Liberation," *Ebony* 24, no. 10 (August 1969): 54–58, 62. Courtesy EBONY Media Operations, LLC. All rights reserved. Reprinted by permission of Evelyn Neal, Estate of Lawrence Neal

Elsa Honig Fine, "The Afro-American Artist: A Search for Identity," *Art Journal* 29, no. 1 (Fall 1969): 32–35. Reprinted by permission of Elsa Honig Fine

Ameer [Amiri] Baraka, "The Black Aesthetic," *Negro Digest* 18, no. 11 (September 1969): 5. Reprinted by permission of Chris Calhoun Agency, © Amiri Baraka

Roy DeCarava: Thru Black Eyes (unsigned text), pamphlet for exhibition held at the Studio Museum in Harlem, New York, September 14–October 26, 1969. Courtesy the Studio Museum in Harlem Archives, New York

Edward K. Taylor, "Foreword," and Joe Overstreet, untitled statement, in *New Black Artists*, catalogue for exhibition held at the Brooklyn Museum, October 7–November 9, 1969. Every effort has been made to obtain the appropriate permissions for this text. It appears here in the service of scholarly interest.

Lawrence Alloway and Sam Hunter, "Introduction"; Frank Bowling, "Notes from a Work in Progress"; and William T. Williams, Jack Whitten, Melvin Edwards, Al Loving, Daniel LaRue Johnson, and Frank Bowling, untitled statements, in *5+1*, pamphlet for exhibition held at the Art Gallery of the State University of New York at Stony Brook, November 12–23, 1969. Reprinted by permission of Frank Bowling

Frank Bowling, "Joe Overstreet," *Arts Magazine* 44, no. 3 (December 1969–January 1970): 55. Reprinted by permission of Frank Bowling

Samella S. Lewis, "Introduction"; Ruth G. Waddy, "Introduction"; and Gary Rickson, David Hammons, John Outterbridge, Betye Saar, Dana Chandler, Cliff Joseph,

Marie Johnson, David Bradford, David Driskell, Phillip Mason, Samella Lewis, and Robert Sengstacke, untitled statements, in Samella S. Lewis and Ruth G. Waddy, eds., *Black Artists on Art* (Los Angeles: Contemporary Crafts, 1969). Reprinted by permission of Dr. Samella S. Lewis

Claude Booker for the Black Arts Council (BAC), letter soliciting members, undated (ca. 1969). Every effort has been made to obtain the appropriate permissions for this text. It appears here in the service of scholarly interest.

Charles White, "Art and Soul," lecture delivered at the Los Angeles County Museum of Art, October 27, 1969. © 1969 Museum Associates / LACMA. Transcription of audio recording by Allie Biswas

Charles White, untitled statement, in *Wanted Poster Series*, catalogue for exhibition held at the Heritage Gallery, Los Angeles, January 1970. Every effort has been made to obtain the appropriate permissions for this text. It appears here in the service of scholarly interest.

Al Loving, untitled statement, in *Al Loving*, pamphlet for exhibition held at the Whitney Museum of American Art, New York, December 19, 1969–January 25, 1970. © 1970 Whitney Museum of American Art, New York. Reprinted by permission of Mara Kearney Loving, Estate of Al Loving

Robert Newman, "*America Black*: Faith Ringgold at Spectrum," press release for exhibition held at Spectrum Gallery, New York, January 27–February 14, 1970. Every effort has been made to obtain the appropriate permissions for this text. It appears here in the service of scholarly interest.

Debbie Butterfield, "Contemporary Black Art," and Samella Lewis, "Epilogue," in Jehanne Teilhet, ed., *Dimensions of Black*, catalogue for exhibition held at the La Jolla Museum of Art, San Diego, California, February 15–March 29, 1970. Reprinted by permission of Dr. Samella S. Lewis

Melvin Edwards, untitled statement, and William T. Williams, "William T. on M.E.," in *Melvin Edwards: Works*, pamphlet for exhibition held at the Whitney Museum of American Art, New York, March 2–29, 1970. © 1970 Whitney Museum of American Art, New York. Reprinted by permission of William T. Williams

A. D. Coleman, "Roy DeCarava: *Thru Black Eyes*," *Popular Photography* 66, no. 4 (April 1970). "Roy DeCarava: *Thru Black Eyes*" © copyright 1970 by A. D. Coleman. All rights reserved. By permission of the author and Image/World Syndication Services, imageworld@nearbycafe.com

"Object: Diversity" (unsigned article), in "Black America: 1970," special issue, *Time* 95, no. 14 (April 6, 1970). From TIME. © 1970 TIME USA LLC. All rights reserved. Used under license

Walter Jones, "Critique to Black Artists," *Arts Magazine* 44, no. 6 (April 1970): 16–20. Reprinted by permission of Walter Jones

Carroll Greene, "Perspective: The Black Artist in America," and "Black Art: What Is It?" (questionnaire), *Art Gallery* 13, no. 7 (April 1970). Every effort has been made to obtain the appropriate permissions for this text. It appears here in the service of scholarly interest.

Dore Ashton, "Introduction," and Smokehouse Associates, "Smokehouse," in *Using Walls (Outdoors)*, catalogue for exhibition held at the Jewish Museum, New York, May 13–June 21, 1970. Courtesy of the Jewish Museum, New York. Reprinted by permission of William T. Williams

Unsigned statement on poster for *AFRICOBRA 1: Ten in Search of a Nation*, exhibition held at the Studio Museum in Harlem, New York, June 21–August 30, 1970. Courtesy the Studio Museum in Harlem Archives, New York

Benny Andrews, "The Black Emergency Cultural Coalition," *Arts Magazine* 44, no. 8 (Summer 1970): 18–20. © Estate of Benny Andrews / VAGA at Artists Rights Society (ARS), NY

Edmund B. Gaither, "Introduction," in *Afro-American Artists: New York and Boston*, catalogue for exhibition held at the Museum of Fine Arts, Boston, May 19–June 23, 1970. Reprinted by permission of Edmund Barry Gaither

Hilton Kramer, "Black Artists' Show on View in Boston," *New York Times*, May 22, 1970; Hilton Kramer, "Trying to Define 'Black Art': Must We Go Back to Social Realism?" *New York Times*, May 31, 1970; Hilton Kramer, "'Black Art' and Expedient Politics," *New York Times*, June 7, 1970. © 1970 The New York Times Company. Reprinted with permission

Benny Andrews, "On Understanding Black Art," *New York Times*, June 21, 1970. © 1970 The New York Times Company. Reprinted with permission. © Estate of Benny Andrews / VAGA at Artists Rights Society (ARS), NY

Douglas Davis, "What Is Black Art?" *Newsweek* 75, no. 25 (June 22, 1970). © 1970 Newsweek

Henri Ghent, "Black Creativity in Quest of an Audience," *Art in America* 58, no. 3 (May–June 1970): 35. Originally published in *Art in America*, May–June 1970, p. 35. Copyright © Artnews Media, LLC. Reprinted by permission of Artnews Media, LLC

Margaret G. Burroughs, "To Make a Painter Black," in Floyd B. Barbour, ed., *The Black 70's* (New York: Porter Sargent, 1970), 129–37. Every effort has been made to obtain the appropriate permissions for this text. It appears here in the service of scholarly interest.

Bayard Rustin, "The Role of the Artist in the Freedom Struggle," and Jacob Lawrence, "The Artist Responds," *The Crisis* 77, no. 7 (August–September 1970). Gregory R. Miller & Co. wishes to thank Crisis Publishing Co., Inc., the publisher of *The Crisis*, the magazine of the National Association for the Advancement of Colored People, for the use of two articles from the August/September issue of *The Crisis*.

LeGrace G. Benson, "Sam Gilliam: Certain Attitudes," *Artforum* 9, no. 1 (September 1970). © *Artforum*, September 1970. Reprinted by permission of LeGrace G. Benson

Barbara Rose, "Black Art in America," *Art in America* 58, no. 5 (September–October 1970): 54–67. Originally published in *Art in America*, September–October 1970, pp. 54–67. Copyright © Artnews Media, LLC. Reprinted by permission of Artnews Media, LLC

Joseph E. Young, "Los Angeles" (interview with David Hammons), *Art International* 14, no. 8 (October 1970): 74. © 1971 Museum Associates / LACMA

Jeff Donaldson, "AFRICOBRA 1: *10 in Search of a Nation*," *Black World* 19, no. 12 (October 1970). Reprinted by permission of Jameela K. Donaldson, Estate of Jeff Donaldson

Robert H. Glauber, "Introduction," and Ralph Arnold, Sam Gilliam, and Joseph B. Ross Jr., untitled statements, in *Black American Artists/1971*, catalogue

for exhibition held at the Illinois Bell Telephone Company Lobby Gallery, Chicago, January 13–February 5, 1971. Courtesy AT&T, Illinois

Joseph E. Young, *Three Graphic Artists: Charles White, David Hammons, Timothy Washington*, catalogue for exhibition held at the Los Angeles County Museum of Art, January 26–March 7, 1971. © 1971 Museum Associates / LACMA

Edward Spriggs, "Preface," and David Driskell, "Introduction," in J. Edward Atkinson, ed., *Black Dimensions in Contemporary American Art* (New York: New American Library, 1971). Every effort has been made to obtain the appropriate permissions for this text. It appears here in the service of scholarly interest.

Charles Childs, "Larry Ocean Swims the Nile, Mississippi and Other Rivers," in Larry Rivers, *Some American History*, catalogue for exhibition held at the Institute for the Arts, Rice University, Houston, Texas, February 1–April 30, 1971. Courtesy of Woodson Research Center, Fondren Library, Rice University

Eugene Eda, Mark Rogovin, William Walker, and John Weber, "The Artists' Statement," and William Walker, untitled statement, distributed at *Murals for the People*, exhibition held at the Museum of Contemporary Art Chicago, February 13–March 13, 1971. Reprinted by permission of Eugene Eda Wade

Keith Morrison, *Black Experience*, pamphlet for exhibition held at the Bergman Gallery, University of Chicago, February 16–March 20, 1971. Reprinted by permission of Keith Morrison

Carroll Greene, "Romare Bearden: The Prevalence of Ritual," in *Romare Bearden: The Prevalence of Ritual*, catalogue for exhibition held at the Museum of Modern Art, New York, March 25–June 7, 1971. © 1971 The Museum of Modern Art, New York

Noah Purifoy, "Statement by the Artist," in *Niggers Ain't Gonna Never Ever Be Nothin'—All They Want to Do Is Drink and Fuck*, catalogue for exhibition held at the Brockman Gallery, Los Angeles, March 7–26, 1971. Reprinted by permission of Noah Purifoy Foundation

Frank Bowling, "It's Not Enough to Say 'Black Is Beautiful,'" *ARTnews* 70, no. 2 (April 1971): 53–55, 82–86. Originally published in *ARTnews*, April 1971, pp. 53–55, 82–86. Copyright © Artnews

effort has been made to obtain the appropriate permissions for this text. It appears here in the service of scholarly interest.

Ray Gibson, "Roy DeCarava: Master Photographer," *Black Creation: A Quarterly Review of Black Arts and Letters* 4, no. 1 (Fall 1972). Every effort has been made to obtain the appropriate permissions for this text. It appears here in the service of scholarly interest.

Louis Draper, "The Kamoinge Workshop," *The Photo Newsletter* 1, no. 4 (December 1972). Every effort has been made to obtain the appropriate permissions for this text. It appears here in the service of scholarly interest.

Sue Irons (later Senga Nengudi), "CAPS GRANT— SCULPTURE: Statement on Work" (grant application), 1972. Reprinted by permission of Senga Nengudi

Edward Spriggs, "Search for a Black Aesthetic," in Richard L. Pope, ed., *The 1973 Compton Yearbook: A Summary and Interpretation of the Events of 1972 to Supplement Compton's Encyclopedia* (Chicago: William Benton, 1973). Every effort has been made to obtain the appropriate permissions for this text. It appears here in the service of scholarly interest.

Faith Ringgold, "A Message to the Could Be Political Artists of the World from Faith Ringgold," statement delivered at 61st Annual Meeting of the College Art Association, New York, January 25, 1973. Every effort has been made to obtain the appropriate permissions for this text. It appears here in the service of scholarly interest.

Barbara Jones-Hogu, "The History, Philosophy and Aesthetics of AFRI-COBRA," and Carolyn Lawrence, Jae Jarrell, Barbara Jones-Hogu, Frank Smith, Gerald Williams, Wadsworth Jarrell, Howard Mallory, Napoleon Henderson, and Nelson Stevens, untitled statements, in *AFRI-COBRA III*, catalogue for exhibition held at the University Art Gallery, University of Massachusetts at Amherst, September 7–30, 1973. Every effort has been made to obtain the appropriate permissions for this text. It appears here in the service of scholarly interest.

Diane Weathers, "Kay Brown: An Artist and Activist," *Black Creation: A Quarterly Review of Black Arts and Letters* 4, no. 1 (Fall 1973): 39–40. Every

effort has been made to obtain the appropriate permissions for this text. It appears here in the service of scholarly interest.

Betye Saar, "Black Mirror," *Womanspace Journal* 1, no. 2 (April–May 1973). Reprinted by permission of Betye Saar

Claudia Chapline, "Reflections on Black Mirror, March 31–April 22," *Womanspace Journal* 1, no. 3 (Sum-mer 1973): 20. Every effort has been made to obtain the appropriate permissions for this text. It appears here in the service of scholarly interest.

Samella Lewis, "Introduction," and Josine Ianco-Starrels, untitled text, in *Betye Saar: Selected Works, 1964–1973*, catalogue for exhibition held at California State University, Long Beach, October 1–25, 1973. Reprinted by permission of Dr. Samella Lewis. Reprinted by permission of Elissa Kline, Estate of Josine Ianco-Starrels

Benny Andrews, John Coplans, Dana Chandler, Ademola Olugebefola, Howardena Pindell, and Wee Kim, "Black Artists/White Critics," panel discussion presented in conjunction with the exhibition *Blacks: USA: 1973*, held at the New York Cultural Center, September 26–November 15, 1973. Courtesy The Camille Billops and James V. Hatch Collection. Transcription of audio recording by Allie Biswas

Toni Morrison, "Foreword," and Clayton Riley, "Introduction," in Joe Crawford, ed., *The Black Photographers Annual 1973* (New York: The Black Photographers, Inc., 1973). Every effort has been made to obtain the appropriate permissions for this text. It appears here in the service of scholarly interest.

Milton W. Brown, "Jacob Lawrence," in Milton W. Brown with Louise A. Parks, *Jacob Lawrence*, catalogue for exhibition held at the Whitney Museum of American Art, New York, May 16–July 7, 1974. © 1974 Whitney Museum of American Art, New York

Jack Whitten, "From an Interview with David Shapiro, April 1974," in *Jack Whitten*, pamphlet for exhibition held at the Whitney Museum of American Art, New York, August 20–September 22, 1974. © 1974 Whitney Museum of American Art, New York

Vivian Browne, "Norman Lewis: Interview, August 29, 1974," *Artist and*

Influence: The Journal of Black American Cultural History, no. 18 (1999): 70–91. Courtesy The Camille Billops and James V. Hatch Collection

Linda G. Bryant, "Introduction," in *David Hammons: Selected Works, 1968–1974*, catalogue for exhibition held at the Fine Arts Gallery, California State University, Long Beach, September 29–October 17, 1974. Reprinted by permission of Linda Goode Bryant

Martin Kilson, "A Debate: The Black Aesthetic—Opponent," and Addison Gayle, "A Debate: The Black Aesthetic—Defender," *Black World* 24, no. 2 (December 1974). Every effort has been made to obtain the appropriate permissions for this text. It appears here in the service of scholarly interest.

Randy Williams, "The Black Art Institution," *Black Creation: A Quarterly Review of Black Arts and Letters* 6, no. 4 (1974–75). Reprinted by permission of Randy Williams

Mimi Poser, Linda Goode Bryant, and David Hammons, "Just Above Midtown Gallery," *Round and about the Guggenheim*, WNYC–New York Public Radio, January 2, 1975. Reprinted by permission of Linda Goode Bryant. Transcription of audio recording by Allie Biswas

Allan M. Gordon, "Allan M. Gordon Interviews Himself: The Phenomenology of a Black Aesthetic; Introductory Remarks," in David C. Driskell, ed., *Amistad II: Afro-American Art*, catalogue for exhibition held at Fisk University, Nashville, Tennessee, 1975. Courtesy of Fisk University, Nashville

Benny Andrews, "Jemimas, Mysticism, and Mojos: The Art of Betye Saar," *Encore: American and Worldwide News* 4, no. 5 (March 17, 1975): 30. © Estate of Benny Andrews / VAGA at Artists Rights Society (ARS), NY

Linda Goode Bryant, "Greasy Bags and Barbecue Bones," press release for exhibition held at Just Above Midtown, New York, May 5–30, 1975. Reprinted by permission of Linda Goode Bryant

Elizabeth Catlett, "The Role of the Black Artist," in "Arts and Literature," special issue, *The Black Scholar* 6, no. 9 (June 1975): 10–14. © The Black World Foundation, reprinted by permission of Taylor & Francis Ltd, www.tandfonline.com on behalf of The Black World Foundation

Burton Wasserman, "Where the Flesh Ends and the Spirit Begins," in *Barkley L. Hendricks: Recent Paintings*, catalogue for exhibition held at the Greenville County Museum of Art, Greenville, South Carolina, August 23–September 28, 1975. Every effort has been made to obtain the appropriate permissions for this text. It appears here in the service of scholarly interest.

Cindy Nemser, "Conversation with Betye Saar," *The Feminist Art Journal* 4, no. 4 (Winter 1975–76). Reprinted by permission of Betye Saar

Earl G. Graves, "The Importance of Art Patronage," in "The Business of Fine Art," special issue, *Black Enterprise* 6, no. 5 (December 1975): 5–7. Every effort has been made to obtain the appropriate permissions for this text. It appears here in the service of scholarly interest.

David C. Driskell, "Evolution of the Black Aesthetic: 1920–1950," in David C. Driskell with Leonard Simon, *Two Centuries of Black American Art*, catalogue for exhibition held at the Los Angeles County Museum of Art, September 30–November 21, 1976. © 1976 Museum Associates / LACMA

Samella Lewis and Val Spaulding, "Editorial Statement," *Black Art: An International Quarterly* 1, no. 1 (Fall 1976). Reprinted by permission of Dr. Samella Lewis

Betye Saar, "Juju," in *Recent Works by Houston E. Conwill: Juju*, catalogue for exhibition held at The Gallery, Los Angeles, 1976. Reprinted by permission of Betye Saar

Senga Nengudi, "Statement on Nylon Mesh Works, 1977," distributed at *Répondez s'il vous plaît*, exhibition held at Just Above Midtown, New York, March 8–26, 1977. Reprinted by permission of Senga Nengudi

Benny Andrews, "A JAM Session on Madison Avenue," *Encore: American and Worldwide News* 6, no. 6 (March 21, 1977). © Estate of Benny Andrews / VAGA at Artists Rights Society (ARS), NY

Studio Z, untitled statement, in *Studio Z: Individual Collective*, catalogue for exhibition held at Long Beach Museum of Art, California, December 11, 1977–January 15, 1978; Studio Z, untitled statement, distributed at performances and events held at "The Studio," 2409

Slauson Avenue, Los Angeles, undated. Every effort has been made to obtain the appropriate permissions for this text. It appears here in the service of scholarly interest.

Yvonne Parks Catchings, "Is Black Art for Real?" *Black Art: An International Quarterly* 2, no. 3 (Spring 1978). Every effort has been made to obtain the appropriate permissions for this text. It appears here in the service of scholarly interest.

Linda Goode Bryant and Marcy S. Philips, *Contextures* (New York: Just Above Midtown, 1978). Reprinted by permission of Linda Goode Bryant

April Kingsley, "Black Artists: Up against the Wall," *The Village Voice*, September 11, 1978. Reprinted by permission of April Kingsley

Benny Andrews, "The Big Bash" (originally published in *Black Creation: A Quarterly Review of Black Arts and Letters* 6, no. 4 [1974–75]); Benny Andrews, "New York's 21 Club" (originally published in *Encore: American and Worldwide News* 6, no. 9 [May 9, 1977]); Benny Andrews, "Black Artists vs. the Black Media" (originally published in *Encore: American and Worldwide News* 6, no. 13 [July 5, 1977]), in *Benny Andrews, Between the Lines: 70 Drawings and 7 Essays* (New York: Pella, 1978). © Estate of Benny Andrews / VAGA at Artists Rights Society (ARS), NY

Lowery Stokes Sims, "Third World Women Speak" (account of panel discussion held at SOHO20, New York, October 13, 1978), *Women Artists News* 4, no. 6 (December 1978). Every effort has been made to obtain the appropriate permissions for this text. It appears here in the service of scholarly interest.

Dawoud Bey, "Reflections on *Harlem U.S.A.*" (state-ment about exhibition held at the Studio Museum in Harlem, January 14–March 11, 1979), in Matthew S. Witkovsky, ed., *Dawoud Bey: Harlem U.S.A.* (Chicago: Art Institute of Chicago, 2012). Reprinted by permission of Dawoud Bey

Larry Neal, "Perspectives/Commentaries on Africobra," in *Africobra/ Farafindugu 1979*, catalogue for exhibition held at Miami University, Oxford, Ohio, 1979. Reprinted by permission of Evelyn Neal, Estate of Lawrence Neal

April Kingsley, "Afro-American Abstraction," in *Afro-American Abstraction: An Exhibition of Contemporary Painting and Sculpture by Nineteen Black American Artists*, catalogue for exhibition held at P.S.1, Queens, New York, February 17–April 6, 1980. Reprinted by permission of April Kingsley

Benny Andrews, "Charles White Was a Drawer," and M. J. Hewitt, "We Got the Message and Are Grateful," in "Charles White: Art and Soul," special issue, *Freedomways: A Quarterly Review of the Freedom Movement* 20, no. 3 (Fall 1980). © Estate of Benny Andrews / VAGA at Artists Rights Society (ARS), NY

Lorraine O'Grady (as told to Lucy Lippard), "Performance Statement #1: Thoughts about Myself, When Seen as a Political Performance Artist," 1981. © Lorraine O'Grady. Reprinted from Lorraine O'Grady, *Lorraine O'Grady: Writing in Space, 1973–2019*, Duke University Press, 2020

Dawoud Bey, "David Hammons: Purely an Artist," *Uptown* 2, no. 3 (1982). Reprinted by permission of Dawoud Bey

Emma Amos, "Some Do's and Don'ts for Black Women Artists," in "Racism Is the Issue," special issue, *Heresies*, no. 15 (Fall 1982): 17. Reprinted by permission of the Estate of Emma Amos

Hugh M. Davies and Helaine Posner, "Conversations with Martin Puryear," in Karen Koehler, ed., *Martin Puryear*, catalogue for exhibition held at the University Gallery, University of Massachusetts at Amherst, February 4–March 16, 1984. Reprinted by permission of Martin Puryear

Benny Andrews, Sam Gilliam, Al Loving, Faith Ringgold, Jack Whitten, and William T. Williams, untitled dated statements, in Joseph Jacobs, ed., *Since the Harlem Renaissance: 50 Years of Afro-American Art*, catalogue for exhibition held at the Center Gallery of Bucknell University, Lewisburg, Pennsylvania, 1984. Reprinted by permission of the Samek Art Museum, Bucknell University

The *"Soul of a Nation" Reader: Writings by and about Black American Artists, 1960–1980* is published in 2021 by Gregory R. Miller & Co.

GREGORY R. MILLER & CO.

Gregory R. Miller & Co.
62 Cooper Square
New York, NY 10003
grmandco.com

Generous support for this publication has been provided by the Absolut Art Award and the Ford Foundation.

Distributed worldwide by:
ARTBOOK | D.A.P.
artbook.com

ISBN: 978-1-941366-32-5
Library of Congress Control Number: 2021934451

Book design: Julia Ma, Miko McGinty, Inc.
Copy editing: Jennifer Bernstein, Tenacious Editorial
Proofreading: Amelia Kutschbach
Typesetting: Tina Henderson
Color separations: Professional Graphics, Rockford, IL
Printing and binding in Canada by Friesens

Cover illustration: David Hammons. *Black First, America Second* (detail), 1970. Body print and screenprint on paper, 41¼ × 31¼ in. (104.8 × 79.4 cm). Tilton Family Collection (see p. 40)